Restless Ambition

Restless Ambition

Grace Hartigan, Painter

CATHY CURTIS

OXFORD
UNIVERSITY PRESS

Oxford University Press is a department of the
University of Oxford. It furthers the University's objective
of excellence in research, scholarship, and education
by publishing worldwide.

Oxford New York
Auckland Cape Town Dar es Salaam Hong Kong Karachi
Kuala Lumpur Madrid Melbourne Mexico City Nairobi
New Delhi Shanghai Taipei Toronto

With offices in
Argentina Austria Brazil Chile Czech Republic France Greece
Guatemala Hungary Italy Japan Poland Portugal Singapore
South Korea Switzerland Thailand Turkey Ukraine Vietnam

Oxford is a registered trade mark of Oxford University Press
in the UK and certain other countries.

Published in the United States of America by
Oxford University Press
198 Madison Avenue, New York, NY 10016

Library of Congress Cataloging-in-Publication Data
Curtis, Cathy (Writer on art)
Restless ambition : Grace Hartigan, painter / Cathy Curtis.
pages cm
Includes bibliographical references and index.
ISBN 978-0-19-939450-0 (alk. paper)
1. Hartigan, Grace. 2. Painters—United States—Biography.
3. Women painters—United States—Biography. I. Title.
ND237.H3434C87 2015
759.13—dc23
[B] 2014020233

9 8 7 6 5 4 3 2 1
Printed in the United States of America
on acid-free paper

In memory of my parents,
who taught me to read, encouraged my writing,
and were baffled by modern art

Contents

PART FOUR: *Fame (1956–1960)*

PART FIVE: *Beginning Again in Baltimore (1961–2008)*

How I Came to Write This Book

WHEN I MET GRACE HARTIGAN—she came out to California in 1988 for the opening of The Figurative Fifties, a museum exhibition that included paintings of hers from the 1950s—she was an earthy and voluble sixty-six-year-old woman, enjoying a second hurrah of renown. I was a young cultural reporter and art critic at the *Los Angeles Times*, pleased that her chattiness was making my job so easy.

Sitting on her sunny hotel balcony, Grace talked about how, when she was thirty-one and her painting *The Persian Jacket* was purchased by the Museum of Modern Art, she no longer had to live on "oatmeal and bacon ends." About how odd it was to see a photograph of herself in *Newsweek* in 1959, across the page from a shot of Judy Garland. And about how, although she considered herself an Abstract Expressionist, she felt "absolutely free" to use recognizable images in her work. "You don't live a category," she said. "You were just hanging out with a lot of interesting people."

Fast-forward to October 2010. Visiting the Museum of Modern Art on a trip to New York, I rounded a corner at the Abstract Expressionist New York exhibition and came face to face with a nearly eight-foot-tall painting. I was stunned at the power and beauty of its slashing blocks of vivid color—a work that held its own among canvases by the likes of Jackson Pollock and Willem de Kooning. Peering at the label, I saw that this was *Shinnecock Canal* (plate 11), painted by Grace in 1957.

Who was this woman who had shouldered her way to the top of the male club that was the New York art world of her era? How did she get there, and why did she fall so abruptly off the art map? Always fascinated by biography, I was avidly reading obituaries in search of someone whose life combined great achievement with a complex, intriguing personality. Now I had finally found her.

I called Paul Schimmel, chief curator of the Museum of Contemporary Art (MOCA) in Los Angeles. He had co-organized The Figurative Fifties at what was then the Newport Harbor Art Museum. What did he think about my writing a biography of Hartigan? Very good idea, he said, giving me a list of key art-world people to contact.

I discovered that Grace had entered adulthood with no goals except to escape her family. But once she became a painter, her self-regard and ferocious drive colored her relationships with the men she loved and the women she held at arm's length, and caused a fatal breach with her only child.

Although Grace lived to be eighty-six, I decided to devote nearly half of this biography to the 1950s, the decade of her finest paintings, when she managed—against great odds—to carve out a major career in New York. In dealing with this period, I broadened my focus to look at the personalities and achievements of those "interesting people" Grace hung out with and at the ways her life both resembled and differed from that of other women painters in her circle.

I came to understand that Grace's professional life was a roller-coaster of struggle, triumph, neglect, and rediscovery, while her personal life was blighted by alcoholism, romantic missteps, and personal tragedy. Yet she never stopped believing in her talent and her vision. Alone, in the studio, she spent her finest hours.

A Note About the painting reproductions in this book: Some of the works I discuss at length are not included among the color plates. There are several reasons for this, including the unavailability of certain images, overly restrictive reproduction stipulations, and the need to limit book production costs.

Restless Ambition

The Weekend That Changed Her Life

ON A SPRING DAY in 1960, Grace Hartigan was headed uptown to the ritzy Sherry Netherland hotel, to meet one of her collectors—a scientist from Baltimore. The world was finally paying attention to her paintings, but the constant interruptions that came with her new fame were encroaching on her precious studio time. Meanwhile, her private life was in its usual state of turmoil. Only a few months had passed since her honeymoon in St. Croix, but she already felt restless. She had gravitated to Bob because he seemed sensible and down-to-earth after the instability of so many of her other relationships. Well, she should have listened to all her friends who wondered what she saw in him. At this point, the only thing that really mattered was her painting. She would just try to shut out everything else.

AFTER YEARS OF STRUGGLE, Grace had triumphed. *Life* magazine had run a full-page photo of her in her studio, calling her the "most celebrated of the young American women painters."[1] Major museums were buying her work, as well as high-profile people like Nelson Rockefeller and the playwright William Inge. She was the only woman and youngest artist included in a groundbreaking Museum of Modern Art exhibition of Abstract Expressionist painting that toured eight European cities in 1958–59. Celebrity photographer Cecil Beaton's glamour shot of Grace ran with an article in *Newsweek* that said she frequently received "the most fervent praise" of all the artists in the show.[2]

Despite the accolades, Grace felt unsettled. In addition to the demands on her time by "thousands of devouring strangers,"[3] she was frustrated with her painting, feeling as though she had "lost contact" with something vital in herself.[4] She was also losing the sense of community that had buoyed her during the early fifties in her drafty loft on the Lower East Side of Manhattan.

The shared poverty, poor sales, and sky-high aspirations of the artists whose days were filled with solitary attempts to capture a hard-won personal

vision were giving way to a more contentious atmosphere. When Jackson Pol-
lock—along with Willem de Kooning, the most celebrated of them all—died
in a car crash in 1956, it was a watershed moment. Collectors were finally will-
ing to pay serious prices for the work of top New York School artists, as the
Abstract Expressionists[5] were also known. Some of those who were left out of
the loop responded with jealousy masked as contempt. Others had left the
city.

Then there was Grace's private life. After two early marriages, years of
tumultuous, on-and-off relationships with fellow struggling artists, several
one-night stands, and an awkward involvement with a wealthy and cultured
businessman she respected but was not attracted to, Grace had married the
stodgy owner of a bookstore with a small art gallery. It was not a happy union.
A tall, curvaceous woman with a mobile, intelligent face and a brash social
veneer that masked her introspective side, she was attractive to many men.
The problem was that they always seemed to be the wrong ones.

Months earlier, Beatrice (Beati) Perry, director of an art gallery in Wash-
ington, D.C., had told Grace that a client wanted to meet her. An enthusiastic
collector of modern art, Winston Price had purchased her painting *August
Harvest*, an abstract work in yellow and orange energized with nimble brown
brushwork, inspired by potato fields in rural Long Island.

Price was a rising star himself, an associate professor of epidemiology at
the Johns Hopkins University School of Hygiene and Public Health who had
received the prestigious Theobald Smith Award in Medical Sciences. In 1957,
he had experienced his own media moment—including effusive write-ups in
Time and *Life* magazines—for his work on a vaccine against the common
cold, Newspapers around the country had besieged him for interviews and
published breathless, often wildly inaccurate stories about how his work with
serum mucoids (colonies of bacteria in the blood) would result in a cure for
cancer and other major diseases.

At first, when Beati offered to let Grace know of Price's interest in her, he
responded strangely. "I'm not ready yet," he told her. Months later, he called
the gallery again. "OK," he said, "I'm ready for Grace."[6]

ALIGHTING FROM THE BUS, Grace hurried down the last half-block to the
hotel, past gleaming shop windows displaying elegant jewelry and other
lovely things she would likely never be able to afford. She moved briskly
through the marble lobby lit by a grand chandelier, past the roundels carved
with Roman goddesses in diaphanous gowns, and waited for the elevator to
descend.

At thirty-six, Price was a solidly built man of medium height with penetrating dark eyes set in an impassive, fleshy face. He was said to be extremely private, guarded about all aspects of his life beyond his laboratory work. Up until now, Grace had thought of scientists as "little men with big heads."[7] But then she met Price. "He opened the door, and there was this handsome, tall, gray-haired man."[8] Soon after Grace walked into his lavish suite, filled with the brilliantly colored flowers he had specially ordered, she was smitten.

Never having known a scientist, she was fascinated by the high-level research he was pursuing and was thrilled to be able to talk about her painting with someone deeply interested in adventurous modern art. For the next three days, they holed up in their luxurious home away from home, enjoying an intimate world of bliss. It was clear that he was as passionate about her as she was about him.

By the time Price returned to Baltimore, the die was cast. Grace soon confronted her husband, shocking him with the news that she had never loved him, and initiating the annulment of their marriage. Life with her new man would mean leaving New York and the tense and crazy and furiously driven art world that had helped her develop her extraordinary mastery of color. But she was ready to make the leap.

"I had to marry someone from a totally different walk of life, someone who would be good to me, make it possible to paint," Grace once said.[9] What she hadn't counted on was her sense of loss. For more than a decade, she had lived in a tiny world in which everyone she knew was intensely focused on the kind of art that mattered—from the famous paintings in museums to canvases still drying on studio walls—and constantly engaged in alcohol-fueled arguments about what art was and should be. In Baltimore, she would be isolated from that world, living with a man who would change her life in ways she couldn't possibly imagine.

Escape Artist (1922–1944)

1

Dreaming

FROM HER UNSEEN PERCH in a flowering apple tree, Grace Hartigan spied on the gypsy families whose caravans were parked in an empty field next to her home—an exotic sight in the 1930s in placid Millburn, New Jersey. Grace wanted to be a detective when she grew up, but her stakeout was driven by sheer visual delight.[1] She was captivated by the women's lustrous, brightly colored skirts and large golden earrings, by the knives the men sharpened, glinting ominously in the sunlight, and by the flicker of bonfires that cooked mysterious food in big black pots.[2] She yearned to make friends with these fascinating people, but her mother, muttering darkly about gypsies stealing children, had forbidden any contact.

DECADES LATER, GRACE would trot out versions of this story as the defining feature of her youth. The gypsies stood for a tantalizing otherness and for everything her middle-class family found alien and threatening. When she discovered the gypsies, Grace was living with her parents, two younger sisters, and baby brother in a two-story house with a neat stretch of lawn at 527 Wyoming Avenue. The broad, curving street was part of South Mountain Estates, a spacious new subdivision just five blocks from Taylor Park. Grapevines stretched along one side of the house and a patch of violets grew in back of the garage.

Millburn was a step up from the two-family house in Bayonne, New Jersey, squeezed next to its neighbors a half-block from Newark Bay, where Grace—born in Newark on March 28, 1922—had spent the first seven years of her life. Multi-family homes like Grace's accommodated an immigrant population accustomed to living with their extended families. Before his marriage, Grace's father, Matthew, had lived in Bayonne with his Irish-born parents. Working as an assistant foreman at Babcock & Wilcox, a large boiler manufacturing company, he claimed an exemption from the World War I draft at age twenty-five because he was their sole means of support.[3]

Many of Bayonne's residents were immigrants toiling in the silk, cotton, and wool mills, at Standard Oil of New Jersey, and in more than seventy factories

that produced chemicals and industrial components.[4] City life was colorful and cacophonous in the 1920s. Women carried their shopping in baskets and jugs, as they did in the Old Country, and vendors broadcast their wares through megaphones: "Watermelons! Roasted peanuts! Heeeere peaches-tomatoes-potatoes heeere!" (Decades later, Grace would be enchanted by a similar environment in the pushcart throngs of Manhattan's Lower East Side.) Newark Bay offered scavengers' treasures and fiddler crabs hiding under rocks at low tide. In winter, there was ice skating on Hudson County Park pond.

With few cars on the roads, children were allowed to roller-skate in long lines, holding each other at the waist. Girls played hopscotch on the sidewalks; boys flipped baseball cards and played stoop ball and stickball. Corner candy stores did a brisk business in sweets and comic books. Every Saturday, people crowded into the local theatres; for thirty-five cents you could watch two feature films, newsreels, cartoons, and ten vaudeville acts.[5]

Grace's unmarried Aunt Kate Hartigan lived with the family at 24 Edwards Court. After graduating from Columbia University, she had traded her dream of becoming a writer for a career as a schoolteacher. Grace fondly remembered how Aunt Kate used to take her to the movies on Saturday afternoons. Although the first "talkie" was released when Grace was five, theatres were still showing silent films, which were wholly dependent on the mesmerizing quality of black-and-white moving images. This was a thrilling early experience—huge faces on a glowing screen!—that Grace later credited as an influence on her preference for large canvases.[6] The close-up was Hollywood's gift to Abstract Expressionism, she believed, endowing American painters with a new, super-sized American scale.

Grace was also close to Nana, her Hartigan grandmother Mary Agnes. (Her maternal grandmother died long before Grace was born.) Sitting on Nana's comfortable lap, Grace was charmed by the ballads and stories Mary Agnes had learned as a child.* One of these was "The Raggle-Taggle Gypsies," an eighteenth-century song about a well-born married woman who runs off

* Hartigan's great-grandfather John Hartigan (originally O'Hartigan) emigrated from County Cork to Charleston, South Carolina, in the mid-nineteenth century, fleeing the Great Famine. According to family legend, he and his wife Ellen and their children—including Grace's grandfather Patrick, born in 1849—moved north to Bayonne, New Jersey, after hearing the first shot fired on Fort Sumter in 1861, launching the American Civil War. In the 1900 and 1910 U.S. Census, Patrick Hartigan gave his occupation as "machinist." He and his wife, Mary Agnes (a dressmaker who worked at home, born in 1868 in New Jersey to immigrants from Ireland and England), had four children, including Hartigan's father, Matthew, born in New York in 1891.

to join a band of gypsies.[7] In one version, when the lord of the manor chases her down, she replies, "What care I for a goose-feather bed / With the sheet turned down so bravely-O? / For tonight I'll sleep in a cold open field, / Along with the wraggle-taggle gypsies, O!" Grace could never have guessed that she would one day be happily living in the urban equivalent of the "cold open field"—an industrial building with no heat or electricity—with a rule-breaking man of her own. When Mary Agnes died, in 1951,[8] Grace was devastated. Her grandmother's loving embrace and their shared fantasy life were a refuge from her mother's chilliness and narrow-minded opinions.

Grace later claimed that she learned how to read on her own at age five, when she was bedridden for a year with a severe case of pneumonia that may have led the family to move inland to Millburn two years later. When she was ten, her father introduced her to the novels of Charles Dickens and the short stories of Edgar Allan Poe. The books were probably his own treasured copies. Unlike Bayonne, Millburn had no public library until 1938, when Grace was sixteen; a public official had declared that such an institution would be a hotbed of "anarchists and Communism."[9]

With a population of less than twelve thousand (less than one-sixth the size of Bayonne), Millburn had a cozy, small-town feel when Grace was growing up.[10] When she was ten, the Millburn Bicentennial Committee staged a July 4th pageant in which the resident playing George Washington rode on a white horse in Taylor Park[11] and danced a minuet with local men and women dressed in eighteenth-century costumes.[12] Some residents still kept cows, and the dense woods of 2,000-acre South Mountain Reservation, on the town's northern border, seemed almost primeval. Most people got around by walking, bicycling, or taking the streetcar, which linked Millburn with the big-city attractions of Newark. To drum up business during the Depression, Millburn's Ford dealer was not above accepting a saddle horse as a deposit on a new automobile.[13]

Everyday life proceeded according to accustomed patterns, remote from the threatening headlines of the national press. The prominent clock on the facade of Kaiser's Drugs on Main Street could have served as a symbol of the town's steady heartbeat. Before classes began, schoolchildren prayed, listened to a Bible reading, saluted the flag, and sang patriotic tunes and folk songs.[14] On weekends, the flashing lights of the Millburn Theatre marquee beckoned. Fifty cents would buy a Saturday-matinee double feature, cartoons, and a serial, fortified by candy from Cole's diner. One year, local news items included a traffic backup caused by people admiring the fall foliage, and the death of Smoke, the firehouse's mascot, a legendary mutt known for somehow

being able to distinguish emergency telephone "bells" from routine calls.[15] (The volume of calls would have been relatively light because only about a third of Millburn residents were phone-service subscribers.[16])

Although midtown Manhattan was less than an hour from Millburn by train—round-trip fare was sixty-five cents in the early 1930s—Grace later said that her family never went there to sample the city's cultural riches. For her mother, Manhattan was simply a destination for Christmas shopping, an excursion to Macy's, with Arthur in tow.[17] A proud and finicky member of the Daughters of the American Republic (DAR), Grace Gertrude Orvis Hartigan favored her son, who cemented their attachment when he applied for Sons of the American Revolution (SAR) membership at age twenty.[18]

Mrs. Hartigan seems to have inherited a privileged view of life from her own mother, Caroline Fulker Orvis. Born in England to a wealthy family— her father owned a coal-mining company—Caroline Orvis was accustomed to a household run by servants. She viewed domestic labor as beneath her despite the wavering fortunes of her husband, which at one point necessitated a move from a mansion in Newark to an apartment in New York City. Caroline may have met Wisconsin-born Orel Dighton Orvis—a Civil War veteran descended from a family that traced its roots to the seventeenth century— when he spent several years in England in the 1880s.[19] A sense of entitlement permeated both sides of the Orvis family. Orel had already worked his way through three wives before he married Caroline; the others, according to family legend, were not considered worthy of bearing his heirs.[20]

Grace never got along with her mother, who narcissistically bestowed both her first and middle names on her eldest daughter. (She once even wrote a check to "Grace Hartigan Jr."[21]) Toward the end of her life, apropos her painting *Mothers* (2004),[22] Grace remarked that its surface has "an edgy, scratchy feeling, like my own mother." Even the word *mother* made her think of *smother*, she said. "My mother was a killer.... Some women are good mothers. I just didn't happen to get one."[23]

The standoff between mother and daughter was exacerbated by the Great Depression, which made serious inroads into the family's finances. Grace's father—now an auditor at the Guarantee Trust Company of New York[24]— kept his job, but his pay was cut several times. After leaving his office in lower Manhattan, he would have taken the Erie-Lackawanna ferry to Hoboken Terminal and the train to Millburn. Grace, who loved him intensely, would run to meet him in the evenings as he walked the few blocks from the train station to their home. At dinner, which Grace's mother would render virtually inedible at the best of times—even good cuts of steak were plopped into a

water-filled frying pan until they turned gray[25]—a small piece of meat would be reserved for the man of the house. He would cut it into tiny pieces and lovingly fork it into the mouths of each of his children, like a mother bird feeding her young.[26]

During the last week of the month, when Grace's father's paycheck had been spent—she would later blame the shortfall on her mother's poor household management—the family often lived on cornflakes or boiled potatoes.[27] Breakfast would be milky coffee and peanut butter on crackers.[28] When bill collectors knocked on the door, everyone hid and kept quiet to preserve the illusion that no one was home.[29] In those pinched years, escapism for most people came mostly through movies, books, and dreams. Yet Grace may have exaggerated the direness of her family's poverty. She once invoked a pathetic scene of her family pressing their noses against the glass windows of restaurants, watching other people eat dinner,[30] yet Millburn had no dining establishments at that time.[31] Every summer, the Hartigans managed to spend a week or more at the Jersey shore, renting a cottage near the beach or the bay, a good crabbing spot. Grace's brother Arthur recalled that she and their father were the only family members who would eat the boiled crabs.[32] A beach photograph from the early thirties shows tall, skinny Grace with her mother, younger sisters, and baby brother, all squinting into the sun.

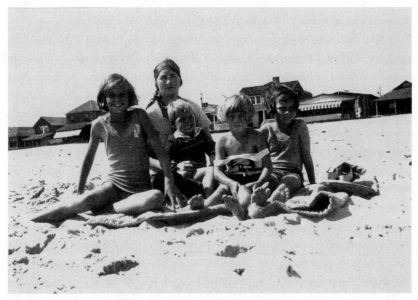

Hartigan family on the beach, Manasquan, New Jersey, ca. 1933. From left: Grace, Grace Gertrude with Arthur, Barbara, and Virginia. (Photo: Matthew Hartigan. Courtesy of Arthur Hartigan)

Mrs. Hartigan, who was nominally Methodist Episcopal[33]—she mostly liked the social aspect of belonging to a church[34]—looked down on her husband's Irish Catholic background. But neither parent was religious. Matthew Hartigan never attended church; in his view, belief in God was sufficient. The story went that his father—who had lived in Charleston, South Carolina, after emigrating—showed up at the Catholic church in Bayonne on a hot summer day in his shirtsleeves, routine practice in the South. Told that a tie and jacket were necessary, he turned around and went home, never to return. But for Grace, the otherworldly aura of the Catholic church offered another form of escapism. With a friend, she sometimes sneaked into Sunday Mass to marvel at the stained glass windows, the priest's elaborate garments, the flickering candles, and the solemn mystery of incense-scented ritual, so different from everyday life.

Quarrels between Grace's parents were the backdrop to her childhood, producing "an atmosphere of constant tension."[35] The stress entailed by Matthew Hartigan's long hours and financial worries was compounded by life with a difficult woman. A tall, sturdy man with a gentle demeanor, he had diverse interests, including sports (golf, baseball, and fishing), rose cultivation, and self-improvement—night-school courses in "whatever caught his fancy."[36] Grace's mother was primarily concerned with her social position, clinging for self-validation to her family tree, which she believed to include a French baron on her mother's side and distinguished English forebears.

Mrs. Hartigan's loudly voiced opinions and constant nagging grated on her daughter's nerves. She came to believe that her love of books and music and theatrical make-believe—all disparaged by her mother—were "something to fight for." Because they were forbidden, they were "maybe kind of magical," she said later, making her feel "as though I had a private life."[37] When Grace listened to the newly launched Metropolitan Opera broadcasts on Saturday mornings, her mother would brusquely snap off the radio.[38] She doubtless didn't see the irony: the ancestor through whom Mrs. Hartigan claimed DAR status was one Ambrose Orvis (1758–1844), a soldier in the American Revolution whose singing entertained the freezing troops in George Washington's winter camp and who played the snare drum at both of his inaugurations.[39]

Growing up, Grace mostly kept to herself. Her brother Arthur, the baby of the family, doesn't recall her coming along when they visited relatives. "She did as little as possible with the family," he said.[40] Grace rarely invited anyone to the house, and never to family meals. As a teenager, she sometimes prepared lunch for a friend, setting out sandwiches on a card table—a precursor of her improvised dinners in a bare-bones loft in New York. Her sister Barbara,

who was six years younger, told Grace later on that she spent her childhood trying to keep her independent older sister from "escaping."[41] Her sister Virginia, who was three years younger than Grace, had her own problems with their mother. Mrs. Hartigan looked askance at the girl's dark hair, which struck her as lacking the requisite blue-eyed, blonde WASP appearance of her other children.[42]

Grace's mother was always telling her, "You're so dissatisfied—so restless," a state of mind Grace would later ruefully call "my greatest curse and greatest *potential* asset, all in one."[43] But Mrs. Hartigan appeared to be equally dissatisfied, having married a man whose father had been a lowly blacksmith in Ireland and who—despite his diligent work habits—could not keep the family from the edge of poverty during the Depression years. (Never mind that he had supported his parents and enabled his three siblings to attend college.) Her own restlessness—her daughter Barbara jokingly called her a nomad—took the form of a series of household moves. After Grace left home, the family moved to a huge Victorian with a servant's entrance in Redbank, New Jersey, then to Plainfield, back to Millburn, and farther afield, to Lake Charles, Louisiana—a move dictated by Matthew's transfer to the office of an oil developer, where he headed the accounting department. Later, they returned to Millburn and eventually moved to another large Victorian in Westfield.

Always self-dramatizing—a trait Grace unwittingly adopted—Mrs. Hartigan would issue an unconscionable threat to her young daughters when they misbehaved: "When you come home from school, I'll be dead!"[44] When Grace was thirteen years old, her mother told her that her father's ritual goodnight kiss, delivered when Grace was tucked in bed, was somehow tainted and had to be discontinued. Grace was devastated. Toward the end of her life, she said that "I love you" were the three words her mother never uttered.[45]

As a small child, Grace owned a plump-cheeked Patsy Ann doll; made of painted wood pulp mixed with glue, it was designed to look like a little girl. Yet she envied her friends' more costly satin "bed dolls"—long-limbed creatures with bright red cupid's bow lips and made-up eyes that were the last word in flapper chic, designed to recline on a woman's pillow.[46] Decades later, dolls would repeatedly figure in her paintings. While Grace would talk about modern dolls as symbols of the hopes and dreams of American girlhood, and of the marketing clout of American manufacturers, the doll she owned as a child was her "Rosebud."† It was the constant companion of her childhood

† In Orson Welles's film *Citizen Kane*, the enigmatic last word of protagonist Charles Foster Kane turns out to refer to the brand of sled he had as a child.

fantasy life in a zone removed from her mother's toxic combination of smothering attention and lack of empathy.

Escaping to the world of her imagination, Grace turned an old car the family owned into a miniature theater, partitioned boxes to make "rooms" for caterpillars, and tried to coax abandoned plants into a "magical garden."[47] Her private world intersected with her real life when she was chosen as Queen of the May at a local celebration, an honor that allowed her to wear a gold-painted cardboard crown and dance with the other children around a maypole.[48] Decades later, she said that she had managed to retain "the child in me and the [sense of] play and those joys" throughout her life.[49]

Like many little girls, she also liked to draw pictures of princesses in her diary. Her fascination with the larger-than-life aspect of royalty would surface many years later in her painting series *Great Queens and Empresses*. But when her eighth-grade art teacher instructed the class to copy a calendar picture of a smiling girl wearing a tasseled skating cap, Grace struggled.[50] At the time, noting that other students were able to make accurate copies of the picture, she felt awkward and inept.[51] Frustrated because she couldn't get the teeth in the woman's "toothpasty" smile to look right, Grace avoided anything to do with art or art-making for nearly a decade. (In what may be a private joke, she included a "toothpasty" smile—from an ad for the Ipana brand—at the top of her 1957 painting *Billboard*. Her mentor Willem de Kooning had led the way, affixing a woman's smile cut from a cigarette ad in a magazine onto his 1950 painting *Woman*.) At the height of her fame, she dismissed the junior-high exercise as having nothing to do with real art-making: "Whatever that combination of the hand and the emotions is which makes an artist from birth wouldn't let me copy things like the rest of the class."[52]

Apart from art class, Grace seems to have had no trouble fitting in and succeeding in school. She was lucky to live in a town where the public school classes were small, French was taught from second grade through high school, and the English and drama instruction was "extraordinary."[53] Once Grace entered Millburn High School, she became a star, not only in the literal sense (she took the lead in school plays and was voted Best Actress of the Class of 1940[54]) but also in terms of her academic performance and involvement in numerous extracurricular activities. A fixture on the school's honor roll, she was a student council representative and assistant editor of the yearbook. She was also an active member of the Forum Club, which debated such timely issues as "What Should the United States Do in the Present Situation?" (In December 1939, the "situation" was likely the potential amendment of the U.S. Neutrality Act to allow the sale of arms to the Allied forces.) Although

Grace didn't become actively involved in politics as an adult, she was always firmly on the side of liberal causes.

Earlier that year, in a speech to the local Rotary Club, Grace cannily couched a defense of extracurricular activities—apparently under review for budgetary reasons—in terms of her generation's "terrifying problem" of adjusting to a strife-torn world. In her speech, printed in full in *The Millburn & Short Hills Item*, the weekly newspaper,[55] she asserted that activities like the drama club provided important life lessons. These included "a submergence of the selfishly personal to the group expression, and a development of understanding both through working with other people in a common striving for good performances and through an honest, sincere attempt to interpret and understand characters that are different from us." As a starry-eyed young woman, Grace could not foresee that she would never learn the first of these life lessons.

Frieda E. Reed, an English teacher who also directed the drama club's performances, had taken the teenager under her wing. Warming to the novelty of having an adult listen to her dreams and encourage her interests, Grace thought she might pursue an acting career. A spinster (as unmarried women were unflatteringly known in those days) who dedicated her entire working life to high school teaching, Reed was no more a role model for Grace than her schoolteacher aunt. Yet Grace would later tell *Current Biography* that Reed was "one of the strongest influences of her adolescent years."[56] Reed's ongoing interest in her development filled the void of her mother's indifference and may well have influenced Grace's deep involvement in the lives of her graduate art students decades later. "She spent a lot of time with me outside of school," Grace later recalled. "I think she thought I had…an unusual sensitivity and a kind of brain that interested her."[57] Talking about books with Reed allowed Grace "to think of myself as a feeling, thinking, developing person."

But her brain was not an asset when it came to dating, or even making friends. Despite her lovely face and slim figure, boys were not attracted to her—or so she claimed decades later. Tall and shy, she was perceived as a girl who "thought too much" and "read too much."[58] Grace's earnestness contrasted with the rah-rah spirit of many of her classmates, whose excitement reached a fever point when the high school's football team aced the state championship in 1940. It's hard to imagine Grace being attracted to male classmates whose idea of fun was daring one another to dangle off one of the town's bridges.[59] She had only one close friend in high school, a girl who shared her interest in literature. They both felt persecuted, she said—Grace,

because of her "differentness" and Dorothy, because she was Jewish.[60] In later years, Grace would have a special affinity with her Jewish friends and lovers. Meanwhile, her parents pressured her to try to be more like other young people, adding to the stress of her home life. Even her interests in literature and theater were judged to be "weird."[61]

In her junior year, Grace played Mrs. McIntyre ("an understanding mother"—not exactly a role for which Grace could draw on personal experience) in *Growing Pains*, by Aurlania Rouveral, billed as "a comedy of adolescence."[62] In the senior class play, *Pride and Prejudice,* Grace took the role of Mrs. Bennett, whose foolishness, narrow-minded views, and blatant social climbing must have seemed more familiar. The novel's protagonist, Elizabeth Bennett, would have been the leading female role, but perhaps Grace specifically wanted to play Mrs. Bennett, knowing that her mother would be in the audience, along with the rest of her family. (Mrs. Hartigan's response has not been recorded.) Grace later claimed that during this time she also had a bit part in a professional production at the Papermill Playhouse, built on the site of a former paper mill.[63] She retained a lifelong fascination with the trappings of theatricality—costumes, masks, the power of gesture—precisely because of their larger-than-life dimension.

Grace's picture in the *Millwheel*, the high school yearbook, captures her heart-shaped face, wide-set eyes, and radiant smile, framed by immaculately waved blonde shoulder-length hair that catches the light. She wears a strand of seed pearls over a demure high-necked sweater. On top of the page, in her distinctively elongated handwriting, Grace wrote a note praising a fellow student's acting abilities, politely suggesting that the other girl should have won the "Best Acting" award. Her entry was written with the self-conscious peppiness of generations of yearbook scribes:

> Popped expectantly out of the auditorium to see the august senior member of the Student Council [i.e., Grace] waltzing up and down the halls to the tune of the "Blue Danube" à la "gay nineties." In Press Club, again cornered the perennial heroine of Millburn play productions, concentrating on a prospective scoop for the "Item" [the local paper]. However our co-editor's favorite pastime seems to be riding around in that sporty apple-green convertible…. [T]he honor roll just wouldn't be the honor roll without Grace. [The car belonged to a friend.]

Grace's father always told her that she could do anything she put her mind to,[64] and even her mother realized that this daughter was not cut out to be a

housewife.[65] "My parents never treated me as if I was going to be anything but difficult and different," she once said. "They knew it, as if they had a changeling"— a fairy child—"on their hands."[66] Grace would always think of herself as someone special and unusual, a state of mind evoked in many of her journal entries of the early fifties. Decades later, summing up her early life, she wrote, "I came from a middle-class family where my brilliance and imagination had been encouraged when I was very young, [but] every attempt [was] made to squash it when I reached my teens."[67] Grace's sisters would follow more conventional paths, with lasting marriages and children, though neither was a stay-at-home wife. Virginia and Barbara—whose husbands were best friends since childhood—both worked for many years at Rutgers University. As a young woman, Barbara was a fashion model at the Ford Modeling Agency in New York.

Grace's outstanding high school record won her two scholarships, one from what was then known as Ryder Business College.[68] Surprisingly, she chose not to accept either one. She later explained that she owned only one dress—surely an exaggeration—and that her family couldn't afford to buy her a new wardrobe.[69] The more likely problem was that she would have had to live at home to save money. It's also possible that Grace worried about being groomed for a business career. According to her brother Arthur, "At that time she was just interested, seemingly, in getting married and getting out of the house."[70] He was the lucky one; by the time he was in high school, the Depression was history, his father had passed the CPA exam and landed a better position, and there was money to buy Arthur a car and send him to Lehigh University.

While many of the women who became Grace's artistic peers attended college, higher education was by no means a given for middle-class women in those years. In 1940, fewer than 30 percent of women twenty-five years or older in the United States had completed high school, and only 4 percent had completed college.[71] A good high school like the one Grace attended provided a thorough grounding in English literature, history, and other traditional subjects, which would serve her critical thinking skills in the years to come.

After graduation, she followed in her father's footsteps, taking a clerical position at the Prudential Insurance Company in Newark, New Jersey. That's where she met "brilliant,"[72] "idealistic"[73] Robert Lincoln Jachens, her husband-to-be. Two years older than Grace, with a compact physique and an open, friendly face, he had also grown up with a difficult mother. It is likely that her hearing loss made her constant arguments with her husband unusually loud and long. Louise Preston Lincoln Jachens was a schoolteacher who considered herself superior to her husband, Diedrich Claus, a baker with little formal education. Robert, who had rheumatic fever as a young child, heard

the doctor yell to his mother, "I say he has a fifty-fifty chance of survival!"[74] Knowing at such a young age that he might die may have contributed to the anxieties and lack of self-confidence that haunted him as a young man.

Robert lived with his parents in Bloomfield, New Jersey, while working as an accountant. After enrolling in 1937 as a humanities student at Columbia College—part of Columbia University in New York—he had at left the end of his second year. Whether he was discouraged with academic life or simply needed to earn money in a Depression year is not known. (In the early decades of the twentieth century, the accounting profession was still inventing itself; only a high school diploma was required for the Certified Public Accountant examination.[75]) He returned to Columbia a year later, in September 1940, only to drop out again in January 1941. Seven years later, he enrolled in the university's School of General Studies but dropped out at the end of the school year and never graduated.[76] The reason for his sporadic attendance may have been lack of money, but it is more likely that he felt he couldn't measure up, that he didn't believe himself to be cut out for a life of the mind. "I think he didn't get the satisfaction from intellectual pursuits that he did from using his hands," his fourth wife said after his death. Curiously, he told her that he threw his diploma—which, in fact, he had never received—in his mother's face.[77]

Robert had entered Columbia at a serendipitous time, when the undergraduate curriculum in humanities included a mandatory freshman survey of the classic works of Western literature and philosophy. In those years, Columbia undergraduates had the benefit of small classes that encouraged discussion and debate as well as writing, with the goal of fostering "analytic, discursive, and imaginative thinking."[78] The Columbia faculty included such luminaries as the poet, literary critic, and legendary professor Mark van Doren, whose students included Alan Ginsberg and Jack Kerouac.

Robert used what he gleaned from his Columbia education—which may also have included a new elective course in visual arts and music—to woo his smart and attractive young officemate. New to such romantic attention, Grace was smitten because he was "the first boy who read poetry to me."[79] (But not the last. Years later, another man—her close friend Frank O'Hara—would read her his own poems, some of which he dedicated to her.) Robert also introduced her to the Metropolitan Museum of Art, where she was enchanted by the rooms of seventeenth-century paintings—portraits of elaborately dressed men and women, formal scenes at the Spanish court, and dashing male aristocrats on horseback.

Without realizing it at the time, Grace was inspired by the costumes and the grand sense of style displayed in these paintings, which would become sources of imagery for her own work a decade later. But she could not begin to envision what the future might hold. On the cusp of her twenties, she had no outlet for her restless, unfocused ambition.

2

Searching

INSPIRED BY THE 1935 movie *The Call of the Wild* (loosely based on Jack London's adventure novel, published three decades earlier), Grace and Robert hit on the wildly improbable idea of becoming pioneers in what was then the Alaska Territory.[1] In the movie,[2] Clark Gable plays a prospector during the Yukon Gold Rush who rescues a sled dog and a woman (Loretta Young), shown in the film's poster as a damsel in distress swooning in Gable's arms while both are pelted by a blizzard. The vehicle for the two stars (who were secretly real-life lovers) added a romantic angle that doesn't exist in London's book. Young's character, married to another prospector who has temporarily vanished, explains that she came on the trip with him because of their love for each other. It's not hard to imagine a teenaged Grace enraptured by this scenario.

In reality, the rugged climate and frontier rawness of Alaska made it a foolhardy destination for a young couple accustomed to city and suburban life. Grace and Robert probably were not aware of the Alaska Railroad's settler-recruitment efforts—an illustrated pamphlet and a poster for display in post offices—because they targeted American farmers.[3] In the decades between the Dustbowl migrations and the Beats' famous road trips—and long before hippies traveled to exotic places in search of enlightenment—family and economic considerations generally kept young Americans in their hometowns. But Grace's romantic imagination was sparked by this great adventure, and she was desperate to put considerable mileage between her herself and her family.

It isn't clear whether she ever told her parents what she and Robert had in mind. In fact, just about everything about their wedding—on May 10, 1941—and the couple's subsequent life seems off-kilter. More than four months elapsed before the wedding announcement was published in *The Millburn & Short Hills Item*. On September 26, the social column announced that the nuptials had taken place at the "Chelsea Baptist Church, New York City." Why a Baptist church? In any case, there was no Chelsea Baptist Church in Manhattan at that time.

Compounding the mystery is the fact that Grace's eleven-year-old brother not only did not attend the wedding but also was completely unaware that it had taken place.[4] While her status-conscious mother surely would have wanted a traditional ceremony, Grace later said that she never had a "white" wedding. Perhaps there was no money for a wedding dress, though the Hartigans somehow managed to afford the dinner party they hosted in honor of the married couple.[5] It's likely that the wedding was a hasty, private affair, for reasons that remain unclear. Did Grace's parents disapprove of Robert? Was there a tussle about the right church for the ceremony? This doesn't seem to have been a "shotgun" marriage; the couple's child was born nine months and seventeen days after the wedding. It's possible that Mrs. Hartigan fabricated the wedding date as a cover-up, but the fact that Grace would cite the May date in later years—when she was outspoken about many personal details of her life—seems to rule out that possibility. In any case, Mrs. Hartigan (who always made herself out to be several years younger than she was) would not have been above a bit of subterfuge. Sending the newspaper a delayed notice specifying a nonexistent church in a major city would make the ceremony sound suitably conventional yet conveniently untraceable.[6]

The social column article also contains another odd piece of news. The young couple, it reports, "will leave Oct. 1 to make their home in Los Angeles." The way Grace always told the story, she and Robert wound up in Los Angeles only because they ran out of money. Of course, "to make their home in the wilds of Alaska" would not have had quite the right ring for the society page. Even Los Angeles must have sounded unusually distant from New Jersey in an era when married middle-class children generally settled near their parents, and there was no mention in the article of future employment for Robert that would have prompted the move. It's possible that Grace's parents didn't know the couple's planned destination. Perhaps Mrs. Hartigan was simply too annoyed and embarrassed to announce this crazy plan to the good people of Millburn.

Grace and Robert traveled across the United States by bus. Unfortunately, they left no record of what must have been an eye-opening journey for two young people who had never ventured west of New Jersey. If they were on a Trailways bus, the five-day trip from New York would have taken them through Chicago, Peoria, Hannibal, Kansas City, Topeka, Wichita, Dodge City, Denver, Santa Fe, Albuquerque, Flagstaff, Phoenix, and Barstow, as well as more than a dozen small towns along the way.[7]

Judging by Grace's fascination with the vegetation and atmosphere of the American South on a later trip, and the luminous abstract versions of Long

Island farmland she painted, the changing landscape would have intrigued her. Flat expanses of wheat and corn fields, immense wind-carved mountain silhouettes, the sparse look of scrubland—all would have seemed utterly foreign to someone from the tame green leafiness of small-town New Jersey. Increasingly weary and rumpled as the days wore on, Grace and Robert would hope to find a hasty meal at a roadside greasy spoon—fast-food options were years away—before climbing aboard again. When the bus finally pulled into the Central Bus Depot on South Main Street, the couple found themselves at the dreary edge of downtown Los Angeles.

The city would have seemed exotic to a pair of Easterners, atmospherically different in both senses of the word. In 1941, Los Angeles had its first experience of smog, described by an observer as "a gloomy forbidding cloud over the metropolitan area" caused by a toxic combination of diesel truck and auto exhaust, backyard incinerators, and industrial plant emissions.[8] At night, the urban sky was crisscrossed by arc lights heralding yet another premiere, though not necessarily of the headline-making variety. While some of these events involved movie stars swathed in furs and ogled by adoring crowds, others heralded the launch of supermarkets, gas stations, and hot dog stands.[9]

Los Angeles was still inventing itself. At thirty-two stories, City Hall towered over a city in which a hodgepodge of building styles rubbed shoulders. Victorian-era brownstones sat next to boxy industrial structures and modest stucco apartments; maverick restaurants stood out with buildings shaped like a shoe or a hat. Billboards touted brand-name goods, real estate bonanzas, and religious sects offering a direct line to God. Off in the distance, bobbing oil derricks and lush orchards were the visible sign of this land of promise.

But for Grace, the excitement of arrival was tempered by something she hadn't counted on—pregnancy. At first, she drew on her romantic imagination. "That's all right," she thought. "Pioneers have children…in the fields and tuck them under an arm and go on."[10] (In another interview, she offered an alternative scenario: She didn't want a child but feared the dangers of an illegal abortion, the only kind available at that time.[11]) Grace was soon laid low with severe morning sickness in a cheap rented room, and the couple had run out of money. All the fun had drained out of this adventure.

Robert, who had never skied, smooth-talked his way into a job as a department store ski instructor and salesman. He tried to ease Grace out of the doldrums, telling her, "I know you're not going to be a housewife. Now, what are you going to do? You're creative."[12] Grace had given up her dreams of becoming an actress, claiming later that she had been impatient with the stagey dialogue of plays of that era. "I got so sick of saying those crummy words," she

said, intoning a remembered passage from Maxwell Anderson's 1930 blank-verse drama *Elizabeth the Queen*: " 'Where I walk / In a hall of torture, where the curious / gods bring all / their racks....' What intelligent being can go around saying stuff like that?"[13] She also claimed at various times that she "hated to be an interpreter of someone else's expression"[14] or that at age nineteen she wasn't sufficiently narcissistic to display herself onstage. "How about writing?" Robert asked. She wasn't talented enough. Music? It was too late to start now. Well, maybe she could learn how to draw and paint.

Robert and Grace both enrolled in an evening class in drawing at a high school. The Los Angeles public school system was a national pioneer in adult education, with twenty-four schools offering day and night classes in diverse subjects. We don't know where the couple studied, but a likely candidate is Manual Arts High School,* conveniently located near a streetcar stop on South Vermont Avenue, which offered "Drawing Freehand."[15] A similar class at Los Angeles City College during those years was described as "Drawing from still life, landscape and figure. Development of feeling for quality in line and mass."[16] Line and mass gave Grace a hard time. Trying to draw a still life of flowers turned out to be just as hard as getting that calendar woman's smile to look right. "I was really totally untalented," she confessed decades later to an interviewer. But, she added, "I knew I was involved because I began to cry.... [Robert] would sit next to me looking at me in bewilderment while he was very nicely drawing vases and flowers, and I would be sitting there with a pencil and piece of paper, trying to make marks on it and crying."[17] Yet she was hooked. "I knew there was something very deep and mysterious there. It was like I had a calling."[18]

Meanwhile, Grace and Robert explored their new home. In a photograph taken in an unidentified wooded setting, Grace—whose pregnancy isn't showing yet—poses demurely in a pale blouse and full skirt with an embroidered border next to a rough-hewn wooden cross. But the couple had hardly begun to get acclimated to Los Angeles and learn the rudiments of drawing when Japan attacked the U.S. naval base at Pearl Harbor on December 7, and the United States entered the war.

Jeffrey Arthur Jachens was born on February 27, 1942, when nerves were on edge in Los Angeles. Five days earlier, the shelling of an oil well eighty miles up the coast by a Japanese submarine had led to the false report that enemy planes were poised to attack Los Angeles. Grace, who had been in

* Manual Arts became famous in later years for its day students of the 1920s, who included the painters Jackson Pollock and Philip Goldstein (later Guston), whom Grace would meet in New York.

labor for a day and a half, declared that she never again wanted to go through the ordeal of childbirth.

Robert knew that he would be drafted, so there was no point in trying to stay in Los Angeles. Soon after Jeffrey's birth, the couple returned to New Jersey to live with Robert's parents. In a photograph, Grace wears a smart blouse and slacks as she bends over her baby. A year or so later, another snapshot shows his metamorphosis into a cute blond boy in short pants and a large-collared shirt. Next to him, Grace poses in pearls, button earrings, and a black dress with fringed sleeves. She looks happier, perhaps because she is finally on her own. Robert was drafted into the Army as a private in April 1943. Years later, he said that he and Grace had agreed to go their separate ways because he expected to be killed in the war. "Good-bye," he told her. "Go ahead and make a life."[19] Of course, it wasn't really as simple as that. Grace later mused on how little sense of herself she had when she married. Although she didn't elaborate, it's clear that she was in thrall to half-baked romantic notions that were swept away by the realities of marriage to a man she hadn't known well and a child she hadn't planned for.

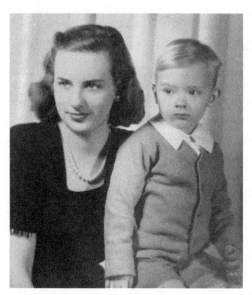

Grace with her son Jeffrey, 1943. (Grace Hartigan Papers, Special Collections Research Center, Syracuse University Libraries)

Unwilling to remain with her in-laws in Bloomfield, New Jersey (she privately called the town Bataan, a bitter joke[†]), and unable to support herself and her son on Robert's meager income as a private, she had decided to look for work. Robert had told her that rather than seek out another clerical job, she could make more money at a factory as a "tracer," a person who locates lost or missing pieces of machinery. Factories were gearing up for wartime production, and women were assuming a greater role on assembly lines. Borrowing a page from Robert's playbook, Grace claimed to be an experienced tracer.

Through a fortuitous mix-up, she was hired to trace machine parts in the drafting department of a new Wright Aeronautical factory.[20] It had opened in 1942, a few miles north of Newark, to accommodate wartime production of the Wright Cyclone radial piston engine for the B-29 bomber. Pleased to see that she "knew how to hold a compass," unlike the last woman the company hired, her supervisor arranged for her to enroll in night school at Newark College of Engineering.[21] After she became a full-fledged "woman draftsman," she discovered that the man working next to her, producing the same type of drawings, was making twice as much. So she took her complaint to the boss and got a raise.[22]

Now financially independent, if barely so, Grace lived in the drab Cathedral Park Apartments on Clifton Avenue, at the edge of a depressed area of the city.[‡] The one bright spot was the view across the street of the vast and inspiring Cathedral of the Sacred Heart, built in the French Gothic style.[23] With three rose windows and an abundance of stained glass, the church appealed to her sense of grandeur and ritual, though it is not known whether she ever stepped inside.

And Jeffrey? He spent most waking hours of his infant life in a daycare facility, the first of several displacements that would eventually drive a permanent wedge between him and his mother. On weekends, Grace tried to paint in watercolor, unwittingly choosing a medium difficult for an amateur to master. Not having better models, she copied hackneyed subjects like Dutch shoes with trailing ivy.[24]

But she was young, intelligent, vivacious, and pretty—a tall blonde with a curvaceous figure—and she was about to find a mentor.

† Bataan is the province in the Philippines that became notorious for the "death march" of American and Filipino forces by the victorious Japanese in 1942.

‡ Now Section 8 housing, this building, with ornate vintage molding on its facade, is a likely candidate for the apartment where Grace spent despairing months in the mid-forties. We don't know the address because she was not listed in the Newark city directory of 1943 (no directory was printed in 1944).

3

Learning

ONE OF THE MANY SERENDIPITOUS ENCOUNTERS Grace had in her early career was a chat with a fellow draftsman at her factory job. "Do you like modern art?" he asked. She said she didn't know what it was.[1] So he showed her a book of reproductions of paintings by the French painter Henri Matisse, then in his early seventies. After early years of obscurity, followed by volleys of wrath and scorn from the art establishment, he was now revered by modern art enthusiasts as a master of color and exuberant yet disciplined line. He had dared to paint the world around him not as others saw it, not according to rules accepted by centuries of artists, but as he intuitively experienced it. Yet, although he had been on the cover of *Time* magazine in 1930, Matisse was still hardly a household name in the United States, overshadowed by the tremendous fame of Pablo Picasso.

In 1904, Matisse had made a bold move. Although working in the radical style of the artists who would soon be known as the Fauves ("wild beasts"), he had been trying to support his wife and three children with sales of conventional still lifes to a dealer who offered to buy as many as he could supply. It was a financially perilous time; he struggled to put food on the table. (To cope, Matisse and his wife were obliged to send their two sons to live with relatives; Matisse's daughter by an earlier liaison remained at home.)

As he told the story decades later,[2] one day while putting the final touches on a still life, he realized that he could not go on denying his personal vision. He destroyed the painting, dating his artistic "emancipation" from that moment. ("Destroying" actually meant putting his wife and daughter to work scrubbing away the paint; he was too poor to sacrifice the canvas itself.[3]) Yet even in 1951—when, at the age of eighty-two, he received a major retrospective exhibition from the Museum of Modern Art—he still suffered from overwhelming doubts. (His insomnia, exacerbated in 1905, when he made his great breakthrough, also never abated.) When he finished a painting, he believed it was the best he had ever done; after thinking about it, he wasn't so sure. Matisse compared this situation to a traveler taking a train to another

city but discovering that he either hadn't reached his destination or that it wasn't really where he wanted to go.

Along with Willem de Kooning, Matisse would be Grace's primary touchstone during her early years as a painter, when she struggled to learn from him without overtly borrowing from his work. His twinned emotions of supreme assurance and coruscating doubt were ones Grace would also experience, and record in her journal. But when she first saw the reproductions of his paintings, "it was love at first sight, mostly, I must confess, because it looked so easy, I thought I could do it, too."[4] As she said years later, "The thing I got from him was the line that makes volume, the sensual line."[5]

Grace's draftsman colleague told her that he was studying two nights a week with Isaac (Ike) Lane Muse, a local art teacher and painter. When she met Ike, she was twenty; he was thirty-six.[6] He was a father figure, but with a twinkle in his eye and a dashing artist's beard and mustache. A photograph of Ike in a testimonial ad for Grumbacher artists' oil paints shows him in his cluttered studio on New Street in Newark, wearing an open-collared shirt with carelessly rolled-up sleeves and a splotch of paint on his shirt pocket. His closed-lipped smile gives him a self-satisfied look. According to the ad, he was "a leader in the important Art Movements of New Jersey"—whatever those may have been—and someone whose "interesting and original views on art have made him known in the Eastern states." Ike was also represented in several museum collections, including those of the Whitney Museum of American Art and the "Modern Museum" (the Museum of Modern Art, which acquired a painting of his in 1943).[7] His work was later shown at the Whitney (1947–48) and at the Bertha Schaefer and Mortimer Levitt Galleries in New York (1951).

It is easy to see how such a genial self-promoter acquired a student following. Born in Maysville, Kentucky, in 1906, Ike studied with several painters in Indiana and eventually made his way to New York, where he was a pupil of Russian émigré Ivan Olinsky—best known for his murals and portraits—at the National Academy of Design. By the time Ike met Grace, he had moved to Newark, where he painted in a decorative, Cubist-derived style. Beginning in 1941, he was active in the Newark cooperative gallery he cofounded, Artists of Today.[8] An unsigned *Herald Tribune* review of a one-man exhibition at the Artists' Gallery in New York in 1942 describes his paintings as "light, engaging fare" in a "lyrical style" with a "pleasurable feeling toward color."[9] His show of watercolors at the gallery the following year elicited a spattering of adjectives from a reviewer: "young, accomplished, experimental, energetic, and sensitive."[10]

Grace later realized that Ike's teaching had its limitations. On the positive side was "his liking for and encouragement of emotion and intensity even when accompanied by little or no skill," an attitude Grace herself would demonstrate when she began teaching.[11] "The bad part of his instruction was that he taught design while believing he was teaching art," she said. "His favorite words were 'texture,' 'pattern,' [and] 'light and dark.' … He really didn't know about modern art; he thought he did, but he didn't."[12] It wasn't until she began to hang out with accomplished painters in New York that Grace heard discussions of key modern-art issues like maintaining the flatness of the picture plane (avoiding the illusion of perspective, in which distant objects appear smaller than close ones). What she had been doing with Ike was "poetic and imaginative and dreamy," she said later. "But it wasn't painting."[13]

Ike's major gift to Grace during the three years she studied with him was twofold: a crash course in Old Master paintings and the birth of modern art (especially Cubism and Matisse), and a drawing technique he borrowed from an intriguing new book, Kimon Nicolaides's *The Natural Way to Draw.**

Nicolaides, a teacher at the Art Students League in New York, proclaimed that there is "only one right way to learn to draw." This method had nothing to do with mastering a technique or understanding aesthetics. "It has only to do with correct observation," Nicolaides wrote, "and by that I mean a physical contact with all sorts of objects through the senses." He believed that "art should be concerned more with life than art." And he wisely observed that "the sooner you make your first five thousand mistakes, the sooner you will be able to correct them." Today, we talk about putting in 10,000 hours to master a subject. That, in essence, was what Nicolaides was teaching.

He advocated a three-pronged way to learn to draw, but the most significant element for Grace was free and rapid "gesture drawing." Perle Fine, an Abstract Expressionist painter who studied with Nicolaides, said that the quick sketches ("almost scribbles") she learned from him "were more important than we thought" because "we went for the spirit of the action rather than the outlining of the figure."[14] Nicolaides helped energize the work of the artists later known (in Harold Rosenberg's phrase) as "action painters."

While Grace was absorbing these precepts, she was also falling in love. Decades later, she would tell me that Ike was "a terrific lover and he taught me more to do in bed than he did about painting, actually."[15] After sex with Ike, she told another interviewer, "I was aching from head to foot."[16] The possibilities

* Still in print, *The Natural Way to Draw* was first published in 1941, three years after Nicolaides's untimely death.

were a revelation. Robert, who was posted at a brewery in the Netherlands, had simultaneously become involved with the brewmaster's daughter, and the marriage had fallen apart. "By the time I was in my late twenties…I didn't know my first husband [and] he didn't know me," Grace said later.[17] The couple was granted a New Jersey divorce on January 24, 1947, on the grounds of Grace's adultery;[18] it's not clear why she officially became the "guilty" one.[†] Her ex-husband would remain in Jeffrey's life to a much greater extent than Grace did, especially after Robert moved to California and met the woman who became his second wife.

Grace was loyal to her exes and old flames when interviewers would ask about them in later years, offering fond tidbits or laughing dismissals that gave little away. She never had much to say about Robert. But a single, un-elaborated comment in her journal in 1953—she compares him to "an almost frighteningly restrained" lover whom she believes to be "deeply and violently emotionally disturbed"—rings alarm bells.[19] What could she have meant? Robert admitted to his fourth wife that he "was not a terribly nice person" during his years with Grace, but he didn't explain further.[20] His passive side is obvious—in the Army, even his drill sergeant mocked him for wielding a bayonet "with all the [aggressiveness] of an eight-year-old Girl Scout." (To which he said he proudly replied, "Thank you, Sir."[21]) But it is hard to fathom the reasons for Grace's stinging indictment.

Honorably discharged in 1946 as a technician fifth grade, just two ranks above private, Robert did not see combat. His medals—American Service, Good Conduct, European African Middle Eastern Service, World War II Victory—were the kind that any soldier in good standing received.[22] But he told his fourth wife that while stationed in the Netherlands during the final year of the war, he risked official wrath to keep requisitioning extra food, which he gave without authorization to starving villagers whose homes and fields had been destroyed by the Germans.[23] By the time his superiors discovered the discrepancy and cut off his supplies, he said, the war was over. After his discharge, Robert suffered from what was then called combat fatigue, now known as posttraumatic stress syndrome (PTSD).[24] That summer, he walked around in an overcoat because he always felt cold. At one point, he kept nineteen cats in his apartment. In an effort to deal with his sense of dislocation, Robert underwent Reichian therapy (Wilhelm Reich is famous for his controversial theories about orgasm), the results of which are unknown.

† No-fault divorce was not an option in New Jersey until 1971.

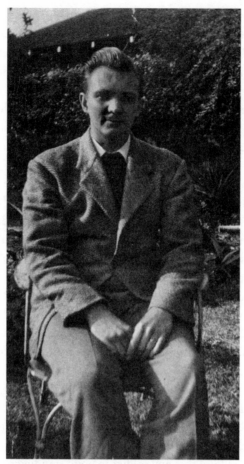

Robert Jachens in Los Angeles, 1942. (Courtesy of Linda Johnson)

One of the few comments Grace made publicly about Robert is that he entered the war as a private and never moved up in the ranks, "something no soldier has ever done in the history of the United States Army," Grace told one interviewer.[25] She was exaggerating on both counts, but her remark reflects her bafflement at a man who lacked her drive and ambition. She would soon discover what life was like on the other side of the coin.

AT ONE POINT during her affair with Ike, Grace became pregnant and sank into a terrible depression. It is not clear whether she lost the baby or had an abortion—likely the latter—but she wrote several years later that "life could never be so black again as it was in those years."[26] (In fact, it would be even blacker, but she didn't know this yet.) The grimness was due not only to her

pregnancy but also to her "continual frustration" with trying to learn how to paint while working full time to support her son. She spent her days executing painstaking machine drawings (showing the sizes, shapes, and assembly procedure of small tools and fixtures)—a cramped output that clashed with the exciting freestyle Nicolaides-method drawing she was learning. Viewing this period from the vantage point of her new life as an artist, she mused, "It's a miracle I survived."[27]

In 1945, when Ike decided that a move to New York would further his career, Grace followed her man. The present was a continual disappointment, the future was a blur, and she simply had nothing to lose.

New York Adventure (1945–1949)

4

Risking

GRACE ONCE SAID that she was in love with New York even before she knew she was an artist. Looking back at her life fifty years later, she realized that "going to New York was [like] running off with the gypsies."[1] Living with Ike in a cold-water flat at Seventh Avenue and West 19th Street, Grace played the dual role of adoring student and financial support system. As a wartime factory worker, she had learned to execute specifications to one-sixty-fourth of an inch. Now she commuted daily to White Plains to a drafting job she detested at the Diamond Match Company while Ike had the luxury of staying home to paint.

She later said that she brought in "a great deal of money" at this job, which also helped her relationship with her parents.[2] We don't know exactly what Grace worked on at Diamond—possibly, specs for the matchbook company's photoengraving equipment (used to print advertisements on the matchbooks), which required the separate films for each color to be perfectly aligned for accurate registration. A photograph taken at Christmastime shows Grace with her coworkers—six sober-looking men in shirtsleeves, one attempting rakishness with a wreath around his neck and an arm around Grace, who wears a slinky sheath dress and dangly earrings, a drink in her hand.

Ike held evening drawing sessions with a model that sometimes attracted accomplished artists. Among them were Milton Avery and his wife Sally Michel. Largely self-taught, Avery painted in a figurative style that became increasingly abstract but never strayed from recognizable subject matter. By the late forties, he had developed his signature style of rendering figures and landscapes in flattened interlocking shapes with vivid and unusual color harmonies. The powerful critic Clement Greenberg tipped his hat to Avery—and to painter and celebrated teacher Hans Hofmann, whom Grace would meet a few years later—for keeping alive "Matisse's influence and example" when younger painters generally scorned him in favor of Picasso.[3]

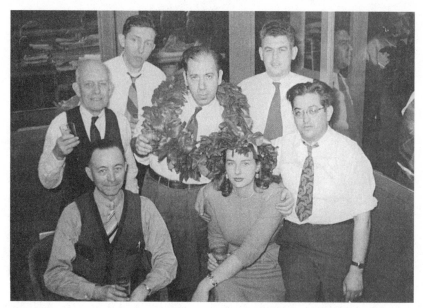

Grace with office workers, Christmas 1947(?). (Grace Hartigan Papers, Special Collections Research Center, Syracuse University Libraries)

Avery and Michel lived in a succession of small, cluttered apartments, with one room dedicated to his studio. Michel, a native New Yorker who first showed her paintings at the Ten Dollar Gallery during the Depression—all the works had the same low price tag—had decided to become an artist at age six, when she saw a drawing of Christopher Columbus in school and tried to copy it from memory.[4] Seventeen years younger than Avery, she met him one summer while painting in Gloucester, Massachusetts, and married him when she was twenty-two. She supported him and their daughter as a freelance illustrator for ad agencies and department stores, and then with an illustrating job at the *New York Times*. Michel also served as his intermediary with galleries and museums, and even wrote her husband's responses (signed "Milton") to requests for interviews and catalogue essays.[5]

The only time during these years when Michel was able to work on her own painting—in a flat, colorful style related to Avery's, but more detailed and less radically hued—was during an extended stay in Vermont one summer. "I really thought that Milton's work was really so much more important than mine," she told an interviewer in 1967.[6] Grace's awareness of Michel as a wife whose primary activity was serving as Milton's helpmate may have helped shape her determination to break free of Ike. For the moment, though, she was simply "the young girl friend," tagging along with him to artists' parties.

Through the Averys, Grace met the painters Adolph Gottlieb and Mark Rothko—both years away from their breakthrough abstract styles. Avery's approach influenced Rothko's use of color as a means of expression, which ultimately led to his signature paintings of large soft-edged areas of color stacked above each another, appearing almost to vibrate. In the early thirties, the three artists and their wives—both younger artists married in 1932—rented houses near each other for the summer in Vermont or Gloucester, Massachusetts, where they would spend their days painting. (To afford this idyll, the artists would give up their city apartments, put their possessions in storage, and then find new places to live when they returned.) At first, the younger couples often visited the Averys to see Milton's new work, hear him read poetry aloud, and drink tea, the only beverage the couple could afford.

During World War II, the younger artists drifted away from Avery to develop their own styles. Gottlieb, seeking a new way of painting mythic themes, began developing his "pictographs"—shapes loosely based on African and Native American motifs that were anchored in separate compartments on the canvas. Rothko was struggling to develop a painted language that would express complex philosophical ideas. Meanwhile, Avery remained uninterested in the world beyond his studio (he didn't even vote).[7] Yet after his death, Rothko would deliver an eloquent tribute, referring to his paintings as "the poetry of sheer loveliness, of sheer beauty... [with] that inner power in which gentleness and silence proved more audible and poignant."[8] Grace did not agree, later damning Avery for "oversimplifying," and linking him in her mind with Muse's ineptness as a painter.

The New York "art world" in the late forties was a tiny, impoverished group of men and a few women who met in cafeterias over five-cent cups of coffee and who were sadly accustomed to rejection from the elegant galleries on 57th Street. (As late as 1952, one observer noted, there were so few shows of the work these artists made that they could all be seen on a lunch hour, with time left over for lunch.[9]) Wealthy collectors favored Europeans of acknowledged pedigree, not necessarily the artists who emigrated to the United States as a result of World War II. Most Americans were either ignorant of or baffled by the new abstract art, and their negative views were heartily supported by mass-market magazines and newspaper art critics. In U.S. government circles, there were deep suspicions that abstract artists were profoundly un-American, either because they had left-wing political connections or simply because their art failed to reflect "American values." The United States still had a sizable rural population, and the kind of art Americans generally liked celebrated everyday life in small towns, not the anguished personal expressions of a generation

forever changed by the power of the atomic bomb. One artist later remarked that Abstract Expressionism was the first American art "filled with anger as well as beauty."[10]

In 1946, painter Ad Reinhardt drew a sardonic cartoon, "How to Look at Modern Art in America," that took potshots at Americans' distrust of abstraction, corporate sponsorship of art contests that mostly supported realist painters, and the kind of art "where no demand is made on you." Growing from a tree with a trunk labeled "Braque Matisse Picasso" are branches with the names of artists written on the leaves. Abstract artists ("hardest to understand") grow on the left-hand branches. Artists working in representational styles cluster on a branch that's about to fall off because it's hung with a big weight labeled "subject matter." The eighty-six abstract artists include Jackson Pollock, his wife Lee Krasner, Willem de Kooning, Adolph Gottlieb, Robert Motherwell, Clyfford Still, and Mark Rothko, as well as older artists like Arthur Dove, Hans Hofmann, and Josef Albers, and many whose names are now unfamiliar.[11]

Grace was not yet a part of this world, and her current situation was stultifying. Ike's paintings hung all over the house, while hers were restricted to the tiny room where she spent evenings and weekends working on her technique. Once, when the couple gave a party, Ike allowed her to hang one of her paintings in the living room. When guests congratulated him on the best work he'd ever done, he was infuriated. From then on, he badgered Grace to give up painting.[12] Even her son Jeffrey would come home from Grace Church School and look accusingly at his mother: "I know, you have been painting again!"[13] In a photograph taken around this time, Grace poses in a folkloric, off-the-shoulder blouse, one hand planted on her hip. She looks disgruntled. Above her hangs Ike's romanticized painting of her, with longer hair and the same blouse in a lower-cut version. If it was meant as a heartfelt tribute to his lover and breadwinner, he had misjudged her growing impatience with him.

IN JANUARY 1948, Grace and Ike ventured uptown to the Betty Parsons Gallery—which had opened two years earlier on the fifth floor of 15 East 57th Street, steps from Fifth Avenue—to see the first show of Jackson Pollock's drip paintings. A negative piece in *Time* magazine had piqued Grace's curiosity.[14] Scornfully titled "The Best?" the article used postage stamp-size photos to illustrate excerpts from a rave review by Clement Greenberg of Pollock ("the most powerful painter in contemporary America"), David Smith, and Hans Hofmann.[15] Grace said later that she had also heard the Averys laughing about the drip paintings.[16]

Grace with her portrait by Ike Muse. (Grace Hartigan Papers, Special Collections Research Center, Syracuse University Libraries)

Made by pouring webs of paint onto huge sheets of canvas lying on the floor, Pollock's paintings looked radically different from other artists' work—so baffling that most critics were dubious and only two of the sixteen new paintings sold. But Grace was mesmerized by Pollock's canvases and returned many times to see them. "You can't imagine what it is like to see, for the first time, something that has never before existed," she said later.[17] Ike predictably thought they were terrible, which led to a blistering war of words between the couple. She realized that although she still loved Ike, the relationship left her with "nothing for myself."[18]

As the months passed, the creative gulf between the minutely disciplined machine drawings she produced by day and the paintings she worked on at night became almost as unbearable as her living situation. What happened that spring was a testament to Grace's powerful drive to succeed and the high-stakes propulsion of her romantic spirit. During one whirlwind week in April,

she asked her boss to fire her (so that she'd receive a year's unemployment compensation), deposited Jeffrey with his father's parents, and moved out. Her new digs, at 330 East 33rd Street—an apartment on the seventh floor of a cold-water walk-up near the East River—were cramped and inconvenient. But no longer would she be beholden to anyone else's beliefs or schedules or needs, not even her son's. Instead, she vowed, "I was going to paint every day of my life."[19]

5

Connecting

SETTLING INTO HER NEW LIFE, Grace met an ever-growing circle of young artists, including Harry Jackson—a stocky, square-jawed painter born Henry Aaron Shapiro Jr., in Chicago in 1924*—who became her next lover.

As a child, Harry's interests were divided between Saturday morning art classes at the Art Institute and tales told by cowboys at the diner his mother ran near the stockyards. A 1937 *Life* magazine story about cowboys at Pitchfork Ranch in Wyoming[1] influenced him to hitchhike to cattle country at the tender age of fourteen. Working as a ranch hand, he eventually made it to Pitchfork, which he later called his "spiritual home." He managed to combine both his passions by studying with Edward Grigware, a fellow Midwesterner and former Detroit Tigers baseball player who co-founded the Frontier School of Western Art in Cody, Wyoming.[2] Grigware was Harry's kind of guy; the older artist's painting of four women in chaps showing off their naked buttocks remains a tourist attraction at the city's Holiday Inn Bottoms Up Lounge.

Harry had enlisted in the Marine Corps in 1942 and was wounded in action during World War II. While he was recovering, he came across a reproduction of an early painting by Pollock in an obscure arts magazine.[3] This abstract, symbolic painting struck him as "totally authentic, honest, down to earth and real."[4] He saw in it a "visceral" aspect akin to what he had experienced in combat.[5] After his discharge, he moved to New York and studied with the Mexican muralist and printmaker Rufino Tamayo, then teaching at the Brooklyn Museum, and subsequently with German émigré painter Hans Hofmann.[6] Like Grace, Harry was bowled over by Pollock's first exhibition of drip paintings in January 1948 at the Betty Parsons Gallery.

Harry lived on Baruch Place, near the East River, not far from the gloomy Monroe Street building whose residents included composer John Cage and Sonia Sekula, a Swiss-born painter of haunting abstract works who also

* His last name was changed to his mother's maiden name in 1934, when his parents divorced.

showed with Parsons. When Grace and Harry told Sekula how enthralled they were at Pollock's paintings, she suggested that they call him and let him know. Pollock, whose show was dismissed by the critics with words like "monotonous intensity" and "meaningless,"[7] was understandably pleased to hear their enthusiasm. "Come out and see me," he said. "None of the young people seem to like my work and you two do."[8]

In May 1948, Harry borrowed a car and the two of them drove out to The Springs, on Long Island—about one hundred miles from Manhattan. (In another version of this story Grace told decades later,[9] she and Harry hitchhiked. But since he brought his paintings with him, it's more likely that they drove.) The Springs was still a quiet village of farmers and fishermen, though it was part of the East Hampton township, where wealthy New Yorkers built summer homes and landscape artists had been attracted by the misty coastal light since the nineteenth century.

Pollock was living with his artist wife Lee Krasner in poverty and rural isolation on five acres fronting Accabonac Creek. He had turned a small barn into his studio. When Grace went out to see his new paintings, they lay on the floor where he worked on them, still wet. She was "astonished and stunned" by their epic dimensions.[10] These intricate webs of paint were still unfathomable to her. Yet, "the allure was enormous."[11]

It took several years for Grace to begin to understand that an abstract painting could be much more than an arrangement of pleasing shapes—that an artist could tap into her unconscious to express a powerful and mysterious sense of unknown worlds. This was a sensibility Lee would similarly imbibe from Pollock, pushing her painting into a more intuitive realm. Pollock had written a statement about his approach to painting that was published earlier that year in a new avant-garde magazine, *Possibilities*.[12] He explained, "when I am *in* my painting, I'm not aware of what I'm doing. It is only after a sort of 'get acquainted' period that I see what I have been about. I have no fears about making changes, destroying the image, etc. because the painting has a life of its own."

The couple couldn't afford to heat more than one floor of the farmhouse at a time with their coal furnace; even a $21 cord of wood for the kitchen stove was beyond their means.[13] (The house was so cold that in April 1946, when Pollock's former dealer, Peggy Guggenheim, came out for a visit, the water in the toilet froze.) Undaunted, Lee had turned a small unheated upstairs bedroom into a studio, where she developed her abstract "Little Image" paintings in the mornings, when daylight revealed the full brilliance of the oil paints. Completely filling a canvas or board with small, thickly painted blocks of

color, like tesserae in a mosaic, the paintings eventually morphed into all-over grids of tiny rectangles filled with real and imaginary letter forms. When it was too cold to work in the bedroom, Lee came downstairs to the back parlor, which was awkwardly situated in the direct path of anyone coming in the door.[14] The year before Grace and Harry's visit, Lee made two real mosaics in this cramped space, patiently piecing together shards of colored glass bottles, pebbles, shells, and her own costume jewelry on two old wagon wheels spread with plaster.

Grace shyly told Pollock that she liked one of his paintings in particular. He said that it needed more work; he'd have to get back into it. This was a new thought for Grace, who didn't understand what Pollock meant until later. Unlike Ike, who might feel the need to repaint a little spot in one corner, Pollock was saying that he had to redo the entire canvas. In this kind of painting, you didn't just fix something; you started all over again.

Harry had brought some of his Cubist paintings to show Pollock and was disappointed that he didn't care for them. (The following year, Harry turned his back on Cubism and started dripping.) But the two couples amicably sat down to dine on the "wonderful, big fat hamburgers" Lee made, followed by Pollock's homemade apple pie.[15] When the men went out to a bar, Grace and Lee—who was fourteen years older than Grace and had weathered many struggles of her own—sat at the kitchen table. Without mentioning her own painting, Lee brought out Pollock's gallery announcements, reviews, and photographs of his work for Grace to peruse.

Harry had insisted that Grace keep quiet about her work "because he wanted to be the painter"[16]—shades of Ike's attempt to dominate her professionally. Now, Lee said, "Confess. You're a painter, aren't you?" So the two women talked about Grace's paintings.[17] It is not clear whether Grace was too self-involved to bother trying to draw Lee out, or whether Lee was simply unwilling to talk about her work while she was going through a difficult period. Several days later, she finally admitted to Grace that she was a painter but hadn't been working during the last year "because Jackson didn't want anyone painting around him."[18]

Here was yet another lesson for Grace about the soul-destroying rivalry inherent in dual-artist couples when the man insists on his identity as the dominant one. Although Lee came from a humble background and had supported herself in New York mostly by waitressing, she had the benefit of a long and thorough art education beginning in high school (she commuted from Brooklyn to an elite girls' high school in Manhattan because it offered a studio art major). At nineteen, she enrolled in the tuition-free National Academy of

Design, which accepted students on the basis of ability. She took the traditional sequence of courses, beginning with drawing from plaster casts of classical sculpture, then drawing from a live model, and finally, oil painting. During the next few years, she studied briefly with several other artists, including Hans Hofmann, who had known Matisse and Mondrian,[†] and was considered the leading expert on using color to create spatial relationships in a painting. While working on her abstract, Cubist-influenced paintings, Lee spent many hours at the Metropolitan Museum of Art and the new Museum of Modern Art, and eagerly sought out the company of fellow artists.

One day, in the late fall of 1941, Lee ran into an artist friend while out walking. He introduced her to John Graham, a Russian émigré painter, writer, and collector who had Americanized his name from Ivan Dombrowsky. (Lee had also tinkered with hers, changing Lena to Lenore and then to Lee, and dropping an *s* from Krassner.) Graham had written an influential book, *System and Dialectics of Art*, that Lee had read. It urged artists to tap into their unconscious and use symbolic elements found in ancient and tribal art in order to produce more personal and meaningful work. After visiting Lee's studio, Graham invited her to be part of an exhibition of French and American paintings that included work by Picasso, Matisse, and several other leading Europeans.

The following year, when Lee came to see this show at the McMillan Gallery, she was especially intrigued by the intensity of *Birth*, by Jackson Pollock, an obscure young painter she had never heard of. The swirling energy of his painting incorporated mask-like faces inspired by Native American art, vividly demonstrating the new approach Graham had championed. Not knowing that Pollock generally disliked visitors, she knocked on his door—just a block away from her 8th Street studio. By the fall, she had moved in with him, using the studio space formerly occupied by his brother Sande, who had taken a job in Connecticut.

Pollock's viscerally expressive work led Lee to rethink what she was doing. At thirty-four, she had spent more than a decade as a dutiful student, by proxy, of Cézanne, Matisse, Picasso, and Mondrian. It was time to loosen the ties that bound her to Hofmann's teachings and to Cubism. While searching for a new direction, she wound up scraping down failed paintings to a gray nothingness that depressed her. A turning point of sorts came in 1945—the year

† Piet Mondrian (1872–1944) was a Dutch painter who spent his last years in New York. Beginning as a landscape painter, he established a unique abstract style based on his study of theosophy, which perceives an "essential oneness" that connects every aspect of life, from subatomic particles to galaxies.

she married Pollock and they moved to The Springs—with *Image Surfacing*, an abstract painting with one startling image: an eyeball.

During the next few years, Lee threw her energies into fixing up the house and keeping an anxious eye on Pollock, whose drinking binges were the reason they had moved out to the country. (Harry would soon would help lead him back to his old boozing ways.) By the time Grace and Harry visited, Pollock had had five solo gallery shows in New York, and his paintings were included in group shows at leading museums.

Granted that Lee's modest, intricate work of this period lacked the bravado and brilliance of Pollock's, she kept a self-effacingly low profile, not showing her work again in New York until 1951.[19] But at least she didn't have to hold down a regular job to support Pollock's art—unlike the wives of other artists, like Barnett Newman and Adolph Gottlieb.)

Decades later, Grace remarked that Lee "deliberately submerged her personality to [Pollock's] genius. That was their thing. I have never been like that."[20] But in her mid-twenties, as a fledgling artist attracted to creative men, Grace had few alternatives. In the late 1940s and '50s, after the women who had done war work were replaced by returning veterans, men regained the upper hand in daily life. The tiny world of avant-garde art was no different, except that underneath the macho posturing, men were having tremendous problems with acceptance—gallery representation, reviews, sales—of their work. Insecurity was rampant. Lee, for her part, had gone from a relationship with a suave, womanizing painter‡ who paid attention to her work but publically disparaged her looks and her Jewish religion, to a famously troubled union with Pollock, whose alcoholic rages were legendary.

While Grace was at the farmhouse, she asked Pollock which other artists she should know about. He said there was only one other guy who was any good, somebody named Willem de Kooning: "Everyone's shit but de Kooning and me."[21] At forty-four, de Kooning had finally had his first one-man show that spring, at the new Charles Egan Gallery, operating out of a tiny fourth-floor studio apartment at 63 East 57th Street, where paintings were stored in the bathtub.[22] Most of the ten abstract works were painted with black and white enamel house paint, which was much cheaper than artists' paints. Sometimes using recognizable letter shapes or hints of objects (a hand,

‡ Igor Pantuhoff (1911–1972) was a White Russian émigré whom Krasner far surpassed in art-world terms; he eventually became known for his kitschy paintings of wide-eyed waifs in a style resembling Walter Keene's.

a building, a still life), he depended on the destabilizing function of competing black and white lines and shapes to create a tantalizing rhythmic energy.

Two reviewers were bowled over. Clement Greenberg—who would later castigate de Kooning for introducing figures into his work—effused in *The Nation*, the venerable journal of politics and culture, that this previously unknown artist was "one of the four or five most important painters in the country."[23] Fledgling *Art News* critic Renée Arb deftly celebrated the works' "virtuosity disguised by voluptuousness."[24] Meanwhile, a plea from a Russian émigré artist friend of de Kooning's led painter Josef Albers to offer him a summer teaching position at Black Mountain College in North Carolina—a lifesaver because he and his artist wife Elaine were broke; nothing had sold.[25] (In October, months after the show closed, de Kooning received the art world's highest honor: the Museum of Modern Art purchased a work called *Painting*, for $750.[26]) Although Pollock was incensed that de Kooning had stolen his spotlight, he was nonetheless sufficiently fair-minded to praise him to Grace.

When she got back to Manhattan, the show had closed, so she walked over to de Kooning's studio and rang the bell. "This head popped out: 'Who are you?' I'm Grace Hartigan. Pollock said it would be OK if I came by. He said, 'Sure, come on up.'"[27] De Kooning was a compact man with a beguiling Dutch accent, thick blond hair, and bright blue eyes that seemed to miss nothing. Trained at the Rotterdam Academy of Fine Arts in the Netherlands while serving as an apprentice at a commercial art and decorating firm, he had worked his way from figurative painting to uniquely complex, space-filling abstractions, which would soon give way to aggressive-looking images of women. Influenced by the idealistic credo of the Dutch de Stijl group,[§] he had come to the United States in his early twenties (as a ship's stowaway) intending to be an applied artist, but discovered to his chagrin that he made more money as a house painter. So he kept painting houses in New Jersey and subsequently worked as a sign painter and carpenter in New York while painting in his spare time.

In 1935, de Kooning was briefly part of the Federal Arts Project (FAP), a Depression-era government program within the Works Progress Administration (WPA) that hired unemployed artists to decorate newly constructed public buildings. Although his non-citizen status got him kicked off the FAP,

§ Believing in the superiority of "ideal" geometric forms, the de Stijl artists and architects structured their paintings, furniture, and buildings using only horizontals and verticals, and limited themselves to primary colors (red, green, and blue) plus black, white, and gray.

he later said that the experience gave him such a good feeling that he decided to devote his days to painting and do odd jobs only as needed. (Lee also worked for the FAP; at one point, much to her annoyance—why couldn't she create her own design?—she was assigned to enlarge an abstract drawing by de Kooning for a mural.)

Despite his glimmer of fame—just a hint of what was to come—he remained universally beloved by fellow artists for his unpretentious personality, supportive attitude, and unique brand of wit, as well as his brilliance as a colorist (the black-and-white paintings were an experimental detour) and a master manipulator of flowing line. He worked unremittingly on a single canvas (or a Masonite panel), day after day, for months, constantly wiping away passages that did not meet his standards, fighting his natural facility with paint. Often, the only reason he would stop tinkering with a painting was that someone had begged to buy it. If you met him on the street and asked him how his painting was going, a fellow artist reminisced, he would to say, "I'm struggling."[28]

Grace found him "devastating…because of his brilliant articulateness."[29] The painting she saw in the studio that first day—*Seated Woman* (1940), a study for a portrait that retains a haunting delicacy despite its anatomical distortions—remained one of her favorite works of his. In 1950, she was able to observe the evolution of his game-changing painting *Excavation*, a majestic eight feet wide and six feet high. As the weeks and months went by, what had started out as an interior with figures became a vast, all-over network of angular lines and flickering bits of human anatomy seemingly pushed into the pale yellow paint. By painstakingly building up and scraping down the surface of the canvas, he was feeling his way toward a new vision. He may have mentioned to Grace some of the sources for this painting—construction sites in Manhattan he used to peer at during his nocturnal rambles, a *Life* magazine photo of women in a flooded rice field (a publicity shot for the Italian film *Bitter Rice*), the pileup of bodies in Pieter Brueghel the Elder's sixteenth-century painting *Triumph of Death*.[30]

At one point, when the canvas was still clearly figurative, Grace noticed that there was something peculiar on the top edge of the painting—an image of a skylight. She hesitated to mention this at first, but when she finally mustered the courage to say something, de Kooning said it was there just to help him adjust the scale of the figures and would be painted out eventually.[31] Unlike the popular image of an "action painter" working in an inspired frenzy, de Kooning spent a lot of time sitting on a wooden chair in his studio, pondering his painting and trying to decide what to do next.[32]

Grace invited him to visit her studio—such reciprocal visits were the norm in those days, and de Kooning was known for his generosity toward young artists. He looked at her formulaic, Ike-influenced abstract paintings and delivered his verdict: "This shows a complete misunderstanding of modern art."[33] The tough-love lesson was that she needed to find her own "world" in her painting, her own content. Grace later said that this critique led to a three-day crying jag, "but through some odd osmosis I understood what he meant, and this comprehension showed in my [later] paintings. They had deeper content and a more painterly form."[34] De Kooning told her that she needed to start by looking closely at real things, to give her "a feeling" that she could transmute into paint. He may have said (as he told someone else) that his goal was not to reduce life to a geometric abstraction but to keep *adding* more and more to his canvas: "drama, anger, pain, love, a figure, a horse, my ideas about space."[35]

Grace began to grasp the concept of a new kind of space that stayed on the surface of the canvas yet implied boundless extension and "the freedom and mobility of gesture."[36] De Kooning spoke of "getting *into* a painting," a radical concept for someone who had been fastidiously daubing away on an easel, putting "an apple here and a pear there and a vase there."[37] What de Kooning was talking about—what would soon be called "all-over painting"—was incredibly exciting.

De Kooning also introduced Grace to the drab, smoke-filled Cedar Tavern in Greenwich Village, which was just coming into its own as the favorite bar of artists living in lower Manhattan. They included older men who had been employed as mural painters by the Works Progress Administration during the Depression, younger men who were veterans of World War II, immigrant artists like de Kooning, and the few women who had the drive and moxie to muscle their way into the group. They were united by the feeling that there was no longer anything to believe in after the devastation of the war, and that the most heroic act they could aspire to was to face a blank canvas and make their mark on it.

Decades later, Grace asserted that for a while she was "the only woman"[38] in the New York art world of the late forties, a position she enjoyed immensely. According to her self-serving chronology, Helen Frankenthaler was the first to share her limelight ("I reluctantly made room for Helen and we actually became very good friends"[39]), and then Joan Mitchell stepped onstage. ("She really impressed me with her ability to swear. I had never heard language like that coming from a woman."[40]) Lee—who, as we've seen, was working only sporadically on her painting during these years and not exhibiting at all[41]—was

not included on Grace's short list of female rivals, nor were other promising women artists (like Jane Freilicher) whose temperaments were more low-key.

Grace later destroyed most of her work from this period, when she was still figuring out what modern art was all about. In the next few years, as she developed her own painterly vision, her unique combination of fierce dedication, coloristic brilliance, and full-bodied zest for life would make her a memorable player among the younger generation of Abstract Expressionist painters. But now, her eagerness for adventure was about to entangle her in Harry's postwar nightmare.

6

Coping

GRACE AND HARRY had known each other for only seven months and "were just on the verge of a split up," he wrote in his journal, "when we up and married and started planning a trip to Mexico."[1] Rufino Tamayo had fired up his pupil with tales of vast fields of roaming cattle on the outskirts of the mountain town of San Miguel de Allende, which had an art school where Harry planned to use his G.I. benefits.* Founded in the late 1930s in a former convent by an amateur American painter, the Escuela Universitaria de Bellas Artes had become a magnet for former G.I.s, who helped rescue the fading colonial outpost from oblivion.

Grace wanted to come along—this would be the south-of-the-border equivalent of her thwarted Alaskan adventure—and as a married man Harry would receive an extra $35 in his stipend that they could both live on. But why did Grace want to marry him if their relationship was so rocky? Was the lure of Mexico so great, or was this simply another manifestation of her impulsive nature? Grace later told a gay acquaintance that she was attracted to Harry "because he seemed so *butch*."[2]

Grace and Harry both stated their occupation as "student" on their marriage license at the city clerk's office in Manhattan. Three days later, on January 8, Lee and Pollock hosted the wedding as dusk fell at their chilly farmhouse in The Springs.[3] A neighbor, Judge J. Wilmer Schellinger, presided, and the Pollocks served as witnesses. (Lee signed the marriage certificate as "Lenore Pollock."[4]) Jackson baked another apple pie, a welcome homey touch for such an austere event.[5] No family members were present. Harry noted in his journal a few days later that his love for Grace was growing, "and our love for each other has constantly brought us through the damndest messes ever."

* The G.I. Bill, officially known as the Serviceman's Readjustment Act, provided full tuition, books, and supplies for four years, plus a living stipend, for anyone who was on active duty between September 1940 and July 1947. The stipend varied by family size.

He felt confident that "Mexico will help set this marriage into something wonderful."[6]

The contrast between the traditional view of a bride celebrating "the most important day in her life" and Grace's let's-just-get-it-over-with weddings inspired a major theme of her paintings, from *Grand Street Brides* (1954) to the unreal, misty world of *Society Wedding* (1988). Decades after her marriage to Harry, she said, "It seems ludicrous to me to go through all that fuss," adding that she painted "things I'm against to…give them the magic they don't have."[7] She once said that she had "two serious marriages and two frivolous ones."[8] Harry slotted into the latter category.

HARRY ADMIRED BOTH de Kooning and Pollock ("Three words from Bill or Jackson can be like strokes of well-aimed lightning"[9]), but he felt a special kinship with Pollock, who struck him as "simple and grand at the same time."[10] Later that month, on a visit to Grace's studio, when Pollock suddenly turned an abstract painting of hers upside down, both Grace and Harry appreciated this perceptive gesture.[11] They helped hang Pollock's second show at the Betty Parsons Gallery. When Pollock's Long Island shipper came to the gallery with a damaged painting—it was missing a sizable chunk of paint from the center of the canvas—Grace loaned Pollock some paint to make a thin, hasty patch. He figured no one would be the wiser, which turned out not to be the case.[12] After the January 24 opening, the newlyweds dined with the Pollocks, the de Koonings, Milton Resnick, and other painter friends at a Japanese restaurant on 29th Street—a rare occasion when Pollock was sober.[13] Then Pollock and Lee walked home—during the run of the show, Grace offered them her apartment at 350 East 33rd Street, near the East River[14]—and the others went on to the Minetta Tavern in the Village. At this neighborhood dive, decorated with cartoons of better-known patrons and raffish locals, the painters drank and talked until 2 A.M.[15]

Harry bought a used car for $100 in early February and worked on it with a mechanic friend to get it ready for the journey south. Nervous about the trip, he and Grace were both on edge, and he was plagued by a "terrible headache" that may have been a warning of health problems to come. On February 19, the couple finally left for Mexico. The adventure was nearly over before it started when they reached Monterrey, about 130 miles south of the U.S. border, and ran out of money. Harry's family refused to help, but Pollock wired $250 (money Harry later claimed to have given him to buy his Model A Ford).[16] On their first night, Grace and Harry enjoyed a romantic horse-and-carriage ride, dined at venerable

Sanborns restaurant, and strolled in the Plaza Zaragoza before returning to their room with its stately double bed and shuttered windows opening onto the plaza.[17]

The first signs of real trouble appeared in early March, just before the couple reached San Miguel, when Harry suddenly drove off the dirt road into a cornfield.[18] Grace, who didn't drive, tried to grab the wheel, but he held on fiercely. When the car finally came to a stop, Harry lost consciousness; his body stiffened and began jerking uncontrollably.

Unbeknownst to Grace, he had been having seizures and violent episodes for the past two years. At a party the previous December, a woman Harry was chatting with on a sofa suddenly realized that he wasn't able to hear her. She waved her hands in front of his eyes, and it was clear that he couldn't see her, either; he was having a seizure. People rushed over to stretch him out and cover him up, and he fell asleep. Not long afterward, he went to a party at the Hans Hofmann School of Fine Arts in an agitated state of mind. For no apparent reason, he suddenly erupted in anger, breaking chairs, putting his fist through the wall, ripping out the phone, and throwing a woman into the air.[19]

Harry also failed to tell Grace what happened to him one day in September 1947. He had gone to a class at the Brooklyn Museum Art School with a severe headache, and his teacher urged him to go home. The next thing he knew, he was in Kings County Hospital; he had been walking in the opposite direction of his apartment when he had a seizure, lacerating his scalp when he fell on the sidewalk. He was eventually sent to the Payne Whitney Psychiatric Clinic, where a psychiatrist described Harry as a poorly dressed young man with an "unkempt" appearance—such was the fate of a downtown artist in a suit-and-tie world—who talked in a "loud, boisterous manner."[20] After relating that he suffered from headaches, abdominal pains, and "anxiety concerning instinctive desires," in addition to the seizures, Harry learned that he probably had epilepsy and a "well-established character disorder with obsessive-compulsive trends."

In mid-January of 1949, at his final doctor's appointment (the Veterans Administration had stopped authorizing treatment), he was told that he needed to see a neurologist for his epilepsy "at least once a year for the rest of [his] life." By then Harry was married, but he hadn't said a word about any of this to Grace.

Harry had been the youngest official U.S. Marines combat artist in World War II, his incisive sketches capturing the grim urgency of men on the battlefield. In an era before autofocus cameras, a sketch could portray action a cameraman had no time to capture. On November 20, 1943, during the bloody three-day Battle of Tarawa in the Pacific, in which more than 1,100 members

of the Marines' Second Division were killed,[21] Harry was seriously wounded—hit by bullets and thrown into the air by a Japanese mortar that temporarily blinded him and killed the soldier next to him.[22] He received a Purple Heart for his bravery,[23] but this harrowing experience left him vulnerable to grand mal seizures and inexplicable rages that would plague him for the rest of his long life. As his eldest son Matthew said, "He was a force of nature, full of rage, love, humor, and madness."[24]

A WEEK AFTER Grace and Harry arrived in San Miguel, they decided to rent a large, dilapidated house and have it fixed up. But the renovation proceeded slowly, the car broke down, Grace wasn't feeling well, and Harry was depressed. While they found the town "beautiful and friendly," Harry intensely disliked the American colony ("snobs, fakes, old women and homosexuals," was his derisory opinion) and disdained the art school's classes ("deadening") and students ("duds").[25]

In April, settled in a different house that cost just $25 a month and came with daily maid service for another $10, they were finally free to paint all day.[26] Grace's largest canvas, *Secuda Esa Bruja*, is a six-foot-tall abstract composition animated by flickering swipes of orange paint.† (*Bruja* is Spanish for "witch," and the title is generally translated as The Witch Is Flying, but the idiomatic sense is closer to The Witch Is Stirring Things Up.[27]) The charged energy of witchcraft—which Grace conveyed through the looming verticality of the canvas, high-keyed color, and slicing brushwork—was a folkloric theme that she encountered on her rambles through the village.‡ Harry's frightening "possession" by epileptic seizures may have contributed to her fascination with this aspect of the supernatural. Using cheap Duco enamel (manufactured for use on cars) on this and other paintings, she was experimenting with quickly brushed, unpremeditated compositions in an effort to leave her formulaic early work behind.

When she wasn't working, Grace gamely shared Harry's cowboy interests—photographs show her mounted on a pony, wearing a cowboy hat and jeans—or explored the local markets, using the Spanish phrases she had begun to learn. But this trip was not to be the idyll she had counted on.

† This is one of few early paintings that Hartigan didn't destroy, probably because she used the reverse of the canvas in 1952 to paint *Frank O'Hara and the Demons*. (See chapter eight.)

‡ Hartigan was also enthralled by family lore that in-laws who married into the Orvis clan were persecuted as witches in the Salem trials of 1692–93, though her Orvis ancestors didn't arrive in New England until decades later.

In late May, Harry wrote in his journal that "Grace is very sweet and is in a very difficult position, but we do not belong together for many reasons." He did not mention the main one: his epilepsy. A new series of seizures had continued for three days. He and Grace had been talking in bed about a painting he had finished (in his account, he was reading a book[28]) when he suddenly passed out. Panicked, Grace located a Mexican doctor, who administered potassium bromide, a common treatment at the time for epilepsy. The more Harry took of this medicine, the worse he felt. He later learned that he had bromide poisoning.

His illness didn't stop the couple from traveling to Mexico City a few weeks later to see the murals by José Clemente Orozco at the National Preparatory School. Harry and Grace were shocked to see that these powerful images had been badly defaced.[29] Orozco's dark view of the uncomprehending sacrifices made by the working class in the Mexican Revolution was considered traitorous by local residents, who jeered at the two Americans. They spent an afternoon with Tamayo and his wife Olga Flores, and drove back to San Miguel with an American couple, admiring the dramatic volcanic landscape en route.

During this period, Harry began a series of abstract collages and monoprints§ that displayed the swirling, dripping influence of Pollock. As he bragged years later, "I would court caprice and invite outrageous accident."[30] Among his sketches are many images of Grace, sometimes in erotic poses. His creepily Surrealist painting *Large Head of Grace* presents her as a creature with a swirl of blonde hair and a completely blank, elongated face.

Perhaps this was one of the three paintings he worked on feverishly during the couple's final days in San Miguel. After completing the last one, he fell into a foggy state and demanded to be left alone. When Grace walked into his studio hours later, she found him lying on the floor, unconscious. His skin was deathly white, and his eyes seemed to have retracted into his head. To her horror, he kept having convulsions and uttering incoherent sounds for the next twenty-four hours—his worst epileptic attack ever. She summoned a Mexican doctor, but he said there was nothing to do but wait until Harry recovered.[31] The next stage in Harry's illness was a prolonged state of lethargy, making preparations for their return to New York even more difficult. He

§ These prints were apparently made by pressing two sheets of paper together to transfer paint from one to the other. A monoprint—a single-image print—is normally made by painting on a zinc or glass plate and using a printing press to transfer the image to a sheet of paper. The couple would have had no printing equipment in Mexico unless they were able to use resources available at the art school.

later said that his painting *Tall Man in Black*—an abstracted figure with one eyeball rolled up—"represents the isolation of epilepsy."[32] The elongated figure and Harry's choice of title suggest the disconnection between reality (he was a few inches shorter than Grace) and his mental self-image.

By now, Grace realized that she had married a man who—far from being the anchor, lover, and colleague she needed—required even more care and attention than a child. (Harry later agreed: "I was just in an impossible state."[33]) Despite her lack of a driver's license, she steeled herself to pilot them back to New York, where they arrived on October 1, after a detour to Philadelphia for a quarrelsome visit with Harry's father. In a photograph taken in that city, the couple stand side by side, next to a car with a rope-attached tarp on top to shield the paintings they made in Mexico.[34] Grace's face is a study in blank resignation, Harry smiles as if on cue, one arm flung stiffly around his

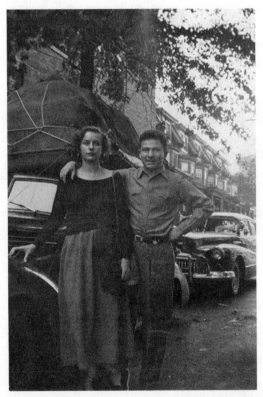

Grace and Harry Jackson in Philadelphia on their way back from Mexico, 1949. (Grace Hartigan Papers, Special Collections Research Center, Syracuse University Libraries)

wife. Soon after they returned, Lee Krasner met Grace on the street. "How's Harry?" she asked. Grace said, "Harry who?"[35]

For years afterward, Grace told people that the problem was the art school—after some of the American students complained about the quality of instruction, the U.S. government removed the school from the approved list for G.I. Bill recipients.[36] It was an honorable way to save face for Harry at a time when epilepsy was a taboo subject. Grace didn't mention his illness publicly until her 1993 interview with Vicky Goldberg of the *New York Times*, though her dealer John Myers had revealed the truth a decade earlier in his autobiography. He recalled Grace saying—with typical exaggeration—"By the time he came to [after one of his attacks], I was so mad at being deceived that I grabbed my bag and beat it right back to New York."[37]

The couple didn't officially separate until January 1950, but the marriage was effectively over, its demise due not only to Harry's illness. Unlike Lee Krasner, Grace was unwilling to be a promoter of her husband's work, or even simply a helpmate; she always had to be the star of her personal show. Harry was every bit as self-centered and stubborn as she was. Having cast himself as a mythical West-erner, a tough-talking, swaggering, hyper-masculine guy, he wasn't about to cede the limelight to a woman. He needed to be the dominant artist in the relation-ship—a situation intolerable to Grace. It took her a long time to realize that artists could be good companions and sex partners, but they were unreliable as husband material. "Creative men have tremendous difficulties with…truly loving relation-ships," she said later.[38] Especially during the difficult early years, the male artists she know would say, "Look, I'm the genius around here."[39] They didn't want to share whatever small glory came their way. But neither did she. "Grace would have been hard to be married to," one of her students said. "She was already married to some-thing"[40]—her painting.

Increasingly in thrall to grandiose theories about himself and the universe, married five more times (mostly briefly) before his death in 2011, Harry would soon reinvent himself artistically as a painter and sculptor of Wild West themes. Raoul Middleman—a painter who was also fascinated by the mythic aspect of the American frontier and had worked as a cowhand in his youth—met Harry in New York long after he and Grace were no longer a couple. Middleman remembers Harry as a talkative self-promoter, a blowhard ("Have you ever killed anybody? Well, I have") who was nonetheless a lot of fun. "He prided himself on being a lady's man," Middleman said.[41] Harry's sculptures were collected by John Wayne, whom the artist immortalized in painted bronze as U.S. Marshal "Rooster" Cogburn in the original *True Grit* film—a commission for the August 8, 1969, cover of *Time* magazine.

Grace kept in touch—she stayed on good terms with nearly all the former men in her life—and jokingly, but without malice, mentioned to me decades later that Harry had an 800 number for collectors of his art. She claimed never to view any event in her life as a mistake. Quoting the song Edith Piaf made famous, "Non, je ne regrette rien," Grace once said, "I regret nothing.... I wouldn't be the way I am ... if I hadn't had those experiences."[42]

WHILE GRACE AND HARRY were away, America was introduced to Pollock via a story in the August 8 issue of *Life* magazine ("Jackson Pollock: Is he the greatest painter in the United States?"). The accompanying photo showed him with arms crossed, a cigarette clamped in his lips, next to his eighteen-foot-long canvas *Summertime: Number 9A*, a hypnotically rhythmic dance of black, blue, and yellow drips and pours. Harry noted in his journal that fall that New York was "full of little Pollocks."[43] Major changes were in store for the New York art world and for Grace's career.

Rising Star (1950–1955)

7

Struggling

SHARING A LEATHERETTE BOOTH with sculptor David Smith at the Cedar Tavern, Grace laughed loudly as she gestured with the hand holding her cigarette, nearly upsetting her drink. Her assertive voice with its Jersey accent was well suited to this noisy, dimly lit refuge for downtown artists, reeking of smoke and beer. On any given night, tough-talking Joan Mitchell, one of Grace's few female rivals, was likely to be trading barbs with brash Alfred Leslie and brooding Philip Guston. Cultural critic Harold Rosenberg, a bulky man with a booming voice, might be holding forth in another booth with Larry Rivers, nervously drumming his fingers on the table. At the bar in front, Franz Kline's rumbling baritone would rise above the din with a nonstop flow of talk that rarely failed to mesmerize his listeners. His stories were hilarious and reliably off-color—"very macho," as a friend fondly recalled.[1] "He would wheel around a subject…like an acrobat," another artist friend said, always managing to return to the point he was making "in the most poetic and wonderful and humorous way."[2]

After a day of work in her Essex Street studio, Grace would stroll over to the Cedar, at 24 University Place. The half-hour walk led her through the Bowery, New York's skid row. As dusk fell, she stepped past the nodding alcoholics on the sidewalk, past the flophouses and saloons hunkering under the perpetual shadow of the Third Avenue El tracks. She would have dinner at the Cedar—a reasonably edible steak cost about $2.75—and then she would simply wait for her friends to show up. During the day, she normally wore her painting outfit—a button-down shirt and dungarees—instead of the ladylike full-skirted dresses of the era. But at night, she took pains to change into a snug sweater and skirt, groom her blonde hair, clip on shiny earrings, and add a slash of lipstick. "When I go out," she once said, "I'm all woman."[3] With her statuesque five-foot-eight figure, innate sensuality, quick intelligence, and seemingly boundless energy, the twenty-eight-year-old was a magnet for men. A gay acquaintance observed that "men's nostrils seemed to flare when Grace was at a gathering."[4]

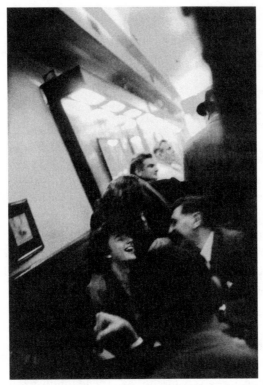

Grace with others at the Cedar Tavern. (Photo: John Cohen. Getty Images)

Artists felt comfortable at the Cedar because it had no pretentions. You could sit at the bar and keep an eye on the door, ready to hail your friends and be pelted by loud remarks from friends and enemies alike. Coming in with a group, you could hole up in a leatherette booth to continue your conversation. The Cedar provided a pay phone for those who might need to call in an excuse to someone waiting at home. But there was no T.V. and no jukebox, just peeling industrial-green walls incongruously adorned with a few dusty old British sporting prints. The ringing of the cash register mingled with the clinking of glasses and bottles, and the hubbub of argument and conversation stayed lively until the 3 A.M. closing time. Some women wouldn't set foot in the Cedar because they were intimidated by men on the prowl. But others were stimulated by the tavern's inclusiveness. As a newcomer, you could sit at a table with leading artists and semi-famous ones.

Mercedes Matter—nine years older than Grace, and celebrated as a femme fatale as well as an intellect and an accomplished abstract painter—was ambivalent about the "dismal, dirty" Cedar. She later recalled that the hands

on the clock in the back of the tavern sometimes moved backward, which she thought was absolutely right for a place where there was no sense of time, just "talk, talk, talk."[5] By the mid-fifties, she found the constant "judging and categorizing" dismaying.[6] Yet listening to painters talk about what they were trying to do and what they had borrowed from painters of the past who inspired them was an education in itself. She later said that she "learned more in those years at the Cedar Bar probably than in any other way."[7]

The talk was about everything under the sun. Women—lusted-after, loved, stuck with. What somebody said on a panel at the Club, the artists' intellectual center.[8] Injustices of the world. Baseball. Comic strips. Pre-1940s jazz versus bebop. The meaning of art. A famous seventeenth-century painter. Whether somebody's new show was a "breakthrough" or not. There also was grandiose speechifying, the kind that sounds brilliant when everyone is sharing the same bleary haze. (Art, said de Kooning is "the forever mute part you can talk about forever."[9]) Elaine de Kooning liked to tell a story about Franz Kline at the Cedar. It was midnight, and she wanted to go home, but he ordered twelve Scotch-and-sodas. The waiter, seeing just two people in the booth, was puzzled. Were they expecting friends? "No, they're for us," Kline explained. "Six for her and six for me."[10]

Nobody was making money. Elaine and Bill de Kooning often had to decide between buying food or cigarettes, usually voting for the smokes.[11] Decades later, Grace related a story that sums up the grinding poverty of this period. Kline had discovered the body of his dog next to a half-chewed bar of soap. Elaine de Kooning quipped, "Look, an artist can live where a dog dies."[12] One day, when Kline didn't have 30 cents[13] for the round-trip subway ride to the home of an art collector who wanted to buy one of his paintings for $50, Grace cashed in her stash of empty soda bottles.[14]

In the mid-fifties, when artists had more cash to spend, Scotch replaced beer as the drink of choice. Lubricated by alcohol, fights occasionally broke out, most notoriously those instigated by Pollock when he arrived already drunk. One night, a lesser-known painter was sitting at the bar with Kline and two other artists—one of them, a giant of a man—when a drunk stranger came over and said to the painter, "I don't like your work. I think it stinks." The painter, who had had a few himself, told the man to step outside and "decide" the matter. When he stood up, the tall man also rose to his feet, and the drunk chickened out. Kline said, "You know, artists in our position must expect this"—kindly including his friend in the pantheon.[15]

But in 1950, the Cedar was still simply a gathering place for people who had spent their day in solitude, wrestling with a glimmer of a notion about

color and form that they were trying to nail down on a canvas. "The air was electric," Grace recalled later. "We were each other's audience …. It was pure. There were no temptations because there was no money in it."[16]

Still, she needed money to live. On her own again after leaving Harry, she no longer had the cushion of unemployment benefits or his G.I. Bill income. It was time to look for paying work that was least likely to interrupt the long days she needed to spend in the studio. Modeling looked like a good bet, despite her checkered history. Before her ill-fated trip to Mexico with Harry, she had posed in the nude for painter Will Barnet at the Art Students League. An artist's model is expected to hold a pose silently, but Grace was not one to follow rules when they got in her way. Speaking about the nineteenth-century French painter Jean Auguste Dominique Ingres—who famously upheld the importance of drawing—Barnet said something negative about Ingres' compatriot Eugène Delacroix, who championed the primacy of color. A student in the class who thought Grace was an ideal model, with her "beautiful" body, noted that she looked angry. Finally, Barnet said something that drove Grace into a fury. From her position on the model stand, she loudly contradicted him. Everyone stared, openmouthed. Such a thing had never happened before.[17]

Grace had also disrobed for realist painter Eugene Speicher, best known for his nudes, who told her she was his favorite model. Nearly forty years her senior, he had asked his wife to come into the studio to check out Grace's "beautiful arches"[18]—likely a polite cover for alluring physical features he hesitated to praise to his wife. Now she tried modeling for Hans Hofmann, a German émigré painter with a towering reputation as a teacher in Europe, his own highly regarded school in Manhattan, and a distinctive theory about the spatial effects of color. A broad-shouldered man who seemed to take up a lot of space, Hofmann spoke loudly in a thick accent. (Lee Krasner said later that for the first six months, "I couldn't understand a word of what the man said."[19]) Compounding the communication problem, Hofmann had a habit of ending his sentences with "*nicha?*"—a contraction of the German *nicht wahr* (isn't that so?).[20] Moving energetically around the room, he quickly corrected students' work.

When he saw Grace on the model stand for the first time, he exclaimed, "Ach! a Titian!"—the Italian sixteenth-century painter of richly sensual nudes.[21] Although universally beloved, Hofmann was entirely wrapped up in the world of art. One day, Grace was in an open-legged pose while Hofmann lectured. Pointing inches away from her crotch, he said, "And *ziss* is vot vee mean by negateeff [negative] space!"[22] Modeling for Hofmann was ultimately unsettling, even though Grace absorbed some of his precepts, especially the

importance of using color to make a painting appear to glow from the inside. As the weeks went by—spending hours in a creative setting, but with her body dissociated from her own creativity and point of view—she realized that it was time to find another way to earn money.

Meanwhile, she had met a new man. In a way typical of the tiny, close-knit art world of the era, Grace and Alfred Leslie were brought together by painter Tony Smith, who admired Harry's paintings.* Five years younger than Grace, Alfred was a feisty former gymnast and bodybuilder from the Bronx who had lost much of his hearing as the result of a childhood illness. After serving in the Coast Guard at the end of the war, he earned his living waxing office floors at night. His painting studio, where he lived illegally without the luxury of running water, was on West 4th Street off Washington Square. Alfred discovered that he could collect as much as a hundred dollars a month plus a book allowance on the G.I. Bill if he enrolled in college. A practical man, he figured that New York University's School of Art Education was the logical choice because it was just a couple blocks away, and he was already using the shower at the building.

Alfred and Grace immediately became a couple. "A lot of people have said, 'Oh, wasn't she beautiful?'" he recalled. "I never thought of her as beautiful or not beautiful. I just thought of her as a remarkable person whose force of personality and radiance of self came before anything else. She was very smart and very devoted to her work. She could be imperious from time to time, which I loved about her. A lot of people thought she was very aggressive. I never thought so. She just liked to make herself part of the moment wherever she was. It was a struggle for her to survive."[23]

It was a struggle for both of them to survive. They lived and worked in a fourth-floor loft, a former sewing machine factory at the corner of Essex and Hester streets that rented for $30 a month. The loft was intended strictly for use as an art studio,[24] but like Grace, Alfred had experience getting around inconvenient rules. He designed a bed that would roll up to look like the back of a sofa and purchased a $1 luncheonette permit to serve food so that he and his "employee" could legally eat in the loft. When they first moved in, they used Coleman lanterns for lighting because all the electrical wiring had been removed when the factory moved out. Thanks to Alfred's handyman skills, the loft was soon outfitted with propane lights hung from the ceiling, a propane stove, and a cold-water pipe hooked into the sink that drained onto the roof. There was a toilet on the floor below and a galvanized tub for baths.

* Later known for his monumental sculptures, Smith was then a painter.

During the winter, one of the building superintendents took pity on the freezing couple—Grace later recalled that they had tried to caulk the drafty windows with papier-mâché[25]—and gave them a small potbellied coal stove. Discarded crates on the sidewalk were prized finds, yielding strips of wood to make stretcher bars for canvases.

Although this was the middle of the twentieth century, when middle-class people in New York were accustomed to central heat, tiled bathrooms, and modern kitchens, Alfred and Grace lived much like the starving mid-nineteenth-century artists in the opera *La Bohème*. The couple's frugality extended to transportation (they sometimes walked for miles to save the 10 cent subway fare) and, especially, food. Most of the neighborhood people in those years were peddlers, Hasidic Jews who had dairy farms in New Jersey and came to Manhattan to sell their goods. "They knew we had no refrigerator and no money," said Alfred, who was also working sporadically as a model in addition to doing carpentry work. "They loved us because we were frugal and took care of ourselves." For Grace, "these men with beards and long black robes and big fur hats" were proof that she was living "in an exotic land."[26] The aroma of vinegar and spices permeated the building, a visitor later recalled, wafting up from pickle barrels at street level. He noted Grace's delight at her surroundings ("Isn't it a heavenly spot to live in!") as she offered him a dill pickle.[27]

In the mornings, Grace or Alfred would walk down the three flights of stairs to buy a single egg or a pat of butter. They would elbow their way through the shouting crowds at the Essex Street Market for whatever could be bought for a few cents: stale bread, spoiled fruit, bacon ends.[28] Decades later, the sharp edges of her early life softened by memory, Grace marveled at the tasty dark bread that seemed to be a neighborhood specialty and the "big wooden tub...full of sweet butter," a new treat.[29] But in 1953, Grace would look back at her scavenger's diet of 1950 with relief that she no longer had to suffer hunger, indigestion, and frequent illnesses.[30]

Loft living was precarious in other ways. Once, a near-tragedy provided a treasure trove of cigarettes and junk food. A candy seller with a chip on his shoulder who operated out of a ground-floor counter, open to the street, had set the building on fire. Grace and Alfred managed to put out the blaze and then discovered that the man had left all his goods behind when he fled.

Another night, two police officers grew suspicious when they saw lights in the windows at eleven o'clock. Shining their flashlights upward, they demanded to know what was going on. When Grace and Alfred walked down to talk to them, it was clear that the couple weren't burglars. But who were they, and

what were they doing? Realizing that the cops had had a few drinks, Alfred suggested that they come up for coffee, and Grace scurried upstairs to heat the kettle. The cops trudged behind the couple, still cautious, still beaming their flashlights.

When they stepped inside the loft, with Grace's big abstract canvases leaning against the walls and Alfred's mess—the floor on his side was covered with bits of paper he used for collages—it was clear that they had never seen anything like it. The cops hooted with laughter. "What is this?" one of them asked. "This is our work," said Grace, doubtless wondering what to say to people whose notion of art was likely a calendar picture. (The following year, the janitor who cleaned the roof told her he loved the studio because it was "like living in Coney Island," the amusement park.[31])

Fortunately, the cops didn't ask where the couple slept, so astounded were they by the primitive condition of the loft. "You don't have electricity?" one of them asked. "Who lives in New York without electricity?" The other cop announced that he was in urgent need of a toilet, and was instructed to walk downstairs. A few minutes later, there was a tremendous crash. His partner pulled out his gun and raced downstairs, with Grace and Alfred running after him. It turned out that when the man had yanked on the chain, the entire tank fell down, drenching him. Although the police department refused to repair the damage, the couple's good-hearted landlord agreed to do it at no charge.

Most of the time, life was more peaceful. When they weren't painting or working at odd jobs, Grace and Alfred often walked up Fifth Avenue to catch the double-decker Fifth Avenue bus at Washington Square Park and ride to 53rd Street.[†] This was the hallowed ground of the Museum of Modern Art. Unlike other art museums, it was dedicated to showing a broad range of objects—photographs, furniture, and well-designed consumer goods, as well as painting, sculpture, and prints. A small exhibition in spring of 1950 offered what the museum's press release cautiously called "highly controversial works by younger American abstract painters," including Pollock and Arshile Gorky, a groundbreaking artist who had committed suicide the year before. In those days, director René d'Harnoncourt—whose affable personality made his towering, six foot, six inch stature less imposing—found time to prowl the galleries and talk to artists. "If he saw you," Alfred recalled, "the big asparagus would come over and take you to lunch." Most important for artists' careers were Alfred H. Barr Jr., the scholarly former director who was now director of

† Now a one-way downtown street, Fifth Avenue had traffic in both directions in the fifties.

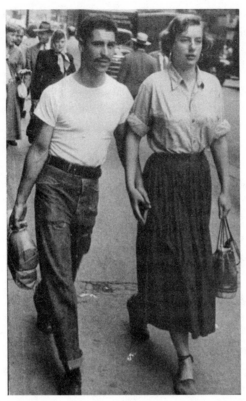

Grace and Alfred on the street in Manhattan, July 1950. (Grace Hartigan Papers, Special Collections Research Center, Syracuse University Libraries)

collections,[‡] and Dorothy Miller, the astute, hardworking curator. They followed the progress of Grace's work, waiting for it to become worthy of a museum purchase.

Faced with denunciations of the new trend in abstract painting as somehow "un-American"—Congressman George Anthony Dondero of Michigan had thundered against it as a Soviet-led strategy to spread communism in the United States[32]—Barr would publish a vigorous defense in the *New York Times*.[33] He wrote that the new abstract paintings have "a sensuous, emotional, aesthetic and at times almost mystical power." But this power had

‡ Barr was appointed director of the Modern in 1929, the year it was founded. He was forced to resign in 1943 for reasons that ranged from conservative trustees' displeasure at certain exhibitions to his relative weakness as an administrator and his distaste for the social duties of the position. But he remained loyal to the Modern and in 1947 was appointed director of museum collections.

nothing to do with political infiltration. Barr pointed out that the Soviets had been condemning abstraction as decadent for the past thirty years.

IN EARLY 1950, Grace's painting *Secuda Esa Bruja* was chosen by leading art critic Clement Greenberg and art historian Meyer Schapiro for the New Talent 1950 group exhibition at the Kootz Gallery.[34] The show, which opened in late April, marked the first time she felt she had broken through "to something that I felt was my own."[35] Grace's new abstract paintings demonstrated an increasing ability to translate aspects she admired in de Kooning's and Pollock's works of the late forties into a personal style. Although she didn't borrow Pollock's drip technique, her paintings had the new "all-over" look: "no beginning, no end, no central image, no background—all the revolutionary ideas that were then in the air."[36]

Grace had learned from de Kooning and Pollock that painting was not just making a picture but "having the painting be the artist and life itself, a more crucial, essential feeling."[37] She understood that a painting "must be thrown into chaos," with all the risk that implied—the risk of fatally losing your way and having to destroy days, weeks, even months of work. What really counted was *process*, the act of creation. It was even more important than the finished work.

One of Grace's most assured paintings from this year, despite its debt to Pollock, is *The King Is Dead*,[38] a dense, rhythmic interplay of quick hits of color and dry-brushed trails of black and white, on a heroic scale. (The painting is nearly five-and-a-half feet tall and eight-and-a-half feet wide.) The king was Picasso, whose succession of strikingly innovative styles had ensured that Paris remained the center of the painting universe. But now, Grace said, "there was this tremendous feeling with everyone that painting had come to America, and that Paris [was] dead."[39]

In *Months and Moons*, Grace leavened curving black brushstrokes with passages of white, yellow, and red, which—given the title—prompt thoughts of both moonlight and menstrual blood.[40] Although the skinny drips, abstract forms, and black-white contrasts are indebted to de Kooning, Grace's rhythms are slower and moodier. A tiny swatch of yellow near the bottom of the canvas is actually a collaged ad for pancakes from *Life* magazine, which Grace added "to keep the picture going."[41] Throughout her career, her paintings would contain metaphors of personal experiences. *Months and Moons* may reflect her nerve-wracking wait for her period every month at a time when birth control was chancy and abortion illegal, and she desperately did not want another child.

Eight-year-old Jeffrey had spent most of his short life with his grandparents. In a reversal of the usual order of things, he saw his mother during brief visits. Her 1950 painting *Kindergarten Chats*—a dense composition of vaguely geometric shapes in bright colors spiked with patches of olive green—was inspired by the toys Jeffrey had left on her studio floor on one of these occasions.[42] Grace's self-absorption seemed to crowd out the instinctive empathy that normally bonds mother and child. But she was hardly alone in living without children.

Musa Mayer, daughter of the painter Philip Guston, recalled searching "incessantly" for "evidence of family life among my parents' friends.... With few exceptions, artists didn't seem to have children; or if they did, they'd been left behind long before, with their failed marriages."[43] Hans Hofmann cautioned fellow painter Fritz Bultman when he married that he shouldn't have children because "an artist has to put his whole life into his career."[44] (Bultman and his wife chose to ignore this advice.) Cynthia Navaretta, whose husband Emmanuel Navaretta was an artist, recalled that "the women didn't want to have children because it would stop their careers. The men were reluctant because they couldn't afford them."[45] At gatherings, artists passed her baby around as if he were an exotic toy. Navaretta noted that although painter Mercedes Matter did have a son, he "was never visible in the art world as a child." Matter's son, born the same year as Jeffrey, contracted polio when he was a preschooler. During his infancy, when Matter and her husband lived in Los Angeles, lack of money for a babysitter meant that her painting life was essentially on hold.

Grace was not unique as a creative woman in separating herself from her son. Several prominent twentieth-century women in the arts gave up their children, temporarily or permanently, to focus on their work—with varying outcomes. When twenty-two-year-old poet Louise Bogan left her first husband in 1919, she wanted to live unencumbered in New York. So she deposited her toddler Maisie with her parents in a small Massachusetts town.[46] Fifteen years later, when Bogan's second marriage collapsed, Maisie finally came to live with her mother, having weathered her mother's neglect with remarkable equanimity.

Dorothea Lange's two sons were not so fortunate in the 1930s. At ages four and seven, they were sent by the photographer and her then husband, artist Maynard Dixon, to live with other people, a separation that would be repeated several times over the next seven years. (Sending children to board with foster parents or relatives was not uncommon at the time, even for women with jobs. Childhood experts believed that so long as a child's basic needs were taken care of, all was well.) Lange herself had been abandoned by her father

and suffered unremitting anxiety about her sons. Yet even in their old age, they never forgave her.[47]

Painter Alice Neel was thirty years old in 1930 when her husband took their daughter Isabetta to Cuba on a false pretext, leaving her with his parents. Desperately poor and on the verge of a breakdown, Neel seems to have felt that there was no way she could rescue and care for her infant, and also keep on painting. Isabetta—who saw her mother only two or three times afterward, under upsetting circumstances, and remained bitter about her abandonment—eventually committed suicide.[48]

The novelist Doris Lessing, three years older than Grace, is perhaps the most famous creative woman who walked out on her children. Lessing, similarly alienated from her own mother, was in her mid-twenties when she left her first husband and their son and daughter for a new life of left-wing protest. After divorcing her second husband and moving from Southern Rhodesia to London with their child, she sent him to a family in the country for two-week periods. Late in her life, she told an interviewer, "No one can write with a child around You just get cross."[49]

Certainly, far less opprobrium attaches to men who abandon their children, whether for another woman or simply out of restlessness. And what about fathers who are physically present but emotionally absent, like the painter Philip Guston, movingly evoked in his daughter's memoir?[50] Yet Grace could seem exceptionally self-centered. She occasionally recorded concerns about Jeffrey in her journal—when he cried himself to sleep because he wanted to live with his parents, when he had appendicitis, and at Christmastime, ostensibly because she couldn't afford better presents for him. But he remains a shadowy presence in these pages. In one entry, Grace noted how "heart-breaking" it was to hear him cry, yet she added, in a curiously distanced tone—as if she were his biographer rather than his mother—that "there was nothing to be said that could soothe him—he has his tragedies defined for him at an early age."[51]

When Grace and her family and Jeffrey spent a summer week at the Jersey shore in 1952, she laid out her feelings in a letter. "I think Jeff's glad I'm with him," she wrote. "He's been very sweet, but he's either the most uninteresting child in the world or he keeps his true self well guarded. I can't manage to find that he has any interests apart from comics, movies, T.V., [an amusement park], and swimming. No material for imaginative, pixie-like 'child world' conversations."[52] Jeffrey was nine years old at the time; his interests sound completely normal for a child his age. Grace was apparently hoping for a replica of her idealized young self: a child who read the classics for fun and created homemade theatrical productions.

Decades later, when Grace gave a lecture at an art school, someone in the audience asked about her son. Her response was shockingly blunt. She never liked children, she said. Though she does "make exceptions," her own child was "not one of the most favorite children in my life.... I hated being a mother."[53]

Grace's real "children" were her paintings. Many had a difficult birth; some were stillborn. She was proud of the ones that she felt succeeded and enjoyed hearing them praised by people whose opinions she cared about. At one point in the late spring of 1951, she wrote, "My children are scattered"[54]— one painting at her gallery, another on view at the Ninth Street Show. As an artist, Grace was a proud mother who missed her grown offspring but was pleased that they found their way in the world.

IN NOVEMBER 1950, John Bernard Myers, a young man from Buffalo, New York, who had edited an avant-garde magazine and staged sophisticated puppet shows for adults, opened an art gallery on the first floor of a long, narrow apartment, under the rattling trains of the Third Avenue El. Tibor de Nagy Gallery, at 206 East 53rd Street, took its name from Myers's partner, cultured émigré Tibor de Nagy, an economist who had been an art collector and leading banker in his native Hungary before becoming a member of what he wryly called the "nouveau poor" in New York.

Two years earlier, the men had struck up a conversation during the intermission of the Balanchine-Stravinsky ballet *Orpheus* at the City Center of Music and Drama, and de Nagy found himself agreeing to invest his meager savings in Myers's puppet company. This was the era of Howdy Doody, the freckle-faced boy marionette star of a wildly popular children's show on NBC. Myers hoped to duplicate the show's success, beginning with staged marionette productions for children that involved his poet, playwright, composer, and puppet-world friends. The struggling marionette company never made it to the golden land of TV. But the partners began to make history when Pollock, Krasner, and Greenberg convinced them to open an art gallery. For the first six years, financial support came from polymath Dwight Ripley, who put up a $500 stake plus a monthly allowance of $300. Once he became a U.S. citizen, de Nagy spent his days working at Manufacturers Hanover Bank, tending to the gallery's needs on evenings and weekends.

To announce the new enterprise, Myers's grandiloquent statement proclaimed that the gallery would provide "anything that an astonished or adoring eye might select instantaneously from the cinema of life."[55] He was looking for young artists, and Greenberg and Pollock put in a good word for Hartigan. When Myers came to her studio, his first impression of Grace was a tall

woman, "as fresh as is the month of May, with what people used to call clean-cut American good looks."[56] Decades later, he recalled the "electrifying energy [that] poured out of her."[57]

Myers was the first homosexual Grace believed she had ever met. "John was one of the most outrageous gay men that you can imagine at a time when most gay people were not out," Alfred Leslie said later. "He was as flamboyant a queen as you could imagine. He was almost like a caricature." In Grace's view, the "wit, 'secret life,' and courage" of John Myers and the other gay men she met in these years "appealed to everything in me that the bourgeoisie had tried to repress. Here were men having FUN. And making a gay (the word had the original meaning then) life in the middle of poverty."[58]

Grace recalled the phone call that led to the meeting consisted of Myers's "talking like a manic typewriter about a new gallery where the light cords twined like huge spiders across a sky blue ceiling."[59] She was "swept into the Myers milieu, where poetry and painting met marionettes and stand-up comedy." (De Nagy, whom Grace met later, offered a study in contrasts, with his restrained bearing and Old World courtesies. She always remembered that he was the first man to kiss her hand.)

When Myers invited Grace and Alfred to dinner, she met his roommate, Waldemar Hansen, a prickly writer who would be part of Grace's inner circle for several years.[60] Myers prided himself on his cooking and menu planning, deftly orchestrating a medley of vegetables with no meat—to keep his guests from feeling stuffed and sleepy, he once explained (or, more likely, to save money). Grace, accustomed to living on throwaway scraps, marveled at the eggplant dish Myers served. As she said later, "Enchantment set in."[61] Typical of this hothouse atmosphere, so delightfully new to Grace, was Hansen's remark about the temperamental gas stove in the apartment: "I just pretend that it's Betty Grable and I'm Darryl Zanuck."[62]

Myers, whose interest in people was largely a product of his own fanciful interpretations, later remembered Grace in these years as someone whose passions—outside of "painting large, dashing canvases"—were limited to Alfred, movie magazines, and cooking.[63] For her part, Grace was intrigued by Myers's gay friends' camp habit of calling each other by the names of famous women in the arts. (Myers became "Carson," after the novelist Carson McCullers.) Camp, as Susan Sontag memorably wrote, is a type of "artifice and exaggeration" practiced by "small urban cliques."[64] Looking at the world through camp glasses, style is everything and everyone is always playing a role, the more unnatural and extravagant the better: "What is most beautiful in virile men is something feminine; what is most beautiful in feminine women is something masculine."[65]

Grace once said that she and Myers jointly came up with "George" as her alter ego for publicity purposes. (Her canvases were signed simply "Hartigan.") De Nagy claimed that he tried to get Grace to use her own name, but she refused.[66]

In later years, Grace sometimes invoked her "romantic identification" with the nineteenth-century novelists George Sand (Aurore Dupin) and George Eliot (Mary Ann Evans) as the basis for the name. At other times, she trotted out the camp-name story. ("Darling," Myers trilled, "You won't have to change your monogrammed sheets!"[67]) Of course, she may well have wondered if her large, bold paintings would have a better chance of being reviewed and sold if they appeared to be the work of a male artist. In the early sixties, one of her collectors wrote that Grace "was reluctant to be known as a woman painter with whatever ambivalent emotions that classification might arouse."[68]

In addition to Lee Krasner, other prominent American women artists of the twentieth century who adopted a male or androgynous first name included the photographer Lee Miller (who traded "Elizabeth" for "Lee" at age twenty), and painters I. [Irene] Rice Pereira, Romaine [Beatrice Romaine Goddard] Brooks, and Loren McIver. A painter poised between figuration and abstraction, McIver was born Mary Newman in 1909; although her work has a fragile quality that contemporary viewers would have seen as "feminine," she got rid of "Mary" at age eighteen, when she enrolled in a drawing class.[69]

Granted, women were a tiny minority in the miniscule downtown art world of those years and—the early no-woman rule at the Club is a case in point—were often viewed with suspicion by men. The famous 1951 *Life* magazine photograph of the so-called Irascibles—leading abstract artists who signed a petition against the Metropolitan Museum of Art because it appointed jurors unfriendly to modern art to choose work for a major survey exhibition—included only one woman, Hedda Sterne.[70] She signed her work "H. Sterne" as "a kind of self-protection."[71] Yet the odds were stacked against *all* American abstract artists in those early days. (The Europeans at least had the imprimatur of Old World culture.) Galleries were reluctant to show these artists, even relatively sophisticated collectors generally disdained their work, and the few sales were for pitifully small amounts.

Because the art world of the early fifties was so small, everyone already knew who Grace was, and no one seems to have been fooled by the name change. (She continued to sign her paintings "Hartigan" or, occasionally, "G H.") Despite the fact that for her first four shows, Grace's exhibition announcements read "George Hartigan," reviewers either used the feminine pronoun or sidestepped the issue by writing "the artist" or "Hartigan."[72] The name she used also had no apparent effect on the attention and respect her

work received. Grace had undeniable talent and (despite periods of self-doubt confided only to her journal and to close friends) an abiding belief in herself. One observer said of her, "I never knew anyone, male or female, who appeared to have more self-confidence and determination."[73] Years later, when she was asked if anyone ever told her, "You paint as well as a man," she responded, "Not twice."[74] Grace also had the advantages of being attractive and highly sexed, and was willing and able—as we shall see—to use her ebullient public persona to her advantage.

By 1954, Grace he began to realize that using a man's name was more trouble than it was worth. Artists who had a show at Tibor de Nagy had to "sit" the gallery on Saturdays (when Myers was checking out other gallery shows), and she found it awkward to refer to her works as though a different person had painted them. "I started to get creative schizophrenia," she said.[75] So she occasionally used the name "Grace George Hartigan,"[76] until the "George" disappeared entirely, in 1955. "I sort of eased my way out of it," she said.[77]

Although this was a brief interlude in Grace's career, commentators during the second wave of feminism in the 1970s became fixated on What It All Meant. Hoping to put an end to this speculation, Grace told one art writer that the name "has absolutely nothing to do with the feeling that I was going to be discriminated against as a woman."[78] To another, a decade later, she wrote, "They think that I wanted to be a man, and that never entered my head."[79] Grace was hostile to the women's movement. As far as she was concerned, she was a painter who was a woman, not a "woman painter." She had battled for recognition in a man's world on her own terms, and she had won.

What *is* significant about the "George" interlude is the identity of Grace's two real-life heroines—two gifted women who defied social norms to pursue rebellious personal and professional lives. George Sand dared to wear trousers (initially, for ease when hunting) and smoked cigars in public; she also had liaisons with numerous men, most famously, the composer Frédéric Chopin. In her autobiographical novel *Lélia*, the title character restlessly pursues one lover after another in her search for emotional and sexual fulfillment. Like Sand, a published novelist at a time when women were generally scorned or ignored by publishers, George Eliot lived with a man outside of wedlock. It's tempting to see Grace's sense of herself as a girl as akin to the youth of Eliot's headstrong heroine Maggie Tulliver in *Mill on the Floss*[80]—fascinated by gypsy life, close to her kindly father, and impatient with her foolish, fretful mother.

TIBOR DE NAGY GALLERY was something of an anomaly in the macho world of Abstract Expressionism. Embracing collaborations between artists and

poets—several of whom (Frank O'Hara, John Ashbery, James Schuyler)—
were gay, the gallery represented younger painters whose approach was gener-
ally more lyrical and indirect than the first generation of Abstraction Expres-
sionist artists. But Tibor's (as it was known) was open to all kinds of painting
as long as it was fresh and strong, and represented an unusually large number
of women artists. During the fifties, the gallery's roster included representa-
tional painters (Jane Freilicher, Nell Blaine, Fairfield Porter, Larry Rivers) as
well as abstract artists (most notably, Helen Frankenthaler, whose early work
retained a strong connection to landscape), and painters who worked in both
modes (Grace, Alfred). There was also the unclassifiable Marie Menken—a
flamboyant artist and experimental filmmaker entranced by the rhythmic
effects of moving images and reflected light—who had a show of her broken-
glass-encrusted paintings at the gallery, installed by Alfred. She posed in the
nude for Grace, who unsparingly evoked her pendulous breasts and pillowy
stomach with a few scratchy lines in an ink drawing.[81]

Myers thrived on gossip and was on the phone to Grace almost daily.
Later, his needling comments would create a rift between them, but in the
beginning Grace was delighted to be part of the swirling emotional energy of
the gallery. Jane Freilicher recalled that it had a significant social component,
functioning "as a kind of salon where John and Tibor held court with many of
the most interesting people of the day...from the New York literary and art
world."[82]

The King Is Dead, *Kindergarten Chats*, and *Months and Moons* were among
the seven paintings and three gouache studies in Grace's first one-person
show, which opened at the gallery on January 16, 1951. A young woman from
the avant-garde theatre world who came to the opening noted approvingly in
her journal that Grace's "sensitivity is female, but she paints with a vigor that
men claim as exclusively masculine."[83] Lawrence Campbell gave the work a
positive review ("such vitality that they seemed to give off sparks") in *Art
News*.[84] The *New York Times* critic also praised her work, for its "inventive and
frequently beautiful harmonies of pungent color."[85] Years later, Grace said the
show was "what they kindly call an artistic success. That is, my friends liked it
and some of the older men [painters] liked it."[86] But few people came to see
the exhibition, and only one painting sold—for $50, to a young man whose
mother made him return it.[87]

On March 30, two days after her twenty-ninth birthday, Grace wrote an
extended entry in her new journal. She worried about having finished only
one painting since her show, which had closed in early February. It was time,
she wrote, to fulfill "the promise."[88] This oddly disengaged phrase (she didn't

write "*my* promise") reflects both her powerful sense of personal destiny and her ability to stand outside herself and judge the value of what she had accomplished. Meanwhile, her ferocious concentration on her work during this period was taking a toll on her mental state. While walking down a street in her neighborhood, she found herself unable to read the shop signs; they seemed to be in some unknown language.[89]

At a party with guests that included Pollock and the critic Clement Greenberg, Grace was piqued at not being asked how her painting was going. She confided to her journal that social gatherings always gave her a "frenzied desire to make my strength felt."[90] Casting herself as the fiercely combative folk heroine of France, she wrote, "What would you say to Jeanne d'Arc at a cocktail party?" And she lashed out at fellow painter Helen Frankenthaler for being "the fairy princess" who "hasn't seen the dragon yet."[91]

Six-and-a-half years younger than Grace, Helen was the much loved youngest daughter of a New York Supreme Court judge who died when she was eleven. The Frankenthalers lived on Manhattan's well-heeled Upper East Side. Helen went to Dalton, a top private school, where she studied with the Mexican modernist artist Rufino Tamayo, then living in New York. She was fifteen when she first visited the Museum of Modern Art with her sister and was intrigued by *The Persistence of Memory*, Salvador Dalí's painting of melting watches. Five years later, she graduated from progressive Bennington College, where she studied with Cubist painter Paul Feeley, who exposed his students to exciting new developments in the art world.

As we've seen, when Grace was twenty, she worked at a wartime job to support herself and her child, and was just beginning to learn about modern art and to think of herself as a potential artist. At the same age, Helen had already spent years honing her skills and soaking up a culturally sophisticated liberal arts education. Slender and pretty, she had no children, no money worries—and the self-assurance of privilege. Although she had never met Clement Greenberg, then writing for the highbrow *Partisan Review*, she picked up the phone and invited him to an exhibition of art by Bennington graduates. Clem, as he was known, told her that he loved "Bennington girls." But he would come only if drinks were provided. Helen assured him that there would be martinis and Manhattans.[92] Divorced and nearly twenty years older than Helen, the tall, balding critic had made a name for himself a dozen years earlier with his essay, "Avant-Garde and Kitsch."[93] At the art show, he walked around with Helen and criticized a painting that—in Hollywood meet-cute style—just happened to be hers. The two of them instantly hit it off, sharing a similar sense of humor and a love of baseball.

When Helen first saw Pollock's drip paintings, it was at the Betty Parsons Gallery, with Clem. She later recalled how he "threw" her into the room "and seemed to say, 'swim.'"[94] She saw Pollock's achievement as "staggering" and said that it affected her own work "within months."[95] Like Grace, she went out to The Springs to visit him and see his work. Although Helen also looked carefully at de Kooning's work of the early fifties, she felt a greater affinity with Pollock's paintings, attracted to their vestiges of Surrealism and their evocation of vast space. In *The Sightseers* (1951), she filled a sheet of paper with pastel-colored crayoned shapes that vaguely resemble figures and landscape elements, corralled with scattered swipes of black enamel paint. Audaciously, she scribbled her first name just off-center instead of following the hallowed tradition of signing work humbly in the lower-right corner.

While Helen was romantically involved with Clem, she became friendly with Grace and Alfred who were among the artists invited to Helen's cocktail parties, held around the pool at her uptown apartment building.[96] Grace and Alfred would also double-date with Helen and Clem at Ed Winston's Tropical Gardens on 8th Street, another artists' hangout. (Helen incorporated the cel-luloid palm tree decor in her 1951–52 painting titled after the bar-restaurant.[97]) Clem liked to hang out with young people. He often talked to them about their work and occasionally visited their studios. But Grace—who had a con-tentious relationship with him—later recalled that unlike de Kooning, who offered valuable insights, Clem "just grunted" when he liked something.[98]

Grace paid close critical attention to what the other abstract artists were doing. In April, she noted in her journal that she had spent a day visiting the uptown galleries with Alfred to see work by de Kooning, Mark Rothko, David Hare, and other artists, only to return "with the usual 57th St. head-ache."[99] What did that mean? Alfred explained years later that artists fortu-nate enough to be represented by one of the few galleries in existence sent their work out as soon as it appeared to be finished, rather than taking time to contemplate it. As a result, he said, "the level of the work you saw was often indifferent." It's also quite possible that Grace worried about finding an equiv-alent in her own work to the new approaches of these artists. She was her own severest critic. "Your color is getting too sweet!" she scolded herself in her journal that spring.[100] What compelled her to keep working was "the com-plete feeling of repulsion I experience on looking at my 'finished' paintings."[101]

Other viewings of art by others yielded useful lessons for her work. A show of paintings by Robert Goodnough suggested to her that using a prominent color could resolve the problem of creating a unified overall effect. A week later, she came to some important conclusions about how to proceed. "A picture

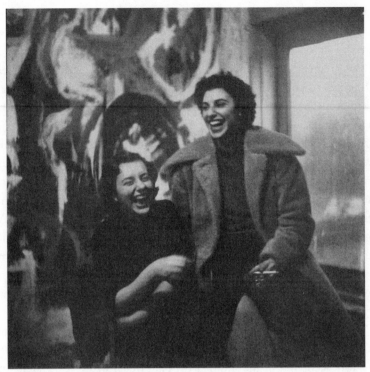

Grace and Helen Frankenthaler, 1952. (Photo: Walter Silver. Courtesy of George Silver and Irving Sandler)

must reach out toward its edges and gather itself in," she wrote, evoking an image of a painting as a living thing, imbued with a will and physicality of its own.[102] Artists of the fifties frequently spoke metaphorically about their work, but it is striking that Grace—whose large-scale paintings engaged her entire body—would employ such an active image.

Later that spring, she was one of more than sixty artists—including Pollock and de Kooning—represented in the landmark Ninth Street Show, held in a vacant storefront with high ceilings at 60 East 9th Street.[103] The exhibition was organized by several artists and Leo Castelli, several years away from opening his own gallery but already in the thick of things.§

"A lot of [artists] lived on Ninth Street then," painter Ludwig Sander recalled. "One building had Conrad Marca-Relli, Franz Kline, and John Ferren.

§ Castelli was an early client of Tibor de Nagy Gallery and one of the few non-artist members of the Club, which had a policy against organizing exhibitions. That's why he agreed to take charge of this one.

And Milton Resnick was across the way." Two months of rent for the store cost $70, and money was also needed to wire the space for electricity. "Everybody was supposed to give [Castelli] five bucks for expenses," Sander said. Someone remembered that a Surrealist show had called attention to itself by putting a bare 200-watt bulb out front. The second floor of the store had a flagpole socket, so Sander and another artist added a flagpole and hung a high-wattage bulb from it. Inside, they painted the walls white.

A big crowd attended the opening on May 21, announced with a banner stretched across the building facade. Banks of taxis pulled up, carrying people in evening dress who stepped out under blinding illumination that reminded Sander of a klieg light. "It was like the old newsreel pictures from a movie opening in Grauman's Chinese Theatre in Hollywood," he said. *Art News* magazine reported that "[a]n air of haphazard gaiety, confusion, punctuated by moments of achievement reflects the organization of this mammoth show."[104] The haphazard quality was partially due to the fact that some artists who hadn't been asked to participate just showed up and hung their work anyway. Seventy-two artists were represented by one work apiece.

No one had ever seen such a wealth of up-to-the-minute abstract painting and sculpture gathered in one place. "Almost everyone who was part of the New York scene was in the show," artist Paul Brach wrote years later, "and it must have made them feel less alone."[105] Sander seconded his opinion. "It gave us some enthusiasm about ourselves," he said. "It did us more good in our own eyes than it did in any other way." Alfred Barr of the Museum of Modern Art was reportedly surprised and impressed to see the sheer number of New York artists working in an abstract style. One of the paintings he singled out was Grace's *Six Square*,[106] despite her disparagement of the color as "tremendously feminine...which of course I detest."[107]

GRACE AND ALFRED were often too broke that spring to afford canvas and paint. At one point, Myers said he would try to send them a few hundred dollars, but nothing seems to have come of this. In July, after more than a month of failing to bring in any money—her paintings weren't selling and she had no outside job after abandoning a stint as a file clerk in May—Grace began working three days a week, from 3:00 P.M. to 11:00 P.M., at a travel bureau in the Savoy-Plaza Hotel, overlooking Central Park.

July was a month of upheaval. Grace's beloved Nana died; she wound up forking over precious dollars to someone who turned out to be a professional con man;[108] and Alfred moved out "after a week and a half of insanities, ills, and heart breaks."[109] While this seems to have been a mutual decision, Grace

was tormented about the breakup, and it made the need to earn money even more pressing. The only peace she could find, she told her journal, was through continued work on her paintings: "It is in this way and with this knowledge that I'll be able to face the emotional tensions of being alone again."[110] There is no doubt that she considered Alfred a rival. At a party in June, she had to stifle her irritation when a gallery supporter lavishly praised his work.[111] Decades later, Alfred said that he and Grace remained friends, and "there was never any enmity when we separated." But about two years into their affair, he said, their lives no longer seemed to run along parallel lines. "We still had the same gallery; we still had the same friends," he said. "But we were just drawn apart. And it was a better situation."

In August, Helen wrote a chummy letter to Grace, commiserating with her about "the last act curtain" (the breakup).[112] She sounded disappointed that Grace had turned down an invitation to visit her and Clem in a rented house in upstate New York, where they were spending the month with Clem's teenage son and visiting the nearby sights. It's likely that Grace was not in the mood to play fifth wheel, much as she would have liked to get out of town. Like all impoverished city-dwellers trying to beat the muggy heat, she dragged a sheet and blanket to her fire escape at night to catch a stray breeze.

It never took Grace long to find another lover. Within the month, she became involved with Walter Silver, a Brooklyn-born photographer a year younger than she was. Walter had served in the Air Force during World War II.[113] When he met Grace, he was separated from his first wife—he would marry four more times—and had left the photography studio he ran with an Air Force buddy to become a freelance commercial photographer. The salesmanship required for success in this field eluded him. And although his candid photographs of artists and their milieu were occasionally shown in galleries, the only markets for this work were poorly paying art magazines and museums. He tried his hand at selling antiques for a while, but it wasn't until two decades later, when he began teaching photography in Boston and New York, that he had a stable job.

Dark-haired, with an earnest-looking face, Walter has been portrayed by acquaintances in a bewildering number of guises (loud and prone to exaggerations, pleasantly sociable, silent and gloomy), which likely means that his emotional temperature was highly variable. His brother George, who never could fathom Walter, thought of him as "a strange bird" who would mutter about things, seemingly unable to utter a complete sentence.[114] In 1951, Walter was so devastated by the death of his two-year-old son from leukemia that he left his wife and lost touch with his family for several months.

Despite his moodiness, he was devoted to Grace, and she discovered the advantages of a peaceful relationship with a man who—because he wasn't a painter and lacked a combative attitude—would not be a professional rival. In return, she gave him increased confidence in his photography. "I came at the right time to give him HIMSELF," she wrote decades later, "to believe that he was a photographer and introduce him to the avant-garde milieu."[115] Grace added that she felt "more Jewish than he was"—because of her love of blintzes and other ethnic foods available on the Lower East Side—which helped her bond with Walter's mother Frieda.

In the summer of 1952, during a week spent with her family and Jeffrey at the Jersey shore, she wrote a passionate declaration to Walter: "I never realized how close we were. I need you terribly. I think if I went much longer than this without your love and closeness, I'd get all dried up and very tense and fierce."[116] Yet, vital as his presence was to her feeling of well-being, what's missing here is any mention of the qualities she loved in *him*. Tellingly, for someone so verbal—her deep friendship with the poet Frank O'Hara would be rooted in engrossing conversations—she also noted that the "tremendous intimacy" she shared with Walter "has nothing to do with words." (After his death, she wrote to his sister-in-law that "as I often told him, he was a lovely lover."[117]) There was also the matter of support, a factor that would play an increasingly central role in her relationships. Two months after the relationship began (and intermittently thereafter), Walter agreed to pay for the couple's basic expenses with his freelance photography so that she would be free to paint.

Both Grace's brother Arthur and niece Donna Sesee (who met Walter after he and Grace were no longer a couple) remember him as a friendly guy who came to all Grace's openings.[118] Sesee recalled that Grace and Walter liked to make each other laugh. Others, like the poet John Ashbery—who accompanied Grace, Walter, and several other people on a car trip to Mexico a few years later—described Walter (whom he barely remembered decades later) as morose.[119] Alfred, while admitting that he was no expert in psychiatry, said he thought Walter might have been "clinically depressed" without being aware of it. "I never understood how Grace survived being with him," Alfred said, "except that he took care of her."

In the mid-fifties, Alfred had a major falling out with Walter that illuminates the photographer's passive-aggressive side. Alfred had painted a stage set for an avant-garde play[120] on six eight-foot-tall panels of Masonite. Attached, they spanned twenty-four feet. He was working in a form of abstraction that consisted of colorful stripes, much praised by both Grace and Clem. Because the set was so huge, and Alfred was then living in Hoboken, New

Jersey, he asked if he could drop it off at the Essex Street studio. Months went by, and somehow it was never the right time to pick up the painting. Finally, Alfred discovered that Walter had chopped up the painting and incorporated parts of it in a new studio wall. ("Grace was very embarrassed," Alfred said.) In 1966, after Alfred's own studio burned down, destroying years of his work, he asked Walter (who had documented the play) to send him the photos. But Walter would not do this. The stalemate continued to Walter's death, twenty-two years later.

Whatever his personal failings, as a documentary photographer Walter cannot be faulted. As fellow artist Wolf Kahn said of Grace, "Walter was her Steiglitz."[121] When he lived with her, and for years afterward, his evocative black-and-white photographs captured major events and random moments in the public and private lives of Grace and her friends.[122]

One of the key figures in these photographs is the poet Frank O'Hara, who arrived in New York in August 1951 from Ann Arbor, where he had been working on his master's degree in English literature at the University of Michigan. A Harvard graduate, four years younger than Grace,[123] he immediately took to Manhattan. Universally described as a wonderful person to know—because of his infectious enthusiasms, quick wit, and genuine interest in other people—he had a deep background in art and was a trained pianist. O'Hara loved the energy of the city, a marked contrast to the small-town life he had known growing up in Massachusetts.

At one of art dealer John Bernard Myers's Thursday night gatherings, "a very slim man walked through the door," Grace recalled years later, "and I thought he was one of the most chic men I'd ever seen in my life."[124] She was fascinated by the way he wore a V-neck Shetland sweater without a shirt underneath and walked on the balls of his feet. "Frank and I immediately became friends," she said, echoing the pattern of just about everyone he met and liked. In contrast to Myers's flamboyant style, Frank was "witty, buoyant, subtle."[125]

"We started to meet in the Cedar Bar," Grace said, "and he'd bring a poem in and we would sit around and read [it] over a beer, and he'd come down to the studio every time I'd do a painting."[126] She found his sexual orientation no impediment to their growing closeness. "I love men—why shouldn't he?" she once wrote. "It never—what would?—interfered with our love for each other. I'm not the first person to say that sex isn't necessarily love and vice-versa."[127] She would grow close to him in the next few years, sharing her innermost thoughts and incorporating elements of his poetry in her work.

Grace usually described her long and intimate connection with O'Hara as though it happened suddenly. But there is a reason why his name doesn't appear in her journal until the following spring. His close friendships with

women were on a more exclusive basis—he favored a flexible version of serial monogamy—and when he first came to New York, the woman in his life was the painter Jane Freilicher. He had met her through John Ashbery, a friend from Harvard, on a visit to New York in the 1940s. A few months later, Frank and Jane reconnected at a literary party given by Ashbery.

Two years younger than Grace, who was guardedly friendly with her, Jane was a witty and attractive native New Yorker. She had studied art at Brooklyn College, spent a year drawing from the model at Hans Hofmann's school, and—supported by work as a cocktail waitress—earned a master's degree in art education from Columbia Teachers College. Like Grace, she had married young, eloping with a jazz pianist at age seventeen.[128] In the early fifties, she was separated from her husband and involved with fellow artist and sax player Larry Rivers, whom she had met through her husband (he was playing in Larry's band).[129] Rivers later remarked that Jane was "the first girl I knew who didn't wear high heels," which—once he got over his initial negative reaction—made him realize that she was "something other than a sex object."[130]

Although Jane had started out trying to paint abstractly, she soon found herself edging toward a form of realism. Unlike Grace, she worked on an easel-painting scale; her style was muted, contemplative, and quietly lovely, adroitly avoiding the traps of sentimentality and preciousness. Once Frank moved to New York, he frequently came up to Jane's studio to help her stretch her canvas or pose for her. "He would just sort of hang out while you were painting," she recalled.[131] "It was very flattering to have somebody who would sit and look at you in wonderment. Every word that you said he would think was some profound utterance. And he meant it."[132]

Grace later admitted that she had to learn how to keep up with the repartee characteristic of Frank and the other poets in his circle, while Jane was naturally quick on her feet. But Frank would soon be sharing his innermost thoughts with Grace. She would replace Jane as the subject or dedicatee of some of Frank's poems. And it was Grace, not Jane, who would be the chief beneficiary of Frank's association with the Museum of Modern Art.

IN 1951, GRACE worked on at least twenty-five paintings of various sizes.[133] She abandoned some of them because they didn't coalesce. A few were snapped up by her gallery. One in particular, *The Hero*, caused her enormous stress. On September 1, she noted in her journal that she had been "painting my guts into this picture." She wasn't sure if the six-foot-by-seven-and-a-half-foot canvas was finished, but clearly felt that it was going in a good direction. Sixteen days later, she worried about the color: "too dead and arbitrary."[134] Five days after that, she decided that the painting "stinks." On the same day,

six hours later, her verdict changed again: "Not so bad now, but still needs work."[135] By September 25, having worked only on this one painting all month, she declared it "nearly there. It is harsh and strong. Not at all lyrical." This, in her mind, was a very good thing; for the past year, she had been trying to rid herself of what she viewed as a softness in her painting. Then, on October 15, she destroyed *The Hero*. Now she had nothing to show for nearly two months of intense daily work. But—and this is central to Grace's achievement—she pushed herself to keep painting. "I must hold onto myself," she wrote, "I know things will come now...."

In November, Grace wrote in her journal that she must "reach somehow into the complete unknown" and paint from "blind, inspired feeling" to get beyond superficial visual appeal.[136] Using a plural pronoun, as if she somehow spoke for her generation, she added, "We must be massive and ugly to find something new."[137] Soon after writing this, she went to see the Henri Matisse retrospective at the Museum of Modern Art. It was a landmark show of seventy-five paintings and works in other media by the eighty-one-year-old French artist. His lyrical canvases combine fluid line with intensely expressive color in a unique way—mingling sensuality, playfulness, and an abiding fascination with decoration. Grace, an instinctive colorist, felt that the exhibition had taught her something, but she couldn't yet articulate what this was.[138] Eight months later, she had begun to figure it out: What she particularly liked about Matisse's best works is their lack of coziness, the way he "always puts you off."[139]

The following month, at an artists' party, Grace was incensed by Clem's description of women painters as "too easily satisfied" with their overly polished, candy-like pictures, unlike the men, who "struggle." She wrote in her journal, "Am I to scream at him, I struggle too, I do!"[140] Grace would never be easily satisfied. She would work through thousands of intuitive decisions and second thoughts, mercilessly criticizing her work until it achieved its breakout form.

At the end of the year, she enjoyed the triumph of having one of her paintings, *Paris, 1910*, selected by Leo Castelli for American Vanguard Art for Paris, a group show organized by the fledgling Sidney Janis Gallery that would travel to the Galerie de France in Paris in the winter of 1952.** Anxious and intense in the last months of her twenties, Grace could not know that everything she yearned for and half-glimpsed would be revealed to her in the next two years, resulting in a new way of working that would bring her deep personal satisfaction and increasing acclaim.

** Opened by Sidney Janis, an art collector who was a member of the Museum of Modern Art's advisory board, the 57th Street gallery would soon be representing the cream of the Abstract Expressionist painters, including Pollock, de Kooning, Kline, Motherwell, Mark Rothko, Philip Guston, and Adolph Gottlieb.

8

Launching

GRACE'S RESOLUTION FOR 1952 was to work harder, with "more and more search and courage."[1] It was a good thing she didn't mention trying to curb jealous responses to other artists' work: in a matter of days, she haughtily dismissed Joan Mitchell's airy abstractions in her first one-person show as "a fantastic display of youthful talent and virtuosity, without the real thing."[2] But courage would certainly be required for Grace's growing realization that she needed to reject the "pure" abstraction her artist friends viewed as the only valid modern approach to painting.

As she said a decade later, "I felt that purely abstract expression was not my own. I had acquired a direction without living through it."[3] She told one interviewer, "I thought I was a robber, that I had taken from people, older than I, who had struggled tremendously for years to find this breakthrough. I thought I didn't deserve it."[4]

De Kooning had urged Grace to study the paintings of great artists from earlier centuries. As she said later, "I never had any art history, and I discovered the best way to learn it was to paint it. And so I painted things after Tiepolo and Dürer and Velázquez and Goya... and I added my own thing to it."[5] What intrigued her about Diego Velázquez, court painter to King Philip IV of Spain in the seventeenth century, was the way he used light and color to create form. She also liked "his irony"—his shrewd view of the royal figures in his portraits.[6] Francisco Goya, a painter at the Spanish royal court in the late seventeenth century who is also known for his darkly apocalyptic paintings and satirical etchings, appealed to her for the same reasons. Decades later, she would claim that after about a month of working from a great artist's paintings, she would begin start talking to him (it was always a "him"), doling out praise and criticism ("What happened to that leg?") as if he were present in her studio.[7]

During one of her black periods of self-doubt about her skills, Grace studied briefly with Abbo Ostrowsky, a Russian-born academic painter.[8] He sat her down in front of a plaster cast of Julius Caesar and told her to render

it in charcoal. When she finished an accurate drawing in a few hours, he was enraged; she was supposed to work on it for a week. Grace was a disruptive element in the class, arguing the merits of Old Master painting reproductions by holding them upside down to see their painterly qualities more clearly, but the experience gave her more confidence in her draftsmanship.

In early January, while helping Alfred get over the flu, she decided to paint an Old Master subject: a "massacre." The idea of working with a big theme excited her. By January 15, she reported happily that the abstract canvas was "in a state of juicy chaos." Two days later, she was appalled at what seemed to be unconscious stylistic borrowings from Larry Rivers and another artist. Six days after that, she was sure the painting was awful. But by the end of the month, it seemed to be "hold[ing] up very well," with the exception of one corner. In June, having gained more critical distance—these were months when Grace was constantly in the throes of painterly discovery—she praised the "freedom, boldness and openness" of the composition but worried that it was overly effusive. Early the next year, as she ventured uncertainly into figurative painting, she realized that *The Massacre* (plate 3) "summed up every thing [*sic*] of my former style."[9]

Meanwhile, Tibor de Nagy Gallery was facing a grim future because financial backer Dwight Ripley—unable at the time to lay claim to his inherited fortune in England—announced that he would have to pull out at the end of the season. (In fact, he contributed $1,600 in 1953, which more than covered the $1,020 rent.[10]) Grace, whose personal finances were even shakier, had to toil for three weeks at a clerical job she detested to make enough money to pay for expenses related to her upcoming show.

BY SPRING 1952, Grace and Frank O'Hara spoke on the phone every day and saw each other two or three times a week—a ritual that would continue for nearly a decade. With mutual interests that included movies, boyfriends, and the parties they attended, as well as art and poetry, there was plenty to talk about. They would meet at the Cedar Tavern, where Frank would read his latest poem over a beer, or he would come up to her studio, offering astute comments on her current painting. Once, when she had given him a paint-stained pair of her work boots (she and Frank took the same size), he joked to people that he had "put himself in Grace Hartigan's shoes"—a remark that was metaphorically true as well.

"Frank made everything so important, so exciting," Grace told an interviewer. "He couldn't wait to see the next painting, couldn't wait to hear the next piece of music, couldn't wait to see the next ballet. His enthusiasm, his sense of fairness...influenced everyone."[11] For a long time, Frank was her private

cheering squad: "He regarded every painting I did as an event in his life, a cause for celebration."[12] It was his example—the seemingly impulsive, now-I-do-this, now-I-do-that style of many of his poems of the fifties—that inspired Grace's freedom to toss anything she pleased into a painting. Because of the increasingly personal emotional content of her own work, it is telling that what particularly attracted her in his poems was "a kind of madness…a confessional quality."[13]

In February, Frank had written *Grace and George, An Eclogue*, a play filled with wild stage directions and fantastical language that celebrated Grace's dual identity.[14] (George was her professional alter ego at the time.) We can only imagine what was going through Walter Silver's mind when he made a series of photographs of Grace and O'Hara, sitting on a daybed, in a tête-à-tête of soul mates. Somewhat patronizingly, fellow poet Kenneth Koch said that Frank gave Grace's thoughts "wings of language."[15] In addition to his witty conversation about art and literature and movies and other people, he brought

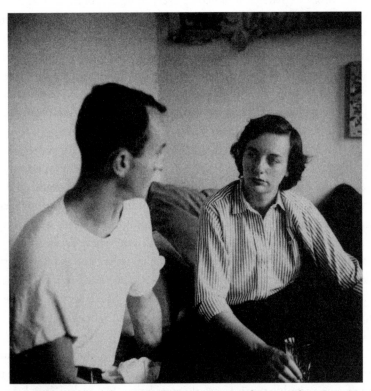

Grace and Frank O'Hara. (Photo: Walter Silver. Courtesy of George Silver. Grace Hartigan Papers, Special Collections Research Center, Syracuse University Libraries)

to his close friendships a deep mindfulness. Larry Rivers described it as a "glow" that "fills me with strength and a power to go on against all the difficulties and jealousies of my contemporaries."[16] Like Grace, Frank had a troubled relationship with his self-dramatizing, controlling mother. Grace, who never met her ("because I was so loyal to Frank and I thought she caused him so much pain"[17]), didn't want him to meet her parents, either. She believed that you left your family ties behind when you created an identity for yourself as an artist.

In March, O'Hara, who had become a mover and shaker in downtown New York's tiny art world, invited Grace, Alfred, Larry Rivers, Joan Mitchell, and Jane Freilicher to be on a panel on Abstract Expressionism at the gathering place known as the Club, a rambunctious forum for artists working in diverse styles. Founded in October 1949 in a rented loft at 39 East 8th Street—a few blocks from Grace and Alfred's studio—the Club was the place where artists and invited guests talked about painting and sculpture and their relationship to other art forms, philosophical concepts, and popular culture. The Club's third-floor space in a former factory building was simply furnished with a table and wooden folding chairs (one of the artists had thrown away the more comfortable second-hand furniture because it was "too bourgeois"[18]). There was a kitchen with a decrepit stove that de Kooning and another artist patiently disassembled, cleaned, and restored to use.

In the beginning, before the Club began to offer specific events on Friday nights, artists would just drop by whenever they pleased and pull up a chair near fireplace.[19] (True to their frugal habits, they picked up discarded wood crates on the street to use as firewood.[20]) De Kooning later explained that the initial idea was simply to start a social club for artists, like the ones run by Greeks and Italians.[21] Since the early forties, the older artists had been meeting at night at the Waldorf Cafeteria on the corner of Sixth Avenue and West 8th Street, which stayed open until eleven o'clock and was home to a motley crowd of servicemen on leave, artists and writers, pickpockets, and black marketers. (Cafeterias were poor people's only affordable restaurants. At another one, a bowl of soup cost 25 cents and came with unlimited quantities of bread, pickles, and coleslaw.[22]) When the Waldorf's owners realized that the artists were hogging tables that could have brought in more cash, the crackdown began. No more than four chairs were allowed at a table that normally accommodated eight, the toilets were closed, and you had to buy a second cup of 5-cent coffee if you wanted to keep your seat. (Some artists had taken to making a "poor man's tomato soup" by adding the contents of the ketchup bottle on the table to a cup of free hot water.[23])

Women were scarce at these gatherings, but not necessarily because they were not wanted. There were few police on the streets late at night in those years, and muggings were not uncommon. Any woman who arrived alone— Grace, Elaine de Kooning, and Mercedes Matter were among the brave ones—faced a nerve-wracking walk home.[24] Matter, who used to buy vegetables and fruit at a stand on Sixth Avenue after leaving her studio late at night, often stopped at the Waldorf on her way back to her house on nearby MacDougal Alley.[25]

When the price of a cup of coffee at the Waldorf doubled to a dime, that was the last straw.[26] Artists tried meeting under an awning at a cigar store—a makeshift arrangement even in warm weather. Unmarried, divorced, or married to women who went to bed early because they had jobs, the men would leave home around 11 P.M. to buy a newspaper and cigarettes, "and see what was going on."[27] This was a pitiful alternative to the café life European artists took for granted, where friendships were cemented and ideas debated, and where your seat at a spindly table was yours as long as you wished. So it's no wonder that the Club, bare-bones though it was, seemed like a great luxury: at last, a place where artists could get together and have coffee without being hassled.

Another artist-run enterprise, grandly titled Subjects of the Artist, had opened in the late fall of 1948[28] in a loft at 35 East 8th Street. Founded by uptown artists Robert Motherwell, David Hare, William Baziotes, and Mark Rothko, Subjects of the Artist was intended to promote the serious study of abstract art and, not incidentally, provide the impoverished artists serving as teachers with salaries. But the money to pay them failed to materialize, and there was never more than a handful of students. Before Subjects closed, in May 1949, it was notable mostly for Friday night lectures by artists, open to the general public for a small fee.

"Those Friday evenings, as they came to be called, became the magnet, the center, for everybody in New York who was interested in the avant-garde to come to," Motherwell later recalled. "Originally it was just for the school. Then people would call up and say, 'Can we come, too?' And pretty soon we were renting a couple hundred chairs.... We were so poor then that the pay for whoever gave the lecture was to be taken to dinner and given a bottle of his favorite liquor. In those days we all drank seventy-five cent sherry." If the speaker wanted Scotch instead, it was a real hardship: "Seven dollars was like seven hundred dollars now."[29]

For the artists, who were otherwise totally ignored by the outside world, the Friday events were a tremendous ego boost—an opportunity to justify

what they were doing. Even if you weren't giving a talk, you could participate in the general discussion that followed and feel part of a community that was gaining traction in the cultural life of the city. There were some memorable moments. When sculptor and painter Jean Arp was a speaker, someone in the audience asked him to describe "a running line." He walked off to the men's room, leaving the door open so everyone could hear him urinate, returned to the group, and said, "I just saw one."[30]

In the fall of 1949, a group of artists teaching at the School of Art Education at New York University took over the Subjects of the Artist space as a lecture venue, renaming it Studio 35. Two seasons of lectures by a roll call of artists who later became famous were followed by a marathon closed session— with discussions ranging from how to title paintings to whether artists have any relationship to the outside world. (De Kooning said that they had none: "We just insist on being around."[31]) Studio 35 closed in the spring of 1950; by then, the Club was the place to go.

The Club had a few rules: no pictures on the walls,[32] no chess playing (then associated with the Communist Party), no liquor, and no artistic manifestos. "One artist would phone another and say, 'Look, I'm bringing over a couple of loaves of bread, you get the baloney, and I think there's coffee there but maybe you ought to pick up a pound,'" recalled one of the original members. "There was great love and cohesion and respect for each other.... We just sat around and shot the breeze...after a long lonesome day in the studio."[33] Lionel Abel, a playwright and essayist who was a regular member, borrowed a racetrack metaphor James Joyce used to describe the atmosphere of Paris in the late twenties and early thirties. The artists at the Club, Abel wrote, were like horses at a starting gate on the eve of the Kentucky Derby.[34]

The Club's original members—you had to be sponsored and voted in to join, and pay a $10 initiation fee and a few dollars in dues—included de Kooning, Kline, Ad Reinhardt, Conrad Marca-Relli, Milton Resnick, Jack Tworkov, and other artists who are little-known today.[35] Typically for the era, although two women—Elaine de Kooning and Mercedes Matter—attended the early meetings, they were not considered charter members.[36] At first, no women, communists, or gays were allowed to join, because of their supposed cliquishness. Later, whenever a woman's name came up for possible membership, the men would inquire about her measurements before voting.[37]

As many versions of the Club's history exist as there were artists involved with it. According to Elaine de Kooning, the notion of an artist's clubhouse was slow to get off the ground. The coffee pot was there, but the artists weren't. Sculptor Philip Pavia realized that specific events were needed to lure artists,

and that's how the Friday night panels began.[38] Another version maintains that by 1950, the casual drop-ins coalesced around Wednesday night gatherings. At one of these, somebody asked the artist Will Barnet, who was expounding on his views to a receptive audience, if he would present a formal talk. This worried some of the members. One painter said, "This is going to end up like a women's club. We're going to be lectured to. And we don't want that." Another painter suggested that if the chairs were left scattered around the room, Barnet's talk would just be a continuation of the informal gatherings they enjoyed. But someone set the chairs up in rows and put a bridge table and chair in front for Barnett, and the formal program was born.[39]

By the end of 1951, thanks to increased involvement by younger artists, membership had grown from the initial 60 to 120. By no means was everyone working in, or even supportive of, what came to be called Abstract Expressionism,[40] which helped fuel the contentious atmosphere. Still, there were general points of agreement. Picasso was almost universally disliked. With some notable exceptions, members were not interested in discussing the history of art or the mechanics of painting. There was no talk about sales, which were virtually nonexistent. What mattered was what everyone in the group was doing, what it all meant, and where it would lead. Four years earlier, Clement Greenberg had written about the "striving young [abstract] artists...who live in cold-water flats and exist from hand to mouth...and have no reputations that extend beyond a small circle of fanatics."[41] Greenberg explained that these downtown artists were even more involved in "the ferocious struggle to be a genius" than other artists in New York, yet "[t]heir isolation is...crushing." Now, at least there was a glimmer of hope.

In the early fifties, coffee was still the beverage of choice at Club meetings because it was much cheaper than liquor. Later, a bottle of whiskey would be supplied for the panelists, to ensure free-flowing dialogue. Eventually, members would pass a basket for donations to purchase whiskey for everyone, dribbled into paper cups in meager half-inch rations. Artists would bring favorite records—Pavia liked polkas—to spin on the radio–record player for hectic late-night dancing. As one woman recalled, "If you were a pretty girl, you could write your own ticket" at these weekend parties.[42] The parties became such a draw that some members began showing up just for the festivities. Pavia outwitted them by starting the meetings after the announced 8 P.M. time, so that unwary partygoers wound up having to listen to the speaker, too.

Sometimes, a panel of artists would discuss a specific topic, such as "American Versus French Art" or "American Criticism of American Painting." Other Fridays featured performances of classical or experimental music, or a talk by

a guest speaker. Pavia, whose Jesuit teachers had instilled in him a philosophical cast of mind, organized most of the discussions, with input from other members. He had been in Paris in the thirties, part of a diverse group of expatriate writers and artists who exchanged ideas around a café table, and he yearned to import that experience to New York. Invitations to speak went out to leading intellectuals (Hannah Arendt, Joseph Campbell), artists and art critics (Robert Motherwell, Max Ernst, Ad Reinhardt, Clement Greenberg, Thomas Hess), and composers (Virgil Thomson, Morton Feldman, John Cage, Edgard Varèse). For the many artists whose education ended in high school, these sessions were the equivalent of a university education.Some of the musical evenings featured work so radical that most people wouldn't even call it music. But painters and poets faithfully attended these evenings, patiently enduring the seemingly miscellaneous sounds that constituted a piece. "I spent devoted hours at John Cage concerts waiting for [pianist] David Tudor to go *bup*," Grace recalled, referring to a sound he made on a "prepared" piano, which had various objects placed between the strings to create unusual timbres. "Then, five minutes of silence patiently waiting for him to go *gunk*."[43] Cage and Tudor repaid the favor by coming to see her shows, and Cage later confided, "It was really nice for all of you [artists] to come to my concerts. I know you didn't like my music, but if you hadn't come, there wouldn't have been anybody there."[44]

Lionel Abel, who had given a talk at the Club in 1951 that linked the flourishing of abstract art to the future of radical politics, was invited back in the winter of 1952. On his way to 8th Street, he ran into Robert Motherwell, who urged him to stay away from the Club, saying darkly, "It's Bill de Kooning's political machine." Ignoring this, Abel pressed on to deliver his talk. Its gist was that, "speaking as a layman," he had gotten to the point where he needed modern painting to "prove its worth."[45] This did not go down well, needless to say. De Kooning glowered, and John Myers, busy launching his gallery, vented his annoyance. Such was the heated atmosphere swirling around the downtown artists.

Grace hated the constant arguments. But they were the Club's heart and soul—impassioned discussions about the meaning and purpose of art by artists who had come from different backgrounds and worked in wildly diverse styles. "You didn't have to agree with what somebody thought or did," Alfred recalled.[46] "You would simply *acknowledge* somebody. Bill [de Kooning] would say something. And then you'd hear another voice. You'd think, 'Oh, that's Bill again.' But it would be [Russian-born] Milton Resnick. And then Joop Sanders, who's Dutch. They all have really different points of view." Everyone would be chiming in about what moves them to paint. "Then Ad Reinhardt

would get up and say, 'I only paint when I have a show'"—perversely upending the notion that artists are driven by an inner compulsion.

At a certain point, when everyone was shouting and opinions were flying, Aristodemis Kaldis, an imposing-looking Greek-born artist with a large mole on his nose, would stand up to make a concluding statement. But no one wanted to close down the discussion. "And so the minute he would stand up, people would say, 'No, Kaldis! Not yet!'" Kaldis, who called himself a primitive painter and painted only expressionistic Greek landscapes, actually hated abstract art.[47]

Pavia wrote that the panels had "the rhythm of a seesaw," with artists supporting a point of view immediately countered with opposing arguments.[48] Painter Alice Baber, who was six years younger than Grace and content simply to listen to everyone, was fascinated by the way artists on panels scolded one another and used expressions she had never heard before. "I think everyone was just involved in their own language," she said. De Kooning's thoughtful remarks especially intrigued her. "And then," Baber recalled wryly, "there were the ones who would come in drunk and insult other people."[49] One artist recalled that some panel members would first stop at the Cedar Tavern to talk over their strategy "and get themselves oiled up."[50] Marcia Marcus, a painter who began attending Club meetings in 1953, remembered that the Club served "the worst bourbon in the world," one glass of which was guaranteed to produce a hangover.[51]

In addition to the panelists, other artists—known as "floor panelists" because they spoke from their chairs in the audience—would speak up when the spirit moved them. The floor panelists were a rowdy bunch, "shooting from all sides [of the room] with their arrows and bullets."[52] Women were prominent in the ranks of these vocal artists—including Grace and fellow painters Joan Mitchell, Elaine de Kooning, Mercedes Matter, and Alice Yamin, and writers May Tabak (married to art critic Harold Rosenberg) and Rose Slivka.

As Pavia wrote, the women constantly "hounded, badgered and out-talked the podium panelists. There were tears in the eyes of the podium panelists but certainly no tears in the eyes of these women sharpshooters.... Where else could a woman have a chance to talk on art or heckle a man on art?... Where else could a woman get up and tell a large male audience, 'You are wrong!'"[53] Looking back years later, he viewed this display of female moxie as the birth of the women's movement.[54] When painter Jon Schueler was on a panel about women artists, he opined that the creativity of women "was in the womb." As he described the scene, "all hell broke loose. Joan [Mitchell] got Grace and Helen to join the panel, and they raked me over unmercifully."[55]

At the January 18 "Expressionism" panel—Harold Rosenberg as moderator and five male painters (Philip Guston, Ad Reinhardt, Jack Tworkov, William Baziotes, and Franz Kline)—Grace summoned the courage to ask, "What about the role the artist plays in the outside world? The attitude?" Reinhardt, a strict abstractionist later known for his seemingly all-black paintings, responded that "the only right attitude is detachment."[56]

The panel on March 7, "A Group of Younger Artists," was particularly fractious. Alfred, who often resorted to shock tactics—probably to compensate for his severe hearing loss—shouted, "I invented painting!" enraging art dealer Charles Egan, who rose from the audience to hit him. (Alfred remembers Egan saying, "Kill him before he gets any older!"[57]) Nervous about speaking her mind in front of this contentious group, Grace reflected a few days later that she was disturbed by "the bitter aloneness of all of us."[58] Brightening her mood was the gift of "a tender and moving" new poem by Frank O'Hara, "Poem for a Painter" ("Grace / you are the flowergirl.../ with fingers smelled of turpentine").[59]

That spring, Grace and fellow Tibor de Nagy artists and their friends made fanciful kites in Grace's loft, and the group took their handiwork to Sheep Meadow, an expansive grassy area in Central Park where sheep had once grazed. A photograph of the outing shows a happy-looking Grace in a sleeveless blouse and long skirt, trying to fly her kite. But, as gallery director John Myers recalled, the wind was blowing at almost gale force, destroying the kites. "A real fiasco is what we've got," was Grace's pronouncement.[60] The kites were supposed to have been the centerpiece of a visit by Grace, Alfred, Helen, Myers, and de Nagy to The Falls, the Hudson Valley farmhouse where gallery supporter Dwight Ripley—an Oxford-educated poet and botanical illustrator—lived with his companion, Rupert Barneby, a self-taught botanist.[61] In one of Barneby's photos, Grace sits apart from the others, huddled in a dark top and long skirt, and looking at someone we can't see—Alfred. He was busy setting up the model airplane he had constructed to make up for the missing kites. Its rubber-band motor had to be turned 250 times.

Grace's second one-person exhibition opened at Tibor de Nagy Gallery on March 25. She showed nine paintings, two of which she subsequently destroyed, and several drawings.[62] Reviews were positive. In the *New York Times*, Stuart Preston called her paintings "ebullient," with "generous swabs [*sic*] of handsomely harmonized color which loop and frolic in and out of each other."[63] James Fitzsimmons, who would play an ambivalent role in Grace's personal life during the next few years, praised her "growth" in his *Art Digest* review, noting that her colors were more subtle and the organization of her paintings "less complicated, more complex." He pronounced her drawings

"excellent."[64] In *Art News*, fellow painter Robert Goodnough singled out *The Cue*, *The Hero* ("flamboyant...rough and sturdy"), and the "reserved fullness" of *Portrait of W.*, in which a more subdued composition of larger abstract forms suggested Walter's quiet demeanor.[65] Even more promising was the news that Dorothy Miller, the Museum of Modern Art curator, had stopped in to see the show. Grace was pleased that it was still up when she celebrated her thirtieth birthday, on March 28. Still, the exhibition was poorly attended, and none of her work sold.

Meanwhile, worried that she was coasting on the hard-won efforts of painters like Pollock and de Kooning, Grace was struggling with a new approach, a blend of abstract mark-making with clearly representational subject matter. Clem had visited Grace's studio earlier that month, and he didn't like what he saw. Grace was blindsided. A year ago he thought she was so promising; how could he now be so dismissive? "I was furious and screamed at him that day," she recalled years later. After he left, she had picked up "some cups and saucers or glasses or whatever" and hurled them against the wall. Without actually spelling out his problem with her work, he just said, "Don't do it, stop doing that, that's not what you do. You have to stay avant-garde."[66] Grace was sure his disgust was due to her failure to stay true to abstraction.

Grace drawing from the model in 1952 at the sketch group she hosted at her loft—which included Larry Rivers, Jane Freilicher, and other artists, Frank O'Hara, and fellow poet Kenneth Koch. (Photo: Walter Silver. Courtesy of George Silver. Grace Hartigan Papers, Special Collections Research Center, Syracuse University Libraries)

A few days before the opening, she noted irritably in her journal that her friend Helen Frankenthaler had reneged on her promise to help hang the show—symptomatic of the fraught relationship Grace had with her during these years.[67] (Grace claimed to want "undying devotion" from her friends, even though she knew this was unreasonable. It was part of the single-minded determination with which she led her life, and possibly also a legacy of her mother's coldness.) When Helen's lover Clem announced at the opening that Harry—Grace's self-promoting, soon-to-be-ex-husband—was the "greatest American painter since Pollock," Grace was deeply upset.[68]

More devastating was the reaction of her colleagues to her venture into figuration. Most of her painter friends were firmly committed to the risk-taking improvisation of abstract painting. They were invested in discovering new worlds on the canvas—and also in disdaining the crowd-pleasing realism of American artists who portrayed workers and farmers and people on the street. Any step backward into recognizable subject matter was viewed as a betrayal.

De Kooning—who had been working for the past three years on his *Woman* series, paintings and pastels that melded sensual curving forms with slashing abstract brushwork—was sympathetic to Grace's new direction. He counseled her that it was important to "look for the picture to become itself, to tell you, 'Here I am,' rather than imposing yourself on it."[69] Larry Rivers, who had temporarily turned to sculpture as he tried to find his own way of painting figures, also commiserated with her struggles. But Pollock thought Grace was turning her back on the brave new world of abstraction. "He was quite unpleasant about it," she said later. "Franz Kline was pretty nasty about it too, but he liked me a lot, so it was back and forth. [Mark] Rothko didn't think much of it."[70] Joan and Helen were equally dismissive. Joan disparaged Grace's seeming inability to make up her mind about whether to paint abstractly, and Helen—doubtless influenced by Clem's negative view—told her flatly that she was on the wrong track. An artist Grace didn't identify came up to her at the Club and told her she should be thrown out. "I lost friends for that year," she said. "I had a lot of fights... but I had to do it."[71]

A few years later, when Grace showed her "city life" paintings—stunning works in which imagery and abstraction are fully integrated—"everybody got friendly again because they thought they were pretty good and they'd forgive me for throwing a mango in, or something that looked like a bicycle."[72] By then, she had finally figured out how to imbue the entire canvas with the structural solidity she was still searching for in 1952. Now, she told herself, "If I must look conservative—reactionary—timid—or even (horrors) feminine...then

it must be. I think I know how really strong I am, and if a great painter like Matisse could paint weakly and timidly to clear his eyes for what was to come then I can too."[73]

The powerful originality that modern artists strived for was the antithesis of "feminine," which Hedda Sterne described as connoting a painting "without strong contours, without sharp angles…delicate, sensitive, and tentative, or perhaps thinly painted."[74] When Grace and Elaine de Kooning looked at designs for priests' vestments that Matisse had completed a few years earlier for the Chapel of the Rosary in Vence, France, Grace remarked that if a woman had used the same colors (purple, pink, green, and red), people would call them "typically feminine."[75]

To pay off several hundred dollars in debts, Grace took a two-month drafting job in April, hoping to save enough money to be able to paint through the summer. On the bright side, this meant a temporary end to annoying conversations with the often cruelly gossipy John Myers. A few weeks later, Grace experienced something that she called "the nightmare," without further explanation.[76] This may have been an unwanted pregnancy and subsequent illegal abortion, a scenario repeated several times in her life. Whatever it was, it kept her from writing in her journal for the entire month of May. By early June the "terrors…of the outer world" had abated "for awhile" and she was back to work in her studio.

A major exhibition of paintings and drawings by Paul Cézanne opened on April 4 at the Metropolitan Museum of Art, and Grace traveled uptown to see it. She spent most of the day there, returning a week later for another look. One of the greatest artists of the nineteenth century, Cézanne looked afresh at the way we perceive objects in space, using finely calibrated brushstrokes to evoke weight and density while scorning traditional rules of composition. Most famously in his paintings of Mont Sainte-Victoire, he captured the conflict between what the mind knows is solid and what the eye records under constantly shifting conditions of light and human focus. To Matisse, who bought his first Cézanne painting (*Three Bathers*) when he was barely able to feed his family, the older artist was unsurpassed. Grace was especially interested in Cézanne's paintings of nude bathers, a subject also famously painted by Matisse. She wrote in her journal that she was "filled with…the overwhelming need to make my own work more solid."[77] Thirteen months later, she would paint *River Bathers* (plate 4), happily noting that "for the first time I am using color as a powerful structural element."[78]

Of course, there was also much to be learned from the great artists of centuries past. Grace studied the works of Velázquez, Goya, Francisco de Zurbarán,

and other painters in reproductions and on visits to the Metropolitan Museum of Art and the Hispanic Society of America. When the Met acquired a Velázquez equestrian portrait (*Don Gaspar de Guzmán, Count-Duke of Olivares*), she rushed to see it. Her attraction to the elaborate Spanish colonial art and architecture she had seen in Mexico now seemed particularly meaningful. Spanish art justified her "heavy hand" as a painter in a way that the French tradition did not.[79] A few years later, still under the spell of the Spanish masters, she joked that if she visited the Museo del Prado in Madrid, she'd have to be carried out on a stretcher.

THE ONLY PEOPLE she felt close to now were Walter, Frank O'Hara, and her writer friend Waldemar Hansen, who had invited her and Walter for a weekend at his and Myers's rented summer house in Westchester Country. Hansen, who seems to have been hugely self-absorbed and quick to find fault, bitchily described the entrance of Lee Krasner and Jackson Pollock at a cocktail party as "throwing long shadows of envy and hatred."[80] A few months later, he sent Grace a postcard with a drawing of the large-eyed, long-nosed George Sand, suggesting that she resembled the great but homely novelist.[81] A year later, he dropped out of the picture completely, writing to her that he had "drifted away…from the painters and poets."[82] Frank existed in a completely different realm. In May, he wrote a mysterious and beautiful poem for her, "Portrait of Grace"—based on Larry Rivers's drawing of her "as a girl monk"— that renewed Grace's sense of self-worth; she had begun to feel "as though only the paintings are real."[83]

Trying to be helpful, Walter attempted to interest a woman in buying one of Grace's paintings, but the woman's husband hated it. By early August the couple were in a deep financial hole. They owed a rent payment, $30 to the gas company—which threatened to turn off service in a week—and $15 to the phone company. Grace, who would soon have to take a temporary job as a receptionist, realized that it would help if she had a more practical attitude. Spending the couple's last $10 on a dinner of broiled sweetbreads with a red Bordeaux, she figured that they might as well "go broke with a flourish," like the Jazz-age novelist F. Scott Fitzgerald.[84] Her devil-may-care approach was rooted in her charmed life; she was used to being saved from financial disasters at the last minute. Sure enough, Walter soon found well-paying work. Equally sustaining was Frank's gift of William Carlos Williams's epic poem *Paterson*, which came with a treasured note: "To years and years of lunches and rosy futures and works!! Love Frank."[85]

In contrast, a week at the Jersey shore in August with her son Jeffrey and her family made Grace irritable. She wrote in her journal that she was "in a

strangely withdrawn trancelike state the whole time, without a single intense thought or feeling. A kind of protective shell, so that I could bear it." Clashes with her mother prompted Grace's only surviving reference to her son's vulnerability and positive personal traits. While "it was sweet to be with Jeff," she was annoyed that her mother was trying to make this "naturally shy and gentle child" more outgoing, in the normative, glad-handing style of the fifties.[86] Grace was in the grip of massive guilt about her son. In a letter to Walter, written at midnight ("the full moon sneaking through the sassafras trees and a fool bunch of crickets chirping their heads off"), Grace told him that she "watched wheels and merry go rounds [sic] till my head swam gathering material for a painting all about fear."[87] That fall, she found herself painting a portrait of Jeffrey (and one of herself), for reasons she could not explain.

Grace felt increasingly alienated from artist friends who were unsympathetic to her ideas about painting and unavailable when she needed their help. She had come to realize—shades of her youthful immersion in classic literature and romantic appreciation of Catholicism—that themes like "demons, gods, death, heroes, devils, saints" held more meaning for her than subjects taken from the real world. Or rather, when she painted a real-life subject, like her friend Frank, she needed to express her feelings about him in non-naturalistic ways. One of these paintings, *Frank O'Hara and the Demons*, depicts the nude poet with a knot of miniature devils barnacled on his hip, a response to a line in his play *Grace and George: An Eclogue*: "you may summon all the devils who amuse you." Frank, in turn, would describe his appearance in this painting ("a plate of devils at my hip") and in Grace's *Ocean Bathers* ("One of me is standing in the waves") in his poem, "In Memory of My Feelings," a gift to Grace in 1956.

NEW YORK'S CULTURAL LIFE started up again in the fall. One evening, Grace was delighted by John Cage's performance of a piece for prepared piano and percussion. It was "a lovely thing, full and rounded, with great delicacy," she wrote in her journal, "like an exquisite [painting by Paul] Klee."[88] Afterward, Grace moved on to the Cedar and spoke at length with friends about the paintings of Fairfield Porter at Tibor de Nagy Gallery—the forty-five-year-old artist's first one-man show. Porter, a Harvard-educated *Art News* reviewer, had been painting his family and a small circle of artists and poets in a realist vein for more than twenty years—most recently, in a light-filled style with an undercurrent of tension. Going from a concert of adventurous new music to a discussion of an artist who wasn't the least bit avant-garde—though both men's work shared a certain quiet reserve—was part of the adventure of downtown life. And so was an outing to the Coney Island amusement park in Brooklyn.

Walter Silver, Jane Freilicher, Grace, and Larry Rivers in a bumper car at Coney Island amusement park, fall 1952. (Grace Hartigan Papers, Special Collections Research Center, Syracuse University Libraries)

Even on her tiny budget, Grace took full advantage of the downtown performing arts scene, with exhilarating productions like *An Evening of Bohemian Theatre*, a three-play sampler presented by the Living Theatre at the Cherry Lane Theatre. Gertrude Stein's *Ladies Voices* (which zipped through four acts in less than ten minutes) was based on fragments of a gossipy conversation she had heard in the Spanish resort town of Mallorca. Picasso's surrealist play *Desire Trapped by the Tail* was Grace's favorite: "a real sex circus, a lot of fun."[89] The main event was T. S. Eliot's verse drama *Sweeney Agonistes*, which presented a man adrift in a violent and materialistic world—a theme that resonated with the outlook of the Abstract Expressionists. This was no coincidence. Co-founder Julian Beck (formerly a painter) later wrote that in the Living Theatre's productions of the 1940s, he and his wife Judith Malina wanted to evoke the poetic quality of Pollock and de Kooning's paintings, which "impl[ied]...a level of consciousness and unconsciousness that rarely found itself onto the stage."[90] Malina, who was four years younger than Grace, shared her lack of a college education, her freewheeling sexuality, and her fierce dedication to the avant-garde life—though she was devoted to her own young son. But her defiantly anti-bourgeois outlook (by deliberately making a production "unbearable for the audience," she hoped they would be motivated to create a new social order)

was alien to Grace's guilt-free embrace of popular culture, unencumbered by political angst.

Her other entertainments this year included a British horror film, *Dead of Night*—supernatural stories recounted by guests at a country house party—that Grace saw for the third time, "absorbed as ever by the puppet sequence." Michael Redgrave plays Maxwell, a ventriloquist whose dummy Hugo makes him commit a crime; in jail, Hugo taunts him, telling him that he's going to leave Maxwell, team up with the man he shot, and perform for Maxwell when he is sent to an asylum. Enraged, Maxwell suffocates Hugo and crushes his head underfoot. Grace was intrigued by the split-personality theme. Melodramatically calling it "my theme and my horror," she compared it to painting a self-portrait and puzzling over what her face really looked like and whether it was the same self she knew.[91]

Grace accompanied her father to her Aunt Kate's funeral in October, musing that while she had always loved the ritual of the Mass, with its incense and candles, religious devotion struck her as pointless.[92] What she worshiped was great art—the works she had seen at the Met. A month later, Grace had finished *The Persian Jacket* (plate 2), a large painting of a seated woman that would be her ticket to recognition by museums and collectors. The figure's masklike face with unseeing eyes (obscured with swaths of gray paint) exists at a cold remove from the bravura display of her vivid orange jacket, painted in bold, slashing strokes.

Although Grace later mentioned other paintings that influenced her at the time, *Jacket* most closely recalls El Greco's *Portrait of a Cardinal*, also owned by the Met. The Spanish master painted the cardinal wearing glasses, which appear to tint the skin around his eyes gray. He sits with his hands draped over the edge of the chair and his red mozzetta (cape) flaring around him. Painting a woman in an exotic costume was a time-honored practice, with memorable examples by Matisse, Manet, and other artists. Grace imbued the composition with a tensely dramatic presence. The costume (based on a thrift-shop purchase) has a flamboyant personality, but the figure itself—Grace's alter ego—is a cipher, commanding yet unknowable. She finished *Jacket* ("in many ways the best painting I've ever done"[93]) on November 5, while brooding over Adlai Stevenson's loss to Dwight Eisenhower in the presidential election.[94]

In what would become a typical pattern as the fifties progressed—when she began drinking more heavily in social settings—Grace shot herself in the foot at the December 12 meeting of the Club, which had elected her as a

member just two months earlier.* The evening's panel, "American Criticism of American Painting," consisted of James Thrall Soby, a trustee of the Museum of Modern Art, and critics Robert Goldwater and James Fitzsimmons, with painter John Ferren as moderator. Almost incoherent with rage, Grace shouted that the men were boring and pedantic, and dismissed leading critic Clement Greenberg as having nothing more to say.[95] Embarrassed, she soon resigned from the Club.[96] Two months earlier, upset at Alfred's negative remarks about her work, she got "terribly drunk" at a dinner given by the Castelli gallery, hoping that she nevertheless managed to leave a good impression on Alfred Barr of the Modern.[97] The following April, at the opening of her third solo show at the de Nagy gallery, heavy drinking led her to flirt with a collector who intimated that he would buy one of her paintings if she slept with him, a quid pro quo she managed to reject.[98]

All the downtown artists began drinking more heavily once they made a few sales and emerged from dire poverty. The lone cups of coffee of the immediate postwar period were replaced by bottles of beer and, eventually, rounds of Scotch. For Grace, who always experienced the social demands of openings of her shows as a kind of torture, alcohol transformed her anxieties into a raucous bravado. Days later, she would write apologetic notes to the people she remembered having insulted. But there is no evidence in these years that her drinking affected her output or the quality of her work. It wasn't until a tragic event during her fourth marriage that maintaining an alcoholic haze became a daily habit, a curtain drawn against the grim reality of an idyll turned nightmare.

Despite all her frustrations, the year ended on a positive note. Tibor de Nagy Gallery sold three of Grace's paintings, including *King of the Hill* (plate 1), an exuberant composition of tightly knit slashes of pink, yellow, green, black, and white on a nearly six-foot-tall canvas. After declaring the "king" (Picasso) dead in two years earlier, she now wittily employed a royal title that referred to a children's game.[99]

The best news was that Alfred Barr and Dorothy Miller had requested three of Grace's new works at the gallery—*Still Life, Venetian Self-Portrait,* and *St. Serapion*—to be sent to the museum on approval. At seven o'clock in the evening, two days before Christmas, Frank O'Hara called Grace from the front desk to report that the three paintings were in Barr's office. Even if the museum chose not to buy one, Grace wrote in her journal, "it has given me a terrific

* Grace later claimed that although she was voted in, she never actually joined the Club—"I said I wanted to go but not be a member," she said in her Archives of American Art interview. "I hate joining things."

lift."[100] Earlier that month, in the grip of one of her self-aggrandizing moods—her way of armoring herself against a world that didn't care enough about her and her work—Grace declared that she was "the first woman of major stature in painting." She qualified this boast, noting that she was merely "the medium" through which her paintings were created, yet couldn't resist restating her great ambition: "I feel that given a long life and sufficient courage and energy, I may become a great artist."[101]

9

Succeeding

GRACE TYPICALLY MADE a reckoning of her life at the beginning of each year. On January 2, 1953, she noted in her journal that she felt good about her relationship with Walter and her friendships with Frank, Jane, and Larry.[1] But just a few weeks later, she wrote that she wanted to withdraw from her friends and especially from the incessant interruptions of John Myers, her dealer. She was painting Walter's portrait that January and was grateful for the "emotional security" he provided, allowing her the "inner aloneness" that would enable her to "learn & discover [her]self."[2]

Grace's small *Self Portrait*—a thickly painted, oddly homely image of herself with eyes averted—hung in the Second Annual Exhibition at the Stable Gallery, a second installment of the previous year's Ninth Street Show. Walter photographed her next to this canvas, her fine-featured face, carefully groomed hair, and direct gaze at odds with her painted self. On the public invitation, Clem described the new exhibition as "a range of the liveliest tendencies within the mainstream of advanced painting and sculpture in New York." He cannily added that the show would have a positive effect on artists because "you have to be aware of what your rivals are doing if rivalry is to provoke self-criticism."[3]

Visiting the show put Grace in a good mood. In her journal, she praised her own painting as well as Larry Rivers's sculpture, figure studies by both Elaine and Willem de Kooning, work by Robert Goodnough, a still life by Fairfield Porter, an abstraction by Joan Mitchell, and—getting a trifle bitchy here—Jane Freilicher's "little modest flower piece."[4] The next day, a purchase of apples and artificial flowers and leaves prompted Grace to experiment with painting a deliberately clichéd subject, a venture that she would repeat with other content—and increasing success—in later years.[5]

Back in her studio in early February, after two weeks of work for an insurance school—to pay for expenses related to her upcoming solo show at the de Nagy gallery—Grace felt pleased that she had been able to continue painting at night and had kept "a sense of myself going all the time."[6] Three days later,

Grace at the opening of the 1953 Stable Gallery exhibition, with her *Self Portrait*. (Photo: Walter Silver. Courtesy of George Silver. Grace Hartigan Papers, Special Collections Research Center, Syracuse University Libraries)

her self-confidence was shattered. Learning that the Museum of Modern Art did not want to purchase her paintings despite the purchase committee's acknowledgment of her "talent," she was plunged into despair.[7] What should she be pursuing in her art? Where were the guideposts? Feeling persecuted by "lies, politics [and] deceits"—probably on the part of Myers, who loved intrigue—she reiterated her need for "calm and quiet" to find her own way.[8]

Grace habitually found solace in reading about the struggles of great artists. Now she read the journals of the nineteenth-century French painter Eugène Delacroix, who quoted the novelist Honoré de Balzac on the subject of genius, "the only strength that absolute power cannot attack." Identifying with this model, she lashed out in her journal at "mediocre people…who have an answer for everything," whom she identified as some of her fellow young painters and "and even Clem."[9]

In March, she destroyed *Carousel*, which she first envisioned the previous May, pondered further in June, and had been working on since November. Initially meant to express "some of the horror I feel about 'fun,'"[10] this image of a boy on a carousel horse "escaping from the merry-go-round" and a mother waving, seen from the back, now struck her as "too specific and associative."[11] She seems to have realized how nakedly this painting revealed her mixed

feelings about her son. In his long poem "Second Street,"[12] Frank O'Hara memorably describes "the whirling faces in their dissonant gaiety," which Grace "spasmodically obliterated with loaves of greasy white paint." The poem celebrates the zestfulness of her destruction of these images ("this becomes like love to her") and links it to the strength of their close friendship ("our promise to destroy something but not us").

We don't know how much Frank knew about her history with Jeffrey, so it's not clear how (or if) the poem is also meant to allude to the more personal emotional resonance of the subject of this painting. But there is no doubt about the bond between poet and painter. Grace later said that she and Frank "were truly in love with each other [and] we were jealous of each other. I was jealous of Jane Freilicher, so jealous of Patsy Southgate [the woman to whom Frank later turned his attentions]. He was jealous of my men friends. He'd make it clear, when we go to a party, you're with me; you're not leaving with anybody else but me."[13]

The following day, Grace went to see de Kooning's Sidney Janis Gallery exhibition, which featured six of his large *Woman* paintings. The show was shocking to many, and not only because these freely brushed images of women were so shrilly portrayed, with huge, devouring grins and splay-legged postures. De Kooning had been an inspired abstract painter, and now he seemed to be a traitor to all that abstraction stood for. But Grace was enthralled. She realized that he had had to invent his own private world, and she admired his gifts as "a great seducer" in the visual sense.[14] How, she wondered, did he paint a woman who sits but doesn't look like she is sitting? Skilled at translating what she learned from other artists' work into a constructive view of her own painting, Grace suddenly realized that *Carousel* failed because all the figures should have been in human scale.

Her third solo show at Tibor de Nagy Gallery opened on April 2, with a gratifying splash. Fitzsimmons and her artist friends sent flowers—gladiola, tulips, a long-stemmed rose[15]—and swarmed the opening. (O'Hara brought an anemone, a flower redolent with mythological history.[16]) Grace confided to her journal that she felt "really glamorous" as she signed copies of *Oranges*, a collaboration with Frank, and downed a half-pint of Scotch. Then she went to a "marvelous" cocktail party given by one of her young collectors, editor Roland Pease (a friend of Tibor de Nagy's), where the drinking continued. Her guard down, she flirted shamelessly with moneyed collector Charles Lansing Baldwin, who told her he wanted to buy her still life *Artificial Flowers and Apples*. Sobered up, she figured that he wouldn't be interested once she told him it wouldn't come with sexual benefits.[17]

The *Oranges* collaboration began in November 1952, after Grace told Frank that she wanted to incorporate his work into her paintings. He gave her a suite of poems he had written four years earlier, *Oranges:12 Pastorals*. Despite the title, the poems have nothing to do with fruit. They are deliberately skewed versions of pastoral poetry, a classic literary form in praise of nature. *Oranges* are rather longwinded attempts by Frank—who wrote much more accessible poetry in the fifties—to "inject a Surrealist note into the neo-Symbolist poetic landscape of postwar America"[18] by juxtaposing classical motifs (the music of Orpheus) with weirdly beautiful (burnt mauve grass) and repellent sights (snot), smells (excrement), and sounds. Increasingly concerned to avoid the slightest trace of sentimentality or even lyricism in her paintings, Grace found Frank's approach refreshing.

"The thing I loved about those poems was the irony," Grace said years later. "This is one of the things I found in the sharp-witted homosexual I knew [i.e., Frank]—nothing was straight. If you started to get moony, you'd be told to cut it out."[19] Using house paint on the heaviest newsprint[20] she could find—she lacked money for oil paint or canvas—Grace decided to incorporate excerpts from the poems in her paintings, choosing images that struck her as "interesting and important."[21] The words appear in varying formats (squeezed together, stretched out) next to sometimes hard-to-decipher imagery, which becomes meaningful only after reading the poems. She wanted to "have the words become part of the composition, so that they would appear and disappear in space."[22] As she pointed out later, it was a time when she was shifting from purely abstract painting, "So [Frank] was handing me image after image after image in those things."[23]

The crowded appearance of these paintings derives in part from Grace's inability to make changes—unlike canvas, the thin paper could not support the usual process of rubbing out passages that weren't working. But there is also a sense of frenetic inclusion, captured by another of Frank's poems, "Why I Am Not a Painter," in which he claims that he had so much to say in writing *Oranges* that the color name never actually makes it into the poems. In her paintings, Grace shared his growing passion for tossing in an abundance of references to his real and imagined life; as Frank wrote the following year, her work involves "a continual effort to put more into the picture."[24]

In *Oranges No. 5*, a face with dramatic eyes is obscured from the nose downward ("the spume from your nostrils") and overlaid by another figure (perhaps one of the "girls dropping dead in laundry yards") in an indeterminate space filled with the swelling and shrinking lettering of the entire poem. Grace later said that she based the figure with the large eyes on Frank.[25] In

contrast, in *Oranges No. 11*—which illustrates a poem permeated with references to flowers and death—Grace included only the first and last words of the poem: *voyagers* and, in evocatively squashed-together letters, *smother*.[26] The dominant image in the painting is a black still life of hollyhocks "smothered" by a fog of grayish white paint.

Frank equates dolls with death in "Oranges No. 11"; in the last lines, the speaker buries a "dear doll" under a yew tree. As a boy, Frank would not have been given dolls to play with. For him, they operated as symbols of artificiality. But Grace, as we've seen, had intense attachments to and yearnings for dolls in her youth, and they continued to fascinate her throughout her life. Suffused with pale pink, muted yellow, and a watery blue, her painting *Oranges No. 6* draws attention to the words YOUR DOLLS, which appear in larger letters on the right side of the painting. The figure in the lower left corner wearing black gloves was based on the satin bed dolls Grace had once coveted, transformed into what she called "a grotesque version."[27] Directly above the doll is a seated child, which Grace described as "me looking out."[28] The large blonde, doll-like girl wearing a huge hair bow is also a version of Grace, whose mother affixed a similar bow (a popular girls' style of the 1920s) on her head.[29]

In addition to the twelve *Oranges* paintings, which she finished in February, Grace painted a heaping bowl of oranges (the twelfth one becomes the "O" in the title) on the covers of about twenty mimeographed copies of the poem suite. Despite her efforts, there were few takers, even at $1 apiece. Around the time Grace worked on *Oranges*, she saw a round-faced cloth doll with painted features—like a Raggedy Ann without the hair or the grin—in a shop window. Lacking $10 to buy it, she became obsessed with it, often mentioning it to people she knew. At the opening of her show, Myers presented her with the doll, which she kept all her life. (In 1959, the gallery showed the *Oranges* again, along with lithographs by Larry Rivers from his own collaboration with O'Hara. In a photo taken during the exhibition, Grace's doll perches on a chair underneath *Oranges No. 6*.)

Among her other works in the 1953 show was *The Knight, Death and the Devil*.[30] Grace had read a newly published poem of the same title by Randall Jarrell,[31] based on a famous sixteenth-century engraving by Albrecht Dürer (though the poem conspicuously lacks any reference to the steadfast Christian faith the theme traditionally evokes). Begun in April 1952, *The Knight* was Grace's first poetry-inspired painting, paving the way for her collaboration with Frank O'Hara. Her image of the knight—whose eyes are covered with black paint resembling blinders—relates to Jarrell's portrait of a resolute hero who "has no glance to spare" for Death or the Devil. Grace worked on

Grace's doll, perched below her painting *Oranges No. 6* at a Tibor de Nagy Gallery exhibition in 1959. (Photo: Walter Silver. Courtesy of George Silver. Grace Hartigan Papers, Special Collections Research Center, Syracuse University Libraries)

this painting for a couple of months, not entirely happy with its lack of boldness and freedom, yet finding something to admire in its "tenseness."[32] She wrote in her journal that she wasn't sure why she painted *The Knight;* decades later, she claimed that she saw herself as "embarking on a journey with these new paintings to who knew where."[33] (Grace tended to view the heroes and heroines she painted as versions of herself; later on, she even gave the women her own facial features.)

The critic Dore Ashton, who was a friend of Grace's, reviewed her exhibition in the *New York Times*. (Apparent conflict of interest was not an obstacle for critics in those days, as we've already seen with Frank.[34]) Although somewhat nonplussed at what she saw as the "slapdash" nature of the prints, she admired their "refreshing" quality and the way Grace's fragmented forms complemented O'Hara's Surrealist juxtapositions.[35] In *Art News*, fellow painter Betty Holliday vividly evoked the assured energy of Grace's brushwork and aptly described her new work as "combin[ing] earthiness with an almost cynical mystery."[36] (The magazine's editor, Thomas Hess, liked to hire artists as critics, noting that "they bring a sense of actuality" to their writing, so that readers can "see" the work.[37])

James Fitzsimmons's *Art Digest* review praised Grace's "strong and assured rather than slashing" brushstrokes.[38] That spring, Grace was enjoying a flirtatious relationship with him, pleased that at least one person with clout appreciated her work. She mused that his aura of extreme restraint was unnerving, perhaps a sign of emotional disturbance.[39] Yet despite her doubts, Grace found herself succumbing to his flattery. Although the affair that followed was brief, it was understandably upsetting to Walter. Fitzsimmons's review in the West Coast magazine *Art & Architecture* invoked the sensuous quality of Grace's paintings more directly—he wrote that they expressed "the darker, instinctual side of life."[40] Reflecting the only kind of power a woman was traditionally allowed to possess (would he have said the same thing if the artist were a man?), this description may have been unconsciously colored by Fitzsimmons's experience of Grace as a sexual partner.

In early May, a vote of confidence dramatically boosted her career. Alfred Barr visited the de Nagy gallery, lavished praise on *The Persian Jacket*, and brought the painting back to the Modern on approval. Frank, watching from the front desk, gave Grace a blow-by-blow account of the awkward entrance of the massive canvas through the front door. The next day, however, Barr called her to say that there was a problem with the upper left-hand corner of *Jacket*: Grace had failed to maintain the flatness of the surface. At his suggestion, she came to the museum the following Monday with her paints and spent a half-hour fixing the blend of colors in that spot. "Ah now, that's better," he said, in his calm, professorial voice. Although Grace normally didn't go back into a painting after finishing it, this was a special situation, and she agreed that the area had been problematic. Both Grace and Barr recalled a famous art history touch-up: Delacroix was said to have repainted the background of his *Massacre at Chios*, shown at the Salon of 1824, after seeing Samuel Constable's *The Hay Wain* hanging in the same exhibition. Grace

loved being in such august company. She was proud of her painting, noting in her journal that it looked "more full and arrogant" than she had remembered.[41]

It took two months for the sale to go through—Barr needed to have a patron buy the painting (for $400) and donate it to the museum—but the recognition was a great triumph for Grace. She was the first of her circle of younger painters to have a work acquired by a major museum. The following year, the Modern would buy her painting *River Bathers* and honor it further by lending it to a 1955 exhibition in Paris at the Musée d'Art Moderne.

Five days after *Jacket* arrived at the Modern, working in a white heat that left her feeling sick, Grace finished *River Bathers* (plate 4). This brilliantly accomplished painting, influenced by her immersion in works by Matisse, demonstrated her mastery of color as a powerful structural element. She had studied Matisse's *Bathers by a River* (1916–17)[42] at the Modern's exhibition of his work when it opened in November 1951.

In his huge painting—more than eight feet high and twelve feet wide—Matisse created four massive, faceless, grayish figures with schematic bodies. Each is oriented in a different direction, sealed into her own solipsistic world. The two figures on the left side are superimposed on a cartoon-like pattern of giant foliage. Matisse abstracted the waterfall he had initially sketched into a repeated motif of twin curving lines and washes of pale blue that seem to slice through one figure and invade the body of another. Based on memories of a mountain glade he had seen on a walk in the countryside,[43] and influenced by Cubism, the painting conveys a pervasive quality of isolation and hollowness that was the artist's response to the horrors of World War I.[44] He ranked it as one of the five most significant paintings he ever made.

Grace didn't realize what an effect this painting had made on her until others mentioned it to her ("Oh, Matisse—that's what comes from association with Alfred Barr," said an acerbic Jane Freilicher[45]) and she came across a postcard she had purchased of the painting.[46] Barr had published his magisterial study, *Matisse, His Art and His Public*, in 1951. Grace viewed this book "like the Bible," admiring such statements as, "Freedom and purity are perhaps the two important spiritual values of Matisse's Fauve painting at its best."[47]

River Bathers is entirely Grace's own, but what she borrowed from Matisse was a sense of how to avoid trying to compete with the beauty of nature—by opposing it with the rigor of a reimagined human figure. ("I find nature so complete that I think it is arrogant to think of reproducing it," she said years later.[48]) Her deliberately awkward, sketchily painted nudes are variously skinny or lumpy—no muscle men or bathing beauties here—and they're all

caught in unflattering poses. Except for the lack of clothing, these figures could have come straight out of a snapshot of ordinary people on a public beach, as they spread out their towels or walked down to the water. (In early August, Grace would spend another week at the Hartigans' rented beach house in Ocean Grove, New Jersey, with her son and her family.) Grace's energetic brushwork and shards of color—pale and dark blue, red, yellow, green, and a milky white—create a kaleidoscopic image of a sun-struck beach alive with movement.

Even as she enjoyed her public success and private sense of accomplishment, there were troubling aspects. One was a cramping sense of "pressure and responsibility,"[49] because she would now be expected to keep making the same kind of work. For Grace, always restlessly pursuing the next great idea, working consistently in one mode was inconceivable. Another thorn in her side was the jealousy of fellow painters. Years later, Grace adamantly rejected "beautiful" as an adjective applied to her work. Yet now she was crushed when Joan Mitchell told her she admired the courage it took to make "ugly" paintings. Grace angrily noted in her journal that she had worked hard to make them all beautiful.[50] There was also the issue of mortality. Two months earlier, the lyrical abstract painter Bradley Walker Tomlin died at age fifty-three, of a heart attack, just a few years after he had decisively broken from Surrealism to establish a personal style. Tomlin had been particularly encouraging about her early work, and uppermost in her mind now was her anxiety that she might not live long enough to develop fully as an artist.[51]

Meanwhile, her finances were as shaky as ever; on May 18, she was down to her last $30. Yet less than two weeks later, that didn't stop her from deciding to quit an annoying part-time job—on the same day that a would-be buyer returned a painting of hers to the gallery. She soon lucked into one of her best freelance jobs, editing reports for Simmons Market Research, which let her come and go as she pleased so long as she worked a certain number of hours. Grace preferred to do such work at night, leaving her days free. "I must remember the absolute necessity for me of painting or being in the studio every day, all day," she wrote in her journal that summer. "This is the only way I can sustain the inner energy out of which painting comes."[52] As with most artists, "being in the studio" did not always mean actively working. Grace settled into a pattern of spending the morning drinking coffee, studying the book about Matisse that Walter had given to her, and talking to friends on the phone. Afternoons were for painting.

In July, she spent a long weekend with Walter in East Hampton, staying with married artists Miriam Schapiro and Paul Brach. They were experimenting with

a summer away from Manhattan, renting a cottage with Joan Mitchell and her lover, painter Michael Goldberg. A year younger than Grace, Schapiro was her temperamental opposite. She would later become a leading feminist artist working in several media. But in the early fifties, she was too shy to speak up at the Club, appalled at the way men treated women at the Cedar, and insecure about her work which—like Grace's—was often inspired by Old Master paintings.[53] That weekend, Grace spoke about the emotions—"loneliness, alienation and anxiety"—she felt she brought to her paintings. She said that they ask, "What are we doing here?" and "What do we mean to each other?"[54] (Six months later, she embarked on a painting, *Grand Street Brides,* that actually does pose these questions.)

As in her reported conversation with Lee Krasner several years earlier, Grace's journal reflects only her own thoughts about painting. Schapiro's conversations with women artists in the fifties usually centered on women's concerns, rather than artists' issues.[55] But she was then in awe of what she saw as the wholly self-confident work of Helen and Joan, and apparently listened without comment as yet another brash woman painter went on and on about her artistic concerns. Brach later recalled that after he disagreed with Grace's contention that she was the Matisse of her generation and Larry was the Picasso, he heard her sobbing in her bedroom.[56]

Grace expanded her world and her art practice that summer by working on *Folder,* a project for the fledgling Tiber Press, which supported its avant-garde publications by designing and printing stylish greeting cards and calendars sold in upscale shops. Richard Miller was the business manager; his wife, poet Daisy Aldan (who had bought Grace's painting *Artificial Flowers and Apples*), served as editor; and recent Italian émigré artist Floriano Vecchi was enlisted as master printmaker. Miller and Vecchi, who had met in the late forties while studying at the University of Rome, were lovers; Miller's marriage to Aldan, a lesbian, was one of convenience.[57] A year younger than Grace, Aldan was a former child star of the Saturday morning children's radio show *Let's Pretend* (her mother was an actress) and something of a prodigy— she made her debut in the magazine *Poetry* before she turned twelve. A graduate of Hunter and Brooklyn colleges, she taught creative writing to high school students at what was then known as the School of Industrial Art[58] while also writing and translating poetry. Petite and lively, she was warmly encouraging to those in her circle.

Grace, Frank, and John Ashbery joined the team to assemble five hundred copies of the premiere issue of *Folder,* a hand-typeset magazine of new poetry and art by leading abstract artists, published as loose sheets of paper within a

sturdy paper folder. Vecchi's technical assistance enabled Grace to make her first silkscreen prints for the issue—a lyrically abstracted still life and two images based on her paintings *The Persian Jacket* and *River Bathers*, with simplified compositions and more vivid colors. In *The Persian Robe*, an ambiguously sexed seated figure wearing a red robe over black trousers sits squarely on the chair—an image that she felt possessed "an emotional intensity."[59] With well-deserved beginner's luck, Grace received a graphic arts prize from the Museum of Modern Art for her prints.

Later that month, on a visit to her brother Arthur's home in Westfield, New Jersey, Grace looked at the work she had stored there and decided to destroy almost all of her paintings from the mid-forties. She singled out the paintings done under the influence of Isaac Muse and Milton Avery as "especially awful."[60] Family matters briefly preoccupied her that summer. After her ex-father-in-law's death from lung cancer, Jeffrey came to stay with her parents—now living in a Victorian house in Westfield—for a few days. "I don't know yet how this will affect his life," she wrote, without elaboration.[61] Presumably, "this" meant her son's continued life apart from her. She mused that she identified with the nineteenth-century Austrian poet Rainer Maria

Grace working on lithographs for *Folder* with Floriano Vecchi, July 1953. (Photo: Walter Silver. Courtesy of George Silver and Irving Sandler)

Rilke's "shy but at times powerfully sure, mystical, misanthropic" personality. (Did she know that Rilke's wife, sculptor Clara Westhoff, left their infant daughter with her parents to join the poet in Paris?) The American novelists Nathaniel Hawthorne—who viewed his wife Sophia as his "sole companion"—and Herman Melville also appealed to Grace as role models as she alternately fantasized withdrawing from all but "a few trusted friends"[62] and worried that she was so afraid of loneliness that she allowed herself to be too dependent on Walter.

At least she was able to begin resolving one lingering personal issue. On a sweltering August day in a stuffy Brooklyn courthouse, she was finally granted a hearing for the civil annulment of her marriage to Harry, on the grounds of his failure to disclose to her that he suffered from "an incurable disease known as epilepsy."[63] Yet Grace didn't let this formality get in the way of a continuing art-driven friendship with him. Two months later, she asked to see his new paintings. At his studio, she was impressed by one painting in particular. While she studied it, she heard a crash in the kitchen—Harry and his current girlfriend were fighting. The woman came out to scream at Grace, "I consider you Harry's worst enemy!"[64] Harry's girlfriend eventually left, though not before Harry showed Grace a flatiron with which he said the woman had planned to hit Grace. It was a frightening experience, yet it didn't keep her from a long chat with Harry on another day—at *her* studio—about what subjects were appropriate for an artist to paint. When Harry, ever the cowboy manqué, told her he planned to turn to Western themes (which he would pursue, with notable financial, if not critical, success), Grace was encouraging.

Frank had decamped—temporarily, as it turned out—to the Hudson River village of Sneden's Landing to stay with his new flame, pianist Bobby Fizdale.[65] Grace came to visit one weekend and had the pleasure of a private recital of sonatas by Francis Poulenc in the sparsely furnished drawing room. It held only two pianos and a Victorian love seat, on which she and Frank huddled together for warmth under a blanket. Her natural sociability kept undermining her absolutist, lone-artist posture. She resolved to end her friendship with Jane Freilicher because her paintings were "so weak," only to spend a three-day working holiday with her in Nyack, New York, trying to "simplify and become more stark and direct in my experiences as I paint."[66] (Freilicher would later remember Grace as a whirlwind of "technicolor fireworks, love affairs, dramatic scenes."[67])

Meanwhile, she basked in the flattering attention of Alexander M. Bing, a seventy-four-year-old real estate developer, philanthropist, and art collector. Assuming that he was too old to be sexually attracted, she happily accepted

his presents of books and money. Eventually she realized that he really did fancy her but was too gentlemanly to make a move, limiting himself to chaste evenings at his apartment and avuncular letters about art during his trips abroad. Talking about Bing to her artist friends at a gathering that fall—another chink in the armor of her Lonely Girl self—she cruelly enjoyed a few laughs at his expense.[68] Bing was probably the "old gentleman who was interested in my paintings" whom Grace later described as escorting her to a first-row orchestra seat at the ballet,[69] which she had previously seen only from cheap balcony seats. Surprised to see the strain on the dancers' faces and feel a drop of perspiration land on her wrist, she suddenly became aware of the performers' "anguish"—a theme she would incorporate in watercolors of dancers in the early 1980s.[70]

In October, Grace and Walter's relationship finally ended, or so she thought. "All I would do is destroy him," she wrote in her journal. "I hope I can bear the sexual frustration and not become involved in a new relationship."[71] Eating a solitary dinner in her studio, sipping a beer, with only a mouse scuttling across the floor to invade her privacy, she was finally experiencing the solitude she thought she craved.

Grace at her plant- and music-filled Essex Street studio. (Photo: Walter Silver. Courtesy of George Silver. Grace Hartigan Papers, Special Collections Research Center, Syracuse University Libraries)

A lecture the German figurative painter Max Beckmann gave a few years earlier to art students at a woman's college in Missouri uncannily echoed Grace's ongoing dilemma of how to find the balance between the sometimes competing demands of making art and sexual passion. He described how a woman painter can be infatuated by a handsome man who wines and dines her, and could lift her out of poverty. When the affair ends, she swears never to be in thrall to another person and to remain alone "with myself and my will to power and glory." Yet "the passion still gnaws." Beckmann's über-romantic conclusion was that the inability to give up "the world of delusion" is what it means to be an artist.[72]

Grace was reading *Lélia*, André Maurois's new biography of nineteenth-century novelist George Sand, who had flung herself into many love affairs yet retained her innate self-possession.[73] Feeling inspired, Grace considered trying to snare the shy young composer Edi Franceschini as a lover, reveling in her potential power to do so. (He seems to have resisted her advances.) She wrote in her journal that she felt "a sharp awareness of my destiny"[74]—typical of the self-aggrandizing remarks that so annoyed her fellow artists. Was this her way of whistling in the dark, attempting to build up her spirits? Or did she really feel destined to accomplish great things? In any case, she lacked the strength she admired in Sand to live alone for long periods at a stretch. Less than a month after the breakup, she happened to run into Walter and felt her heart turn over. So back he came.

Borrowing from Sand's famous declaration, "There is only one happiness in life, to love and be loved,"[75] Grace wrote in her journal, "having loved and been loved, I rush into myself with new strength. It is only love that can make me free and objective and whole."[76] In other respects, she felt embattled. Her habit of shooting from the hip often alienated people she needed on her side. John Myers did not appreciate her candor ("complete fiasco"[77]) about an evening of two plays at the Artists' Theatre, which he and his lover Herbert Machiz had co-founded that year. If only she could be like Frank, who privately agreed with her but politely praised the production to Myers.[78]

Frank's own one-act verse play *Try! Try!* had been staged by Machiz months earlier, which may have accounted for the poet's diplomatic response. Grace's journal is oddly silent about that evening of three short plays, which also included poet Kenneth Koch's *Red Riding Hood*, for which she painted the set on huge sheets of taped-together brown paper and contributed all the furniture in her studio. (She is credited in the program as "George" Hartigan.) Living Theatre co-founder Judith Malina noted in her journal that during a preview performance of his play, Frank held her hand "as if he were in a dentist's chair, happy when I respond feelingfully."[79] Had Grace been

present, this would have been her role. She later claimed to have attended the rehearsals, reveling in "the madness of the theater, actors and actresses screaming at each other and crying and yelling at the director and him yelling."[80] In May, Grace had attended the dress rehearsal of an Artists' Theatre triple bill by three poets at the Comedy Club, a tiny theater off Lexington Avenue. In her journal, she praised John Ashbery's *The Heroes*—which takes place at a house party with characters based on Greek myth—as "a little masterpiece."[81] But she coolly dismissed Barbara Guest's *The Lady's Choice*, with a set by Jane Freilicher, as "mush," tut-tutting "how few women artists have that core of objectivity necessary to make a work of art live by itself." Barbara had visited Grace's studio the summer before, though the two women initially seemed wary of a closer connection. But in November, Barbara wrote to praise Grace's work and asked her to illustrate a book of her poems. This led Grace—who liked to conduct a periodic reckoning of friends whom she thought genuinely believed in her work—to include Barbara in the outer circle of her loyalty club.

The other members of this group were Ashbery, poet James Schuyler, Alfred, Larry Rivers, and two of her collectors. Tellingly, Barbara was the only woman, and she was a poet,[82] not a painter, though she wrote art reviews for *Art News*. Years later, she would become one of Grace's closest friends, but as of December 1952, she had yet to gain admittance to the inner circle. Its current members included Walter (drawn to her physically as a lover, he now seemed to value her work, too), Myers ("in spite of his weakness"), and maybe even Waldemar Hansen, "when he's able to think of someone but himself."[83]

As the year ended, Grace's relationship with her painting was increasingly uneasy. No matter what style she pursued, she worried that it would somehow trap her forever. If she based her work on Old Master paintings, she might never be wholly original. If she painted from photographs, she might never be able to paint from nature again. If she struggled with a painting, she was probably overdoing it. If a painting came into focus too easily, there was likely something wrong with it. She also felt increasingly nervous about how public her work had become after her sale to the Modern. And then there was her slow, painful working method, focusing on one painting at a time. Looking enviously at the famously prolific Picasso—talk about being hard on yourself!—she wondered if she would ever develop that "over-flowing energy."[84]

Although Grace attempted to stay away from the Cedar and artists' gatherings for a while, there was no escaping Myers's constant stream of gossip and the jealousies her museum sale provoked. Clem had accused Grace of "wooing" Alfred Barr and claimed that "everyone" was boycotting the de Nagy gallery because of the "intrigues" Myers was fomenting.[85] No doubt

egged on by Clem, Helen had severed her connection with the gallery and was suing Myers for a painting of hers that he could not locate. Other discouragements included the Modern's failure to purchase a print Grace showed in their Young American Printmakers exhibition. As of December 3, she once again was down to her last $25.

Up until now she had felt part of a group of like-minded artists. Wrestling with these issues (and probably still under the spell of George Sand), she attempted to redefine herself as a "solitary" artist. It was up to her to find her own path, her own reference points. She was mindful that her friend Larry Rivers had accomplished this in his version of Emanuel Leutze's nineteenth-century painting *Washington Crossing the Delaware* by remaking the stereotypically heroic composition with isolated, blurry figures in a murky river, to evoke the miserable reality of this dangerous surprise attack.[86]

In her journal, Grace made an inventory of what interested her in the work of the great artists she admired. She was attracted to the exotic aspects of Delacroix (his Algerian paintings), Renoir, and Matisse, and she admired the irony with which Velázquez and Goya infused their paintings of court life. Her own potential subject matter might include "opera, ballet, theater," the glamour of the movie and high-fashion worlds, "elegant homosexuals," and "people with extravagant ideas of dress." She noted that these ideas would "take *years* to digest, discover and express."[87] But there was no way she could know that she had just defined some of the key subjects that would sustain her painting for the next fifty-four years.

In December, she acted on an idea that had been gathering force in her mind—a painting of a matador. Grace admired the "arrogance and elegance" of Édouard Manet, particularly the works of his Spanish period. She had seen his *Mademoiselle V... in the Costume of an Espada* in the Met's Art Treasures of the Metropolitan exhibition the year before, but she couldn't figure out how it could influence her own work. Now she was ready to take it on. With $10 of her $25, Grace bought canvas duck and wood and screws for the stretcher bars. The French artist had painted model Victorine Meurent, who was herself a painter, in a black velvet toreador outfit, gazing out at the viewer. Walter rented a red velvet costume and posed for her, taking photos to preserve the image for Grace to use as she worked on the painting. Visitors to the studio that winter would praise *Matador*, which made Grace feel uneasy, afraid of ruining it.[88]

Except for her perennial twinge of guilt about Jeffrey, the holiday season was unexpectedly pleasant. Her Tiber Press friends Richard Miller and Floriano Vecchi came to visit, bearing gifts: violets, liqueur, a gingerbread man,

and a $100 bill. Grace's parents sent a $25 check, and there were several small sales of her work. On December 24, the annulment ending her marriage to Harry finally came through. The power of great art also sustained her. After hearing a performance of Hector Berlioz's radiant oratorio, *L'Enfance du Christ*, she reflected that "even tenderness must be strong."[89] (Two days after Christmas, Grace also attended a program of short films, including Rudy Burkhardt's urban rumination *The Automotive Story*, starring Jane Freilicher, with Frank providing piano accompaniment and a text by poet Kenneth Koch. But for some reason—jealousy?—her journal has nothing to say on this subject.[90]) As 1953 ended, she wrote that she was "filled with optimism" about the following year. Her nineteenth-century heroes from the worlds of music, literature, and art—Chopin, Sand, Balzac, Delacroix, Byron, and Berlioz—had taught her to embrace the romanticism and "excess" in her own nature, to pursue her ambitions for "an all-encompassing art," and to retain her faith in herself.[91]

Grace's overwhelming focus on herself led her to feel (temporarily) estranged from Frank, whom she blamed in her journal for not giving her "that final, deep allegiance that I need from my friends."[92] But she seemed not to be aware of problems in his personal life, including a Dear John letter from Fizdale, sandwiched between Acts I and II of a tormented affair with Larry Rivers.[93] Meanwhile, Frank had resigned from his front-desk job at the Modern, ostensibly to free up his days for writing. (He would be rehired a year later as a special assistant in the International Program.) In January, Grace got together with Frank and Larry to see a performance of *In the Summerhouse*, a play by Jane Bowles about a rebellious teenager dominated by her widowed mother-from-hell. As Grace wrote in her journal, when the daughter exclaimed, "Don't leave me—I love you!" the three of them "burst into tears."[94] But she avoided mentioning the obvious link between her emotional response and events in her own life.

10

Asserting

ONE DAY IN late January of 1954, Grace paused at the window of the bridal shop owned by her landlord on nearby Grand Street, one of many storefronts in the neighborhood that displayed mannequins in cheap lace bridal gowns. She noted that the seated maid-of-honor wore a "bilious" violet dress. The French author Simone de Beauvoir, who visited New York seven years earlier, vividly evoked the scene:

> To the right, to the left, for more than a mile, young girls smile under tulle veils crowned with orange blossoms.... This virginal street, which promises all the city's Cinderellas the kiss of Prince Charming and delightful transformations, opens onto the Bowery. Men without wives are standing in the rain, leaning on gray walls, or crouching on the steps of little stairways—ragged, hungry, lonely. When they cross this road, the white brides in satin dresses smile at them, but they don't look; they drift impassively through this lily-white triumph that's taking place in another world.[1]

The shop window display gave Grace the idea of painting a modern version of the court scenes in the works of Velázquez (she was fascinated by a new book about him) and other seventeenth- and eighteenth-century artists. But first, she tackled a smaller painting, *Bridal Portrait*, working from a model posed in a two-dollar gown purchased at a thrift shop.

Self-critical as always—decades later she would scold a student for expressing pleasure in his own work, telling him, "If you're not anxious about your painting, something is wrong"[2]—she decided that the structure she had been bringing to her paintings might have been excessive. It was time to "loosen my brush again."[3] When she experienced a rare moment of happiness with her work a few weeks later, she wished she could retain the mood "as armor" during her upcoming solo show at Tibor de Nagy Gallery.[4] She viewed it as a last-ditch financial opportunity: if her work didn't sell, she would have

to get a job and stop relying on handouts from Bing, which he would some-times disarmingly describe as advances for painting purchases.

Meanwhile, the third Stable Annual group show opened with her paint-ing *Greek Girl*, an image of a seated woman in a red cloak whose stalklike neck supports a small head with deep-set eyes and a bright red mouth—a stylish cousin of *The Persian Jacket* figure. Grace was upset that her painting had been hung by the artist organizers in the gallery's unheated, poorly lighted basement, with work by "other unpopular, disliked or less well known painters."[5] They included artists who are now forgotten, as well as figurative painters Jane Freilicher and Fairfield Porter, who were still scorned by ab-stract artists as renegades. "The only thing to do," Grace wrote in her journal, "is to become so famous and powerful that they don't dare mistreat you. They all loathe Pollock, but they wouldn't ever put him in the basement!"[6] Nonetheless, *Greek Girl* received widespread notice, with reproductions in *Art News*, *Art Digest*, and *Art in America*. It was supposed to have been pur-chased by the Whitney Museum but instead was acquired by the Walker Art Center in Minneapolis.[7]

Grace's February de Nagy gallery show—ten paintings, including *River Bathers* and *Matador*, and several drawings—was favorably reviewed in *Art in America* and the *New York Times* ("skillful ease... visual enjoyment"[8]). In *Art News*, Frank O'Hara wrote that she "brings dramatic intensity to tradi-tional subjects," noting that these subjects were not necessarily related to the emotional qualities her paintings express: "*Black Still-life* might as well be called *Dark Night of the Soul*."[9] A month before the exhibition opened, Grace was featured as one of five "Eastern Artists"—and the only woman—profiled in *Art in America* by a group of distinguished museum people.[10] John I. H. Baur, then a curator at the Whitney Museum, wrote that she sought to combine structural discipline with "very personal harmonies of color" and approvingly noted that her work "has grown calm, massive and monumental in design."

Always on pins and needles in these days, even when the news was good, Grace wrote in her journal, "I fear all this official approval and am sent into questioning and self-doubt."[11] But the article may have spurred the Whitney to select *Standing Figure (Self-Portrait with Hydrangeas)*, pending purchase approval from museum officials. Private collectors bought *Matador*, three other paintings, and a drawing of a seated woman after a painting by Jean-Louis David. (One of the striking things about this drawing—other than Grace's clumsiness in portraying hands—is that it foreshadows a theme and style of paintings from the last decades of her life.)

The real coup was the sale of *River Bathers* to the Modern, for $1,000. Barr had stopped by the gallery—he missed the show's opening—and called the painting "a work that shows genius."[12] (When Grace went to visit her painting at the museum the following April—it was hanging in the members' penthouse area—she was hugely pleased. The painting "seemed more myself than I am, and reminded me that I am only a medium for my gifts."[13]) The sale must have seemed a sweet victory after James Fitzsimmons's baseless and typically lofty pronouncement in *Arts & Architecture* that the painting's composition was not up to snuff because "its forms neither dovetail nor exert adequate magnetic attraction upon each other."[14]

As usual, good news mingled with bad that winter. Two weeks after the opening, Jeffrey underwent an operation for appendicitis. It was successful, but Grace felt guilty about her ex-husband's stubborn refusal to credit her son's real pain. Thinking it was all in the child's mind—a notion possibly influenced by his Reichian therapy—Robert had put him at risk of peritonitis or worse by initially taking him to a psychologist instead of a physician.

GRACE'S MONEY WORRIES persisted because of the time lag between the gallery's sale of a painting and her receipt of the check. Her journal is filled with columns of numbers—money owed, money received, money pending, money loaned to friends. Walter, who was getting unemployment checks, agreed to pay for her food. In late February, when she finally put together a thousand dollars' worth of her portion of the sales, a big chunk of the money was already committed. She had to buy painting materials and repay loans—from Myers, from her sister Virginia, from Robert for Jeff's operation, and from Walter, who had also stepped in with rent and utility money. Yet she couldn't resist living it up for a while, buying tickets to a visiting kabuki troupe,[15] two bottles each of Scotch and Champagne, dinners, lunches, taxis, a pair of shoes, and a trench coat. Grace was always an eager consumer of fashion, as well as food and drink. She was shocked to discover in early May that her nest egg had dwindled to $75.

Intensely focused on completing her painting of brides, she felt she was right to abandon the bright, pure color of *Greek Girl* and to be influenced by Matisse's linear, architectonic work of the early teens. But she was forced to venture outside the studio for several days after learning that Frank had been shot in the hip by a mugger—as if those devils in her painting had actually turned on him. Grace was horrified, noting in her journal that the two of them had talked that very day about violence and his fear of being murdered.[16] She and Jane Freilicher both visited Frank at Metropolitan Hospital—Jane bearing poems by the nineteenth-century French symbolist Stéphane Mallarmé, Grace

carrying a batch of movie magazines.[17] For the time being, he praised Jane's paintings in print and dedicated one last poem to her ("To Jane, Some Air.") But he expected his friends to be "completely at his disposal," which was no longer practical for her.[18] Of course, this was precisely the type of relationship Grace wanted for herself. That spring, she became his new soul mate. Frank's first offering of devotion was "For Grace, After a Party." In this poem, he says that while he was venting (presumably, at the party) about someone he actually felt indifferent about "it was love for you that set me / afire."[19]

Grace could hardly wait to tackle her six-foot-by-nine-foot painting, eventually titled *Grand Street Brides* (plate 5). She thought about what colors she would use in the painting as she walked around the neighborhood looking at the gowns—drifts of white tulle displayed on daintily gesticulating mannequins with a regal bearing, sequestered behind plate glass. The thrift-store dress she bought was tacked to the studio wall for further inspiration, along with Walter's photos of bridal shop windows. It struck Grace now that what all her best paintings had in common was "a strange combination of 'nature' and 'abstraction.'"[20] By early April, she saw the combined influences of Larry Rivers, the English painter Francis Bacon, and Picasso (his famously fractured 1907 painting of prostitutes, *Les Demoiselles d'Avignon*) on her canvas. By the mid-fifties, Picasso and the European Surrealists whom the older artists had fought against were no longer seen as a threat; the art wars were over, and the Americans had won. Grace was so wrapped up in her bridal theme that Larry Rivers, anticipating her upcoming visit to his Long Island home, teased her in a letter: "It is said she will arrive in a bridal gown."[21]

Noting that the bridal shop windows contained no grooms, she thought of the court scenes of Velázquez and Goya, visualizing the brides as princesses. (It's possible that she saw a reproduction of Goya's *The Family of Charles IV*, owned by the Prado Museum in Madrid. In this painting, the eighteenth-century Spanish painter audaciously portrayed members of the royal family in all their smug, richly garbed glory. A shaft of light illuminates the powerful, fatuously preening queen at the center of the painting; the king's passive, blankly staring face contrasts with his gleaming medals.)

Alternating as usual between "great pride" and "great doubt," Grace worried that by wiping down the paint with rags she had created too many "soft" areas. She wrote in her journal that "tension in a painting should exist down to the tiniest area."[22] Days later, she wrote about herself in the self-aggrandizing way that marked her most feverish investment in a painting. Again assuming the mantle of a latter-day Joan of Arc, she viewed herself as "a crusader, or a missionary" with "the voice that can speak to thousands."[23] This

statement would sound almost delusional if *Grand Street Brides* were not such a powerful painting. Facing front, seemingly unaware of each other, the six brides register a range of expressions: sweetly blank, vulnerable, inward-focused, coldly staring, stricken, resigned.

As a group, the women seem possessed by a frightening insecurity, even a sense of doom—their own, or the world's, or both. Grace stripped the mask off the popular image of a wedding as a woman's "most important day"—an elaborate fantasy remote from the realities of marriage. In later years, she often said that the painting was about weddings as "empty ritual." But the psychological aspect gives the painting its unusual gravity. As she once said, it expresses "a strange rivalry of ugliness and hope."[24] *Grand Street's* unsettled quality reflects postwar alienation, the sense of being adrift in a meaningless world.

"Some of my subjects are loneliness, alienation and anxiety," Grace wrote to Harold Rosenberg that spring, echoing her remark to Miriam Schapiro and Paul Brach the previous summer. "The figures in my paintings ask, 'What are we doing? What do we mean to each other?'"[25] As her journal makes clear, these were questions Grace was asking herself all the time. This aspect of the painting has not always been evident to viewers. As early as 1961, an essay by John I. H. Baur (now associate director of the Whitney) in the museum's catalogue for the exhibition American Art of Our Century describes the painting as reflecting a "not so anguished" form of expressionism. Baur wrote that Grace painted the mannequins' "blank faces and elegant attitudes in a way that preserves the absurdity yet creates its own beauty of slow and ample rhythms."[26] Decades later, a newspaper critic wrote that the painting "looks like *Gone With the Wind* rewritten by Samuel Beckett."[27] Both men somehow missed the emotion that underlies Grace's restrained technique.

Alongside Grace's painterly anguish was her real-world combativeness. In early April, she drafted an daringly incendiary letter to Clement Greenberg that accused him of being "irresponsible" in his remarks about her as "not even a painter." She upbraided him for complimenting her work in person and then complaining about it behind her back. "Whatever opinion you have about my work," she wrote, "you must respect my seriousness and energy. When an artist presents a show he backs it up with his life. You are a coward, because you back your works with more words. Conversation is not criticism." Calling him a "cocktail critic," she presented a foolhardy ultimatum: "I must ask you to put up or shut up."[28]

Another thorn in her side was James Fitzsimmons. She found his review of her show in *Arts & Architecture* irritating because he praised an insignificant still life and criticized the composition of *River Bathers*.[29] His negative view

of de Kooning's paintings of women ("the ugliest and most horridly revealing that I have seen"[30]) also rankled. When she told de Kooning that the critic interpreted a slash of red on the chest of one figure as blood, de Kooning famously answered, "Blood? I thought it was rubies."[31]

Grace was working on a new painting, *Two Woman* (also known as *Portrait of Two Elegantly Dressed Women*), for which she asked *Folder* editor Daisy Aldan and her partner Olga Petroff to pose in folkloric outfits. Comparing Walter's photo of the bored-looking couple with the finished painting, you can see that this is not a portrait in the traditional sense. Petroff was much plumper than Aldan, but Grace rendered both of them with stylized, flattened faces and angular figures. (True to the original pose near the studio's windows, a shadow falls over Aldan's upper body while Petroff is fully in the light.) It seems as if Grace just needed two women—any two women—to look passive as they modeled embroidered clothing normally worn by members of a traditional society. But knowing that the models are actually women leading an untraditional lifestyle (as lesbians), while Aldan was nominally the wife of a man in a long-term relationship with another man, adds another dimension to the painting.

Grace had begun to articulate the themes—empty ritual, costume, and the masks people hide behind—that would continue to inspire her work throughout her life. She mused in her journal that she had more or less come to terms with her approach to painting, working slowly until "things seem to become inevitable and then it all speeds up so fast that I can hardly get it down."[32] In a pensive mood, she reflected that she would be celebrating her thirteenth wedding anniversary had she not divorced Robert Jachens. "How little sense of myself I had at that time," she wrote.[33]

People in her current circle continued to annoy her. She discovered that when a gallery client had purchased paintings by Larry Rivers and herself, John Myers had allowed Larry to receive the entire amount of the client's first payment installment without saying a word to Grace. When Larry said she could have the entire amount of the second installment, she viewed this as an act of generosity—until she accidently discovered the earlier payment. Furious, Grace lashed out at Myers, thoughtlessly choosing a moment when others were present, including the de Koonings and the collector who bought the paintings.

In a typical pattern, she then withdrew from the outside world for a while and took refuge in the wisdom of Flaubert, one of her nineteenth-century heroes. Especially appealing to her were the French novelist's remarks—in letters to his friend Maxime du Camp and lover Louise Colet—that he was not concerned with fame but with pleasing himself, that he admired the way great writers pursue an idea to its "furthermost limits," and that "the greatest

characteristic of genius" is "energy."[34] Grace's own energy spilled over in her relationships with fellow artists. She mused that she was "always making people feel uncomfortable with my excessive enthusiasm or my excessive indifference."[35] This form of extreme behavior seems closely linked to her abrupt changes of mood. One day she would announce to her journal that she was in love with life; five days later she was plunged into gloom, for no apparent reason. Larry wrote to her in early June, worried about her "two-week silence" and wondering what he might have done to hurt her.[36]

During this period of lurching emotions, Grace found herself drawn to German popular music of the 1920s—"consumed with nostalgia for something I never knew," she remarked drily in her journal.[37] Emboldened by her growing self-confidence, she even asked the singer Lotte Lenya—whom she had seen that year in a celebrated English-language version of Bertolt Brecht and Kurt Weill's *Threepenny Opera* in Greenwich Village—to pose for her, but was turned down. ("Of course I mean nothing to her, so why should she bother?"[38]) Undaunted, Grace painted Lenya anyway; after all, she was used to working from photographs. (Later that year, Frank sent her a photo of Marlene Dietrich singing "It's in the Air" to cabaret singer Margo Lion, in hopes that Grace would "immortalize both in paint." But Dietrich had to wait until 2006 for Grace to get around to her, in *Lili Marlene*, a painting of a woman titled after the haunting love song the chanteuse made famous in the 1940s.)

Inspired by a pile of old clothes and costumes at an outdoor market on Orchard Street in late June, Grace decided to paint *Masquerade*, a large-scale fancy-dress group portrait.[39] One of her goals was to prove that she was not, as several reviewers had written, borrowing her style from Max Beckmann. (The German émigré figurative painter, whose crowded scenes are typically packed into a shallow space, had died four years earlier.[40]) For inspiration, Grace posed Jane (in a wedding dress), Frank, a truculent-looking Ashbery wearing only his briefs, and the *Folder* magazine staff in various configurations. Walter shot a contact sheet of photos.

With its cast of zombie-like figures squeezed together yet not relating to one another—their bodies seem insubstantial, almost vaporous, their eyes obscured or hollow or unfocused—the painting seems to exist in a fictive realm, an otherworld similar to the one Frank conjured in his poetry. He wrote of this painting that "the individual identities are being destroyed by costumes which imprison them"[41]—an apt description possibly also influenced by the discomfort of posing in costume in an airless loft in hot weather. Unseen in the photographs, Grace included herself in the painting, as the large, hooded figure at the upper right.[42] As a self-portrait, it is frightening.

The lack of facial features and the isolation imposed by the hood suggest that she was deeply troubled about her identity and her ability to relate to others. While working on the painting, she spent several days on the New Jersey shore with her family and Jeffrey. These gatherings were always tense times for her; afterward, she came down with a virus. "Surely no other picture has cost me so much as this one," she wrote in her journal. "I am weak and spent."[43]

Beginning in late July, Grace spent several weeks with Walter and Frank in Southampton, at the home of painter Fairfield Porter and his family (who were staying at the Porter family home on Great Spruce Head Island in Maine). Grace led a distinctly different life during this interlude. She often rode Fairfield's bicycle to a deserted beach, passing potato and wheat fields, high dunes, and grassland—a setting that inspired five landscape paintings. Sitting in her wide-brimmed Italian straw hat under the baking sun to paint was undeniably soothing, despite the potato bugs jumping onto the canvas. One of her paintings from this sojourn is *Southampton Fields* (plate 6), an atmospheric melding of abstraction (the wavy brushstrokes representing the fields) and recognizable imagery that recalls the landscapes of John Marin, who had died the previous year.[44]

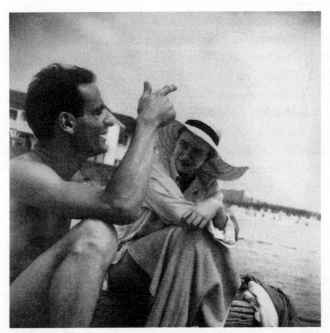

Larry Rivers and Grace on the beach in Southampton, 1954. (Photo: Walter Silver. Courtesy of George Silver and Irving Sandler)

Even though she had to cook for the men (including Fairfield and Anne's college-age son Laurence), she felt like a "lady of the manor,"[45] basking in a state of entitlement that (consciously or not) was one she shared with her mother. Grace enjoyed the ease of spacious surroundings as much as the energy of struggling urban neighborhoods. The stately early nineteenth-century house at 49 South Main Street, framed by a pair of towering horse chestnut trees, was situated on a rambling property with an orchard and meadow that bordered a lake. With its medley of antiques, junk-shop treasures, and paintings by de Kooning and others, the house had a casual charm. Porter, who ignored the crumbling exterior, took pains to choose just the right paint colors and patterned wallpapers for each room.[46]

Walter's photograph of Frank evokes the pensive spaciousness of a Porter painting. The poet sits on a chair against the wall with one leg stretched out in a dancer-like pose; Grace is silhouetted in the open doorway. Three years later, Porter would paint Frank half-reclining on a flowered sofa.[47] Wearing abbreviated white shorts, he alights in an almost impossible position, with the left side of his foot on the floor, his right thigh hovering in space, and his right calf barely grazing the edge of the sofa. The image suggests Frank's poetic gift for destabilizing the present moment in a rush of associations that freely move backward and forward in time.

Like Pollock and Lee Krasner, the Porters had lived in the area year-round beginning in late 1949. Now other artists were beginning to spend the summer in the Hamptons, a ritual that had begun in the 1870s. Winslow Homer, William Merritt Chase, and Thomas Moran are among the best-known of the New York painters who made the tedious journey by train, boat, and stagecoach to East Hampton. Much like the Parisian painters who drew inspiration from sojourns in the village of Barbizon, the New Yorkers were captivated by the dazzle of sunlight on the ocean, the flat expanses of beach and marshland, the windswept dunes, and a tranquil atmosphere conducive to scenes of reverie. A novel by a friend of Grace's evokes modern visitors' enchanted discovery of the sky ("unusually deep and clean"), the ocean ("a glistening cobalt stallion"), the potato fields' soil ("fresh-turned, clotted and fragrant"), and "the startling spectacle of stand after stand of white dogwood shimmering in the sun like oil-stained sheets of polished metal...."[48]

While Grace, Walter, and Frank relaxed at the Porter home, Elaine and Bill de Kooning, Franz Kline, and Ludwig Sander rented "a completely empty house; not a stick of furniture in it"[49] on Main Street in Bridgehampton, filling it with the miscellaneous furnishings of a friend who needed a place to store his family's possessions. The plumbing was dodgy—the artists were

Grace and Frank O'Hara at Fairfield Porter's house, 1954. (Photo: Walter Silver. Courtesy of George Silver. Grace Hartigan Papers, Special Collections Research Center, Syracuse University Libraries)

grateful for the old outhouse—but there was plenty of room to work on paintings and for scrounged-up dinners with friends who dropped in. They included Pollock, who broke his leg horsing around on the property; while he recovered, he left his old Model A Ford for Sander's trips to the grocery store.[50] For a croquet party that August, Elaine made paper flowers, sprayed them with perfume, and attached them to the trees. Bill created additional decor by painting the toilet seat in the outhouse to look like marble.[51]

The social scene in the Hamptons was lively that year. In addition to the Bridgehampton and Southampton contingents, The Springs was the summer haven of artists Joan Mitchell, Miriam Schapiro and Paul Brach, Charlotte Park, James Brooks, Larry Rivers, Philip Pavia, and Esteban Vicente, critic Harold Rosenberg, and dealer Leo Castelli, still at the Janis gallery.[52] Cocktail parties, clambakes, and dinners brought everyone together. Joan wrote to her

sometime lover Michael Goldberg (who would briefly become Grace's lover the following summer), that Grace was issuing "pronunciamentos" on various subjects, including the category of "great painters" whose styles were "excessive," into which she put herself, Larry, and the nineteenth-century French painter Jean Auguste Dominique Ingres.[53] (Grace had an unusual reaction to his neoclassic style, with its emphasis on beautifully drawn forms, perceiving it as "filled with emotion and the tension of the edge."[54]) Jane Freilicher, whom Grace dismissed as an also-ran, snorted that this ranking system resembled the gold star/demerit system at a Girl Scout camp. Oddly, Grace's journal entries reveal nothing of the competitive world of artists at play. While she mentioned that "many diversions" were available, she focused on her negative feelings about nature.[55] Grace tended to panic in bucolic surroundings. She worried that she was in a "preoccupied stupor," lacking her accustomed tension. The paintings she made struck her as "worthless" next to her urban scenes. She wondered if she needed to feel unhappy to paint at a deeper level.[56]

Back in Manhattan, while Grace set to work fixing up her studio with new paint and used furniture, in an effort to approximate the style of the Porter house, her unsettled feelings persisted. Larry wrote that he was worried about her state of mind, suggesting, "Perhaps you are feeling 'funny' because of the particular point you have reached in your work." In a handwritten note at the end of his typed letter, he added, "I suppose only in a love affair do we try to run down the well for something and we either don't see what we look like or don't care or are too passionate about what we want to bring back."[57]

In September, Al Bing told Myers that he wanted to buy *Masquerade* and donate it to a museum. On the same day, a collector paid $750 for Grace's enigmatic *Bride and Owl*—in which a stuffed white owl replaces the groom—despite a visibly patched tear, collateral damage from an exhibition. The painting was also marred by a swath of cobalt violet oil paint that bled through the new acrylic paint Grace had added to speed up the drying process.[58] She never used acrylic again. Decades later, she rhapsodized in typically visceral terms about oil paint's special qualities: "It has a heartbeat, and I get in rhythm with it....I beat it up and it beats back."[59]

To extend the theme of *Masquerade*, Grace embarked on *The Masker*—a masked portrait of Frank—seeking to activate every inch of the canvas. Playing a role, or hiding behind a mask, is central both to mid-century stereotypes of femininity (as seen in the packaging of a movie star or the exhortations of beauty magazines) and to the closeted era of gay life, when even avant-garde artists in New York were expected to reflect the macho Pollock-style stereotype. Yet a mask can also be freeing, allowing one person to (as another prominent gay American

poet put it) "contain multitudes."[60] The easy camaraderie of Frank's sittings for Grace, in tights and bare feet, was briefly shattered when he lashed out at her at a party in late September, accusing her of being jealous of Larry's acclaim. He had a tendency to do this late at night, after steadily drinking for hours. By day, he would be remorseful and try to smooth things over with a phone call.[61] When Grace finished *Masker*, she felt an "enormous" sense of completion, deeming her efforts superior to a similarly Matisse-influenced painting by Harry that she had been storing.[62] Matisse died that fall at age eighty-four, a passing she noted with sadness.

On an October visit to the Museum of Modern Art with Walter, she discovered a new installation of contemporary paintings on the third floor. It was a shock to see her *River Bathers* hung alongside works by Kline, Rothko, Clyfford Still, and the Surrealist-influenced William Baziotes. (Grace had a recurrent nightmare at one point that her work had changed into his.) She was thrilled to see strangers in the gallery stop in front of her painting,

Frank O'Hara posing for Grace, 1954. (Photo: Walter Silver. Courtesy of George Silver and Irving Sandler)

including a man explaining it to his child, and to think of the thousands of people who would see it.[63]

Never shy about assessing the value of her work, she wrote in her journal that *River Bathers* was "a beautiful picture" with "everything that is young in me, and ecstatic." Grace was proud that Alfred Barr had realized she was "the equal—and more—of most of my American contemporaries." With her usual mix of self-judgment and bravado, she told herself that she needed to develop greater expressiveness and a more original way of painting—though without settling into a set style. She pondered the dilemma of being a woman with "countless flaws of vulnerability" who had been endowed with a "great gift."[64] Her triumphant, world-beating mood deflated at the museum's formal opening event for the installation, where no one recognized her except her friends from *Folder* and fellow artist Fay Lansner and her journalist husband Kermit. Clearly, the "glory of achievement" was to be found only in the experience of painting.[65]

Walter took some several nude and semi-nude photographs of Grace this year. In one, she wears jewelry that eroticizes her nakedness and sits in a casually open-legged pose; in another, she reclines in the traditional "odalisque" manner, wearing a robe that has fallen open. The photos were likely intended as source material for her painting *Odalisque*, a nude self-portrait selected for the Whitney Annual the following year. Grace's poses seem to have been inspired by Delacroix's *Odalisque* (1857), which coincidentally was based on a photograph of a nude model taken by Eugène Durieu at the painter's request.

In November, Grace gave a talk at Vassar College, which was showing fourteen of her paintings in the college gallery. She told the students and their young instructor, Linda Nochlin, that she was reading Virginia Woolf's *A Writer's Diary*, published the previous year. Many aspects of Woolf's experience resonated with Grace, including the difficulty of beginning a new work when you were living in two worlds at once—the everyday one and your own.[66] Surveying her assembled paintings, dating from 1949 to the present, she said that she valued being able to assess the progression of her work and its quality. Grace discussed the challenges of developing a personal style based on looking at paintings by artists of the past. Answering a question from a Vassar student about her sources of inspiration, Grace emphasized the influence of both art and nature on her work.[67]

Vassar art major Emily Dennis was impressed by Grace's "energy and passion about [her] work" as she spoke "about how difficult it was to be a woman in the world of male painters."[68] Another student recalled her imposing presence and brisk stride, so different from the mincing "feminine" walk

Grace posing as an odalisque, May 1954. (Photo: Walter Silver. Courtesy of George Silver. Grace Hartigan Papers, Special Collections Research Center, Syracuse University Libraries)

cultivated by other women.[69] Decades later, Nochlin wrote about how exotic Grace seemed in the demure setting of a women's college of that era. Speaking "confidently" off the cuff and larding her remarks with four-letter words that startled her listeners, she appeared in full command of her powers.[70] Several of her paintings in the exhibition sold; *The Massacre*[71] was purchased by Robert Keene, who would later embark on an ill-fated romance with Grace.

Despite her towering ambition, she felt unsettled by a flurry of media interest that included an interview with *Newsweek* and lunch with a *Glamour* magazine feature editor.[72] She asked her journal, "Who am I?"[73] But she soon began painting again, working on *Lady with a Fan* and a still life with "all my favorite white crockery."[74] Reading George Eliot's novels *Mill on the Floss* and *Adam Bede*, pondering her role as an artist ("putting it together" rather than "tearing it apart"[75]), Grace was upset by the news that her next one-person exhibition at de Nagy would have to be in March (rather than April), replacing a planned show of Jane Freilicher's paintings. This meant that she couldn't send her new paintings to a show of work by younger artists in Minnesota because they wouldn't come back in time.

But the year ended on a positive note, thanks to a reassuring conversation with the critic Harold Rosenberg and his wife, writer May Tabak, and a treasured Christmas present. Two years earlier, Rosenberg published "The American Action Painters" in *Art News*—a philosophical validation of what the Abstract Expressionists were doing. The new painting was not a specific style, he wrote, but rather "an arena in which to act" that "has broken down every distinction between art and life." In his eyes, a painting was "inseparable from the biography of an artist," in the sense that every painter was free to express a unique "emotional and intellectual energy."[76] Grace appreciated Rosenberg's keen mind and openness, in contrast to Clement Greenberg's doctrinaire attitude, and he helped her understand her need to do figurative work despite the scorn of committed abstract painters. (Two decades later, he would write to her that "the enemy of art is conformity," by which he meant even adherence "to one's <u>own</u> established style."[77]) Best of all was "Christmas Card to Grace Hartigan," a glorious poem by Frank in which he avowed that he "would rather the house burned down than our flames go out."[78]

ON NEW YEAR'S EVE, 1955, Grace threw party in her loft, a festive evening of talk, music, and dancing. To everyone's surprise, even dignified Alfred Barr attended. The next day, she made a reckoning of her financial situation. In 1954, Tibor de Nagy Gallery had sold $5,500 worth of her paintings, $3,660 of which she received after the gallery took its cut. Grace had just $500 left after an admittedly self-indulgent shopping spree: new clothes, paint and canvas, a visit to the dentist, and good food and drink that had caused her to gain ten pounds. That fall, she had enjoyed a dinner of lamb chops with kidneys, beefsteak tomatoes, red wine, a brown pear with Port Salut cheese, and a "new blend" of coffee—all itemized in her journal "just in case, in retrospect, life at 25 Essex Street seems hard."[79]

At the end of January—when Grace was alternating between reading detective stories and wandering the streets and galleries in search of inspiration—she mustered her courage to join another panel at the Club, "Nature and the New Painting," moderated by Frank. This time, everything went well—with intelligence and wit, and no outbreaks of anger or violence. In 1954, Frank had published an essay in *Folder* with the same title that discussed the work of several younger painters—including Grace (recipient of the lion's share of attention), Elaine, Jane, and Larry—who were taking a closer look at "nature."[80] A thoroughly urban man by taste and temperament, he wasn't referring to painting landscapes. Rather, he was celebrating the painters' conscious use of the full breadth of their own visual experience as the subject of their work.

Grace's paintings, he wrote, involved "a continual effort to put more into the picture without sacrificing the clarity she loves in Matisse." He celebrated the "passion" of her work and her ability to "bring together wildly discordant images" through an awareness of their functional relationships ("their being together in the world"). Grace loved Frank's ability to evoke the essence of her work and compared his critical writing to the work of French poets Charles Baudelaire (who wrote perceptively about Delacroix and other artists) and Guillaume Apollinaire (author of a key essay on the Cubist painters).[81] Joining Grace and Frank on the panel were four other younger painters: Elaine, Joan Mitchell, Milton Resnick, and Mike Goldberg.

It was clearer than ever to Grace that her paintings should create their own world. (Decades later, this would be her best-remembered advice to her students.) Reading Harold Rosenberg's essay, "Parable of American Painting," in the January issue of *Art News*[82] helped clarify her thinking. He compared formally predetermined painting styles (such as Cubism) to the tradition-steeped battleground tactics of the British "Redcoats" during the Revolutionary War, and free abstract painting—with its spontaneous vigor and openness to accidents—to the improvisatory warfare of the American settlers ("Coonskins"). Problems arise, he wrote, when free abstraction becomes a set style; the Coonskins turn into Redcoats.

Grace realized that she needed to find a new way to work, without "any preconceived notions of composition"[83] but also without leaning on Abstract Expressionist "energy." She had been hoping that her fascination with costume would keep her painting fresh. After looking at Old Master paintings at the Met, as well as the radical figurative work of English painter Francis Bacon, she decided to pay more attention to the relationship between figures and their surroundings. As the weeks passed, she reformulated her goal: What she really needed was more *structure* in her paintings. She would have to replace the "falseness and brilliance"[84]—the slashing strokes of high-keyed color that came so easily to her—with, well, something deeper. But what? The stress of trying to find it that winter dragged Grace from drowsy immobility to nervous frenzy. She constantly worried about money—in early March she had $1.99 in the bank—and then chided herself for wallowing in self-pity. After all, de Kooning was penniless, too.

Watching the farewell performance of Vicente Escudero, a flamenco dancer in his sixties—famed as a renegade practitioner of the form, with a self-invented style—she noted that by "trying to use wit to fill the gaps" he telegraphed a sense of his former greatness to the audience. Inspired, she embarked on a painting of flamenco dancers, only to abandon it a month later

after working the surface up to "the moment of truth."[85] Several months later, a terse journal entry summed up her ongoing struggles: "Today destroying all of yesterday."[86]

Vassar student Emily Dennis, who was writing her senior paper on Grace, visited her studio this spring—the first of several trips to watch her paintings evolve. "I felt as if I had just arrived in Montmartre in 1905, climbing up those stairs, passing a Larry Rivers plaster sculpture on the landing to arrive at her big, wide-open, well lit, minimally furnished studio," Dennis recalled. "She also walked me around the Lower East Side neighborhood that she loved…show-ing me the storefronts of bridal gowns on Grand Street…the fruit stands, the flea market on Sunday, and all the rich, kitschy abundance."[87]

Over the course of several weeks, Grace told Dennis about her goals and struggles. "She had much self-confidence about what she was doing and attacked her work with a kind of fierce determination, but it seemed to me that this went with a good deal of self-questioning and struggle," Dennis said.[88] "She was going for something deeper than easy surface beauty and wow effect, and thought a great deal about ways of achieving it. We also talked about poetry.… [S]he turned me on to [Russian poet Vladimir] Mayakovsky and a short story she liked by William Faulkner about airshow flyers." (Maya-kovsky was one of Frank's favorite poets; the title of a poem he wrote that year about his personal anguish bore the Russian poet's name.[89])

After Dennis sent Grace an essay she wrote about her paintings, Grace remarked in a letter that "so much of painting is working in the dark, some-times knowing in great flashes of understanding, and sometimes blindly trust-ing to luck, talent, inspiration or what have you."[90] Still tussling with what it meant to abandon pure abstraction, she added that when she painted "specific human areas," as distinguished from "just painted ones," she wanted them "always to seem inevitable, to be correct in their volume and tension."

Weeks after the close of Grace's March solo show—which included *Grand Street Brides* and the two painting with images of O'Hara, *The Masker* and *Masquerade*—James Thrall Soby published a long, celebratory article about her in *The Saturday Review*, a weekly general-interest magazine. Soby had begun buying important works of art as a young man; now middle-aged, he was the author of several books about twentieth-century artists and served as chair of the Museum of Modern Art's collections committee.

He praised *Giftwares* (plate 7), a painting that translates a store window cluttered with bric-a-brac into layered imagery bathed in bright color, for cap-turing "the tacky vitality of America" while transforming everyday objects into "sensuously beautiful forms."[91] Grace was thrilled. She had painted this

canvas with the inspiration of Matisse's *Variations on a Still Life by de Heem* (1915), seen in reproduction in the catalogue of the Modern's 1952 retrospective.[92] Matisse had used a seventeenth-century Dutch still life by Jan Davidsz. de Heem as the jumping-off point for his radically flattened and simplified composition. Begun as a charcoal drawing, Grace's painting was soon covered with washes of high-keyed color. Next, she began "opening it up with slashes and strokes of white."[93] Then came the hard part—tossing out "all elegance, skill, 'style,'" to retain "the spirit of Matisse and not the look."[94] A brash vivacity replaces Matisse's precisely ordered composition.

As Grace explained in a letter to Dennis about the value of art criticism, "What an artist wants perhaps first is what Soby just did for me—an enthusiastic article in a prominent magazine by a famous writer on art. It has immense 'professional' value, and the encouragement is tremendous."[95] Soby's approbation may have made up for reviews that compared her to other artists, to her chagrin. *New York Times* critic Howard Devree, who aptly called her work "tensely personal," also found it "somewhat reminiscent of Beckmann,"[96] a comparison Grace disavowed. She was annoyed by "all the critics [who] seem to think I am an 'expressionist,'" as she wrote to Dennis.

In *Art News*, Lawrence Campbell praised *Masquerade* for its "elliptical drawing reminiscent of [German expressionist painter Ernst Ludwig] Kirchner" and ascribed the "unpleasant" features of her work (such as the "smarmy lipstick" in one painting) to his condescending notion that Grace's "romantic" approach had not yet been touched by "the softening effect of civilization."[97] Grace bridled at Campbell's pointlessly personal remark, meaningless to outsiders, that "[s]he does things that are simply not done in her social circle." What was her "circle," anyway?[98] Yet she defended his description of *Odalisque*—a nude self-portrait—in his review of the Whitney Annual exhibition as "a kind of poetic aversion for the subject."[99] This phrase, she wrote to Dennis, was an apt summary of her attitude toward her subject matter— "popular culture, 'kitsch,' junky windows, Hollywood glamour girls, those things I hate and love."[100] It was an odd remark, considering that the odalisque (a concubine in a harem), was famously a subject of Ingres and other nineteenth-century painters. But perhaps she was thinking of her *Odalisque* as a riff on pinup calendar and *Playboy* centerfold versions of a female nude.

The Art Institute of Chicago purchased *Masquerade*, another feather in Grace's cap, and Alfred Barr scooped up her still life in the show, *Peonies and Hydrangeas*, which would be donated to the Museum of Modern Art by Nelson Rockefeller—even though he hadn't even seen the painting. (Grace always had a soft spot for plants, lovingly tending pots of geraniums in her

various studios.) But the sales didn't help her finances; the money was already spent. She had to borrow money to pay the rent. What she longed for now was a collector who could commit to buying her more adventurous work on a regular basis.

In recent months, Grace was drinking more often on her own, in addition to the well-lubricated social scene at parties and the Cedar. As her thirty-third birthday neared, she wrote a brief, depressed journal entry in an alcoholic haze. Brandy warmed a rapprochement with Helen after several years' silence, despite a prick of jealousy when Helen's work was chosen for the Carnegie International (the venerable contemporary art exhibition at the Carnegie Museum of Art in Pittsburgh) and Grace's was not. She would explain decades later that "Helen's argument with me was that I was using imagery and I should be abstract. My argument with her was that her paintings looked as though she had painted them between cocktail time and dinner."[101] Meow. But despite the youthful "bitchery" that Grace acknowledged in middle age, she and her rivals agreed on one thing: that painting was the most important aspect of living.

News that the Whitney Museum would purchase *Grand Street Brides* revived her spirits—and would soon fatten her bank account—but soul-searching about her current work continued. Now she was convinced that her painting goal was utter simplicity, in the spirit of Matisse. Because she didn't want to lean on him, she would have to muster the courage to let her work look "clumsy." In early May, the doubts resurfaced. "I am lost and floundering—and worst of all, I can't even flounder on a canvas, it is all in me," she confided to her journal. "I can barely force myself to work. I don't know what I want to paint, or how." She was humiliated that Joan witnessed one of her "nervous crises."[102]

This may have been the same night—at a party given by Myers—that Larry saw her burst into tears. Deeply affected by this, he wrote her a concerned letter, asking what was bothering her. He figured that "it had to do with painting," but maybe the cause was a remark made by him or Frank on a recent visit to her studio. Promising to call, he suggested a gallery exhibition: "Go see the Rodin—DON'T commit suicide."[103] As her journal entries show, worries about the direction of her work were eating at her. A weekend with May Tabak and Harold Rosenberg helped give her a sense of perspective, an understanding that most of the critical attacks on the gallery's painters who dared to work in a representational vein as "reactionary" or "conservative" were not aimed at her, and that she needed to "fight only my own battles."

Yet she had other worries—about her son—that she would not share with her art-world friends. Before Grace left for the weekend with the Rosenbergs,

she sent thirteen-year-old Jeffrey—still living with her parents—a check for $50. Her mother wrote to her that he was "very pleased," and Jeff dutifully added that he would use it for clothes and spending money ("My grandmother is holding it for me, and giving it to me when I need it."[104]) Grace's arm's-length relationship with her son would soon become a geographical rift. Robert had moved to Los Angeles and fallen in love with Evelyn Schlonsky Daniels, a New Yorker whose parents were Russian émigrés.[105] The couple, who married in November 1955, lived in a working-class neighborhood, near a park. Grace had already sensed that Jeffrey was not going to be a creative person;[106] in other words, he was not destined to become a version of herself—perhaps the only guise in which she could love a child. Telling herself that the bohemian lifestyle of downtown artists was not the right environment for a sensitive boy on the cusp of adolescence, she decided to send him to live with his father.

Publicly, Grace tried to rationalize the situation, telling an interviewer years later that moving to Los Angeles had saved Jeffrey from the need to carry a switchblade on the streets of the Lower East Side.[107] She would not see him again for more than thirty years. Near the end of her life, she told a close friend that when her therapist asked her if she felt guilty about not feeling guilty about her son, her answer was no.[108]

IN LATE MAY, Grace left for an eighteen-day trip to Mexico. She traveled with Walter, poet John Ashbery, and Jane Freilicher and her fiancé Joe Hazan, who needed to obtain a Mexican divorce from his first wife. (Jane's teenage marriage to a jazz pianist had been annulled several years earlier.) Hazan, who had trained as a dancer—and, like Grace, worked as a draftsman during World War II and as an artist's model for Hans Hofmann—would later become a painter. Now in his late thirties, he had met Jane through the artist and film-maker Rudy Burkhardt.[109] Ashbery, a graduate of Harvard and Columbia, was in his late twenties. He toiled at low-level publishing jobs to support his writing, which included a novel and his first poetry collection. Never having been out of the country, he was keen to go on the trip. (Oddly—had Grace taken a dislike to Ashbery for some reason when he posed for her painting?— Jane later told him that Grace had hoped he wouldn't come along.[110])

Stuffing five creative people into a car for a 4,000-mile journey led to some petty quarrels,[111] but Grace was passionately attracted to the passing scene, from the new growth of grass in Virginia "becoming touched with blue" to the "high sweeping skies" in Tennessee.[112] Slipping into her vainglorious mode, she re-marked in her journal that she was driven to interpret the immensity of the American landscape for others in her paintings because she possessed "that huge

feeling," unlike the "puny" artists whose work was sentimental Americana.[113] She adored the motel the group stayed at in Texas, with its kidney-shaped pools and greenish outdoor lighting; it seemed like something out of a Hollywood B movie. Decades later, she would revel in similar details in her painting inspired by the Madonna Inn, a kitschy hotel in California.

In Monterrey, Grace and Walter indulged in the touristic activities—a horse-and-buggy ride; Sanborns restaurant, which advertised "delectable native dishes"; a stroll in the plaza—that she had enjoyed on the ill-fated trip with Harry. But she worried that drinking tequila at her comfortable colonial-style hotel in the city was a betrayal, revealing a typically American distaste for the earthy smells of small-town life in Mexico. A day in the countryside gave Grace the opportunity to play the freewheeling adventuress, taunting her travel mates for their worries about the sanitation in the restaurant she chose for their lunch. (Guidebooks of the time warned tourists incessantly about the dangers of *turista*.) But as Ashbery said later, Hazan—who had lived in Mexico for a while and spoke passable Spanish—and the others were hardly intent on sticking with bland, American-style accommodations.[114]

Soon after the group reached Mexico City, where Grace was disappointed to see manufactured clothing and furniture replacing local crafts, she and Walter traveled separately by bus to Guanajuato, a colonial city squeezed into a narrow valley. Feeling queasy and fighting off mosquitoes, Grace nonetheless enjoyed the lazy life of a tourist, drinking dollar-a-bottle rum in a room that cost the equivalent of $6.80 a night. She browsed the market, watched birds roost in the plaza, and feasted on tropical fruit, *huevos rancheros*, and chocolate while dosing herself with stomach medicine. Decked out in earrings and a *rebozo*, Grace caught the disapproving stares of the "proper ladies" at their hotel.

One day, she and Walter took a taxi to El Museo de las Momias, where the mummified bodies include cholera victims open-mouthed with the shock of having been buried alive. After wandering down dirt roads, Grace discovered a rococo church that she sketched and visited an old silver mine, still in use. She marveled at how old and new coexisted in rural Mexico. Rejoining the others, with a stop in Ciudad Juarez for Joe's divorce—Grace called this "a sordid morning,"[115] without elaborating; was she thinking of the end of her own marriages?—the couple returned to New York in mid-June. All in all, it was a good trip, and it was a relief to be back in a country where efficiency, prosperity, and clean water could be taken for granted. Preparing to get back to her painting, she felt confident, telling herself, "One must be fierce."[116]

Twelve days later, the boom fell: Walter moved out. Stricken, Grace wondered if her love life would ever stop being a roller coaster. As usual, she and

Walter continued to obsess over the relationship, with Walter wondering if he loved her too much and had lost his sense of self. What he probably meant was that he was fed up with the way she always called the shots (as she did on the trip), tired of her sexual straying, and jealous of her growing fame. Grace, who had enjoyed more long-term closeness with Walter than with any of her other men, began to feel that she would never have the "comfort" of a permanent relationship. And yet, wasn't it really just the act of sex that gave her new strength? The couple's falling out was apparently a big topic of conversation among their friends, abetted by James Schuyler's gossip. He mentioned the break-up in a letter to Barbara: "This time, he left her. Grace, I gather is not too stricken. Though I don't really know what she thinks about it."[117] As usual, Walter and Grace soon kissed and made up; he agreed to sleep with her again, just not every night.

Relieved to have her sex life back, Grace was easing back into painting. She fell into a pleasant routine, starting her day around nine and listening to the symphony on the radio during breakfast. Then she might read a bit and talk on the phone (a lifelong umbilical cord to her closest friends) before spending several hours in the studio. After a snack and a couple glasses of rum and Rose's lime juice, she would return to whatever book she was reading and listen to records. Sometimes her solitary drinking escalated; one night she downed four highballs (probably Scotch and soda) with a plate of scrambled eggs, leaving her too fuzzy to do more than listen to "schmaltz music" in her wing chair.[118] Fortunately, her friends were still an important part of her life. One summer night, she had dinner with Frank before a movie (*East of Eden*). On another night, her dinner-and-movie companion was fellow painter Mike Goldberg. Afterward, she stayed up until three o'clock in the morning talking with Franz Kline about ("of all things") the British royal family.

Grace was coming into her own as a public speaker. In October, listed as "George Hartigan," she took part in "The New Vanguard in Painting and Poetry," a panel discussion at the de Nagy gallery, moderated by Myers, with Jane, Nell Blaine, Alfred, Larry, Fairfield, Mike, and poets Frank, John, and Kenneth Koch. The following month, she was the youngest person and only woman on a panel called "The Search for Community," at The New School for Social Research. The evening was billed as a discussion of the "significance of what happens in [Greenwich] Village as a local phenomenon and as a symbol for our time." Grace was joined by eight painters and sculptors working in diverse styles, including de Kooning and Motherwell, art historian Lloyd Goodrich, artist and critic George L. K. Morris, and Holger Cahill, former director of the Federal Arts Project and briefly acting director of the Modern.[119]

Reading novelist André Gide's journals, Grace found his remark about wanting "only one thing and wanting it constantly" to be a useful touch-stone—no wonder, considering her ferocious drive as an artist. She agreed completely with Gide's caution that virtuosity is insufficient in itself without underlying emotion. Yet all this theoretical musing was not helping her move forward with her new painting, *The Showcase*.[120] One day, Grace spent "a half-hour of weeping with rage and impotence, then *hurling* [herself] at this painting, using the brushes like clubs," only to wipe out the whole thing the next day.[121] Finally, toward the end of July, she seemed to be getting some-where.

In the upper left corner, a mirror in the shop window reflects the faces of a couple on the sidewalk—the woman resembles Grace—who peer at the jumble of mannequins and other items. (Prompted by Gide's interest in art that contains reflections of itself, Grace looked to the use of mirrors by Velázquez and sixteenth-century Flemish painter Quentin Matsys.) The fig-ures in this painting are blurred, glimpsed as if partially obscured by reflec-tions on the glass. Unreadable geometric forms separate a mannequin couple from a mannequin child turned away from the viewer—it is tempting to see him as Jeffrey—who stands next to a pair of crutches. Steeped in twin under-currents of yearning and rejection, the painting mirrored Grace's deeply am-bivalent mood.

The Showcase would be selected for the Whitney's 1955 Annual Exhibi-tion of Contemporary American Painting. (Earlier that year, when Grace was desperate for sales, she lamented that collectors Roy and Marie Neuberger couldn't decide which of her works to buy. They would purchase this one in 1956 and give it to the Met.) But she found it hard to work when her personal life remained rocky—her relationship with Walter still unsettled, and too many nights spent alone. If only she could rely on art alone to provide the peace and sense of fulfillment she longed for!

Fame (1956–1960)

11

Celebrating

NINETEEN-FIFTY-SIX WAS A breakthrough year for Grace Hartigan. Six of her paintings were selected by Museum of Modern Art curator Dorothy Miller for the exhibition Twelve Americans.[1] Grace was the only woman artist in the show, thoughtfully designed as a sequence of one-person showcases for the eight painters and four sculptors. In her statement for the catalogue, Grace proclaimed that she had found her subject: "that which is vulgar and vital in American modern life."[2] (Consciously or not, she echoed de Kooning's remarks at a 1952 symposium at the Modern: "Art never seems to make me peaceful or pure. I always seem to be wrapped in the melodrama of vulgarity."[3]) She was represented by works from the Modern's collection (*The Persian Jacket, River Bathers*), two recent paintings (*City Life* and *From Chinatown*), and two works in private collections: *Ocean Bathers*—inspired by Grace's interest in ancient Roman wall paintings and obliquely immortalized in Frank O'Hara's poem, "In Memory of My Feelings"—and the quizzically humorous *Bride and Owl*, for which she had splurged on a model to pose in a wedding dress.

Grace wrote that what she wanted to produce was "an art that is not 'abstract' and not 'realistic'—I cannot describe the look of this art, but I think I will know it when I see it."[4] To crown her achievement, *City Life* (plate 8)—a brilliantly colored, fractured image of a fruit vendor's awning-topped cart stuffed with oranges and lemons—was purchased by Nelson Rockefeller. A distinguished trustee of the Modern Museum of Art, he would soon be elected governor of New York. (While the painting was still at the gallery, a model wearing a sleeveless dress was photographed in front of it, for *Mademoiselle* magazine. The caption noted that "Miss Hartigan...is taking a turn toward realism."[5])

Grace also rated a mention in a *Mademoiselle* article, "Is Abstract Art Dead?" which offered a benign view of artists who turned away from total abstraction, proposing that "the sincere, creative statement of any artist in tune with his time will be 'modern.'"[6] A carping note came from *Arts* magazine's reviewer. Leo Steinberg, at the start of his own illustrious career as a critic and

Grace at the opening of Twelve Americans, Museum of Modern Art, May 1956. (Photo: Walter Silver. Courtesy of George Silver. Grace Hartigan Papers, Special Collections Research Center, Syracuse University Libraries)

art historian, jumped on what seemed to be an indecisiveness in her statement, which he claimed (unpersuasively), to see as a weakness in her paintings. If they were neither abstract nor realistic, what were they?[7]

The other painters in the exhibition included Philip Guston, then working in a lyrical abstract vein; Larry Rivers, whose in-your-face redo of the sober nineteenth-century painting *Washington Crossing the Delaware* had outraged just about everyone three years earlier; and Franz Kline, whose large-scale abstract black-and-white paintings often suggested the dynamic energy of bridges and the harsh landscape of coal country in his native Pennsylvania. One of his paintings in the show was *Wanamaker's Block*, painted after he watched the Wanamaker's department store—a few blocks from his studio—go up in flames. Grace's father, who found abstract art baffling, came with her to see the exhibition. As she told the story, he walked up to *Wanamaker's Block* and said, "Now that looks just like a burned-out building to me!"[8]

For several years, despite more public involvements with other artists, Grace enjoyed passionate trysts with Kline, whose wife Elizabeth was a patient in a mental hospital.* A compact, muscular lady's man who moved like an athlete, he

* His English-born wife, a former dancer, was released from Central Islip Hospital in 1960; she died in 1984. Another Elizabeth—Elizabeth Ross Zogbaum, wife of sculptor Wilfred Zogbaum—was Kline's companion during his last years.

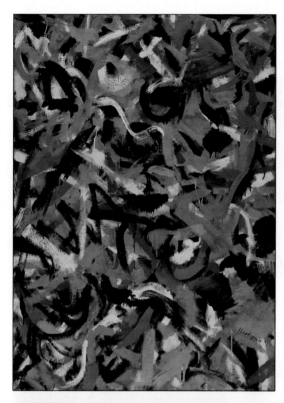

King of the Hill, 1950
Oil on canvas; Worcester Art
Museum, Massachusetts;
Sarah C. Garver Fund /
The Bridgeman Art Library.
© The Estate of Grace Hartigan.

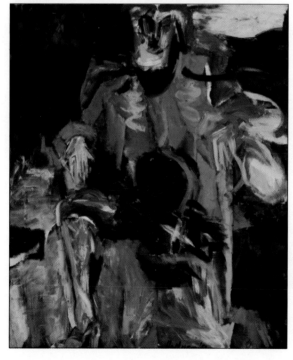

The Persian Jacket, 1952
Oil on canvas, 57½ × 48
inches; The Museum of
Modern Art, New York;
gift of George Poindexter
(413.1953). Digital image
©The Museum of Modern
Art / Licensed by SCALA /
Art Resource, NY. © The
Estate of Grace Hartigan.

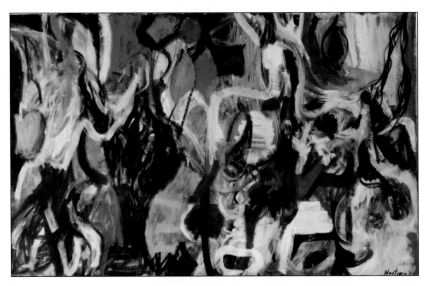

The Massacre, 1952
Oil on canvas, 60 × 127¾ inches; Kemper Museum of Contemporary Art, Kansas City, MO; Bebe and Crosby Kemper Collection; gift of the Enid and Crosby Kemper Foundation (1995.38). © The Estate of Grace Hartigan.

River Bathers, 1953
Oil on canvas, 69⅜ × 74¾ inches; The Museum of Modern Art, New York; given anonymously. Digital image © The Museum of Modern Art / Licensed by SCALA / Art Resource, NY. © The Estate of Grace Hartigan.

Grand Street Brides, 1954
Oil on canvas, 72⁹/₁₆ × 102³/₈ inches; Whitney Museum of American Art, New York; purchase, with funds from an anonymous donor (55.27). Digital image © Whitney Museum of American Art. © The Estate of Grace Hartigan.

Southampton Fields, 1954
Oil on canvas, 32 × 36 inches; The Metropolitan Museum of Art, New York; Gift of Edmund E. Levin, 1982 (1982.105). Image © The Metropolitan Museum of Art; image source: Art Resource, NY. © The Estate of Grace Hartigan.

Giftwares, 1955
Oil on canvas, 63 × 81 inches; Collection Neuberger Museum of Art, Purchase College, State University of New York; gift of Roy R. Neuberger. Photo: Jim Frank. © The Estate of Grace Hartigan.

City Life, 1956
Oil on canvas; Collection of Kykuit, National Trust, Nelson A. Rockefeller Bequest. © The Estate of Grace Hartigan.

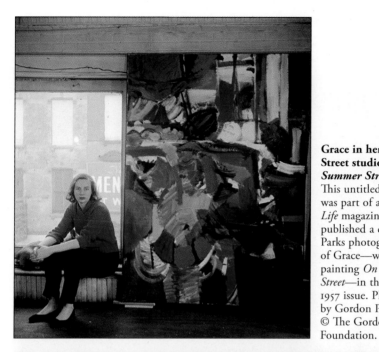

Grace in her Essex Street studio with *Summer Street* (1956). This untitled image was part of a shoot for *Life* magazine, which published a different Parks photograph of Grace—with her painting *On Orchard Street*—in the May 13, 1957 issue. Photograph by Gordon Parks. © The Gordon Parks Foundation.

New England, October, 1957
Oil on canvas, 68¼ × 83 inches; Albright-Knox Art Gallery, Buffalo, NY; gift of Seymour H. Knox Jr., 1958. Photo: Albright-Knox Art Gallery / Art Resource, NY. © The Estate of Grace Hartigan.

Shinnecock Canal, 1957
Oil on canvas, 7 feet 6½ inches × 6 feet 4 inches; The Museum of Modern Art, NY, gift of
James Thrall Soby. Digital image © The Museum of Modern Art / Licensed by SCALA / Art
Resource, NY. © The Estate of Grace Hartigan.

Broadway Restaurant, 1957
Oil on canvas; 79 × 62¾ inches;
Nelson-Atkins Museum of
Art, Kansas City, MO; gift of
William T. Kemper (F57-56).
Photo: John Lamberton.
© The Estate of Grace Hartigan.

Billboard, 1957
Oil on canvas, 78½ × 87 inches; Minneapolis Institute of Arts, The Julia Bigelow Fund
(57.35). © The Estate of Grace Hartigan.

Frederiksted, 1958
Oil on canvas, 81.63 × 88.88 inches; Rose Art Museum, Brandeis University, MA; gift of Mr. and Mrs. Larry Aldrich, New York. © The Estate of Grace Hartigan.

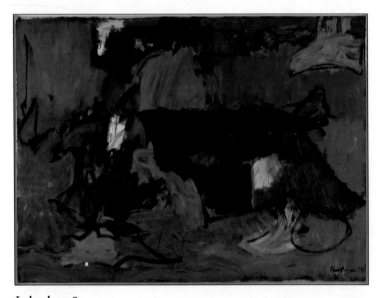

Ireland, 1958
Oil on canvas, 78¾ × 106¾ inches; The Solomon R. Guggenheim Foundation, Peggy Guggenheim Collection, Venice, Italy. Photo: The Solomon R. Guggenheim Foundation / Art Resource, NY. © The Estate of Grace Hartigan.

painted at night after holding court for several hours at the Cedar Tavern. As one acquaintance said, "He could play with language as he was talking; it was so fast and so intricate—and clear. It all made sense." Artists remembered his pithy remarks about the incredibly difficult thing they were all trying to do: "The real thing about creating is to have the capacity to be embarrassed," and "Painting is like hand-stuffing a mattress." Toward the end of her life, Grace recalled how extraordinary it was for Kline and Pollock to endow abstraction with "emotional content"—something, she said, that had never happened before or since.[9]

Even as he developed a measure of fame, Kline remained everyone's pal, forever willing to listen and advise; the only change was his ability to afford nattier clothes and a better car. His habits remained much the same, too, including his beer and pastry breakfast upon arising in the early afternoon; and a bacon and egg meal at a diner just before daybreak.[10] Sometimes Kline would swing by Grace's loft before he got down to work. Once, during a heavy rainstorm, he wore only a trench coat and immediately threw himself on her, a thrilling memory she savored for decades. She always said that Kline was the best lover she ever had.[11] On one occasion, when they made love on the floor of his studio, he pulled out her diaphragm—a seemingly hostile move that Grace later laughed off.[12] Months before his untimely death at fifty-one, of heart disease, he managed to come down to Baltimore to see her one last time.[13] (Around the time that she was involved with Kline, she met the reclusive artist Joseph Cornell, who arranged small "found" objects and vintage photographs in glass-fronted boxes to create a unique form of visual poetry. As she told the story, he asked her out and she declined, citing her current relationship. So he made her a little red heart pendant with hammered-in nails to represent his broken heart. Later, when she tried to make amends by asking him to lunch, he turned her down.[14])

Grace's sensual painting *Sweden* (1959; plate 17) is like free jazz translated into abstract art. Patches of gray and white are softened with a thin glaze of paint (a process known as scumbling) and enlivened by vivid bursts of bright color and enigmatic outlines (some, suggestively phallic) drawn with a nearly dry brush. The title refers to the way Kline used to tease her, saying that she looked like a Swedish skier. He came to her studio while she was working on the painting, which she would dedicate to him. When she told him she was worried that the lower right-hand corner wasn't quite right, he looked at her in disbelief and said, "You mean you want to make it better?"[15] What he meant was that the whole point of their kind of painting was to work in the white heat of impulse and emotion. Grace already knew this. She told an interviewer, "The time I know when a painting is finished is when it leaves me alone. When it finally does, I wouldn't dream of touching it." Almost too

vividly, she continued, "I get pregnant from the image I'm working on. I live with it, dream of it, and finally the labor pains begin."[16]

Not that there wasn't still more to learn about painting. One evening at the Cedar, Landes Lewitin, a sixty-four-year-old artist who had long been a fixture of the downtown scene, saw Grace and motioned to her to come over. He had just seen the Twelve Americans show. "Do you want me to tell you the truth?" he asked. "Can you take it?" Grace said, "Try me." Lewitin leaned forward to impart his wisdom. "Transubstantiate," he intoned.[17]

Grace pondered this enigmatic piece of advice for some time. Finally she realized what he meant: You're not supposed to make paint look like paint. A devout Catholic receiving Holy Communion believes in transubstantiation (the literal transformation of the consecrated wafer and wine into the body and blood of Christ). A committed artist transforms the raw material of paint into a uniquely personal expression. A few years later, Grace told a *Mademoiselle* magazine interviewer that her abstract works "have a content that is produced through the feeling or idea I have about a particular subject."[18]

City Life ushered in a string of strong works that became known as Grace's "city life" paintings. They were valentines to her beloved neighborhood, which she adored "in full summer heat—the watermelons and pineapple slices on ice, the park filled with people, all the life & smells in the street."[19] Grace later credited de Kooning's example for the idea of doing "place" paintings, probably referring to canvases like *Gotham News* (1955) and *Easter Monday* (1955–56), which are essentially abstract but with glimpses of urban street life.[20] Her painting *East Side Sunday* is based on the view from the window of her loft, looking down at Henry Alford's fruit stand. The painting is semi-abstract, but you can see the crammed-together pile of cartons holding the fruit, the wavy green awning at the bottom, and (at the right) an aerial view of a customer wearing a hat. Alford was so used to seeing her look out of the window that he sometimes held up a choice piece of fruit for her inspection in case she wanted to paint it close up.[21]

Experimenting with interlocking planes of vivid color, Grace took large sheets of paper, covered them with oil paint, and moved them around the canvas to gauge the effect. She was attempting to reverse traditional, looking-into-the-distance perspective by projecting the scene into the *viewer's* space. At the same time, she deliberately undercut this effect by aligning swaths of complementary colors, like green and red, orange and blue.[†] These violent

† Complementary colors traditionally employed by painters are those that create the strongest contrast when placed next to each other. Each complementary color pair consists of a primary color (red, yellow, or blue) and a secondary color (green, violet, or orange).

Grace with her painting *City Life*, 1956. (Photo: Walter Silver. Courtesy of George Silver. Grace Hartigan Papers, Special Collections Research Center, Syracuse University Libraries)

contrasts give the paint itself a central role, emphasizing the flatness of the canvas. She told an interviewer that although she never knew where on the canvas specific colors might go ("that's the fun, that's the adventure"), she would say to herself something like, "This is going to be an impossibly green and red painting."[22]

A big issue for her in these works was how to avoid leaving any "negative space," so that every square inch of the canvas would be activated—if not with a recognizable object, then with areas of paint that created their own drama. As a self-described colorist, she worked to maximize the effect of color, creating "both a feeling of tremendous life, and an inevitable stillness."[23] Years later, one of her collectors wrote to tell her how much pleasure her "Essex Street painting" from 1956 ("so crowded with life giving images") had given him and his wife. "Seeing it with the early morning [sun] highlighting its colors makes waking up a celebration," he wrote.[24]

Grace was on a roll with her jazzy paintings, which also included *The Vendor, Summer Street, From Chinatown, On Orchard Street,* and *Billboard*.

When Gordon Parks photographed her for the *Life* magazine article "Women Artists in Ascendance" (published the following year), she sat in front of her studio window wearing black slacks, a red sweater, and a slash of red lipstick. The photograph in the magazine shows Grace with *On Orchard Street*, a large-scale abstract rendering of a street market—broad sweeps of hot color sparked with white, and small shapes suspended like a juggler's balls. Working with what she described as "maximum color intensities," she sought "a kind of color that is not naturalistic."[25]

Propped up on the floor alongside Grace in another, unpublished, Parks shot (plate 9) was her rambunctious abstract painting *Summer Street*.[26] Nearly seven feet tall, the canvas features an abstracted image of Elaine de Kooning riding a bicycle in a colorful outfit and sunglasses, and a pile-up of fruit and vegetables that seems to be simultaneously indoors and outdoors. In November, the painting would be part of the Whitney's 1956 Annual Exhibition of Sculpture, Paintings, Watercolors, Drawings.

Billboard (plate 13) was a thrilling departure for Grace. She hit on the idea of taking popular culture and "making it beautiful" by painting the banal subjects of magazine ads for products like Jell-O and Ipana toothpaste in a bold, simplified style and placing them within kaleidoscopic swaths of colorful brushwork. She explained years later that she was trying to "make sense" of a world that she perceived "in fragments...like being on a fast train and getting glimpses of things in strange scales as you pass by."[27]

A dozen years later, when a jigsaw puzzle company wrote to ask Grace if she would allow them to create a *Billboard* puzzle, she readily agreed. The company, which had lured her with the mention of other notable artists whose works were transformed into puzzles—Picasso, de Kooning, Joan Mitchell, and Jasper "Jones"[28]—likely had no idea that Grace would be charmed by the idea of one of her paintings being pieced together by anyone who could afford the modest price of a puzzle.

Amid her growing fame, Grace still found time to entertain her friends. The guests at one dinner she gave, on the tar-papered roof of her studio, included Frank, fellow painters Robert Goodnough and Mike Goldberg, and Goldberg's then-girlfriend (after his stormy period with Joan and a brief interlude with Grace)—the stunning and enigmatic Paris-born sculptor Maria Sol Escobar. Known as Marisol, she was studying with Hans Hofmann. Another friend of Grace's, recent Vassar College graduate Emily Dennis, who worked in the press office of the Met, remembers that she always served wine and a store-bought dessert at her dinners; her larger parties—like everyone's in her circle—featured ample quantities of Scotch, cigarette smoke, talking, and flirting.

IN THE SPRING of 1957, the Whitney loaned Grace's painting *Grand Street Brides* to The New York School: Second Generation exhibition at the Jewish Museum in New York. This show was the first to boldly state that certain younger painters were part of a "second generation" of Abstract Expressionists—much to the annoyance of artists who felt that this designation made them sound weak and derivative. In addition to Grace, the twenty-three up-and-coming painters included Helen, Joan, Alfred, Elaine de Kooning, Wolf Kahn, Milton Resnick, Jan Müller,[29] George Segal,[‡] and two representatives of a new approach to painting, Jasper Johns and Robert Rauschenberg.[30] In his introduction to the slender catalogue, art critic Leo Steinberg played it both ways. First, he warned viewers that "with few exceptions," the paintings in the show were "uncompromising." Not only were they "so large that they are hard to move…and hard to sell," but they also looked unpolished and contained ambiguous images rather than objects that can be easily recognized. Then Steinberg wheeled around to point out that these elements were nothing new—part of a tradition of artistic rebellion, beginning with the paintings of Cézanne and van Gogh. With nothing left to demolish, the younger artists were "the first generation that is not in revolt." What they offered viewers, Steinberg concluded lamely, is "a creative adventure."[31]

The so-called second generation *were* different in certain ways. By the time they came into their mature styles in the fifties, Surrealism—which held sway over avant-garde American painters of the 1930s and early forties, giving their work a brooding, dreamlike quality—was no longer a major influence. Less interested in the workings of the unconscious, the younger artists were more likely to find inspiration in the everyday and natural world. Unlike the slightly older first generation, the second generation wasn't burdened by the need to reject the weighty influence of European painting. All the painters for whom Pollock "broke the ice" were free to pick and choose the artists and formats that seemed most inspiring at any given moment. For Grace, the paintings of Matisse were always an important touchstone, though she initially took her cue from aspects of Old Master paintings. The younger artists were also helping to extend the reach of Abstract Expressionism. As Grace cheekily declared decades later, "[The first-generation] needed us in many ways more than we needed them."[32] By the mid-fifties, the second generation had infused Abstract Expressionism with a lighter, more airy look, a lyrical rather than a tormented energy.

‡ George Segal was a painter before he started making the life-size cast sculptures for which he is known.

March marked Grace's sixth solo exhibition at Tibor de Nagy Gallery, with nine "city life" paintings and five related collages. *New York Times* critic Stuart Preston praised their color harmonies and the way they reflected her delight in looking, though he had to persuade himself that a vendor's fruit stand was a sufficiently "profound" subject.[33] He also suggested that the paintings were on the verge of becoming overcrowded, a criticism echoed by the *Arts* magazine review, which perversely viewed the "uninflected hedonism" of these scenes as a sign of "unease."[34]

Grace was also among the fifteen artists—including Helen, Joan, Alfred, Elaine de Kooning, and Larry Rivers—who represented the United States at the Fourth Annual Art Exhibition of Japan in Tokyo in May, organized by the Modern's International Program. (Before the Modern's evening event in New York to celebrate the Tokyo show, Helen wrote to Barbara Guest in a grumpy mood. She complained that Grace would be wearing "<u>long</u> black" while her own long dress was "so wintery," and admitted that Grace's invitation to dine with Nelson Rockefeller made her "green with envy."[35]) Another feather in Grace's cap resulted from Frank's request to Barney Rosset, owner of Grove Press (and Joan's former husband), that Grace create the frontispiece for a signed limited edition of Frank's new poetry collection *Meditations in an Emergency*. "I do feel that Grace and I have had a strong mutual influence on each other in our work," he wrote.[36]

These public and private pleasures may have partly made up for Grace's failure to be included in Thomas Hess's lengthy *Art News Annual* article about members of the younger generation of Abstract Expressionists who were likely to be "accepted as internationally important."[37] (Grace knew about this piece months earlier, claiming that she was "interested, but not upset."[38]) Helen, Joan, Elaine, Larry, Robert Goodnough, and Fairfield Porter were among the twenty-one painters—several of whom soon sank into obscurity—who made the cut. Grace also weathered another disappointment: her bid for a Guggenheim fellowship was rejected, despite impressive references from the likes of Dorothy Miller, *Art News* executive editor Hess, and John Baur, now director of the Whitney Museum.[39]

In late June, Grace threw a party in her studio to celebrate Frank's thirtieth birthday. Soon afterward, with typical generosity, he gave her a beautiful gift, the poem "In Memory of My Feelings." The lines "Grace / to be born and live as variously as possible" summed up both her life and his. Although Frank was the junior member of the selection committee for the American entry to the Bienal de São Paulo—work by nine artists, including Grace—he wrote the introduction for the catalogue.[40] As he became increasingly identified with

the movers and shakers of the art world, some of his artist friends felt he was trying too hard not to show favoritism. But his loyalty to Grace was still unshakable.

For the first time in ten years, she no longer had to sleep on her building's fire escape during the oppressively humid Manhattan summer. Grace rented the guesthouse at The Creeks, the sixty-acre wooded estate in East Hampton purchased in early 1952 by artist and patron Alfonso Ossorio, who had inherited a fortune from his family, owners of a sugar refinery in the Philippines. A Harvard fine arts graduate who had served as a medical illustrator in the U.S. Army during the war,[41] he lived with his longtime partner Ted Dragon, a former ballet dancer.

The Creeks was built in 1899 for an artist couple, Albert and Adele Herter, who had the means to add a formal garden, two cottages, and a studio sufficiently vast to hold the murals Albert painted. Designed in a U-shape, the main house offered sunrise views of Georgica Pond, a shimmering coastal lagoon edged by sand dunes. Ossorio filled the interior with books, a grand assortment of globe-spanning objects (ranging from Baroque crucifixes to a Turkish shoeshine stand), and paintings. He had sent Lee Krasner $200 a month as a down payment on unspecified paintings by Pollock that he and Dragon would want "in the future."[42] One of these was *Number 1* (1950), now known as *Lavender Mist*, which hung in the high-ceilinged piano room, illuminated by sunlight flooding through the glass doors. Other paintings in the house were by the French artist Jean Dubuffet, who worked in a spontaneous style incorporating bits of glass, pebbles, dirt, and other materials. Dubuffet had also sent Ossorio more than a thousand pieces of Art Brut ("raw art," known today as "outsider art")—largely the work of mental patients[43]—which hung in six large rooms at The Creeks.

Influenced by Surrealism, depictions of martyred saints, his observation of severely injured patients in the army hospital, and his struggle as a practicing Catholic to reconcile his sexual leanings, Ossorio went through a period in the late forties and early fifties of painting visceral images of tortured figures. His more recent work included canvases with brightly colored allover patterns that telegraph a frenetic nervous intensity and abstract depictions of "a sort of molten volcanic despair."[44] We don't know what effect these paintings had on Grace at the time, but their phantasmagoric aspects likely became part of the mental repertoire of painting possibilities that she drew on in the years to come, especially in the fraught 1970s.

A sunburned Helen wrote to Grace from her New York home in early June to thank her for three days of hospitality that, despite their differing moods, yielded "mutual revelations" and "understandings, rapport, pleasure,

Grace in East Hampton, summer 1957. (Photo: Walter Silver. Courtesy of George Silver. Grace Hartigan Papers, Special Collections Research Center, Syracuse University Libraries)

helpfulness," a warmth and closeness rare in their hectic lives.[45] The women's A-list socializing included drinks with Dorothy Biddle, doyenne of flower arranging, dinner at Alfonso Ossorio's, and a party given by Barney Rosset. Now more mature and sure-footed as artists, the two women were able—for a while—to experience a closeness removed from the bitter sting of competition. In her letter, Helen added that Paul Brach had seen "Giorgio"—Grace's lover George Spaventa, a curly-haired, bear-like sculptor of delicately modeled small figurative works who had been living with her. "You must miss him," Helen wrote, assuring Grace that he would likely be visiting her in East Hampton "by next week."[46] Frank O'Hara also reported a Giorgio sighting in Manhattan before jokingly asking Grace for a full report—including "sighs, wriggles and smiles"—whenever she spotted newlyweds Arthur Miller and Marilyn Monroe, who were summering in the Hamptons.[47]

A native New Yorker four years older than Grace, Spaventa had studied art in Paris, where he met Alberto Giacometti, whose attenuated figures had a marked influence on his own work. Spaventa often kept to himself, more comfortable with gestures than speech, though he was much admired by his fellow artists. A visitor to the loft recalled him as "a sweet, somber presence."[48] Elaine de Kooning called him "a man of eloquent silences." He could also be tersely

eloquent on paper, judging by a statement he wrote about the relationship between sculptors Constantin Brancusi, who died that year, and Auguste Rodin. Noting the modern artist's dual need to reject the work of his predecessors while affirming his connection to his own time, Spaventa wrote, "In his *no* there must certainly be a *yes*."[49] By early July, he had come out to Long Island to join Grace under the sun.

Her sexual competitiveness had asserted itself the previous year, when the dealer Sidney Janis visited Spaventa's studio—a major event in the unrecognized sculptor's life, especially because Giacometti showed with Janis. Although she had invited Mercedes Matter, Grace became annoyed when the painter lingered at the studio. Then in her early forties, Matter, a former student of Hans Hofmann, was a stunning women with a large-featured, alertly intelligent face. She was married to Swiss designer and photographer Herbert Matter, but she had a starry history of artist lovers, including Fernand Léger and Arshile Gorky, as well as a previous relationship with Spaventa. Grace seemed to believe that the older woman had devised "a diabolical scheme" to break up her affair. On the contrary, Matter wrote to Grace, "I have been glad and grateful that Giorgio is as happy as he is and that his work is coming into its own as a result. For this reason, I have the warmest feelings toward you."[50] Decades later, Grace called Spaventa "a great intellect, powerful, wonderful, sensitive…with a terrible series of crippling depressions that would keep him from working too much."[51]

THIS SUMMER, GRACE felt more at ease working from nature. As she told an interviewer, experiencing "the full cycle of the seasons" was a balm for "the tension and anxiety of New York."[52] Her sojourn at The Creeks yielded several of her most beautiful and accomplished paintings—*Montauk Highway*, *Shinnecock Canal*,[53] and *Interior, The Creeks*—inspired by the leafy countryside on the car trip from Manhattan. *Montauk Highway*, a celebration of "nature as imposed on by man,"[54] began as a series of collages of objects she noticed on the drive out to the Hamptons. She made them from cut or torn pieces of rejected work—a practice that was one of Hans Hofmann's favorite ways of improving the compositional abilities of his students. Wanting her painting "to vibrate with life, with inner automobile feelings, the soul of the car, so to speak,"[55] she equipped it with shifting planes that mimic the ever-changing field of vision from the car—"the gray of the highway, the glimpse of billboards and then the greens of the potato fields."[56]

De Kooning also painted a *Montauk Highway* (1958) loosely based on his enjoyment of the same drive, during which he noted the "flawless" shoulders and curves of the road, and the blur of scenery; this was part of his series of parkway

"landscapes."[57] But de Kooning's paintings are totally abstract, while Grace's incorporate glimpses of images from billboards. Describing the scene years later—"you have a highway up close and in the distance billboards to the right and left and a field to the right"—she explained that she also had to add a hit of orange to make the painting work.[58] This was the freedom that Abstract Expressionism gave her, to take bits and pieces of everyday life and subject them to painterly decisions that were purely about creating a rhythmically persuasive picture. With its bravura juggling of planes of color and small eruptions of linear brushwork, *Montauk Highway* is one of Grace's masterpieces. The Whitney Museum honored the painting by showing it in the 1958 Annual. In those years, catalogues for these group shows always included each artist's home address; Grace's entry departed from her usual Essex Street listing to read "Easthampton" [*sic*].

Two years later, when Mark Rothko angrily withdrew from a commission for the Four Seasons Restaurant in the new Seagram Building on Park Avenue, the restaurant purchased *Montauk Highway* for $10,000 to help fill the empty space. Rothko knew that his paintings would hang in the "vulgar" setting of a fancy restaurant for wealthy people—he said that he hoped his paintings would "ruin the appetite of every son of a bitch who ever eats in that room"—but he initially was somewhat mollified by being told, erroneously, that his work would be visible from the employees' dining room.[59] Grace had visited Rothko, praised his paintings, and tried, over a half-bottle of bourbon, to convince him not to pull out of the lucrative project—$30,000, or about $235,000 in today's money—at a time when he desperately needed cash. "When you die, you can't tell where your paintings are going to be," she said. He remained unconvinced.[60] Decades later, one of her students asked Grace if she ever worried about the fate of her paintings. She responded, "Once it leaves my studio, good-by!" The student overheard her telling an older student who had children, "Would you keep your fucking kids in your house the rest of your life?"[61]

THE HAMPTONS HAD BECOME the artists' summer gathering place—"like moving New York to a potato field," Grace said—and she enjoyed the company of Estaban Vicente, Conrad Marca-Relli,[62] and her new friend Mary Abbott Clyde, a pretty and vivacious abstract painter who traced her lineage to John Adams. Marriage to a stockbroker did not stand in the way of her casual liaison with de Kooning.[63] Mary introduced Grace to Robert Keene, a gregarious Southampton bookseller with "a distinctive roar of a laugh"[64] and a Down East accent.

In 1955, when Keene moved from a tiny, cluttered shop at 38 Main Street (where he slept in the attic) to a larger location down the street, Larry Rivers sug-

gested that he also show the work of local artists. Occupying a sixteen-square-foot corner of the shop, Keene's tiny gallery gave the Abstract Expressionist painters of the Hamptons their only local venue before the opening of the Signa Gallery in East Hampton in 1957.[65] He provided Champagne-and-martini-fueled openings, and when he made a sale, the artist would receive his share on the spot. "It was a big deal because he got cash and could take everyone out to dinner and talk about art into the wee hours," Keene reminisced years later.[66]

In the summer of 1957, when local outrage greeted his display of Rivers's four-by-five-foot nude portrait of his teenage son, Keene had removed it from view. He told a reporter from *Newsday*, "Business prevented me from being a martyr for art."[67] The next day, people lined up outside for a chance to view the painting, which could be seen "on request," according to a sign Keene posted on the door. A photo taken that year at an opening shows the humble setup of the gallery, with fluorescent lights shining over bookshelves in the background and paintings hung on partitions.

Keene had come to town in June 1946 as a twenty-seven-year-old Army veteran from Bar Harbor, Maine, to manage E. Schmidt & Co., an antique silver and fine porcelain shop. It opened every summer in Southampton for well-to-do visitors who also patronized the store's winter headquarters in Palm Beach, Florida.[68] The second of ten children of a harbormaster, Keene had hitchhiked around the country for several years after high school before joining the army.[69] It was during this peripatetic period that he mastered his gift for gab and (in Washington, D.C., where he worked nights as a junior messenger at the Library of Congress and afternoons at the Republican National Committee) developed his intense work ethic and began learning about books and politics.[70]

Perhaps motivated by his memories of well-to-do tourists in his hometown, when Keene arrived in Southampton he seemed determined to attach himself to the clubby, brass-buttoned blazer world of blueblood society. Four years later, he opened Southampton's first year-round book store—paying $1,400, saved from his army pay, for a book inventory and $50 a month in rent[71]— while still working at the antiques shop. He managed this by selling books before leaving for work, during the lunch hour, and from 5:00 P.M. to midnight.[72] Keene's garrulous sociability—he was a regular at Herb McCarthy's Bowden Square Restaurant, where the bar featured "the most sophisticated drinkers in town"[73] and Anne's Luncheonette, breakfast hangout for local politicos—led to a stint as secretary of the East End Businessmen's Association. The position paid $30 weekly and allowed him to quit the antiques business.[74]

Early on, he summoned the courage to lambast the mayor of Southampton for allowing the two local museums—the Parrish Art Museum and the

Southampton Colonial Society—to remain closed. (They were soon reopened, and Keene was elected to the Colonial Society's board of directors.[75]) While Keene's star rose in the eyes of year-round residents, his bookstore attracted notable writers summering in town, who dropped in to shop and chat, or to sign their books. Once, when the playwright Edward Albee and novelists Truman Capote, Irwin Shaw, John Steinbeck, and John O'Hara stood chatting outside the store, Keene noted that each man held an identical purchase—a new novel by Gore Vidal—behind his back.[76]

Considered something of a catch, the dark-haired, solidly built Keene was known for his pursuit of attractive local women. He organized a "bachelor's club" that held co-ed boat trips on weekends in good weather. To Grace, his primary attraction—other than his obvious interest in art and books, hyper-masculine persona, and hearty appreciation of talk and liquor—was likely his down-to-earth sociability, so different from Walter's moody personality. Still, it seems odd that she would be seriously interested in a man who bowed to local pressure to remove Rivers's painting, worshiped Old Guard society, and aligned himself with the Republican Party during the presidency of Franklin Delano Roosevelt. Decades later, a *Newsday* story about the town's attempts to open a restaurant on the beach quoted Keene as saying that he was against it because it would attract buses from Harlem.[77] It's not hard to imagine Grace's profanity-laced response. Oddly, she never seems to have recognized his kinship with everything she disliked about her mother.

IN EARLY AUGUST, James Thrall Soby, the patrician collector, author, and museum trustee, wrote to Grace to set up an interview for a *Saturday Review* article.[78] He asked if it would it be helpful if Alfred were there, too. An uptown man, distanced by geography and wealth from the circles that Grace moved in, Soby didn't realize that Grace and Alfred hadn't been a couple for several years. During his visit, Soby took a snapshot of Grace for the article, causing her to confess her dissatisfaction with many photographs of herself. Yet, realizing that people might wonder "what kind of a woman would paint like that," she added that it was important to show what she looked like.[79]

A letter from Helen, summering in Martha's Vineyard, bragged about her dark tan and relaxing holiday. She sympathized with unspecified "things" that Grace was struggling with, probably her love life.[80] Spaventa had been Grace's main man, though he was meeting increased competition from Keene. "George's only compensation for the attention he wasn't receiving from the art world was the hot-and-heavy he was having with Grace 'The Blonde Ace' Hartigan," Larry Rivers later recalled.[81] (Spaventa's first—and only—solo

show, praised by Frank in an *Art News* review, was still seven years in the future.) One summer night after many drinks at the Cedar,[82] the sculptor took up a collection from his artist friends for the hundred-mile taxi ride to Grace's guesthouse. Two hours later, when he knocked on the door, Keene was standing (naked, according to Rivers[83]) in the doorway. When Spaventa drew back his arm to punch Keene, he parried the blow, wrapping a groaning Spaventa's punching arm around his own neck. From the darkness inside, Grace cautioned Keene not to hurt Spaventa, so he was bundled back into the taxi for a humiliating and expensive trip back to Manhattan.[84] The affair petered out, but Grace was one of several artist friends who spoke at his memorial service in 1978; he had died of a heart attack in his studio.

Another potential romantic triangle loomed when Grace invited Frank and his lover Joe LeSueur for the weekend. Frank locked eyes with Grace over dinner, making LeSueur feel like a fifth wheel.[85] Afterward, Frank lingered at Grace's bedroom door and said he wanted to sleep with her. "And ruin this? No way?" she said.[86] LeSueur said that Frank didn't seem to be upset about Grace's response, though he insisted that LeSueur not mention the episode to anyone. Grace and Frank were physically affectionate in other ways. In a story he wrote that takes place in Southampton, a Grace-like woman named June "stroked my arm with her toes in the affectionate, sexy way an intimate friend will rumple your hair without meaning it."[87]

LeSueur, who was not a member of Grace's fan club, also witnessed her callous side. Once, when he and Frank and Grace left a party, she became annoyed at a drunk painter who was following them down the street. She turned and hit the man on the head, propelling him into the gutter. While Frank helped the man stand up, Grace kept walking. Why, LeSueur asked, would she do a thing like that? "I can't stand a man who doesn't act like a man," she replied. Frank loyally stood up for her when the two men were alone, claiming that "the guy was asking for it."[88]

August brought the tragic news that Jackson Pollock, drunk and speeding in East Hampton, had crashed into two trees and died. The accident also killed one of the two women riding with him. Jackson's wife, Lee, who was in Paris, immediately returned home. During the days that followed, artists gathered at the Cedar to drink to Jackson's memory and relate stories about his troubled life. His death marked a watershed in the lives of the downtown artists, at a moment when the best-known Abstract Expressionists were finally receiving wider attention and significant prices for their work.

A FALL CAR TRIP to the picturesque coastal village of Castine in Maine inspired *New England, October* (plate 10)—a sensual tribute to her feelings

about that landscape, with a broad swath of orange paint energized by a brushy central area in blue, white, yellow, red, and magenta. "I was interested in how to present an inner emotional state, in abstraction but related to nature," she wrote later. "I was especially moved by Castine, the yellows of the trees in the rain, the glimpses of white colonial doorways....At that time I used thrusting planes against more organic forms. Also apparent is that not one of these forms had any reference to the look of the visual world."[89]

Ever self-critical, Grace would disparage these paintings years later. "I get so lyrical that I am just limp," she told an interviewer. "I lose the edge. I like that tension. I need something a little harsh, a little grating to react against, to make beauty about. If all is beauty around you, all you can do is just sing songs to it. But if you have harshness—all cities have harshness—you have this counter-effect. It is a kind of power that sets me on edge to see if I can counterbalance it."[90]

Of course, Grace had every right to prefer her paintings based on edgier motifs. But even nature has its dark side—decay, manmade devastation—and it is hard to understand why she didn't see that her quasi-landscape paintings were every bit as accomplished as the city-based works. Tellingly, in an interview a decade later, she said that (apart from her current work), the paintings she made in 1956–57 were her favorites because she was "beginning to feel [her] own powers, [her] own voice."[91] It is puzzling that Grace's lush nature-based abstractions *New England, October* or *Shinnecock Canal* were not included in Nature in Abstraction, a major exhibition of painting and sculpture by more than fifty artists—including de Kooning, Pollock, Frankenthaler, Mitchell, Kline, and Gottlieb—that traveled from the Whitney to other museums in 1958. Organized by John Baur, who had written so favorably about Grace in 1954, the show was intended to make a case for the relationship between nature and abstract art. Perhaps, given her negative views, Grace had turned down the chance to be labeled with the dread word "nature."

In 1957, Grace sold everything she painted. Collectors were eager for her work, and it took her at least a month to finish a painting. (She habitually worked on just one canvas at a time.) Still, her prices remained low. "More Art Than Money," a photo feature in the December issue of *Vogue*, included one of Grace's collages, available for "$350 with frame."[§] Grace later compared supporting herself with her art to someone making a living as a clerk. Yet she

§ About $2,800 in 2012 dollars. Photographer and graphic designer Herbert Matter—husband of painter Mercedes Matter and a close friend of several leading artists—was credited for the photo and likely helped Grace receive this exposure.

A back table at the Five Spot, 1957. From left: David Smith, Helen Frankenthaler (back to camera), Frank O'Hara, Larry Rivers, Grace Hartigan, Sidney Rolfe, Anita Huffington, Kenneth Koch. (Photo: Burt Glinn, Magnum Photos)

was finally able to devote her full attention to the one thing in the world she really cared about; her long string of hated temporary jobs was over. She painted all day and socialized at night, often having people over for drinks or walking to the Cedar to see who was there.

The new gathering place was the Five Spot Café, a jazz club that had opened the previous fall at the corner of Cooper Square and St. Mark's Place, at the edge of skid row.** Beginning with Cecil Taylor, the Five Spot presented the wizards of bebop, including the Thelonius Monk quartet with John Coltrane on tenor sax, and two years later, the New York debut of the Ornette Coleman Quartet. The music was loud enough to be heard in painter Herman

** The original Five Spot was a neighborhood bar under the Third Avenue El that had begun to book jazz groups, at the urging of several artists. When the El was razed in 1955, the bar was demolished as part of a gentrification effort. The owners subsequently renovated a former corner cafeteria and tobacco shop, and acquired a cabaret license.

Cherry's studio, across the street, where sculptor David Smith was hanging out one night. They both liked what they heard, so they dropped in for drinks and spread the word; 75-cent pitchers of beer and a bar open until 4 A.M. were part of the lure.

A photograph taken this year[92] shows Grace, Frank, and Larry Rivers sitting at a small corner table in the back under a bulletin board. Grace is holding forth, one finger of the hand holding her beer glass jabbing the air to make a point. Noted economist Sidney Rolfe, sitting next to Grace, leans forward to talk to Helen, who has pulled up a chair, and David Smith. At the next table, poet Kenneth Koch[††] shares a table with twenty-two-year-old Anita Huffington, moodily smoking a cigarette. She had come to New York to study modern dance with Martha Graham and Merce Cunningham, and was paying $22.48 a month for a sixth-floor cold-water walk-up while working as a photographers' model. (Later, she would become a sculptor.)

"There was a lot of excitement in the air," Grace recalled a few years later. "There were many enthusiastic young friends, poets, musicians, composers, dancers, as well as my fellow painters. It was a very good time."[93]

[††] When a slightly different version of this photograph (with Rolfe turned toward Grace, and Smith engaging with him instead of with Helen) ran in the July 1957 issue of *Esquire*, accompanying the article "New York's Spreading Upper Bohemia," Koch was misidentified as "Bill Hunter, a neurosurgeon." Could this have been a private joke?

12

Swerving (1958–1960)

A FIRE BROKE OUT on April 15, 1958, on the second floor of the Museum of Modern Art, where workmen were installing a new air-conditioning system. Margaret Scolari Barr, Alfred's wife, rushed over—impeded by her tight suit skirt and crowded sidewalks—from her job as a translation editor at McGraw-Hill, nine blocks away. "There were women with beautiful hats on up in the [museum members' sixth-floor] penthouse screaming and yelling and looking down," Scolari Barr recalled. "The firemen were beginning to slash the windows."[1] Staff members, Frank O'Hara among them, battled the smoke filling the building to form a bucket line to rescue as many paintings as they could. Some works, including Larry Rivers's *George Washington Crossing the Delaware* and Pollock's *Number 1, 1949*, suffered burns or smoke damage, and the museum had to close for repairs until early October.

But the Modern was making waves in Europe, where it had sent a ground-breaking exhibition to eight European cities beginning that month. Continuing her string of successes, Grace was the youngest artist, only woman, and only member of Frank's inner circle chosen for this showcase of Abstract Expressionism. The New American Painting offered huge, boldly executed works by a roll call of top artists: Willem de Kooning, Jackson Pollock, Franz Kline, Adolf Gottlieb, Philip Guston, Mark Rothko, Robert Motherwell, William Baziotes, James Brooks, Sam Francis, Barnett Newman, Theodore Stamos, Clyfford Still, Bradley Walker Tomlin, Jack Tworkov, Arshile Gorky... and Grace.

For her artist's statement, Grace reused the provocative remarks she wrote for the Modern's Twelve Americans exhibition two years earlier. "I want an art that is not abstract and not realistic—I cannot describe the look of this art but I think I will know it when I see it," she wrote. Her paintings are about "that which is vulgar and vital in American modern life and the possibilities of its transcendence into the beautiful."[2] Three of her most prestigious private collectors, Nelson A. Rockefeller, his sister-in-law Blanchette Rockefeller, and the architect Philip Johnson, loaned three of her most vibrant paintings,

Essex Market, City Life, and *Interior, The Creeks*. While the first two incorporate recognizable snippets of city life—an awning, fruit, shoppers—*Interior* is almost purely abstract, with its great swath of intense red punctuated by a flurry of irregular, black-bordered shapes that seem to drift across the canvas in slow motion. Also on view were the museum's *River Bathers* and *On Orchard Street*, from the collection of B&M Railroad president Patrick B. McGinnis and his wife.

A critic in Barcelona wrote that a single detail would illustrate how big the American paintings were: the upper portion of the metal door of the Museo Nacional de Arts Contemporáneo had to be sawed off to accommodate the canvases by Grace and Pollock. In *Le Monde*, the highbrow French newspaper, French art historian André Chastel remarked that Grace's "brilliant and clashing patches of color" reminded him of the Fauves, the French painters of the early twentieth century whose simplified, boldly colored works did not attempt to reproduce the actual colors of objects.[3] For a Frenchman to compare an American painting to a celebrated French art movement was no small thing.

A decade later, the exhibition became a focus of controversy among art historians who accused it of being a form of cultural imperialism—a charge Grace scoffed at because of the longstanding enmity between artists and right-wing American politicians. Museum director René d'Harnoncourt's foreword for the catalogue of the exhibition states that it was organized "at the request of European institutions for a show devoted specifically to Abstract Expressionism in America." Sponsored by the museum's International Council (a new group made up of wealthy art patrons), the exhibition was circulated by the museum's International Program, which also sent works of art—including Grace's—to American embassies abroad. Cold War strategist George F. Kennan said in a speech at the museum in 1955 that sending distinguished art abroad was one way to correct the impression that "we are a nation of vulgar, materialistic *nouveaux riches*…interested only in making money." He rejected the notion that "irrelevant personal attributes," such as artists' political affiliations, should have anything to do with whether their art was included in the exhibitions.[4]

In the absence of willing major donors, the Central Intelligence Agency (CIA) secretly made it possible for avant-garde art to be seen outside the United States. When the Tate Gallery in London was unable to afford to show *The New American Painting*, an American millionaire (Jules Fleischmann) was said to have come to the exhibition's rescue. In fact, the funds were channeled via a dummy organization, the Fairfield Foundation; Fleischmann was its president.

The CIA's covert funding of cultural endeavors, including the literary magazine *Encounter*, created an uproar when articles documenting this support were published in 1967.[5] As far as the Modern's exhibitions were concerned, the fact that this dubious backing was happening in secret struck many as outrageous. Yet hardly anyone seems to have condemned the *results* of the CIA's involvement—European exposure to significant American contemporary art. (Ironically, one reason for the CIA connection was the fact that Congressman Dondero[6] and his ilk would not have stomached official U.S. endorsement of Abstract Expressionism.)

SINCE JANUARY, GRACE had been receiving a flurry of media attention, beginning with her Merit Award in art from *Mademoiselle* magazine, which noted that Grace was the only woman of the five American painters invited to participate in the prestigious Bienal de São Paulo.[7] Wearing a man's work shirt over a striped button-down shirt in her magazine photo, an unsmiling Grace looked a lot less demure than most of her fellow award-winners. They included a radiant Carol Lawrence, who had recently debuted on Broadway as Maria in *West Side Story*; Toshiko Akiyoshi, at the start of her long career as a jazz pianist; and African-American tennis champion Althea Gibson. Grace showed the magazine's guest editor a new painting that she said was inspired "by a cardinal in an apple blossom tree," evoking the colorist's sensibility that underpinned all her best work.

Helen Frankenthaler married fellow painter Robert Motherwell that spring, and Grace organized a shower for her. A note on her calendar page for April 4 listed the guests, who included Elaine de Kooning, May Tabak, Musa Guston (Philip's wife), and author Sonya Rudikoff Gutman, Helen's former Bennington friend and New York roommate.[8]

In May, Grace was the subject of a flattering article in *Newsweek* ("the most American of painters") that provided a capsule history of her life ("I worked just enough at moron jobs to make the $12 a week I needed").[9] In the accompanying photo, by the celebrated British fashion photographer Cecil Beaton, Grace stares out pensively under a chic, wavy coif that surely involved a trip to the hairdresser. *Time* magazine devoted an entire page in its June 16 issue to a reproduction of her 1957 painting *Broadway Restaurant* (plate 12), then on view in Brussels in the Modern's traveling show. "After a year's work on themes of Manhattan's Lower East Side," the caption noted, "New York-loving Hartigan, 'struck by the light and the piles of catchup bottles' of a brassy Broadway tavern, splashed its vibrant frenzy with condiment-toned colors."[10] (This may sound like an early sighting of Pop Art, but Grace was using the colors of catsup and mustard to spice up a painting that merges glimpses of restaurant

decor and tabletop clutter with a rhythmic abstraction.) Two months later, Grace was mentioned ("a melancholic mood piece by Grace Hartigan") in a *Time* magazine art review of a show at the Signa Gallery in East Hampton. Her work hung alongside paintings by Pollock, Willem de Kooning, Elaine de Kooning, Richard Pousette-Dart, and Jean Dubuffet.[11]

That summer, *Art News*, then the leading contemporary-art publication, published Grace's opinion on the burning question, "Is today's artist with or against the past?"[12] Her extended reply was printed alongside responses by de Kooning, Ad Reinhardt, Robert Rauschenberg, and ten other artists—all men. She said that she had initially felt impelled to figure out what her past was by making paintings influenced by Velázquez and Goya, Picasso and Matisse. When they were of no further use to her, she turned to Pollock and de Kooning. Now, she said, she is trying to forget not only other artists' paintings but also her own work from earlier years. Searching for "intimate and personal" subjects, she might be influenced by a green sign on the street or "the sunlight on those oranges under the awning." The article reproduced her 1957 painting *On Orchard Street* along with a playful photo of Grace in a cozy corner of her studio, taken by her former lover Walter Silver.

Grace's paintings were now selling for as much as $3,000, the equivalent of about $24,000 today. (To put this in perspective, Pollock's magisterial *Number 11, 1952* [*Blue Poles*]—later acquired by the National Gallery of Australia for more than $2 million—sold for just $6,000 in 1954.) No longer flummoxed by speaking in public, she delivered poised, assured remarks to fellow artists, as well as to the media. At a Club panel, "What We Don't Have to Do Anymore," she made the case for younger Abstract Expressionists, who were sometimes disparaged as simply riding the coattails of the older generation. ("If a condition exists that makes their painting still vital, it exists for us as well," she asserted.[13])

But the strain of being in the public eye was already beginning to wear her down. After the *Newsweek* photo session, she wrote a note to herself: "I must close my doors so I can be alone again. I must have time to think and paint without constant interruption."[14] She would later say that she felt "that I was being devoured....I felt that everyone wanted to eat me up and it had nothing to do with my work. My life as a person was very involved with love and friendship and not involved with thousands of devouring strangers. It was a very confusing time."[15]

GRACE'S LOVER BOB KEENE accompanied her on her first trip to Europe, in September and October 1958, which she later claimed was "just for fun,"[16] even though it coincided with the traveling exhibition of her work. In August,

Frank O'Hara had sent her a letter from Rome, where he was traveling for the Modern, suggesting that he could put her in touch with a museum director in Madrid and sighing over a Spanish translator with whom he had fallen in love. Grace traveled with pages from a spiral pocket notebook filled with suggestions of sights to see and people to meet, written in fountain pen—probably by John Myers, bursting to relate what he learned on his first trip abroad two years earlier.[17] (Most of the people are described as "sweet" or "terribly sweet," in Myers's effusive style.) The writer noted that Harry's Bar ("best food in Venice") was the place to go for a quiet lunch between 1:30 and 3:30, and for drinks "around 7:00," and that Peggy Guggenheim—the prickly heiress who ran an avant-garde art gallery in New York before decamping for Venice— wanted to buy one of Grace's paintings. (She did eventually acquire *Ireland* [plate 15], one of the works inspired by Grace's European travels, which May Tabak viewed with pleasure in Guggenheim's palazzo on the Grand Canal several years later.[18])

Another little notebook[19] outlined Grace's itinerary, beginning with Madrid (where she made a note to see the "black Goyas" at the Prado, Room 56) and proceeding to Valencia, Barcelona, Rome, Florence, Perugia, Ravenna, Venice, Innsbruck, Basel, Geneva, Paris, and Dublin. Grace proudly jotted down the menu for her first dinner in Paris: fish soup, escargots, and gratin de crevettes (shrimp with a cheese sauce), washed down with Muscadet, a white wine. An engraved card marks her appointment at a Christian Dior fashion showing,

Grace's 1958 passport photograph. (Grace Hartigan Papers, Special Collections Research Center, Syracuse University Libraries)

but Grace visited less expensive shops for her purchases—skirts, sweaters, shoes, hats, gloves, jewelry, and perfume (Arpège, Ma Griffe, and Réplique), all carefully noted with the corresponding prices in dollars. To soothe a minor injury, a Parisian doctor wrote a prescription for ointment to be massaged on "la region douloureuse" (the painful area) three times a day.

In Paris, Joan Mitchell had found Grace and Keene a room in a hotel on the Quai Voltaire—a prime Left Bank location—for 2,200 francs a day (about $5) and told her that their mutual friend Barbara Guest was also in town. Joan advised Grace that it would be okay to sign the hotel register as Mr. and Mrs. "since they only seem to look at one passport."[20] (In the fifties, unmarried couples worried about not being allowed to share a room, even in France.) When Keene was laid up with a stomach ailment, Grace dined with Frank, who was busy making arrangements for the exhibition's arrival in January. He was now working for Porter McCray, the fifty-year-old head of the Modern's International Program for Painting and Sculpture Exhibitions, who later said he was baffled at the "cult" that had grown around Frank; to McCray, Frank was simply an intelligent man with taste and an annoying habit of coming in late to the office.[21] As Grace and Frank walked past the Gothic splendor of Notre Dame Cathedral, she reflected that he seemed less than his usual ebullient self, which she supposed was due to the heavy weight of his museum responsibilities.[22]

Later that week, Grace, Frank, Joan, and Barbara got together for lunch, happy to be recreating their Cedar Tavern life, however briefly. Barbara suggested they visit the Bateau-Lavoir, the famous dilapidated building in the Montmartre district that once housed Picasso and other leading artists and writers of the early twentieth-century in Paris. But Frank, who always preferred to look forward, not backward, refused to go in. "'That's their history, Barbara,' Frank said, bristling as only Frank could. 'We're making our own.' "[23] In a poem he wrote soon afterward, "With Barbara Guest in Paris"—notably, neither the title nor the poem itself mentioned Grace—he moodily wondered whether the two of them would ever leave a similar legacy.[24] (Yet when he sent Barbara this poem, he wrote that he enjoyed the Montmartre evening "and the bateau lavoir being the color of Ricard [the green anise-based liqueur] was perfect!"[25]) Frank's attentions had begun to shift from Grace to an attractive young woman, Patsy Southgate, who had married Michael Goldberg, an abstract painter (formerly Joan Mitchell's lover) whom Frank fancied. Frank and his lover Joe LeSueur lived on the ground floor of the Goldberg-Southgate carriage house for a while during this period. A visit to the Lascaux caves in southwestern France—site of the famous Paleolithic paintings of

lifelike animals, soon to be closed to the public—was a high point of the trip. Years later, in the grip of a personal crisis, Grace would memorialize the cave's images of stags in a painting, *I Remember Lascaux*.

Grace also made an unexpected detour to Dublin and its environs, the source for at least two paintings inspired by the trip. *Ireland* (plate 15). evokes the damp, sooty shabbiness of her family's ancestral city in abstract terms, with a rich blue swath of paint standing in for the Liffey River. (In a review, the poet James Schuyler compared the "urban" colors of this painting to weathered posters, bricks, and cheap garments "drying and fading" on clothes-lines.[26]) An orange tower-like shape might be connected to Grace's visit to the fortress tower in Sandycove, where Stephen Dedalus holds forth as a mock priest in the opening pages of James Joyce's *Ulysses*. (Grace later jokingly claimed that she kept up a Joycean stream-of-conscious murmur while work-ing on the canvas: "Dublin Dublin oh James Joyce ah the Guinness Brewery…"[27]) The nearby harbor town of Dún Laoghaire must have struck her as another visually inspiring location; she titled a painting after it.[28]

Back in New York, Grace gave a brief interview to the college student serv-ing as guest editor-in-chief for *Mademoiselle*'s August issue. Asked about con-temporary art in Europe, she said, "Americans are doing the most exciting things in painting today."[29] Grace herself was part of the excitement. She had begun working on *Essex and Hester (Red)* (plate 16), named after the inter-secting streets where her studio was located. Calligraphic black brushstrokes and wittily interlocking shapes in high-keyed and muted colors drift across the subtly modulated red expanse of the nearly seven-foot-long canvas. One of Grace's most accomplished works, it was shown in the prestigious Annual Exhibition of the Whitney Museum, which had included a painting by Grace every year since 1954.[30] (With the exception of the 1959 show, she would con-tinue to have a presence in the Annual until 1964.)

Other paintings from this year include *Kansas*, dedicated to the play-wright William Inge, a collector of de Kooning paintings.[31] In the film ver-sion of Inge's play *Picnic,* Cliff Robertson played Alan Benson, the wealthy fraternity buddy of the central character, a drifter who had been a college football star. Grace and Robertson—who had a brief sexual encounter[32] after meeting at an airport[33]—may have met through the playwright. Both of their lives were in flux; Robertson's 1957 marriage to television actress Cynthia Stone would end in 1959. In this intimate brush with the fleeting illusions of the movie world that so intrigued Frank—most famously in "Poem (Lana Turner Has Collapsed!)"—it was if Grace were able to borrow a screen god for temporary use in real life.

That fall, Grace, Helen, and Fairfield Porter were on a panel about modern art in the Long Island suburb of Great Neck, part of the public school system's adult education program. Fairfield wrote rather confusingly to Barbara that he and Grace "came prepared to be antagonistic to each other: we each hoped to astonish the other." (It sounds like he thought they both expected a demonstration of one-upmanship, at least on Grace's part; Fairfield famously disliked any form of confrontation, which was probably the reason he labeled this behavior "antagonistic.") When Grace asked where she could get a drink of water, and Fairfield told her where the drinking fountain was, "she looked at me as if she could never trust me again."[34]

IN 1959, GRACE began looking inward again in her work. She told a newspaper interviewer that in a painting like *Sweden*—with its vaguely landscape-like, vaguely phallic forms and a mysterious cloudy whiteness lightly sketched with the outlines of ambiguous shapes—she was expressing her state of mind. "The shapes I use have no reference to anything material or objective," she said. "This way I get a more direct, emotional expression than I would if I were involved with external objects."[35] The following year, she would tell *Time* magazine— which featured her, Helen Frankenthaler, and Joan Mitchell in an article titled "The Vocal Girls"—that she was "trying to find her own internal world rather than the world that is across the street or down the stairs."[36] (Serendipitously, a reader's letter in the next issue noted the similarities between Grace's semi-reclining pose and striped dress in the accompanying photo by Cecil Beaton and the Matisse painting *The Purple Robe*.[37] As we've seen, Matisse was a key influence in her use of color; Beaton doubtless intended the allusion.)

Reviewing Grace's one-person exhibition at Tibor de Nagy Gallery that spring, poet James Schuyler singled out *Sweden* as the strongest painting in a show he praised highly for going beyond "simple boldness" to "a deceptive spareness, charged with implication."[38] Grace's other notices for the show included a convoluted review by painter and critic Sidney Tillim in *Arts Magazine* that acknowledged her talent but took her to task for not being totally original (surely an impossible goal) and leaning too much on her coloristic gift. In the same issue, he bashed Helen Frankenthaler for "reflecting the influence of her husband, Robert Motherwell."[39] More encouragingly, the reviewer for the artistically conservative collectors' magazine *Apollo* raved that Grace's street scene compositions "exude vitality" in a "real and convincing" way. He pronounced her "one of the more important artists of the advanced tendency."[40] Even Frank's lover Joe LeSueur, who had been suffering creative doldrums, was in thrall to the new work; seeing her paintings, he wrote, suddenly lifted his depressed state of mind.[41]

During the past few years, a growing number of New York artists were attracted to the peacefulness of rural life by the sea in the Hamptons. Willem and Elaine de Kooning were there, and so were painters Adolf Gottlieb, James Brooks, Jane Wilson, Larry Rivers, sculptor Ibram Lassaw, and his wife Ernestine. With the idea of spending summers and weekends in this environment, Grace purchased a rambling three-story Greek Revival house known as Ludlow Grange in Bridgehampton. Built in 1820 as a humble saltbox, the property at 2782 Montauk Highway had been turned into an estate by the original owner's son, a whaling ship commander. Lantern-topped brick posts held a scrolling metal gate that barred the driveway leading to the porte-cochere. Other features included a generous wraparound porch and a windowed turret—which might have clinched the deal. (Grace would fall for another turret-topped building a few years later in Baltimore.) Another selling point was the barn overlooking potato fields, which she began turning into a studio.

Frank soon wrote to ask which weekend he and Joe LeSueur could come out to her "potting shed."[42] Roland Pease, one of Grace's collectors, dispatched a truck filled with antique furniture. While he sent most of the pieces in exchange for an unspecified work by Grace, a mahogany colonial desk was his housewarming gift to "a wonderful girl, aside from all your exciting talent."

Grace in her studio garage at Ludlow Grange. (Photo: Walter Silver. Courtesy of George Silver. Grace Hartigan Papers, Special Collections Research Center, Syracuse University Libraries)

Whenever he looked at the study for *River Bathers* that she had given him, he wrote, "the original comes swimming into view."[43]

That summer, while Grace enjoyed the career boost of having work included in the international art exhibition Documenta II, in Kassel, West Germany,[44] she worked on a record number of paintings—seventeen.[45] Leonard Bocour, owner of an artists' paint company, had sent Grace new colors developed by DuPont, and she was delighted with them: "The colors just sing. When tinted down with white, they get very brilliant."[46] Bocour was naturally pleased and promised to develop a "Hartigan Violet"—evidently at Grace's suggestion—once he had located a pigment "worthy of the name."[47]

Despite—or possibly because of—her efforts to shift the focus of her work, Grace was growing closer to Keene as he ingratiated himself in the artists' colony. A visitor recalled that with Bob, Grace "had found a new kind of domesticity that suited her," serving cold lobster and corn on the cob followed by a platter of good cheeses.[48] But he remains invisible in surviving photos taken at a big Fourth of July party the couple hosted, which show Grace and friends waving flags from the porch of Ludlow Grange. (The cast of characters includes Jane Freilicher, Alfred, Philip Guston, artist Athos Zacharias, and James Thrall Soby.) It's possible that Keene took all the snapshots, but more likely that Grace didn't save any photos in which he appeared.

Keene was doing well as a dealer. At a Ludlow Grange party, he sold de Kooning's *Pink Lady* (ca. 1944) to art dealer Martha Jackson—who would later become Grace's New York dealer—for the then-princely sum of $1,800 (about $14,000 in today's dollars). The painting was leaning against a sideboard in the kitchen, he remembered years later, and Jackson—who had been a dealer far longer than Keene—asked him if he thought that was a fair price. She may have expected him to back down, but he didn't, and she bought it.[49]

One of the fruits of Grace's summer painting frenzy was *The Fourth*, a glorious, explosive riff on the American flag—a visual equivalent of the version of "The Star Spangled Banner" Jimi Hendrix would play eleven years later.[50] This emotional work—utterly different from Jasper Johns's coolly investigative flag paintings of the mid-fifties, first publicly shown in January 1958 at the Castelli Gallery—was displayed at the American Embassy in Brussels the following year. Yet despite her productivity, Grace soon concluded that being immersed in nature was draining the tension from her paintings. Just two years earlier, she had told Soby that "the openness here helps me to open my paintings: the stretch and reach of the potato fields are inspiring."[51] But now she once again concluded that her work fell apart when displaced from the urban grittiness of the Lower East Side.

GRACE, JANE, HELEN, Larry, Franz, and Willem de Kooning were among the contributors to *A New Folder: Americans: Poems and Drawings*, edited by Daisy Aldan, a publication heralded by a midnight presentation at the Living Theater in June. The event included projected images of the drawings and readings by the poets, including Barbara Guest and Frank. His contribution was "Ode to Willem de Kooning." The poem ends with an evocation of New York at dawn, concluding with the painter's remark about the slashes of red in his *Woman* paintings—"maybe they're wounds, but maybe they are rubies"— which Frank expands with a final, complex image: "each painful as a sun." Although a de Kooning drawing was published alongside Frank's poem, most of the art in the book is unrelated to the poetry. A forcefully compressed still life drawing by Grace accompanies "But What of the Tiger?" a quizzical love poem by Joy Gould.[52]

Grace was at the center of quarrels that flared up this summer, including a mysterious dustup involving Grace, May Tabak, and Frank. Tabak—who would type long, obsessive letters about things that bothered her—anguished about the misunderstanding to Frank, causing him to respond with a two-page letter. In a postcard to Grace, he wondered if May "will ever forgive me." He was glad that Grace had at least warned him about the issue, "or I would have fainted as I read."[53] On August 20, Frank slipped a note of apology about another contretemps into Grace's mailbox. "What a funny evening! I'm sorry for my share of it going wrong," he concluded. "Love always, Frank."[54] Grace told a friend years later that Frank had stood on a table at the Cedar and screamed about her being "bourgeois."[55] (A colleague of Frank's noted that "[h]is tongue could be sharp and, after a few drinks, more than that. He loved a fight, he loved drama."[56]) Three days earlier, he had written to Barbara Guest that a new painting of Grace's at her studio "really looked marvelous." She seemed to be "in a splendid mood" at a party Barbara gave and also the day afterward, "so I guess we were both being over-apprehensive about her depression."[57]

With his note to Grace, he enclosed a poem written the previous day ("L'Amour Avait Passé Par Là"), which, he wrote, "turned out to be prophetic and I did have trouble meeting you in the Cedar." Frank was then enmeshed in an agonizing affair with a dancer, Vincent Warren—whom Grace disliked because he kept Frank at arm's length—and coping with a heavy workload and infighting at the Modern, where he had recently been promoted to assistant curator. In the poem, he leaves the museum, where he is feeling romantically bereft, "to get to the Cedar to meet Grace," who will brighten his mood in a spirit of "unrelaxed honesty."[58]

Meanwhile, Grace was embroiled in a dispute with Tibor de Nagy. Because her paintings were selling so well—grossing $26,320 so far this year (the

equivalent of more than $200,000 in 2012)—she wanted the gallery to defray all her business expenses. These costs included catalogue production, photography, and shipping, and half the price of frames for her painting. (She was not the only gallery artist annoyed about the need to provide frames. A few years later, de Nagy told Fairfield Porter, who nailed together thin lengths of wood to frame his paintings, that more impressive frames might help his sales. Porter's response was that if he had to buy a frame, the gallery should add its cost to the sale price of the painting.[59]) Grace told de Nagy that she still wanted to recoup two-thirds of her sales, which was the gallery's usual net commission in the fifties; Porter had the same arrangement.[60] During the summer, when the gallery was closed, Grace wanted unnamed "other agents" to be allowed to sell her work on a split commission with the gallery. (Bob sold two of her new paintings and two older ones that summer, netting Grace $2,272.68 after the de Nagy gallery's cut.) She also stipulated that her prices must remain firm, except for a 10 percent discount to collectors buying more than one piece at a time and the traditional 10 percent discount for museums.[61]

De Nagy replied that he had asked six other galleries for their policies before responding to her letter. Based on this information, he rejected some of her demands, reiterating that the gallery "always tried every possible way to help our artists," but had experienced a sharp rise in overhead causing him to scrutinize even minor expenses.[62] (He had also experienced an exodus of some of his key artists, including Helen, to the André Emmerich Gallery.) After a visit to Ludlow Grange, de Nagy thanked her in his gracious way for sustaining the illusion that Grace and Bob had employed a cook and servants to achieve such fine hospitality when Grace was so busy painting. De Nagy wrote that he loved her new work ("endless gorgeous experiences") but found her complaints depressing. He enclosed a housewarming gift with the letter: a French-made tool for cutting the top off a soft-boiled egg. Grace was to think of him when using it: "each time you decapitate an egg all the aggression should go in the egg [a]nd we only will get your kisses!"[63]

In September, Grace and de Nagy appeared to have reached a truce, which the dealer jokingly called "The Treaty of Ludlow Grange." Yet their disagreements would only escalate, causing her to leave the gallery in 1960. She later blamed Myers for her defection, saying that he was "a terrible mischief maker" who liked to break up his women artists' relationships, and that she feared what he could do to hers.[64]

In early October, Barbara Guest wrote from Washington, D.C., to say how much she missed Grace. By return mail, Grace announced her big news: she and Keene were now engaged. In a light-hearted mood, she also listed her eclectic current reading list. In addition to novels by Virginia Woolf and William

Faulkner, and *Modern Screen* magazine ("with tragic facts about Liz and Debbie's fatherless children"*), she was gleaning tips from *Vogue's New Beauty Book* and the *Esquire Cook Book*—signs of both an awakened sense of herself as a Desirable Woman and her interest in feeding her new man.[65]

"I want to see that ring!" Barbara replied two days later. "How could you guess that the one thing Ludlow Grange needed was a weddin'?"[66] She envisioned a pleasant life for the couple in Bridgehampton.[67] (The previous fall—when Grace was visiting London, where Barbara and her husband were then living—she told Grace that she was "busy all the time making the scene romantic," and Grace responded drily, "If anyone can, you can."[68])

Slender and blonde, Barbara was two years older than Grace and had been married three times herself—in her twenties, to sculptor and painter John Dudley; a few years later, to English writer and translator Stephen Haden Guest; and finally, in 1954—the year she was divorced from Guest—to military historian Trumbull Higgins. Frank O'Hara had written a poem about her, "With Barbara at Larrés"—Larré's was a French restaurant near the Modern—in which he related a fragment of her conversation about dining there with her English husband and evoked the broken rhythm of the two poets drinking martinis at the bar at lunchtime, "listening / for each other's silence."[69]

Decades later, Grace would claim that Barbara condescended to her because of her lower-class Irish origins.[70] But despite Barbara's genteel manner and cultured voice, she came from a modest background—her father was a probation officer—and her early life was unsettled. After a peripatetic early childhood in West Virginia and Florida, she was sent to live with relatives in Los Angeles. Her young adult years were equally restless; she enrolled at UCLA (where she earned money as a typist for the novelist Henry Miller), spent a year at a junior college that she felt was better equipped to teach modern poetry, returned to UCLA, and graduated from the University of California, Berkeley. Moving back to Los Angeles in 1943—after Grace had returned to New Jersey—Barbara was employed as a social worker dealing with the problems of airmen who had returned from bombing missions during World War II. In the mid-forties, both women moved to New York with a man—Barbara's first husband; Grace's art teacher—and (though still unknown to each other) simultaneously discovered the delights of Greenwich Village.

* Debbie Reynolds was married to singer Eddie Fisher; they were divorced after Fisher became involved with Elizabeth Taylor, whose husband, producer Mike Todd, had died in the crash of his private plane in 1958.

What Grace was reacting to was probably Barbara's aloofness, in person as well as on the page. As one acquaintance explained, "she viewed the world from the high vantage point of imagination,"[71] giving her a dreamy, not-quite-there quality. Yet Barbara was able to laugh at herself—it was a charming, girlish laugh—and as her letters show, she was just as immersed in everyday minutia as any woman of her time. In some ways, the two women, both eldest children, were actually quite similar. If Barbara had a "majestic" demeanor (another literary-world friend thought of her as "the Countess of Berkeley"[72]), Grace herself, for all her earthiness, became quite the diva as she aged. Although sometimes annoyed at Grace's self-absorption, Barbara was genuinely fond of her painter friend.

She dedicated her poem "Heroic Stages" to Grace after a visit to her studio in May 1958, portraying an artist to whom "In the sunlight each morning / is delivered to your table / among the oranges and wine bottles / the Quest."[73] The poem casts Grace as a valiant knight (much like the conqueror of her early painting, *The Knight, Death and the Devil*) who has triumphed over challenges and dangers ("anger and starvation"), and is now among the elect—assured of her place in history now that "Biography" is on her side. "Heroic Stages" has also been read with a feminist lens, as an acknowledgment of a woman who has made the testosterone-fueled heroic goals of Abstract Expressionism her own.[74] As Grace later wrote to Barbara, she told an audience of young women that "to be afraid and go on anyhow ... is what I guess modern heroism is."[75]

In a confessional mood, Grace wrote to Barbara in November, "I don't know if there ever has been an artist who has made as many embarrassing mistakes and false steps as I have."[76] Barbara responded that what Grace had done that summer was to try to force a passionate intensity in her painting—in an effort to move her art to the next level—when she still hadn't finished her series of "place" paintings. The poet, who was dealing with the same issue herself, sagely noted that "there is so much that is so extraordinarily subtle about passion and if one is not watchful, using it as an 'end' leads to decoration."[77]

That fall, in an exhibition that also included work by Larry Rivers, the de Nagy gallery showed Grace's *Oranges* paintings—the ones in which she incorporated lines from Frank's poems. For once, Lawrence Campbell accorded her a full measure of praise in his *Art News* review, noting approvingly how she "flung" Frank's words into her paintings and comparing the painting-poems to the energy of "dance halls" and "exciting movie posters."[78]

Grace once said that *December 2*—the only painting she ever titled with a date—was about "something that was going on in me that day."[79] She did not elaborate, and this semi-abstract landscape from 1959 presents the greatest

Grace in her Essex Street studio. (Photo: Walter Silver. Courtesy of George Silver. Grace Hartigan Papers, Special Collections Research Center, Syracuse University Libraries)

mystery in all of her work. Inside an orange cave-like form, gleaming against the blackness, are a white rectangular slab resembling a funerary monument and a tiny white (grieving?) figure. At the upper right of the painting, a rough black rectangle resembling a window surrounds the face of a spectral woman and a slash of white that looks like an open book—both scribbled over with blue paint. Is the woman in the window related to, or identical with, the grieving figure? Who (if anyone) has died? One possibility is that Grace became pregnant—either with Keene or another lover—and had a miscarriage or, more likely, an abortion. She had multiple abortions during these years; exactly how many is unknown. This speculation would fit with her remark about the painting, but the truth may never be known.

GRACE AND KEENE were married on December 14, 1959—a date that worried Grace's new dealer in Washington, D.C., because she wasn't sure Grace could have her show ready for the January opening.[80] Grace's family and most of her friends were surprised to hear of Grace's latest nuptials because she and Keene didn't seem particularly compatible. "That was one [romantic attachment] that baffled me completely," her brother Arthur said. "There was a complete mismatch.... He was very meek. There just didn't seem to be a real connection."[81] One weekend guest recalled Keene as "a quiet, unremarkable guy."[82] Others saw Keene's cranky, opinionated side and his worship of good breeding, both of which became more pronounced as the years went by. The

couple honeymooned in St. Croix. Surviving photos taken there show Grace and her painter friend Mary Abbott Clyde—who was visiting with her husband Tom—on bicycles and at the beach, with no Keene in sight.

It's likely that these snapshots actually date from the previous year, when Grace visited the Clydes in Frederiksted, a trip that inspired a painting named after the port town.[83] *Frederiksted* (plate 14) recreates Grace's experience of a coastal setting in the tropics with broad expanses of translucent emerald green and vivid abstract details. An orange fish shape swims near the bottom of the canvas; near the top, flame-colored brushstrokes cluster mysteriously. Deftly combining licks of high-keyed color with white accents and subtle drips, Grace infused the canvas with an inner radiance and the rhythmic zest of a Caribbean steel band.

GRACE AND TIBOR DE NAGY were still at loggerheads. De Nagy argued that it was in her best interests to have an exclusive dealer who worked to get her into major exhibitions and important collections—efforts that would not be made if she also had relationships with other dealers. He was willing, as he wrote in February, to offer a two-year contract covering all expenses at issue except photography. The contract would permit dealings with other galleries so long as they were all handled through his gallery. (Bob would be allowed to sell a few paintings on his own in the summer without paying the gallery a commission.) In his final paragraphs, he took her to task for having a lawyer and her new dealer call to complain that a painting Tibor de Nagy Gallery had sold to Washington University was supposed to have gone to a private collector. "If our relationship has deteriorated to such a low point," de Nagy wrote sadly, "there is not much hope left."[84]

In an interview years later, he complained that she was getting too pushy about pricing her work.[85] But once Grace got her footing as a painter of note, she initiated what would become a lifelong struggle to raise her prices—often, in gallery owners' view, to the detriment of sales. While admitting that she was at fault in the painting mix-up, she scribbled irritable notes on the rest of de Nagy's proposal. As he surmised, a long and close relationship was coming to an end. (Though as late as January 1960, John Myers wrote to Barbara to announce that he had found a source for a grant to Tatyana Grosman—founder of the printmaking workshop Universal Limited Art Editions—to produce a book of poems with lithographs by Grace, which he described as having "all the earmarks of a really glamorous collaboration, such as we used to have with [poet Paul] Éluard and Picasso."[86])

She would later look back wistfully at the gallery in its heyday. "What fun we had! What work we did! It was Camelot and we didn't know it until it was gone."[87] When Grace—by now a veteran of rocky negotiations with other

dealers—spoke at de Nagy's memorial in 1994, she announced that they had recently reignited their friendship. While "Tibor the exquisite gentleman" had long been celebrated, Grace said, he was also a "witty adventurer" who had written a "funny and highly critical poem" about the controversial 1993 Whitney Biennial that was widely circulated.[†] When they attended the opening of another Whitney exhibition that included her work,[‡] Grace mischievously introduced him to the museum's then director, David Ross, who revealed that he had a framed copy of the poem in his office.[88]

Her new dealer was Beatrice (Beati) Perry, who would unwittingly play a key role in reshaping Grace's personal life. At a time when she was fed up with John Myers's constant provocations[89] and unable to obtain the terms she wanted from de Nagy, Perry must have seemed like a refreshing change of pace.[90] A vivacious art-lover and fabled hostess whose husband Hart served as deputy director of the newly founded U.S. International Loan Fund, she was co-owner and director of the Gres Gallery at Washington's tony Dupont Circle.

In early September, Perry had written effusively to Grace that, "Having become so deeply interested in your paintings, meeting you was almost a shock. It was as though I was astonished to find you were a person, a beautiful woman, when what I had come to know so well were your paintings."[91] Grace responded right away, leading Perry to send her another ebullient missive: "Your letter was so good that it made me want to go right home, light a fire in my kitchen fireplace, brew a hot pot of coffee, and have several Hartigan *Sunflowers* [one of the paintings Grace promised to send her] warm my soul."[92] Perry was thrilled by Grace's work, finding "everything that I love about America…in them," including "the grandeur of the content and of the nation, the big dumb brute power it wields, the anguish out of which it has come to exist."[93]

On January 19, 1960, at the crowded opening of Grace's show of eight paintings at the Gres Gallery,[94] she was accompanied by her "brand-new husband," yet "continually surrounded…by a circle of enchanted males," the *Washington Post* reported.[95] In the grip of her usual opening-night attack of nerves, she blurted out that her lawyer told her she should stop bartering her paintings for designer clothing, hats, and furs. At the post-opening supper party, the guests—who, thanks to Hart Perry's diplomatic ties, included the Greek and Yugoslavian ambassadors, and the correspondent for *France-Soir*,

† The 1993 Biennial was notorious for subordinating aesthetic considerations to issues of race, ethnicity, and sexual identity.

‡ Hand-Painted Pop: American Art in Transition, 1955–1962, shown at the Whitney from July 16 to October 3, 1993.

as well as the directors of the Corcoran Gallery and the Baltimore Museum of Art—dined on chicken tetrazzini and a trendy avocado and grapefruit salad.

Not present at the opening was Winston Harvey Price, a taciturn but ambitious young epidemiologist at Johns Hopkins University in Baltimore who told Perry that he was interested in collecting Grace's work. He had already paid $5,500 for *August Harvest* (1959; plate 18), an abstract rendering of Long Island potato fields, with lush passages of red and ochre animated by sinuous dry black brushstrokes and accents of muddied white, blue, and green.[96]

With receding, prematurely gray hair, a jowly face, and a sturdy build that would later become Buddha-like, Price was not exactly a dreamboat. In any case, he was married. But he was obviously going places. In 1954, at age thirty-one, he had received the Theobald Smith Award in Medical Sciences—presented to someone thirty-eight or younger "who has shown unusual a-bility to carry out creative work in the field of medical science"—for his lab and field studies in Rocky Mountain spotted fever and other rickettsial diseases. A year earlier, the Department of Defense had approved his proposal to study the typhus epidemic in the armed forces.[97]

In September 1957—parallel with Grace's growing public acclaim—he briefly became a media star when a flurry of articles in the *New York Times* and *Time* and *Life* magazines reported that he had isolated a virus responsible for up to a third of all common colds, and had developed a vaccine for it.[98] Wearing his Johns Hopkins lab coat and a serious expression, he posed for his *Life* photo holding test tubes of tissues used to create the vaccine (named "JH" for the university). The longer articles allowed Price to demonstrate his qui-etly matter-of-fact personality. "We found the virus purely by luck," he told the *Times.* "We weren't searching for it."[99]

An enthusiastic collector of abstract painting, Price counted Philip Guston as a friend and corresponded with Robert Motherwell, bonding over a shared passion for baseball, as well as for his and Helen Frankenthaler's paintings. Perry, who was keen to cultivate an ongoing client relationship with Price, kept asking if he would like to meet her artist. But although he requested a photo of Grace, he kept saying that he wasn't ready. (He was apparently trying to decide whether to divorce his wife, Judy.[100])

Perry suggested that Grace let her know when she began a new painting, so that the information could be relayed to Price. In a letter to Grace in early February, after she returned from her honeymoon on St. Croix ("by now you and Bob must be relaxed and sun-drenched"), Perry noted that Price "can't be here"

on the weekend of February 26, when Grace and Bob would be visiting Washington. Still, she added, her collector did want to meet her, "as you know."[101]

A native New Yorker, Price was the younger of two sons. His father was a physician.[102] In later years, he told at least two friends—one of whom remarked that Price was a compulsive tale-teller[103]—that his father was a noted rabbi. Why he would lie about his parentage was a mystery, and a harbinger of far more devastating untruths. As a prep school student, he became interested in color changes in bacteria. A teacher suggested that he get in touch with the bacteriologist Hans Zinsser, who taught at Harvard Medical School. Meeting this man—who was also a published poet and winner of a National Book Award for his autobiography[104]—had a life-changing effect on Price, who called him "the most stimulating person I ever met."[105] As a Jew, Price may have been particularly inspired by the achievements of a man of his faith at a time of rampant anti-Semitism.

Another key influence on young Price was Sinclair Lewis's novel *Arrowsmith*,[106] which traces the career of an obsessive fictional Midwestern medical scientist who never forgets the lessons of his testy German Jewish émigré mentor, Max Gottlieb. (Based on two distinguished real-life scientists, Frederick George Novy and Jacques Loeb, Gottlieb is also something of an art collector; he owns drawings by the English visionary poet and artist William Blake.)

Throughout his career, Martin Arrowsmith is stymied by administrative pressures and gung-ho personalities he finds repulsive. He marries Leora, a poor and modest woman who adores him. She insists on accompanying him to a West Indies village where he tests his bubonic plague vaccine but she doesn't bother to give herself an additional shot to bolster her immunity and dies a horrible death. Devastated, he finds release in the arms of Joyce, a wealthy, status-conscious woman with a busy social life. She is thrilled that he now heads a new department of microbiology at his institute, but she resents his long days and nights at the laboratory. With the counterpoint of a senile Gottlieb on his deathbed and an increasingly prominent Arrowsmith poised to become the institute's next director, the book ends with him bolting from his unhappy marriage to work with a colleague in barren surroundings—finally achieving the "rapture" of a life dedicated to scientific research.

Price, then married to a woman who resembled Joyce, was not the first science student to find this story compelling. Graduating from the University of Pennsylvania with a chemistry and biology major, he worked in a laboratory during World War II, researching burn and poison-gas treatments for the armed forces. After earning a Ph.D. from Princeton in physiology and biochemistry, he spent the next two years at the Rockefeller Institute of Medical

Research, where he found another key mentor. John Howard Northrop, a co-winner of the Nobel Prize for chemistry in 1946 for his study of enzymes, proteins, and viruses, impressed on his young colleague the importance of using control groups in lab experiments. The deaf Northrop was also something of a loner, a trait Price shared. In 1951, Price joined the Johns Hopkins University faculty as an assistant professor of biochemistry and a research associate in epidemiology. To investigate the causes of Rocky Mountain spotted fever, he spent his summers doing field work in Montana and laboratory work in Baltimore. This research led him to study various respiratory diseases, including influenza.

Wondering where flu viruses go when an epidemic is over, he hypothesized that they might be in the bodies of people with colds. Price isolated a virus from cultures taken from Johns Hopkins nurses during an outbreak of respiratory illness.[107] He then developed an experimental killed-virus vaccine that was tested on 100 children ages ten to fourteen whose parents had given consent. This was a double-blind trial; neither the researchers nor the parents of the children, who lived together in what Price described as a "cottage" (more likely, a substantial building known as the Harriet Lane Home, Johns Hopkins's first children's hospital[108]) knew which children were injected with the vaccine and which ones received a placebo. He reported that the children who received the inactivated virus were eight times less likely to come down with the respiratory illness than the control group.[109]

The scientific community was impressed; George Hirst, director of the Public Health Research Institute in New York, called Price's work "a promising lead in the attack on the common cold."[110] Yet when asked by the media about the prospects for marketing the JH vaccine, Price sounded vague. He noted that there was no single-bullet cure for the common cold; other viruses would need to be isolated using similar methods. (It is now known that there are more than one hundred types of cold viruses.). Meanwhile, behind the scenes, Johns Hopkins administrators were dismayed at the breathless tone of the press reports. Price's supervisor, Dr. Ernest L. Stebbins, cautioned reporters that much more work needed to be done. The reason for Johns Hopkins's administrative caution was never publicly revealed. Years later, Maurice Hillman, a leading microbiologist who developed eight of the vaccines most commonly given today, declared that Price's study "was a complete fraud. He made up his data."[111] Hillman discovered this while working in the Department of Respiratory Diseases at what was then known as Army Medical Center. A scientific experiment must be able to be duplicated in order for it to be accepted as valid, and neither Hillman nor anyone else has been able to do so.[112]

However, the JH *virus*—as distinguished from the vaccine, and now known as RH or *rhinovirus*—has continued to be cited without prejudice in papers on infectious disease.[113]

A generalist in a dawning age of specialists, Price told the *Times* that his real interest was in broader issues of public health, such as environmental and genetic influences on arteriosclerosis and heart disease. (The virus study he directed was nonetheless ahead of its time in drawing on multiple specialties, including biology, biochemistry, epidemiology, microbiology, pathology, and physiology.[114]) For inspiration, he kept on his desk a photograph of the intense-looking Dr. Max Theiler—a Roosevelt Institute colleague who received the Nobel Prize "in Physiology or Medicine" in 1951 for developing a vaccine against yellow fever.[115]

By early 1958, Price had grown restless at Johns Hopkins and was in discussions to join the staff of the National Heart Institute to work on a heart disease project in Memphis. Either the offer never materialized or he decided against it after hearing of his potential promotion to full professor. (Already in the works, for some reason the promotion didn't take effect until July 1964). It's tempting to wonder how Grace's life would have turned out had he been living in Tennessee. He might have ceased to be an active client of the Gres Gallery and never met Grace, or he might have had to coax her to live in what was then a small southern city known mostly for rock 'n' roll and barbecue, neither of which would have tempted her.

AFTER A PHONE CALL to Grace, who told him she had several paintings he could see in her studio, Price traveled to Manhattan,[116] installing himself at the Sherry-Netherland hotel. He asked her to come up to his suite for a drink before lunch, which segued into the three days of intimacy that launched their affair. It was clear that he was as passionate about her as she was about him. With the breathtaking speed of an impulsive person about to make a huge change in her life, Grace told Keene she was going to leave him, much to his bewilderment and his friends' dismay.[117] They had been a married couple for only four months.

A middle-aged friend of Keene's, so upset that she didn't bother with proper stationery etiquette, scribbled a note to Grace on three mismatched scraps of paper. "It's a good thing I was sitting down when I read your letter," she wrote. "I was truly more shocked than by anything I have heard in years.... I just can't understand your worrying him and saying you never loved him as a wife should."[118] Keene later said that he "was not of the art world" and that Grace's friends disparaged him as "a small town guy...too provincial."[119] His shock at Grace's abandonment was of a piece with his history of other

romantic disappointments that he never saw coming. "He would keep claiming to love them so much, so you had to be suspicious," an acquaintance said. "He liked to embellish and color things."[120]

Years after the annulment, Grace's brother visited Keene on a trip to the Hamptons. "He held himself back, but you could see that he had tremendous resentment," Arthur said.[121] Keene later became president of the Southampton Colonial Society, now known as the Southampton Historical Museum; in 1981, he inherited the mantle of official town historian.[122] His romantic misfortunes continued when his young second wife, whom he married in 1969, left him a decade later.[123] As flashy newcomers began to change the landscape and ethos of his beloved adopted town, his loudly opinionated local profile became curmudgeonly. Grace, who later referred to Keene as her "meatloaf husband,"[124] did feel guilty enough to leave Ludlow Grange to him. (He died on January 31, 1998, of congestive heart failure, at age eighty, two weeks after a minor traffic accident sent him to Southampton Hospital.[125])

The future was all about Winston Price. Grace believed she was in love for real this time, and for once the stars seemed to align. Win, as she called him, was an accomplished scientist who loved art, and someone who would support her, both emotionally and financially. Grace even canceled a summer trip to Europe she had planned, perhaps because he was unwilling or unable to get away. The wedding would take place on December 24—just a year and ten days after her previous nuptials—with Beati and Hart Perry as witnesses.

WHEN TATYANA GROSMAN called Grace to ask if she would like to make lithographs, Grace had to confess that she didn't really know what a lithograph was. Undaunted, Grosman and her master printer Bob Blackburn traveled from their print workshop in Suffolk County, New York, to Grace's studio lugging massive black "prehistoric" stones.[126] In early October, Grace had proposed to Barbara Guest that they collaborate on a printmaking project. During the next two months, the two woman worked out the details for a portfolio of lithographs and poems that would be published in spring 1960. Grace plunged in with her usual gusto, splattering the tusche—the black liquid used to draw on the stone—as she drew, rubbed, and pounded with her rags and her hands. Looking at the results of Grace's efforts, Grosman "let out a sound, sort of a cross between a scream and a moan."[127] This was not the proper way to make a lithograph. But Blackburn—an African American who later singled Grace out as "my kind of person"[128]—assured her that he could print anything. The two experts demurred only when Grace suggested exhibiting the stones as well as the four prints; that simply wasn't done.

Decades later, she rued the fact that "the print process was...so difficult for me, so painful. Part of this is the knowledge that my deepest gift, color, can't be used as it can in oil and watercolor."[129] Still, what she loved about lithography was the obdurate presence of the stone. She regarded it as a living thing she had to wrestle with—struggle was an integral aspect of Grace's art-making process—which is why she never transferred a drawing to the stone but always drew on it directly.

Working that spring on a lithograph to accompany Barbara's poem, "The Hero Leaves His Ship"—about a Ulysses-type figure who has come home at last, marveling at the simplest elements of rural life, after his sea-borne adventures—Grace clearly had her own looming departure for Baltimore in mind. "What I did was to take the poem inside me," she said. In the two lithographs designated as the "Hero,"[130] there is no identifiable hero figure and no sense of the closure the poem brings. Instead, Grace used splashes and scribbles of ink to create a sort of agitated ego that merges with the unsettled landscape Barbara describes: the "dark...mixed / with wings" and the "windy field."[131] The hero is really Grace's unsettled self.

Psychoanalysis had become increasingly popular in literary and artistic circles in New York—Mary Abbott Clyde had asked Barbara for the address of her analyst the previous year[132]—and now Grace was seeing Dr. Abram Kardiner. A founder of the New York Psychoanalytic Society, he had been a patient of Sigmund Freud's as a young man in 1921–22. Previously, as Grace wrote to a friend, "no matter what a mess my life has been at times and what desperate emotional states I have reached[,] my work always seemed to flow."[133] Now, impressed at the change in Mary's paintings that seemed to be a result of her analysis, Grace decided to seek help. Barbara was relieved. "You know, I was worried about you," she wrote the following spring. "I felt that you had pushed yourself so very far."[134] Grace was bound to seek a way out of her distress "because you have such moral strength and honesty and a conscientious regard for yourself." Barbara urged Grace, "don't worry about or fear the pain and just allow. And try to find some <u>rest</u> in it with someone else guiding. You've been a brave girl too long."

But Kardiner may not have been Grace's wisest choice of therapist, because of an issue in his own therapy that Grace would not have known about at the time. His mother had died of tuberculosis when he was three years old; six months later, his father remarried. As Kardiner wrote many years later, Freud told him that in rejecting his stepmother—who had asked him to fondle her breasts when he was a young child—he was "fleeing into [his] unconscious homosexuality" by identifying with his "helpless" natural mother,

who was frequently beaten by his abusive father.[135] Kardiner found this assessment baffling. He was attracted to women, not men, though rejection by an early love wounded him deeply, and he didn't marry until he was fifty-seven. (Although Freud did not consider homosexuality to be a vice or an illness, he viewed it as an immature form of sexuality.)

Now, in advising Grace how to rein in her promiscuous appetites so that she could remain faithful to her husband-to-be, Kardiner told her that she could not have a fully rewarding marriage if she were also in love with a gay man.[136] Or so Grace claimed to one interviewer. This advice seems ill-suited to the problem, given that Grace's sex drive had nothing to do with gay men, and her sex partners had not been her soul mates. Toward the end of her life, she offered a more nuanced version of her therapist's counsel: before meeting Win, she had separated physical intimacy from emotional intimacy; now she would need to merge the two to achieve a happy marriage.[137] Perhaps Kardiner was also concerned that she would fail to form a lasting emotional connection with Win if he were not her sole male confidant. Before she met him, Frank had been the only man whom she felt really understood her.

So awed was Grace by "the great Dr. Abram Kardiner,"[138] and so worried about getting off on the wrong foot with the love of her life, that she wrote Frank a "Dear John" letter. He was justifiably wounded. Even before this, he noted in a letter to her that they hadn't spoken for a long time; every few years they had "a period of silence and mystery," and he hoped this one would end soon.[139] But now that Grace had decisively broken with him, he began making catty remarks about her,[140] and the tone of his review of her 1963 show at Martha Jackson Gallery lacked the special understanding he had previously shown her work.[141] Her relationship with John Myers was also on its last legs. Incensed at what she later called the "vicious lies" he was spreading about Win, Grace felt that he would stop at nothing to destroy her marriage.[142]

At the same time, the sense of community she had felt with other downtown artists all through the '50s was dissipating. The close-knit group of Abstract Expressionists in New York in 1950 had became a small army; Irving Sandler estimated their numbers at just shy of two hundred fifty.[143] The critic Dore Ashton noted that "it was no longer possible to be sure of meeting someone you knew at a bar.... The New York School as such had vanished and what emerged... was a scattering of isolated individualists who continued to paint."[144] Some had already left Manhattan. Joan Mitchell had decamped for Paris; de Kooning and Rivers lived on Long Island; Philip Guston had moved upstate to Woodstock, Franz Kline had bought a house in Provincetown, Massachusetts. As Grace said later, "Everybody had gotten either rich

or famous or dead.... The whole thing had broken up and artists were at each other's throats if someone was showing more than the other or selling more."[145] She was angry that her last show "was referred to by so many people as...'a comeback' as though [she] was Gloria Swanson of *Sunset Boulevard*."[146]

There was now a huge gulf between the prices a leading artist could command and those of lesser-known painters. In May 1959, when de Kooning had a show at the Sidney Janis Gallery, *Time* magazine reported that collectors were so frantic to buy his paintings that they started lining up outside at 8:15 in the morning; by noon, nineteen of the twenty-two works had sold.[147] Fairfield Porter, struggling with financial problems, noted that de Kooning's sold-out show brought $125,000, netting him about $80,000. "He is rich now for the first time in his life," concluded Fairfield (who had recently sold a de Kooning he owned to a collector for $7,000). Tibor de Nagy Gallery had sold a record number of Porter's paintings that year, but for a total of less than $3,000.[148]

Though hardly in de Kooning's league, Grace boasted to an interviewer in 1960 that she was "one of the two percent of artists who lives from the sale of her work" and was now able to wear designer clothes.[149] The real story was more complicated, as Grace had revealed at her Gres Gallery opening. Larry Aldrich, an art collector who had bought one of Grace's larger paintings for $1,000—which he regarded as a steal ("she really had not had that much success")—was a well-known dress designer whose company adopted Paris fashions for American women. He was introduced to Grace at an opening at the Modern in 1957. She was "very tall and very, very attractive, but didn't look anywhere near as attractive as she could have looked," Aldrich recalled years later. "I think Johnny Myers must have told her that I was in the fashion business. She pulled me to one side said, 'You know, I've been working for a long time and living in poverty really.' She said, 'I have a couple of dollars now and do you think I could get some clothes wholesale?' And I said, 'Why of course.' And we made a date for her to come up and...there were so many things that she wanted that she said, 'Gosh, I'm just unable to pay for these.' And so I proposed that we swap." As a result of these paintings-for-clothes exchanges, Aldrich reckoned that he once owned "about twenty Grace Hartigans...some of them as far back as 1946."[150]

IN STYLISTIC TERMS, the battle lines were drawn. When the abstract painter Ad Reinhardt updated his "How to Look at Modern Art In America" cartoon in 1961, he replaced a quote from Russian painter Wassily Kandinsky with the words "Money talks." The cracking branch now held artists he dismissively described as trying to be "both abstract and pictorial"—lumping together

Guston, Kline, Gottlieb, and other stalwarts of the New York School with figurative painters like Moses Soyer and Charles Burchfield.[151]

The other widespread concern was that Abstract Expressionism had hardened into a formula. It became either a caricature of itself (a splattered canvas painted in a frenzy) or an earnest, lifeless imitation (drip here, slash there)— "the stab into the unknown becom[ing] the knowledgeable gesture."[152] During the run of The New American Painting exhibition at the Modern, Hilton Kramer published a somewhat jaundiced assessment of Abstract Expressionism in The Reporter, a leading news magazine. He had overheard an artist at the opening saying that the sight of "everyone worshiping" the paintings meant that "it's over, and now something else will have a chance."[153] In an article that referred to "the twilight of Abstract Expressionism," John Canaday of the New York Times got his digs in once again. He caustically compared the major figures of the Club to the Greek gods of Mount Olympus, with Grace, Helen, and Joan as the goddesses competing for the golden apple—"Aphrodite [goddess of love and beauty], Athene [wisdom] and Hera [marriage], although not necessarily respectively."[154]

Such was the rumbling of negativity about Abstract Expressionism that Art News convened eighteen artists (not including Grace) to discuss the issue and published edited versions of their remarks in its Summer and September 1959 issues.[155] There was no consensus, of course, and much sarcasm, some of it obliquely directed at the activities of Beat artists in San Francisco.[156] Helen noted that "great invention almost always produces conformists." She pointed out that the imitators were now deliberately trying to make their paintings look "slightly ugly," rather than incorporating awkwardness as the inevitable result of imaginative vision.[157] Yet painter Jack Tworkov was not alone in standing up for the continued vibrancy of expressive painting whose characteristics, he wrote, were shaped by the "experience, insight, and awareness" of individual painters.[158]

Still, no one could dispute the growing lack of cohesion among this group of artists who once were constantly in and out of each other's studios. Grace noted that "anyone who got married sort of left [New York]. The people who hung around were people who had loose marriages like Phil Guston and Musa, where he could stay and close the Cedar bar or go to a coffee shop or on to his studio and talk until dawn. But once someone had a family life then they weren't part of it."[159] The Cedar had changed, too. An old-timer recalled "the big influx of mistreated Middle Western art students…who thought that if they sat in the Cedar, Sidney Janis would come in and say, 'I need you for my gallery.'"[160] Young women new to Manhattan would visit the tavern, hoping to snag a big-name painter as a lover or booster, or both. Even the local

police began hanging out there, "muttering at the end of the bar."[161] Mercedes Matter noted that she heard artists "talking about galleries over their bourbons instead of about art as before, over their beers."[162]

WIN HAD FILLED Grace's life with a new sense of purpose, but love's course did not run smoothly. He became distant, claiming that his wife wouldn't agree to a divorce. Stunned and panicked—and with Guest's poem "Dido to Aeneas" in mind—she painted *Dido* (plate 19). In this abstract canvas, bravura brushwork in flaming red and foamy white, and a sea of royal purple convey the fate of the Queen of Carthage, as told in Virgil's epic poem, *The Aeneid*. Dido's passionate yearlong affair with Aeneas, the Trojan hero, ends abruptly when the gods force him to leave Carthage, abandoning her. She orders a funeral pyre built for the couple's bed and the armor Aeneas has left behind in his hasty flight. Flinging herself on the burning bed, she commits suicide with the sword Aeneas had given her: "Let his eyes / Behold this fire across the sea, an omen / Of my death going with him."[163]

Grace later mused that half of the ten paintings she produced in 1960 were based on poems, perhaps because of her "wavering emotional state with Win Price, will I marry him and leave New York or not?"[164] (Fittingly, the last painting she completed before she left New York was *The Hero Leaves His Ship*.[165]) Her other known works from that year—*New York Rhapsody, July, August, Night Landscape Woods Hole*, and an untitled gouache—are poetic in spirit. The words ("But Not For Love") in her untitled abstract collage of 1960—a book jacket for May Tabak's novel of the same title—coincidentally echo her unstable state of mind.[166] Compounding her stress that summer, a male sculptor friend confessed his long-simmering passion for her.[167] (Another man she knew, who had moved to Paris, was sorely disappointed when Grace canceled a planned trip to the city. "I miss you Grace more than you dream," wrote painter David Budd, who was divorced from his first wife.[168])

In early July, Grace traveled to Stockbridge, Massachusetts, to stay with Dorothy Miller and Holger Cahill at their cozy summer home. Miller no longer visited Grace's studio—Grace privately worried that the curator had lost interest in her work[169]—but Cahill had often dropped in to talk about it. Not long after Grace arrived, he died, at seventy-three, from a cerebral hemorrhage.[170] For the next few days, she remained with Dorothy, relaying the sad news to friends and colleagues, beginning with Alfred Barr.

ULTIMATELY, GRACE'S PASSIONATE SELF—or her passionate art, or both— convinced Win to carry out his promise to her. (As if to create a shrine to this

turning point in their relationship, he later asked her to hang *Dido* in their bedroom.[171]) By late July, Grace and Win had regained their romantic footing. She wrote to a friend that just as she was about to leave for a solo trip to Paris, Air France went on strike—and Win's wife finally agreed to the divorce. "So I was able to rent a place up here [in Wood's Hole, Massachusetts] across the road from his cottage and to begin at last to spend time with him." There was no question that he was The One. This was "the first time I have ever loved so deeply or committed myself so completely," she wrote. She hoped the wedding could happen "by September." After that, she would travel to Baltimore to find a studio. "I'll return to New York to pack and then leave forever"—once again the heroine of her own private drama.[172] In fact, she planned to visit Manhattan twice a week for her sessions with Dr. Kardiner: "There are still things I must work out—the kind of isolation that I'll have down there will be completely new to me." Yet her love for Win temporarily erased this troubling vision, and she gaily looked forward to "reviving the art of letter writing with my friends."[173]

Barbara had written to Grace that the English art writer David Sylvester had wanted to make love to her when he saw her paintings in London (in The New American Painting show) and didn't visit her in New York because he was "furiously disappointed" that she was married (to Keene).[174] While this news might once have given Grace a pang, she was now completely committed to Win, as her "lovely, refreshing" letter to Barbara had made clear. Perry sent a rapturous response to Grace's "glowing letter" about her love, written from Wood's Hole. "[D]arling, darling girl my heart is so full for you, and for Win!" she exulted. "At last here is a man who seems to have an inner magnificence to match your own."[175] The letter ends with a flurry of happy doodles: musical notes, a flower, and a rising sun. After visiting the couple the following month, Perry wrote that she and her husband had never seen Grace "more relaxed and radiant."[176] May Tabak wrote that she was "maybe in a not so secret way rather proud of [Grace]," presumably for having the courage to leave her husband when true love beckoned.[177]

Grace was featured in the September 1960 issue of *Look* magazine as one of the "Women of American Art"—along with Helen, Georgia O'Keeffe, sculptors Louise Nevelson and Lee Bontecou, and West Coast artists Joan Brown and Claire Falkenstein. The photo of Grace, unsmiling in a helmet-like hairdo, was awkwardly manipulated to make it seem as though she was somehow *in* her 1957 painting *Montauk Highway*. The extended caption notes that her paintings sell "often before the oil dries, for prices ranging from $2,000 for small canvases to [as much as] $10,000."[178] In the grip of her emotionally

exhausting personal life, Grace babbled to the *Look* interviewer that she intended her work to reflect "the quivering moment that is now." She announced, "I hate the past," and declared that she had to free herself of it to be able to pursue her own artistic direction.

It's hard not to see this renunciation as a protesting-too-much declaration of her determination to turn her back on New York. On a trip to Baltimore, Grace asked a cab driver to show her around the city. When he cruised past the harbor area, she perked up; she liked industrial landscapes. Looking forward to her new life as Win's wife, she dreamed of creating a salon where the city's artists, musicians, poets, and scientists could exchange ideas and enjoy each other's company.[179] Though Barbara probably refrained from playing Cassandra at the time, she privately believed that her friend was making a big mistake, "disastrous for a career just at its peak." The New York art scene, she said later, "never forgives." It was one thing for Joan Mitchell to go to Paris and be involved with a "hot" painter (Jean-Paul Riopelle); it was quite another for Grace to go and bury herself in Baltimore.[180]

Beginning Again in Baltimore (1961–2008)

13

Drifting

BALTIMORE WAS A terrible shock. There was no contemporary arts scene to speak of, despite the existence of the venerable Maryland Institute College of Art and the Peabody Institute, a nationally recognized music conservatory. (Later, when Grace began teaching at the art college, she was surprised that the aspiring artists and musicians never socialized.) There would be no salon. The scientists Win knew had no interest in art, and he shared their lack of interest in poetry. A perceptive friend later noted that once Grace had moved away from New York and her poet friends, poetry was no longer a source of inspiration for her paintings. "Maybe," she mused, "I love poets more than poetry?"[1] Yet in the early Baltimore years, her closeness to Barbara Guest kept a poetic awareness alive in her art.

Always energized by being in the thick of things—despite her recurrent need to spend quiet hours in the studio—Grace was overwhelmed by her new isolation in a city that didn't know or care about her achievements. Harold Rosenberg had told her that she would surely meet nice people in Baltimore, "but you'll always be explaining yourself."[2] Putting on a brave front, she told an interviewer that she was "most grateful" that people in Baltimore respected her privacy, whereas she had been such a center of attention in New York that she could hardly work.[3] (Grace once cracked that "in New York, I wake up in the city that never sleeps, and then I'm glad to come home and wake up in a city that has been asleep with me."[4]) Decades later, she would insist that she would have drunk herself to death had she stayed in New York to witness first-hand the rise of the other art movements—Pop and Minimalism—that made her work suddenly seem old-fashioned. Yet she would also confess that leading "an isolated creative life" added an extra burden to her struggle in the sixties to find her own voice.[5] Artists need to be loved, she told an interviewer, "and to have rejection, silence, and indifference was very difficult."[6] All Grace could think of was what she had left behind, lovingly recalled in *New York Rhapsody* (plate 20). A blue shape resembling a map of

New York State is interrupted at its southern tip by energetic brushwork that seems to symbolize the hectic pleasures of her favorite city.

Her new home was in leafy Roland Park, the first planned suburban community in the United States, developed at the turn of the twentieth century for upper-class families who traveled downtown on the streetcar. Grace found her new neighborhood stifling—too quiet and too tame, with none of the clutter and crassness of popular culture that had inspired her paintings. In an effort to recreate her beloved downtown Manhattan ambience, she rented a four-story building on Calvert Street, in Baltimore's rundown factory district, for $200 a month.[7] A rag baler left behind by the previous tenants testified to the building's earlier life as part of the city's textile industry. Factories were leaving Baltimore for the non-unionized South; once-mighty Bethlehem Steel was undermined by the growing dominance of aluminum. The resulting economic vacuum ushered in decades of increased poverty and crime, and the neighborhood was haunted by derelicts and addicts.

But inside her brick-walled studio, Grace could escape into a world of simple pleasures. On the windowsill of her third-floor studio, alongside carefully tended geranium plants, she kept an empty Champagne bottle, a memento of her celebration of the sale of *The Persian Jacket* to the Modern in 1953. She turned part of the second floor, otherwise dedicated to lithograph and collage production, into a lounge that mingled her bohemian flair with middle-class tidiness. "There is enough chaos inside me without chaos around me," she once said.[8] Her 1950 painting *The King Is Dead*—one of the few early works she still owned—hung over a neatly slipcovered daybed. She kept a metal camper's teapot on the coffee table and grouped an antique sculpture of a woman's head, a vase filled with rushes, a straw basket, and a ceramic sugar pot on a huge, rustic table.

Arriving at her third-floor studio around 10 A.M. on most days, she would change into her painting outfit. In a *Baltimore Sun* photograph from this period, Grace cuts a lithe figure in a patterned turtleneck sweater and blue jeans, standing with brush in hand in front of one of the vividly hued abstract paintings that reflected her early-sixties style. In her left hand, she holds the rag she used to wipe down the canvas, to achieve a flat, unbrushy surface. She worked standing up in five- or six-hour sessions, using paints "arranged in brilliant little mountains"[9] around the top of a white porcelain table. (Grace had organized her colors on the palette in the same way for twenty years: "It's almost like a typewriter. I know where every color is when I'm reaching for it."[10]) To spark her imagination, she might look at photographs—images of Marilyn Monroe and the author Isak Dinesen joined other neatly organized

Grace in her Calvert Street studio, August 1964. Note the empty Champagne bottle, a memento of happier times—when the Modern bought *The Persian Jacket*. (Reprinted with permission of The Baltimore Sun Media Group. All Rights Reserved)

magazine clippings tacked to the wall—or at her collection of dolls and toys, including the battered rag doll that John Myers had given her.

When Grace couldn't figure out what to do next in a painting, she sometimes climbed up to the top floor, which served as a small gallery of her work, and peered down at pigeons and passersby. Still an avid reader, she also used these hours to immerse herself in a biography about another creative person, to reassure herself that even the most celebrated artists and authors had periods of frustration and stasis. At other times, she liked to walk around the harbor and watch the ships. Her love of the waterfront dated back to her early life in Bayonne, when her family's home was just steps from the bay.

SOON AFTER GRACE settled into her new home with Win, they had visitors whose love of postwar art would help ease her transition to Baltimore. Art collector and real estate developer Robert Meyerhoff and his wife Jane, who volunteered in the sales and rental gallery of the Baltimore Museum of Art, had been friendly with Win and Judy. (Win's ex-wife was completely out of

the picture now; a friend noted that whenever she sent Win a letter, he would throw it away, unopened.) Win had been waiting to rent a work of art that the gallery had loaned to an exhibition. A few days before the Meyerhoffs had arranged to deliver the work to him, museum director Adelyn Breeskin happened to mention that he had just married Grace. The Meyerhoffs were dumbfounded; they weren't sure if this was true. Driving a borrowed 1928 Franklin, a luxury car of its day, the couple set out for Win's house with the package.

When they pulled up in the driveway, a window opened "and this woman screams out, 'What a great car!'" Meyerhoff recalled. "So we went in and met Grace Hartigan." Her painting *Essex and Hester (Red)*—which the Meyerhoffs would purchase in 1962 from Win—was hanging on one wall. "She was a beautiful woman," he said. "And she was so verbal. She was delightful."[11] The Meyerhoffs bought a two hundred fifty-acre farm the following year, and Robert began to breed racehorses. Decades later, the thoroughbred he named Hartigan brought him good luck, winning four stake races.

IN THE SPRING of 1961, Grace painted three canvases titled after Pallas Athena, goddess of wisdom, strategic warfare, and the arts and crafts. (Two of the paintings were part of a projected series based on the four elements that she did not complete.) Largely abstract, these works were fueled by the preoccupations of her closest friend of this period, Barbara Guest. Painter and poet kept in touch through frequent letters, communing on a uniquely intuitive aesthetic level. Grace clearly viewed the fierce, savvy, and independent goddess as her alter ego: "full-blown from the head of Zeus—she had no nurturing, and she was an intellectual goddess."[12]

Determined once again to reject her lyrical side, Grace endowed the new paintings—especially *Grey-Eyed Athene*,[13] its somber grays and blacks illuminated by what looks like a burning ship[14]—with a murky, dense, and deliberately unbeautiful appearance. In *Pallas Athene–Earth* (plate 21),[15] curving black brushstrokes set off flurries of muddied pink and white that cluster heavily above a swath of earthy orange reminiscent of the autumnal richness of *August Harvest*. A landscape quality also animates *Pallas Athene–Fire*, with its grove of black and blue tree-like forms, a burning "sky" layered in orange, red, and purple, and a sickly pinkness seeping into the earth.[16] So where is Athena in all of this? She exists in these paintings as a kind of temperamental atmosphere that causes paint to whip itself into black knots and colors to bleed and clump.

Grace's Athena paintings received considerably more attention than other work she made during her early Baltimore years. *Pallas Athene–Fire* and *Grey-Eyed Athene* were shown at the 1961 Pittsburgh International exhibition at

the Carnegie Museum of Art;[17] *Pallas Athene–Earth* was included in American Abstract Expressionists and Imagists at the Guggenheim Museum and in a 1962 exhibition of 102 contemporary American paintings owned by the Johnson Wax Company that toured Japan and Europe. The *Earth* painting was also reproduced in color in the two-volume catalogue for the show.[18] As a sign of Grace's new invisibility in New York, however, Stuart Preston's *New York Times* preview piece for the exhibition omitted her name in his list of the artists, though he did mention Joan Mitchell's.[19]

In an interview published in *Cosmopolitan*, Grace said, "I hope to get her [Pallas Athena] on my side—and also say a lot about women and of course myself."[20] In additional remarks that were not included in the article, she wrote that she viewed the paintings as "self-portraits...in a way."[21] Despite the remark about women, Grace would never admit any overt connection to feminism in her paintings. If most of her figures, whether abstract or figurative, are female, it was because she identified with them. Painting herself in an imagined guise—most dramatically before her wedding, when Win seemed to have abandoned her—was a form of therapy, transmuted into something rich and strange by her brilliant use of color and compositional structure. She hated being called an "expressionist," yet despite her changing styles, her painting retained a deeply personal emotional core.

GRACE WAS PROFOUNDLY inspired by *Archaics*, Barbara's series of seven poems based on Virgil's *Aeneid*.[22] At Tatyana Grosman's request—she wanted to print an illustrated edition of *Archaics* on fine paper—Grace produced a group of lithographs, including *Dido to Aeneas* and *Atalanta in Arcadia*.[23] In October 1961, Barbara came to visit, marveling later how "grounded and real and in command" Grace appeared, with "a lovely aura of awareness."[24] Barbara wrote, "I feel your paintings so acutely that often when I write a poem, I begin to see it as you would paint it, as if I had already imagined the turn you would take." She complimented Grace on her understanding of the poems.[25] Several months earlier, in a letter to Grace, Barbara mused about "how much freer" she and Grace were, as creative women, than the nineteenth-century French painter Berthe Morisot, whose journals Barbara was reading.[26]

Atalanta was a hunter. Intending to retain her virginity, she agreed to marry only the unlikely suitor who could outrun her in a race. But when Aphrodite supplied one suitor with golden apples, Atalanta stopped to pick them up. He won the race and became her husband. In the *Aeneid*, both Dido and Atalanta are tricked by men who themselves were under the thumb of the gods. Barbara's Atalanta is still a free woman with "January wind in her tresses," but the poet rues that there is no one to warn her that "her huntress days are

over" and "her girlhood...consumed." Barbara's Dido is consumed by love—
the words "I love you" appear four times in the twenty-eight-line poem—in
the wake of Aeneas's departure. Both heroines were obviously appealing to
Grace in their freedom, strength, and vulnerability; she was all too familiar
with the power struggle involved in love and marriage.

Her lithographs for these poems are not the images of queenly Dido and
athletic Atalanta that you might expect. In later years, Grace would paint gen-
eralized portraits of mythic and historical women. But now, the freedom she
felt to oscillate between abstract and figurative approaches—sometimes in the
same work—led her to focus on the allusive, fanciful qualities of Barbara's
poems. *Atalanta in Arcadia* is a maelstrom of furious scribbles that evoke Ata-
lanta's impetuous spirit battling with its destiny. *Dido to Aeneas* abstractly con-
jures a woman with long black hair looking out to sea. Grace allowed the white
of the paper to show through in many places, perhaps responding to Barbara's
comment about the "startling" aspect of Dido's death "in all that classical bril-
liant light."[27] *Palm Trees*, another of Grace's lithographs for this poem series—
in classical Greece, a palm branch was awarded to the winner of an Olympic
event—edges closer to figuration: it is clearly a palm tree, though its wind-
blown tumult diverges from Barbara's "Calm fan."[28] A quarter-century later,
after weathering devastating personal problems, Grace—who had disparaged
the tree as "the symbol of American retirement and...terrible people in ter-
rible Florida resorts"—announced that she had developed "a tremendous
affection" for it, because "it goes through hell in those hurricanes."[29] In her
self-centered way, she came to love palm trees because she identified with them.

Grace also worked on three lithographs for *Salute*, a Tiber Press publication
of poems by James Schuyler (including "Salute," written in 1951). Although this
was part of a series of four books that each matched up a poet and a painter, it
wasn't really a collaboration. She had no opportunity to read the poems before
making her prints,[30] and Schuyler—who had long struggled with mental illness,
and was a patient at a psychiatric clinic that spring—didn't see them before the
book was published. Yet she clearly counted him as a good friend. Several years
earlier, in an undated letter thanking him for "wasting" his words on her (in his
letter) instead of putting them into a poem, Grace suggested that he could write
a poem about a collage she made "and then I'll make a collage about the poem."
She told him about her current reading (Proust, John Rewald's *Post-Impression-
ism from Van Gogh to Gauguin*, and Zola's *The Masterpiece*, a fictionalized ac-
count of the author's friendship with Cézanne), commented on his worrisome
thinness, and hoped he would come to dinner soon with Frank O'Hara ("all
fattening food").[31]

What Grace especially liked about Schuyler's poetry was its visual quality and its frequent mention of colors.[32] Her abstract prints for the book show her at the top of her form, especially *The Canal to the Sky* and *This So-Called Angel*, with their lustrous orange or yellow washes in rectangular shapes that appear to recede, setting up a visual tension with the thick, flat, black lines and masses beneath them. One of the other poets in the series was Frank; he was paired with Michael Goldberg rather than with Grace, possibly as a result of the implosion of Frank's friendship with her. Yet Grace had received a new tribute from Frank, whose poem "Favorite Painting in the Metropolitan"[33] recalled the days when he and Grace used to prowl the museum's galleries. Her name appears nowhere in the poem, but the "you" who proclaims her love for Old Master paintings of the Annunciation because of the way the skies were painted and who curses a run in her stockings couldn't be anyone else but Grace. The affectionate tone—Frank compares a small painting by Fragonard to the size and pinkness of her left ear—suggests that his anger at her could not suppress fond memories of happier days.

The next time Grace and Frank saw each other—at a dinner in early 1964—the breach was not fully repaired; Frank complained to Larry Rivers afterwards that Grace was "insufferably opinionated." But two years later, during what would be the last summer of Frank's life, Grace invited him to visit her and Win at a house they rented on Shelter Island. He brought along several male friends—probably to insulate himself against her potential desire for closeness, and closure—but Grace said later that the two of them had a long private talk. We'll never know if Frank, who was in a downbeat mood for other reasons, actually forgave her, but Grace apparently felt that the encounter had cleared the air.[34] After he died, in a freak accident on the beach in July 1966, Grace painted *Frank O'Hara*, an abstract canvas with densely packed, firmly outlined gray and green shapes that she later said were inspired by disparate associations, including tombstones and knightly armor,[35] though she was surely the only person who could perceive these connections.

THE COLLABORATION WITH Barbara had an awkward ending. Grosman cancelled the book the two women had so lovingly planned because Barbara's poems were published by Doubleday in 1962,[36] undercutting the freshness of the projected Universal Limited Art Editions volume. May Tabak took Grace's side. "Barbara must know that your work will be what gets her work around and gives it status," she wrote. "Between friends such values don't count. But when ambition enters then antagonism results."[37] Tabak suggested that Barbara's need for Grace caused her to "get rid of you and her deed" (the collaboration). "Don't feel badly," Tabak added. "Your loving produced some beautiful work by you."

Several months later, Tabak told Grace that she heard from Barbara's "sometime lover," a painter, that Grace hadn't sold any paintings since she left the de Nagy gallery—information that would have come from Barbara. May and Harold closed ranks against the gossiping poet and her other lover, Trumbull Higgins[38] (who both seemed to be taking pleasure in Grace's woes), telling them that Grace's career was "as bright as ever" and mentioning her upcoming show at Martha Jackson Gallery in New York.[39] Grace apparently discussed the betrayal during a visit to her analyst. "Your good doctor was right," Tabak wrote. "We have all been seduced into accepting the crudest psychiatric explanations as excuses for the basest behavior."[40]

In fall of 1966, Grace would write to Barbara that she was sure "you will be as amazed as I was" to know that Grosman had finally printed the lithographs, though without the *Archaics* title, "because of Doubleday."[41] She added that she had been signing prints from each edition from 10:30 A.M. to 5:30 P.M. ("'Palm Trees' isn't so bad to write twenty-five times but 'Who Will Accept Our Offering at this End of Autumn'!!"), and that "La Grossman" would be contacting Barbara to ask for a new poem for a "special edition portfolio." Barbara responded that she was "very eager" to see the lithographs.[42] Grace was delighted with the new poem ("It is intensely visual, you are one of the most visual of poets") and pleased to learn that there was no copyright problem after all in using the *Archaics* title.[43] But when Barbara discovered that Grace's lithographs were being exhibited (at the Martha Jackson Gallery and the Whitney Museum[44]) with no credit to the poems that inspired them, she was understandably upset. After a long silence, Guest brought up this painful subject, couched in an otherwise friendly letter.[45]

More than two decades later, in a conversation with a friend about the prints (which she was selling), Barbara didn't mention her slighted feelings—though she didn't seem interested in getting together with Grace, who was summering nearby in the Hudson Valley.[46] For her part, Grace inexplicably rated Barbara as a lesser poet who didn't push beyond the conventional and (perhaps with more reason) was not an integral part of the early scene that coalesced around Frank O'Hara, James Schuyler, and the other poets in her circle. Guest "shocked no one, least of all herself," Grace claimed,[47] as if this were the litmus test of authenticity. Leaning on her image of Barbara as an upper-middle-class woman who had condescended to her, Grace claimed that the collaboration was a way of exploring her fears that her marriage and move to Baltimore were plunging her into an alien world of middle-class comfort.[48] She recalled that when she had told Harold Rosenberg she was collaborating with Barbara, "he made a face and groaned."[49] But none of this

angst or criticism surfaced in the women's correspondence during the time of the poems' and prints' creation. It may be that what Grace was really reacting to was her memory of impotence, deracination, and critical opprobrium in those early Baltimore years, when her world had shrunk and her options seemed almost nil.

At first, she tried burying herself in the studio. She developed a new collage technique, tearing up her watercolors and assembling the shards on sheets of paper. This was a way of salvaging portions of paintings that didn't work out to her satisfaction and giving them new life—whether as lyrical abstractions (*Variations on Round Pond Themes*) or, in later years, rhythmically complex figural compositions (*The Artisans*) and self-consciously stylized landscapes (*Sarasota Sunset*). In the spring of 1962, when Samuel Wagstaff wrote to ask if she would deliver a lecture at the Wadsworth Atheneum—a prominent museum in Hartford, Connecticut, where he was curator of contemporary art—she turned him down. "Like many things, it is something I do well," she wrote, "but at a terrible cost to myself in time nerves energy etc."[50]

Grace did make one last valiant stand in the New York art world later that year, in a controversy simmering in the pages of *Art News*. B. H. Friedman—a real estate executive and art critic whose later books included a Pollock biography and a monograph on Alfonso Ossorio[51]—had published his first novel, *Circles*. A clumsily written satire of sexual and artistic rivalries, it features an alcoholic artist (a crude version of Pollock) who "paints" by shooting a canvas with a machine gun. May Tabak, whose 1960 novel *But Not for Love* covered similar territory—marital upheaval, rivalries, and other edgy relationships in the East Hampton artists' enclave—but with a sense of humor, wrote a damning review in the April issue of *Art News*. Next came an angry rebuttal by Helen Frankenthaler. Tabak gratefully called Grace's letter in support of the review "a gem of restraint and dignity." Grace, who had seen herself as the heroic Maid of Orléans years earlier, must have loved being described by her friend as "the heroine of the entire saga…the Joan of Arc of the moment."[52] (It was probably especially awkward for Grace to battle Friedman, because he had edited *School of New York: Some Younger Artists*, published three years earlier, which included a glowing and perceptive essay about her work.[53])

When a reviewer in the November issue of *Art News* sniped at Grace and Helen as attractively dressed, comfortably married women—as opposed to Joan Mitchell's bohemian Parisian lifestyle, which the writer linked to praise of her more "original" paintings—Jane Freilicher wrote a suitably frosty response.[54] (Coincidentally echoing Barbara's remark about Morisot, Helen had recently picked out a postcard of Manet's 1870 portrait of his pupil Eva Gonzalés at her

easel to send to Grace, with a note suggesting that she and Helen had zoomed beyond the status of women painters of that era.[55]) A welcome ego boost came with the publication of *Current Biography Yearbook 1962*, which called Grace "[t]he most celebrated woman painter in the United States today."[56]

GRACE WAS STEEPING herself in Virginia Woolf's experimental novel *Jacob's Room*, marveling at how one passage established Jacob's sense of time by describing his view of a ship moving on the water. Ships were also a presence in her own life: she often strolled around Baltimore harbor. During these years, Grace and Win spent part of the summer in Clark's Cove on Maine's Bristol Peninsula, renting an isolated house with a lily pond. She reveled in her new surrounding, exulting in daily visits by great blue herons. Removed from her usual habitat, her visual sense was in overdrive. On the way to the house, she would constantly draw Win's attention to the scenery while he implored her to keep her eyes on the road.[57] One summer in Maine yielded several oil-on-paper paintings inspired by the "really open and wild" landscape—works in which Grace tried to paint "the natural" and "the human" elements either together or separately without specifically aiming to paint a landscape or a figure.[58] She wrote to Barbara that she was using nature to define "the emotional space between oneself and 'life.'"[59]

As artists do, Grace allowed the various environments she encountered to swirl around in her imagination and seep into her work. In an undated note, she once wrote that the difference between abstraction and nature painting is that "one is working out of nature, the other[,] into nature."[60] As if scolding herself, she added, "Life does not exist as raw material ready to be made into art." Joan Mitchell expressed similar sentiments years earlier when she said that she painted "from remembered landscapes that I carry with me—and remembered feelings of them," rather than trying to copy nature.[61]

Grace had worried about the softening influence of nature on her work, yet the combination of a fulfilling love life and the pleasures of a summer retreat inspired a strong group of newly lyrical abstract paintings—including *Lily Pond, Phoenix, Marilyn, William of Orange*, and *The The*—suffused with bright color and laced with the curving shapes of fruit, leaves, and sexual organs. For Grace, color was not a matter of theory, as it was for Josef Albers and Hans Hofmann. Rather, she would consider the mood of a painting and choose her colors based on an intuitive sense of how they could evoke "what the feeling is going to be about." She believed that the most important element in painting is light, and she took pains to create an inner luminosity in her application of color—an attribute she found most highly developed in Rothko's paintings, and not at all in Hofmann's. *Lily Pond* was inspired by

Monet's cyclorama-like water lily paintings from the 1920s at the Musée de l'Orangerie, which she saw on her trip to Paris.

Although *Archaics* marked the end of Grace's involvement with classical themes, she began to embrace images of modern goddesses. Marilyn Monroe's death in 1962 from a barbiturate overdose inspired *Marilyn* (1962). Grace floated vivid details in a giddily feminine pink and purple haze: the actress's gleaming teeth in an open-mouthed smile (from a *Life* photograph), a wavy blonde lock of hair, a blue eye, white klieg lights, and a gesturing hand emerging from a ruffled sleeve (based on a photograph of a detail from a fifteenth-century fresco[62]). Despite the luminous quality of the painting, it has a strangely terrifying quality because of the contrast between the brilliant white arc of Marilyn's teeth—the only area that seems to push forward into space—and the empty black space inside her mouth.

As a subject for serious art, in an era when popular culture was still held at arm's length by highbrow culture, Marilyn Monroe was not on par with Dido and Aeneas. But Tabak had urged Grace not to have any qualms about making a painting about Marilyn. ("What does abstraction mean if she wasn't an abstraction?"[63]) At the opening of Grace's fall 1962 exhibition at the Martha Jackson Gallery, Harold Rosenberg told his wife that this was the most interesting piece in the show.[64] Grace may also have gained courage from her mentor's example. De Kooning had led the way with his big-eyed, lipsticked *Marilyn Monroe* (1954), whose oddly chunky torso echoed the colors of her hair and lips. She could also look to Frank O'Hara, whose poem "To the Film Industry in Crisis," written the following year, evokes the actress "in her little spike heels" in the 1953 thriller *Niagara*.[65] In "Returning" (1956), he facetiously quotes the film goddess on being a sex symbol.

In its wistful sensibility—though, of course, not its style—Grace's version is akin to Audrey Flack's glossy photorealist still lifes *Marilyn (Vanitas)* and *Marilyn (Golden Girl)* from the late seventies. Flack viewed the actress as "a symbol for love, the need for love, and the pain of never having enough love," identifying with her because "she never really got enough love from her mother or father."[66] This was an ache Grace knew well. She and Flack were also both nostalgic about—as Grace put it—a time when people had a choice of gods and goddesses to worship. "We don't have these now," Grace said, "so we set up all of these popular culture idols, and we invest them with qualities of love and hostility and so forth."[67]

Another painting in her gallery show, *William of Orange* (plate 22), is a lush, glowing canvas with vaguely fruit-like shapes painted in nearly transparent layers of vivid color. It was inspired by a patch of orange on another

painting. While looking at it, thoughts of William of Orange, a seventeenth-century ruler of England,[68] popped into Grace's head, reminding her in turn of her mother's English background. She decided to paint one canvas for her mother and one for her father (*Eire*).[69] Why she felt impelled to commemorate her parents just then (or ever) remains a mystery. Grace may have told the world that she hated her mother, but when she needed someone to care for her young son, Mrs. Hartigan repeatedly filled that role, and in the early fifties, when Grace was down to her last dollar, she sometimes turned to her parents for a loan. Despite her differences with her parents, their ongoing support may have begun to mitigate her adolescent rage.

Grace borrowed the odd title of *The The* (plate 23) from the final words in "The Man on the Dump," a poem by Wallace Stevens.[70] The last line reads, "Where was it one first heard of the truth? The the." Stevens (1879–1955) was "the one poet in the forties with whom artists could identify," according to art critic Dore Ashton, because he was able to combine a sense of unreality with "the drift of incidents" in everyday life.[71] In the poem, the man who is "reject[ing] the trash" on the dump—things that have lost their usefulness—is constructing a new world of his own through the creative force of language. Grace seems to have chosen this reference because she was doing the same thing—creating her own world by painting it. The crowded, semi-indistinct images in *The The*—fruit and landscape forms and boats and open books—are washed in vivid pink and red that give way to green and blue on the right side of the canvas. This rhythmic inventory of whatever was passing through Grace's mind at the time has been aptly described as "an image in the making."[72]

Twenty-five years later, Grace explained that *The The* "came as I was struggling for imagery and losing it." In the fifties, after Frank had introduced her to Stevens, she had read the poem over and over. She had always wanted to make "order, beauty out of garbage or chaos," and now, "having moved to provincial, junky, seedy Baltimore, I decided to do a painting about all this…." The painting became more abstract as she worked on it, "just as Stevens's poem begins with concrete images but concludes with an abstract statement." She understood the last words of the poem "as sort of throwaway repetition," like the loosening-up impulse of Abstract Expressionism.[73]

Grace's deep personal connection to modern and contemporary literature was a hallmark of her early career. In a statement for another exhibition of her work of the sixties, she quoted August Strindberg: "For me the joy of life consists in the mighty and terrible struggles of existence, in the capability of experiencing something, of learning something."[74] While some gallery goers may have viewed this reference as mere pretentiousness, Grace clearly felt a

kinship with the Swedish playwright's passionate forthrightness. He was railing against a late-nineteenth-century theatrical scene that favored light farce; she was decrying a mid-twentieth-century art world that had turned against deeply felt emotion, the touchstone of her paintings.

HELEN WROTE TO Grace to assure her that she would be at the Martha Jackson Gallery opening "to support you in spirit and body if necessary." In a letter that playfully ended with the question of who would be crowned Miss America in the upcoming pageant, she remarked that the two of them were like former stars fearful of having to face an audience again.[75]

Jackson, who had studied art history at Smith College, began collecting modern art with inherited money and opened her gallery in 1953. She was one of several women art dealers of the period, including Marian Willard, Eleanor Ward, and Betty Parsons, who became forces to reckon with in the New York art world. Although Jackson was also interested in European modernism, she became known as a leading supporter of Abstract Expressionists, including de Kooning and Gottlieb. Located in a spacious town house on East 69th Street, the gallery marked Grace's first experience of showing her work on the tony Upper East Side. In 1958, Alfred Leslie had been the first de Nagy gallery artist to move to the Martha Jackson Gallery, an exit that enraged John Myers, who would soon lose Helen Frankenthaler and Kenneth Noland to other dealers.

Grace's show was made possible through an arrangement with Beati Perry, who had to close her gallery after the death of her business partner but was reinventing herself as an artist's representative.[76] There was some awkwardness involved in the Perry-Jackson arrangement, with Jackson initially complaining that Perry was uncooperative. The agreement that was finally hammered out stipulated that Perry would pay for one thousand copies of a catalogue measuring eleven by eight-and-a-half inches with the Jackson logo, and would supply photographs of the paintings (a minimum of eleven works on canvas and fifteen on paper). The gallery would pay for public relations, additional press photos, mailing, printing of the announcement, advertising, and transportation of Grace's works from her studio, and would receive 30 percent of the price of each work. The cost of the opening party—to be held at the gallery or at Perry's or Jackson's home—would be split between Perry and Jackson rather than (as was customary) between the artist and the gallery.[77]

In the press release, Jackson chose to quote a remark ("one of the most personal and talented artists of her generation") made by James Thrall Soby back in 1957—not exactly hot off the press, but art-world reputations were less volatile in those days than they are now, and the chorus of enthusiasm for Abstract

Expressionists had quieted to a murmur in recent years. Soby dropped by the gallery before the opening and "especially loved *Marilyn*," Jackson wrote to Grace.[78] (Another delighted viewer was paint company founder Leonard Bocour, who had once been president of the Marilyn Monroe fan club. He offered "congratulations and best wishes from the President of the Grace Hartigan Price Fan Club."[79])

Grace's statement for the exhibition catalogue was intended to register purely on an artistic level, but it also revealed the rapture of a woman deeply in love.[80] She explained that "The 'look' [of the paintings] is the result of a completely new (to me) attitude toward emotion. I have left expressionism, and although the new paintings have feeling, the emotion is that which each painting demands and does not necessarily express my own private, confessed emotion as a human being." Left behind, she wrote, is the "'oh, groan,' the anguish. I now hope to triumph; to bring to each painting as much clarity, beauty, and even ecstasy as I am able. The scream has become a song."[81] *Newsweek* devoted several column inches to Grace's show, quoting her statement and adding her assertion that the fruit forms "are a celebration of abundance and the love of life and things that grow." The accompanying photograph showed the smiling painter next to *Marilyn*, which the article oddly described as conveying "this sense of abundance made human."[82]

Jackson had invited Grace and Win to a dinner the Monday before the show opened, but Win had to give a lecture that day, so they couldn't make it.[83] It is telling that Grace didn't simply come on her own. No longer seeing Dr. Kardiner, she had lost interest—as she wrote to a friend—in traveling to New York by herself.[84] The real reason may have been the painful contrast between her current and former existence, and her belief that—for the sake of both her painting and her personal life—she had to focus on the present, not the past. To her delight, her recent work "flowed like a miracle. I could hardly put it down fast enough."[85] She felt that "this 'breakthrough' accounts for such a strong note of joy and beauty." Typically, she cautioned that "future work won't be 'only' beauty," and she also had "a lot to say" about the "ugly and sad" things she had seen and experienced. Yet, she concluded—as if arguing with herself—"the notes I sound may well always be concerned with triumph...this is what I feel is my purpose in creating."

As luck would have it, on the day before the October 23 opening, she came down with the flu. So her father and mother—who both seem to have followed their daughter's success with pride and pleasure—went in her stead. (Grace once said that her parents began to approve of her career as an artist only when she started to sell her work and receive attention in the press.[86]) It

is noteworthy that she preserved Mrs. Hartigan's letter[87] about the evening, one of very few she kept. The paintings, her mother reported, "were all lovely in a beautiful setting against white walls." Jackson had introduced the Hartigans to collector Larry Aldrich and May Tabak ("very pleasant woman…said she is so fond of you"). Grace's mother was a sharp-eyed observer of the scene, noting "very well dressed people," as well as "some very odd looking characters with wild eyes and long hair, shabby girls with them, poor artists, I imagine."

In her letter to Grace, Tabak described the scene somewhat differently: "the whole art world seems to have turned out…all very enthusiastic."[88] But she was worried. Unable to pick up any clues from the dealer's habitual "perfectly querulous monotone," Tabak feared that Grace might have polio. Jackson had apparently exaggerated the severity of Grace's illness, perhaps out of concern that people might misinterpret her absence.

Grace's parents left early, missing the after-party, held at 10 MacDougal Alley, near Washington Square, the Perrys' Greenwich Village home. A steel band energized the crowd of young artists, famous artists, critics, and museum directors, and Beati supplied copious amounts of party food. But an undercurrent of anxiety ran through the festivities. Hanging over everyone's head was the Cuban missile crisis, which had led many to fear the beginning of World War III. Beati's son Hart, then a teenager, watched in amazement as some of the grownups got totally smashed, one man dangling a woman by her ankles from the second-floor window.[89]

In the *New York Times*, Stuart Preston called Grace's exhibition a "beautiful show" in which Grace "manages to suggest something sensuous and even sensual in the way softly rounded forms snuggle and embrace."[90] More significantly, in *Art News*, Irving Sandler praised Grace's "increasingly exultant lyricism" in "striking and passionate canvases" in which she "succeeds in being gentle, light in spirit and even sentimental, without sacrificing the boldness, vigor and power."[91] Before the review was published, Jackson wrote to Grace that Sandler, like "everyone who has seen the paintings…feels you have taken an important step forward."[92]

Yet despite a lavishly produced catalogue, the exhibition was poorly attended and there were just two sales, of lower-priced paintings on paper. "Had the prices ranged from $2,400 to $4,000, *The The* [$13,000] excepted, I am sure we would have sold most of them," Jackson wrote to Grace after the show closed. "The small oils [priced from $4,500 to $7,000, apparently at Grace's insistence] were much too high for today's market."[93] She explained that the drop in stock prices caused by the political crisis made it difficult to sell work not by "an acknowledged master" for more than $2,500 (about $19,000 in today's money).

Sales were a major problem for Grace during these years. Still, she later called Jackson "a wonderful dealer...who not only supported me emotionally and with faith but supported me financially."[94] Jackson thanked Grace in December for her positive attitude.[95] The harmonious relationship between artist and dealer faltered only once. In 1967, Grace had agreed to donate a painting to the University of Chicago, receiving a note of thanks from the university's president, while Jackson attempted to get a collector to purchase the painting and donate it to the university—a level of interference protested by Grace, May Tabak, and Harold Rosenberg. Jackson wisely agreed to bow out.

Earlier in 1962, in what must have seemed like a shrewd move, Grace donated her 1958 painting *The Vendor* to the Washington Gallery of Modern Art. This new nonprofit institution, supported by a major grant and a board of trustees studded with glittering names,[96] was located in a renovated carriage house near Dupont Circle. Grace's canvas in memory of Jackson Pollock (she added the letters "I.M.J.P." in the lower right-hand corner) was the fledgling gallery's first painting, duly acknowledged in two *Washington Post* stories. One was accompanied by a photograph of Grace—wearing her working outfit of rolled-up jeans, turtleneck, and slipper-like boots—posing with newly appointed gallery director Adelyn Breeskin,[97] a sturdy throwback to decades past in her ladylike hat and sensible shoes.

MEANWHILE, GRACE AND BEATI PERRY were increasingly at loggerheads. In her new role as Grace's representative, Perry wanted to find a broader audience for Grace at a time when interest in Abstract Expressionism was waning. She introduced Grace to a writer who, according to Perry, had explained the work of scientists to the general reader. Perry might not have been paying full attention; the woman's letter to Grace mentions a ghostwritten article for Albert Einstein on the subject of "the relation of love to democracy."[98] When the writer requested that May Tabak forward Grace's letters to her, Tabak wrote to Grace to warn her that "[i]nept admirers can do as much damage as a full time enemy, alas."[99] A few days later, Grace furiously rejected the writer in a letter to Perry as an "inept admirer."[100]

What Grace wanted was a book by a writer with a poetic style equivalent to her own. In her mind, Frank—now, sadly, no longer close to her—would have been perfect. Perry remonstrated to no avail that the time for a book appealing to a coterie was long past. True enough, but surviving letters from the writer indicate that she was unsure about what was involved in a researching a book about an artist. Grace also did not take kindly to Perry's possibly tongue-in-cheek suggestion that she should try selling her own work. Fortunately, Perry, like all of Grace's loyal friends, was able to ride out her angry outbursts.

Although the plan of commissioning a book about Grace's painting fizzled out, she did make the cut for the massive two-volume *Art USA Now*, published in 1963, which profiled more than one hundred abstract and figurative living artists ranging in age from mid-twenties to mid-eighties (though only eight are women). In her statement, Grace neatly summed up her career to date, concluding that she hoped her art "keeps asking the right questions." Five of her paintings were illustrated.[101] In Walter's studio photo for the book, she leans over a table as she delicately touches up one of her screen prints for *Salute*, which is taped to the wall. This seems an odd choice of "action shot" to portray a painter who normally worked in a hugely physical way, on a much larger scale. She also appears in Walter's full-page portrait, wearing her black turtleneck and shiny hoop earrings, her lips midway between a smile and an impending snappy remark.

It is amusing to compare the book's straightforward biographical sketch of Grace as "an explorer who travels inwardly," written by her collector friend Roland Pease,[102] with his portrayal of Georgia O'Keeffe ("a talent feminine and strong"), whom he described physically ("her body slender, quick"), marveling that "she likes to dress up in cowgirl clothes." Of the other women in Grace's circle, Joan Mitchell was included but, surprisingly, not Helen Frankenthaler (mentioned only as the then-wife of Robert Motherwell, one of the few artists who chose to be photographed in a suit and tie).

ALWAYS APT TO REJECT whatever she had just achieved, Grace suddenly turned her back on her joyously sensual paintings. During the summer of 1963, she papered over the windows in her Maine studio to shut out nature and be alone with her feelings of loneliness and rejection. The new paintings that resulted from this strategy—*The Hunted*[103] and *Human Fragment* (plate 24)—are zones of loosely sketched fragments of animal and human bodies; one canvas is filled with furious brushstrokes while the other evokes a sullen torpor. In Grace's statement for her 1964 solo show at the Martha Jackson Gallery, she criticized her paintings of the early sixties as "too lyrical." Instead, she "decided to draw from modern life these elements which seem to me most dangerous or frightening, and exorcise them so to speak in the art of painting.[104] While it might be tempting to look to political events in this era of upheaval as catalysts for Grace's new approach, that would be misguided. The sinister forces she would grapple with in these works were always embodiments of her personal experience, just as they were in Mexico, when she painted her first "exorcism" painting, *Secuda Esa Bruja*.

An article about the Barbie doll ("The Most Popular Doll in Town") in the August 23, 1963, issue of *Life* magazine gave Grace a welcome new subject. She

was incredulous that, while the doll itself was inexpensive, her wardrobe cost $136 (nearly $1,000 in today's money). "I thought, that says a lot about our society," she said later.[105] And so did Barbie's unnaturally stylized, adult figure. When Grace was a ten-year-old girl with roller skates, she pointed out, her doll had roller skates, too: "She didn't have any boobs; she didn't have a boy-friend."[106] Grace worked from the magazine's photos to paint *Barbie* (1964).[107] The doll's pert glamour splinters into fragments—an eye (notably large and heavy-lidded in the original doll), a breast, an evening dress. Grace declared to a friend that she liked *Barbie* and two other new paintings, *Jolie* and *Joy*[108] "as well if not better than anything [I've done] in my life."[109] Decades later, refer-ring to her process of "declaw[ing] the terribleness of popular culture and turn[ing] it into beauty or meaning," she told an interviewer that the painting took a commodity demeaning to women and "made it powerful."[110]

Barbie and Midge (1964)—the freckle-faced, brunette Midge Hadley doll was introduced the previous year as Barbie's best friend—further decon-structed the Barbie mystique with phallic, buttock, and breast shapes, as if the two dolls were competing for sexual favors. (Though likely not from Ken, a doll designed with a tiny bump covered by painted-on shorts. "If you're sup-posed to think about yourself as a bride that deserves a $100 dress, and you only cost $15, and your husband is a castrated man, boy that tells you some-thing about American morals," Grace joked years later.[111])

Compared with Grace's meditative 1955 painting *Still Life with Dolls*—in which disembodied old-fashioned doll heads lurk like dream images among abstracted vases, bottles, and unidentifiable objects—her Barbie paintings are deliberately raw and vulgar. The "horrendous materialism coupled with a pre-cocious sexuality"[112] that Grace saw in the Barbie doll is on full and furious display.

In her statement for the 1964 show, she wrote that two of her paintings (including *Mountain Woman,* with its cartoonish, white-faced figure planted, like a snow angel, in a barren landscape) originated in "Marilyn's tragedy" and "ended up being about two kinds of women who would not be destroyed." Yet in a letter to the novelist James Michener, who bought the painting, she of-fered a more high-toned explanation: the painting was inspired by "Cézanne who made mountains and women simultaneously."[113])

Grace would return to both Marilyn- and doll-related themes decades later. (In 1989, she painted *Myopic Marilyn (Feathers)*: twin blurs of gray and red obscure the figure's eyes and lips, perhaps signaling the actress's loss of control toward the end of her life, when she was heavily dependent on alcohol and prescription drugs—a condition that by then had become all too familiar

to Grace.) Now, though, she found that even when she started with a specific subject, her abstract impulse still took over. As she told an interviewer, "I would start with subject matter and lose it…except for a few things here and there, in the act of painting."[114]

In a letter to Martha Jackson, Grace claimed that *Jolie*, *Joy*, and *Little Salome* were attempts to exorcise the "brutal, despicable" photographs on the covers of girlie magazines.[115] Her rage at such images seems unwarranted at a time when the typical men's magazine cover featured a cheerful-looking woman posing in her underwear. Yet nothing about *Little Salome*, with its pile-up of brightly colored abstract forms (including petal-like pink "breasts" in the lower-right corner) suggests Grace's grim outlook; the "exorcism" was successful.[116]

Harold Rosenberg once asked Grace if she had had any good ideas lately. As the coiner of the term "action painting," he must have been gratified when she responded, "Put a paintbrush in my hand, and I'll let you know."[117] But the era that had nurtured her artistic development was already history. Included in a *New York Times* capsule-review roundup of "noteworthy exhibitions" in various styles, her paintings were praised only for their sensuous qualities.[118] Tellingly, the next review in the column was of Andy Warhol's silkscreen paintings of flowers in his first show at the Castelli Gallery. Since 1962, Warhol had been producing his own "Marilyn" paintings, based on a black-and-white glossy photo sent to fans of the actress, though these works were not in the Castelli show. While some critics were slow to comprehend what Warhol was doing, Pop Art (and Minimalism) had already knocked Abstract Expressionism off its pedestal. The new styles had nothing in common visually, but both were coolly unemotional—the polar opposite of the work to which Grace and the artists in her circle had dedicated their lives.

She was sadly aware of this state of affairs. Grace told a newspaper reporter that, after years of acclaim, the critical rejection of Abstract Expressionism gave her the feeling of being a deep-sea diver with the bends.[119] In a seminar at the University of Minnesota Gallery in September 1963—where her recent paintings were on view—she bemoaned art as entertainment, the death of the avant-garde, and the lack of interested viewers and sales for artists who had not jumped on the Pop or Minimalist bandwagon.[120] Quoting an essay by the novelist Philip Roth,[121] she worried aloud about the increasingly impotent, self-pitying state of a serious artist or writer who had lost a sense of community and was likely to turn to "the self" as a subject.[122] Grace may not have realized it at the time, but "the self" would play an increasingly dominant role in her paintings.

WHEN GRACE DRANK too much in public—and sometimes, even when she was sober—she would shoot from the hip and anger her friends, as well as people whom she needed to get along with for the sake of her career. As Hart Perry said, "She wasn't a diplomat. She was a fighter."[123] On trips to New York, she sometimes angered her friends with a thoughtless remark or an insensitive gesture. She stopped by Frank's and LeSueur's flat one Saturday afternoon with the goal of picking up an etching by Franz Kline that Frank had impulsively promised her at a party, when he thought she looked sad. Barely glancing at the print and refusing the offer of a drink, she gave him a quick kiss and left. The next time Grace came to see him, he took a painting she gave him off the wall before she arrived and stashed it in a closet.[124]

On another occasion, meeting Frank and Philip Guston and his wife Musa at a Chinese restaurant, Grace made a grand entrance in a fur coat—from a barter arrangement for a painting with furrier Jacques Kaplan—and tactlessly insisted that Guston, then facing serious financial problems, ought to get his wife something similar. Musa quietly insisted that she was happy with her cloth coat.[125] Once, when Grace arrived at the Cedar Tavern in a satin-trimmed black mink coat, an artist remarked that she looked like she had "the keys to Madrid" in her pocket.[126] This veiled reference to Spanish royalty—unflatteringly depicted by Goya—may have been a backhanded compliment. In Grace's small undated painting *Self-Portrait in Fur*, the expression on her face could be read as either snooty or sensuous as she snuggles against the coat collar.[127]

Grace lashed out at her friend May Tabak during this period, accusing her of "hatred" during an altercation at a Thanksgiving dinner at the Tabak-Rosenberg house that resulted in Grace and Win abruptly walking out. "What you heard was shock and disbelief of your questioning and your manner, and shame at your total disregard for Win and your various friends and hosts," Tabak wrote.[128] Grace had been angry because Mary Abbott and her husband—with whom Grace had quarreled—were among the guests.

Compounding Grace's dwindling sense of self, she was unbearably lonely, with Win spending his days in his lab and no Cedar Tavern to hang out in, no poet soul mate to call, no possibility of running into a fellow artist on the street. The notion of meeting a "local" artist—someone whose name was unknown beyond the city—was meaningless to Grace, she later said. In New York, the "local" artists included Guston and Kline.

In the fall of 1964, something finally happened to pull her out of the doldrums. Eugene Leake, president of the Maryland Institute College of Art, called to offer her a show at the college. She turned him down, saying she

didn't have work available, but she asked if there was anything else she could do over there that wouldn't interfere with her painting.[129]

The institute was a venerable Baltimore institution, founded in 1826 as the Maryland Institute for the Promotion of the Mechanic Arts, with the goal of educating workers in a broad range of trades.[130] Baltimore was then the third-largest city in the United States, and the largest in the South. By 1840, the population surpassed the 100,000 mark, with an influx of German and Irish immigrants. In addition to attracting a core student body of mechanics and artisans, the institute invited fine artists to study perspective drawing. Women were allowed to enroll early on—a pioneering step in the history of U.S. art education—leading to the debut of a "Female Department" in 1854 that accepted amateur artists, as well as women planning a career in art. Instruction featured small group sessions and—noteworthy at a time when copying masterworks was considered good training—stressed the importance of original work.

By the turn of the twentieth century, the institute—now known as the Maryland Institute Schools of Art and Design—had opened a school of sculpture, the first of its kind in the nation. After the original downtown building burned to the ground in the Great Baltimore Fire of 1904, a gift from philanthropist Andrew Carnegie made possible the construction of a stately four-story structure on Mount Royal Avenue, in the comfortable Bolton Hill residential neighborhood.[131] In 1923, the institute's art gallery was one of the first in the United States to show work by the still-controversial Matisse, loaned by the city's preeminent collectors, Claribel and Etta Cone.

But a conservative pall—both aesthetic and social—soon settled over the institute, isolating it from the progressive supporters of the Baltimore Museum of Art, which opened in 1929. Modernist art styles were no longer exhibited or taught, and even in the fifties, a woman student who wore slacks to class would be sent home to change. In 1957, a new director who favored abstraction told janitors to smash some of the plaster casts and dump them in the trash. He lasted all of two years.

Enter the institute's savior, a tweedy dynamo who had studied at the Art Students League in New York in the mid-1930s, earned two degrees from Yale, and pursued a lifelong passion for landscape painting. Eugene ("Bud") Leake, stepped into his new job in June 1961, when he was forty-seven. He revised the curriculum and hired faculty primarily on the basis of their track record as artists. During his first two years, enrollment jumped by 30 percent. Leake was delighted to meet with Grace. No matter that her star had dimmed in the art world in recent years; she was part of a fabled era in American art,

her paintings were in the collections of eighteen museums,[132] and she was still young and vigorous, actively pursuing new directions in her studio. Not to mention that she already lived in Baltimore, where a recent newspaper story about her was headlined, "America's Top Woman Painter."[133]

When Leake asked her if she wanted to work with his graduate students, Grace said she was willing. Her timing was perfect; the school was going to inaugurate a graduate painting program, and he realized she would be the ideal person to lead it.

14

Teaching

ON HER FIRST VISIT to the Maryland Institute College of Art,[1] Grace climbed the steps of the imposing Renaissance Revival building that had housed the institute since 1907. The cavernous, barrel-vaulted entryway was adorned with floral carvings, plaster casts of ancient statuary, and wall plaques bearing the names of Italian Renaissance artists. Even the grand staircase leading up to the studios, classrooms, and library recalled the founders' high-minded approach to art education. But the building lacked the one thing art students in the mid-sixties really needed: sufficient studio space to make large-scale work. The institute's Mount Royal School of Sculpture had already been squeezed out, obliged to rent old row houses to accommodate its students.

In his search for an additional site, President Leake had lucked out. The Mount Royal Station of the Baltimore & Ohio Railroad—a massive late-nineteenth-century Romanesque structure down the street from the institute—had closed in 1959 and had fallen into disrepair. Anxious to dispose of it, the B&O sold it to the institute for $250,000. When Grace arrived, the renovation—a superb early example of adaptive reuse, designed by architect Richard Donkervoet of the Baltimore firm CSD[2]—was in its final stages. The building had retained its signature clock tower and the full height of the original waiting room, now embraced by two floors of well-appointed studios, a lecture room, and a library that accommodated nearly five times as many books as its predecessor.

An energetic fundraiser, Leake enabled the institute to hire more faculty and staff, pay salaries in line with remuneration at other art schools, and create a sabbatical program (which Grace would take full advantage of).[3] The new graduate school of painting was named after the Baltimore-based Hoffberger Foundation, which contributed $250,000 (about $1.7 million in today's dollars) to its creation. But for the time being, the school lacked a permanent home. So Grace met with her students in a succession of inconveniently located row houses—one of which had ceramics studios in the basement that produced a thick carpet of clay dust—and then in a former textile factory.

In 1964, her first year at the Hoffberger School, Grace was paid $1,600 (nearly $12,000 in 2012 dollars) for one half-day a week as "painter-in-residence," providing critiques for five graduate painting students. Her official duties soon expanded to include museum visits with her students (four days per semester), registration counseling, selecting and inviting visiting critics, graduate committee work, and assistance in installing the master of fine arts exhibition.[4]

After several intermediate raises, her salary was bumped up to $4,800—unusually high for a part-time art teacher in 1971. "What a lovely surprise," she wrote to Leake. "It's not the money, it's being appreciated that means so much. What am I saying! I sure can use the money too. Many thanks."[5] Grace bridled at the documentation required by the contract renewal process ("a humiliation for both evaluators and the evaluatee"[6]), but in 1980—when she officially became director of the Hoffberger School—her salary began a notable upward climb, soaring to $103,269 in her final year. She remained on good terms with Leake, who retired in 1974, throughout his life. After treating him and his wife to a Champagne dinner when she was emerging from a devastating personal crisis, he wrote, "What a great friend you are."[7]

Leake initially attempted to involve Grace in the academic governance of the institute—the "graduate committee work" stipulated in her contract. A September 1964 note from him politely reminded her that she had "probably received official announcement of the faculty meeting"; a note on her contract renewal for 1968–69 says that she "must serve on one committee." But no one remembers Grace actually attending any meetings. When she became director of the school, such requirements were quietly dropped from her contract. (However, years later she wrote to a friend that if she were faced with attending an all-day graduate faculty meeting or having a needed root canal, she preferred the latter.[8]) During her years at Hoffberger, she kept the rest of the art school at arm's length. "She was a diva," said Fred Lazarus, who was appointed president of the institute in 1978. "She loved the diva role, and she mastered it well."[9]

A Picture Book for Her Grace—a collage with verse assembled as a Christmas gift by two students in 1965—suggests the tone of Grace's early presence on campus: "On Mount Royal Avenue down near the bar / 'Her Grace' hat in hand proceeds from the car / On to the studios, the weekly jokes....Louise is first, with Venus rotting / All the forms are outward knotting / 'Make it bigger,' says the patient sage...."[10] Grace later claimed that she didn't give "boring" technical advice. Instead, she would attempt to "reach into a young person's intelligence and talent and to encourage him to try to bring out his individuality."[11] She believed that students respected her own doubting and questioning of her work: "I would never ask anything of them that I don't ask of myself."[12]

Grace quickly established a significant reputation as a teacher. "Everybody had absolutely profound respect for her because of who she was, because of her reputation, and because of the inherent autonomy of the Hoffberger School of Painting," said provost Raymond Allen, who arrived at the institute in 1970 as a painting teacher. "Without question, she was the most [famous] faculty member, and that in itself was pretty intimidating for most folks. If you square that with her reputation as one tough cookie, *respect* is the word."[13]

In the early seventies, the institute founded the Mount Royal School of Art, initially a three-year program for graduate painting students who required more preparation.[14] Painter Seymour ("Babe") Shapiro was the first director of the school. In 1980, when the Hoffberger School finally landed a permanent home—a renovated four-story brick warehouse known as the Fox Building—the Mount Royal School also moved in. If anything, this new proximity to Mount Royal seems to have stiffened Grace's resolve to have nothing to do with it. Yet she was always friendly with Shapiro, who fondly remembered a trip they both took to Gertrude Kasle, their mutual dealer in Detroit, on a holiday weekend in the 1970s.[15] Grace later claimed that she discovered in 1979 that the Mount Royal director was paid twice her salary and complained about it.[16] For the 1980–81 academic year, she received $19,800, slightly more than twice her salary of the previous year.

Although Grace resigned from the board of directors of the College Art Association in 1968 in a huff, citing a lethal combination of "anger and boredom," the organization presented her with their Distinguished Teacher of the Year Award nine years later. The award committee, which included her old friend Miriam Schapiro, honored Grace in curiously vague terms for "her connection to her environment and to her inner life [which] provides us with a strong example of the way an artist works." Perhaps this unenlightening tribute was meant to allude to Grace's work ethic. "If nothing else, by model alone, she taught how to live a life of productivity," a colleague said. "Students [learned] that you don't look to the public, to the gallery, to the museum, to the press to validate who you are. You look to your inner sense of self, your intellect, your being. That was Grace."[17]

Grace ran the Hoffberger School like her personal fiefdom, stipulating the number of students she would work with in the two-year program: a total of no more than fourteen—"the most I can work with on the one-to-one basis, finding and encouraging the uniqueness in each talent."[18] She made twice-a-week studio visits, "giving my 'eye' to help the painter deepen and grow."[19] When she came to campus for student critiques—artists call them

"crits"—her rapid-fire, devastating assessment might inspire or wound, depending on the recipient. After Grace entered a student's studio, five minutes of silence would typically follow, with no indication of what she was thinking. Then came the verdict.

Decades later, a young male student wryly compared her to the ferocious Gunnery Sergeant Hartman in the movie *Full Metal Jacket*. "She'd always kick you around the room," the student said, "but I appreciate her for that."[20] At worst, enduring Grace's criticisms could be considered good practice for dealing with art-world rejection. A student unaffiliated with Hoffberger who helped Grace toward the end of her life, when she was wheelchair-bound, was treated to a stinging assessment that lasted all of five minutes: "Why are you messing up your paintings on purpose?" Grace asked. "You have a lovely sense of color, but you're ruining it."[21]

Grace's sharp tongue could inflict real pain. Once, as a visiting artist at another school, she was shown an abstract painting by a student who said that it had been favorably compared to work by de Kooning. "[Grace] looked at me," the woman said later, "and in front of all my colleagues, she said, 'De Kooning is a genius. This painting is mush.'"[22]

In 1973, Grace was invited by Mercedes Matter to do a critique at the New York Studio School of Drawing, Painting and Sculpture. Matter was a co-founder of the school, which emphasized drawing from life. Impervious to trends, she remained a believer in the importance of close looking and in the way drawing enables an artist to perceive the essential structure of objects and their relationship to one another. She created meticulous still-life arrangements for her students to paint from her own collection of fabrics, small objects, and dried flowers.[23]

Matter had thought (as she wrote to Grace later) that her old friend would be delighted with the school's ambience and the work some of the students were producing. But Grace was sweepingly negative, not even bothering to differentiate among the eight students, whose still lifes were in markedly different styles. Compounding the soul-crushing effect of this session, one young woman had just learned that her application to the Hoffberger School had been rejected.[24] As Matter noted in her letter, she and Grace differed in their approach to teaching. In a *New York Times* article published the same year, Matter took graduate school art education to task for asking students to "find their own thing" instead of continuing to work on the mastery of drawing. "I think of Matisse in his old age, carefully drawing a leaf," she wrote.[25] But Grace—who used to say that she lacked "a good hand"—was primarily interested in the expressive aspect of painting.

She was generally more supportive of her own hand-picked students (she called them "Hoffbergers"), reassuring them that they were capable of better work—which is not to say that she pulled any punches. She was "kind of gruff and definitely not coddling," one of her students said. "I feel pretty good about what I've done so far," he once told her. "Though of course it isn't fully—." Grace cut him off right there.[26] She believed that if a painting hasn't been fully worked out, the painter has no right to a sense of accomplishment. Her own history of tortured worry about her work was too strong to allow others a different path. She rebuked another student who said he was pleased with his painting by telling him that she never felt good about her work.[27]

Ryozo Morishita, a Japanese painter who was Grace's student in the mid-seventies, has fond memories of her visits to his third-floor studio on Oliver Street, a few miles north of the campus. "Behind her perceptive gaze and sharp tone was a very warm heart," he recalled. Grace never spoke to him about technique or "what painting should be," but she insisted that he stop copying another painter's style. To reinforce her words, Grace repeatedly pinned the phrase "the artist is an individual" to his bulletin board—watchwords that have guided his career.[28]

Grace enlisted her students to help choose visiting artists who would give slide talks about their work and make studio visits. Her students also joined her in the mid-year review of applicants for the next year's class, based on slides of their work. Given her own clumsiness in rendering hands (coincidentally de Kooning's self-professed stumbling block), it might seem odd that Grace looked askance at applicants who avoided painting hands on their figures.[29] She once told an interviewer that she loved to paint hands because of the evocative qualities of gesture[30]—a preoccupation that was part of her life-long fascination with acting and the roles people play in everyday life. So she may have wanted to see whether a potential student showed signs of sustained attempts to meet this expressive challenge.

Evaluating an applicant's work with her students, Grace would often say, "This person has no world."[31] As a former student recalled, "Grace loved narration; she loved stories, storybook stories. If she couldn't go into the painting in some way, feel something, or be transported someplace, she didn't feel it was really happening" on the canvas.[32]

In this belief, she was also—consciously or not—echoing Hans Hofmann, who defined the "world of the artist" as "a spiritual and unified entity" made by "a creative mind in its sensitive relationship to the outer world."[33] As Hofmann's students have remarked, he had a knack for getting them to experiment and explore, no matter what style they preferred, while avoiding talk of

specific techniques. "He was always looking at you and your work," one of his students said. "He made it very personal."[34] Another praised his "genius at drawing out the emotional intensity of his students."[35]

Grace seems to have imbibed Hofmann's ethos of teaching, as observed from the model stand, even though she didn't formally study with him and believed he had little influence on her. (Although she praised his "dynamic, charismatic personality," she had a hard time understanding what he was saying. In later years, the only comment of his that she could recall was directed to Larry Rivers: "A voman's arm is not a sausage, nicht wahr?")[36]

Rather than teaching a particular style or method, Grace tried to encourage each student's unique abilities. "I am a mentor, not a teacher," she would say, referring to her view of herself as a living example of how to devote your life to art. The mentor role was familiar to her from years of being guided by the wisdom of de Kooning, Kline, and other artists she knew in the fifties. (Though she would always remind her listeners that back then, she and the giants of Abstract Expressionism were all "just friends who came together and had a good time."[37])

"She would talk about my color sense, activating certain areas—which were working, which were tentative—and how to edit myself," one student said. "She wasn't good at critiquing unfinished work because she couldn't see where you were going."[38] Another student recalled showing Grace some experimental work still at a beginning stage: "I believe there was a 'fuck' somewhere in her response, and I said, 'OK, not resolved yet! I get it!' And she would laugh."[39]

WHEN SHE SPOKE of her Hoffbergers, Grace was uncharacteristically starry-eyed. "I truly love seeing my students grow and get shows and become well-known and make a living as artists, hopefully, and see their work triumph," she told an interviewer. "I get a lot of joy out of that."[40] Her students praised her ability to lead them to subjects they felt genuinely passionate about and to help them discover a new freedom in the act of painting. Citing her practice of drawing in her paintings as an alternative to modulating the color—a tactic disparaged by some—she would tell students, "You can do whatever you want, if you can get away with it."[41]

Grace told one student that she needed more "Oh, fuck it!" in her painting.[42] Another student was devastated when Grace told her she knew "absolutely nothing" about color. "I remember going back to my apartment and crying," she said. "[Grace] wasn't cruel about it, but it was so upsetting to me. But she was right." It was also helpful to learn that paintings didn't need to

have a satiric punch line, that they could be "a little less obvious as narrative."[43] Amazingly, only one of Grace's students ever dropped out. "And that's because Grace said, 'Look you are not a painter. But...you draw incredibly well.'"[44] The student apparently found this assessment insulting and left after her first year.

Sometimes, Grace would tell students, "Put the paintbrush down. Draw. Just draw. Your language is in drawing." Or, "Why don't you do some three-dimensional things?"[45] At first, according to Leslie King-Hammond[46]—appointed graduate dean in 1976 and ever afterward a close friend of Grace's—she was so fiercely committed to painting that she couldn't bring herself to suggest another medium. "But then, as she worked more and more with artists of all kinds and varieties and intents, she began to realize there were more ways to have a voice.... She even evolved to the point where she grew to accept installation [art]. Put her into near cardiac arrest, but against her will, she did grow."[47] (Though as late as 1998, Grace told an interviewer that she didn't care much for the way an installation obliges viewers to "walk through a lot of stuff." Similarly, she claimed to prefer music videos by "Madonna and those people" to "bo-ring" artists' videos.[48])

Grace was among the last of her breed. By the 1990s, there were hundreds of master of fine arts programs in the United States, but most were led by career teachers, not by artists with major reputations and long-term, high-level connections in the art world. Working with Grace meant sitting at the feet of an inspiring art legend whose often-recounted struggles in a male-dominated arena had made her a stronger person. The attraction of working with her was such that nearly every student she accepted enrolled at Hoffberger, a greater "yield rate" than any other program at the institute.[49] "Everyone wanted to hear her stories," Lazarus said.[50] Some of her students even wistfully said they were "nostalgic" about her life in the fifties.[51]

At the Hoffberger School, fourteen student studios surrounded a spacious lounge with six sofas, a refrigerator, and a coffee pot. On the days she came to campus, Grace would ensconce herself there, presiding over an ongoing conversation about art and life. A letter Grace sent to a student in 1982 provides a glimpse of the high seriousness that she believed must inform the making of art. "The artist's responsibility is to himself to tell the truth as he understands it," she wrote. "Human ego must be put aside, the artist is the medium through which the gift flows. Responsibility to and development of the creative gift has to come first, above all other human considerations."[52]

King-Hammond recalls a male student who was upset because Grace walked past his studio without entering during the first two weeks of the term. King-Hammond advised him to just keep working. "Along about the fourth

Grace with an unidentified student at the Hoffberger School of Painting. (Courtesy of Maryland Institute School of Art [MICA]).

week, she walked into his studio, looked up at the painting, and pointed at the canvas. 'Why did you put that red spot there?' she asked. And he…was in shock. He paused too long. She said, 'I'll be back when you can talk about it.' And she walked away." The next week, when Grace returned, King-Hammond—who could see the entrance to the student's studio from her office—noticed two hands clutching the studio doorjamb. She wondered what was going on. As she watched, the student, who had been lying on the floor, pulled himself up. "He looks up at me and says, 'I just had my first crit.'"[53]

Grace's relationship with King-Hammond was a constant outpouring of close-to-the-bone concerns, often over lunch. "She would call me Miss Leslie and I would call her Miss Grace. Absolutely, those were our terms of endearment for each other."[54] Grace instantly became a mentor and role model for her, as a woman—in King-Hammond's case, a woman of color—in the art world. "She liked me because I was ballsy in my way and I wasn't a suck-up…. And we were very upfront with each other. Very atypical for a relationship of this caliber and of this kind"—as graduate dean, King-Hammond was Grace's supervisor. "I shot from the hip just like she shot from the hip. And she respected that. She did not like weak people. She could not stand women subservient, acquiescent, accommodating."[55] In 1996, King-Hammond sent "Ms. Grace" an affectionate memo with the heading, "New Heights in Stardom" after watching her deliver a public service announcement on late-night TV: "Thank God you can paint, TV is not your thing—However, you looked fabulous!"[56]

AN OMNIVOROUS COLLECTOR of new imagery for her work, Grace became fascinated with youth culture. In 1967, her male students' preoccupation with motorcycles led her to buy copies of a motorcycle magazine and a poster of Marlon Brando on his bike, from the movie *The Wild One*. Two years before *Easy Rider* reignited the biker craze, she painted *Modern Cycle* (plate 26), setting abstracted gas tanks, engines, and wheel components in motion. They snake around her canvas in a collision of swooping line and blocky, overlapping black and metallic gray forms sparked by swaths of red. The entire painting is "straddled" by women's legs on either side of the canvas, and multiple phallic forms keep sex in play.

In the eighties, when Win's death left a huge vacuum in her life, Grace began spending more time hanging out with her students. Unlike the early years, when they arrived with uncertainties about their talents and their future, the Hoffbergers now tended to be more assertive and career-minded. (Similarly, a painter friend recalled Grace saying that her generation "asked what we could do for our masters—you know, for the great artists. Now, my students ask what I can do for them."[57]) Yet to Grace, who always preferred a show of strength to uncertainty, this attitude was evidence of a welcome vitality. The mid-eighties were her shining moment at the institute, a period when she had come to terms with her own personal problems and was making art that related (however inadvertently) to the cresting wave of Neo-Expressionist painting. As one of her students said, "People told me I got her at a good time."[58]

As the gulf between her approach to painting and theoretical discourse about contemporary art became a chasm, Grace began to solicit the help of younger visiting artists and critics. She "was secure enough to bring in someone with whom she didn't share a point of view," Allen said.[59] New York art critic and independent curator Dominique Nahas served as critic-in-residence from 2000 to 2010. What Grace gave her students, he believes, was "her natural intelligence...her ferociously earned self-cultivation and independence of the spirit that had not a hint of anything academic or contrived attached to it."[60]

One of her unique strengths as a teacher was to employ the language of Abstract Expressionism in dealing with figurative work. A key precept of hers, dating from her abstract period, was, "Every area of the painting should advance at the same rate of speed"—in other words, there shouldn't be any dead spots. Grace also deliberately undermined the conventional styles of some of the young painters. "She was always pushing us to loosen up, to let things be flat, to be non-literal about color," one former student said. "We were all taken aback, since

we all came into the program thinking, 'This is the program that will let us paint old-school.'"[61] This student initially hated Grace's approach but felt he had to at least try things her way. After graduation, he returned to literal rendering with realistic skin tones, but with a larger sense of the possibilities inherent in figurative painting.

The attraction of the school for artists pursuing traditional figure painting may help to explain why none of Grace's former students received the critical acclaim and major museum exhibitions that are the hallmarks of a leading contemporary artist. Her increasing remoteness from current trends in painting and her habit of selecting students because she felt she could relate to them personally, not solely based on their ability, were other factors. Allen noted that while she chose "avant-garde, cutting edge students who were taking great risks" early in her tenure, in later years her students were "increasingly more traditional…in terms of figuration and narrative painting."[62] Her figurative bias doubtless led young abstract painters to seek out graduate programs elsewhere.

Grace had been painting in a succession of figurative styles since the mid-sixties. Throughout her tenure at the Hoffberger School, she held fast to her belief that abstraction was no longer a valid approach. She claimed that nothing interesting had been happening in abstract painting for decades, so she didn't even pay attention to it anymore. An abstract painter who was not among the students Grace chose to work with personally recalled that Grace "just walked in to my studio, took a look, and said this wasn't something she could talk about."[63] Toward the end of her life, she told an interviewer that "the best talents today are image-makers."[64] She was fascinated, she said, to see her students rebelling by "going into deep space, which has been forbidden for a hundred years."[65]

Beginning in the early eighties, reports of the "death" of painting—a medium that struck postmodernist critics as hopelessly old-fashioned, insufficiently concerned with cultural critique, and crassly dependent on the patronage of museums—began to percolate through art departments. Decades later, some of her students were still worried about the future of their chosen medium. Grace responded with a long view. "She sat us all down," a student recalled, "and she said, 'Painting will go on. It's eternal. It may not be in the mainstream now, but it will go underground. It will be done in the hinterlands, away from the centers of culture, and then it will come into vogue again. And that's where the innovation happens.'"[66]

A more practical issue was whether the Hoffbergers should go to New York after graduation. As other cities became more hospitable to artists—and

as Manhattan grew increasingly expensive—Grace's response evolved from a forthright Yes to a thoughtful Maybe. Knowing that her students were making careers for themselves in other urban centers, she would say that in Chicago or Boston or St. Louis, you can be represented by a local gallery and sell your work to your community. As a "local artist," you are not going to have your works collected by major museums or be included in art books. But you can have a good life, and you might even make enough to live on.

Grace still believed, however, that for any artist aspiring to a major career, only New York provided the right exposure. As late as 1987—at a panel discussion at a neighborhood art center—Grace called her move to Baltimore "the disaster of my life." She admitted that she still yearned "to be rich and famous" and wanted her work to be seen internationally and be written about in magazines. "To do that," she declared, "you have to exhibit your work in New York."[67] Yet the obsession that sent her to the studio day after day was more primal than a lust for fame. It was a need to come to terms with her life, a need that could only be assuaged with a brush in her hand, letting the multitude of memories and glimpses and desires swirling in her mind take form in paint.

Grace remained loyal to her former colleagues. Realizing that the only way to create the salon she had dreamed of was to import its members from Manhattan,[68] she cannily made guest presentations a central feature of the Hoffberger School. Invitations would go out to artists and critics to talk to the students, deliver crits, and jury painting shows. The institute would pay for travel and dining expenses, and provide overnight accommodations. After meeting with the students, the luminaries would enjoy a dinner party with Grace and Win that featured free-flowing liquor and lively repartee; some visitors also took advantage of Win's invitation to get a checkup at Johns Hopkins Hospital.

Helen Frankenthaler, Larry Rivers, Philip Guston, Fairfield Porter, and the art writer Irving Sandler were among the New Yorkers coaxed down to Baltimore for a small honorarium and the pleasure of Grace's company.[69] Those who couldn't stay for dinner would enjoy a seafood lunch. In a 1977 letter to Sandler asking him for a return visit (an afternoon seminar or slide lecture), she sweetened the deal with a first-class round-trip ticket on Amtrak and flatteringly mentioned that the students had liked him—*him*, not just his presentation.[70] Art critic Dore Ashton recalled how Grace insisted on meeting her at the train station, despite walking on two crutches after one of her hip operations. "She had a generous nature and a sense of humor," Ashton said. "We laughed about a lot of things."[71] Those who didn't perceive the

humor probably weren't attuned to recognize it. As a close friend noted, Grace could veer from seriousness to sarcasm to silliness in the space of a few sentences, and "you had to be able to bob and weave with that."[72]

SEVERAL OF GRACE'S students became friends, feeding her needs in various ways. Fay Chandler, a quiet, dignified older student with a high-profile husband and four children, met Grace when she first came to the institute. Chandler was a patient listener, willing to cater to Grace's whims. One day, Grace called to ask her to drop everything and rush over so as not to miss something "magical"—a bird nesting at the top of the tree growing in a pot inside her studio. Toward the end of Grace's life, she grew close to Michel Modele, a tall, blonde, outspoken young woman who had been a professional skater, accustomed to standing up to tough coaches. Grace clearly saw Modele as a version of her young self. They connected immediately on the level of bodily experience: Grace would ask her how she knew when she would land a jump, comparing this awareness to the intuitive sense that guides a painter's decisions. (Toward the end of her life, she said that her ability to make effortless color choices in a painting was like "a skater showing off with high jumps."[73]) Grace freely discussed and disparaged her husbands ("the husbands were often the third person in the room"), and asked Modele about her own love life. Yet despite their closeness, Grace's critiques could be devastating.[74]

"Grace was never shy about saying, 'See, now I know you; I know all the buttons to push,'" Modele said. "You knew some days that she was ... going to say something and it was going to be really harsh. But then the next day, she'd be like, 'You see?' ... She would beat you, and the cookie would come a couple days later." Being friends did not mean abandoning her critical judgment, any more than it did back in the fifties when she disparaged paintings by artists in her circle. The takeaway, Modele said, was that "she helped you understand how you have to do this process over and over and over again, on your own. Because you may not have the luxury of nineteen of the country's best painters at your disposal to critique you. I think that came from her learning what moving to Baltimore did to her own work." Her male students responded to her in similar ways, though she tended to be less personal in her dealings with them unless they were gay.

The Hoffbergers ranged in age from their late twenties to early sixties. "So when you're that old, you come with baggage," King-Hammond said. "And that's one thing Grace was honest about embracing. ... She felt that people without a world view, without a life experience, really didn't have anything to talk about."[75] Baffled about what one young woman was trying to express in a

painting, Grace learned that it was supposed to be about a miscarriage. She asked the student if she'd ever had one. No, the woman said, she hadn't. Grace told her that she needed to deal with issues she had actually experienced.[76] As she said to another student, "You have to look for those flashpoints—what stirs you up, what ignites you. You'll know it when it becomes obsessive...and you can't stop thinking about it. If you're doing your laundry and you can't stop thinking about [the subject of your painting], that's when you know that you're probably in a vein you should stay in."[77]

"Personal and professional counseling"[78] was part of Grace's self-defined role at the Hoffberger School. Applicants who had made the cut and arrived on campus for an interview with Grace received a taste of her approach during a probing conversation that often became emotional. (A box of tissues was discreetly stationed outside her office.) She once explained that she was "sort of like an art psychiatrist—part older artist to young artist, part advice to the lovelorn," engaging in soul-searching personal discussions with students whom she felt could handle it.[79] There was at least one who could not. This woman complained in a letter to the institute that Grace "inappropriately tried to persuade [*sic*] my opinion on what my financial and personal obligations and commitments are to the man I currently live with."[80]

Leaning on her own history, she subjected students to her unshakable beliefs that making great art demanded total dedication. She cautioned that teaching art would interfere with her students' single-minded pursuit of painting. (Many Hoffbergers nonetheless became gifted teachers at the institute and elsewhere. One of her students, who fondly described Grace as "shrewd and funny," remembers that she took the no-teaching rule seriously for a long time before realizing that Grace herself was a teacher.[81])

Because of her experience in New York, she had little patience for the idea that women traditionally had been shut out of the art world, victims of a male cabal. Her view wasn't blinkered, it just wasn't adversarial. One student recalled that Grace told her, "Men keep all the goodies for themselves; they don't even think of sharing them."[82] The student asked if women "should just act like it isn't happening." And Grace responded, "That's it." She said that the "woman artist" label was a way of sidelining women, not something they should aspire to. In 1987, when the National Museum of Women in the Arts opened in Washington, D.C., with a painting of hers (donated by a collector), Grace was livid. "I am very much against the idea that any form of segregation...can do anything toward integration," she said.[83] In her view, neglected artists of the past deserved their obscurity. Several years later, she wrote to a friend that "the feminists don't give a shit about <u>me</u>, they just wanted me to join their political agenda."[84]

Her pronouncements about women artists could be brutal. A student at another school recalled that when Grace came to offer a guest crit, she said that "we were wasting our time, that we should all just be better in bed with our husbands and better cooks, because we couldn't have a family and be happily married and also be artists."[85] A decade later, at the height of the women's movement, Grace declared that having children was an issue women artists "must slug out for themselves."[86] But she subsequently reverted to her earlier pugnaciousness, telling an interviewer that "women just can't stick with the long haul," unlike her male students who "have more guts for the poverty, the solitude." Without mentioning her often edgy relationships with other women artists, she declared, "All the encouragement and understanding I got…was from men."

Grace even spurned the idea of being a role model for young women artists, pointing out that the recognition she received in the fifties was as "a talented artist," not a "talented *woman* artist." In fact, she added, she had a harder time as a mechanical drafter, demanding pay equal to what her male colleagues were getting, than in trying to make her way as a painter.[87] Yet, as one student noted, despite her acerbity, Grace had "a real sensitivity to female students," because she knew that the artist's life "was always going to be a struggle," and that the important thing was to have "a clear voice."[88]

Apart from art-related issues, Grace was generally in agreement with feminist views. She and Win had decided that theirs would be a marriage of equals, in which dedication to their careers was paramount. Win would not complain about the time she spent in her studio and she would not nag him about his long hours in the laboratory. They also agreed that they didn't want children. When Grace went to Johns Hopkins Hospital for a tubal ligation, she had to obtain permission from her husband for the sterilization procedure. Outraged, Grace yelled, "It's my body! It's my decision!" to no avail. Win was obliged to sign for her "like he owned me."[89]

Grace was an equal-opportunity scold when it came to family life. She told a male student who married after his first year that graduate students should be forbidden to wed.[90] She even discouraged family visits during the summer ("You should be in your studio.") Grace's anti-family stance, a throwback to her own strained relationship with her mother, surfaced whenever parental pressure appeared to threaten an artist's freedom. "We talked a lot about my mom," recalled a forty-year-old student whose mother violently disapproved of her daughter adding penises to family photographs of herself as a child. "Grace said, 'Fuck your mother; this is your work.' "[91]

Modeling herself, Grace made it clear that she disdained artists who were subservient or accommodating, or who leaned on others for validation of

their artwork. She would say, "I hope you're ready to be selfish. Because this is the only way you're going to succeed."[92] One of her male students, who recalled Grace's key advice as "Arrange your life to be responsible to your art," has happily embraced this mantra for more than a decade.[93]

As an administrator, Grace reverted to her fifties-era feistiness as one of the boys. One night, several Hoffbergers got drunk and drove around looking for trouble. After one of them punched a policeman, they all wound up in jail overnight. Archie Rand—a New York painter serving as acting director while Grace was on a leave of absence—recalled that he was lecturing the students about their behavior when Grace suddenly walked in. "'Archie,'" she said, 'let me take care of this.' She stood at the podium looking at them, cigarettes behind their ears, beer bottles in their hands. 'What's the matter with you guys? You fucking pussies or what? I used to hang out with young artists. You know what a young artist does when he gets frustrated? He gets laid. You gotta get out and roll.'"[94]

DESPITE HER EASE with gay men of her generation, Grace could—unwittingly—make gay students uncomfortable with her enthusiasm for what she perceived to be their lifestyle. Once, after registering her dismay at a heterosexual student who was about to get married ("Oh, that's awful! It'll distract you from your work"), she turned to a woman living casually with her girlfriend and said, to the woman's annoyance, "You guys are already married; since you can't legally be married, you don't count."[95]

In the late eighties, when Grace met a buttoned-down staff member who kept his private life to himself, she startled him by saying, "I don't want to know all about your sex life; obviously you're gay. The only thing I want to know is, are you promiscuous?" He said he wasn't. "Good!" said Grace. "That's the only thing I can't stand."[96] Years later, when he had just ended a twenty-year relationship, she greeted him at the opening of a show of her work in Baltimore: "There's a guy I'd like you to meet." From the back of the crowded gallery, she shouted, "This is him!" Embarrassed, the staff member felt obliged to say hello to a man who turned out to have virtually nothing in common with him except gender preference. "Just go have some fun!" Grace urged.

She was, however, deeply troubled by the AIDS crisis. In 1986—three years after HIV was found to cause AIDS, and a year after Rock Hudson was the first major public figure to die of AIDS-related complications—Grace wrote to a woman friend about a man knew who had recently died of AIDS. "I talked to him on the phone two months before he died....He was very calm and brave and sad. This is a nightmare with so many friends."[97]

Grace was also ahead of the curve in terms of her interest in attracting African-American and international students. "She had very strong feelings about race," said King-Hammond, the African-American artist and educator who now directs MICA's Center for Race and Culture. "She had diversity before this school ever came to its knees about the question of diversity. She was global before global became popular.... Grace would ask [potential students] point-blank: Who are you? Where are you from? What's your family?"[98] One year, she exulted in the makeup of her new student body: two Japanese students, a woman from Puerto Rico, a black woman "with yellow hair," and two WASPs ("poor minority dears").[99] Toward the end of her life, she wrote to a friend that she had just gone through three thousand slides to choose the eight students for the next year's entering class, which would include a woman from the Indian subcontinent who worked in the ancient style of miniature painting.[100] Grace would encourage international students to use their cultural experience as a basis for their work.

When Mina Cheon—an artist who is now on the faculty—applied to the Hoffberger School in the late nineties, she spoke to Grace by phone from her home in Seoul, Korea. "Grace told me I was her number-one selection," Cheon said. "I was doing very large paintings...of morphed animal figures and body figures and sort of space creatures, and she was really captivated by the impact and power of the work."[101] Cheon bloomed under Grace's guidance, despite feeling intimidated by her. "Grace was the voice that would linger in your head all the time," Cheon said. "She would come into the studio and say a couple of things, rock your world, and you would stay up nights trying to figure out" how to redo the painting. "She had a cane, and she would fling her cane around. 'This is all wrong! Where are you going with this?' But when I had a breakthrough, she would say, 'Everything has come to this; this is your masterpiece.' "

Totally focused on her work and struggling with cultural differences, Cheon initially had no personal life. Grace buffered the hostility of other students ("Mina has different needs than all of you"), but told Cheon bluntly, "If you continue being the way you are, you're going to be a very lonely person." Cheon accepted this advice and finally agreed to a date with a man who kept pursuing her. "When I told Grace I was getting married [to him], I told her I was converting, and she told me that if she had to choose a religion, it would be Judaism, too."

GRACE'S 1985 EPIC PAINTING *Visions of Heaven and Hell* (plate 30)—nine feet high by sixteen feet long—is filled with large, thinly painted figures, including Grace herself. She and her lover[102] (possibly the younger married man

she was involved with at the time, though the face oddly resembles her por-
trait of Frank O'Hara in *The Masker*) appear as coupling nudes at the far
right. Joining them are a medley of the saved and the damned—nude figures,
all—though it isn't always clear which are which. Eve and the serpent who
tempted her in the Garden of Eden (or Cleopatra and her death-dealing asp?)
occupy a prominent spot on top of the canvas. The figure's pose is based on
Gustave Courbet's lushly erotic painting *Woman with a Parrot*, which Grace
knew from her trips to the Metropolitan Museum in New York.[103]

Next to her, a quartet of male and female figures hang upside down. So far,
no one has offered a satisfying answer to the riddle of whom they represent. In
the Tarot deck, the Hanging Man card—representing selfless sacrifice, as in
the upside-down crucifixion of the Apostle Peter—was used in Jungian dream
analysis. Considering the grand ambition of this painting, which deals heavily
in sex and death, it is also possible that Grace was thinking of one of the rawest
publicly disseminated scenes of World War II—the filming, by U.S. troops, of
the corpses of Italian fascist leader Mussolini, his mistress Claretta Petacci,
and his accomplices, stripped to the waist and hung upside down in front of a
gas station in Milan in 1945.

A seated male figure's pose and gesture recalls Michelangelo's famous
painting of Adam on the Sistine Chapel ceiling, except that his hand is cut off
by one of the hanging figures; he doesn't receive God's touch. Instead, the
accusing finger of a ghostly hand points at Adam's head. Lying next to him is
a figure of ambiguous gender—the head is male but the body lacks sex
organs—strangled by a noose. (In her later years, Grace had a habit of strip-
ping the male figures in her work of power and status, an approach that sug-
gests a simmering anger at the key men in her life.) At the far left, two angels
in white garments remain coolly aloof from the way of all flesh.

Grace's initial inspiration was *Visions of Heaven and Hell*, by Richard Cav-
endish, an historian specializing in studies of mysticism, religion, and the
occult.[104] Other visual sources include William Blake's ink and watercolor
drawings for *Paradise Lost*, which Grace pinned to a wall of her studio, and
details from Hieronymus Bosch's *Garden of Earthly Delights*.[105] The title of
the painting recalls Blake's book *The Marriage of Heaven and Hell*, in which
the eighteenth-century poet and artist describes a visit to hell where "devils"
and "angels" both dwell, a sphere that allows free rein to physical passion.

Fred Lazarus had seen *Visions* at an exhibition[106] and was impressed. "This
is a really terrific painting; it ought to be somewhere," he told Grace. "And she
put a price tag on it that was outrageous. A huge amount—I think it was a
hundred grand.... It put me in a very awkward position. Luckily, a number of

people were interested in helping her and helping us raise the money to buy the painting, as much to support Grace as anything else."[107] Lazarus was irritated that Grace did not offer to reduce the price to acknowledge her long connection with the institute. After all, even the largest of her other paintings usually sold for far less. But her adamancy, he said, was "typical Grace."

A tribute to Grace's outsized personality is the fact that a painting of heroic dimensions—with an ambiguous vision of good and evil, and a figure representing her lustful self—dominates the vast translucent glass atrium of the Brown Center at the Maryland Institute College of Art. Grace remains on stage, proudly emoting, years after she took her last bow on earth.

15

Unraveling

EVEN GRACE ADMITTED, after he died, that Win was "a very difficult man."[1] Ruled by various phobias and quirks, he refused to use a towel more than once, touch money—though, curiously, he did tip lavishly, with $50 bills, on trips to New York—or drive a car. To get from their suburban home to his office at Johns Hopkins, he arranged for a taxi company to pick him up and send him a monthly bill.[2] Win did not enjoy social gatherings away from home and would begin to stutter if he felt put on the spot. Perhaps his phobias had accounted for his decision back in 1954 not to cross the country to attend the ceremony at the University of California, Berkeley, for his prestigious Theobald Smith Award.

While Win's fascination with the artistic process led him to attend Grace's monthly meetings with students at her studio, he sat apart from them and rarely spoke. Robert Meyerhoff recalled that "he'd go to somebody's house and he'd sit in another room watching TV."[3] Painter Audrey Flack was surprised when she met Win. "Grace needed excitement, and here she was with this scientist... whose conversation wasn't invigorating, certainly nothing like the Club."[4]

In 1962, after May Tabak met him, she wrote with uncharacteristic vagueness that it must have been obvious that she and Harold Rosenberg took "real pleasure in Win," because they had no talent for "disguising [their] feelings."[5] Two years later, suggesting a visit to Amagansett, Long Island, she wrote, "I do understand that the light, etc. might make it an ordeal for Win," and suggested that "Win would rather meet [their artist friends] in small doses."[6] (Win had a heightened sensitivity to sunlight; he had covered the windows in the couple's bedroom with bathrobes and pajamas to create a comfortably dark cave.[7]) Cynthia Navaretta—who knew Grace in New York and later in Baltimore, where her artist husband taught at the institute—recalled that when the Prices came to their house for brunch or dinner, Win hardly said anything of interest, confining his conversation to bland topics like the weather. "She was the goddess of the relationship," Navaretta said, "and that suited her fine. He did adore her."[8]

Win did open up a bit more on his own turf and in the company of people with whom he felt comfortable. Grace's good friend and dealer Beati Perry called him "that delightful man."[9] Leslie King-Hammond, Grace's longtime colleague, remembers him as "charming, absolutely charming—a delightful person…a gentle spirit. He had a warm voice; it was a nice complement to the volatility of a Grace Hartigan.…When I would come over, we would sit and drink wine and just talk about whatever was going on in the news—silliness or whatever."[10] Barbara Guest, who met Win in the early sixties, told Grace that he had "a most compelling personality."[11] Grace's self-effacing older student and friend Fay Chandler viewed Win as "a dear person…quiet and serious, very private. Parties and things, he would just prefer not to go.…Win had his own opinions, and I think Grace appreciated that. He was not wishy-washy."[12]

Grace's student Ryozo Morishita and his wife enjoyed a week of conversation, cooking, and walking with Grace and Win one summer at the house they rented on the Maine coast. In the afternoons, Morishita and Win relaxed on beach chairs, observing the gulls. "We spent a lot of time laughing together," Morishita recalled. "[Win's] big belly heaved when he laughed, and his laughter filled the air."[13] His puckish intellect flourished when he could slip into the role of genial host. Ed Kerns (who called Win "the Harv") was a student of Grace's in the late sixties, when he laid the foundation for a lifelong friendship with the couple. During his student days, Kerns was often invited to dinner parties at the couple's home that featured visiting artists. Win would throw out facetious questions like, "What does anyone think of de Kooning's latest show? Was it any good?" It amused him to play the provocateur.[14]

One day, when Win decided that he wanted to watch a Baltimore Orioles game, Kerns went out to get the tickets and pick up de Kooning—Grace's current visiting artist—at the train station. Never having seen a baseball game, the Dutch-born painter marveled at the grassy field, the National Anthem, the umpire ("He's waving—what does this mean?"), and the food people ate. (Win never let a vendor pass by without buying something; he would put away cotton candy, hot dogs, peanuts, and beer as though snacking were the real reason he had come to Memorial Stadium.) Finally, it was time for the seventh-inning stretch. As the spectators rose to their feet, de Kooning said, "What? Are we going to sing again?"[15]

KAREN GUNDERSON, A New York painter who was a close friend of Grace's in her later years, believes that what attracted Grace to Win—beyond his belief in her work, his achievements as a scientist, and the security his job

provided—was his "extremeness." In Gunderson's view, "an artist understands when someone has peculiarities that make them unique in the world."[16] In a similar vein, Grace told Kerns that when she met Win she felt as though she had met her counterpart in the scientific world. She loved the way he thought. As Kerns said, "She had found the other half of the conversation she was having only with herself."[17]

The marriage was a complex melding of personality traits and impulses. On Grace's part, there was deep affection and respect—"she was very much in awe of his intelligence and his research," King-Hammond said[18]—as well as a certain degree of practicality and shrewdness in marrying a degreed professional with a stable and prestigious position. There was also enormous trust. One of her students from the mid-eighties remembers Grace saying that if Win told her to jump off a cliff, she would have done it. ("It was so out of character that it really stuck out for me," the student said.[19]) That unquestioning loyalty, however exaggerated in her casual remark, would eventually lead Grace to unfortunate lapses of judgment, as we shall see. On Win's part, there was surely an initial acquisitiveness—bagging a sexy, attractive art star at the height of her fame. But he also was strongly attracted to Grace's zest and intelligence, and to her grandly heroic sense of herself, so similar to his own self-image. Win's adoration of Grace overrode even his connoisseur's appreciation of her talent. A note he sent her at the opening of her 1967 Martha Jackson Gallery show says it all: "To the greatest artist with all my love."[20]

Grace called him when she finished every painting, and he would ring her every morning at eleven to ask, "How's it going?"[21] She credited him as an infallible "eye," able to tell her if a painting lacked a certain something or should be considered finished.[22] "She asked him about her paintings in an entirely different manner than [she used with] anyone else," Kerns said. "It was as if they had their own language."[23] Win shared with Grace a visual approach to problem solving in his own field. He would design experiments by "putting myself in the position of the thing I was trying to mitigate," he said—imagining how he would act if he were a virus.[24]

WITH *REISTERSTOWN MALL* (1965; plate 25)—one of Grace's most successful works of this decade, based on her visits to a local shopping center that had opened three years earlier—she began to work her way back to more recognizable figures and objects. Returning to her longtime fascination with shop windows, she updated the theme with a suburban environment. A car and driver float in the same space as a plethora of black-outlined objects, from a giant toothbrush and comb to lamps and items of clothing. Grace's circular

composition keeps the painting buoyantly in motion, and the unexpected shifts in scale create a fun-zone cheeriness. But despite the inclusion of consumer goods, this was not Pop Art. Grace was always too passionately involved with her subject matter to accept the deadpan perspective of Pop.

Similarly, the stripped-down, what-you-see-is-what-you-get stance of Minimalist artists was anathema to her. A few years later, she wrote, "As most painting moves closer to sculpture and architecture," she wrote, "my own work moves nearer poetry. It increasingly must be 'read' in terms of meaning and metaphor…not just 'this' standing for 'that' but 'this' existing on many levels."[25]

Gamely trying to adapt to the changing art scene while still staying true to herself, Grace was blindsided by John Canaday's Sunday piece in the *New York Times* on March 21, 1965.[26] Never a friend of Abstract Expressionism— though he had praised Grace's "bright and vigorous" *City Life*[27]—he excoriated Grace, ostensibly for her written remarks about a painting of hers in a show at Finch College. (Pitched to the students, these comments were never intended for a sophisticated audience.) Not content simply to damn the painting with faint praise as "a proficiently slashing, splashing concoction of color," Canaday haughtily dismissed her *entire* body of work as "a supreme arrogance crossed with a supreme innocence [that] adds up to nothing more than a supreme pointlessness."

Ever since that review, "the world hasn't had much interest in what I'm doing," Grace lamented a decade later.[28] Canaday's brutally careless final words about her work, in a two-sentence review of her 1967 Martha Jackson Gallery show, accused her of being "a rather noisy artist" with "lots of wham-bang…but not much socko."[29] In striking contrast, art historian Dennis Adrian wrote in *Artforum* that Grace was in fine form in this show, offering "the brisk and jarring presentation of a well thought out composition" with "a high degree of expressive variation."[30] He concluded by noting that Grace, as "an inventor and participant in the most vigorous phases of Abstract Expressionism," has had to figure out for herself a "more explicit and disciplined structure" which she accomplished "with thumping success."

Unfortunately, this exquisitely thoughtful review was published in an art magazine with a tiny circulation while the *Times* reached hundreds of thousands of readers. (Because of reviews like Canaday's, artists universally discounted reviews in the popular press. Grace once said, "If you were praised by the *New York Times*, you questioned yourself."[31]) Now, for the first time, Grace found it oddly comforting to be living in Baltimore, "a city environment without the pressure to conform, without the pressure to change your work according to what the styles are."[32]

Four months after Canaday's Sunday rant, the influential art historian Barbara Rose published a long, contentious article in *Artforum* about the "second generation" of Abstract Expressionists.[33] Rose wrote that Grace was among the artists whose semi-abstract styles, following in de Kooning's footsteps, had "finally degenerated into facile illustration." Helen Frankenthaler, on the other hand—the subject of a monograph Rose would publish five years later—was "among the few to understand the implications of Pollock's paintings." For Rose, Frankenthaler was the only one whose color choices were "utterly personal" and who could successfully integrate color into the structure of a painting. In Rose's view, the "talent, facility, and virtuosity" of artists like Grace, Joan Mitchell, Alfred Leslie, and Larry Rivers was their downfall. Their work not only lacked the sense of struggle that marked the older artists, like de Kooning (a complaint made by many others) but it also failed to resolve the problem of how to make totally "flat" (non-illusionistic) paintings.

The flatness issue was a big deal at the time; today, the fuss seems much ado about nothing. The criticism that Grace and her cohort were making paintings marked by a lyrical ease rather than a combative drive still bubbles up occasionally. Yet it oversimplifies the way all these paintings were created. Certain artists may have been particularly combative in public, knocking heads at the Cedar or the Club, but in the studio everyone struggled. The lyricism in Grace's work of the fifties and sixties was hard won. At various times, when Grace explained how she gave areas of seemingly flat color "volume"— by subtle color modulation, or by adding drawing to a painting—she also stressed how hard this was to achieve.[34]

During a brief period in the late sixties, Grace made a suite of ten paintings based on the anatomy charts she asked Win to bring home for her. She named two of the paintings after celebrated medical illustrators Max Heim and Max Brödel. More than twenty years later—when these odd, rather unsettling works were shown publically for the first time—she explained that they were her way of improving her figure-rendering skills.[35] In an exercise that another artist might undertake with a pencil rather than a brush, Grace obsessively recorded body parts—a rib cage, a spinal column, pelvic organs—in different scales and from different angles. The anatomy paintings soon morphed into more coherent compositions like *Venus Observed* (1969). Boldly outlined buttocks, breasts, lips, and other body parts, painted in hot colors, swoop and slide to fill every inch of the canvas with an exuberant, crowded energy.

In the summer of 1969, the couple vacationed in Estes Park, Colorado. Grace reveled in the distinctive scent of sage and marveled at the beauties of nature, including the iridescent blue coloring of a bird she thought was a

"Western" jay. "I roam the forests and meadows, glasses in one hand, wildflower book in the other," she wrote to Fay Chandler.[36] Dangling her bare feet in a natural pool near the rapids after sharing a picnic lunch of hard-boiled eggs, Swiss cheese, dark bread, and bottles of imported beer with her husband, she felt blissfully content. Win, she added, was working on two papers and a talk. He needed to be at the Pentagon after Labor Day, "hopefully to start a human volunteer program for his encephalitis vaccine." (Many years later, Grace mentioned to an interviewer that Win's encephalitis research was related to American military deaths from the virus during the Vietnam War.[37] If true, this would explain the Pentagon connection.)

Win's career was flourishing. His research into upper respiratory tract diseases was funded by a ten-year, $1.056 million grant (the equivalent of more than $8.4 million today) from the Vick Chemical Company, believed to be the most generous support to date by a pharmaceutical company for a medical research project. Now director of laboratories at Johns Hopkins University's School of Hygiene and Public Health, he had been promoted to full professor in 1964, a year after receiving the Howard Taylor Ricketts Award for outstanding work in infectious diseases. Ricketts was a scientist at the University of Chicago at the turn of the twentieth century when he demonstrated that Rocky Mountain spotted fever is transferred to humans by ticks. In an era before electron microscopy, it was not known whether the pathogen (the infectious agent) for this disease was a virus, a bacterium, or a combination of both. As part of his research, Ricketts injected himself with pathogens to study their results. While there is a long tradition of scientific researchers experimenting on themselves, the results are sometimes fatal. Ricketts died in 1910 at age thirty-nine from a strain of typhus that he was investigating. The *Rickettsia rickettsii* pathogen that causes Rocky Mountain spotted fever was named after him.

Win would have known about this history, as well as a recent precedent: Werner Forssmann, one of three recipients of the 1956 Nobel Prize in medicine for cardiac catheterization, had risked death by inserting a catheter into his own arm and guiding it into his heart. Years earlier, Win had used himself as a guinea pig while working on a cold virus vaccine, with no serious ill effects. He and his research team had been trying to develop an encephalitis vaccine since the mid-fifties. A viral inflammation, the disease causes brain tissue to swell, which can destroy nerve cells and cause bleeding and brain damage. News reports in the fall of 1964 said that Win had developed a series of vaccinations, but that they had not yet been tested on humans.[38]

He seems to have begun testing the vaccine on himself in late 1965. A mysterious reference to "Win's…heroic gesture" in a December 1965 letter to Grace from May Tabak was accompanied by her advice that Win demand "the epilepsy brain wave test."[39] When Tabak wrote again, the following March, she asked if he were home again.[40] Win had had a stroke and was hospitalized. "Win took his own vaccine against encephalitis last winter, a nightmare time of tests and anxieties," Grace wrote to Barbara. "It is perfect, ten others have taken it, but at great price to his nervous structure."[41] The brain wave test would have made sense only if the stroke had produced seizures. Tabak was an intellectual fascinated by medicine, but it's impossible to know whether her advice was based on knowledge of the nature of Win's brain injury. Although a stroke (which interferes with the brain's blood supply) is far more serious than a seizure, Grace's worries may have been exacerbated by memories of Harry's epilepsy. Fortunately, the only effects obvious to others at this time were Win's slowed speech and more pronounced stutter—in addition to his markedly fewer published papers in 1967.[42] He had become inactive, enjoyed high-fat food, and was growing stout, so it's possible that the stroke was unrelated to his self-experimentation with the vaccine. Still, questions linger.

At first, Grace herself had participated in the experimental trial—dramatic proof of her belief in his work—stopping only when her dealer Martha Jackson told her that as a great artist she should not take such a risk.[43] By late July 1966, Tabak was writing to say that among their friends, "the official story is that Win has colitis…. Since Win is a hero, everyone speaks from then on in hushed tones."[44] In October, she wrote to say how happy she was that Win "is so much better."[45] Meanwhile, Grace was dealing with her own health problems. She wrote to Barbara Guest that Johns Hopkins was "delirious with interest" because she was their youngest patient to have developed osteoarthritis: "As doctors love to say, 'It's only pain.' "[46]

The stakes were high in Win's research, but so was his level of ambition. He wrote to Robert Motherwell in August 1968 that he felt tired because he had published twelve articles in fourteen months, "all of them of good quality and 2 of them being far out."[47] (Using a slang expression just beginning to seep into general usage seems of a piece with his idiosyncratic personality.) The following year, he co-authored nine articles published in the *American Journal of Epidemiology*, the *Journal of Immunology*, *Nature*, and other leading journals. (From 1971 to 1974, he would be the principal or sole author of various publications—a sign of increased stature, as were his signed articles, "Respiratory Diseases" and "Rickettsial Infections," published in a textbook, *Preventive Medicine and Public Health*.[48]) Now that he was in his late forties, the examples

set by his great Nobel Prize-winning mentors must have encouraged him to think big. In 1969, evidently believing that he had reached a breakthrough, Win again injected himself with his experimental vaccine. The toll it eventually took on his health and his personal life would be irreversible.

IN THE SPRING of 1969, when Grace's Calvert Street studio was about to be razed, she spotted a building with a distinctive cupola for rent in Fells Point—a seedy yet colorful neighborhood that reminded her of New York's Lower East Side. Built in 1880 as a dry goods store at the corner of Eastern Avenue and Broadway, it was now a rental owned by the proprietor of a bridal shop, so "it just seemed poetic justice," Grace said later.[49] She signed the lease on April 7.[50] The neighborhood would feed her art and her psyche for years to come.

Although Fells Point was just a fifteen-minute drive from home, it was another world. Hookers prowled nearby (there was a "lounge" across the street with photos of women in G-strings), heroin and cocaine dealers sold their wares in plain view, and gypsies camped out in a storefront. Despite or, more likely, because of the dubious local population, Grace called her new studio space "the great building of my life—I really adore it."[51] The sex supply store that strippers patronized also stocked a few items she found useful "for turn-ons."[52]

The ground floor housed the White Cross Pharmacy; on the next floor was her studio. A tiny living area (later, her bedroom) was sandwiched between the studio and the third floor, which she initially used for storage. The cupola offered bird's-eye views of the entire city. During the mid-seventies, Grace could watch the construction of the 405-foot Baltimore World Trade Center, part of the increasing urbanization of the city. Grace's agreement with Win was that he would pay for household expenses and she would pay for her studio rent and supplies out of her earnings. The monthly rent was cheap; by the mid-eighties it was only $250. ("Break your heart, New York," she joked, in her perpetual dialogue with her favorite city, now grown much more expensive.[53])

A few years later, she told an interviewer how much the neighborhood stimulated her imagination with its trashy shop windows and throw-away culture. One evening, she noticed a six-foot suit of armor abandoned on the block-long extension of Portugal Street, visible from her window. A treasure! After she photographed it, it occurred to her—with the metaphorical leap that artists and poets take—that a lamp shade looked somewhat like a piece of armor. Come to think of it, one of her students had given her beads from Mardi Gras that had four little headless figures in armor. She was on a roll. Titling her painting *Portugal* after the street prompted color choices evoking Spain and the Spanish artists she loved.[54]

Essex and Hester (Red), 1958
Oil on canvas, 53 × 84¼ inches; National Gallery of Art, Washington, DC; Collection of Robert and Jane Meyerhoff (1996.81.3). © The Estate of Grace Hartigan.

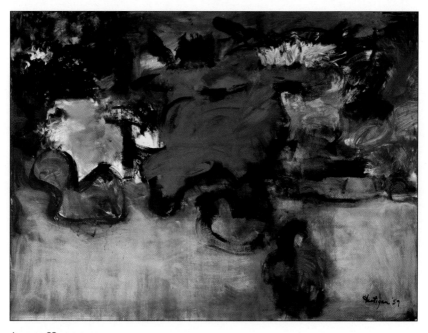

August Harvest, 1959
Oil on canvas, 79¼ × 112¼ inches; The Baltimore Museum of Art; gift of Dr. and Mrs. Winston H. Price, Baltimore (BMA 1964.22). © The Estate of Grace Hartigan.

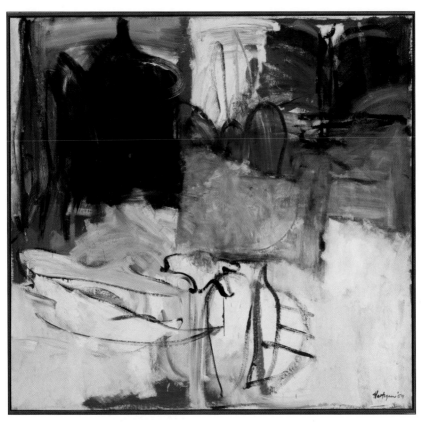

Sweden, 1959
Oil on linen, 83⅞ × 87⅞ inches; Whitney Museum of American Art, gift of Mrs. and Mrs. Guy A. Weill (64.66). Digital image: ©Whitney Museum of American Art. © The Estate of Grace Hartigan.

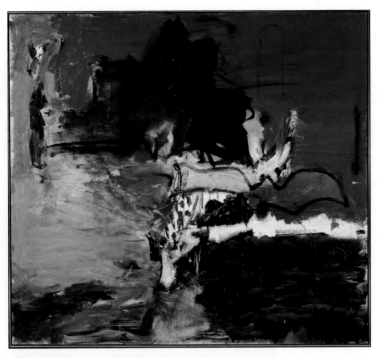

Dido, 1960
Oil on canvas, 82 × 91 inches; Collection of the McNay Art Museum; gift of Jane and Arthur Stieren. © The Estate of Grace Hartigan.

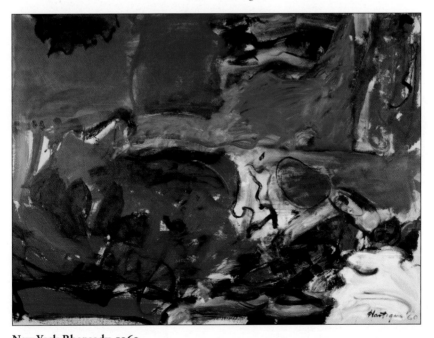

New York Rhapsody, 1960
Oil on canvas, 67³/4 × 91⁵/16 inches; Mildred Lane Kemper Art Museum, Washington University in St. Louis; University purchase, Bixby Fund, 1960. © The Estate of Grace Hartigan.

Pallas Athena–Earth, 1961
Oil on canvas, 64⅛ × 52⅛ inches; Smithsonian American Art Museum, Washington, DC, gift of S.C. Johnson & Son, Inc. Photo: Smithsonian American Art Museum / Art Resource, NY. © The Estate of Grace Hartigan.

William of Orange, 1962
Oil on canvas, 60 × 80 inches; The Baltimore Museum of Art; The Dexter M. Ferry Jr. Trustee Corporation Fund and Fanny B. Thalheimer Memorial Fund (BMA 1962.21). © The Estate of Grace Hartigan.

The The #1, 1962
Oil on canvas, 81 × 115½ inches; Empire State Plaza Art Collection, State of New York.
© The Estate of Grace Hartigan.

**Human Fragment,
1963**
Oil on canvas;
81.875 × 63.875 inches;
Walker Art Center,
Minneapolis, MN;
gift of Alexander M.
Bing, 1963 (1963.44).
© The Estate of Grace
Hartigan.

Reiserstown Mall, 1965
Oil on canvas, 96 × 128 inches; Collection of Hart Perry. Photo: Hart Perry. © The Estate of Grace Hartigan.

Modern Cycle, 1967
Oil on canvas, 108¼ × 78 inches; Smithsonian American Art Museum, Washington, DC; gift of Mr. and Mrs. David K. Anderson, Martha Jackson Memorial Collection. Photo: Smithsonian American Art Museum / Art Resource, NY. © The Estate of Grace Hartigan.

Inclement Weather, 1970
Acrylic on canvas, 78¼ × 88¼ inches; Smithsonian American Art Museum, Washington, DC; gift of Mr. and Mrs. David K. Anderson, Martha Jackson Memorial Collection. Photo: Smithsonian American Art Museum / Art Resource, NY. © The Estate of Grace Hartigan.

Autumn Shop Window, 1972
Oil on canvas, 79⅛ × 110 inches; The Baltimore Museum of Art; gift of Equitable Bank, N.A. (MBA 1990.4). © The Estate of Grace Hartigan.

Lady with Pomegranates, 1985
Oil on canvas, 78 × 65 inches; Tufts University Permanent Art Collection; gift of Mr. and Mrs. Nathan Gantcher (1986.7). © The Estate of Grace Hartigan.

Visions of Heaven and Hell, 1995
Oil on canvas, 108 × 192 inches; MICA Collection; purchased with contributions from students, friends, and collectors of the artist, and MICA faculty, staff, and trustees. Photo courtesy of Maryland Institute College of Art (MICA). © The Estate of Grace Hartigan.

IMPAIRED JUDGMENT, INAPPROPRIATE responses, memory loss, anxiety, and personality changes are all symptoms of encephalitis. Probably because of Win's preexisting social awkwardness and odd behaviors, it took a while for anything to seem amiss. In retrospect, the first clear signs of his illness were a string of unusually expensive purchases—ranging from costly art books the couple already owned to real estate and major works of art (some of which Grace discovered only after his death).

Morishita recalls that Win suddenly asked him to drive him up to New York one day to buy a painting by Cézanne. Arriving at the Waldorf Astoria in the student's beat-up car, and dressed in casual clothes, the two men seemed out of place, Morishita thought. On the trip, Win revealed more of himself than usual. "I learned about the words *anxiety* [and] *suffering*," Morishita recalled.[55]

Win was concerned about losing Grace. When they met, he was a tennis-playing bon vivant; now he was seriously overweight, eating meals while swathed in his bathrobe, and conversing with the slowed speech of a stroke survivor. To add to his miseries, massive amounts of dead skin were peeling from his arms.[56] The couple's sex life—once mutually satisfying—had become a sometime thing. Grace, who always had a big appetite for sex, began to have affairs, which she didn't keep secret from Win. Her candor about this hurtful subject demonstrates how she reserved her soul-mate relationship for him; the other men were just casual sex partners. It was as though Win's role had become closer to Frank's. In the painting *Inclement Weather* (plate 27), a woman's profiled face with a closed eye leaking tears, a hand holding a cup, and shapes resembling buttocks, breasts, and penises reflect the toxic combination of anguish, alcohol, and sexual frustration that had begun to characterize Grace's life.

Win was also anxious about his career. At one point in the mid-seventies, Kerns invited Win to his New York studio to see his new paintings, bound for a 57th Street gallery. "So, is this your best work?" Win inquired. At the time, Kerns thought this was a strange question, but it reflected the older man's own concerns. Well aware that scientists often do their best work when they're young and never again reach the same heights, he gave Kerns a copy of Sinclair Lewis's *Arrowsmith*, still a treasured book.

When Morishita asked Win about the art he owned, he learned that the collection included work by de Kooning, Pollock, Guston, Gorky, and Motherwell. Beyond his patronage of Perry's gallery, Win knew his way around the art world. He had begun corresponding with Motherwell in 1959 about buying his work, after meeting him and his then wife Helen Frankenthaler at

an art opening; in the space of a few weeks "Mr. Motherwell" became "Bob."[57] A letter Grace received from Pierre Matisse, the New York gallery owner who was Henri Matisse's youngest child, indicated that Win had asked about purchasing one of his father's works. (The dealer noted that he hadn't realized "Mrs. Price" was actually Grace Hartigan, "whose paintings I know and enjoyed so much."[58] In this way, Grace's longstanding appreciation of Matisse's paintings had come full circle.)

In August 1974, Grace wrote to Fay Chandler that Win had won a prize for a paper "on the biochemistry of schizophrenia" and used the money to buy two Guston paintings, *Night* and *Smoking II*.[59] Too bad Grace was not more knowledgeable about Win's work. She should have realized that schizophrenia was not one of his research areas. Win was an experimental epidemiologist who pursued clinical trials to test potential methods of preventing and controlling infectious diseases.[60]

Still, it is fascinating that Win would have wanted to own paintings from the early years of Guston's brooding, cartoon-like figurative work, which had been roundly rejected by the art world as a bad joke. Guston was also the artist from Grace's New York past whom she felt closest to during this period. They bonded over their problems with dealers (Guston left the Marlborough Gallery in 1972), with the New York art scene (he lived upstate, in Woodstock), and with the art world's unappealing current view of what art should be.

Guston was consistently supportive of Grace's work, calling her 1964 show at the Martha Jackson Gallery "exhilarating!…full and alive!" and assuring her in 1972 that "you are at the very height of your creative powers now."[61] When he remarked that her forms and colors "at once seem so 'simple' and yet mysterious and baffling,"[62] he could have been describing the effect of his own paintings. (Nearly a quarter-century later, curator Brenda Richardson would hang early and late paintings by the two artists at opposite ends of a gallery at the Baltimore Museum of Art—a gesture that delighted Grace.)

In the late sixties, the disconnect between Guston's lyrical abstract paintings and his rage at the horrors of the Vietnam War made him feel that he was no longer being true to himself as an artist. He had also come to feel that abstraction was too much of an in-group thing—a self-selected group of art lovers communing with the exquisite taste of an artist.[63] This conviction led Guston to renounce the work that had brought him fame and embark on a deliberately crude figurative style. The new paintings—which in some ways harked back to the politically inspired figurative work he was doing in the thirties—were populated with seemingly odd juxtapositions of objects, including the pointed white hoods of the Ku Klux Klan, shoe soles, brick

walls, and dangling light bulbs. A portly chain-smoker, Guston depicted himself as a large disembodied head who used cigarettes, alcohol, and food to self-medicate against a world of terrors he was powerless to change.

Grace loved this work. As an accomplished artist always seeking new forms of expression, she also realized that Guston's new subject matter helped give credence to her own efforts. "He is doing more of what I am doing, picking fragments from the world," Grace wrote. "You grab a little, you pick a snatch here and there, you throw it in and try to make some kind of order, some kind of meaning."[64] But while Guston had created a forceful new vocabulary of images, Grace's scattershot imagery was like jetsam tossed from a sinking ship.

She once said that, as an artist, the more "you reveal yourself very truly and deeply...the more universal your work will become."[65] She compared her process to that of James Joyce walking in Dublin and "listening to snatches of conversation" that he could borrow for *Ulysses*.[66] But Joyce constructed his novel with the utmost rigor. When Grace's life was filled with chaos and anguish, her canvases became dumping grounds for stray perceptions and bouts of venting that were visually and thematically unresolved.

In 1971, she stumbled on a pair of sandals abandoned in the gutter and decided to paint them on an already-begun canvas. Because it was her forty-ninth birthday, the painting is called *Another Birthday*.[67] An airless, phantasmagoric stew of imagery—including birds, animals, plants, legs in armor, a bucket of shells (perhaps recalling summers on the Jersey shore with her son and parents)— the painting is a sad departure from Grace's brilliant medley compositions of the fifties and mid-sixties. Like other incoherent canvases painted during this terrible time, it functioned mostly as an emotional safety valve.

Win also counted himself a friend of Guston's. When Win announced that a retrospective of Grace's work would be shown at the Corcoran Gallery of Art in Washington, D.C., and the Whitney Museum, Guston was delighted to hear it. "[H]ow marvelous!" he wrote in early 1975. "Long Overdue! And a great chance to see all of your work together."[68] Unfortunately, this show existed only in Win's increasing delusional mind. Months later, at a party given by Beati Perry, Guston became aware of the change in Win. "[G]ive him my love," the painter wrote to Grace. "I fervently pray...that he will come back to his normal self."[69] Meanwhile, Win worried about Grace's drinking, which—he told Kerns—was making her less confident in her own decisions about her work and more liable to ask others what they thought.[70] Years later, Grace confided to Kerns her fears that Win had suffered greatly from her increasing inaccessibility, her empathy dulled by a now constant alcoholic haze.[71]

"Grace was not a happy drunk," Kerns said. "I got her home in one piece more times than I care to remember."[72] Already in the late sixties, when he was her student assistant—a job that included gardening, as well as stretching canvases—he'd be cutting the grass at her home at eleven o'clock in the morning and Grace would ask if he wanted to join her in a Scotch or a Beefeater. While under the influence, he said, she would sometimes give away items to friends in a burst of generosity, only to demand their return once she sobered up. Once, while she was speaking to a women's group at the Baltimore Museum of Art, her purse crashed to the floor, breaking the vodka bottle she had stashed inside. Grace later claimed that she had not minded the public exposure—what really mattered was the waste of all that vodka.[73] She did make at least one attempt to cut back, apparently with the help of the drug disulfiram; a letter to her friend Fay Chandler notes that on a trip to Detroit for a show of her work at the Kasle gallery, she did "a minimum of drinking" but had three days of "intense nausea" when she returned to Baltimore.[74]

IN THE MID-SEVENTIES, Grace told an interviewer that her imagery came to her "through various chance encounters" with objects and photographs. She would choose some of them as the basis of a painting without consciously asking herself what they meant to her. Arranging these items near her canvas, she would try to ignore their real-life contexts and her own and other artists' previous work. She was using more drawing in her paintings and working in a flatter style as a way of trying to be "more specific," she said. Yet at the same time she yearned to create imagery that was untethered to real objects—an effect that Arshile Gorky had achieved with dreamlike shapes evoking plant forms and sexual body parts.[75]

Afraid of having her paintings dismissed as narrowly confessional, Grace sometimes bridled at the notion that her work was autobiographical. Years later, she told an interviewer that her habit of veering between lyrical and anguished expression was about "the creative spirit," not a reaction to anything going on in her life.[76] In one sense, this was true. Her real world was filled with anguish and, increasingly, physical pain. Painting existed in an exalted sphere where, thanks to the phenomenon known as muscle memory—the ability to perform familiar activities without conscious effort—she could lose herself in the flow of intense creation. Yet for Grace, who believed above all in the primacy of emotion in art, to paint was to reveal herself.

Knowing when to stop is always an issue for artists who work in an unpremeditated way. Grace never lost her sense of the canvas as an arena—the famous image, formulated by Harold Rosenberg, that characterized the so-called

Action Painters. Rather than stretch a canvas onto a wooden frame in the traditional manner, she stapled it onto the wall to allow her to "walk in and out" as she painted, sometimes beginning or ending on the wall. When this activity ceased, the painting was finished. Grace said that she had retained "the Abstract Expressionist logic, which is that you don't fuss with a painting once the emotion is over."[77] If she felt she had lost the spontaneity, the all-over surface, and the quality of light that were her touchstones, then the painting was dead and fit only for the trash.

Like an actress who can't be typecast, Grace lacked a signature style that would have made it easier for critics and curators to pin a label on her. "I always wanted to get myself in trouble," she said, by devising new challenges to keep her work fresh. "No sooner do I know how to do something than I want to do something else."[78] She was now unafraid of taking great liberties with the scale and realism of the imagery in her paintings. "I don't mind if a head disappears into nowhere," she said, "if an arm comes in with no shoulder attached."[79] Beginning in the 1970s, she often "punished" her canvases—scrubbing them with rags (a return to her *Grand Street Brides* technique) and fine-grit sandpaper, and even stepping on them—to create "chaos." This was another way of avoiding a too-faithful depiction of the way things look in real life in order to uncover the mystic realm she called "the painting's memories."

Yet despite her innovations, she felt sadly out of step. "There is a time when what you are creating and the environment you are creating it in come together," Grace told an interviewer. Now, this was no longer the case: "The world is in one place and I am in another and we are not meeting."[80] When *Artforum* asked for her reaction to the statement that painting was no longer the dominant art form, she responded that there are no unworthy forms of art, just unworthy practitioners. If the magazine would remove its "formalist blinders," she wrote, it would perceive that painting—whether representational or abstract—will always be "a passionate visual explanation of…what it is like to be alive."[81]

In 1970, a casual purchase led Grace to a stylistic shift. On a visit to the Walters Art Gallery to see an exhibition of Greek vases, she looked for postcards in the gift shop and wound up buying *Dragons and Other Animals*.[82] This children's coloring book of real and imaginary creatures was based on the Walters's collection of old illustrated books. Intrigued by the black-outlined figures, Grace took the book's introduction ("color them any way you like") to heart. She began collecting coloring books, pleased that the simplified images allowed her to fantasize freely.

For the densely populated painting titled after *Coloring Book of Ancient Egypt*—based on wall paintings from a Twelfth Dynasty tomb—Grace used

a house painter's mitt to rub the canvas with dark green paint before drawing the outlines of the figures in charcoal. She freely mixed elements (a baboon eating figs, a monkey nibbling the fruit, ancient Egyptians playing a board game) from different wall paintings. Other elements—hand and eye shapes—recall the Jungian-influenced imagery of early Abstract Expressionist paintings by Pollock and others, which Grace had absorbed years earlier. In a statement intended for an overseas exhibition, Grace succinctly summarized her current outlook as a painter: "I think of modern life, memory, myth, the present and the past all as one."[83]

In the eighties, the art world would catch up to Grace's magpie borrowings and simplified images. Reacting to the austerity of Minimalism and conceptual art, artists worldwide were rediscovering passionate styles of the past (the intense colors of Fauvism, the dream worlds of Surrealism, the freedom to exaggerate and deform that was the legacy of German Expressionism), as well as the banal subject matter of Pop Art and spiritual qualities of art from non-Western cultures.

The forms this painters' revolt took included the often bitterly ironic, deliberately awkward renderings of German Neo-Expressionist painters such as A. R. Penck, Jörg Immendorf, and Georg Baselitz, and the folkloric-inspired mystical fantasies of Italian Transavantgarde painters Francesco Clemente, Enzo Cucchi, and Sandro Chia. Some American painters (Robert Colescott, Leon Golub, Nancy Spero, Sue Coe, and others) immersed themselves in passionate social commentary. Others focused on more private realms: David Salle, on troubled human relationships; Eric Fischl, on the myths and rituals of his suburban adolescence; Terry Winters, on the structures of natural science; Susan Rothenberg, on the silhouettes of horses; Brice Marden and Robert Mangold, on finely tuned abstract compositions. Beyond subject matter, the best of these artists developed unique and memorable styles—a feat Grace never quite managed after her Abstract Expressionist heyday had passed.

With its flat, superimposed images and high-keyed colors, Grace's *Baltimore Gown Shop* (1976) has the hyper look of a Neo-Expressionist canvas. The shop's black patrons have red hands with flame-like fingers. A bodiless head wears a mask, and even the mannequins seem animated.[84] Although a local shop may have been the jumping-off point for the painting, its fantastic imagery was surely rooted in Grace's alcohol-fueled desperation to escape her increasingly grim private life. The previous year, discussing her thoughts about burlesque shows and women as sexual objects, Grace said that wearing a mask made her feel "very cat-like, as though my fingernails are growing." Bizarrely, she likened her masked self to her fantasy of being "a secret prowler in the night" seeking out a male "victim."[85]

IT IS A TRUISM that creative artists generally place more value on recent work than on pieces completed years earlier—no matter how much acclaim they received. Rating her paintings from the eighties as the best of her career, Grace was annoyed when her earlier work was valued more highly. Late in her life, at an exhibition devoted primarily to her recent paintings, a young woman came up to her, gushing about Grace's paintings from the fifties. "It's easy to like those," Grace snapped.[86] Well, yes, it is—because so many of them are stunning achievements, uniquely brilliant canvases that orchestrate glimpsed imagery and bravura brushwork and an unerring sense of color. Of course, these paintings are much easier to appreciate today than they were decades ago, when Abstract Expressionism struck many viewers as too raw and undisciplined, and impossible to "read."

With her persistent worries about going "soft," Grace seems to have had trouble distinguishing the worthwhile and necessary difficulties involved in *creating* exceptional work with viewers' enjoyment of it. We don't need to tie ourselves in mental knots to appreciate a good painting on a visceral level. Matisse struggled mightily in the 1940s to paint strikingly original, simplified works that most viewers at the time thought he could have done in his sleep. This state of affairs was deeply frustrating to him. But the point is not that there was something too basic about the paintings—that he should have added more details or tried for a more virtuoso effect. Rather, people failed to understand what was involved in radically rethinking the act of painting, as he had done. They could not conceive of everything he had to throw out to get to what seemed (to enlightened viewers) so startlingly evocative. Grace's extraordinary paintings from the fifties were all the result of intense struggle and lacerating self-doubt. Yet when you look at them, you see powerful rhythms and intensely pleasurable color and compositional harmonies. The struggle remained entirely in her head.

Although her drive to explore new artistic territory must be viewed as a strength, her frequent disparagement of "the beautiful"—of the lush aspects of nature that aligned with her coloristic brilliance—needlessly undermined her legacy. Had she never painted those "easy to like" paintings, she never would have had her shining moment in the history of art. Her combative personality and constant self-criticism led her to prize emotional truth above everything else—including her innate lyrical gift. As an artist, and especially as a woman artist, Grace distrusted this side of herself, which she associated with the shallowness of purely decorative work. Structural qualities were traditionally paramount in art; if a woman artist was a gifted colorist, she was simply expressing to her "feminine" nature. Joan Mitchell, whose embrace of

color was a form of synesthesia,[87] faced the same prejudice despite the equally grand scale on which she worked.

When an interviewer in the mid-seventies complimented Grace on her paintings based on the natural world, she replied, "I could be a very lyrical and beautiful nature painter, but it doesn't bring out my edge, and the edge in me—whether or not it interests other people—is the thing that interests me and makes me go on working."[88] And so she left behind the rich painterly surfaces of her abstract works of the late fifties and the fruitful experiments of the sixties (the vivid organic forms, the energetic compositions).

But this shift was not only an artistic decision. "The seventies were a time when I was insisting on imaging every inch of the canvas," she later told an interviewer. "God forbid I would leave an inch not taken care of. My world was falling apart."[89] As her personal life became increasingly fraught, she was dulling her "edge" with copious amounts of alcohol. During this period, she attempted to transmute her roiling emotions into the stuff of art via muddled agglomerations of imagery. When she finally emerged into the clarity of sobriety, her "edge" became her restless search for subjects to paint, her determination to fight her way back to what she had as a New York artist. But the "edge" had nearly vanished from her paintings. Taking its place, all too often, were simplistic renderings lacking emotional depth.

ONE OF THE most poignant of Grace's images of the seventies is *Broken Hammer with Butterfly*, a watercolor with collage from 1972.[90] The juxtaposition of a rubbery, drooping hammer with an insect emblematic of metamorphosis conveys a startling sense of powerlessness in the face of mortality. In a similar vein, her 1972 painting *Autumn Shop Window* (plate 28) employs a favorite theme of hers from the fifties, now transformed into a visual journal of incidents from her troubled life. She painted philodendron plants from a photo Walter took in Paris, before they met. Blank-faced images of statues she had seen on a walk with her husband suggest Win's own lack of affect. Fruit and a wine barrel evoke the sensual release of her affair with a younger married man,[91] a Greek-American she later called a "marvelous" lover—as well as her continuing romance with alcohol. This man, who began making wire sculptures with her encouragement, would be the last long-term lover in her life.

Seemingly taking a brief holiday from these angst-filled works, Grace painted *Bread Sculpture* (1977), sparked by a book on the subject.[92] Disembodied hands are seen working the dough at various stages of its sculptural life, as it turns into a sun god, sea creatures, and other assorted fauna, including a figure with what look like female and male sex organs. Yet even this goofy

painting may have unwittingly reflected Grace's sense that her life was slipping from her control in both large and small ways.

At one point in the mid-seventies, painter Audrey Flack was a house guest of Grace's Detroit art dealer Gertrude Kasle when Grace was also staying there. Flack remembers waking early and coming downstairs to the sunlit kitchen, where Grace was sitting. "Hey, Grace, good morning!" Flack said, reaching for a tall glass of water on the table. She took a sip and spit it out—it was gin. "For crissake, what are you doing!" she shouted. A long talk followed, in which Grace insisted that drinking was part of the stimulus she needed to make art.[93]

Around the same time, asked by an interviewer what she enjoyed doing when she wasn't painting, Grace mentioned her love of wine and food, walking, and gardening. She liked to look at ships and water. The interviewer probed further. "Do you like people?" Grace chose to respond obliquely, by relating an anecdote. When Adolph Gottlieb asked Franz Kline about what he did when he wasn't painting, Kline deadpanned, "I got interested in sailboating." Gottlieb said, "That's right. You go to bars."[94] Of course, there was no Cedar Tavern or Five Spot in Baltimore. Nor could Grace replicate the many evenings in New York when someone in her circle might drop by for a drink, contemplate Grace's current painting, and—if the friend was Frank—bring a poem he had just written. In Baltimore, most of her friends were graduate students—decades younger, at a different stage of life. When she felt at loose ends, Grace said, she would observe people in an uninvolved way, telling herself that she was doing "research" for her paintings. She responded similarly to another interviewer after rhapsodizing about finding a box of abandoned shoes in front of her studio, which led to a batch of shoe watercolors. "Do people mean the same to you?" he asked. "Let's just talk about the subject material," she said.[95]

Grace's sorrows during this period included the death of her eighty-one-year-old father in December 1972. Two years earlier, he had sent her several odd Christmas presents—a tiny coal scuttle, a toy train set, a purse covered in seashells, an inkwell[96]—as if to remind her of aspects of their earlier lives. Although both her parents had developed Type 2 diabetes, her mother never changed her scattershot cooking habits to accommodate the disease. (One of Grace's nieces remembers that the couple ate a lot of sweets, and that the only thing Mrs. Hartigan cooked well was taffy.[97]) Matthew Hartigan had succumbed to diabetic shock; by the time his wife called for help, he was in a coma. At his funeral, Grace showed up in an elegant black suit and a black fur hat. To fortify herself, she stood in the bathroom of the funeral home with a

hand on her hip, constantly tipping a flask of vodka to her lips.[98] This flask had become her constant companion.[99]

In a 1974 interview with *Arts Magazine*, Grace was asked whether her recent hospital stay—for a hip replacement—had an effect on her work. (She didn't mention the pre-op horror of the surgeon's assistant's shockingly unprofessional gesture: showing her a hip joint from another patient who died from a similar operation.[100]) The surgery caused her to visualize a new kind of drawing, she said, in which images divided and color zoomed in and out of space. In real life, she added, painting gave her the feeling of stopping time; when she wasn't painting, she felt as though she were walking "on quicksand."[101] Although the printed interview reveals nothing about her personal life, "quicksand" was likely her way of voicing fears about her husband.

A month before the *Arts Magazine* interview was published, the art critic Barbara Rose wrote in *New York* magazine that it was a shock in 1957 to see *Life* magazine photographs of Grace, Helen, and Joan "standing…confidently…with their huge paintings," at a time when women had second-class standing in the art world. Rose was making the point that the bad old days were finally coming to an end, with exhibitions like the Whitney's recent solo exhibitions of work by Lee Krasner and Helen Frankenthaler, and the current one of paintings by Joan Mitchell, "at the height of her powers." Rose said nothing further about Grace, who was not honored with a New York museum show and hadn't even had recent exposure in a New York gallery.[102] The tacit comparison must have rankled.

Grace's friend Fay Chandler offered a sage commentary a couple months later: "My guess is that you are perfectly able to cope with New York now—whether you know it or not—largely because you have been able to cope without New York."[103] Guston, ever supportive, remarked that in her letters to him she seemed both strong and vulnerable, "unafraid to trust your own urges and instincts—yes—away from 'art' as we know it and toward something difficult to define."[104]

AT FIRST, GRACE stubbornly denied the full extent of Win's illness, even as she used food and alcohol to cope with it. But in late 1975—when her substantial weight gain had aggravated the stress on her painful hips—she called her husband's travails "the life nightmare" in a letter to Chandler.[105] They were taking it day by day, Grace wrote, with the help of a doctor (apparently, a neurosurgeon) at Johns Hopkins's Henry Phipps Psychiatric Clinic who seemed "wise, humorous, gentle with the scalpel." In an interview that year, she refuted her young interviewer's suggestion that for an artist, life experience is all-important.

"No," Grace said. "You can lose your spirit and you can be broken. You can…lose your belief in yourself. You can…kill yourself. It has happened to many friends of mine." So what keeps her going? "[Painting] is the only thing I can think of that's better than everything else."[106]

Win told Grace that they needed to move because he had a new position at the National Institutes of Health, one of the many subterfuges he employed as his life unspooled. In March 1976—despite mounting evidence of his altered mental state—the couple bought a house in Bethesda, Maryland, a few miles from the NIH. Grace was unhappy because she now had to make a "nerve-wracking" hour-long trek to her Baltimore studio. ("It seems absurd to 'commute' to paint."[107]) The move was "a nightmare,"[108] but she believed that Win's new job would support his growing stature in the medical profession. At dinner one night with Audrey Flack, whose daughter Melissa is autistic, Grace encouraged Win to research autism at the NIH, and Win said he would.[109] It was a heartfelt gesture, perhaps a way of compensating for abandoning her son, but she didn't realize that autism was outside her husband's sphere of research. (He kept up the charade that he was working on a treatment for the disorder, over years of dinners with Audrey and her husband.)

Compounding Grace's worries was her increasing difficulty in retaining her art-world status and a growing impatience with art dealers. Grace later said that, in her view, "a dealer explains me to the world.…If they're sensitive…they do it beautifully."[110] Loyal through the sixties, Martha Jackson had died in 1969. At her memorial, Grace recalled that Jackson had visited often in Maine and Baltimore, "touchingly pleased" by having wildflowers near her bed or fresh whipped butter for her roll.[111] Grace couldn't resist adding that, several years earlier, Jackson had told Win that Grace "is the best abstract painter of her generation in America," adding under her breath, "Sam [Francis] is in Japan."* Even though she had few sales in Jackson's last years, she was shocked when the dealer diffidently asked if she wanted to call it quits. Jackson had a policy of never officially parting with her artists, even when they weren't selling.

At the time of Jackson's death, Grace was working on *When the Raven Was White*, a painting based on the implacable bird in Poe's famous poem and a tale about the Greek god Apollo that may have held a personal meaning for her. (The white bird was supposed to guard one of the god's human lovers; she was unfaithful, and Apollo—furious that the bird hadn't pecked out the

* Sam Francis (1923–1994) was a lyrical colorist who moved from Abstract Expressionism to works containing large blue forms (*Blue Balls* series) and, in the seventies, huge grids of color. He lived in Tokyo for several years.

man's eyes—scorched its feathers, rendering it and its descendants black.) Learning that Jackson had had a heart attack, Grace reworked the painting to include her dealer friend's pet parrot, the flowers she loved, and "her hand reaching up to help and be helped…a combination of her vulnerability and her ferocity"—qualities Grace admitted "might describe this artist too."[112]

Jackson's son David Anderson took over the Martha Jackson Gallery. In 1971, Win—in an unusually assertive gesture—called him to discuss Grace's contract. Anderson wrote to Grace to assure her that she would be provided with "a supply of cash" that would tide her over "for the next year or more."[113] Yet at some point that year, in an undated, handwritten note to Grace—to avoid having an official, typed copy in the files—he rued the gallery's difficulties in selling her work and hinted that changes might need to be made. In a roundabout way, he suggested that if she took a year off without a show, she might be able to develop a new style of painting that would be more distinctive (and more saleable).[114] Grace, who no doubt resented this approach, soon left the gallery.

Other New York dealers who attempted to work with her in the seventies were often rebuffed in angry phone calls and letters. For more than a decade, beginning in the late sixties, she showed with the Gertrude Kasle Gallery in Detroit, a bastion of contemporary art in the otherwise traditional-minded Midwest. Grace sent Kasle businesslike contract terms, which included up to $2,000 to be advanced to her for expenses (painting supplies, photography, framing, shipping) and a 40:60 commission split (the greater part to Grace) after the first $4,000 in sales.

But Grace's one-person show at the Kasle gallery in the spring of 1972 yielded no sales—the first time that had happened in twenty years of gallery exhibitions. Gertrude Kasle regretted that she was unable able to coax art magazine critics to Detroit to see Grace's shows. "It wasn't until she showed in a New York gallery that she got coverage in one of the magazines," Kasle recalled later.[115] Detroit was way off the map as far as the New York art world was concerned. Yet the Motor City still trumped Baltimore when it came to collectors. In 1975, Grace told an interviewer that collectors in Baltimore "who wish to pay—say, more than one hundred dollars—tend to go to New York to buy work." If she had to depend on her local sales, "I would be dead of starvation at this moment." The opening of C. Grimaldis Gallery on Charles Street two years later would help change that situation: Grace became a gallery artist in 1978 and remained loyal for the rest of her life.[116]

After five long years with no presence in New York, Grace finally had a solo exhibition in 1975 at the Madison Avenue gallery William Zierler Inc. The dealer told her that more than two thousand people had come to see the

show (including busloads of students). Her recent paintings and collages elicited a glowing review by John Russell of the *New York Times*, who would eventually become the paper's chief art critic. He praised her for figuring out a way to move on after Abstract Expressionism to "deal with real objects in the real world" while retaining the energy and audacity that made her early work so strong.[117] He also said the unsayable: that Pollock and Kline would have had to grapple with the moving-on issue, too, had they lived.

Russell singled out *Summer to Fall* (1971–72), with its collision of images of late-summer wildlife and sybaritic enjoyments in Maine, deliberately out of scale in relation to one other. Guston had also raved about this canvas, likening it to "a fan opening up the world—muscular and tender at the same time."[118] To reach the top of her huge canvas (nine feet tall, sixteen feet long), she had to stand on a ladder—her viewpoint like that of a goddess creating the fruits of the earth. The blues of creatures of the air and sea merge with the yellows and browns of fowl and autumn vegetables, a grand unfolding that Grace couldn't resist punctuating with signs of a human presence. While the glum Native American woman with an ear of corn makes a certain wry sense, Grace's last-minute decision to paint her own hand holding a tumbler of wine[119] added a needlessly jarring note. It was as if, even when her work was going well, she had to remind herself of the role alcohol played in keeping her going from day to day.

Reviewers seemed to find whatever they wanted in her paintings, she noted resignedly. ("I'm like a living Rorschach test."[120]) In 1977, her first show at Genesis Galleries, newly opened on 57th Street, elicited a positive review from fellow painter Margaret Pomfret in *Arts Magazine*,[121] but Hilton Kramer—who had replaced Canaday as chief art critic of the *New York Times*—offered only grudging praise. Acknowledging her ability to achieve "exceptional power," he nonetheless winced at what he saw as a "vulgarity of feeling" in faces that seemed like caricatures.[122] It now seems clear that Grace's personal anguish colored these faces.

What with the staggering revelations from Win and the inexorable progression of his disease, "I find living with myself hard, and the world equally so," Grace wrote.[123] Her doctor had prescribed Compazine (presumably for severe anxiety), which caused her hands to shake—a terrible ailment for a painter—and told her to stop drinking so that her enlarged liver would heal. Leslie King-Hammond, Grace's protective supervisor, was aware that, while she didn't drink at the school, she often imbibed before arriving on campus. To keep her from falling on the ice during winter storms, King-Hammond would call her and suggest that she stay home.[124]

Meanwhile, Grace—hampered by the as-yet unquestioned clinical practice of keeping relatives in the dark about the patient's prognosis—was giving friends overly optimistic reports of Win's health.[125] In early 1979, May Tabak (who liked to puzzle her way through Win's scientific papers) wrote to Grace to commiserate about a plan of Win's that didn't come to fruition, adding, "But how lucky that he recovers and is once more his own bright self."[126] Two months later, Grace told Fay Chandler that Win might have suffered brain damage, but that tests would indicate the possibility of "retraining another part of the brain."[127]

The consequences of Win's condition eluded her. He told her—and she believed—that he was waiting to hear whether he'd be hired for a prestigious position at Upjohn or Eli Lily, or that he might receive funding to work on a cancer cure at Harvard. The falsehoods and financial dodges piled up. Win told Robert and Jane Meyerhoff that he had purchased all of de Kooning's sculptures (the painter had recently begun making plaster figures that were cast in bronze) with money he had inherited.[128] He told Ed Kerns that he was trying to leverage an inheritance of eight or nine hundred thousand dollars—a substantial sum but not nearly enough to cover his purchases—by sending a few thousand dollars at a time to galleries that were pestering him to pay up.[129] He had a Cézanne painting delivered by a gallery "on approval," which Grace had to return because they couldn't afford it.[130] In September 1978, after Win asked Grace to accompany him on a European trip he said he needed to take the following spring—a total fantasy—her gallery contacted the U.S. Information Center to try to set up talks at American embassies.

It strains credulity to see Grace constantly caught up in Win's lies without ever acknowledging that something was seriously wrong with her husband., "She always said to me [that] she should have known, but she didn't really know because she didn't want to know," Chandler recalled. "And that's unlike Grace."[131] The blinders that kept her from facing the truth were her outsized belief in her husband's scientific achievements—in her self-involved way, she had never been sufficiently interested to learn what he actually did at his lab—and the numbing effect of alcohol.

Beginning in the sixties, Grace often held court in the dark confines of the Mount Royal Tavern, the campus hangout. (Years later, an article about the tavern's renovation noted that was "probably the only bar in the world where most of the patrons know who Grace Hartigan is." It was surely the only one with a multiple-choice quiz about Grace in the restroom.[132]) Now, Grace's abrupt treatment of anyone with whom she disagreed had become the stuff of gossip. According to stories that made the rounds, when she got into an argu-

ment at the tavern with realist painter Gabriel Laderman—a visiting artist from New York—she abruptly walked out, leaving him (versions differ) without a place to stay or a return ticket.

At one point, Win announced that he was about to receive the Nobel Prize and suggested that she buy a new dress for the ceremony. Grace must have believed this, because she called her friend Jane Meyerhoff to tell her the news and discuss what to wear.[133] Insistent on knowing the details, Grace finally discovered that Win had been obliged to take early retirement from Johns Hopkins in 1975—apparently, for fudging experimental data.[134] To fool her, he had left home every morning in the taxi but spent the day looking at art in museums.[135] (She later claimed that she didn't want it to be generally known that Win was forced to resign his Johns Hopkins post because she was worried about losing her privileges—as the wife of an eminent scientist—at the university hospital.[136]) Another revelation—that Win had been involved with one or more young women when Grace was out of town—was mercifully not revealed to her until years after his death.[137]

Win's prestige and income had vanished, and his spending spree had decimated their savings. One day, Grace got a call from an art dealer in Washington: Had Win decided whether to keep the de Kooning drawing? This was the first she'd heard of it. She found the drawing stashed in a closet, among other undisclosed art purchases. (Realizing that she needed to establish her own credit, Grace applied for a Master Charge[138] card as "Grace Hartigan," only to discover that the card company had called Win to ask why his wife needed her own credit card.[139])

By the late seventies, when the couple visited Elaine de Kooning in East Hampton, Win was drifting in and out of lucidity, saddled with the terrible burden of knowing that he was losing his mind.[140] Worried about Win's horrific decline, Grace doubted the value of his psychiatric treatment. She would eventually draft a furious letter to his doctor about the sexual role-playing he had apparently advised, despite Win's tenuous grip on reality. She told the doctor that she forgave this "blunder" but worried that the next one "could cost me my life."[141]

Two years earlier, she had been more than willing to give it up. In 1978, in the grip of unending depression, Grace painted the eerily serene *I Remember Lascaux*. Its central image is a white gazelle at rest, inspired by her visit to the caves twenty years earlier. Then she swallowed about fifty Valium pills, chased with a bottle of vodka. She always explained that she was saved from suicide at the last minute by Win (apparently in a lucid state at the time), who called the paramedics.

The Lascaux painting was reproduced on the cover of the catalogue for her solo show that fall at Genesis Galleries. A thoughtful review in *Art News* noted that Grace was faced with the problem of figuring out how to freshen her approach to painting and praised her combination of "expressive powers of subtlety with...strong gestural movements" in the best works on view.[142] In addition to *I Remember*, the reviewer singled out the way Grace superimposed elements of the three figures in her painting *American Indians* so that it recalled a dance photographed in multiple exposures.

At the party Beati Perry gave for Grace at the opening of her show, she lashed out at the art critic Irving Sandler, who had always been supportive. Nearly three months later, Grace finally wrote to ask forgiveness for "being so horrible to you....As a long time artists' friend you know an opening brings on temporary insanity. There is such a sense of being exposed and needing approval."[143]

The following year, when Genesis Galleries was about to close, Grace told an interviewer that she dreaded having to find another New York gallery because the art world had become "cynical and corrupt."[144] Guston applauded what appeared to be a fortuitous alliance with the young dealer Patricia Hamilton, telling Grace that "[Hamilton] and Jay [Gorney, associate director] are marvelous people...[the large] gallery space is just right for you."[145] Yet despite Hamilton's unwavering admiration, expressed in many cordial letters, Grace severed the relationship soon after her 1981 solo show.

While she allowed herself to express bitterness about the art world, Grace seemingly never let her guard drop about the personal reasons for her state of mind. In 1975, when she first became aware of the full horror of her situation, Grace claimed that if she had to live her life over again, she wouldn't change a thing.[146] A few months after her suicide attempt, she summoned enough of her old élan to declare to a local reporter that she believed she was entering her golden age.[147] It was one of her greatest Unsinkable Grace acts in a lifetime of public performances.

WHEN BRENDA RICHARDSON, deputy director of art and curator of modern painting and sculpture at the Baltimore Museum of Art, proposed a 1980 traveling exhibition of a quarter-century of Grace's collages, she had no idea what was going on in her life. It was a purely curatorial decision: the collages had not received much exposure, and Richardson thought they were "beautiful, incredibly creative."[148] The lure of having the spotlight shine on her again helped Grace regain her balance. "She sort of clawed for it," Richardson said of the show. "She did not have the attention she deserved." (The only

other major exhibition at the time that included Grace's work was the Hirsh-horn Museum's group show The Fifties: Aspects of Painting in New York 1950–1960.[149])

Richardson, who had come to Baltimore in 1975 from the University Art Museum, Berkeley, shared Grace's dismay at the city's lack of a professional art scene. "To call it provincial would be an understatement," she recalled. "Whatever art scene there was here was artists scratching out a living in their studios [and] teaching."[150] After living in a city famous for its liberal outlook, Richardson was also shocked at the segregated life of Baltimore in those days, "Jew and gentile, rich and poor, not just black and white." She had accepted the position because of the museum's distinguished profile (the collections include works by Matisse, Picasso, Cézanne, and Gauguin, donated by fabled local collectors Claribel and Etta Cone) and because she was hired specifically to bring contemporary art to Baltimore—an exciting challenge. "But there would be days in the week when I would sit in the Matisse gallery, the Cone gallery, sit and cry," she recalled. "What have I done?"[151] When she mounted a retrospective of Andy Warhol's paintings during her first year at the museum, dozens of Baltimoreans canceled their memberships. "To my shock and amazement, they claimed we were Communists."[152]

Richardson's relationship with Grace was cordial but distant. "She was warm and gracious and so enthusiastic when I got here and brought Hartigan paintings out," the former director said.[153] "When I see an early Hartigan, it just stops me in my tracks... that soaring brilliance that [evokes] the physical response you have to great abstract painting." Grace and Win had donated *August Harvest* to the museum in the mid-sixties. She had grown oddly non-chalant about this stunning painting—a key purchase of Win's before he met her. For years, Alfie, the couple's bulldog, had rubbed alongside it, leaving a dirty stripe. *William of Orange* was a museum purchase from Grace's 1962 Martha Jackson Gallery show.

In the early eighties, when Philip Johnson donated *Interior, the Creeks* to the museum, Richardson wrote Grace a warmly appreciative letter ("I am in full accord with you that it is one of the best you ever did!... It is truly a signif-icant addition to our modern collection."[154]). Richardson received a delighted thank-you letter when the museum honored Grace with a special installation of her work.[155] And when the museum's contemporary art wing opened in 1994, Richardson naturally included Grace among the famous painters, not as a "local" artist. Two years later, when Grace's work shared a West Wing gallery with Philip Guston's paintings, a group of de Koonings was hung nearby. She was delighted and fascinated by the similarities—"in the early paintings[,]

heavy surface[s] packed with angst.... And the late works similar in the spirit of openness, filled with light and air."[156] She also had no idea—until Richardson mentioned it in a letter[157]—that the curator had actively tried to interest several leading New York galleries in Grace's work.

Yet Grace was hostile to the new art movements Richardson was especially interested in, irritated that her own work had been sidelined for decades in favor of styles like Minimalism that she felt were bogus. What with this unresolvable difference of opinion and Grace's prickly personality, Richardson says that she "walked on pins and needles" when dealing with her.[158] But Grace always preferred to duke it out with an equal sparring partner. She appreciated what it meant to stick to your guns in a hostile environment. After Richardson had weathered a barrage of criticism from the local press— for, among other things, the museum's purchase of Warhol's *The Last Supper*— Grace wrote to her, "Strong people make strong enemies and strong friends. You have a strong and appreciative friend in Grace."[159]

Had she not been forced out by a new museum director in early 1998, Richardson said she would have "absolutely" wanted to curate a retrospective exhibition of Grace's paintings. By then, she said, "enough time had passed."[160] (In fact, Charles Parkhurst, the museum's previous director, had dangled the lure of a "big show" for Grace back in 1968,[161] but nothing came of it, and Parkhurst left for the National Gallery two years later.)

Grace was painfully aware that both Lee Krasner and Helen Frankenthaler had already received retrospectives—from the Museum of Modern Art, no less.[162] Joan Mitchell's career would be surveyed by the Whitney Museum in 2002. Grace's sole museum retrospective[163] was organized in 1981 by the Fort Wayne Museum of Art in Indiana. The catalogue, obviously done on the cheap, was skimpy, with a brief, vague essay. Although the author claimed to have interviewed Grace, a single, uninformative quote is the only vestige of this conversation. The show traveled to museums in Athens, Georgia, and Charlotte, North Carolina, bypassing New York entirely. (In the museum world, the major league doesn't host shows mounted by the minor league.)

ADDING TO HER WOES during these years, Grace was on the receiving end of desperate notes from her mother. Living in a series of nursing homes, she constantly complained about her treatment and demanded to be sent home. Grace's brother Arthur always made sure she had a private room ("I wanted her to have as comfortable a life as possible"[164]), but Mrs. Hartigan could not be placated. Her anger at the staff and the food may have been justified, but she also believed that Medicare (she wrote "Medicaid") was somehow conspiring

against her. Finally settled in a facility in Ocean Grove, New Jersey, where she seemed relatively content, she would try to hide her nerve-damaged legs from the doctor—a tactic that had unfortunate results. When Arthur's wife Nadia discovered on a visit that one of Mrs. Hartigan's legs had turned gangrenous, she was hospitalized and the leg was amputated. Back at her nursing home, suffering from a staph infection, her desperation level increased. She attempted to send the local police chief a $50 check to rescue her[165] and even tried to plead her case to the editor of the *Asbury Park Press* ("Please get me out of here," in large, shaky handwriting).[166]

It was during this period that Grace's old flame Alfred Leslie saw a woman at an airport who "looked bloated [and] had a terrible limp."[167] Passing her in the terminal, he turned his head away, trying not to stare at the stranger. Then Grace called his name. "When I walked over," he said, "we were this close and I didn't recognize her. She seemed to be heavily medicated. And she was very angry with me, that I didn't recognize her. . . . I [had] never [seen] her wounded in the way she was wounded then. I didn't know how to make it up to her. I would have liked to, because we were good friends, always. But that was it." They never spoke again.

Renewing

IN EARLY APRIL 1981, when it was clear that Win's condition would never improve, Bud Leake wrote to Grace. "What a horrible condition for poor Win—and for you another horror...as sad as death and in a way worse." He reminded her that "painting is a blessing...that holds hope."[1] Win was in a coma during his last weeks, and Grace came to the hospital every day and read to him. He died on the last day of the month; his obituaries in the *New York Times* and the *Baltimore Sun* gave the cause as meningitis, a neurological disorder caused by bacterial infection of the membranes covering the brain and spinal cord. Grace's brother Arthur asked if she would like to have him identify the body, but she insisted on doing this herself. She had his remains cremated and the ashes scattered in the seaside village in Maine where the couple had spent so many happy summers.

Then she fell into a deep despondency. She had lost her soul mate, and everything she took for granted for so many years had been swept away, from her daily routine (a friend noted that she had "a drinking time and a working time"[2]) to the comfortable lifestyle Win's salary had made possible. Soon afterward, Robert and Jane Meyerhoff took Grace out for dinner at one of her favorite restaurants. "Good evening, Ms. Hartigan," said the maître d'. "How is your husband?" Without breaking her stride or thanking him for his concern, she snapped, "Dead."[3]

Among the condolence notes was one from her first husband, Robert, who wrote two years later (after Jeffrey told him about Win's death) and added, rather oddly, that he wanted nothing from her "except your good will."[4] Grace's collector friend Roland Pease thoughtfully couched his condolences in praise of her paintings, several of which he owned. "You are a constant presence in my home," he wrote.[5]

At first, she was unable to paint, unable even to read a book. And then she suddenly couldn't stop reading novels—by Virginia Woolf, Elizabeth Bowen, Anne Tyler. "The women I am astonished by are the women who write," she told an interviewer.[6] Grace managed to put up a good front when a journalist

interviewed her a few months after Win's death, detouring around her emotional state by noting that a painting of hers from 1960 had recently sold for $10,000, and that new ones were fetching as much as $20,000.[7] She also decided to go ahead with a four-artist exhibition at the Hamilton Gallery of Contemporary Art in New York and a retrospective of her watercolors and collages at C. Grimaldis Gallery in Baltimore.

Unable to bear living in her home—after selling the Bethesda house in 1979, she and Win had moved to an apartment in Charles Plaza on Saratoga Street in downtown Baltimore—Grace decided to hunker down in her Fells Point studio space. In her small bedroom, she surrounded herself with objects that represented a medley of comfort, glitz, and better days, including "a mink teddy bear, and photographs of her father, a sister, her late husband and a past lover."[8] Her mother's death in May 1982, at age eighty-six (she had waffled about her birth date over the years, slicing off as many as six years on official documents) was hardly unexpected, but it threw into relief their lifelong inability to understand one another. Constant drinking was the only outlet for Grace's intense mental anguish.

Near death with liver disease, Grace was hospitalized at Johns Hopkins Medical Center. Her doctor told her that a single teaspoon of alcohol would kill her, a terrifying prospect that cut through her web of rationalizations. When she was ready to leave the hospital, he arranged to have her meet with a representative of Alcoholics Anonymous, telling her that he would refuse to sign her out unless she left with this person. "Her first reaction was to be furious," Fay Chandler said later. "And then she realized that it would save her life."[9] Willful as she was, Grace finally realized she had no choice if she wanted to continue painting. As she wrote to Chandler, "As far as I can tell the two things that God wills me to do [are] not drink and continue painting. And love life, as I do, and love my friends, as I do you."[10]

The mention of God was something new. An appeal to Chandler's strong spiritual beliefs, it also reflected Grace's membership in Alcoholics Anonymous. One of the first twelve-step programs, A.A. asks its members to seek guidance and strength from a higher power and to make amends for the hurt they caused people while under the influence of alcohol. In her letter to Chandler, Grace wrote that she was going to chair an A.A. meeting about how to distinguish God's will from our own, "something I pray to know." For Chandler's benefit, at least, Grace continued to nurture her spiritual side. On a summer trip to Maine seven years later, she wrote, "I used to feel God's presence more in nature than in my cities. That's no longer so—the presence is a constant."[11] She confessed to Chandler that she had "called out 'Help' so often

in the last year, for relief from worldliness and ambition, financial insecurity and new territory in painting—and gotten that feeling of spiritual embrace."[12]

On the other hand, Grace had a cheerfully irreverent attitude toward the trappings of religion, describing two of her "icon" paintings of the eighties as "a batty saint with pursed lips" and a "naughty" Madonna with a sidelong glance—features that surprised her when she found herself painting them.[13] These figures—and the distracted-looking Madonna holding her Son near her right hip, as if wishing someone would take Him off her hands, in the watercolor *Madonna in Red Bed* (1994)—incorporate facets of Grace's own personality, as well as people she encountered in everyday life. She told an interviewer, "You draw from the visual material around you.... [A]ll of the Madonnas [in Old Master paintings] were the artists' girlfriends or their wives."[14]

Angels began to populate her painting in her final decades, most memorably in *Visions of Heaven and Hell* and *Angels Over Manhattan*, her private commemoration of the horror of the September 11, 2001, terrorist attacks—specifically, the doomed employees at the World Trade Center who jumped to their deaths. Although descendants of the benevolent angels painted by the eighteenth-century artist Giovanni Battista Tiepolo can be seen in this painting, Grace's primary visual inspiration was a sequence in Wim Wenders's 1987 film *Wings of Desire* in which an angel, in the guise of a middle-aged man, attempts to prevent a man standing on a rooftop from committing suicide. When he jumps, the angel screams in sorrow and frustration.[15] As a devoted reader of the poems of Rainer Maria Rilke, Grace knew his *Duino Elegies*. In the first of these poems about the burdens of being human, he writes: "Who, if I cried out, would hear me among the angels' hierarchies?" Even if an angel "pressed me suddenly against his heart," Rilke wrote, it would not be consoling, because "Every angel is terrifying." Yet, he concludes that we "do need such great mysteries" as death because "grief is so often the source of our spirit's growth."[16]

Despite Grace's desire to believe in something larger than herself, she retained her skeptical core. When she spoke of the way her search for larger-than-life subjects led her to movie stars "worshiped" by the public, she would add that she herself did not hold conventional religious beliefs. In *Visions of Heaven and Hell*, she portrayed an ambiguous afterlife in which only the angels clearly belong to the traditional notion of a heavenly sphere.

Asked why she painted a scene of the Annunciation—*Gabriel and Mary* (2002), based on a late fifteenth-century painting by Lorenzo di Credi[17]—if she didn't believe in it, she replied that she found it "amazing" even though

she was "not a Christian," and that perhaps she did believe in angels.[18] Then she added, "to tell you the truth, Mary is me." Although her Mary figure echoes the gesture of the original (normally understood as expressing astonishment, from Luke 1:34: "How shall this be, seeing I know not a man?"), Grace maintained that she was really saying, "I don't want to know this."[19] It is not a big leap to pregnant Grace in 1941, had she been endowed with foreknowledge of her son's fate.

After Grace stopped drinking, she regained her ability to empathize, though (as we shall see) with certain unconscionable blind spots. Toward the end of her life—responding to a heartfelt letter from her brother Arthur, who had become a Jehovah's Witness and asked her to look for him when she was resurrected[20]—Grace wrote that she could not believe in the literal truth of the Bible or in heaven, "but in a powerful life force I call God."[21] Yet, she added kindly, if her brother turned out to be right about a bodily existence after death, she looked forward to their encounter.

IN AUGUST 1982, Grace wrote to Fay Chandler, "I think I've found the music again, or started to."[22] The "music," of course, was her painting. She later called *Eastern Avenue Florist* "the first painting of my sobriety," imbued with "the clearness of hope."[23] Across the street from her studio was a florist shop that displayed only plastic plants in the window. Grace decided to "make them seem very alive."[24] Her painting transformed the shop window display with bright, translucent color and the symbolic additions of a Madonna statue and a goofily hopeful Raggedy Ann doll. As she once wrote, "the subject of my art is like the definition of humor—emotional pain remembered in tranquility."[25]

A new source of inspiration was Tom Tierney's *Glamorous Movie Stars of the Thirties Paper Dolls* book.[26] She remembered these screen goddesses from her youth, and once again they served as fantasy creatures that fed her fascination with the manufactured aura of stardom. In *Constance* (1981), based on a paper-doll image of the perky blonde actress Constance Bennett, Grace used candy colors borrowed from the French Rococo painter Watteau overlaid with thin streams of black paint—as if black tears were raining on Bennett and her airy costumes. Grace would have known that in *What Price Hollywood*, one of the actress's best-known films, the man with whom she is carrying on an extramarital affair is an alcoholic who eventually kills himself. (After Win's death, Grace veiled one of her paper-doll series paintings in black, added a drawing of Alfie the bulldog, and retitled the work—which she never showed publicly—*Goodnight, Sweet Prince*.[27])

Using paint diluted with turpentine and a rag or sheepskin mitt as a blotter, Grace controlled the drips[28] that she sent coursing down canvases primed with white paint. She described this style as a way of retaining an emphasis on the painting's surface—always a prime goal of Abstract Expressionists—and resisted suggestions that it had anything to do with her state of mind. Granted, de Kooning had punctuated the bulky forms of his black-and-white abstractions of the late forties with skinny drips of white and black paint at rhythmic intervals. Yet in Grace's paintings, the effect is lugubrious—as if a dark rain is falling, distancing us from the subjects of the paintings. It is impossible to look at these paintings and not see a connection to her disorientation and sense of loss. Typically, she put her own spin on the drips, once likening them to "veils of tears or…bead curtains that you have to lift"[29]—the curtains' cheesy glitz factor neatly counteracting the raw emotion evoked by the tears. This was a very Frank-like conflation of images—a sob in a boudoir.

Grace's coloring-book borrowings continued with paintings based on *The Renaissance: A Bellerophon Coloring Book*. These canvases combined the simplified figures of the coloring books with a return to one of her first loves: Old Master paintings. She borrowed elements of two portraits in New York museums by the sixteenth-century Italian painter Angelo Bronzino—*Portrait of Lodovico Capponi* and *Portrait of a Young Man*[30]—to paint *Bronzino's Young Man* (1985). In *Portrait of Lodovico Capponi*, the young man's right hand holds a cameo portrait (his finger blocks out the face but reveals the inscription: "fate"). Grace paints this hand, stripped of its aristocratic glove, as if it were a double exposure. This strikingly agitated gesture, coupled with the figure's prominent eyes, the omission of his codpiece,* and the painting's rivulets of black and green paint, give him a vulnerable, haunted quality. Bronzino was also a poet, and the book carried by his unnamed "young man" in the other portrait was likely related to his literary pursuits; was Grace thinking of Frank?

She found another serendipitous source for her work in fashion illustrator Tom Tierney's *Great Empresses and Queens Paper Dolls* book, published by Dover in 1982. Tierney, who had studied art and art history in college in the 1940s, and continued his art education at the Pratt Institute and the Art Students League, was initially inspired by his mother's collection of paper dolls from the silent movie era.[31] Researching the paper dolls as a way of learning

* Codpieces were shaped and padded pouches worn by men of the era over the genitals as a sign of virility.

about the subjects' personalities, as well as about the clothes they wore, he aimed to capture characteristic gestures seen in paintings or photographs.

Grace's *Great Queens and Empresses* series from 1983 (she reversed the book's title) allowed her to portray powerful women from distant eras whose real selves have dissolved into myth. The queens include versions of Tierney's Elizabeth I of England, Eleanor of Aquitaine, and Liliuokalani, queen of the Hawaiian Islands; the empresses are Josephine and Theodora. (The face of Grace's Empress Theodora is blank, which has caused several commentators to wonder What It Really Means. They may not have known that Tierney's book is full of faceless images—the gowns-with-headdresses that are meant to slip over the paper dolls—so Grace had a readymade source, whatever her motivation may have been.[32])

She borrowed this and other details from Tierney's paper dolls, but felt free to alter the originals. For *Elizabeth I*, she retained Tierney's choker necklace, deep décolletage and the fan and gloves the queen holds in her hands—based on a painting of the Virgin Queen by Marcus Gheeraerts the Younger.[33] But she swapped the immense heart-shaped lace ruff for a pair of awkwardly attached giant wings—more useful in escaping Elizabeth's many suitors, perhaps, or possibly a tribute to her peace efforts at a time of raging religious and political conflicts. A fanciful jeweled wire ornament morphs into a few token dots of color and tiers of fringe-like thin drips in uneven lengths, one of Grace's new signature devices.

Elizabeth's face, like that of virtually all Grace's heroines, is a cartoon version of her own; once you've seen a number of these paintings, the repetitiveness can be tiresome. Was it simply self-centeredness that caused her to replicate herself? Or is there a lurking sense of self-parody, a costume drama in which—ha, ha!—she finally gets to play the grandiose roles envisioned by playwright Maxwell Anderson without the blank verse that she found so boring. Painter Ed Kerns, her former student and longtime friend, believes the reason is simply that "abstract [artists] paint their own experience."[34] Why should she give up that approach, even when her subjects were famous people she had never met? Grace once told an interviewer that "it is very hard to reinvent a face.... You have to measure the psychological effect... with the formal problems involved."[35] In 1993, she wrote to a friend that "like Frank's many selves...I am the metaphor for all the women I paint[,] stars and queens and goddesses and mothers and daughters."[36] Sadly, she apparently failed to realize that the results look formulaic; unlike Frank in his best poems, she had failed to turn her personal experience into an aesthetically heightened form.

Josephine was forty-one when she was crowned empress; five years later, unable to bear an heir, she was divorced by Napoleon. For the brief remainder of her life, she lived with constant personal and political insecurity. Grace must have been intrigued to read that Tierney patterned Josephine's empire-style gown from a print showing Napoleon confronting her about the divorce. Posing with a baleful look, Grace's *Josephine* half-disappears into the darkness around her as if unwittingly caught in a spotlight in her bright yellow dress. At first, Grace was stymied by a technical problem—how could she make a figure appear separate from the background while retaining a flat, depthless surface?

She found her answer in New York on a trip to the Metropolitan Museum of Art, which mounted a Manet retrospective in the fall of 1983.[37] Studying Manet's paintings to see how he created the edges of his figures, she discovered that "when you stand back, it seems to be a fixed edge," she said. "But from up close the edges quiver, as the image slips into the ground, and ground slips into the image."[38] Grace viewed Manet's black backgrounds as symbolic of a modern sense of isolation, of "being nowhere,"[39] a feeling she knew only too well.

A key carryover from the "action painting" energy of her abstract work was her feeling that a painting needs to be "the event itself, as it is happening right there" rather than merely a depiction of something.[40] She cited Rembrandt as an artist who makes viewers feel that they are looking at a real person thinking and reacting in the moment. Grace still tacked her canvases to the wall, but now she was working with thickly applied oil paint. ("Oil has a life of its own," she told an interviewer,[41] seemingly pleased to be working with a medium as feisty as she was.) She would scrub the surface with steel wool, twine, and sandpaper, and then repeat the paint-and-obliterate process until she was satisfied with the results. For the sinuous lines of her compositions, she used flat, soft-bristled sumi brushes, employed by Japanese painters to achieve fluid thick and thin lines with a few deft strokes.

IN 1980, GRACE had asked Rex Stevens, a street-smart first-year Hoffberger student in his mid-twenties, if he could stretch canvases for her, suggesting that he bring a friend to help. Rex invited his buddy Tom, a finish carpenter, to come along.[42] The painting Grace wanted stretched was large, about six by nine feet. "Can you just stretch it on the wall and tape it?" she asked. Then there was a table to move, other things to be cleared away. "The space was huge," Rex recalled years later, "like, 3,000 square feet of open studio space." He and Tom finished the job in about twenty minutes, which raised Grace's suspicions, so she walked upstairs to make sure everything was completed to her satisfaction.

"Then she goes and gets her purse. 'Here's twenty dollars; split it between you.' She gave me the twenty. I ripped it in half and gave Tom half. She's saying, 'What are you doing? That's real money!'" But his audacious gesture appealed to her. "From that day on," Rex said, "I could do no wrong. Grace saw some kind of spirit in me that she could get behind." He became her Hoffberger graduate assistant and, almost immediately afterward, her studio assistant.

In the mid-eighties, Stevens and his wife Regina (who had also been a Hoffberger student) moved to the top floor at Fells Point, and he worked for her for the rest of her life—thanks to the good influence of Elaine de Kooning. Rex had met her when she was a visiting artist during his first year at the Hoffberger School. One day, Grace asked him to drive to Elaine's house in East Hampton (she lived separately from Bill by that time) to pick up her paintings for a show at the institute. No one answered Rex's knock on the door. The friend who had come with him got impatient and decided to barge in. "Elaine!" he called. No answer. Then the phone rang, and much to Rex's consternation, his friend picked it up. The caller—painter Connie Fox, a good friend of Elaine's—promised to track her down. About fifteen minutes later, Elaine returned. Fortunately, she remembered having met Rex at Grace's studio and issued an open-ended invitation to visit her and Bill.

Four years older than Grace, Elaine approached life with a markedly different temperament—generous to a fault, surrounding herself with friends, family, and pets—which had enabled her to make a life with an artist whose fame eclipsed hers. (Elaine was an accomplished painter of semi-abstract figures, often seen in rhythmic activity, and a brilliantly perceptive art critic; when she began writing for *Art News* in 1948, she was the magazine's only practicing artist.) After dropping out of Hunter College to enroll at the grandly named Leonardo da Vinci Art School in New York, she met Willem when the school's director pointed him out as the star student. (In another version of the story, she met him at one of the cafeterias that artists frequented.)

Elaine began studying with him and soon became his lover.[43] Married in 1943, they were a head-turningly attractive couple—Elaine was slim and vivacious, with strawberry-blonde hair, finely chiseled features, and pale skin—and fiercely devoted to their work. They had no children, and Elaine managed to avoid wifely household duties. The de Koonings lived apart beginning in the mid-fifties, when his pursuit of other women became impossible to overlook: he had a daughter by another woman. But Elaine was always there for him—in the late seventies, to help him stop drinking, and in the eighties,

when his mental acuity began to decline. Her home and spacious studio was just five minutes from his on Alewife Brook Road. "Elaine never got bitter," Grace said. In her eulogy for her friend, she noted that when Elaine was asked what it was like to live in de Kooning's shadow, "she said that she lived in his light."[44] Visiting Elaine and Bill in the 1990s, Grace praised him as the greatest painter of the twentieth century: "Picasso [was] the greatest image-maker and Matisse [was] the greatest colorist, but Bill [had] the greatest hand." When she said this, "you would have thought I had given [Elaine] the most wonderful compliment in the world."[45]

On one of Rex's visits, Elaine asked him what he planned to do when he graduated. Rex said he thought he would move to New York, but Elaine said, "What about Grace's problem?" Focused on his own future, Rex was unaware of any problem. "Who's going to take care of Grace?" Elaine asked. She urged Rex to stay and help out, suggesting that he and Regina could live rent-free in the top floor of the Fells Point building. It took some persuading—in addition to broken windows and pigeon droppings, the space was crammed with former students' paintings—but Rex agreed, with one stipulation. He told Grace that he didn't want her to critique his work. ("I said, 'We'll do the reverse. I'll critique you.'")

Rex helped Grace move into her studio and renovated the space. In addition to performing physically demanding studio tasks, like cutting canvas to the outsized dimensions she specified, and purchasing supplies, he eventually took charge of other matters. "She's a very impulsive poison-pen writer," he said. "I don't think there's anybody who's a quicker thinker about how to slice you with words. My thing is, that's not necessary." He would badger her to write a second version, less likely to make enemies. "You gotta wake up ready like a prizefighter with Grace," he said. "She's movin' like a locomotive." (At some level she seems to have taken this advice to heart. Toward the end of her life, she called Audrey Flack—who had sent her a draft of an article criticizing certain practices of the Whitney Museum—to tell her not to publish it. "Don't make any more enemies than you need to," Grace said.[46])

Perplexed that Grace would want to change her style when her work was selling, Rex would urge her to keep working on a theme. ("I think you've got a couple more in you") When she shifted gears, he said, "it would take me a couple weeks before I got on board, because I'd still be stuck on what she used to do." But he understood what motivated her restlessness. "I think that comes from being self-made," he said. "I think it comes from your heart, when you get excited about something. It's like falling in love. Holy moly! And then, it's why people stray. They're going, Whoa, *that* one looks better to

me.... She could never settle for just doing something she knew how to do. That's why she would try sumi ink with watercolors. See how that works. Oil paint on paper without priming the paper. And I'm going"—Rex hit his head in disbelief. "So it was a lot of fun to watch her change, but sort of disheartening at times because you never knew what's coming next." While artists often need to produce a certain number of works in a new style to get up to speed, Rex said that Grace could be "like a blues singer who just starts up, no warmup, and tells you his life story in about five minutes."

GRACE HAD BEGUN to conflate her personal rebirth after her husband's long illness and her long battle with alcohol with the subject matter of her paintings. She believed that they convey "what it's like to be alive" and that "to live is a triumph...over despair, over adversity."[47] Wishful thinking, perhaps, but her paintings of this period frequently do display a sense of humor—albeit often at a male figure's expense—that was shared by few of her peers. (Robert Colescott is one notable exception.) Who else would paint a droopy *Saint George* (1985) without a sword who confronts a pipsqueak dragon and is burdened with two maidens to save?

Still, after painting *Visions of Heaven and Hell*, Grace floundered for a while. Her attempt to paint interior spaces resulted in a few awkward canvases that she disowned. "Furniture tells people how they have to live," she told an interviewer just before embarking on this work.[48] This whimsical conceit—reversing the usual notion that people choose furniture because it suits their lifestyle—would likely have taxed the painterly imagination of any artist. Yet the idea simmered in Grace's mind, and she found a way of painting interiors at the end of her life (*Caribbean Interior, Parisian Bathroom*), drawing on lessons learned from Matisse's *Red Studio* of 1911.

Grace's reputation had begun to emerge from obscurity. In 1983, a stint as a visiting artist at the newly founded Milton Avery Graduate School of Arts at Bard College brought with it inclusion in a three-person exhibition with Elaine de Kooning and abstract painter Stephen Greene.[49] The following year, Gruenebaum Gallery reintroduced Grace to Manhattan with a show of her *Great Queens and Empresses* series and other work, including paintings of women after Velázquez. Poet Gerrit Henry—who had followed in Frank O'Hara's footsteps by working at the Modern's information desk earlier in his career—reviewed the exhibition in *Art in America* as though he had read Grace's mind.[50] He wrote that she had created tragicomic queens "that can be crowned and dethroned at will." Her ability to show them "at once so clever and so stupid" proclaimed the power of art to create an aura of divinity around these women and also to scrutinize what it really means.

In an *Artforum* review, sculptor Jeanne Silverthorne noted the relationship of Grace's queens to de Kooning's *Queen of Hearts* from the early forties (with her big, bulging eyes) as well as her kinship with Philip Guston's late, cartoon-like paintings.[51] Silverthorne's description of the way Empress Theodora's costume "waits" on the left-hand side of the painting for her "to step into it and come into her power" vividly captures the theme of transformation that she saw in these works. In their different ways, both reviews position Grace as a queenly personage in her own right: a powerful artist (Henry) with a benevolent outlook (Silverthorne). Grace must have been thrilled to see her work so thoughtfully parsed. She relished the timelessness of courtly robes—she used to warn her students that figures with miniskirts would soon look dated—as well as the opportunities they provided for lavishing paint on ornamental details.

In June, six of Grace's finest paintings[52] from the years of her greatest fame were included in a dazzling exhibition, Action/Precision: The New Direction in New York, 1955–1960. Traveling from Newport Harbor Art Museum in Newport Beach, California, to New York University's Grey Art Gallery, with stops at galleries and museums in Massachusetts, Ohio, and Texas, the exhibition also included work by Alfred Leslie, Joan Mitchell, Norman Bluhm, Al Held, and Michael Goldberg.

In his catalogue essay, Newport Harbor curator Paul Schimmel illuminated what he saw as the differences between these artists—the so-called second generation—and their forerunners.[53] He wrote that the artists "heralded a new interest in light and space, in the gesture, and in the substance of paint," as well as in a more formal painting structure that "embraced the natural world."[54] The second generation felt free to find inspiration wherever it existed—in particular, in the tradition of European landscape painting. Light was an especially important component. But whereas the Impressionists focused on capturing the quality of light on a particular landscape, the second-generation painters evoked a nonspecific atmosphere based on a cumulative, deeply felt experience of the natural world. As Schimmel noted, Hofmann's teachings were a key link between the European past and the American present.

While Schimmel called Grace's nature-inspired paintings of the late fifties "romantic," art historian Robert Rosenblum (perhaps thinking of *Billboard*) focused on the way Grace "keeps wrenching us away from the potential serenity of the artist's studio into the bumps, collisions, and chance encounters of a raucous reality outside."[55] Both remarks are on target; Grace was not one to be easily pinned down.

The *New York Times* review of the show was perfunctory, comparing each artist's work of the fifties to what they were doing in the eighties.[56] But in *Art in America*, Kenneth Baker looked afresh at the notion of a "second generation" as a group of younger artists who viewed painting as a way of "giving meaning, rhythm and momentum to [their] interaction with the world."[57] He called Grace's paintings "the most decorative and the most unpretentious" work in the show. While "decorative" is normally a term of disparagement in an art review, he was referring to the sensual ease she demonstrated as a painter, her lack of signs of struggle in paintings like *Montauk Highway* and *Sweden*. He added that hers were virtually the only works that reflected sheer enjoyment with the act of painting—a "lilt and dance of marks" that had sustained her work through the decades. Baker unconvincingly faulted Grace's brashly energetic *Billboard* and *Summer Street* ("cute failures") for including recognizable bits and pieces of everyday life.

Delighted to be exhibiting with fellow painters from her glory days in New York, Grace nonetheless chafed at the constant references to the group as the "second generation." She always maintained that she felt every bit the equal of de Kooning and the other first-generation Abstract Expressionist painters. They were all in and out of each other's studios all the time, she said, free to criticize each other's work. (Yet, around this time she did note that although she and Helen and Joan considered themselves friends of Kline and Guston, Pollock and de Kooning were in a different category "because they were earlier."[58])

The rise of Neo-Expressionism and the return of figurative painting in general also helped rescue Grace from oblivion, though she always made clear that she viewed expressionism in any other form than Abstract Expressionism as self-indulgent and messy-looking. In interviews in the mid-eighties in which she denied any connection between her current work and that of Neo-Expressionist painters, Grace dismissed their "dirty color" and "badly drawn images." What she believed in, she said, was "beauty…beautiful drawing…elegance…luminous color and light."[59] She declared that she was involved "with elegance, with transcendence." But her true passion was for *glamour*, the larger-than-life lushness—so deliciously campy—that she and Frank enjoyed on their movie outings. When talking about her use of themes and images from popular culture, she insisted that her goal was "to make it wonderful, beautiful, grand, glorious, glamorous in the highest sense that Velázquez made things glamorous."[60]

At sixty-three, Grace seemed to be easing into her new life of sobriety, serenely coming to terms with her aging self. But the old fire was still in evidence

in *Bacchus* (1985), based on three paintings (*Bacchus, Self-Portrait as Bacchus*, and *Boy Bitten by Lizard*[61]) by Caravaggio, the seventeenth-century bad boy of art. If she couldn't drink anymore, she could still paint the god of wine, ritual madness, and ecstasy. He makes a trio of appearances in this painting— demurely proffering a wine glass; bare-chested, with a glazed look, clutching a bunch of grapes; and recoiling with fright. (For the third image, Grace omitted the lizard; the "bite" is the loss of self-control that she knew all too well.) To Grace's delight, Mick Jagger bought the painting. Her dealer Julian Weissman remembers that when he stood to one side as the superstar admired the work, it occurred to him that the full, parted lips of the figure on the right echo Jagger's.[62] (When Grace chose the larger-than-life subjects for her paintings, however, her loyalty was to movie stars—the luminous faces on the silver screens of her youth—not rock stars.)

Artforum published a review of her 1986 Gruenebaum show of new work. The fact that a leading American art journal still thought Grace worthy of a review was probably more significant at this point than its rather snide assessment that she had successfully combined elements of Abstract Expressionism with "the game of art-historical quotation."[63]

Two years later, six of Grace's paintings from the early and mid-fifties[64] were shown in The Figurative Fifties: New York Figurative Expressionism.[65] Traveling from Southern California to Philadelphia and San Antonio, the exhibition brought together paintings by thirteen artists with disparate styles to make the point that artists in New York who were part of the Abstract Expressionist scene were not all abstract purists. The show included Willem and Elaine de Kooning, Jackson Pollock, Larry Rivers, and Alex Katz, as well as lesser-known figures such as Jan Müller, Bob Thompson, and Robert Beauchamp.

Critics found the choice of artists arbitrarily limited—Milton Avery and Alice Neel weren't included because they had been painting figures long before the fifties; California painters David Park and Elmer Bischoff didn't live in New York. Grace helped knit the show together in brief remarks at the Pennsylvania Academy of Fine Arts. She explained that all the artists represented knew each other and each "took a position regarding Abstract Expressionism," the most extreme being Fairfield Porter's, who rejected the movement entirely. For her part, she said, working abstractly made her feel that "I had found a new way of painting without going through an investigation of my content."[66] As we've seen, her subsequent "investigation" began as a direct borrowing from older art (as in *The Knight, Death and the Devil*), but soon matured into de Kooning's "glimpse of something, an encounter...like a flash," with forms that carry "an emotion of a concrete experience."[67]

Buoyed by all the attention, Grace told an interviewer that she woke up in the morning feeling "charged," and that collectors and museums were now "waiting" for her work.[68] But what they wanted were mostly her early canvases. The Guggenheim had acquired *Ireland* in 1976 as part of the Peggy Guggenheim Collection; the Metropolitan Museum of Art had purchased several of Grace's lithographs in the sixties and seventies, and received *Southampton Fields* (1954) and *Young Louis* (1984) as gifts in the eighties.[69] Thanks to quiet, behind-the-scenes donations by the self-effacing Fay Chandler, Grace's paintings were beginning to find more homes in museums outside Manhattan. If major collectors were not exactly clamoring for her recent work, it did sell steadily through the C. Grimaldis Gallery in Baltimore.[70] She had become a local legend—so much so that she eventually stopped attending AA meetings because people would approach her.[71]

To a writer for an out-of-town paper, Grace confided that facing a blank canvas when you're in your sixties was "a pretty anxiety-making situation, believe me. And then when it's finished and I don't know if it's any good or not, that's anxiety making, too."[72] This was the old Grace, the one who confided her day-by-day worries about her work to her journal. Now, of course, she had a lifetime's perspective on the problem, noting that once she had painted a number of works in a particular vein, she was able to single out the better ones from the rest—which, in her vintage slang, she called the "not so hotski."

To the local press, however, she always put her best foot forward. "I'm at the height of my powers," she announced. "I have discipline, curiosity, humor, daring, passion."[73]

Prevailing

IN THE EARLY eighties, Grace revived a custom abandoned since the final years of Win's illness, when it was no longer possible to spend languid summers in Maine. She rented a spacious cottage in the Hudson Valley village of Rhinebeck, about a hundred miles north of Manhattan, not far from the estate owned by Beati Perry and her husband. A windowed barn on the property, with a view of "the darkest green woods" on one side and the "ultramarine light" of a swimming pool on the other, became her studio.[1]

One summer, Grace issued invitations to recent MICA graduates Joan Stolz and Maura Maguire, and to John Myers. Patching up their old quarrels, Grace found him "tremendous fun,"[2] though she continued to complain about him behind his back. "Grace would have these wonderful lunches," Stolz said. "Everything she made was delicious. She was so gracious and generous with us. You'd go there and feel quite spoiled."[3] She recalled the "aristocratic and charming" Beati, who would trill, "Hellooo," when a visitor came to the door.

When friends weren't visiting, the telephone increasingly replaced letter writing as Grace's lifeline. "She would call you up and expect an hour or more, until she was finished with what she wanted to discuss," Ed Kerns said.[4] Correspondence with her close friend, painter Karen Gunderson, consisted mostly of greeting cards; when Grace had anything important to say, she would pick up the phone. Since she no longer kept a journal, most of her day-to-day ruminations about art and life during her final decades have vanished into the unstable realm of other people's memories.

Grace's leafy surroundings in Rhinebeck inspired *Lady with Pomegranates* (1985; plate 29), an image of her alter ego as a serene elderly woman in an old-fashioned maroon dress. Dissatisfied with her initial, crowded composition, she was browsing in a local bookshop when she came across an illustration from a fifteenth-century alchemical treatise: a tree of life—an ancient mystical symbol—that floated in space, with symbols of the four evangelists

attached in a row to the top branches.[5] This image gave her the idea to paint a fragmentary tree trunk and four blurry fruits that seem to be descending at different speeds, above her figure's head. The plummeting pomegranates are Grace's impish way of destabilizing her depiction of peaceful old age: In this life, you never know what will hit you.

AS IF TO MARK a final get-together, several of Grace's paintings joined Helen Frankenthaler's and Joan Mitchell's in an exhibition at the Museum of Modern Art. Curated by painter Elizabeth Murray as part of the museum's "Artist's Choice" series, it included rarely seen works in various media by seventy twentieth-century women artists, beginning with Murray's early role models—Grace, Helen, Joan, and sculptor Lee Bontecou.[6] Before the show opened, Grace was under the mistaken impression that it would include major works by women and minor works by men. In an interview, she joked, "When there's nothing to gain in worldly terms, men and women are great pals as creators."[7]

Divorced from Motherwell in 1971, Helen would marry an investment banker in 1994 and spend her last years in a wealthy enclave in Connecticut with a view of Long Island Sound. She and Grace were a study in contrasts. While Grace was a voluble interview subject, full of feisty comments and personal revelations (however codified they became over the years), Helen's remarks always seemed tightly scripted and intended to enclose her in a veil of privacy. Although both women were fiercely opinionated, Grace would come out swinging and Helen would freeze out the unwary questioner. Unlike Grace's, Helen's star continued to shine brightly in the art world, with shows in leading New York and European galleries and seven retrospective exhibitions by the mid-eighties, beginning in 1960 at the Jewish Museum in New York.[8] That show was organized by Frank O'Hara, who also wrote the catalogue essay, which must have given Grace a bitter pang. In 1969, Helen was the only woman included in the Met's huge (and hugely controversial) exhibition New York Painting and Sculpture 1950–1970. Her retrospective at the Modern came at age sixty, in 1989.

We don't know if Grace noticed that a smiling Helen posed in her studio for a Rolex ad. The copy noted that "Although Frankenthaler leads a calm, ordered life, she embraces risks and adventure in her art." She is quoted as saying that despite the "variety of directions and themes" she has explored, "in all my painting you can see…the work of one wrist"—the one wearing the $7,000, 18-karat Oyster Perpetual Lady Datejust.[9] Grace, of course, was no longer famous enough to pose for a luxury goods ad, but Blackglama mink's "What Becomes a Legend Most?" campaign would have suited her to a T.

Helen never lost her place in the art-world pantheon. Her sales remained robust. For example, *Green Arena*, a painting from 1965, sold for $410,500 at Christie's New York on November 15, 2012. (At the same auction, Grace's *Wedding Day* from 1965—a painting of comparable size—sold for just $62,500.) Two years after Helen's death in 2011, the Gagosian Gallery in New York exhibited rarely seen paintings of hers from the fifties, accompanied by a lavishly illustrated catalogue written by John Elderfield, former chief curator of painting and sculpture at the Modern.

Among the fascinating differences between Helen and Grace that emerge after their long careers are the ways they viewed the roles of accident and fig-urative elements in their work—reflections of their individual personalities. In the late eighties, Helen was interviewed about selected paintings dating from 1956 to 1988 for the catalog of a retrospective exhibition.[10] She stressed that everything in her paintings was the result of conscious decisions on her part; even an element like "a few accidental drops from the brush" (in *Nude*, from 1959) was something she "seized" upon and "put to work."[11] (In con-trast, a perceptive early essay by Helen's friend Sonya Rudikoff notes that "[t]he role of accident in her work is large and salutary; the art is responsive, expressive, and improvisational."[12]) Despite the title of *Nude*, and shapes that she admitted look like a head and breasts, Helen briskly added that "the picture's basic order and success have nothing whatsoever to do with a nude."[13] Although certain of her paintings were influenced by real-life expe-riences, such as the desert colors of the Arizona landscape and the waters of Provincetown Bay, in Massachusetts (the painting titles, often proposed by others—Helen was not keen on labels—reveal as much), she would not dis-cuss them in those terms.

Helen was almost fanatically dedicated to the notion of pure abstraction entirely under control of the painter and untethered to any aspect of life—as if Clem continued to whisper in her ear. Whereas Grace, who never viewed figurative art as somehow less worthy than abstraction, freely acknowledged the role of accident in her work, and openly credited her environment and her experiences for enriching the content of her paintings.

Influenced by Old Master paintings at different stages of their careers (Grace, in the early fifties and in the eighties through the end of her life; Helen, in the late fifties and seventies), each painter found something quite different in them. For Helen, the inspiration from Goya (*Las Mayas*, 1958),[14] Titian (*Portrait of Lady in White*, 1979), and Il Bassano (*Hint from Bassano*, 1973) was strictly related to color and form. Grace took her cues from the poses and gestures of the figures in the paintings she chose, adding her own

stylization, painterly qualities, and color. "I don't need anyone else to tell me about color," she said.[15]

For example, in *Greuze's Woman in White* (2002), Grace borrows the modestly downcast eyes of the young woman in Jean-Baptiste Greuze's 1759 painting *La Simplicité* (*Simplicity*),[16] but amplifies her figure and removes the coy symbolism of the original.* While Greuze's woman plucks a daisy in a "he loves me, he loves me not" gesture, Grace's woman protectively shelters two nosegays in her hands. Given Grace's tendency to identify with her subjects, this pose may reflect (consciously or not) her nurturing influence as a painting teacher. As she once said, "I paint things that I don't explain to myself as I'm doing them."[17]

In quoting from famous paintings, Grace did not share the point of view of an "appropriation" artist like Sherrie Levine, who copies well-known works to challenge the notion and value of originality and the status of famous works of art as commodities. Rather, Grace used reproductions of paintings by artists of the past as jumping-off points for her own imagery. She wasn't questioning the greatness of her models; she was communing with them. "Working with a great artist every day is a very elegant association," she once said.[18] She imagined the great painters of the past saying "Use me, child, I'll help you out."[19] Art history was "something that was larger than I am," and she wanted to "yank it, kicking and screaming... into my Modernism."[20]

As late as 1975, Grace called Joan, "my good friend."[21] Living and painting for decades in Vétheuil, near Paris, she shared Grace's lack of visibility in New York and remoteness from the Pop and Minimal era. Joan had withstood critical silence and unenthusiastic reviews, compounded by the difficulty—as a woman artist—of getting an exhibition in Paris.[22] But after Martha Jackson's death, she moved to the distinguished Xavier Fourcade Gallery, which also showed de Kooning and other leading artists. By the eighties, her multi-panel paintings were selling for as much as $100,000. Like Grace, she suffered from several maladies in middle age—in Joan's case, hip dysplasia and cancer of the jaw and esophagus—but she never stopped drinking. (When Elaine de Kooning finally started going to A.A. meetings in the mid-seventies, she urged Joan to follow her example, to no avail.[23]). Joan died in 1992, leaving an estate valued at $22 million. Three years later, Grace was invited to join the board of

* Greuze's canvas was painted for the clever and quietly influential Madame de Pompadour, a commoner whom King Louis XV selected as his mistress, causing her to ask him for a formal separation from her husband. By 1759, she had been celibate for eight years, partly because of a gynecological condition and partly so that she could take communion again.

directors of the Joan Mitchell Foundation. "It's fun spending Joan's money to help artists," she joked.[24]

ROBERT JACHENS WAS sixty-five and ill with colon cancer when he died of a heart attack on January 18, 1986. He had become a bishop in the Church of Jesus Christ of Latter-Day Saints (the Mormon Church) and was living in Salt Lake City with his fourth wife, now known as Linda Johnson, who was twenty-seven years younger. A calm, devout man who ran a custodial maintenance company, he took pleasure in simple things, like cleaning the grounds of his church. Robert had converted soon after his third marriage in 1962—which took place a week after his divorce from Evelyn—much to the vexation of his new wife, Ella. (They divorced eight years later.) Mormonism suited him. At the time a fellow Mormon (she has since left the church), Johnson admired the way "he was able to see the message of God clearly and help people out mostly by letting them [talk]." One night, on the telephone, he read her a Mormon tract, *Lectures on Faith*. "It really touched my heart," she said,[25] echoing Grace's response when he read poetry to her decades earlier.

Remembered fondly by his granddaughters, Vicky and Valerie, Robert had been a pillar of support when Jeffrey, their father, was lost to his drug habit. In the summer of 1986, they visited him in North Hollywood, California, where he worked as a carpenter. Valerie was twenty-one, an office manager for a tire store, and Vicky was twenty-three, working as a waitress while enrolled in beauty school. At the house, Vicky came across a catalogue for one of Grace's exhibitions. Jeff had preserved the envelope, which bore Grace's address.

She wrote to her grandmother to find out more about the mysteries of her father's life. "What happened between you and grandpa? How come you didn't raise my dad? I've asked dad lots of questions. But he always avoids answering me."[26]

In a few devastating sentences, Vicky also explained what it meant to be Jeffrey's child. When her mother was pregnant with Valerie, he had left her for another woman. Then their mother died. They went to live with an aunt and subsequently with Jeff and his new wife. As a result of constant beatings by their stepmother, they were shuttled to their grandparents and finally—in the mid-seventies, when Vicky was twelve—to their maternal aunt and uncle in Oregon "who we now call mom and dad." She wrote that she felt bitter toward her father. Yet, she added brightly, "Your artistic ability has gone right through the generations…Dad is very artistic."

Not mentioned in the letter was another painful litany of loss: Jeff had married Vicky's pregnant nineteen-year-old mother Ruth in April 1962. She

died in April 1970 in a one-car accident; baby Valerie, who was riding with her, was miraculously spared. That December, Jeff had a son (Jason) with Penny Baker, a fellow drug addict,[27] and they married in July. At some point, they split up, and she eventually decided that she didn't want to care for Jason anymore. She called Robert, threatening that if he didn't take the boy she would put him up for adoption. So Jason lived with Robert and Linda for a few months—until Penny came and took the child away. In 1978, Jeff married his third wife, a go-go dancer, three weeks after he was released from prison for stealing checks from his employer while high on heroin. According to relatives, he had kicked his drug habit while in prison, but he realized that as long as he lived in Los Angeles, he could never shake off his junkie friends. So Jeff abruptly walked out on his wife, taking only his clothes and leaving behind several paintings Grace had sent him.

One of the letters from Vicky to Grace contained a recent photograph of Jeff, Vicky, and her little girl, taken by Valerie at Disneyland. Standing awkwardly, Jeff is a solidly built man with a moustache and slicked-back hair. This trip marked the first time his daughters had seen him since they stayed with him in Los Angeles when they were young. The following year, when Vicky was divorcing her first husband, she thanked Grace for a Christmas gift of money, mentioning that Jeff had refused to help her.[28]

"The war separated Bob Jachens and me[,] then death took Win, but no matter how it happens, a marriage breakup is hard and sad and it take [*sic*] a long time to heal," Grace replied five months later,[29] offering a rare peek at her true feelings about her own divorces. She added that she would some day pay Vicky's travel expenses from California so that she could visit Grace. But that day never arrived.

Vicky said later that once he stopped taking drugs, Jeff had become "a very mellow person…very funny."[30] He stayed with each of his daughters for a while and tried to revive his carpentry business. During his last decade, he lived with a girlfriend in northern California. Needing a new thrill, he began riding dirt bikes. "I'd be scraping gravel out of his legs," Vicky recalled, "and telling him, 'Dad, you're too old for this!'" Loyal as ever, she took him to a free clinic when his health began to fail—he couldn't afford insurance and was not eligible for disability benefits—and patiently sat with him all day until he was seen.

The year after Vicky had broken the ice, Valerie began sending Grace cards and letters describing her job, her romantic life, her father's attempts to deal with his problems ("Him and Jan are going to Alcoholics Anonymous every week and to a Catholic Church every Sunday"[31]), and her regret that her father had not previously allowed her to contact her grandmother. In 1991, Grace sent

Valerie one of her paintings as a wedding present. But the reply card with the wedding announcement was never sent, and Grace did not attend.

IN THE SUMMER of 1988, when The Figurative Fifties: New York Figurative Expressionism opened at the Newport Harbor Art Museum in Newport Beach, California, Grace flew out to see the show and take part in a panel discussion. That's when I met her and was bowled over by her majestic presence and riveting declamatory style. During her visit, Grace had taken Ellen Breitman, the museum's vivacious curator of education, under her wing. That fall, Breitman wrote to Grace with the happy news that she had been introduced to a wonderful man "who loves art, music, tennis, cycling, travel, cooking and me!"[32] A few days later, Grace responded with a fond note. "AH LOVE—I'm happy for you," she wrote. "I blush to say that I have been DATING (ugh what a dumb word) for the past year. ([D]ating doesn't <u>necessarily</u> mean bed-ding. All younger men, 10–15, even 20 years younger! <u>They</u> find Me. Its soooo confusing. I need to see you for woman to woman talks! I want something that isn't marriage and isn't casual sex. I'm sure it's there for me, somehow."[33]

This trip also prompted a long overdue reunion with Jeffrey, now forty-six and working as a cabinetmaker. A postcard he sent to Grace is the only documentation of this event. In the same polite but terse manner he had employed over the years to acknowledge various gifts (checks, her artwork, a copy of the monograph written about her), he wrote to thank her "for the great dinner and conversation."[34] We can only speculate about her reasons for sending him her paintings, but guilt surely was a major factor. However awkwardly and unacceptably, she needed to prove to him that her other "child"—her art— was worth the emotional cost of abandoning him.

Four years later, probably for Christmas, he sent her a bottle of Van Cleef & Arpels perfume spray. We don't know if he chose blindly or realized that it was once a favorite of hers. But the image of a man of fifty sending the mother he hardly knew a bottle of old-fashioned perfume—a tribute to her glamour, as if selected by a lover of eras past—is a poignant one. Grace jotted down the name of the perfume on the gift enclosure,[35] like a harried bride worried that she would forget who gave her what, suggesting an unbridgeably chilly distance.

BEGINNING IN 1986—WITH a visit to fashion designer Gene Ewing, a collector of Grace's work—Grace's trips to California inspired a new theme she called "glitz and trash," which swept away the last remnants of her melancholic drip-laden style. California seemed incredibly exotic to her: The balmy climate and youth-oriented outdoor lifestyle exacerbated the gap between her

still-intense libido and her aging body. Her paintings of posturing, cavorting figures, animated by a sense of unease, served as a safety valve for her frustrations; she even tried to jazz up *L.A. Boudoir* (1987) with the names of three of her all-time great lovers and then coyly blurred them out. In *Madonna Inn* (1987)—an homage to the kitschy theme-room hotel on California's Central Coast—Grace populated the Caveman Room with half-naked men and women glimpsed in flickering light and shadow.

Humor rescues *El Azteca*, an over-the-top depiction of a woman's rape fantasy, featuring a dark-skinned man wearing a yellow breastplate and plumage who carries the limp body of a doleful pink-skinned woman in an aqua dress.[36] *Tarzana* (1987),[37] with its bevy of nude and nearly nude women lounging and pleasuring themselves in and alongside a pool, was Grace's phantasmagoric response to the ten days she spent in the affluent Los Angeles community. Left on her own in Ewing's sprawling, immaculate guesthouse with a giant video screen, swimming pool, sauna, Jacuzzi, and "piles of *Vogue* magazines" to keep her company,[38] she felt in need of more stimulation. So she asked the gardener to drive her to the fashion district in downtown Los Angeles, where the grimy, hustling life of the streets once again called to her.

IN THE MID-EIGHTIES, Grace developed a new way to work, born of frustration. After ripping one of her paintings off the wall and walking over it with bare feet because she was so annoyed with it, she began moving all her paintings to the floor after filling them with images. Grace enjoyed the added freedom this gave her, allowing the painting to "go into chaos where I just about lose it" until she rescued it by focusing on what she viewed as the "essential images."[39]

As she once said, "I'm a restless artist. As soon as I know how to do something, I get bored and I want to do something else."[40] With typical abruptness, she turned from glitz-and-trash[41] to the world of grand opera. No opera buff, Grace listened to jazz records while she painted. What interested her about opera was its grandeur and fakery—elaborate costumes, exaggerated makeup, stagey gestures. Echoing her youthful interest in acting, the theme was also a continuation of her hunger for larger-than-life figures. Portraits of characters from operas, not of specific singers, these simplified bust-length figures suggest cartoons as well as some of Picasso's large-figured neoclassical drawings of the late teens and early twenties—one of Grace's typical mash-ups. Typically, while she presented some characters individually (Wotan, Carmen), she also felt free to mix up different operas, so that Jules Massenet's Don Quixote was "on stage" with Puccini's Madama Butterfly.

As she said a decade later about her geisha series, the opera theme was simply an "excuse" for painting, "because it's more interesting to paint a costume than just a large area of color." She added that, in each series—movie stars, queens, geishas, opera characters—there was one painting that reflected her desire to look beneath the "costumed icon" to find "the real person."[42] Yet, beginning with *The Persian Jacket*, Grace's figurative paintings are overwhelmingly stylized and impersonal. The theme of "masking" as it played out in gay circles at a time of sexual repression, surfaced in many of her works. Although Frank O'Hara made her aware of this theme, she would not have pursued it so consistently had it not aligned with her own need to keep other people at arms' length. Grace's tough-girl image was a construct; similarly, her divahood was deliberate. She was a self-created creature, a wearer of masks that became part of her personality. "Whatever we do," she once said, "we are always masked in some way."[43]

Grace painted the opera series in watercolor, a medium that was both more limiting (quick work was necessary before the colors dried) and more freeing (constant adjustments were impossible because the paper would tear). Working barefoot on eight-foot lengths of paper lying on the floor, Grace joked that each piece "sighed like a lady getting out of a tight girdle" after it was cut from the roll.[44] When a reporter came by to watch, Grace was wearing a tracksuit, her current painting uniform for the colder months. In the summer, she popped a muumuu over bare skin so that, as she breezily explained, "the sweat just flows down to my ankles."[45] With sumi brushes (which can be used flat or tapered into a point) and a sponge on the end of a stick, she drew the main contour lines of the figure. After the paper dried, she wet the paper again and went back in. She liked the way watercolor has a life of its own, spreading across the paper as it dries. For *Stripper (After Blaze Starr),*† Grace was inspired to strip off her own clothes, step into the shower, and scrub the painting with a sponge.

In 1988, on a visit to Chicago, she revisited Georges Seurat's *Sunday Afternoon on the Island of the Grand Jatte*, a calm scene of strolling figures in a park. One hundred years earlier, Seurat had created the figures and landscape by applying tiny painted dots. How, she wondered, could she make use of his painting? She decided to attack her own images with a blizzard of spattered paint, a technique she called "pointillist abstract expressionism" (or, in a wryly self-deprecatory mood, "Seurat gone insane").[46] Grace was not interested creating a Seurat-like tranquil scene, or in forming imagery with the dots of

† Starr was a fixture at the Two O'Clock Club in Baltimore, beginning in the early fifties.

paint. Rather, their staccato rhythm served as a kind of disruption, part of Grace's lifelong fascination with the limits of chaos. In her imagination, each color was going to do whatever it wanted. (She joked in a slyly sexual way about talking to the paint: "Hey Blue, would you like to be on top?"[47])

Grace would have known Frank O'Hara's poem "On Looking at *La Grande Jatte* the Czar Wept Anew." Written in the early 1950s,[48] the poem conflates the emotions of a lonely Russian ruler in winter and the modern-day speaker's state of mind as summer wanes, guests are about to arrive, and he looks longingly at a reproduction of Seurat's painting—a world that would "welcome him with open umbrellas." The new chapter of Grace's life, a re-awakening after death and despair, was for her also a change of season.

The splatter paintings were, of course, a nod to Pollock, whose dripped style was so singular that it never spawned serious imitators. But it was de Kooning who remained her constant guide and touchstone. Around this time, a friend showed her one of his late paintings. Beginning in the early sixties, de Kooning's canvases reflected his fascination with the quality of light in eastern Long Island; in the seventies, they borrowed the turbulence of ocean swells; in the eighties, swaths of whiteness penetrated lithe traceries of vivid color. Although critics were largely unimpressed by his late style, ascribing its looseness to the ravages of alcoholism and Alzheimer's disease, Grace adored it. "I hope that I have a last sublime expression like Bill de Kooning," she said.[49]

The full-bodied activity needed to produce the new paintings was not easy for a woman who had grown stout and had hip and knee replacements. Still preferring to work in the mornings—after breakfasting on *café au lait* and toast, and tackling a couple of crossword puzzles—she was as likely as ever to brood about her work during the rest of the day. (The crossword puzzles were a confidence booster for her; she did them because she was good at them,[50] and probably also because they gave her a sense of completion.)

To an interviewer, Grace offered the sardonic observation that if you're an artist, you get to do whatever you please—"if you pay the price, which is having no one else want it."[51] Over the years, her hours in the studio had served as a ballast against physical and emotional pain, rejection, and indiffer-ence. Yet the process of deciding where to situate each element of a painting and thinking about each stage of its development also involved a fraught per-sonal journey. Grace would talk about "holding it inside me" until the point at which the painting finally becomes an entity separate from herself—an-other variant of her pregnancy metaphor. "When I'm on a painting," she said, "it possesses me. I can tell when a painting is done because it leaves me alone—

doesn't haunt me anymore. I'm free of it."[52] Toward the end of her life, she told an interviewer, "I've cried in front of canvases. And they're just a piece of cloth with color on it. Isn't it magical that can happen?"[53]

Grace's New York gallery situation was still in flux. In March 1988, Gruenebaum Gallery—which had represented her for five years—mounted Grace Hartigan: Painting the Renaissance. The ten-painting show, which also included some of her "glitz and trash" paintings, was reviewed positively ("virtuosic paint handling…psychological drama") by Art in America.[54] But at her opening, she was astounded to see owner Thomas Gruenebaum (who was also an artist) distributing announcements of his own show, at another location. Grace, who had earlier accused Gruenebaum of a "hard sell attitude" and lack of professionalism,[55] severed her connection with the gallery, which filed for bankruptcy that summer.

She moved to the Kouros Gallery in 1988, which agreed to pay her $36,000 a year in monthly installments for paintings with a combined retail price of $120,000, and gave her a four-decade retrospective in 1989. (Her top price for recent work was $25,000; in contrast, The King is Dead, from 1950, was listed for $100,000.[56]) Soon after her retrospective closed, Grace decided to bow out, conveying her decision in an unusually polite letter and leaving her unsold work on consignment through the end of the year.

The publication in 1990 of a monograph about her work, Grace Hartigan: A Painter's World, by Robert Saltonstall Mattison,[57] a young associate professor of art at Lafayette College in Easton, Pennsylvania, brought a trio of local shows in its wake—at MICA; her Baltimore gallery, C. Grimaldis; and the Baltimore Museum of Art. (Grace wore an orange jacket to her docent talk at the museum to harmonize with the predominant color in her four paintings on view.) She also had a New York show—a retrospective of work from 1950 to 1990—at her new dealer, ACA Galleries, a fixture of the New York art world since the 1930s. The exhibition prompted a New York Post interview by longtime journalist Jerry Tallmer. "She's still at it," he reported, "still terrific on the canvas, salty with the tongue."[58]

Unfortunately, Grace wrote to Brenda Richardson, nothing sold.[59] (After the show closed, several paintings did find buyers.) She also rued that "not one writer or scholar with the exception of Bob Mattison has seriously written about my forty years of painting." Grace ascribed the cause of this lack of interest to her "restless, inventive spirit," which was hard to pin down. In an art-book round-up in New York magazine that mentioned the monograph, critic Kay Larson called Grace "still something of a cipher in New York despite her brief success as an abstract painter in the fifties."[60] Larson's capsule

description of the current work—"just plain (bright, humanized) expressionism"—was probably as irritating to Grace as the mention of her current art-world status. She was always quick to repudiate what she saw as the sentimentality of expressionism.

True to form, she actively battled what she viewed as wrongheaded views of her career, even when they were well intentioned. After reading a draft of the press release for the monograph—which apparently suggested that her good looks as a young woman influenced her early recognition—she sent a blistering letter to the publicist. This remark was "insulting and sexist," she wrote, pointing out that de Kooning was so handsome that he could have been a movie actor.[61] Grace also took issue with being labeled as a second-generation Abstract Expressionist painter, and with the notion that artists needed to stay in New York to do good work. So she rewrote the press release, calling herself "one of the most visible artists and dynamic personalities of the New York 1950s art scene" and an "original artist known for her intelligence and wit."

Grace could be philosophical about the limits of her personal renaissance. Spotting a reproduction of a detail from her painting *Masquerade* on the cover of the 1993 paperback edition of *Modern American Women Writers*, she was amused; it was as if her rightful place was really with writers rather than painters.[62] A conversation between one of her students and the sculptor John Chamberlain, famous for his welded pieces made of crushed car bodies, offered proof that she had fallen into semi-obscurity. Five years younger than Grace, he always had a presence in New York even while living elsewhere. When the student she told him she was working with Grace, he was surprised—he'd thought she was dead.[63]

On January 12, 1992, a fire broke out in her studio building, caused by an electric heater in the drugstore on the ground floor. Some of her furniture was destroyed by smoke or water, and one of her paintings was damaged. Grace had only $20,000 worth of personal property insurance; her paintings were not covered. She told a reporter for the *Baltimore Sun* that insurance on her work would be far too expensive because the neighborhood was fire-prone.[64] Nor could she move her work to a fireproof storage unit because the paintings had to be available to visiting dealers, who brought their clients to see work. (This may have been wishful thinking.) Asked if she had any intention of moving away, Grace demurred. But she left the door open to return to New York in her eighties or nineties.

A few days later, good news from New York arrived, in a letter from art historian and critic April Kingsley, who had included several of Hartigan's

paintings in her mid-eighties traveling exhibition, Emotional Impact: New York School Figurative Expressionism. Kingsley wrote that in her forthcoming book, *The Turning Point: The Abstract Expressionists and the Transformation of American Art*, Grace would be grouped with the "first" generation rather than the second.[65] "My conviction is that the movement was powerful enough by 1950 to have swept people like you, [Bradley Walker] Tomlin, [Jack] Tworkov, and Guston into it," Kingsley wrote, "and that you all were making fully Abstract Expressionist paintings at this time."

Grace was part of another major museum exhibition that year, Hand-Painted Pop: American Art in Transition, 1955–62.[66] Opening in Los Angeles at the Museum of Contemporary Art, it moved to the Museum of Contemporary Art in Chicago and the Whitney Museum of American Art in New York. With work by twenty-one painters, from Larry Rivers's *Washington Crossing the Delaware* (1953) to Andy Warhol's *Dick Tracy* (1960), the show made a case for Pop Art as part of a continuum with Abstract Expressionism rather than as a radical break from it. Grace's 1957 painting *Billboard* was right at home here. *Giftwares* (1955), her other painting in the show, was more of a stretch because the objects in it—mostly lamps and vases—are more like the components of a traditional still life than the consumer-culture items favored by Pop artists.[67] The only vaguely "Pop" aspect of the painting is its title, indicating that we are supposed to read the objects as elements in a shop window. Her reviews were mixed. Hilton Kramer, writing in the *New York Observer*, witheringly suggested that Grace was included in the show simply for affirmative-action reasons.[68] (Conversely, in her experience, being the sole woman was always a great honor.)

By the nineties, Pop had long been eclipsed by other art movements. Grace, who disliked it as much then as she did in its heyday, would normally not have wanted to have anything to do with this exhibition. But she must have realized that it would have been foolish to pass up an opportunity for prime art-world exposure. Interviewed by the *New York Times*, Grace memorably said that she'd rather be remembered as a originator of a movement she hated than as the second generation of a movement that she loved. When asked how she would respond, she laughed and said, "I think I'll run with it."[69] But, she added, she didn't view Pop paintings as real paintings because they failed a major test: to "tell you what it is like to be a human being."[70] She had started putting new kinds of subject matter in her paintings because she didn't want to feel limited by traditional non-abstract formats (landscapes, still lifes, nudes, and so forth) and because, hey, she liked looking in junky shop windows. The challenge, Grace once said, was to "tame" popular culture rather than disdaining it or let-

ting it "devour" you.[71] Unlike the Pop artists, Grace said, "my attitude toward art history is not ironic, condescending, or campy. I'm respectful."[72] Irony was simply not in her lexicon. From the fifties onward, Grace's passionate direct-ness was as much a part of her as her gray-blue eyes.

The exhibition did not deal with another aspect of Grace's use of popular imagery that appears as early as 1950, in *Months and Moons*, with its collaged fragment of a *Life* magazine pancake ad. Here was Grace brashly appropriat-ing a snippet of all-American consumer culture—in the magazine that told Americans what was important in the world—in order to further her vision for a totally abstract painting that most of *Life*'s avid readers would dismiss as mere scribbles. The point is that her vision came first; the borrowing was simply a means to an end. "Even when she goes back to a kind of Pop image," said her longtime friend, art historian and critic Irving Sandler, "it's based on her experience, so it circles back...to what her values were."[73]

With the Pop Art spotlight shining on her Marilyn Monroe paintings, Grace felt called upon to explain that they have "an emotional element...not just a deadpan repetition, like in Andy Warhol's work, which showed a big façade. My work gets into the woman herself."[74] Although she shared with Warhol an interest in the packaging of a pop symbol, she lacked his allied fas-cination with media as the subject of art. For Grace, Marilyn was "the last goddess," and she wanted to show the personal cost that involved. (She even tiptoed into feminist territory by saying, "If I can change...the way the world regards women as dolls and...empty-headed actresses, if I can make mar-velous paintings that glorify images of woman, then I feel that I have done a pretty good job. For humanity and for women."[75])

A CLUSTER OF Grace's new works that layered drawing with painting were shown at ACA Galleries in the spring of 1994. Brenda Richardson wrote to Grace that the paintings allowed her to employ "your uncanny and sponta-neous line," a direction "that has really set you free."[76] In *Hollywood Interior*, she layered a schematic image, painted in shocking pink—a young woman in a tight, low-cut dress lying on her back with her feet up—over drawings of women in sexy outfits, with bits and pieces of an interior filling in the space. The problem of devising interesting ways of painting interiors continued to obsess Grace. It is not really resolved here; in these paintings, she focused mostly on accessories, like vases, rather than interior architecture. But the new works moved away from her focus on faces, which she finally realized were too generic,[77] and allowed her the painterly freedom that was her lifeblood.

That spring, a significant small-scale exhibition in New York—Reclaiming Artists of the New York School: Toward a More Inclusive View of the 1950s[78]—honored Grace's contribution to Abstract Expressionism with her 1955 painting, *The Showcase*. New York was still the center of her world, "the city where I feel most alive and most myself." In 1984, she had rented a tiny studio apartment, a walkup on Mott Street, not far from her old neighborhood. A small bookcase still holds Grace's collection of classic twentieth-century works (Proust, Malraux, Rilke, Kafka, Artaud, Djuna Barnes, James Agee, Beryl Markham) as well as Mimi Sheraton's *Best Restaurants 1989* and mysteries and thrillers by Len Deighton, Rex Stout, and Sara Paretsky. Favorite bits of bric-a-brac complete the decor: a fur lampshade, candleholders shaped like cobras, her Cecil Beaton portrait photograph in a striped dress. "Even in a hotel, she would bring something to make it hers," said her niece Donna, who shared the apartment and has preserved it as her own pied-à-terre."[79]

Part of Grace's New York mindset involved dressing for the part. She once remarked that she reserved certain clothing, jewelry, and even makeup exclusively for her New York life.[80] Even when her outfits ran to leather caps and bulky sweaters, her strong hands were manicured and her earrings were in place. "She was, even as an older woman, aware of her looks," one of her students said. "She'd get fixated on shoes.…It was fascinating to see this girlie side of her."[81] Perhaps she would return to Manhattan permanently one day, she told an out-of-town interviewer, preferring not to picture herself forever tucked away in Baltimore. Back home, her public statements vacillated, depending on her mood. At least once, she confessed to feeling like an expatriate ("New York is my home"), but declared that Baltimore was a better place to work because it was "slower," and there were no major contemporary artists—none of those New York "hotshots" whose work would compete with her own vision.[82]

When painter Raoul Middleman, a longtime member of the MICA faculty, asked Grace to sit for what became a seven-by-five-foot portrait, he prepared a palette of oranges and reds to honor her gift as a colorist. To provoke him, she showed up dressed in black. "I got you now!" she joked. Even so, "it was so easy to paint her," he said. "She was like a dramatic event. It's like having a great landscape, with storm clouds rolling over the hills. She had that sense of self—very clear and dramatic and exceptional."[83]

For Grace, painting remained a totally absorbing activity. She struggled to "sustain the anxiety" in a painting during the weeks it took to finish—an activity she mischievously compared to "a whole month of foreplay."[84] She told an interviewer that she was so focused on her work that when the bank across

the street was robbed, she never even heard the blaring police sirens.[85] Her style had shifted again, to scenes with multiple figures whose faces and hands were sketched as if with a pen rather than a brush. These agitated compositions would give way to the amplitude of Grace's late canvases of simplified bust-length figures from literature, art history, or popular culture. The subjects ranged from the novelist Stendhal, wearing his Napoleonic war medals on his jacket, to a sixteenth-century woman in a puffy hat who would have been at home in a Brueghel painting. Free to ransack a lifetime of influences and memories, Grace painted Matisse's wife—sandwiched between flowered, Matisse-style wallpaper and a tabletop still life—and the imaginary Lili Marlene of the famous song, in a Dietrich-like feathered hat.

To relax, she watched James Bond movies with Rex Stevens and the occasional classic French movie with her friend John Moran. She read murder mysteries—Dick Francis, Agatha Christie, Tony Hillerman. "It gave her brain a rest," Rex said. "I'd tell her, 'Grace, you read that one already.' She'd go, 'Ehh, I don't remember.'"[86] After years of serious reading, this was background music. (The tune was familiar. Back in the late forties, Elaine and Willem de Kooning, William Baziotes, and other downtown artists were avid detective-novel readers; Elaine remembered parties when the big discussion was not about art but about the comparative merits of Raymond Chandler and Dashiell Hammett.[87]) Yet Grace did try to keep up with more literary fare, writing to a friend that she had ordered novelist Dawn Powell's diaries and a two-volume biography of Colette.[88]

In 1999, she was interviewed about her life for a book about "seductresses,"[89] which must have tickled her at age seventy-seven. This was a form of feminism she could get behind: no need to be submissive, gorgeous, or young to enjoy lusty adventures in which you never have to relinquish your power. Grace told the author that when she and Helen tried to imagine what alternative life could have made them give up their careers, Helen imagined herself as a Rockette (a member of the precision dance company at Radio City Music Hall) and she envisioned herself as the sort of glamorous woman who steps out of a stretch limo onto the opera cape gallantly laid over a puddle, Walter Raleigh-style, by a "film god."

MOST OBSERVERS SAY that after Grace stopped drinking, she became less combative, yet she was still liable to throw her listeners off-balance. In June 1987, at a panel discussion at the Tate Gallery in London, moderated by art writer Irving Sandler, Grace remarked tactlessly that as far as she was concerned, there was no modern art in Britain.[90] (Sandler nonetheless remained a loyal friend throughout Grace's life and recalled her fondly after her death.[91])

Amid the polite eulogies at Elaine de Kooning's memorial in 1990, Grace brashly recalled how—when Willem de Kooning's girlfriend Joan Ward had his child—Elaine came to the hospital and said, apparently without rancor, that she and Bill had always wanted a baby. Grace was proud of her take-no-prisoners stance. She once confided, in her hyperbolic way, that she had left "thousands of bodies in the road," and didn't feel guilty about it.[92] Even her devoted friend Fay Chandler, charitable to a fault, remarked that Grace was "her own worst enemy."[93] Their friendship, Chandler said delicately, "was so specifically not about my painting." Grace praised Chandler's whimsical sculptures, not a genre she herself would ever pursue, pleased that "there was never any question of competition." Chandler filled much the same supportive role for Grace that Walter had, except for the romantic aspect.

At a talk that summer at the Skowhegan School of Painting and Sculpture, in Maine, Grace segued from answering a question about feminism to announcing without apology that she had abandoned her son, allowing him to be raised by his grandparents and his father. "I don't like kids," she said, admitting that there were exceptions "but my own child was not one of those." She said she hated being a mother. The startling aspect of this and similar declarations is her utter lack of compassion for her son.

In demand now for talks at colleges and art centers, Grace became accustomed to telling her story. She began comparing her departure from New York to the way Matisse and Picasso moved from Paris to the countryside. "It gets lonely," she said. "You reach into yourself. You don't get better but you deepen…you take on more subtleties."[94] Unlike poetry, painting is "a mature expression," she said. "I feel now, at last I can really paint."[95] She told students that she had gone through a roller coaster of rejection and fame and rejection before being simply ignored, which was the worst of all, "but I've gone on and on because I'm obsessed."[96] In the mid-eighties, she summed up her career by saying that she had gone back and forth from abstraction or mythic subjects to aspects of modern life, and figured she would stick with popular culture ("the stuff I felt the Pop artists had robbed me of").[97]

With an eye on posterity, Grace was still working out the best way to assert her position in art history. She told an interviewer in 1990 that she had the good fortune of being born "in the right place at the right time…a time of classic Abstract Expressionism," which enabled her to "make it my own so fast."[98] During the fifties, "I touched every subject that I've dealt with since: formal means, use of the past, reproduction, popular culture, autobiography." Three years later, she asserted to the same interviewer that Abstract Expressionism was too narrow a niche for her ("I was not an abstract painter"[99]). On

some occasions, she said that she really belonged to no movement, like the sculptor Alberto Giacometti or the English painter Francis Bacon. At other times, she insisted that she was still a New York School Abstract Expressionist. As late as 1994, in a note to a friend, she proclaimed that "the act of creation (action painting) is all that matters, not the end, the finished work....Like Bill and Jackson, I truly don't give a fuck what anyone thinks of the work[;] all that counts is that it lives, it didn't die."[100] Yet she noted wistfully that "without some kind of a mythic [quality]—a glamour so to speak—fame and fortune does [*sic*] not come one's way."[101]

A few years before her death, she touchingly repeated for an interviewer a phrase she said the *New Yorker* had used in a capsule review of her work: Grace was "an underrated American treasure."[102] Rare morsels of praise like this had helped keep her spirits up when she felt slighted by the amnesia of art history. (She was dismayed to find not a single mention of her name in the celebrated 732-page biography of her mentor, *de Kooning: An American Master*.) Not that she was above settling old scores. By the time Clement Greenberg, her once-powerful old nemesis, died in 1994, Grace dismissed him as no longer relevant. And she was delighted that two of the artists he had singled out as supreme bearers of the abstract standard he upheld eventually went their own ways—Jules Olitski, moving from color field painting to landscape, and Anthony Caro, embracing figurative sculpture and architectural projects.[103]

ON A VISIT to Manhattan, Grace took David, the young son of her painter friend Karen Gunderson and dealer Julian Weissman, for a meal at a favorite Greenwich Village restaurant. (Painted in her faux pointillist style, *Noho Star* immortalizes the neighborhood eatery's condiment-topped tables much as *Broadway Restaurant* did thirty years earlier.) David asked her if she was famous. Oh, no, she said, to be famous you have to be recognized by people, and they have to know your name when they see you. As if on cue, a waitress stopped at their table. "Excuse me, are you Grace Hartigan?" she asked.[104]

Grace was fond of David. "When I was twelve or thirteen, she really took me seriously," he recalled. "She was just a lot of fun, a woman who could make you laugh, and I loved the fact that there was no bullshit. You could always get an answer from her—what she thought about anything. Whether you agreed with the answer was another story."[105]

David and Beati Perry's son Hart (who made a gloriously phantasmagoric 16-millimeter film in the mid-sixties about Grace's painting—his senior thesis at Columbia University) were the kind of young men Grace could relate to, unlike Jeffrey. Although he had been off heroin for a decade, he did not give

up alcohol; on December 9, 2006, he died of liver failure, at age sixty-four. His son, Jason, had died five years earlier, at age thirty, of a heroin overdose.

Grace had remained deaf to her granddaughters' invitations to include her in their lives. After her 1992 visit to California, Vicky wrote, "It hurts my feelings that you never want to see me."[106] Two weeks after Jeffrey's death—three days before Christmas—in what was probably the cruelest, most unforgivable act of her entire life, Grace sent a letter to Valerie, her other granddaughter. After writing the salutation in her usual script, Grace resorted to capital letters—as if concerned that her message might otherwise not be perfectly clear—for the body of the letter.

She began relating a story about her life as if it were a fairy tale or fable: "About 65 years ago," a girl and boy married and "much to their horror she got pregnant and had a baby." When Robert returned from his army service, "she was an artist and he was a lost man." After Jeffrey went to live with Robert in California, Grace wrote, "I saw him once in 50 years." Then came a stinging blow: "I met his daughters briefly, they are women with whom I have nothing in common." Grace proclaimed that "family feelings do not come with the accident of birth but through constant loving and nurturing." But whose fault was that? "I'm sorry you lost your father. I lost my son 50 years ago."[107]

Granted that Grace felt no closeness to her granddaughters, this abrupt dismissal was an act of appalling selfishness. Mourning her father and in the process of separating from her alcoholic first husband, Valerie was deeply wounded by the letter. It is hard to find excuses for an eighty-four-year-old woman in full possession of her faculties, and no stranger to suffering, who could be so cruel to a grieving close relative. Perhaps Grace's many years of alcohol addiction had impeded her ability to empathize.[108]

IN HER LATE SEVENTIES, Grace talked about getting on a ladder with three brushes and three colors of paint to bring to life a painting of two geishas. ("I did one of them and I said, 'There, hang on, I'll give you a friend!'"[109]) But during her last decade, she could no longer walk unassisted and was in constant pain. One of her last students remarked on the toll it took for her, as such a full-bodied painter, to deal with her physical limitations: "Some days I could tell she really hurt. [But] she would work through. It was just like there was this internal engine and it was all focused right there."[110]

Sweetening her final years was a close friendship with John Moran, an older male student—a soul mate if not a physical intimate—whose loving attention led her to paint male images again after years of focusing on female figures. "I've never met anyone like her," he said. "I had lunch with her every week...."

[S]he shared about everything you could imagine." Moran is a former FBI agent. "I met J. Edgar Hoover and didn't like him particularly," he said, "but I never was intimidated by anyone except Grace Hartigan!" Despite her apparent gruffness, he added, "underneath she was so fragile...in the way everyone is—we all need to be loved and feel loved. Yet she didn't want to appear open to that...because of fear of rejection." Her hauteur had a way of undermining her best interests. Moran recalled escorting her to a cocktail party at which a woman wanted to introduce a newly appointed curator at the Hirshhorn Museum. But Grace declined because "they only have one of my paintings."

Despite her openness with Moran about her personal demons, she exuded tremendous confidence about her work ("Now *that* was painted by a master!"). Self-centered as always, she berated her dear friend (at a time when Rex was away with his family) when he had to go out of town for a family crisis involving his drug-addicted son. "I never could understand, having been in recovery [herself], how she had such contempt for others who hadn't made it," Moran said. You have to wonder whether she saw him as choosing to come to the rescue of a stand-in for her rejected son in lieu of dancing attendance on her.[111]

Probably because they were so rare, Grace's expressions of fellow-feeling were remembered by her colleagues. Ray Allen recalled that in 2002, after his mother died, he and Grace were leaving a meeting at MICA. "Now, just because your mother's gone doesn't mean you have to stop talking to her," she said. "I talk to Win"—who had died twenty-one years earlier, and whom Allen never met—"every day. Don't hold back if you're pissed off at her." This was the only time in all the years they were colleagues, he said, that Grace had revealed herself to be vulnerable.[112]

In the fall of 2003, MICA exhibited Grace Hartigan: Painting Art History, fifteen works mostly from the 1980s and '90s, organized by The Trout Gallery, Dickinson College, with an authoritative catalogue.[113] Grace's Baltimore gallery presented a concurrent show of her recent work—a new foray into still life. Now in her early eighties, she temporarily put aside her long preoccupation with the figure to paint objects culled from travel souvenirs, gift-shop purchases, and other bric-a-brac in her studio. She had Rex photograph the objects, which included a life-size ceramic bulldog and a horned mask from Mexico. One of the paintings, *Collectibles*, recalls a tidied-up version of *Giftwares*.[114] The mask is joined by dolls, a clock, and other items in what Grace probably meant as an amused response to the burgeoning market for what used to be viewed simply as junk.

Although she began borrowing Japanese themes in the early seventies, with *Black Velvet* (which incorporates faces from one of the Japanese kites she

collected), *Still Life with Japanese Landscape* (2005) was inspired by Grace's annual ritual of buying a large wall calendar. (It's intriguing that she returned to her old high school art-class nemesis, the calendar— though now, of course, she no longer needed to copy anything.) Grace would carefully inspect the calendar selection in local bookstores and museums, looking for source material. "She was always searching," Karen Gunderson said. "She believed in images. It was a way of following her path. Different things would happen to her that would catch her attention. Then this other part of herself would say, 'How can I make this become something powerful?'"[115] One of Grace's students remembers watching her flip through a book about Japanese landscapes to try "to get the symbols, the mark-making, to understand the language." The finished painting, the student told her, was beautiful. "Ehh, I don't like that word," she said.[116]

IN A SNAPSHOT from the MICA exhibition opening in 2003, Grace sits in her wheelchair with her curly white hair neatly coiffed, a string of plump

Grace at the opening of Grace Hartigan: Painting Art History at MICA, 2003. (Courtesy of Maryland Institute School of Art [MICA])

pearls around her neck, and a radiant smile—the glow of a star who always enjoyed the spotlight.

"There are some people who are room-changers," remarked one of her students, regardless of whatever physical incapacitation they may have.[117] When two strong men lifted her up several steps to a gallery event, she basked in the attention like a queen with royal bearers. Filmmaker John Waters, a fellow Baltimore legend, remembered her openings as major events, "packed with all the local collectors." Grace had hired him in years past to do crits at MICA, and they had a cordial if distant relationship.

"She was just a tough broad," Waters said. "She was always like a grand dame—she assumed that everyone knew who she was, which was what I liked about her.... I knew she had this great fame in the art world. Yet in Baltimore, a lot of people don't care about that. Nobody kisses her ass in this town, and I think she might have been suspicious if they did.... She ended up making Baltimore work for her; she always scared people, and she liked that."[118]

Grace was finally slowing down, plagued by multiple ailments. She had a melanoma removed from her arm. Living with only one kidney—a legacy of her chronic alcoholism—left her prey to high blood pressure and fluid retention. After three hip and two knee replacements for her osteoarthritis, she had been wheelchair-bound for years, and she continued to enjoy sweets and rich food. By 2006, when ill health often kept her from coming to campus for student critiques, MICA administrators tried to get her to resign. But she steadfastly refused, and no one wanted to force her out. A few years earlier, Grace had invited MICA president Fred Lazarus to lunch. "Do you want me to quit?" she suddenly asked him. "Because I don't plan ever to quit." He laughed about this after her death, saying "If you knew what was good for you, you didn't get in her way."[119]

Grace's six-figure salary from MICA was a lifeline. Money had been a constant worry in her life from her teenage years onward, and her fear of not having enough never abated—especially after the shock of Win's profligacy. (A letter she wrote in 2001 to her dealer in New York traced her anxiety about money to her family's struggles during the Depression, which she recounted in heartrending detail, and claimed falsely that her MICA salary paid only for "basic monthly expenses."[120]) In 2004, Grace had been forced to vacate the Fells Point building she had rented for more than thirty years. Despite having promised her that she could live there as long as she wished, her landlord jumped at an opportunity to sell the property, which was converted to multifamily housing. She sold a de Kooning drawing to raise the down payment on her last home, in suburban Lutherville, Maryland, where she moved

with Rex, Regina, and their son. Grace occupied a guest wing of the house. In her bedroom, she displayed a photograph of Frank O'Hara, whom death had restored to his soul mate status.

GRACE WAS UNABLE to travel to her last major group show in her lifetime, Action/Abstraction: Pollock, de Kooning, and American Art, 1940-1976, which opened in May 2008 at the Jewish Museum in New York. She was represented by *Summer Street* and *New England, October*. A section of a catalogue essay subtitled "Blind Spots" notes that although Clement Greenberg had recommended Grace for her first show at Tibor de Nagy Gallery and Harold Rosenberg (and his wife May Tabak) were close friends of hers, her work was overlooked in both critics' writings.[121]

That fall, Grace's weakened body was finally unable to recover from a failing kidney and liver damage. Her beloved niece Donna Sesee—daughter of Grace's favorite sister, Barbara—had looked to her aunt for advice and encouragement since she was a teenager. Now Donna sat by her bedside, feeding her chocolate pudding—one of the many sweets that had replaced the alcohol. Grace was too ill to attend a dinner in her honor, with a menu she selected from her hospice bed: classic 1950s dishes she treasured as links to her life in New York. She still asked about her students and what was going on at the school. "She wanted to know that things were going the way that she wanted," a student remarked.[122] Toward the end of her life, when asked about future directions for her painting, Grace replied that she would like to explore "deep space."[123]

During her last days, when she was lapsing in and out of consciousness, Rex—whom she had appointed executor of her estate—asked if there were people to whom she would like to leave her paintings. According to him, Grace, who had been generous with her work for many years, said that she thought everyone already had what they wanted. (MICA would receive twelve paintings made between 1987 and 2004. Another five paintings went to Maryland Art Place, a Baltimore-based contemporary art center, so that they could be sold as a group to benefit the institution. Her papers went to Syracuse University, which had requested them.) Some acquaintances worried that Grace was allowing gratitude, force of habit, and ebbing strength to keep her from setting up a foundation with a board of directors to guide the dispersal of her artwork, as many of her peers had done. "[Rex] ended up with control because he was there, and she was too weak," said her longtime friend Ed Kerns. He called her frequently during this period, and she would always say, "Big Ed, I'm dying."

In 1990, she had written to Fay Chandler that she didn't want a living will (a document stipulating a patient's decisions about life-prolonging measures). Having tried to interfere with the "will greater than mine that guides my life"—by attempting suicide—Grace did not want to get in the way of her "destiny."[124] She added that, despite her terrible grief during Win's last days, she had learned valuable lessons about dying. "Even in a coma, he was aware—and when he wanted to die, he did. Or when God wanted him."

Karen Gunderson, another frequent visitor at the hospice, remembers that Grace seemed to want to get the business of living over with. "I had the feeling that she was OK with it all," Gunderson said. "She wasn't bitter. She wasn't angry. She was her same no-nonsense self."[125] Her only regret, she told a student, was that she had never learned to tango.[126] (A few years earlier, however, she said that her greatest disappointment was not having a retrospective exhibition.[127])

Grace died on November 15, 2008. According to her wishes, she was cremated and there was no memorial service. (At MICA, one of her students organized a small gathering.) After her death, the rocking chair she used to sit in during crits found a home in a student's studio. One day, the student walked in and the chair was rocking as if Grace had just settled herself in for another truth-telling session.

In 2006, she had told an interviewer that she believed history would place her with Franz Kline and Philip Guston, not as an innovator but as a major artist.[128] More than three decades before her death, she admitted to an interviewer that "many things that happen to a creative person, like acceptance and neglect, loss of health and loss of love…are beyond anyone's control."[129] But, she added, she had tried to live her life so as to "avoid being a victim."

Grace once said, "I didn't have any talent. I just had…genius."[130] It was a genius for self-invention and self-preservation, for holding her own in a tough male-dominated arena. And most of all, it was a genius for passionate emotional involvement with painting, her deepest and truest love.

Acknowledgments

I AM FORTUNATE to have many people and institutions to thank, and I hope that I have managed to remember them all on these pages.

There are certain individuals to whom I owe a special debt of gratitude. When I began this project, Paul Schimmel, now a partner in Hauser Worth & Schimmel, gave me his blessing and an invaluable list of contacts. Terence Diggory, emeritus professor of English at Skidmore College, provided extensive counsel throughout the project; in addition, with infinite kindness, on a rainy fall day, he drove me to see Grace's childhood homes in New Jersey. Janice Page, a cherished friend who is book development editor at the *Boston Globe*, listened uncomplainingly to my tales of the many stumbling blocks on the way to publication, offered wise guidance, and introduced me to my agent, Lane Zachary. Lane's enthusiasm for this project led to patient tutoring in the art of writing a book proposal. Norm Hirschy, my simpatico editor at Oxford University Press, has responded with warmth and detailed attention to this first-time author's many concerns. Thanks also to OUP senior production editor Natalie Johnson and assistant editor Lisbeth Redfield for their invaluable assistance and can-do attitude.

I am deeply grateful to Grace's extended family—her brother Arthur Hartigan and his wife Nadia, her nieces Donna Sesee and Barbara (Bobbi) Sesee, her granddaughters Vicky Jachens Herendeen and Valerie Terrones, and Linda Johnson, formerly married to Grace's first husband—for interviews that revealed the artist's complex personality and for family photographs. The artist Alfred Leslie, who retains a cinematic memory of the early 1950s, related vividly detailed stories about his life with Grace during my visit to his New York studio. George Silver reminisced about his photographer brother Walter and kindly granted permission to publish his evocative images of Grace and her friends. Rex Stevens, trustee of the Estate of Grace Hartigan and chair of the drawing and general fine arts departments at the Maryland Institute College of

Art (MICA), spoke candidly about his long association with Grace and allowed publication of her paintings. Svetlana Alpers, professor emerita at the University of California, Berkeley, goaded me into richer and deeper thoughts about the connections between Grace's struggles in life and on the canvas. Dona Munker enlarged my perspective by allowing me to sit in on several meetings of the New York authors group Women Writing Women's Lives. My colleagues at Biographers International Organization have provided a rich lode of practical advice both informally and at the annual conferences.

In trying to understand Grace Hartigan from the inside out, there is no substitute for reading her own words. *The Journals of Grace Hartigan, 1951–1955*, published by Syracuse University Press, is one of the most soul-searching documents of its kind. I thank Alice R. Pfeiffer, the press's director, for permission to publish numerous excerpts from this book. Robert Mattison's 1990 monograph, *Grace Hartigan: A Painter's World*, offered a useful starting point for research. Henry Adams, professor in the Department of Art History at Case Western Reserve University and author of a forthcoming biography of Grace's second husband, artist Harry Jackson, provided key information about his illness and war injuries. Matthew Jackson, president of Harry Jackson Studios, generously sent me crucial documents, as well as images of his father's paintings.

Others who have been especially helpful include Mary Cummings, manager of the archives at the Southampton Historical Museum, and—at the Special Collections Research Center, Syracuse University, home of the Grace Hartigan Papers—Nicole C. Dittrich, reading room supervisor, and William T. LaMoy, librarian. At MICA, I owe special thanks to Raymond Allen, provost; Douglas Frost, vice president for development emeritus; Leslie King-Hammond, graduate dean emeritus; Fred Lazarus IV, president emeritus; and Jessica Weglein Goldstein, director of public relations, without whose help there would be no Chapter 14. I spent charmed hours visiting three of Grace's close friends—Fay Chandler, in Boston; Suzi Cordish, in Baltimore; and Karen Gunderson, in New York—and discovering additional facets of her life. Robert Meyerhoff offered a revelatory interview, as well as a tour of his extensive art collection. Mark Chamberlain restored several contact sheet photos taken by Walter Silver that were graciously loaned to me by Irving Sandler during our interview. Barbara Mack kindly took the time to retrieve myriad pages of Ancestry.com data. A friend who has declined to be mentioned by name offered astute criticism of an early draft of this book.

I would like to thank individuals not previously named who graciously agreed to be interviewed and/or loan correspondence: Mary Abbott, Patricia

Albers, John Ashbery, Dore Ashton, Bill Berkson, Ellen Breitman, Liz Wade Cairns, Mina Cheon, Erin Cluley, Dan Dudrow, Audrey Flack, John Gruen, Emily Dennis Harvey, Jeriah Hildwine, Wendy Jeffers, Wolf Kahn, Scott Kelly, Ed Kerns, Denise Lassaw, Ernestine Lassaw, Raymond Majerski, Emily Mason, Raoul Middleman, Michel Modele, John Moran, Ryozo Morishita, Dominique Nahas, Cynthia Navaretta, Cindy Nemser, Maureen O'Hara, Hart Perry, Marjorie Perloff, Patia Rosenberg, Archie Rand, Brenda Richardson, George Silver, Lauren Sleat, Seymour (Babe) Shapiro, Judith Stein, Joan Stolz, Mina Tang, Jane Wilson, David Weissman, and Julian Weissman.

At the Baltimore Museum of Art, Helen Grabow, curatorial assistant, Department of Contemporary Art, made it possible for me to look at Grace's paintings in storage; thanks also to Emily Rafferty, associate librarian and archivist, and Claire O'Brien, image services and rights assistant. At the Museum of Modern Art, my path to viewing paintings in storage was guided by Hope Cullinan, department coordinator, Collection Management and Exhibition Registration; Danielle King, Department of Painting and Sculpture; Liz Desjardins, Registar's Office; and Steve West, manager, Queens storage facility. Other assistance came from Eric Brown, co-director, Tibor de Nagy Gallery; Philip Earenfight, Trout Gallery, Dickinson College; and Mikaela Lamarche, curator, ACA Gallery.

I owe a huge debt to staff at archives, libraries, and other nonprofit institutions. Margaret Zollar, Archives of American Art, Smithsonian Institution, and Keith Kesler and Katalin Baumann at the Glendale (Calif.) Public Library Main Branch fielded many inquiries. Others who were especially helpful include (in alphabetical order): Lisa Attanasio, Bayonne (N.J.) Public Library; Melissa Watterworth Batt and Kristin Eshelman, Allen Collection of Frank O'Hara Letters, Thomas J. Dodd Research Center, University of Connecticut; Cathy Billings, Brand Library and Art Center, Glendale, Calif.; Ryan Haley, New York Public Library, Photography Division, Miriam and Ira D. Wallach Division of Art, Prints and Photographs; Andrew Harrison, Alan Mason Chesney Medical Archives, Johns Hopkins Medical Institutes; Linda Pendergrass and Lisa Cohn, Bloomfield (N.J.) Public Library; Lynn Ranieri, Milburn-Short Hills Historical Society; Greg Reynolds, Los Angeles Central Public Library; Bill Santini, Columbia University Office of the Registrar; Doug Sheer, Artists Talk on Art; David Smith, retired research librarian, New York Public Library; and Lori Lynn Turner, The New School Writing Program.

Other institutions I consulted include: Albin O. Kuhn Library & Gallery, University of Maryland, Baltimore County (UMBC); Arthur and Elizabeth Schlesinger Library on the History of Women in America, Radcliff Institute

for Advanced Study, Harvard University; Bayonne (N.J.) Historical Society; Bayonne (N.J.) Public Library; Beinecke Rare Book and Manuscript Library, Yale University; Getty Research Institute, Los Angeles; Frick Art Reference Library, New York; The Huntington Library, San Marino, Calif.; Los Angeles County Art Museum Library; Mandeville Special Collections Library, University of California, San Diego; Maryland Historical Society; Milburn (N.J.) Free Public Library; Robert Motherwell Archive, New York; and the University of Minnesota Libraries.

I am grateful to my next-door neighbors, Katie Mills and Rick Bolton, for their friendly support and willingness to silence noisy workmen while I conducted phone interviews, and to Janelle Hernandez, who listened to the unfolding saga of this project during years of salon appointments. Finally, special thanks to M.L. for his steady encouragement, sound advice, and flirtatious good cheer.

Notes

PROLOGUE

1. [Dorothy Sieberling], "Women Artists in Ascendance," *Life*, May 13, 1957, p. 75.
2. Allen Barber, "Making Some Marks," *Arts Magazine* 48, no. 9 (June 1974): 51.
3. "The 'Rawness,' the Vast," *Newsweek*, May 11, 1959, p. 113.
4. Cindy Nemser, *Art Talk: Conversations with 12 Women Artists* (New York: Scribner, 1965), 132.
5. As Hartigan succinctly defined the term years later, Abstract Expressionism is abstraction with emotional content.
6. Author's telephone interview with Hart Perry, Beatrice Perry's son, April 24, 2012.
7. Hartigan, quoted in Constance Adler, "Lunch with Grace Hartigan: Grace Notes," *Baltimore Magazine*, July 1988, p. 130. She told this story many times, varying the details somewhat. See Hartigan's Archives of American Art oral history interview and her *Art Talk* interview with Cindy Nemser.
8. Hartigan, in Adler, "Lunch with Grace."
9. Author's interview with Marjorie Perloff, Los Angeles, February 16, 2012.

CHAPTER 1: DREAMING

1. Nemser, *Art Talk,* 152.
2. Eleanor Munro, *Originals: American Women Artists* (New York: Simon & Schuster, 1979), 203.
3. Matthew A. Hartigan, World War I draft registration card. His family lived at 785 Boulevard, today known as John F. Kennedy Boulevard West, a block from the public library.
4. Fifteenth Census of the United States: 1930—Population, 1: 710, United States Census Bureau, 1931. The immigrants were primarily from Ireland, Austria, Hungary, Italy, England, Scotland, and Wales. Bayonne Historical Society.
5. I am grateful to reminiscences from M. E. (Carbin) Johnson, Camille Di Donato, Charles Albano, and William A. Goodhart posted on a Bayonne Free Public Library web page that unfortunately no longer exists. Thirty-five cents in 1927 is equal to about $4.53 in 2012 dollars.

6. Hartigan, quoted in J. Bowers, "Grace and Will," *Baltimore City Paper*, November 19, 2003.

7. Robert Saltonstall Mattison, *Grace Hartigan: A Painter's World* (New York: Hudson Hills, 1990), 10. The song is also known as "The Raggle-Taggle Gypsy" and other similar titles. As "The Wraggle Taggle Gypsies O," it was published in 1906 in *English Folk Songs for Schools*.

8. For some reason, Hartigan told Mattison that she was a child when her grandmother died. (Mattison, *Painter's World*, 10). But in her journal entry for July 5, 1951, she mentioned that Nana had died the day before, adding, "if one draws upon personal agony for pictures, then I'll be a great artist." T. La Moy and Joseph P. McCaffrey, eds., *The Journals of Grace Hartigan 1951–1955* (Syracuse: Syracuse University Press, 2009), 10 (hereafter, *Journals*).

9. "Seems Like Only Yesterday," *The Item*, April 9, 1931, and *Thistle* 9 (February 1985) 2, Millburn-Short Hills Historical Society, http://www.millburn.lib.nj.us/hst/SearchArchives.htm.

10. In 1937, the city's population was estimated at 11,500 in the Property Acquisition Bulletin for Millburn Township Public Schools, http://www.millburn.lib.nj.us.

11. The park was the gift of a wealthy resident in 1924.

12. "Thirty-Two and a Half Years in Short Hills," *Thistle* 26 (April 1999), Millburn-Short Hills Historical Society.

13. "How Times Have Changed Department," *The Item*, March 1931 and October 1936. *Thistle* 17 (November 1993), 3, Millburn-Short Hills Historical Society.

14. William R. Forstchen, "Remembering Millburn," *Thistle* 35 (Summer 2005), Millburn-Short Hills Historical Society.

15. Forstchen, "Remembering Millburn."

16. According *Your Telephone Service: Yesterday, Today, and Tomorrow* (1946), there were 2,956 telephone subscribers in 1930. Millburn-Short Hills Historical Society.

17. Author's interview with Arthur Hartigan, Huntington Beach, CA, August 13, 2011.

18. Application for Membership, National Society Sons of the American Revolution, signed January 10, 1951, approved February 9, 1951.

19. Prior sojourns in England (1881–83, 1884–87) are listed in Orel Orvis's application for a U.S. passport in 1921. (Ancestry.com). Confusingly, his marriage to Caroline Fulker is listed in the Cook County, Illinois, Marriages Index as April 15, 1899, yet Grace Gertrude was born in May 1896, and his passport photo also includes two older daughters (and a young son).

20. Author's interview with Arthur Hartigan.

21. Notes by Terence Diggory from visit to Hartigan on August 31, 1998, courtesy of Terence Diggory.

22. The poses of the figures are based on paintings by Agnolo Bronzino (*Portrait of Eleonora of Toledo de' Medici and Her Son Giovanni*, 1545) and Justus Susterman (*Maria Maddalena of Austria with Her Son*, 1632), and a drawing by Jean Auguste Dominique Ingres (*The Stamaty Family*, 1818).

23. Sharon L. Hirsh, *Grace Hartigan: Painting Art History* (Carlisle, PA: Trout Gallery, Dickinson College, 2003), 24–25.

24. Matthew Hartigan was listed as an auditor—someone who evaluates the validity and reliability of the financial records of a company—in the 1938 Millburn Phone Directory. Employer information from his 1942 World War II draft registration card.

25. Author's interview with Arthur Hartigan.

26. Hartigan letter to Dorian and Jeffrey Bergen, Hartigan Papers.

27. Hartigan oral history interview, May 10, 1979, by Julie Haifley, Archives of American Art, Smithsonian Institution; and Hartigan letter to Dorian and Jeffrey Bergen, July 1, 2001, Hartigan Papers. In October 1938, the Stop and Shop Market on Millburn Avenue sold fifteen pounds of potatoes for 19 cents, less than half the price of a movie ticket, or about $3 in today's money.

28. Author's interview with Donna Sesee, June 11, 2011, New York.

29. Hartigan letter to Dorian and Jeffrey Bergen. Hartigan Papers.

30. Author's phone interview with Raymond Majerski, November 5, 2012.

31. Arthur Hartigan email to author, February 11, 2014.

32. Arthur Hartigan email, February 11, 2014.

33. A forerunner of today's United Methodist Church.

34. Information about the Hartigans' religious practices from author's telephone interview with Arthur Hartigan, August 27, 2012.

35. Handwritten biographical statement, n.d., Hartigan Papers.

36. Author's interview with Arthur Hartigan.

37. Hartigan letter to Dorian and Jeffrey Bergen, Hartigan Papers.

38. The broadcasts were launched in 1931. A lifetime later, Hartigan told an interviewer that she wasn't particularly interested in opera music but loved the singers' "grand gestures—and the fact that they don't look like other human beings." Elisabeth Stevens, "The Art of Painting the Opera," *The [Baltimore] Sun*, April 3, 1986, p. 5C.

39. Arthur Hartigan's application for membership in the National Society Sons of the American Revolution, January 10, 1951, SAR member 73685. Ancestry.com.

40. Author's interview with Arthur Hartigan.

41. Hartigan oral history interview, Archives of American Art.

42. Author's interviews with Barbara (Bobbi) Sesee, June 23, 2013, and Donna Sesee.

43. *Journals,* October 8, 1952, p. 45.

44. Author's interview with Donna Sesee, recalling what her mother Barbara had told her.

45. Author's telephone interview with John Moran, December 13, 2012.

46. Hartigan lecture (video), Schick Art Gallery, Skidmore College, March 26, 1993.

47. Robert S. Mattison, "Grace Hartigan: Painting Her Own History," *Arts Magazine* 59 (January 1985): 67; and Hartigan interview by Patrick Taylor, October 2, 1981, Hartigan Papers.

48. Hartigan lecture, Schick Art Gallery.

49. Hartigan lecture, Schick Art Gallery.
50. Grace Hartigan, "The Education of an Artist," n.d., notes, Art Teachers Association, courtesy of Irving Sandler; Hartigan oral history interview, Archives of American Art; and Hartigan interview by Taylor, Hartigan Papers. Copying pictures was not an unusual assignment in art classes of the era. Despite the growing influence of innovative educator John Dewey, self-expression was still a radical concept in art education, not widely accepted until after World War II.
51. Hartigan oral history interview, Archives of American Art.
52. Hartigan, quoted in Rosemary Donihi, "As Value Soars, Hartigan Won't Barter Art Again," *Washington Post*, January 20, 1960, p. C5.
53. Hartigan interview by Taylor, Hartigan Papers.
54. "M.H.S. Paintress," *The Miller* (Millburn High School newspaper), November 20, 1962, p. 2. Hartigan Papers.
55. *The Millburn & Short Hills Item*, May 12, 1939, Millburn-Short Hills Historical Society.
56. *Current Biography Yearbook* (New York: H.W. Wilson Co., 1962).
57. Hartigan interview by Taylor, Hartigan Papers.
58. Hartigan interview by Taylor, Hartigan Papers.
59. Ed Mazurki, "Remembering Two Short Hills Estates and Please Feed the Dog," *Thistle* 34 (Fall 2004), Millburn-Short Hills Historical Society.
60. Hartigan interview by Taylor, Hartigan Papers.
61. Hartigan interview by Taylor, Hartigan Papers.
62. The play opened in New York at the Ambassador Theater on November 27, 1933; RKO released a film version in 1950.
63. Hartigan oral history interview, Archives of American Art.
64. Mattison, *Painter's World*, 90.
65. Hartigan, "The Education of an Artist."
66. Nemser, *Art Talk,* 152.
67. Hartigan letter to Terence Diggory, April 30, 1992, courtesy of Terence Diggory.
68. Author's interview with Arthur Hartigan. Ryder (now Ryder University) is in Lawrenceville, NJ. The other scholarship offer is not known, but several other colleges were within commuting distance, including Bloomfield College, College of St. Elizabeth (both in Morristown), Montclair State Teachers College (Montclair), and Seton Hall College (South Orange).
69. Hartigan oral history interview, Archives of America Art. The first performance at the playhouse was in November 1938.
70. Author's interview with Arthur Hartigan.
71. Thomas D. Snyder, ed., *120 Years of American Education: A Statistical Portrait*, National Center for Education Statistics, January 1993, U.S. Department of Commerce, Bureau of the Census, Historical Statistics of the United States, Colonial Times to 1970, http://nces.ed.gov/pubserach/pubsinfo.asp?pubid=93442; and *Current Population Reports*, Series P-20, Educational Attainment in the United States, various issues. While a number of Hartigan's male artist peers would attend

college with financial aid made possible by passage of the G.I. Bill of 1944, this form of support was not available to her because she was not a World War II veteran.

72. Hartigan oral history interview, Archives of American Art.

73. Handwritten autobiographical statement, n.d., Hartigan Papers.

74. Linda W. Johnson letter to author, July 3, 2013. Johnson was Jachens's fourth wife.

75. Anita Dennis, "No One Stands Still: The CPA Firm in 1900, 1950 and 2000," *Journal of Accountancy*, http://www.journalofaccountancy.com/Issues/2000/Jun/NoOneStandsStillinPublicAccunting.htm.

76. Registrar's Office, Columbia University.

77. Author's telephone interview with Linda W. Johnson, June 25, 2013.

78. Columbia University website, http://www.columbia.edu/content/history.html.

79. Hartigan oral history interview, Archives of American Art.

CHAPTER 2: SEARCHING

1. Mattison, *Painter's World*, 11.

2. *Call of the Wild*, 1935, film directed by William Wellman, screenplay by Gene Fowler and Leonard Praskins, a Darryl F. Zanuck Production, 20th Century Pictures.

3. Orlando W. Miller, "Before the Matanuska Colony," *The Frontier in Alaska and the Matanuska Colony* (New Haven: Yale University Press, 1975). Accessed online July 11, 2013, as "Alaska's Early Agriculture," www.alaskafb.org/~akaitc/alaskaAITC /.../ Miller-FrontierinAlaska.doc.

4. Author's interview with Arthur Hartigan.

5. *The Millburn & Short Hills Item*, September 26, 1941, p. 10.

6. There is a venerable Chelsea Baptist Church on Atlantic Avenue in Atlantic City, New Jersey. It's possible that Mrs. Hartigan misstated the city, for reasons of her own, or that the paper made an error.

7. Based on a Trailways bus schedule of the era.

8. Matt Weinstock, *My L.A.* (New York: Current Books, 1947), 235.

9. Weinstock, *My L.A.*

10. Hartigan oral history interview, Archives of American Art.

11. Hartigan, quoted in Constance Adler, "Lunch with Grace Hartigan: Grace Notes," *Baltimore Magazine*, July 1988, p. 130.

12. Hartigan oral history interview, Archives of American Art.

13. Hartigan, quoted in Cathy Curtis, "The Figurative '50s—for Sentimental Reasons: Clinging to the '50s and Exploring the '80s," *Los Angeles Times*, July 24, 1988.

14. Hartigan oral history interview, May 15, 1975, Maryland Historical Society.

15. Class information from *Adult Education Prepared for Teachers and Visitors*, N.E.A. Booklets on Special Divisions & Activities, Los Angeles City School District, Office of the Superintendent, 1931, p. 7.

16. *Los Angeles City College Bulletin* 12, no. 1, General Catalogue For the Session of 1941–42, Los Angeles City Schools, 1941, p. 36.

17. Hartigan oral history interview, Maryland Historical Society.
18. Hartigan oral history interview, Archives of American Art.
19. Hartigan told Alexander Russo (*Profiles on Women Artists* [Frederick, MD: University Publications of America, 1985], 90) that he was drafted a year after they returned to New Jersey. He was drafted on April 9, 1943 (Enlisted Record and Report of Separation), so it's likely the couple left California in spring 1942.
20. Russo, *Profiles,* 91. Wright Aeronautical was the Paterson, New Jersey-based aircraft engine division of the Curtiss-Wright Corporation. The factory was in Woodridge, New Jersey. http://www.scribd.com/doc/12467677/History-of-Curtis-Wright-Aeronautical-Company.
21. Hartigan oral history interview, Archives of American Art.
22. Russo, *Profiles,* 95; and author's telephone interview with Raymond Majerski, November 7, 2012.
23. The fifth largest cathedral in North America, it is now known as the Cathedral Basilica after Pope John Paul II granted it minor landmark status in 1995. City of Newark: Historical Landmarks; www.ci.newark.nj.us/visitors/landmarks_points_of_oten.php.
24. Cherrill Anson, "America's Top Woman Painter," [*Baltimore*] *Sun Sunday Magazine*, March 16, 1963, p. 18.

CHAPTER 3: LEARNING

1. Nemser, *Art Talk,* 153.
2. Janet Flanner, "Profiles: King of the Wild Beasts–II," *The New Yorker,* December 29, 1951, p. 36.
3. Hilary Spurling, *The Unknown Matisse—A Life of Matisse: The Early Years, 1869–1908* (New York: Knopf, 2005), 279.
4. Hartigan, "The Education of an Artist."
5. "Artist Grace Hartigan: New York Artist Made a Career in Baltimore," *The* [*Baltimore*] *Sunday Sun Magazine* Anniversary Issue May 17, 1987, p. 34.
6. Hartigan, oral history interview, Archives of American Art. In the interview, Hartigan said that he was "about twenty years older," a discrepancy that may reflect his evident relish in the role of all-knowing mentor.
7. Museum of Modern Art press release, June 14, 1943. Muse is mentioned as one of thirteen artists—including Arshile Gorky, Jack Levine, I[rene] Rice Pereira, and David Smith—whose unspecified recently acquired works were to be exhibited in the museum's New Acquisitions gallery.
8. During the early forties, his work was exhibited in regional venues, including the San Diego Fine Art Society, Art Institute of Chicago, and Fitchburg [Massachusetts] Art Center (1941); Denver Art Museum and Elizabeth Ney Museum, Austin, Texas (1943); and Albany [New York] Institute of History and Art (1945).

9. "Newark Artist," *New York Herald Tribune*, March [?] 1942, New York Public Library, Art and Architecture Collection, Artist File (microfiche), Isaac Lane Muse.

10. Unsigned review, possibly in *Art News*. New York Public Library, Artist File, Isaac Lane Muse.

11. Hartigan, "The Education of an Artist."

12. Hartigan, "The Education of an Artist."

13. Luther Young, "Grace Hartigan Took the Big Chance—and Won," *The* [*Baltimore*] *Sun*, September 13, 1981.

14. Perle Fine oral history interview, January 19, 1968, Archives of American Art, Smithsonian Institution.

15. Hartigan, quoted in Curtis, "The Figurative '50s—for Sentimental Reasons."

16. Hartigan, quoted in Mark Stevens and Annalyn Swan, *de Kooning: An American Master* (New York: Knopf, 2005), 159. The interview took place on March 15, 1999.

17. Hartigan oral history interview, Archives of American Art.

18. Final Decree, Petition for Divorce, Chancery of New Jersey. The City of New York license validating Hartigan's second marriage states that that she was cited in the court papers as the adulterer in this divorce. For some reason, the divorce date was typed as October 23, 1946, on the New York document.

19. *Journals*, March 25, 1953, p. 74.

20. Linda Johnson letter to author, July 3, 2013.

21. Linda Johnson letter to author.

22. U.S. Army Enlisted Record and Report of Separation: Honorable Discharge, March 13, 1946.

23. Author's telephone interview with Linda Johnson, June 25, 2013.

24. PTSD was not formally classified as a mental disorder by the American Psychiatric Association until 1980, in the aftermath of the Vietnam War.

25. Hartigan oral history interview, Archives of American Art.

26. *Journals*, July 13, 1953, p. 89.

27. *Journals,* July 13, 1953.

CHAPTER 4: RISKING

1. Debbie Forman, "A Palette Fresh and Brilliant," *Cape Cod Times*, August 21, 1986, p. 13.

2. Hartigan interview by Taylor, Hartigan Papers.

3. Clement Greenberg, "American-Type Painting," in *Abstract Expressionism,* ed. Katy Siegel (New York: Phaidon, 2011), 252.

4. Sally Avery oral history interview, February 19, 1982, Archives of American Art, Smithsonian Institution.

5. Sally Avery oral history interview.

6. Sally Avery oral history interview.

7. Sally Avery oral history interview. According to his wife, Avery was a nondrinker, which further separated him from the Cedar Tavern crowd.

8. Mark Rothko, "Written Tribute to Avery," ca. 1965, Archives of American Art, Smithsonian Institution.

9. Rose Slivka, "Essay," in *The Spirit of Abstract Expressionism: Selected Writings*, by Elaine de Kooning (New York: George Braziller, 1994), 21.

10. Robert Motherwell, in *Painters Painting: The New York Art Scene 1940–1970* (film), 1972, produced and directed by Emile de Antonio.

11. Published in the journal *P.M.*, June 2, 1946.

12. Hartigan oral history interview, Archives of American Art.

13. Hartigan, quoted in Nemser, *Art Talk*, 154.

14. Hartigan, "The Education of an Artist."

15. "The Best?" *Time*, December 1, 1947. Greenberg's article, "The Present Prospects of American Painting and Sculpture," appeared in the October 1947 issue of *Horizon*, the British arts magazine.

16. *Grace Hartigan and Irving Sandler* (video), November 11, 1994, interview, Fulcrum Gallery, New York, *Artists Talk on Art* series, Douglas I. Sheer, executive producer.

17. Nemser, *Art Talk*, 155.

18. Mattison, *Painter's World*, 12.

19. Hartigan lecture, Skowhegan School of Painting and Sculpture, Madison, ME, Summer 1990, Museum Archives, Museum of Modern Art, New York.

CHAPTER 5: CONNECTING

1. "Winter on the Range," *Life*, February 8, 1937, pp. 42–45.

2. Biographical information from Harrison Brewer, "Edward Thomas Grigware, 1889–1960," *The Cody Enterprise*, February 4, 1960.

3. The magazine *Dyn* reproduced Pollock's *The Moon Woman Cuts the Circle* (ca. 1943). Steven Naifeh and Gregory White Smith, *Jackson Pollock: An American Saga* (New York: Clarkson Potter, 1989), 879n. The authors give the date of the painting as 1944.

4. Naifeh and Smith, *American Saga*, 563.

5. Naifeh and Smith, *American Saga*.

6. See chapter seven, this volume.

7. "monotonous intensity": "Reviews and Previews," *Art News*, February 1948; "meaningless": Robert Coates, "The Art Galleries," *The New Yorker*, January 17, 1948, p. 57.

8. Hartigan lecture, Skowhegan School of Painting and Sculpture.

9. Hartigan oral history interview, Archives of American Art.

10. Mattison, *Painter's World*, 12.

11. Mattison, *Painter's World*.

12. *Possibilities*, which was to have only one issue, was edited by painter Robert Motherwell (art), Harold Rosenberg (literature; he wasn't writing about art yet), Pierre Chareau (architecture), and John Cage (music).

13. Naifeh and Smith, *American Saga*, 557.

14. Gail Levin, *Lee Krasner: A Biography* (New York: William Morrow, 2011), 237, 249.

15. *Grace Hartigan and Irving Sandler* (video). She also recalled, with a laugh, being impressed that Krasner's jeans had her name on them: Lee.

16. Hartigan oral history interview, Archives of American Art.

17. Hartigan oral history interview, Archives of American Art.

18. Levin, *Lee Krasner,* 250.

19. Levin points out in her biography of Lee that Jackson prevailed on his dealer Betty Parsons to give his wife a solo show in 1951, so he was demonstrably supportive of her painting.

20. Nemser, *Art Talk,* 151–52.

21. Naifeh and Smith, *American Saga,* 617.

22. John Elderfield, *de Kooning: A Retrospective* (New York: Museum of Modern Art), 224–25.

23. Clement Greenberg, "Review of an Exhibition of Willem de Kooning," *The Nation* 166, no. 17 (April 24, 1948), reprinted in *Clement Greenberg: The Collected Essays and Criticism, vol. 2: Arrogant Purpose, 1945–1949,* ed. John O'Brian (Chicago: University of Chicago Press, 1986), 228; Elderfield, *de Kooning: A Retrospective,* 252.

24. Renée Arb, "Spotlight on de Kooning, *Art News* 47, no. 2 (April 1948): 33

25. Naifeh and Smith, *American Saga,* 617.

26. Elderfield, *de Kooning: A Retrospective,* 190. Stevens and Swan, *American Master,* give the price as $700. Artists in those days usually made two-thirds of the net sales of their work.

27. *Grace Hartigan and Irving Sandler* (video).

28. Rudy Burkhardt oral history interview, January 14, 1993, Archives of American Art, Smithsonian Institution.

29. Naifeh and Smith, *American Saga,* 713.

30. Elderfield, *de Kooning: A Retrospective,* 219, 221, 222.

31. Irving Sandler, *A Sweeper-Up After Artists* (London: Thames & Hudson, 2004), 53.

32. Sandler, *Sweeper-Up.*

33. Hartigan, "The Education of an Artist."

34. Hartigan, "The Education of an Artist."

35. Stevens and Swan, *American Master,* 250.

36. "Artist Grace Hartigan: New York Artist Made a Career in Baltimore," *The [Baltimore] Sun,* May 17, 1987, p. 34.

37. *Grace Hartigan and Irving Sandler* (video).

38. Brad Gooch, *City Poet: The Life and Times of Frank O'Hara* (New York: Knopf, 1993), 272. He interviewed Hartigan on February 14, 1988.

39. Gooch, *City Poet.*

40. Gooch, *City Poet.*

41. Decades later, however, she would claim, "I was working all the time. I doubt our relationship [i.e., hers with Pollock] could have existed at all if I weren't working."

Inside New York's Art World: Interview with Lee Krasner, 1978, VHS, Box 179, Barbaralee Dimondstein-Spielvogel Collection *1976–99*, Rubenstein Library, Duke University, Durham, NC; available on YouTube.

CHAPTER 6: COPING

1. Harry Jackson, *Journal,* January 14, 1949, Harry A. Jackson Trust, Cody, WY.

2. John Bernard Myers, *Tracking the Marvelous: A Life in the New York Art World* (New York: Random House, 1983), 140.

3. In the late eighties, Hartigan told Mattison (and Naifeh and Smith) that the wedding took place in March 1949. However, the correct date appears on the couple's marriage certificate, a printed form filled out by hand by Judge Schellinger (who added the license number, 308). Harry A. Jackson Trust.

4. Noteworthy because she had been calling herself "Lee Krasner" both privately and professionally since the previous fall. Levin, *Lee Krasner,* 253.

5. *Grace Hartigan and Irving Sandler* (video).

6. Harry Jackson, *Journal,* January 14, 1949, Harry A. Jackson Trust.

7. Hartigan, in *Meet the Artist: Grace Hartigan* (video), Smithsonian American Art Museum. Available on YouTube.

8. Hartigan oral history interview, Archives of American Art.

9. Harry Jackson, *Journal,* January 8, 1949.

10. Harry Jackson, *Journal,* January 14, 1949.

11. Harry Jackson, *Journal,* January 14, 1949.

12. Hartigan oral history interview, Archives of American Art. (She wrongly remembered this event as happening after she and Harry Jackson returned from Mexico.) Because she said that artist and collector Alfonso Ossorio purchased this painting from the show, we know that it was Pollock's *Number 5.* As Hartigan relates, Ossorio did spot the patch, and Pollock repainted it. In 1990, Hartigan told another interviewer a slightly different version of the story, in which she got the year wrong (in early 1948, Ossorio had not yet purchased his first Pollock and Hartigan hadn't even met the artist). Milton Esterow, "The Second Time Around," *ARTnews,* Summer 1990, pp. 152–53.

13. Japanese restaurant: Harry Jackson, *Journal,* January 24, 1949, Harry A. Jackson Trust. Sobriety: Naifeh and Smith, *American Saga,* 578.

14. Naifeh and Smith, *American Saga* (578) write that Hartigan's apartment was occupied by Pollock's brother Sande and his wife Arloie, who were visiting New York for the occasion, but there is no mention of this in Jackson's journal. It's not clear if Grace was using the apartment as a studio or if some sixth sense made her hang on to the apartment after the wedding.

15. Harry Jackson, *Journal,* January 24, 1949.

16. Naifeh and Smith, *American Saga,* 578.

17. Hartigan, *Journals,* June 2, 1955, p. 178. Hartigan recalled this trip when she returned to Mexico in 1955.

18. Harry Jackson, quoted in Jeffrey Potter, *To a Violent Grave: An Oral Biography of Jackson Pollock* (New York: Putnam, 1985), 105.

19. Incidents recounted in a January 13, 1954, letter from Sidney Hirsh, assistant chief social worker (Jackson's description of the party on December 21, 1948) and a letter from Margaret Ramey, social worker, the woman he threw into the air. She thought he was deluded when he said he was a friend of Jackson Pollock's. These letters formed part of Harry Jackson's testimony at a hearing (hereafter, "Testimony") on October 7, 1964, in which he attempted to receive restitution for war injuries he believed had caused his epilepsy. Thanks to Jackson's biographer, Henry Adams, for this document.

20. Harry Jackson, "Testimony."

21. While the Marines had an unprecedented amount of ammunition, their boats could not navigate the shallow water. Proceeding on foot, they were far from shore when the tide went out and stranded them in waist-high water—sitting ducks for Japanese gunners.

22. The battle is infamous for its heavy losses; more than six thousand combatants on both sides were killed.

23. He also was awarded a Gold Star after being wounded the following July in the Battle of Saipan.

24. Dennis McLellan, "Harry Jackson Dies at 87; Western artist created famed John Wayne Sculpture," *Los Angeles Times*, May 1, 2001.

25. Harry Jackson, *Journal*, March 8, 1949.

26. Hartigan oral history interview, Archives of American Art. The Mexican peso was devalued in June 1949; $1 was now worth more than eight pesos.

27. Spanish translator Carlos Johnson has suggested this version. Elizabeth Stevens Prioleau, *Seductresses: Women Who Ravished the World and Their Lost Art of Love* (New York: Penguin, 2004), 158.

28. Harry Jackson, "Testimony."

29. Harry Jackson, *Journal*, June 15, 1949.

30. Jackson, in *The Art of Harry Jackson* (video), written, directed, and narrated by Harry Jackson, 1987, www.harryjacksonstudios.com.

31. He later took phenobarbital for his seizures, but either the Mexican doctor was unaware of this drug or it was unavailable.

32. Jackson, *The Art of Harry Jackson* (video).

33. Harry Jackson, "Testimony."

34. The back of this photograph bears a note in ballpoint pen: "Phila 1949." Hartigan Papers.

35. Krasner interview with Cindy Nemser, recalled in author's telephone conversation with Nemser, November 29, 2012.

36. This was how she described the couple's return to Mattison, *Painter's World*; his monograph does not mention any of the agonies of the Mexico trip or the reason the marriage ended. In her lengthy Archives of American Art oral history, Hartigan is similarly mute on this subject.

37. Myers, *Tracking the Marvelous,* 140.

38. Hartigan oral history, Maryland Historical Society.

39. Hartigan lecture, Skidmore College.

40. Author's interview with Michel Modele in Baltimore, October 3, 2012.

41. Author's telephone interview with Raoul Middleman, November 9, 2012. Middleman met Grace at the Maryland Institute College of Art, where he has taught since 1961.

42. Hartigan interview by Patrick Taylor, Hartigan Papers.

43. Harry Jackson, *Journal,* November 12, 1949.

CHAPTER 7: STRUGGLING

1. Based in part on a recollection by Pete Hamill, "Beyond the Vital Gesture," *Art & Antiques,* May 1990, p. 110. Hamill's description dates from spring of 1958. Kline's friend was filmmaker Rudy Burkhardt. Burkhardt oral history interview, Archives of American Art, Smithsonian Institution.

2. Mercedes Matter, quoted in Ellen G. Landau, "To Be an Artist Is to Embrace the World in One Kiss," in *Mercedes Matter,* by Ellen G. Landau, Phyllis Braff, and Sandra Kraskin (New York: MB Art Publishing, 2010), 76, 115n. From Matter's interview with Sigmund Koch and Andrew Forge, December 20, 1986, Aesthetics Research Archive, Boston University.

3. Hartigan, quoted in Myers, *Tracking the Marvelous,* 127. The photographer John Gruen, interviewed by the author on November 11, 2011, recalls Hartigan wearing her paint-stained clothes in social settings, although he could not be more specific. But she is neatly dressed in surviving photographs of her in public settings.

4. Myers, *Tracking the Marvelous,* 127. Hartigan later wrote that she played down her beauty "for a long time, until I began to use it to attract the men I wanted." Hartigan letter to Terence Diggory, April 30, 1972, courtesy of Terence Diggory.

5. Matter, quoted in Landau, "To Be an Artist," 50.

6. Matter, draft of unsent letter to Willem de Kooning, ca. 1954–55, quoted in Landau, "To Be an Artist," 49.

7. Matter, quoted in Landau, "To Be an Artist," 50.

8. See chapter eight, this volume.

9. Matter's undated, unpublished memoir of de Kooning, quoted in Landau, "To Be an Artist," 50.

10. Musa Mayer, *Night Studio: A Memoir of Philip Guston* (New York: Knopf, 1988), 67.

11. Michael Kimmelman, "Willem de Kooning Dies at 92; Reshaped U.S. Art," *New York Times,* March 10, 1997.

12. Graham Heathcote (Associated Press), "Jersey Artist Recounts the True Stories of the Few Who 'Made It' and Just How," *Sunday [Newark, NJ] Star-Ledger,* July 26, 1987, p. 19.

13. The 10-cent subway fare rose to 15 cents in July 1953.

14. Author's telephone interview with John Moran, December 13, 2012.

15. William Kienbusch oral history interview, November 1–7, 1968, Archives of American Art, Smithsonian Institution.

16. Hartigan, quoted in Cherrill Anson, "America's Top Woman Painter," 17.

17. Lawrence Campbell to Grace Hartigan, April 10, 1994, Hartigan Papers. Campbell, a critic, painter, and art teacher, was informally known as the Art Students League's historian.

18. Myers, *Tracking the Marvelous,* 126. He mistakenly wrote that Hartigan modeled for Speicher at the Art Students League; Speicher was a top-selling portrait painter who did not teach.

19. *Inside New York's Art World with Lee Krasner,* 1978, Barbaralee Diamondstein-Spielvogel Video Archive, David M. Rubenstein Rare Book & Manuscript Library, Duke University, Durham, NC; available on YouTube.

20. Katherine Kuh, *My Love Affair with Modern Art* (New York: Arcade, 2006), 231.

21. Judith Stein's notes from Hartigan lecture at Pennsylvania Academy of the Fine Arts in January 1988, courtesy of Judith Stein.

22. Stein notes, Hartigan lecture at Pennsylvania Academy of the Fine Arts.

23. Author's interview with Alfred Leslie at his New York studio, June 11, 2011. All quotes from Leslie and anecdotes involving him in this chapter are from this interview.

24. The lease for 25 Essex Street, dated February 10, 1950, specified "art studio, occupancy limited to five (5) people." With thanks to Alfred Leslie.

25. Hartigan, quoted in Mattison, *Painter's World,* 42.

26. Hartigan lecture, Skidmore College.

27. Myers, *Tracking the Marvelous,* 125.

28. The market, which still exists today, was established in the 1930s by Mayor LaGuardia to reduce the congestion of peddlers' carts on the streets.

29. Hartigan lecture, Skidmore College.

30. Hartigan, *Journals,* March 6, 1953, p. 72.

31. *Journals,* April 17, 1951, p. 4.

32. George Anthony Dondero (1993–1968) first spoke against abstraction, which he claimed "aims to destroy by the creation of brainstorms," in a speech ("Communism in the heart of American art—What to do about it") to the U.S. House of Representatives on August 16, 1949. He told *New York World-Telegram* art critic Emily Genauer—whom he had singled out in his speech as a pernicious influence—that "art which does not glorify our beautiful country in plain simple terms that everyone can understand breeds dissatisfaction. It is therefore opposed to our government and those who promote it are enemies." (Emily Genauer, "Still Life with Red Herring," *Harper's Magazine,* September 1949, p. 89.) On March 17, 1952, in another congressional speech ("Communist conspiracy threatens American museums"), the Republican congressman again linked abstraction to a communist

conspiracy. By the late fifties, however—in part through the efforts of the Museum of Modern Art in exhibiting this work internationally—the rise of New York-based abstraction had became synonymous with both American freedom of expression and artistic prestige. So much for Dondero's jingoistic concerns.

33. Alfred H. Barr, "Is Modern Art Communistic?" *New York Times Magazine*, December 14, 1952, pp. 22–23, 28–30.

34. The exhibition also featured work by Alfred, Harry Jackson, Franz Kline, Elaine de Kooning, Larry Rivers, and eighteen other artists.

35. Hartigan oral history interview, Archives of American Art.

36. Stein notes, Hartigan lecture at Pennsylvania Academy of Fine Arts.

37. Grace Hartigan interview by Bob Lesser, April 20, 1965. "Listening to Pictures" program, Brooklyn Museum. Archives of American Art, Smithsonian Institution, Washington, DC. Gift of the Brooklyn Museum.

38. Hartigan stopped short of incorporating Pollock's signature drips in *The King Is Dead*, now in the collection of the Snite Museum of Art at the University of Notre Dame, Notre Dame, IN.

39. Hartigan lecture, Skowhegan School of Painting and Sculpture.

40. Hartigan was so broke that she painted *Months* on the reverse of a canvas fellow artist Robert Goodnough had thrown out. Horizontal creases near the top of the canvas are traces of the wrinkles left when it was stuffed in a trash bin. (Hartigan lecture, Skowhegan School of Painting and Sculpture) The painting remained in her possession until ACA Galleries sold it in 2000 for $42,000, netting her $21,000.

41. Hartigan, quoted in Mattison, *Painter's World,* 13.

42. Mattison, *Painter's World,* 16. The title was borrowed from a lecture about creativity by architect Louis Sullivan, published in 1947 as the fourth volume in the *Documents of Modern Art* series edited by painter Robert Motherwell. Hartigan may have borrowed that unusual olive green—soon to be stylish in home decor—from army uniforms.

43. Mayer, *Night Studio,* 68.

44. Jeanne Bultman, quoted in Ann Eden Gibson, *Abstract Expressionism: Other Politics* (New Haven: Yale University Press, 1997), 144.

45. Author's telephone interview with Cynthia Navaretta, August 18, 2011.

46. Elizabeth Frank, *Louise Bogan: A Portrait* (New York: Columbia University Press, 1986), 42.

47. Linda Gordon, *Dorothea Lange: A Life Beyond Limits* (New York: W.W. Norton, 2010), 108–11.

48. Phoebe Hoban, *Alice Neel: The Art of Not Sitting Pretty* (New York: St. Martin's, 2010), 70–74, 121, 145–46, 314, 354–60.

49. Doris Lessing, quoted in Nigel Farndale, "Doris Lessing: Her Last Interview," *The Telegraph* (UK), interview conducted April 2008, posted online November 17, 2013.

50. Written when Mayer was her mid-forties, her book offers a sensitive and clear-eyed portrait of her father, whose "unpredictable dark moods" and need to spend long hours by himself in his studio were frightening to her as a child.

51. Hartigan, *Journals*, April 30, 1951, p. 7.

52. Hartigan letter to Walter Silver, August 3, 1952, Hartigan Papers.

53. Hartigan lecture, Skowhegan School of Painting and Sculpture.

54. Hartigan, *Journals*, May 20, 1951, p. 8.

55. Gallery announcement, reproduced on the back cover of *Painters & Poets: Tibor de Nagy Gallery* by Douglas Crase and Jenni Quilter (New York: Tibor de Nagy Gallery, 2011).

56. Myers, *Tracking the Marvelous*, 125.

57. Myers, quoted in Vicki Goldberg, "Grace Hartigan Hates Pop," *New York Times*, August 15, 1993.

58. Hartigan letter to Terence Diggory, April 30, 1992, courtesy of Terence Diggory.

59. Hartigan, quoted in "Artist's Comments," *Gallery News*, Brooklyn College Art Department, April 19, 1990, unpaginated.

60. (Charles) Waldemar (a.k.a. Valdemar) Hansen (1891–1960) was the Oslo-born author of many novels, mostly published in Norwegian. He was best known in the English-speaking world for *The Peacock Throne: The Drama of Mugul India*, published posthumously in 1972.

61. Hartigan lecture, Skidmore College.

62. Waldemar Hansen letter to Hartigan, June 23, 1952, Hartigan Papers. Grable was a movie star whose heyday was in the 1940s; she was the top moneymaker for 20th Century Fox, run by Zanuck.

63. Myers, *Tracking the Marvelous*, 127.

64. Susan Sontag, "Notes on 'Camp,'" in *Against Interpretation* (New York: Dell, 1966), 277.

65. Sontag, "Notes on 'Camp,'" 281.

66. Tibor de Nagy oral history interview, March 29, 1976, Archives of American Art, Smithsonian Institution. Myers did not mention the "George" episode in his memoir, so there is no first-hand evidence that he suggested or approved of the pseudonym.

67. Hartigan letter to Terence Diggory, April 30, 1992, courtesy of Terence Diggory. In her letter, she absent-mindedly wrote "monographed" for "monogrammed."

68. Roland Pease, "Grace Hartigan," in *Art USA Now*, vol. 2, ed. Lee Nordness (New York: Viking, 1963), 356. Pease quoted her as saying that she had "an excruciating reaction to exhibiting," without explaining further.

69. MacIver, whose new last name was a variant of her mother's maiden name, was the first woman represented in the Modern's permanent collection. Unbeknownst to her, her husband, poet Lloyd Frankenberg, brought her paintings to the Modern in 1935. Director Alfred Barr bought one for the museum and one for his private collection. She had a retrospective at the Whitney Museum in 1953 and represented the United States at the Venice Biennale in 1962. Jenni L. Schlossman, "Loren

MacIver: Turning the Ordinary into the Extraordinary," *Woman's Art Journal* 21, no. 1 (Spring/Summer 2000): 11. Schlossman writes that MacIver enrolled at the National Academy with the first name "Lawn," but it's a good bet that an official misheard or mistyped "Loren."

70. While Sterne remained little-known throughout her long life—she lived to be 100—she was named a leading artist under age thirty-six in the March 1950 issue of *Life*. Like Grace, Sterne worked in several styles; unlike Grace, she never considered herself an Abstract Expressionist and called the *Life* photo "probably the worst thing that ever happened to me." The other artists, she said, were "all very furious that I was in it because they all were sufficiently macho to think that the presence of a woman took away from the seriousness of it all." She walked into the photo session late, when all the chairs were taken, so photographer Nina Leen asked to stand on a table. Hedda Sterne oral history interview, December 17, 1981, Archives of American Art, Smithsonian Institution.

71. Hedda Sterne, quoted in Gibson, *Abstract Expressionism*, 156.

72. East Coast art magazine reviews in the fifties were signed only with the writer's initials. Reviewing Grace's 1951 solo show, *Art News* critic "L.C." (Lawrence Campbell) (February 1951) and *Art Digest* critic "J.F." (James Fitzsimmons) both referred to Hartigan as "she." Fitzsimmons called her "Hartigan" (no pronoun) in his April 1952 and April 1953 *Art Digest* reviews. She became "Miss Hartigan" in his review in the May 1953 issue of *Art & Architecture*. Since Fitzsimmons was then in the throes of an affair with her, he surely knew what gender she was.

Stewart Preston hedged his bets by calling her "this painter" in his *New York Times* review of January 21, 1951, but in his March 30, 1953 review of Hartigan's second show, he referred to "her." An April 1952 *Art News* review by "R.G." (Robert Goodnough) cautiously opted for "the artist," even though he was a friend of hers. In an April 1953 review, *Art News* critic "B.H." (Betty Holliday) used the female pronoun.

73. Joe LeSueur, *Digressions on Some Poems by Frank O'Hara: A Memoir* (New York: Farrar, Straus and Giroux, 2003), 104.

74. Author's interview with Irving Sandler, November 11, 2011.

75. Hartigan oral history interview, Archives of American Art.

76. Her name is rendered as Grace George Hartigan on the cover of the catalogue for her painting show at the Vassar College Art Gallery in 1954.

77. Nemser, *Art Talk*, 151.

78. Nemser, *Art Talk*, 151.

79. Grace Hartigan letter to Laurie Lisle, February 2, 1986, Hartigan Papers.

80. Hartigan read *Mill on the Floss* (1860): Hartigan *Journals*, December 6, 1954, p. 159.

81. *Seated Female Figure (Portrait of Marie Menken)* from 1952 was auctioned by Doyle New York on May 9, 2012 for $5,000. That price, and all auction prices quoted in this book, includes the auction house charge, a percentage of the sale known as the buyer's premium.

82. Jane Freilicher, quoted in Karen Wilkin, *The First Fifty Years* (New York: Tibor de Nagy Gallery, 2000).

83. January 16, 1951, *The Diaries of Judith Malina, 1946–1957* (New York: Grove, 1984), 144.

84. Lawrence Campbell [L.C.], "George Hartigan," *Art News*, February 1951.

85. Stuart Preston, "Chiefly Modern," *New York Times*, January 21, 1951, p. 89.

86. Hartigan oral history interview, Archives of American Art.

87. Hartigan interview by Bob Lesser, April 20, 1965. Tibor de Nagy remembered the amount as $75, Tibor de Nagy oral interview, Archives of American Art.

88. Hartigan, *Journals*, March 31, 1951, p. 1.

89. Hartigan, *Journals*, March 31, 1951, p. 1.

90. Hartigan, *Journals*, March 31, 1951, p. 2.

91. Hartigan, *Journals*, March 31, 1951, p. 2.

92. Helen Frankenthaler oral history interview, 1969, Archives of American Art, Smithsonian Institution. (All quotes from Frankenthaler in this chapter are from this interview.)

93. Originally published in *Partisan Review*, Fall 1939, pp. 34–59.

94. Henry Geldzahler, "Interview with Helen Frankenthaler," *Artforum* 4, no. 2 (October 1965): 36–38, reprinted in *Theories and Documents of Contemporary Art*, ed. Kristine Stiles and Peter Selz (Berkeley: University of California Press, 1996).

95. Florence Rubenfeld, *Clement Greenberg: A Life* (New York: Scribner, 1997), 151, 155.

96. Rubenfeld, *Clement Greenberg*, 155.

97. Helen Frankenthaler, "Contemporary Experience Lecture, Helen Frankenthaler," Baltimore Museum of Art, February 22, 1970, http://cdm15264.contentdm.oclc.org/cdm/ref/collection/p16075coll3/id/41.

98. Rubenfeld, *Clement Greenberg*, 155.

99. Hartigan, *Journals*, April 10, 1951, p. 2.

100. Hartigan, *Journals*, April 17, 1951, p. 4.

101. Hartigan, *Journals*, April 25, 1951, p. 5.

102. Hartigan, *Journals*, April 17, 1951, p. 4.

103. Ludwig Sander oral history interview, February 4–12, 1969, Archives of American Art, Smithsonian Institution. Sander says that it was a former wholesale store (all quotes from Sander in this chapter are from this source). Other sources, including Thomas Hess's review (T.B.H., "New York's Avant-Garde," *Art News* 50, no. 46 [June 1951]: 46–47), call it a former antiques shop.

104. Hess, "New York's Avant-Garde," 46.

105. Paul Brach, "Two Postscripts," *Artforum* 3 (September 1965): 32.

106. Hartigan, *Journals*, August 10, 1951, p. 12. Further information about this painting, which was included in the Whitney Annual that year. has not survived.

107. Hartigan, *Journals*, April 25, 1951, p. 5.

108. Frankenthaler letter to Hartigan, August 3, 1951, Hartigan Papers. The nature of the con is not explained in this letter or in Grace's journal of that year.

109. Hartigan, *Journals*, July 30, 1951, p. 11.

110. Hartigan, *Journals,* July 30, 1951, p. 11.

111. Hartigan, *Journals*, June 26, 1951, p. 10.

112. Frankenthaler letter to Hartigan, August 3, 1951, Hartigan Papers.

113. According to his archive at the Photography Division of the New York Public Library, Walter Silver was a photo lab technician with the 38th Photo Reconnaissance Group in the Pacific Theatre during part of his service.

114. Author's telephone interview with George Silver, June 25–26, 2013.

115. Hartigan letter to Carole Silver, October 27, 1998, with thanks to George Silver.

116. Hartigan letter to Walter Silver, August 3, 1952, Hartigan Papers.

117. Hartigan letter to Carole Silver.

118. Author's telephone interview with Arthur Hartigan, August 27, 2012. Author's interview with Donna Sesee at Grace's New York pied-à-terre on Mott Street, June 11, 2011.

119. John Ashbery email to author, January 25, 2012.

120. *The Scream*, by Parker Tyler, staged by Herbert Machiz, John Myers's lover at the time.

121. Author's telephone interview with Wolf Kahn, January 2012. Alfred Steiglitz famously photographed the painter Georgia O'Keeffe, whom he eventually married, in many poses from 1918 to 1925.

122. Silver's ability to capture his sitters when they seem most relaxed can be seen in his photographs of Hartigan and her fellow second-generation New York School artists in *School of New York: Some Younger Artists*, ed. B. H. Friedman (New York: Grove, 1959). Friedman credits Silver in the introduction as a New York artist in his own right.

123. He was born on March 27, 1926—a fact he learned late in life, having grown up believing he was born in June. (This was a ruse to cover up his out-of-wedlock birth.)

124. Hartigan lecture, Skidmore College.

125. Hartigan lecture, Skidmore College.

126. Hartigan oral history interview, Archives of American Art.

127. Hartigan letter to Bruce Boone, editor of the 1973 *Panjandrum* special supplement about O'Hara, quoted in Marjorie Perloff, *Poet Among Painters* (New York: George Braziller, 1977), 210.

128. Information about Jane Freilicher (née Niederhofer) from Jane Freilicher oral history interview, August 4–5, 1987, Archives of American Art, Smithsonian Institution. Like Grace's family, Freilicher's descended from its middle-class perch during the Depression. Jane was also a good student who loved to read, and who married early to escape her mother's influence. But hers was a loving mother who coddled her daughter, the only girl and youngest of three children.

129. Larry Rivers's unabashed bisexuality entangled him in various ways with the Tibor de Nagy crowd. At John Ashbery's party in December 1950, Rivers—still involved with Freilicher—met Frank O'Hara, carried on a two-hour conversation, and

then kissed him behind a window drape. (Larry Rivers, *What Did I Do? The Un-authorized Autobiography* [New York: Thunder's Mouth, 1992], 228.) Rivers was also a longstanding, though apparently unrequited, object of gallery director John Myers's lust; he was forever asking his artists to report on Rivers's activities.

130. *Inside New York's Art World: Interview with Larry Rivers* (video).

131. Jane Freilicher oral history interview, Archives of American Art.

132. Gooch, *City Poet,* 178.

133. This number reflects all the titled paintings Hartigan mentions in her journal for 1951. Hartigan, *Journals,* September 1, September 17, September 22, September 25, October 15, pp. 12–14.

134. Hartigan, *Journals,* November 19, 1951, p. 17.

135. Hartigan, *Journals,* September 12, 1951, p. 13.

136. Hartigan, *Journals,* November 6, 1951, pp. 16–17.

137. Hartigan, *Journals,* November 19, 1951, p. 17.

138. Hartigan, *Journals,* December 3, 1951, p. 18. It is worth noting that both artists were late-bloomers: Matisse had no experience with art until he painted his first picture at age twenty.

139. Hartigan, *Journals,* August 18, 1952, p. 42.

140. Hartigan, *Journals,* December 4, 1951, p. 18.

CHAPTER 8: LAUNCHING

1. Hartigan, *Journals,* January 2, 1952, p. 21.

2. Hartigan, *Journals,* January 15, 1952, p. 22.

3. Cherrill Anson, "America's Top Woman Painter," 18.

4. Nemser, *Art Talk,* 156.

5. "Artist Grace Hartigan: NY Artist Made a Career in Baltimore," *The [Baltimore] Sun,* Anniversary Issue, May 17, 1987.

6. Hartigan letter to Emily Dennis, March 9, 1955, courtesy of Emily Dennis Harvey.

7. Jonathan VanDyke, *Grace Hartigan: Painting from Popular Culture* (Harrisburg, PA: Susquehanna Art Museum, 2000).

8. The following description of Ostrowsky's class comes from Hartigan, "The Education of an Artist." She mentioned this class in her 1954 talk at Vassar College, but apparently never spoke of it again in her many subsequent interviews and lectures.

9. Hartigan, *Journals,* January 7, 8, 15, 17, 29, 1952, pp. 21–23; June 17, 1952, p. 35; February 5, 1953, p. 69.

10. The gallery's ledgers from 1952 and the remainder of the fifties have not been preserved, with the exception of the 1953 records, at the Archives of American Art, Smithsonian Institution. Information from Douglas Crase, *Both: A Portrait in Two Parts* (New York: Pantheon, 2004), 273n. According to a statement by de Nagy on the occasion of the gallery's twenty-fifth anniversary, Ripley paid the rent for the first six years. Crase, *Both,* 171.

11. Curtis, "The Figurative '50s—for Sentimental Reasons."

12. VanDyke, *Painting from Popular Culture.*

13. Hartigan oral history interview, Archives of American Art.

14. See Lytle Shaw, *Frank O'Hara: The Poetics of Coterie* (Iowa City: University of Iowa Press, 2006), 105.

15. Gooch, *City Poet,* 213.

16. Rivers letter to O'Hara, July 27, 1952, quoted in Gooch, *City Poet,* 239. Rivers was trying to disentangle his fondness for O'Hara from his disinclination to carry on with their sexual relationship.

17. Gooch, *City Poet,* 211. O'Hara wrote to his brother Philip on January 11, 1963, that his mother was "one of the most mean, hypocritical, self-indulgent, selfish and avaricious persons I have ever known well." Gooch, *City Poet,* 13.

18. Ludwig Sander oral history interview, Archives of American Art, Smithsonian Institution.

19. Kay Larson, *Where the Heart Beats: John Cage, Zen Buddhism, and the Inner Life of Artists* (New York: Penguin, 2012), 148.

20. Sandler, *Sweeper-Up,* 31.

21. Stevens and Swan, *American Master,* 286.

22. *Grace Hartigan and Irving Sandler* (video). She didn't mention the name of the restaurant.

23. Sandler, *Sweeper-Up,* 23.

24. Natalie Edgar, ed., *Club Without Walls: Selections from the Journals of Philip Pavia* (New York: Midmarch Arts, 2007), 10.

25. Landau, "To Be an Artist, 48.

26. Larson, *Where the Heart Beats,* 147.

27. Ludwig Sander oral history interview.

28. According to *Artists Sessions at Studio 35 (1950)* (Chicago: Wittenborn Art Books, 2009), 7. Others have placed the opening in the spring of 1948.

29. Robert Motherwell oral history interview, November 24, 1971–May 1, 1974, Archives of American Art, Smithsonian Institution.

30. Edgar, *Pavia,* 47. Jean Arp (a.k.a. Hans Arp), a founding member of the Dada movement, had renounced Surrealism in 1931. Born in what was then Alsace-Lorraine, he spoke both German and French; his talk at Subjects of the Artist was delivered in French, with simultaneous translation by Robert Motherwell.

31. *Artists' Sessions,* 33.

32. The no-picture rule must have fallen by the wayside at some point because photographs of two sculpture panels show wall décor: images of Washington Square Arch and horses and carriages at Central Park. See Edgar, *Pavia,* 122–23.

33. Ludwig Sander oral history interview.

34. Lionel Abel, *The Intellectual Follies* (New York: W.W. Norton, 1984), 205.

35. Other artists included Landes Lewitin, James Rosati, George Cavallon, and Peter Grippe.

36. Mercedes Matter, who came to the first Club meeting, claimed that she was a charter member, even though—because she was a woman, according to Irving Sandler—she was not on the list drawn up in 1951. She did become a member by 1952. Matter later said that Elaine de Kooning initially refused to join because Aristodemis Kaldis was initially denied membership as a member of a rival faction of the Waldorf Cafeteria artist group. Matter interview, December 19, 1986, Aesthetics Research Archive, Boston University, Tape 1B, quoted in Landau, "To Be an Artist," 75, 109n.

37. Mercedes Matter interview, quoted in Landau, "To Be an Artist," 75, 109n.

38. Elaine de Kooning oral history interview, August 27, 1981, Archives of American Art, Smithsonian Institution.

39. Ludwig Sander oral history interview. Since the nineteenth century, women's clubs were known for their self-improvement efforts—an attempt to fill in for the higher education most women were denied—with uplifting talks on culture and ways to work for the betterment of their communities.

40. Robert M. Coates, art critic at *The New Yorker*, coined that term in a review, "The Art Galleries: Abroad and at Home," March 30, 1946, pp. 83–84. He used a lowercase *a* for *abstract* and offered the term as a "polite" alternative to "what some people call the spatter-and-daub school of painting."

41. Greenberg, "Present Prospects," 29–30.

42. Phyllis Fleiss, quoted in Naifeh and Smith, *American Saga,* 637.

43. Hartigan oral history interview, Maryland Historical Society. Tudor later became a composer of electronic music.

44. Hartigan lecture, Skidmore College.

45. Abel, *Intellectual Follies,* 207–209.

46. Author's interview with Alfred Leslie, New York, June 11, 2011.

47. Edgar, *Pavia,* 4, 137.

48. Philip Pavia, "The Unwanted Title: AE," in Ellen Landau, *Reading Abstract Expressionism: Context and Critique* (New Haven: Yale University Press, 2005), 232.

49. Alice Baber oral history interview, May 24, 1973, Archives of American Art, Smithsonian Institution.

50. Sander oral history interview.

51. Marcia Marcus, in Russo, *Profiles,* 173.

52. Edgar, *Pavia,* 59, 61–62.

53. Edgar, *Pavia,* 64.

54. Edgar, *Pavia,* 110.

55. Jon Schueler, *The Sound of Sleat: A Painter's Life* (New York: Picador, 1999), 248.

56. Edgar, *Pavia,* 110.

57. Author's interview with Alfred Leslie.

58. Hartigan, *Journals,* March 10, 1952, p. 25.

59. "Poem for a Painter," in Frank O'Hara, *Collected Poems* (Berkeley: University of California Press, 1995), 80. O'Hara wrote "(Hartigan)" next to the poem's title in his manuscript. Grace's copy of the poem bears the alternate title "Poet Trapped by the Tail."

60. Myers, *Tracking the Marvelous,* 139–40. Myers's chronology is often vague, but the kite-flying event seems to have happened around the time of Hartigan's gallery exhibition, which opened in March and closed on April 12; Hartigan's sleeveless blouse in a photo suggests that that this was a day in late spring. According to Douglas Crase (*Both,* 172), Myers had coaxed a *Life* photographer to shoot the Central Park event. Barneby's group photo is reproduced on page 49 of *Both.*

61. Barneby was also an art collector; in 1954, he bought Hartigan's painting *Southampton Fields,* which he claimed to prefer to the Dubuffet landscape he owned. Hartigan, *Journals,* October 29, 1954, p. 155.

62. With the exception of *The Cue,* an energetic abstraction from 1951, the other paintings have disappeared into obscurity.

63. Stuart Preston, "British Artists; Painters of This Century—One Man Shows," *New York Times,* March 30, 1952.

64. Fitzsimmons, "George Hartigan," April 1952. Fitzsimmons (1919–1985) founded *Art International,* a leading art periodical, in 1958. In 1961, he moved to Switzerland, where he married a Hungarian-born artist and continued to edit the magazine until his death.

65. Goodnough, "George Hartigan." Hartigan recorded in her journal on March 14 that Greenberg liked this painting "very much." But on March 31, as she considered what she had learned from the show, the painting struck her as "a blind alley." Hartigan later crossed out the title of this painting and wrote "Destroyed" on a copy of the exhibition catalogue.

66. Rubenfeld, *Clement Greenberg,*156. A quarter of a century later, art dealer Harry Litwin wrote to Greenberg about various issues, including Greenberg's objection to Grace's need to learn from Old Master paintings. Clem replied that he had no memory of this. He said that he believed her work "fell off" after 1950—he seems to have forgotten that his problem with it surfaced in 1952—"but I didn't tell her that; she heard it…from a third person." Greenberg denied that she threw an ashtray at him (as Litwin averred), a rumor he claimed never to have heard before. He summed up by saying, "Grace doesn't need my sympathy." She would go on painting, he wrote, and his appreciation or disapproval of her work would have no bearing on it. Clement Greenberg letter to Harry Litwin, October 1, 1977, Hartigan Papers.

67. Hartigan, *Journals,* March 21, 1952, p. 27.

68. Hartigan, *Journals,* March 29, 1952, p. 28.

69. Grace Hartigan on "Community," notes by Irving Sandler, January 14, 1974, courtesy of Irving Sandler.

70. Nemser, *Art Talk,* 156.

71. Hartigan oral history interview, Archives of American Art.

72. Hartigan oral history interview.

73. Hartigan, *Journals,* August 18, 1952, p. 42. The bicycle is part of *Summer Street* (1956).

74. Hedda Sterne, quoted in Gibson, *Abstract Expressionism,* 9.

75. Elaine de Kooning, quoted in Gibson, *Abstract Expressionism*, 9. In fact, Matisse employed traditional ecclesiastical colors associated with the seasons of the Church calendar.

76. Hartigan, *Journals*, June 2, 1952. p. 33.

77. Hartigan, *Journals*, April 8, 1952, p. 31.

78. Hartigan, *Journals*, May 8, 1953, p. 80.

79. Hartigan, *Journals*. October 10, 1952, 46; November 19, 1952, p. 59.

80. Waldemar Hansen letter to Hartigan, July 16, 1952, Hartigan Papers.

81. Waldemar Hansen letter to Hartigan, October 7, 1952, Hartigan Papers.

82. Waldemar Hansen letter to Hartigan, October 22, 1953, Hartigan Papers.

83. Hartigan, *Journals*, August 11, 1952, pp. 40–41.

84. Hartigan, *Journals*, August 8, 1952, pp. 39–40.

85. Reproduction of O'Hara's note; Hartigan, *Journals*, p. 40.

86. Hartigan, *Journals*, August 8, 1952, p. 39.

87. Hartigan letter to Silver, August 3, 1952, Hartigan Papers. Central Park also had a famous carousel that was destroyed by fire in 1950 but replaced the following year with a resplendent vintage model with hand-carved horses; it possible that Jeffrey also rode this one.

88. Hartigan, *Journals*, October 13, 1952, p. 47. Klee (1879–1940) was a Swiss-born artist intrigued by the expressive possibilities of color. His trip to Tunisia in 1913 influenced him to experiment with abstraction; his best-known works have an deceptively childlike simplicity, combining stick figures with abstract elements.

89. Hartigan, *Journals*, March 14, 1952, p. 26. In a September 20, 1959, letter to editor Donald Allen, the poet James Schuyler mentioned that poets Frank O'Hara and John Ashbery "appeared as a couple of dogs, night after night" in this production. William Corbett, ed., *Just the Thing: Selected Letters of James Schuyler* (New York: Turtle Point, 2004), 111.

90. Julian Beck, *The Life of the Theatre* (New York: Limelight Editions, 1986), 13, quoted in Erica Munk, "Only Connect: The Living Theatre and its Audiences," in *Restaging the Sixties: Radical Theaters and Their Legacies*, ed. James M. Harding Jr. and Cindy Rosenthal (Ann Arbor: University of Michigan Press, 2006), 36. Beck listed the program in his diary entry for January 14, 1952. "If this won't save the theater, nothing will," he wrote (36). The company later evolved into a collective that scorned traditional Western theatrical forms.

91. Hartigan, *Journals*, December 5, 1952, p. 61.

92. Hartigan, *Journals*, October 22, 1952, p. 51.

93. Hartigan, *Journals*, November 5, 1952, p. 55.

94. The eloquent liberal governor of Illinois had been the great white hope of artists and intellectuals, but the former supreme commander of the Allied troops won by a landslide.

95. Hartigan, *Journals*, December 17, 1952, p. 63.

96. Hartigan, *Journals*, December 17, 1952, p. 63.

97. Hartigan, *Journals*, October 29, 1952, p. 53.

98. Hartigan, *Journals*, April 2, 1953, p. 75.

99. The winner of the game is the one who pushes everyone else off the top of the hill. Although pleased that her paintings were finding buyers, Hartigan lamented that *King of the Hill* was sold for just $100; she knew that it was one of her best early works. Hartigan, *Journals*, November 3, 1952, p. 54.

100. Hartigan, *Journals*, December 23, 1953, p. 63.

101. Hartigan, *Journals*, December 6, 1952, p. 62.

CHAPTER 9: SUCCEEDING

1. Hartigan, *Journals*, January 2, 1953, p. 66.

2. Hartigan, *Journals*, January 13, 1953, p. 67.

3. Clement Greenberg, *Stable Gallery Second Annual Exhibition of Painting and Sculpture* announcement, January 1953; available at albertkotkin.com/stable1953 .jpg.

4. Hartigan, *Journals*, January 12, 1953, p. 66.

5. Hartigan, *Journals*, January 13, 1953, p. 67.

6. Hartigan, *Journals*, February 2, 1953, p. 67.

7. Hartigan, *Journals*, February 5, 1953, p. 68.

8. Hartigan, *Journals*, March 5, 1953, p. 70.

9. Hartigan, *Journals*, March 5, 1953, p. 71.

10. Hartigan, *Journals*, June 23, 1952, p. 36.

11. Hartigan, *Journals*, March 16, 1953, p. 73.

12. O'Hara, *Collected Poems*, 149.

13. Hartigan lecture, Skidmore College. She said that the actress Jane Alexander once planned a theater piece about "great loves" and asked her how she'd feel if one of the couples was Hartigan and O'Hara.

14. Hartigan, *Journals*, March 18, 1953, p. 73.

15. Grace had strong feelings about flowers, a trait she shared with her rose-cultivating father. In 1952, she went to a flower show and recoiled at the "mad bourgeois [*sic*] vulgarity" of "all those obscene forced flowers." Hartigan, *Journals*, March 21, 1962, p. 28.

16. The revenge theme haunting the mythological background of the anemone (from the Greek word for "wind")—which O'Hara surely would have known—makes it an odd choice of tribute. Chloris, goddess of flowers, turned the nymph Anemone into a flower that withered before the arrival of her suitor Zephyr, god of the spring wind. Anemones also haunt the story of Aphrodite, goddess of love. When Persephone had Aphrodite's lover Adonis killed, her tears turned into anemones.

17. Hartigan, *Journals*, April 2, 1953, p. 75.

18. Perloff, *Poet Among Painters*, 41.

19. Hartigan lecture, Skidmore College.

20. Newsprint—low-cost paper made of pulp from softwood such as spruce or pine—was available in various weights and sold in pads. The disadvantage of using this type of paper is its tendency to become yellow and brittle when exposed to air and sunlight.

21. Hartigan lecture, Skidmore College.

22. Hartigan lecture, Skidmore College.

23. Gooch, *City Poet,* 216.

24. Frank O'Hara, "Nature and New Painting," in *Standing Still and Walking in New York*, ed. Donald Allen (San Francisco: Grey Fox, 1983), 45.

25. O'Hara, "Nature and New Painting."

26. With thanks to the analysis by Daniel J. Kushner, in "Text Painting: Grace Hartigan and Frank O'Hara at Tibor de Nagy Gallery," *Huffington Post*, February 23, 2011, available at http://www.huffingtonpost.com/daniel-j-kushner/text-painting-grace-harti_b_827263.html.

27. Kushner, "Text Painting."

28. Kushner, "Text Painting."

29. Hartigan quoted in Terrence Diggory, "Questions of Identity in Oranges by Frank O'Hara and Grace Hartigan," *Art Journal* 52 (Winter 1993): 46.

30. Perhaps because of its bleak allegorical subject matter, this painting found no buyer until 1970, when Grace sold it to a board member of a private boys' school north of Baltimore for a series of monthly payments totaling $1,500.

31. "The Knight, Death, and the Devil," *The Nation,* June 16, 1951, p. 566, collected in Randall Jarrell, *The Seven-League Crutches* (New York: Harcourt, Brace, 1951).

32. Hartigan, *Journals*, June 17, 1952, p. 35.

33. Hartigan, *Journals*, June 12, 1952, p. 34. Hartigan, quoted in Robert Saltonstall Mattison, "Grace Hartigan," in Paul Schimmel and Judith E. Stein, *The Figurative Fifties: New York Figurative Expressionism* (Newport Beach, CA: Newport Harbor Art Museum, 1988), 92.

34. The lack of concern about any appearance of conflict of interest is illustrated by an incident in 1956. When James Schuyler wrote the introduction for a Tibor de Nagy Gallery exhibition of paintings by Fairfield Porter, he told Thomas Hess, executive editor of *Art News*, that this surely made him ineligible to review the show, as he had been intending to do. Hess reportedly said, "I don't see why." James Schuyler letter to Fairfield Porter, August 26, 1956, in Corbett, *Selected Letters of James Schuyler,* 56.

35. Dore Ashton, "Art: Painters Meet Poet," *New York Times*, January 25, 1959.

36. Betty Holliday [B.H.], "George Hartigan," *Art News* 52 (April 1953): 39.

37. *Inside New York's Art World: Interview with Thomas Hess*, Barbaralee Diamondstein-Spielvogel Video Archive, David M. Rubenstein Rare Book & Manuscript Library, Duke University, Durham, NC; available on YouTube. The date listed for the video (1979) is incorrect; Hess died in 1978. The video was recorded in 1977, as an internal reference makes clear.

38. Fitzsimmons, "George Hartigan," *Art Digest* 26 (April 1, 1953): 17.

39. Hartigan, *Journals*, March 25, 1953, p. 74.

40. Fitzsimmons, "Art," *Art & Architecture* 70 (April/May 1953): 4.

41. Hartigan, *Journals*, May 9, 1953, p. 80.

42. A long misunderstood and maligned painting, *Bathers* did not find a home until the early fifties, when New Yorkers Henry and Rose Pearlman bought it from the widow of Matisse's dealer Paul Guillaume. It was acquired by The Art Institute of Chicago in 1953. Purchase information from Art Institute website.

43. Hilary Spurling, *Matisse the Master—A Life of Matisse: The Conquest of Color, 1909–1954* (New York: Knopf, 2007), 286.

44. Spurling, *Unknown Matisse*, 187.

45. Hartigan, *Journals*, May 12, 1953, p. 81.

46. Hartigan, *Journals*, May 12, 1953, p. 81.

47. Hartigan letter to Emily Dennis, April 27, 1955, courtesy of Emily Dennis Harvey.

48. Hartigan oral history interview, Maryland Historical Society.

49. Hartigan, *Journals*, July 31, 1953, p. 90.

50. Hartigan, *Journals*, July 31, 1953, p. 91.

51. Hartigan, *Journals*, May 13, 1953, p. 81.

52. Hartigan, *Journals*, June 16, 1953, p. 4.

53. Miriam Schapiro oral history interview, September 10, 1989, Archives of American Art, Smithsonian Institution.

54. Hartigan, *Journals*, August 30, 1953, pp. 94–95.

55. Miram Schapiro oral history interview.

56. Patricia Albers, *Joan Mitchell: Lady Painter* (New York: Knopf, 2011), 199. Grace noted in her journal (July 7, 1953, p. 86) that her hosts were "most agreeable, and certainly more gracious and easier to be with than Larry or any of my friends," yet the visit was "much less rewarding" in an unspecified way.

57. Terence Diggory, introduction, in Hartigan, *Journals*, xxii. Vecchi would later print a silkscreen of a dollar bill drawing by Andy Warhol, which launched his game-changing use of silkscreen printing.

58. The school is now known as the High School of Art and Design. In the 1960s, Aldan's pupils included Calvin Klein, Art Spiegelman, Tony Bennett, Harvey Fierstein, and Warhol studio members Gerard Malanga and Jackie Curtis.

59. Hartigan, *Journals*, July 27, 1953, p. 89. The print appeared in the first issue of the Tiber Press publication *Folder*.

60. Hartigan, *Journals*, July 13, 1953, p. 88.

61. Hartigan, *Journals*, July 21, 1953, p. 89.

62. Hartigan, *Journals*, August 11, 1953, p. 92.

63. Quoted from the Summons and Complaint delivered by Hartigan's attorney to Harry Jackson, dated November 28, 1951, courtesy of Harry A. Jackson Trust.

64. Hartigan, *Journals*, October 14, 1953, p. 100.

65. Fizdale lived platonically with fellow duo pianist Arthur Gold, who was conveniently involved with the poet James Schuyler, Frank's roommate. (Gooch, *City Poet*, 242) O'Hara's affair with Fizdale was brief, but it led to several artistic outcomes. O'Hara wrote several poems inspired by Fizdale and his music, including "Sneden's Landing Variations," dedicated to Fizdale. Gold and Fizdale commissioned Ned Rorem to compose *Four Dialogues for Two Voices and Two Pianos*, a 20-minute piece about the trajectory of a (heterosexual) romance, with lyrics by O'Hara, in 1954.

66. Hartigan, quoted in Gooch, *City Poet*, 243.

67. Vicki Goldberg, "Grace Hartigan Still Hates Pop," *New York Times*, August 15, 1993.

68. Hartigan, *Journals*, October 17, 1953, p. 101.

69. It isn't clear which ballet company this was; both New York City Ballet and Ballet Theatre (from 1957 onward, American Ballet Theatre) had New York seasons in the 1950s. American touring companies in 1953 included the Agnes de Mille Dance Theatre.

70. Josephine Novak, "Tracking the Marvelous Grace Hartigan," *The [Baltimore] Evening Sun*, [March?] 1983, Hartigan Papers.

71. Hartigan, *Journals*, October 12, 1953, p. 99.

72. Max Beckmann, "Letter to a Woman Painter," lecture delivered to students at Stephens College, Missouri, January 1948, translated by Mathilde Q. Beckmann and Perry Rathbone, *College Art Journal* 9, no. 1 (Autumn 1949): 39–43; reprinted in Stiles and Selz, *Theories and Documents*, 180–83. Beckmann came to the United States in 1947, three years before his death.

73. André Maurois, *Lélia: The Life of George Sand*, trans.George Hopkins (New York: Harper & Brothers, 1953). Maurois could have been writing about Grace when he said of Sand, "Tossed on a storm of passion [her estranged lover, the poet Alfred de Musset, had threatened to kill her, yet begged for a final meeting], George made it clear that she could still retain her presence of mind, and exercise her gifts for organization" (192).

74. Hartigan, *Journals*, October 15, 1953, p. 101.

75. Aurore Dupin (George Sand) letter to her daughter-in-law, Lina Calmatta Dudevant (wife of her son Maurice), March 31, 1862, in *Yale Book of Quotations*, ed. Fred R. Shapiro (New Haven: Yale University Press, 2006), 662.

76. Hartigan, *Journals*, November 2, 1953, p. 102.

77. Hartigan, *Journals*, November 4, 1953, pp. 102–103.

78. Yet Hartigan's disparagement of Machiz as a director was shared by others, even by Machiz himself. He once lamented that he wasn't cut out to direct "intellectual" plays. John Gruen, *The Party's Over Now: Reminiscences of the Fifties—New York's Artists, Writers, Musicians, and Their Friends* (Wainscott, NY: Pushcart Press, 1989), 90.

79. Judith Malina, *The Diaries of Judith Malina, 1947–1957* (New York: Grove, 1984), February 24, 1953, p. 270.

80. Hartigan oral history interview, Archives of American Art.

81. Hartigan, *Journals*, May 18, 1953, p. 82. (The third play was by James Merrill.) *The Heroes* set was by the painter Nell Blaine, a Tibor de Nagy Gallery artist. Written in 1950, the play received its first performance at the Living Theatre. Judith Malina described the play as "a poetic discussion of the foibles of the figures of the Greek myths, like an 18th century play written by a young 20th century poet whose pen has been dipped in surrealism." Malina, *Diaries*, p. 232.

82. Her first book of poetry would be published by Tibor de Nagy Gallery in 1960.

83. Hartigan, *Journals*, December 6, 1952, p. 62.

84. Hartigan, *Journals*, November 13, 1953, p. 105.

85. Hartigan, *Journals*, December 3, 1953, p. 107.

86. Rivers later said that he had been reading *War and Peace*, and viewed his painting as his answer to Tolstoy.

87. Hartigan, *Journals*, December 4, 1953, p. 109.

88. Hartigan, *Journals*, January 7, 1954, p. 116.

89. Hartigan, *Journals*, December 30, 1953, p. 113.

90. While sources consistently date this film as 1954, the film program reads "Sunday, December 27, 1953." Box 38, Hartigan Papers. Perhaps the version shown then was not in its final form. O'Hara played unidentified pieces by Debussy, Poulenc, and Scriabin; the film provides a unique opportunity to witness his skill as a pianist.

91. Hartigan, *Journals*, December 30, 1953, p. 113.

92. Hartigan, *Journals*, December 31, 1953, p. 111.

93. Gooch, *City Poet*, 242–47.

94. Hartigan, *Journals*, January 28, 1954, p. 119.

CHAPTER 10: ASSERTING

1. Simone de Beauvoir, *America Day by Day*, translated by Carol Cosman (Berkeley: University of California Press, 1999), 321–22; originally published as *L'Amerique au jour le jour* by Editions Gallimard in 1954.

2. Author's interview with Raymond Majerski, November 7, 2012.

3. Hartigan, *Journals*, January 6, 1954, p. 115.

4. Hartigan, *Journals*, January 22, 1954, p. 116.

5. Hartigan, *Journals*, January 18, 1954, p. 118.

6. Hartigan, *Journals*, January 18, 1954, p. 118.

7. Hartigan mentions a sale to the Whitney Museum (*Journals*, February 23, 1954, p. 126) but in fact, the Walker Art Center purchased it in 1955 and later sold it to Martha Jackson Gallery in exchange for another Hartigan painting. Jackson gave it back to the Walker in 1964.

8. Stuart Preston, "Abstract Roundup," *New York Times*, February 7, 1954, p. X10.

9. Frank O'Hara, "George Hartigan," *Art News* 52 (February 1954), p. 45.

10. John I. H. Baur, "Eastern Artists," *Art in America* 42 (January 1954): 18–19; The other artists discussed in the article are little known today.

11. Hartigan, *Journals*, February 4, 1954, p. 120.

12. Hartigan, *Journals*, February 19, 1954, p. 126. Barr's comment was relayed to Hartigan by John Myers.

13. Hartigan, *Journals*, April 26, 1954, p. 138.

14. James Fitzsimmons, "George Hartigan," *Arts & Architecture* 71 (March 1954): 30.

15. Though billed as kabuki—the stylized, all-male theatrical form—the Azuma Nihon Buyo Company was actually a predominately female Japanese group presenting dance.

16. Hartigan, *Journals*, March 12, 1954, p. 129.

17. Gooch, *City Poet,* 251.

18. Gooch, *City Poet,* 252.

19. O'Hara, *Collected Poems,* 214.

20. Hartigan, *Journals*, March 30, 1954, p. 131.

21. Larry Rivers letter to Hartigan, April 18, 1954, Hartigan Papers.

22. Hartigan, *Journals*, April 11, 1954, p. 134.

23. Hartigan, *Journals*, April 16, 1954, p. 137. Joan of Arc would be the subject of two of Hartigan's paintings, both titled after the heroine, in 1973 and 1996. In the earlier painting, she stands with her spear and shield, surrounded by real and imaginary animals; in the later one, she prays, grim-faced, besieged by hands and faces and armor on a field of blood red.

24. Hartigan, with no source noted, in "Grace Hartigan" (obituary), *The Telegraph* [UK], November 18, 2008.

25. Hartigan letter to Harold Rosenberg, March 25, 1954, Hartigan Papers.

26. Lloyd Goodrich and John I. H. Baur, *American Art of Our Century* (New York: Whitney Museum of American Art, 1961), 177.

27. William Wilson, "The Figurative '50s—for Sentimental Reasons," *Los Angeles Times,* July 24, 1988.

28. Hartigan letter to Greenberg, April 1, 1954, Hartigan Papers. It is not known whether she actually sent this letter.

29. Hartigan, *Journals*, April 14, 1954, p. 135.

30. Fitzsimmons, "Art," *Arts & Architecture* 70 (May 1953): 4.

31. Hartigan, quoted in Nemser, *Art Talk,* 158.

32. Hartigan, *Journals*, May 4, 1954, p. 138.

33. Hartigan, *Journals*, May 10, 1954, p. 140.

34. Hartigan, *Journals*, May 25, 1954, pp. 141–42.

35. Hartigan, *Journals*, June 4, 1954, p. 143.

36. Larry Rivers letter to Hartigan, June 9, 1954, Hartigan Papers.

37. Hartigan, *Journals*, June 4, 1954, p. 142.

38. Hartigan, *Journals*, June 4, 1954, p. 142. Lenya was married to Weill.

39. The painting sold at a Sotheby's New York auction on May 10, 2012, for $60,000, the low estimate (Lot 165).
40. The apparent connection between Grace's work of this period and Beckmann's angular style surfaced again in a review decades later: Helen L. Kohen, " 'Emotional Impact' shows real expression," *Miami Herald*, February 10, 1985, p. 6L.
41. "Nature and the New Painting," in O'Hara, *Standing Still*, 45.
42. Mattison, *Painter's World*, 36.
43. Hartigan, *Journals*, July 21, 1954, p. 147.
44. This painting is now owned by the Metropolitan Museum of Art.
45. Hartigan, *Journals*, July 28, 1954, p. 147.
46. Justin Spring, *Fairfield Porter: A Life in Art* (New Haven: Yale University Press, 2000), 171–72.
47. Fairfield Porter, *Portrait of Frank O'Hara*," 1957, reproduced in Russell Ferguson, *In Memory of My Feelings: Frank O'Hara and American Art,* Museum of Contemporary Art, Los Angeles (Berkeley: University of California Press, 1999), 84.
48. May Tabak, *But Not for Love* (New York: Horizon, 1960), 25–26.
49. Ludwig Sander oral history interview, Archives of American Art.
50. Ludwig Sander oral history interview.
51. This piece was rediscovered in 1985 and put up for auction in 1992 in New York as if it were a full-fledged de Kooning. Despite talk of a possible million-dollar sale, the highest bid was $7,500, far below the reserve price.
52. He opened his own gallery in 1957.
53. Joan Mitchell letter to Michael Goldberg, August 10, 1954, quoted in Albers, *Joan Mitchell,* 209–10.
54. Hartigan, in "Painting From Popular Culture: A Discussion with Grace Hartigan," in VanDyke, *Painting from Popular Culture.* For this interview, see http://jonathanvandyke.com/beta//files/hartiganvandykeinterview.pdf.
55. Hartigan, *Journals*, August 11, 1954, p. 148.
56. Hartigan, *Journals*, August 5, 1954, p. 147.
57. Larry Rivers letter to Hartigan, October 28, 1954, Hartigan Papers.
58. In contrast, de Kooning was then experimenting with ways of keeping oil painting from drying too quickly.
59. Hartigan, quoted in Russo, *Profiles,* 93.
60. Walt Whitman, "Song of Myself," stanza 51.
61. Richard Poirer, "The Scenes of the Self," *The New Republic*, August 2, 1993, p. 34.
62. Hartigan, *Journals*, September 29, 1954, p. 151.
63. Hartigan, *Journals,* October 10, 1954, p. 152.
64. Hartigan, *Journals,* October 10, 1954, p. 152.
65. Hartigan, *Journals,* October 20, 1954, p. 154.
66. The notion of finding your own world would become a key precept of Grace's teaching.

67. Mina Tang, "Painter Discusses Evolutionary Style," *The Vassar Chronicle*, November 20, 1954, p. 5.
68. Emily Dennis Harvey email to author, September 14, 2013.
69. Author's telephone interview with Mina Tang Kahn, October 27, 2013.
70. Linda Nochlin, "The Rules of Abstraction," *Bookforum*, April/May 2009. Mina Tang's *Vassar Chronicle* article made no mention of Hartigan's demeanor.
71. It is now owned by the Kemper Museum of Contemporary Art in Kansas City (1995 gift).
72. The *Newsweek* article apparently never ran. (The magazine did profile her in 1959.)
73. Hartigan, *Journals*, November 10, 1954, p. 157.
74. Hartigan, *Journals*, December 1, 1954, p. 159.
75. Hartigan, *Journals*, Deceber 7, 1954, p. 159.
76. Harold Rosenberg, "The American Action Painters," *Art News* 51 (December 1952): 22–23, 48–50, reprinted in Rosenberg, *The Tradition of the New* (New York: Horizon Press, 1960).
77. Harold Rosenberg letter to Hartigan, October 9, 1974, Hartigan Papers.
78. "Christmas Card to Grace Hartigan," in O'Hara, *Collected Poems*, 212.
79. Hartigan, *Journals*, October 29, 1954, pp. 156–57.
80. O'Hara, *Standing Still*, 41–51.
81. Hartigan letter to Emily Dennis, April 27, 1955, courtesy of Emily Dennis Harvey.
82. Harold Rosenberg, "Parable of American Painting," *Art News* 53 (January 1954): 60–63, reprinted in Rosenberg, *Tradition of the New*.
83. Hartigan, *Journals*, January 18, 1955, p. 165.
84. Hartigan, *Journals*, March 28, 1955, p. 171.
85. Hartigan, *Journals*, February 16, 1955, p. 167.
86. Hartigan, *Journals*, July 7, 1955, p. 186.
87. Author's telephone interview with Emily Dennis Harvey, November 22, 2013.
88. Author's interview with Emily Dennis Harvey.
89. Fellow poet James Schuyler suggested the title, "inspired by the well-thumbed copy of Mayakovsky's poems lying on O'Hara's desk." Gooch, *City Poet*, 254.
90. Hartigan letter to Emily Dennis, March 9, 1955, courtesy of Emily Dennis Harvey.
91. James Thrall Soby, "Non-Abstract Authorities," *Saturday Review*, April 23, 1955, pp. 52–53.
92. Mattison, *Painter's World*, 38.
93. Hartigan, *Journals*, March 28, 1955, p. 171.
94. Hartigan, *Journals*, April 4, 1955, p. 172.
95. Hartigan letter to Emily Dennis, April 27, 1955, courtesy of Emily Dennis Harvey.
96. Howard Devree, "About Art and Artists: Schucker, Grace Hartigan and Spruance Represented in One-Man Shows," *New York Times*, March 3, 1955.
97. Lawrence Campbell [L.C.], "Reviews and Previews: Grace Hartigan," *Art News*, March 1955, pp. 51–52.
98. Hartigan letter to Emily Dennis, March 9, 1955, courtesy of Emily Dennis Harvey.

99. Lawrence Campbell, "New figures at the uptown Whitney," *Art News*, February 1955, p. 35.

100. Hartigan letter to Emily Dennis, April 7, 1955, courtesy of Emily Dennis Harvey. The exhibition, the first to be held at the Whitney's new 54th Street location, was on view from January 12 to February 20, 1955.

101. Hartigan, quoted in Nemser, *Art Talk,* 168.

102. Hartigan, *Journals*, May 4, 1955, p. 175.

103. Larry Rivers letter to Hartigan, May 16, 1955, Hartigan Papers.

104. Jeffrey Jachens letter to Hartigan, May 13, 1955, Hartigan Papers.

105. Evelyn Jachens was born on May 25, 1922, and died in Santa Barbara, California, on February 10, 2006. (Social Security Death Index record) Robert told his fourth wife that Evelyn had been in a concentration camp during the war, but this seems improbable. According to the couple's Certificate of Registry of Marriage, November 28, 1955, she was born in New York and both her parents were Russian émigrés.

106. Hartigan oral history interview, Maryland Historical Society.

107. Hartigan, quoted in Russo, *Profiles,* 99.

108. Author's interview with John Moran, December 13, 2012.

109. According to his obituary in *The Villager*, November 21, 2012, Hazan, who died on October 27, 2012, at age ninety-six, had brought along his pet monkey on his first date with Jane; see http://www.thevillager.com/?p-8709.

110. John Ashbery email to author, January 25, 2012.

111. James Schuyler wrote to fellow poet Kenneth Koch that he thought "it would be more soothing to the nerves to drive a load of TNT through the Rockies." Corbett, *Selected Letters of James Schuyler,*18.

112. Hartigan, *Journals*, May 30, 1955, p. 177.

113. Hartigan, *Journals*, May 30, 1955, p. 177.

114. John Ashbery email to author, January 25, 2012.

115. Hartigan, *Journals*, June 15, 1955, p. 183.

116. Hartigan, *Journals*, June 23, 1955. p. 183.

117. Schuyler letter to Barbara Guest, June 28, 1955, Uncat. MSS 271, Box 16, Barbara Guest Papers, Beinecke Rare Book & Manuscript Library, Yale University. Schuyler wrote to Fairfield Porter on July 2 that after his "scandal-mongering about Grace and Walt," he felt bound to explain that the couple were "trying to work things out." Corbett, *Selected Letters of James Schuyler,* 21.

118. Hartigan, *Journals*, July 19, 1955, p. 188.

119. He was married to the Modern's curator Dorothy Miller. The other artists were Abraham Rattner, Stuart Davis, Max Weber, William Zorach, Ben Shahn, and Ibram Lassaw.

120. Hartigan initially called the painting *Display Mannequins*. It was also included in *The Figurative Fifties* exhibition.

121. Hartigan, *Journals*, July 12–13, 1955, p. 187.

CHAPTER 11: CELEBRATING

1. Before her work was chosen for the exhibition, Hartigan had deliberately avoided Miller so that the curator wouldn't think she was being "wooed." Afterward, the two women became close friends. Hartigan letter to Wendy Jeffers, undated (probably 1994), Hartigan Papers.

2. Hartigan, in *12 Americans*, ed. Dorothy Miller (New York: Museum of Modern Art, 1956), 53. Miller later said that she had been "very enthusiastic" about Hartigan but didn't like the work she was doing recently. Fortunately, she was delighted that Hartigan "responded to the invitation with two or three magnificent new canvases." Lynn Zelevansky, "Dorothy Miller's 'Americans,' 1942–63," in *The Museum of Modern Art at Mid-Century: At Home and Abroad*, ed. John Elderfield (New York: Museum of Modern Art, 1997), 75.

3. Willem de Kooning, "What Abstract Art Means to Me" *Bulletin of the Museum of Modern Art* 18, no. 3 (Spring 1951): 7.

4. Miller, *12 Americans*, 53.

5. *Mademoiselle*, June 1956.

6. Aline B. Saarinen, "Is Abstract Art Dead?" *Mademoiselle*, February 1956, pp. 154–55.

7. Leo Steinberg, "'Twelve Americans': Part II," *Arts*, July 1956, p. 27. Steinberg was one of the heavyweights of art criticism in the fifties and early sixties; in later years he wrote scholarly articles and books on art historical topics. He was later married to and divorced from Dorothy Seiberling, the editor and writer at *Life* magazine's art department who made possible the article "Women Artists in Ascendance." In a famous article, "Contemporary Art and the Plight of Its Public," *Harper's*, March 1962, he wrote, "Contemporary art is constantly inviting us to applaud the destruction of values which we still cherish [for reasons that are] rarely made clear."

8. Hartigan, quoted in Cathy Curtis, "Insights to Figurative '50s: Artists at Newport Museum Relive Spirited New York Era," *Los Angeles Times*, July 20, 1988.

9. Hartigan letter to Terence Diggory, December 12, 1994, courtesy of Terence Diggory.

10. Rose Slivka, "Essay," in Elaine de Kooning, *The Spirit of Abstract Expressionism: Selected Writings* (New York: Braziller, 1994), 16.

11. Author's interview with Donna Sesee, June 11, 2011.

12. Author's telephone interview with Audrey Flack, December 3, 2013.

13. Author's interview with Arthur Hartigan, August 13, 2011.

14. Author's interview with John Moran, December 13, 2012. In another version of this story, Cornell had sent Hartigan a fragment of a handwritten letter in Greek, with the inscription, "Beware the gifts bearing Greeks"—a variation on the famous warning about "Greeks bearing gifts" in Virgil's *Aeneid*. In return, Hartigan mailed Cornell a collage she later described as "filled with hearts and puns on Heart-again." The various items he sent in response included the heart with nails, which he called a valentine. But he rebuffed her attempt at a meeting; by the time he had changed his mind and tried to call her, she had left New York. Dore Ashton, *A Joseph Cornell Album* (New York: Da Capo, 2009), 82–83, 85. (Because "Greek

love" is a euphemism for gay coupling, John Myers apparently interpreted the letter as disapproval of Hartigan's association with the gay-friendly de Nagy gallery.)

15. Hartigan oral history interview, Archives of American Art.

16. James Thrall Soby, "Interview with Grace Hartigan," *Saturday Review*, October 5, 1957, p. 26. Hartigan was so attached to this explanation that she repeated it years later to Cindy Nemser, *Art Talk*, 170.

17. Hartigan oral history interview, Archives of American Art.

18. Sally Ann Bixler, "We hitch our wagons," *Mademoiselle*, August 1959, p. 243.

19. Hartigan, *Journals*, July 1, 1985, p. 185.

20. *Grace Hartigan and Irving Sandler* (video).

21. Grace Hartigan interview by Bob Lesser, April 20, 1965.

22. Hartigan interview by Bob Lesser.

23. Hartigan interview by Bob Lesser.

24. Charles L. Baldwin letter to Hartigan, April 18, 1972, Hartigan Papers. I have not been able to locate this painting.

25. Handwritten "Plans," a draft for a Guggenheim Grant application, Hartigan Papers. After "not naturalistic," Hartigan crossed out the words "but man-made," which may have struck her as too imprecise.

26. [Dorothy Sieberling], "Women Artists in Ascendance: Young Group Reflects Lively Virtues of U.S. Painting," *Life*, May 13, 1957, p. 75.

27. Barber, "Making Some Marks," 50.

28. Mr. Jones was actually the painter Jasper Johns. Springbok Editions letter to Hartigan, November 19, 1969, Hartigan Papers. Grace agreed to allow two inches to be cropped off one side of the painting to accommodate the puzzle's square format. *Billboard* is in the collection of the Minneapolis Institute of Art.

29. Jan Müller, who had a heart condition, was just thirty-six when he died the following year.

30. The exhibition was shown at the Jewish Museum from March 10 to April 28, 1957, to mark its tenth anniversary. In the conclusion of his introduction to the catalogue, Steinberg offered a rather tortured explanation of why the museum was exhibiting art that was not necessarily made by Jews or concerned with Jewish themes. Leo Steinberg, *The New York School, Second Generation: Paintings by Twenty-three Artists* (New York: Jewish Museum, 1957).

31. For some reason—perhaps because of the novelty of a modern art show at a museum that normally exhibited religious objects—critics paid little attention. In *Art News*, Thomas Hess gave the exhibition a positive review, though without mentioning Grace. Thomas Hess, "Younger artists and the unforgiveable crime," in *Art News*, April 1957, 46–49, 64–65. The title derives from sculptor Philip Pavia's quote, "The one unforgiveable crime is not knowing what's going on."

32. Hartigan interview with Paul Schimmel, February 1984, in Paul Schimmel, B. H. Friedman, John Myers, and Robert Rosenblum, *Action/Precision: The New Direction in New York, 1955–60* (Newport Beach, CA: Newport Harbor Art Museum, 1984), 25.

33. Stuart Preston, "Diverse Exhibitions," *New York Times*, March 10, 1957.

34. V.Y., "Grace Hartigan," *Arts*, March 1957.

35. Helen Frankenthaler letter to Barbara Guest, sent May 18, 1957, Uncat. MSS 271, Box 16, Barbara Guest Papers, Beinecke Rare Book & Manuscript Library, Yale University. Frankenthaler and Hartigan resumed their friendship in 1957, about a year after Frankenthaler's romance with Greenberg had ended.

36. Frank O'Hara letter to Barney Rosset, April 18, 1956, Hartigan Papers. The book was published in September 1956.

37. Thomas Hess, "U.S. Painting: Some Recent Directions," *Art News Annual* 25 (1956): 75–192. Hartigan, *Journals*, July 1, 1985, p. 185.

38. Hartigan, *Journals*, July 1, 1955, p. 185.

39. Hartigan wrote in a draft of the fellowship application that her project was "to continue painting without interruption." Responding to a question about the duration of her project, she wrote, "I intend to devote the rest of my life to painting." But she had to leave blank the sections asking for information about colleges attended, scholarships received, foreign language ability, "learned, scientific or artistic societies of which you are a member" and "positions held." Draft of Guggenheim Fellowship Application Form, Hartigan Papers.

40. Also on the committee were Porter McCray, James Thrall Soby, Dorothy Miller, and Sam Hunter. The other artists were Pollock, Guston, Kline, Rivers, David Hare, James Brooks, sculptors Ibram Lassaw and Seymour Lipton. Gooch, *City Poet*, 294.

41. He became a naturalized citizen in 1939.

42. Alfonso Ossorio letter to Jackson Pollock, January 21, 1951, Jackson Pollock and Lee Krasner Papers, Archives of American Art, Smithsonian Institution.

43. Ossorio was safeguarding the collection of the Compagnie de l'Art Brut, an association founded in 1948 by Dubuffet. In 1962, Ossorio returned the collection to Dubuffet, who bought a building in Paris to display the works. In the 1970s, the collection was moved to the Chateau de Beaulieu in Lausanne, Switzerland.

44. B. H. Friedman, *Alfonso Ossorio* (New York: Abrams, 1972), 65.

45. Helen Frankenthaler letter to Hartigan, June 4, 1957, Hartigan Papers.

46. Helen Frankenthaler letter to Hartigan, June 4, 1957, Hartigan Papers.

47. Frank O'Hara letter to Hartigan, June 3, 1957, Hartigan Papers.

48. Emily Dennis Harvey email to author, September 14, 2013.

49. George Spaventa, "The Artist inherites [*sic*] all," undated manuscript, Hartigan Papers.

50. Mercedes Matter letter to Hartigan, March 4, 1956, Hartigan Papers.

51. Hartigan oral history interview, Archives of American Art.

52. Soby, "Interview with Grace Hartigan," 26–27.

53. Purchased by James Thrall Soby, who donated it to the Modern in 1960.

54. Soby, "Interview with Grace Hartigan," 26.

55. Soby, "Interview with Grace Hartigan," 26.

56. Hartigan letter to Beverly Rood, March 8, 1979, in Ronald G. Pisano, *Long Island Landscape Painting, Vol. II: The Twentieth Century* (Boston: Bulfinch, 1990), 76.

57. Elderfield, *de Kooning*, 317.

58. Schimmel et al., *Action Precision*, 33.

59. James E. S. Breslin, *Mark Rothko: A Biography* (Chicago: University of Chicago Press, 1993), 375–76.

60. Hartigan oral history interview, Archives of American Art. Rothko viewed even his brightly hued paintings as conveying a tragic conception of the world in which, as the English critic David Sylvester wrote, "violence and serenity are reconciled and fused." Sylvester, quoted in Siegel, *Abstract Expressionism*, 110.

61. Author's interview with Michel Modele, October 3, 2012.

62. Vicente (1903–2001), known for his coloristic virtuosity, was born in Turégano, Spain, and lived in Paris before moving to New York in 1936. He shared a studio with de Kooning on 10th Street for a brief period in the fifties. Although he didn't move permanently to Bridgehampton until the mid-sixties, he spent summers there. Marca-Relli (1913–2000), who moved to East Hampton in 1953, was one of the founders of the Club. He is best known for his massively scaled paintings incorporating collaged elements.

63. Hartigan also claimed to have slept with de Kooning, but just once. Author's interview with John Moran.

64. Mary Cummings, draft of Robert Gilmore Keene obituary, published in *The Southampton Press*, February 5, 1998. (Courtesy of Mary Cummings) A news story after Keene's death noted that he was supposed to have begun work on an oral history of the town that would include adding recorded commentary to old 8-millimeter films. No one else was judged to have his breadth of knowledge of "all the important people." Roger Podd, "Oral History/Keene's Death Could Derail Project," *The Southampton Press*, February 26, 1998.

65. Founders of the Signa Gallery included painters John Little, Alfonso Ossorio, and Elizabeth Parker. Franz Kline and Lee Krasner were among the artists shown in the gallery's first exhibition.

66. Maureen McHugh Huber, "Today's Art Boom Has Its Roots in a Bookshop," *Southampton Press*, September 1989.

67. Ed Smith, "Nude Boy Painting Whips Up Village Furor; It's Removed," *Newsday* clipping, undated (1956), Southampton Historical Museum Archives. The article reported the painting's price as $1,500, which Keene said "proves the worth of the artist." This may have been a canny move on Keene's part, because Rivers's paintings normally sold for just a few hundred dollars at the shop.

68. Dean Mosiman, "He Does It His Way," *The Southampton Press*, 350th anniversary issue, June 1990. Keene said he left with $25 in his pocket and wandered from Boston to New York to Washington, D.C., to Los Angeles (where he unsuccessfully sought a film career) to Brooklyn to the Far East (on a Merchant Marine oil tanker) and then to Palm Beach.

69. He attained the rank of lieutenant, having served in North Africa before the Allied invasion, and subsequently attended officers' school. Cummings, Robert G. Keene obituary.

70. Sidney C. Schaer, "The Bookseller From Down East," *Newsday*, September 2, 1980.

71. Robin Finn, "A Rare and Eccentric Character in an Old-Fashioned Book Store," *Southampton Press*, May 29, 1980.

72. Schaer, "Bookseller From Down East."

73. Dean Mosiman and Ron Ziel, "Keene May Close Bookstore," undated clipping, possibly from *Southampton Press*, Southampton Historical Museum Archives.

74. Mosiman, "He Does It His Way."

75. Finn, "Rare and Eccentric Character."

76. Schaer, "Bookseller From Down East."

77. Mosiman, "He Does It His Way." Keene, whose response was also the subject of a *Newsday* editorial, claimed to have been quoted out of context when he was simply worried about commercializing the beach.

78. James Thrall Soby letter to Hartigan, August 4, 1957, Hartigan Papers.

79. Grace Hartigan letter to James Thrall Soby, September 26, 1957, I: 121, "Hartigan, Grace," James Thrall Soby Papers, Museum of Modern Art Archives. The magazine published this photo instead of the planned image of Hartigan's painting *Montauk Highway*, deemed insufficiently sharp to reproduce properly. Soby letter to Hartigan, September 20, 1957, Hartigan Papers.

80. Helen Frankenthaler letter to Hartigan, August 7, 1957, Hartigan Papers.

81. Rivers, *What Did I Do?*, 301.

82. The poet James Schuyler heard that he was in the Five Spot rather than the Cedar. Schuyler letter to John Ashbery, August 16, 1957, quoted in Corbett, *Selected Letters of James Schuyler*, 81.

83. Rivers, *What Did I Do?*, 301.

84. Gossip had it that the cab fare was $100. James Schuyler letter to John Ashbery, Corbett, *Selected Letters of James Schuyler*, 81.

85. LeSueur, *Digression on Some Poems*, 105.

86. Gooch, *City Poet*, 297.

87. Frank O'Hara, "Good Night, Low," typescript in Hartigan Papers (in Hartigan's handwriting, "by Frank O'Hara").

88. LeSueur, *Digression on Some Poems*, 104–105.

89. Grace Hartigan letter to Buffalo Fine Arts Gallery, July 12, 1968, quoted in *Contemporary Art 1942–72: Collection of the Albright Knox Art Gallery* (New York: Praeger, 1973), 62.

90. Nemser, *Art Talk*, 161.

91. Hartigan interview by Bob Lesser, Archives of American Art.

92. Photo by Magnum photographer Bert Glinn.

93. Hartigan interview by Bob Lesser.

CHAPTER 12: SWERVING

1. Margaret Scolari Barr oral history interview concerning Alfred H. Barr, February 22–May 13, 1974, Archives of American Art, Smithsonian Institution.

2. *The New American Painting as Shown in Eight European Countries 1958–1959* (New York: Museum of Modern Art, 1959), 44.

3. André Chastel, *Le Monde*, January 17, 1959, in *The New American Painting*, 12.

4. George F. Kennan, "International Exchange in the Arts," address at a symposium sponsored by the International Council of the Museum of Modern Art, May 12, 1955; http://www.americansforthearts.org/sites/default/files/pdf/2013/by_program/legislation_and_policy/issues/kennan_internationalexchange.pdf.

5. The involvement of the Modern with the CIA occurred through contracts with the CIA-run Congress for Cultural Freedom, and through the election of museum board members with close CIA ties, including William Paley, a founder of the CIA, and Tom Braden, who had been head of the CIA's International Organizations Division. Five months after *Ramparts* magazine had exposed the CIA's funding of the National Student Association—which led to newspaper accounts of other covert CIA funding—Braden published an article in the *Saturday Evening Post* ("I'm Glad the CIA Is 'Immoral,'" May 20, 1967, pp. 10–14), in which he praised the cultural good works the CIA–Congress connection had made possible.

6. See chapter seven, this volume.

7. "Mlle Merit Awards," *Mademoiselle*, January 1958, pp. 66–69.

8. Rudikoff's nuanced yet celebratory essay on Frankenthaler's paintings would appear the following year in Friedman, *School of New York*. The friendship between artist and writer was not acknowledged in the essay, typical—as we have seen—for a time when the art world was so small that conflict of interest was not called into question. (See also chapter nine, note 34.)

9. "The 'Rawness,' the Vast," *Newsweek*, 113.

10. Untitled photo of *Broadway Restaurant* with caption, *Time,* June 16, 1958. The painting is in the collection of the Nelson-Atkins Gallery of Art.

11. "Human Image in Abstraction," *Time,* August 11, 1958, p. 48.

12. "Is Today's Artist With or Against the Past?" *Art News*, June 1958, pp. 26–27, 44–46, 56–58.

13. Sandler, *Sweeper-Up,* 221.

14. Mattison, *Painter's World*, 53.

15. Barber, "Making Some Marks," 51.

16. Mattison, *Painter's World,* 46.

17. Notebook, Box 38, Hartigan Papers.

18. May Tabak letter to Hartigan, undated (probably 1963), Hartigan Papers.

19. Notebook, Box 38, Hartigan Papers.

20. Joan Mitchell letter to Hartigan, undated, Hartigan Papers.

21. Porter McCray oral history interview, September 17–October 4, 1977, Archives of American Art, Smithsonian Institution. McCray did, however, work behind to scenes to promote O'Hara to assistant curator in the International Program in 1960. Gooch, *City Poet,* 355.

22. Gooch, *City Poet,* 314.

23. O'Hara quote from poet Bill Berkson's talk at The New School, New York, January 31, 2011, accompanying the exhibition The New School Presents 60 Years of Tibor de Nagy Painters and Poets: A Celebration of the Legendary Gallery. Courtesy of Bill Berkson; fuller anecdote in Gooch, *City Poet,* 314.

24. Another poem from this trip, "Far from the Porte des Lilas and the Rue Pergolèse" invoked Joan Mitchell.

25. John O'Hara letter to Barbara Guest, September 14, 1958, Uncat. MSS 271, Box 16, Barbara Guest Papers.

26. James Schuyler [J.S.], "Reviews: Grace Hartigan," *Art News* 58, no. 4 (May 1959): 13.

27. Grace Hartigan letter to Terence Diggory, July 22, 1993, courtesy of Terence Diggory.

28. The nearly six-foot-tall painting last surfaced at a Sotheby's auction on November 2, 1978, where it sold for a pitiful $3,500 (the equivalent of about $12,000 in 2012). Lot 223, Sotheby's New York.

29. Bixler, "We Hitch Our Wagons," 243.

30. The painting is now in collection of National Gallery, Washington, D.C. Before he married Hartigan, Winston Price bought it from the Gres Gallery in 1959; the collector Robert Meyerhoff purchased it from him for $4,000 in 1962 and donated it to the museum in 1997.

31. Mattison, *Painter's World,* 46. Inge, who committed suicide in 1973, was another of Hartigan's gay friends, though he remained closeted throughout his life.

32. Author's interview with Donna Sesee, June 11, 2011. The date of this encounter is unknown.

33. Author's telephone interview with John Moran, December 12, 2012. He recalled Hartigan saying that she hustled Robertson into bed at a hotel that night.

34. Fairfield Porter letter to Barbara Guest, "Christmas afternoon," postmarked December 26, 1958, Uncat. MSS 271, Box 16, Barbara Guest Papers.

35. Meyer and Eli Levin, "Top Woman Artist Uses Rich Colors to Speak Her Mind," *EveryWeek Magazine,* [*Newark, NJ*] *Star-Ledger,* May 17, 1959.

36. "The Vocal Girls," *Time,* May 2, 1960, p. 74.

37. "Abstract Coincidence," Letters, *Time,* May 30, 1960. The correct title of Matisse's 1937 painting, in the collection of the Baltimore Museum of Art, is *Purple Robe and Anemones.*

38. Schuyler, "Reviews: Grace Hartigan," 13. The exhibition New Work by Grace Hartigan was on view from April 28 to May 30, 1959, and contained the paintings *Essex and Hester (Red); Essex and Hester (Spanish), Dun Laoghaire, Guinness, Ireland, Sweden* (which sold for $3,000), *Dublin* ($5,000), *Bray,* and ten collage drawings.

39. Sidney Tillim [S.T.], "Grace Hartigan," "Helen Frankenthaler," *Arts,* May 1959, p. 56.

40. Martin D. Schwartz, "Hartigan at the Tibor de Nagy Gallery," *Apollo* 70 (September 1959): 62–63.

41. Joe LeSueur letter to Hartigan, ca. April 30, 1959, Hartigan Papers.

42. Frank O'Hara letter to Hartigan, May 27, 1959, Hartigan Papers.

43. Ronald Pease letter to Hartigan, May 28, 1959, Hartigan Papers.

44. Under the auspices of the Modern's International Program, Frank O'Hara and Porter McCray selected the 144 American works included in Documenta II, including all the New American Painting artists.

45. Hartigan oral history interview, Archives of American Art.

46. Grace Hartigan letter to Leonard Bocour, June 19, 1959, Hartigan Papers.

47. Leonard Bocour letter to Hartigan, July 28, 1959, Hartigan Papers.

48. Emily Dennis Harvey email to author, September 14, 2013.

49. Maureen McHugh Huber, "Today's Art Boom Has Its Roots in a Bookshop," *Southampton Press*, September 1989, Southampton Historical Museum Archives. *Pink Lady* fetched a record $3.6 million, including a 10 percent buyer's premium— then a record for a living artist—at a Sotheby's auction in May 1987. Keene's last group show included work by Hartigan, as well as paintings by the Canadian artist Jean Paul Riopelle, Joan Mitchell's longtime lover, and sculptures by Rivers, who once painted Keene with three heads.

50. In Mattison, *Painter's World*, 50, this painting from 1959 is reproduced with the caption, "oil on canvas, 69 x 92 inches. Unlocated." Confusingly, a 1957 painting by Hartigan, *Fourth of July*—which looks identical to the 1959 painting except for somewhat different color values, possibly due to photo quality—sold at auction at Christie's on November 19, 1997 (Lot 00255) for $27,600, below its estimate of $35,000 to $45,000. In the photograph of the painting on Artnet, the date looks like "1959." It is possible that someone at the auction house misread the date, since Grace's 9s had very small upper loops. Granted, the 1957 painting is said to be much larger: 91 x168.3 inches. But since the whereabouts of this painting were unknown in the late eighties, when Mattison was writing his monograph, it is possible that these two paintings are actually one and the same, and that Grace had forgotten or misstated the dimensions. See http://www.artnet.com/artists/grace-hartigan/fourth-of-july-ENyqCdAerIwS8VCrZXLNYA2.

51. Soby, "Interview with Grace Hartigan," 26–27.

52. Joy Gould Boyum later became a faculty member in the English department of New York University and wrote *Double Exposure: Fiction into Film* (New York: Plume, 1985).

53. Frank O'Hara postcard to Hartigan, June 4, 1959, Hartigan Papers.

54. Frank O'Hara letter to Hartigan, August 20, 1959, Hartigan Papers.

55. Author's interview with Ed Kerns, June 4, 2013, and Kerns's email to author, August 5, 2013.

56. Waldo Rasmussen, quoted in Gooch, *City Poet*, 356.

57. Frank O'Hara letter to Barbara Guest, August 17, 1959, Uncat. MSS 271, Box 16, Barbara Guest Papers.

58. Frank O'Hara, *Collected Poems*, 333.

59. John T. Spike, *Fairfield Porter: An American Classic* (New York: Abrams, 1992), 176.

60. Spike, *Fairfield Porter,* 102.

61. Grace Hartigan, "copy of Aug 1 business paragraphs to Tibor," n.d., Hartigan Papers.

62. Tibor de Nagy letter to Hartigan, August 5, 1959, Hartigan Papers.

63. Tibor de Nagy letter to Hartigan, n.d., Hartigan Papers.

64. Rubenfeld, *Clement Greenberg,* 198.

65. Grace Hartigan letter to Barbara Guest, October 7, 1959, Box 14, Barbara Guest Papers.

66. Barbara Guest to Hartigan, October 9, 1959, Hartigan Papers.

67. Notes from Terence Diggory visit to Barbara Guest at her Berkeley, California, home, December 27, 1998, courtesy of Terence Diggory.

68. Barbara Guest letter to Fairfield Porter, October 27, 1958, Box 1, Folder 47, Fairfield Porter Papers.

69. Allen, *Collected Poems of Frank O'Hara,* 227–28.

70. Notes from Hartigan phone call to Terence Diggory, December 2, 1998, courtesy of Terence Diggory.

71. Terence Diggory email to author, February 6, 2013.

72. This playful title alludes to a book of poetry by Guest, *The Countess from Minneapolis.* Douglas Messerli, "The Countess of Berkeley," memorial essay, March 2006; http://jacketmagazine.com/29/messerli-guest.html.

73. Hadley Haden, ed., *The Collected Poems of Barbara Guest* (Middletown, CT: Wesleyan University Press, 2008), 27.

74. Sara Lundquist, "Another Poet Among Painters: Barbara Guest with Grace Hartigan and Mary Abbott," in *The Scene of My Selves: New Work on New York School Poets,* ed. Terence Diggory and Stephen Paul Miller (Orono, ME: National Poetry Foundation, 2001), 253–54.

75. Grace Hartigan letter to Barbara Guest, January 9, 1961, Box 14, Barbara Guest Papers. Hartigan spoke to students at Chatham College in Pittsburgh in December 1960. Citation from Daniel Belasco, *Between the Waves: Feminist Positions in American Art, 1949–1962,* Ph.D. dissertation, New York University, 2008, p. 93. I was unable to find the letter in the (uncatalogued) Barbara Guest Papers.

76. Hartigan letter to Barbara Guest, November 17, 1959, Box 14, Barbara Guest Papers.

77. Barbara Guest to Hartigan, December 2, 1959, Hartigan Papers.

78. Lawrence Campbell [L.C.], "Grace Hartigan, Larry Rivers, Frank O'Hara," *Art News* 58 (December 1959): 18.

79. Hartigan lecture, Skowhegan School of Painting and Sculpture. The painting was later donated to the collection of the National Museum of Women in the Arts, a museum Hartigan despised (see chapter fourteen).

80. Reported in Barbara Guest letter to Hartigan, December 9, 1959, Hartigan Papers. Guest was then living in Washington, D.C., not far from the Gres Gallery, whose co-owner she knew.

81. Author's interview with Arthur Hartigan, August 13, 2011.

82. Emily Dennis Harvey email to author, September 14, 2013.

83. A postcard from Helen Frankenthaler to "Miss Grace Hartigan c/o Clyde," post-marked February 26, 1958, documents this trip. Hartigan Papers. *Frederiksted* is in the collection of the Rose Art Gallery, Brandeis University.

84. Tibor de Nagy letter to Hartigan, February 24, 1960, Hartigan Papers.

85. Tibor de Nagy oral history interview, March 29, 1976, Archives of American Art, Smithsonian Institution. Speaking of sales, Nagy said, "Grace Hartigan grew rap-idly. As a matter of fact, Hartigan reached a point where she overdid the financial figure" in comparison to Larry Rivers, whose sales were supporting the gallery.

86. John Myers letter to Barbara Guest, January 28, 1960, Uncat. 271, Box 16, Barbara Guest Papers.

87. "Artist's Comments," *Gallery News*, Brooklyn College Art Department, April 19, 1990, unpaginated.

88 Hartigan, "de Nagy Memorial," April 15, 1994, Hartigan Papers.

89 O'Hara had written to Hartigan (December 20, 1957) about Myers's habit of in-forming an artist that another artist hated him or her, jokingly suggesting that someone give him "manual labor to do in the daytime." Correspondence courtesy of Marjorie Perloff.

90. Hart Perry, Beati's son, said that his mother made a "Peggy Guggenheim deal"—the reference is to Guggenheim's gallery's relationship with Jackson Pollock—to buy all of Hartigan's work "for a year or two." Author's interview with Hart Perry, April 23, 2012.

91. Beatrice Perry letter to Hartigan, September 10, 1959, Hartigan Papers.

92. Beatrice Perry letter to Hartigan, September 23, 1959, Hartigan Papers.

93. Beatrice Perry letter to Hartigan, March 23, 1960, Hartigan Papers.

94. The exhibition was on view from January 18 to February 13, 1960.

95. Rosemary Donihi, "As Value Soars Hartigan Won't Barter Art Again," *Washington Post*, January 29, 1960, p. C5.

96. According to Mattison, *Painter's World*, 53, Price bought *August Harvest* "in early 1959," telephoned her "afterward," and met her six months later. However, a Febru-ary 12, 1960, letter from Hartigan's Washington, D.C., dealer Beatrice Perry to Hartigan (Hartigan Papers) indicates that the painting sale was recent, and that Price was still looking forward to meeting her. Mattison was relying on Hartigan's memory of these events, which was often faulty when it came to dates.

97. The June 23, 1953, letter from the president of the Armed Forces Epidemiological Board approving this study also noted that cutbacks in funding meant that Price likely would not be able to receive the $45,000 he asked for; however, it was no small thing that his stature in the profession was honored in this way. Johns Hopkins University Archives.

98. "Medicine: Cold War Breakthrough," *Time*, September 30, 1957. "Something for Sniffles," *Life*, September 30, 1957. *The New York Times* published six stories about Price's development of the vaccine in a three-day span (September 19–22) and ran a feature article about him (Donald G. Cooley, "Visit to a Common Cold Laboratory,"

November 3, 1957). Price isolated the JH virus in 1954. After further study, he reported his findings in the February 1956 issue of *Proceedings of the National Academy of Science (PNAS)*. He developed the vaccine later that year and began testing it on volunteers. *Baltimore Sun* reporter Weldon Wallace broke the news on September 18, 1957, several days before the publication of Price's more cautiously worded paper in the *PNAS*.

99. Winston Price, quoted in Cooley, "Visit to a Common Cold Laboratory."

100. Information about Price's pursuit of Grace from the recollections of Perry and Hartigan, as recorded by Terrence Diggory on a visit to the women on August 31, 1998, and from author's conversation with Hart Perry, April 24, 2012.

101. Beatrice Perry to Hartigan, February 12, 1960, Hartigan Papers.

102. Family information from the 1925 New York State Census. Price's mother Florence was born in Canada and had emigrated to the United States. His brother Ira was six years older. The family, which employed a servant, lived in an apartment at 1565 Grand Concourse in the Bronx, a neighborhood of upwardly mobile Jewish and Italian families. Price may have developed his love of baseball at the original Yankee Stadium, at East 161st Street—just a mile-and-a-half down the road.

103. Real estate developer and art collector Robert Meyerhoff, who nonetheless counted Price as a good friend.

104. Hans Zinsser, *As I Remember Him: The Biography of R.S.* (Gloucester, MA: Peter Smith, 1970). Zinsser was born in 1878 and died of acute leukemia in 1940.

105. Winston Price, quoted in Cooley, "Visit to a Common Cold Laboratory."

106. *Arrowsmith* was published in 1925. Lewis collaborated with a science writer, Paul de Kruif, author of the classic *Microbe Hunters* and a former employee of the Rockefeller Institute, where Price worked early in his career. In de Kruif's autobiography, *The Sweeping Wind* (New York: Harcourt, Brace & World, 1962), he recounts his firing from the institute (after publishing articles about the shoddy practices of medical science), his divorce after meeting the woman who would be the model for *Arrowsmith*'s Leora ("'Why do you love me?' I'd asked Rhea. 'Because you don't give a damn,' she had answered."), and his collaboration with Lewis.

107. "The Isolation of a New Respiratory Virus Associated with Clinical Disease in Humans," *Proceedings of the National Academy of Science* 42, no. 12 (1956): 892–96.

108. As Rebecca Skloot explains in *The Immortal Life of Henrietta Lacks* (New York: Crown, 2010), medical tests on patients in public wards continued into the 1950s. Johns Hopkins Hospital's public wards drew on the large pool of poor African Americans who came to Baltimore to work in the Baltimore Steel plant. In Henrietta Lacks's case, "giving permission" amounted to signing a brief statement agreeing to any procedure deemed necessary. None of the media reports about Price's work mentioned that the children in his study were likely the chronically ill residents of a children's hospital. The race of the children was not specified.

109. "Vaccine for the Prevention in Humans of Cold-like Symptoms Associated with the JH Virus," *Proceedings of the National Academy of Science* 43, no. 9 (1957): 115–21.

110. Quoted in Paul A. Offit, *Vaccinated: Triumph, Controversy and an Uncertain Future* (New York: HarperCollins, 2009), 66.

111. Hillman (1919–2005), quoted in Offit, *Vaccinated*, 68. There are two relatively minor discrepancies between the trial as described by Price and by Offit, but neither would have affected its outcome. Offit describes Price's procedure as "isolat[ing] a virus from the nose of *a* student nurse," [italics mine] although Price wrote in his paper that an unspecified number of nurses were involved. Offit's account also has Price injecting the killed virus "into the arms of a hundred boys in a local training school," while Price does not specify the gender of the children or the type of institution.

112. Offit, *Vaccinated*, 68.

113. For example, J. C. Holper, L. F. Miller, Y. Crawford, J. C. Sylvester, and S. Marquis Jr., "Further Studies on Multiplication, Seriology and Antigenicity of 2060 and JH Viruses," *Journal of Infectious Diseases* 107, no. 3 (November-December 1960): 395–401. Also, Joshua L. Kennedy, Ronald B. Turner, Thomas Braciale, and Peter W. Heymann, "Pathogenesis of Rhinovirus Infection," *Current Opinion in Virology* 2, no. 2 (June 2012): 287–93; at http://www.sciencedirect.com/science/article/pii/S1879625712000636.

114. Johns Hopkins University press release, July 18, 1955.

115. Cooley, "Visit to a Common Cold Laboratory."

116. The precise date of their meeting is unknown, but it probably took place in April. A long March 23 letter from Perry to Hartigan contains no mention of Price's visit, which Hartigan surely would have mentioned to her, as either having occurred or about to happen.

117. Decades later, he told an interviewer that Hartigan had phoned him from Manhattan to announce that she wouldn't be returning, and he never saw or spoke to her again. Dean Mosiman, "He Does It His Way," *Southampton Press*, June 1990. Southampton Historical Museum Archives.

118. Phyllis [Mrs. Roderick H.] Foster letter to Hartigan, April 21, 1960. Hartigan Papers.

119. Mosiman, "He Does It His Way."

120. Author's telephone interview with Mary Cummings, April 11, 2012.

121. Author's interview with Arthur Hartigan.

122. In that capacity, Keene was quoted by the *New York Times* as a firm believer in the historical importance of de Kooning's painted toilet seat. Lindsey Gruson, "Is It Art or Just a Toilet Seat? Bidders to Decide on a de Kooning," *New York Times*, January 15, 1992.

123. Gruson, "Is It Art." Hartigan received a letter from the Diocese of Connecticut on January 24, 1969, stating that "under Canon law, no marriage such as this Church recognizes exists between him and you."

124. Hartigan, quoted in Prioleau, *Seductresses,*160. Meatloaf figures in another Hartigan divorce story: toward the end of her life, she told a friend that she left a cooked meatloaf in the oven for Harry Jackson when she moved out.

125. Mary Cummings, Robert Keene obituary, *Southampton Press*, February 5, 1998. After relocating a second time, the bookstore had closed in 1982. After Keene's death, a huge book sale was held at Ludlow Grange. Denise Lassaw email to author, August 22, 2011.

126. *Imagine! Painters and Poets of the New York School* (Syracuse: Syracuse University Library, 2006), 30.

127. Hartigan lecture, Skidmore College.

128. Robert Blackburn oral history interview, December 4, 1970, Archives of American Art, Smithsonian Institution.

129. Hartigan letter to Brenda Richardson, April 10, 1991, courtesy of Brenda Richardson.

130. *The Hero Leaves His Ship I (Hero)* and *The Hero Leaves His Ship II (Hero)*. The other two lithographs—*The Hero Leaves His Ship III (Ship)* and *The Hero Leaves His Ship IV (Ship)*—are less abstract, clearly showing the shape of a ship.

131. Haden, *Collected Poems of Barbara Guest,* 10.

132. Mary Clyde letter to Barbara Guest, November 19, 1959, Uncat. MSS 271, Box 16, Barbara Guest Papers.

133. Hartigan letter to Emily Dennis, August 13, 1959, courtesy of Emily Dennis Harvey.

134. Barbara Guest letter to Hartigan, March 28, 1960, Hartigan Papers.

135. "Freud's Analysis of Abram Kardiner," in Beate Lohser and Peter M. Newton, *Unorthodox Freud: The View from the Couch* (New York: Guilford, 1996), 32. Kardiner published *My Analysis with Freud* (New York: Norton) in 1977. Kardiner had also been novelist Mary McCarthy's therapist, in the early 1940s.

136. Gooch, *City Poet,* 360.

137. Author's telephone interview with John Moran, December 13, 2012.

138. Hartigan letter to Terence Diggory, July 21, 1992, courtesy of Terence Diggory.

139. Frank O'Hara letter to Hartigan, March 23, 1960, Hartigan Papers.

140. Gooch, *City Poet,* 360.

141. O'Hara's review of her 1963 show in the magazine *Kultur* said that her work had "repetitiousness of feeling" and "vulgarity of spirit." Yet after his death, Grace's insights into his poetry, in particular, "Second Avenue," prompted English professor Marjorie Perloff—who was writing *Frank O'Hara: Poet Among Painters*—to thank her for being "the most informative, perceptive" of all the people she had interviewed.

142. "Tibor de Nagy 50th anniversary" document, undated, Hartigan Papers.

143. Irving Sandler, quoted in Amy Newman, *Challenging Art: Artforum 1962–1975* (New York: Soho Press, 2003), 22. He was actually making the point that the art world of the late fifties was still relatively small. Clement Greenberg had said that there weren't more than fifty people (including critics, museum people, and dealers)

in the avant-garde art world of 1950; Sandler's count put that total at about one hundred.

144. Dore Ashton, *The New York School: A Cultural Reckoning* (New York: Viking, 1973), 229. She wrote that there were about thirty "respectable galleries" in New York in 1951; by 1960, their numbers had swelled to more than three hundred.

145. Hartigan oral history interview, Archives of American Art.

146. Hartigan oral history interview, Maryland Historical Society. In the 1950 film *Sunset Boulevard*, Swanson—who was a real-life star of silent films—plays a silent-film star hoping to revive her acting career.

147. Elderfield, *de Kooning,* 307.

148. Fairfield Porter letter to his sister-in-law Aline Kilham Porter, October 8, 1959, quoted in Spring, *Fairfield Porter,* 246. The collector sold Porter's de Kooning to a gallery, which put an $18,000 price tag on it.

149. Louise Elliott Rago, "We Visit with Grace Hartigan," *School Arts*, May 1960, p. 36.

150. Larry Aldrich oral history interview, April 25–June 10, 1972, Archives of American Art, Smithsonian Institution.

151. Ad Reinhardt cartoon, *Art News,* 1961, p. 37.

152. Fridel Dzubas, in "Is There a New Academy? Part II" *Art News*, September 1959, p. 60.

153. Hilton Kramer, "The End of Modern Painting," *The Reporter*, July 23, 1959, pp. 41–42.

154. John Canaday, "In the Gloaming: Twilight Seems to be Settling Rapidly For Abstract Expressionism," *New York Times*, September 11, 1960. The article was a review of the Spring 1960 issue of *It Is*, a sporadically published (six issues, from 1958 to 1965) magazine that reproduced and discussed work by the leading Abstract Expressionists artists.

155. "Is There a New Academy? Part I," *Art News*, Summer 1959; and "Is There a New Academy? Part II."

156. One example: To attract tourists, a North Beach bar hired an artist to toss off wildly brushed abstract paintings, accompanied by a jazz combo. Richard Cándida Smith, *Utopia and Dissent: Art, Poetry, and Politics in California* (Berkeley: University of California Press, 1995), 168.

157. Helen Frankenthaler, in "Is There a New Academy? Part I," 34.

158. Jack Tworkov, in "Is There a New Academy? Part II," 38.

159. Gooch, *City Poet,* 360.

160. Ludwig Sander oral history interview, Archives of American Art.

161. Ludwig Sander oral history interview.

162. Mercedes Matter, quoted in Landau, Braff, and Kraskin, *Mercedes Matter,* 76, 116n, from Matter's unpublished memoir of de Kooning.

163. *The Aeneid of Virgil,* trans. Rolf Humphries (New York: Scribner's, 1951), 111.

164. Hartigan letter to Terence Diggory, July 21, 1992, courtesy of Terence Diggory.

165. Hartigan letter to Terence Diggory, July 21, 1992.

166. *Untitled (But Not for Love)* sold at Christie's, South Kensington, England, on July 17, 2012, for 2,126 British pounds ($3,326), below its estimate (Lot 175).

167. Art Brenner letter to Hartigan, June 2, 1960, Hartigan Papers.

168. David Budd letter to Hartigan, [n.d.] 1960, Hartigan Papers. Hartigan once arranged for collector-designer Larry Aldrich to purchase two paintings by Budd.

169. Author's telephone interview with Wendy Jeffers, March 16, 2011. She interviewed Hartigan in 1990.

170. According to Cahill's *New York Times* obituary (July 9, 1960), he was sixty-seven, but several sources, including the New York Public Library, state his birth date as January 13, 1887, so he would have been seventy-three at his death.

171. Notes by Terence Diggory from a conversation with Hartigan, August 31, 1998, courtesy of Terence Diggory. Hartigan dedicated the painting to Price, according to an April 10, 1985, letter from gallery owner Thomas Gruenebaum to a collector couple. Hartigan Papers.

172. Helen Frankenthaler wrote to Barbara Guest on July 27 that Grace's actions were "worthy of General Lee," the Confederate general noted for his tactical maneuvers. "It would be wonderful for both of them if it could work out." Uncat. MSS 271, Box 16, Barbara Guest Papers.

173. Hartigan letter to Emily Dennis, July 29, 1960, courtesy of Emily Dennis Harvey. Quoted by Mattison, *Painter's World*, 54, who wrongly dates it as November 2, 1959—before Hartigan even met Price.

174. Barbara Guest letter to Hartigan, July 28, 1960, Hartigan Papers.

175. Beatrice Perry letter to Hartigan, July 27, 1960. Hartigan Papers.

176. Beatrice Perry letter to Hartigan, August 12, 1960.

177. May Tabak letter to Hartigan, mailed August 22, 1960, Hartigan Papers.

178. Charlotte Willard, "Women of American Art," *Look*, September 27, 1960, p. 72.

179. Nemser, *Art Talk*, 166.

180. Notes by Terence Diggory from his visit to Barbara Guest, December 27, 1998.

CHAPTER 13: DRIFTING

1. Hartigan letter to Terence Diggory, November 2, 1992, courtesy of Terence Diggory.

2. Hartigan quoted this remark in a March 15, 1994, letter to Irving Sandler. Box 11, Folder 16, Irving Sandler Papers, Getty Research Institute.

3. Hartigan interview by Bob Lesser, April 20, 1965.

4. Josephine Novak, "Tracking the marvelous Grace Hartigan," *The [Baltimore] Evening Sun*, [March?] 1983, Hartigan Papers.

5. Handwritten Hartigan autobiographical statement, n.d., Hartigan Papers.

6. Hartigan, quoted in Nemser, *Art Talk*, 161.

7. Ned Oldham, "Grace Hartigan," *Black & White*, June 11, 1998, p. 30.

8. Cherrill Anson, "America's Top Woman Painter," *The [Baltimore] Sun*, March 17, 1963, p. 19.

9. Anson, "America's Top Woman Painter."

10. Hartigan interview by Bob Lesser, April 20, 1965.

11. Author's interview with Robert Meyerhoff, October 9, 2012. The Meyerhoffs' collection included three other paintings by Hartigan, purchased from her galleries; a fourth—a watercolor and collage—was a gift from her.

12. *Meet the Artist: Grace Hartigan* (video), Smithsonian American Art Museum.

13. Hartigan used an alternate spelling, *Athene*, which she may have borrowed from Robert Graves, *The Greek Myths* (New York: Braziller, 1957) and *The White Goddess* (London: Faber and Faber, 1948). *Grey-Eyed Athene* was a side project, not part of the four-elements series. It was inspired by a talk with Guest about the color gray, recorded in a letter, Hartigan to Barbara Guest, April 20, 1961, Box 14, Barbara Guest Papers (cited in David Belasco, *Between the Waves: Feminist Positions in American Art, 1949–62,* Ph.D. dissertation, New York University Institute of Fine Arts, September 2008. I was unable to locate this letter in the (uncatalogued) Guest Papers.

14. In terms of the goddess's story, the ship is a puzzle because nothing in Athena's history (other than her role in keeping Odysseus focused on his voyage) has anything to do with it. And why a burning ship? Belasco, *Between the Waves,* 103, suggests Goya's *Fire at Night* as a source, but this painting was not hanging in a museum in New York, so Grace would have to have seen it in reproduction, and color reproductions of lesser-known works were scarce in the fifties.

15. This painting, with a title that reflects the standard spelling (*Athena*), is now in the collection of the Smithsonian Museum of American Art.

16. Hartigan may have been influenced in her choice of colors by the last stanza of the poem "Pallas," by H.D. (Hilda Dolittle), a favorite poet of Barbara Guest's. She later wrote H.D.'s biography, *Herself Defined: The Poet H.D. and Her World* (Garden City, NY: Doubleday, 1984). Thanks to Belasco, *Between the Waves,* 100–101, for this source.

17. The Pittsburgh International was originally known as the Carnegie International; the name changed several times before reverting to the original title. In the early sixties, this survey exhibition—in which most of the artworks were for sale—was considered on a par with the Venice Biennale and the São Paolo Bienal.

18. Lee Nordness, ed., *Art USA Now*, vol. 2 (New York: Viking, 1963).

19. Stuart Preston, "Art: Contemporary American Show," *New York Times*, September 21, 1962.

20. Jean Lipman and Cleve Gray, "The Amazing Inventiveness of Women Painters," *Cosmopolitan*, October 1961, p. 65. (Before Helen Gurley Brown became editor, *Cosmopolitan* was a general interest magazine, not the "Cosmo" we know today.)

21. Hartigan letter to Cleve Gray, June 25, 1961, Box 2, Folder 22, Cleve Gray Papers, 1933–2005, Archives of American Art, Smithsonian Institution, roll D314, frames 1165–1170. (Gray, a painter in his own right, used part of Hartigan's letter in his October 1961 *Cosmopolitan* article co-authored with Jean Lipman, "Amazing Inventiveness," 65.)

22. Hartigan wrote to Guest twice in March 1960 to tell her so. Hartigan letter to Barbara Guest, March 26 and March 30, Box 14, Barbara Guest Papers.

23. Hartigan had put off working on the *Archaics* project until she was settled in Baltimore, a delay that troubled Guest, whose personal problems exacerbated her worry that work on the lithographs might never begin. Barbara Guest letter to Hartigan, October 5, 1961, Hartigan Papers. Eager to see another of her poems interpreted by an artist, she sent it to Nell Blaine, a de Nagy gallery painter who lived nearby. Blaine had contracted polio in 1959 and was painfully returning to art from her wheelchair. This letter makes it clear that Hartigan had criticized Guest—aware that Blaine didn't share her sensibility—for her misplaced generosity.

24. Barbara Guest letter to Hartigan, October 2, 1961, Hartigan Papers.

25. Barbara Guest letter to Hartigan, October 5, 1961, Hartigan Papers.

26. Barbara Guest letter to Hartigan, March 4, 1960, Hartigan Papers. Morisot met Manet when she was in her mid-twenties; several years later, she married his brother, Eugène.

27. Barbara Guest letter to Hartigan, March 28, 1960. Hartigan Papers.

28. In *Grace Hartigan and the Poets: Paintings and Prints* (Saratoga Springs, NY: Schick Art Gallery, Skidmore College, 1993), Terence Diggory writes that the whiteness of the paper Grace leaves blank "suggest[s] a tree transfixed by light, recalling…'I am replenishing as a light falling on a single tree,' from Guest's 'Dido to Aeneas.'"

29. Hartigan lecture, Skowhegan School of Painting and Sculpture.

30. Hartigan, quoted in *Imagine!*, 28.

31. The Rewald book was first published in 1956; based also on other internal evidence, the letter was probably written late that year.

32. Hartigan postcard to Terence Diggory, July 21, 1992, courtesy of Terence Diggory.

33. Written on July 31, 1961, O'Hara, *Collected Poems*, 423–24.

34. Gooch, *City Poet*, 434.

35. Mattison, *Painter's World*, 70. Hartigan donated the painting to the Smithsonian Institution.

36. Barbara Guest, *Poems: The Location of Things, Archaics, The Open Skies* (Garden City, NY: Doubleday, 1962).

37. May Tabak letter to Hartigan, April 27, 1962, Hartigan Papers.

38. In an April 1, 1963, letter to Hartigan, Beati Perry scornfully related Higgins's feigned ignorance (at a dinner party) about why Hartigan didn't want to be friends with the couple anymore. Hartigan Papers.

39. May Tabak letter to Hartigan, mailed August 8, 1962, Hartigan Papers.

40. May Tabak letter to Hartigan, mailed September 2, 1962, Hartigan Papers.

41. Hartigan letter to Barbara Guest, November 15, 1966, Uncat. MSS. 271, Box 16, Barbara Guest Papers.

42. Barbara Guest letter to Hartigan, November 28, 1966; *Imagine!*, 31.

43. Hartigan letter to Guest, November 29, 1966, Uncat. MSS. 721, Box 16, Barbara Guest Papers. The title of the additional poem is not known.

44. The lithographs were first shown at the Kornblee Gallery in New York, in November 1961.

45. Barbara Guest letter to Hartigan, April 4, 1974, Hartigan Papers.

46. Notes from Terence Diggory visit to Barbara Guest, December 27, 1998. Similarly, Hartigan wrote to Diggory, June 18, 1992, that she didn't want Guest to be invited to Skidmore College in the spring of 1993, when the exhibition he curated, Grace Hartigan and the Poets: Paintings and Prints, would be on view at the college's Schick Art Gallery, and Hartigan would briefly be in residence. (Notes and letter, courtesy of Terence Diggory.)

47. Hartigan letter to Terence Diggory, January 7, 1999, courtesy of Terence Diggory.

48. Notes from Hartigan telephone call with Terence Diggory, December 2, 1998, prompted by a request to quote from Hartigan's letters to Barbara Guest, courtesy of Terence Diggory.

49. Hartigan letter to Diggory, January 7, 1999, courtesy of Terence Diggory.

50. Hartigan letter to Samuel Wagstaff, April 23, 1962, Box 1, Folder 26, Samuel Wagstaff Papers, Archives of American Art, Smithsonian Institution.

51. B. H. Friedman, *Jackson Pollock: Energy Made Visible* (New York: McGraw-Hill, 1972); Friedman, *Alfonso Ossorio.*

52. May Tabak letter to Hartigan, mailed Oct 3, 1962, Hartigan Papers. (Joan of Arc became a subject for Hartigan's 1973 painting titled after the heroine.)

53. Emily Dennis, "Grace Hartigan: The Ordered Creation of Chaos," in *School of New York,* 24–29. Dennis had written her senior thesis on Hartigan at Vassar College in 1955.

54. Eleanor C. Munro, "The Found Generation," *Art News* 60 (November 1961): 31; Jane Freilicher, "Editor's Letters," *Art News* 60 (December 1961): 5.

55. Helen Frankenthaler letter to Hartigan, October 22, 1961, Hartigan Papers.

56. "Hartigan, Grace," *Current Biography Yearbook 1962* (New York: H.W Wilson, 1962), 192–94.

57. Russo, *Profiles,* 102.

58. Hartigan letter to Samuel Wagstaff, April 23, 1962, Samuel Wagstaff Papers.

59. Hartigan letter to Barbara Guest, October 3, 1961, Box 14, Barbara Guest Papers (cited by Belasco, *Between the Waves,* 88. I was unable to find this letter in the (uncatalogued) Guest Papers.

60. Undated notes, Box 4, Hartigan Papers.

61. Joan Mitchell, quoted in label text for her untitled painting of 1952–53 in the collection of the Crystal Bridges Museum of American Art; www.crystalbridges.org.

62. Mattison, *Painter's World,* 62, reproduces Hartigan's collage *Notes for "Marilyn,"* which shows some of the sources for the painting.

63. May Tabak letter to Hartigan, mailed August 16, 1962, Hartigan Papers.

64. May Tabak letter to Hartigan, mailed October 26, 1962, Hartigan Papers.

65. Andy Warhol used a publicity photo from the movie—which marked Monroe's first star billing—for his 1962 *Marilyn Diptych.*

66. Audrey Flack oral history interview, February 16, 2009, Archives of American Art, Smithsonian Institution. Flack also painted a nude *Marilyn* in the mid-sixties.

67. Hartigan, quoted in VanDyke, *Grace Hartigan.*

68. Born in the Netherlands, William of Orange (also known as William III) started life as Prince of Orange; he married his first cousin Mary, daughter of the English Duke of York, invaded England in 1688 in what became known as the Glorious Revolution, sent the reigning King James II packing, and thereby became king of England.

69. Anson, "America's Top Woman Painter."

70. Stevens composed "The Man on the Dump" during the Depression, after seeing someone sitting on the local dump. Hartigan's interest in Stevens may have been reinforced by their shared interest in finding new myths to take the place of formal religion. At some point, the title of Hartigan's painting acquired the additional tag, "No. 1."

71. Ashton, *New York School*, 134.

72. Terence Diggory, "Grace Hartigan's Imagined Worlds," in *Grace Hartigan* (Purchase, NY: Neuberger Museum of Art, 2001). Diggory suggests that the painting is meant to be read from left to right, revealing "new images just coming into being," like the small ovals in a rectangular box that reappear on the right-hand side as larger pink ovals, which he sees as breast forms.

73. Hartigan letter to Glen MacLeod, English Department, University of Connecticut, November 28, 1987, Hartigan Papers.

74. August Strindberg, "Preface to *Miss Julie*," 1888.

75. Helen Frankenthaler to Hartigan, September 6, 1962, Hartigan Papers.

76. Perry, an ardent fan of Hartigan's paintings who often remarked that she hated to let them out of her sight, persistently sought exhibitions of her work in Europe during these years.

77. Martha Jackson letter to Hartigan, July 25, 1962, Hartigan Papers.

78. Martha Jackson letter to Hartigan, October 20, 1962, Hartigan Papers.

79. Leonard Bocour letter to Hartigan, October 30, 1962, Hartigan Papers.

80. Helen Frankenthaler also experienced a heightened creative spurt immediately after her marriage to Robert Motherwell, when her stained painting style shifted into a radiantly serene mode. She wrote to Hartigan that on her honeymoon, "all the feelings and ideas I'd been storing up poured out." Frankenthaler letter to Hartigan, July 8, 1958, Hartigan Papers.

81. *Hartigan '62* (New York: Martha Jackson Gallery, 1962).

82. "Anguish Gone," *Newsweek*, October 29, 1962, p. 51.

83. John Gruen letter to Hartigan, October 13, 1962, Hartigan Papers. (Gruen was associate director of Martha Jackson Gallery.)

84. Hartigan letter to Emily Dennis, November 19, 1962, courtesy of Emily Dennis Harvey.

85. Hartigan letter to Dennis.

86. Hartigan interview by Patrick Taylor.

87. Grace Gertrude Hartigan letter to Hartigan, October 24, 1962. Four months earlier, a letter from her father noted that he and her mother hadn't seen Hartigan for two years.

88. May Tabak, letter to Hartigan, mailed October 26, 1962. Hartigan Papers.

89. Author's telephone interview with Hart Perry, April 24, 2012.

90. Stuart Preston, "Drawings and Paintings," *New York Times*, October 28, 1962.

91. Irving [I.H.S.], "Reviews and Previews: Grace Hartigan," *Art News* 61, no. 9 (November 1962): 11.

92. Irving Sandler letter to Hartigan, September 30, 1962, Hartigan Papers.

93. Martha Jackson letter to Hartigan, December 1, 1962, Hartigan Papers.

94. Hartigan, quoted in Oldham, "Grace Hartigan," 29.

95. Martha Jackson letter to Hartigan, December 18, 1972, Hartigan Papers.

96. In addition to showing leading works of contemporary American art—which had no public venue in Washington, D.C., at that time—the gallery offered lectures, concert and film programs, and an art rental service. Members of the board included Katharine Graham, then wife of the publisher of the *Washington Post*; the second wife of diplomat W. Averell Harriman; and attorney Abe Fortas, soon to be a Supreme Court justice. The gallery's first show was of Franz Kline's paintings. Ironically, in view of Hartigan's dismissal of Pop Art, the gallery is remembered as the site of seminal performance pieces by Robert Rauschenberg that were part of its 1966 Pop Festival.

97. Breeskin (1896–1986) was the former director of the Baltimore Museum of Art.

98. Florence Haussamen letter to Hartigan, December 20, 1962, Hartigan Papers.

99. May Tabak letter to Hartigan, December 15, 1962, Hartigan Papers.

100. Hartigan, quoted in Beati Perry letter to Hartigan, December 21, 1962–January 4, 1963, Hartigan Papers.

101. *Rough, Ain't It!* (1949), *Grand Street Brides* (1954), *City Life* (1956), and *Dawn Painting* (1959)—a little-known work, probably included because the owners were Washington, D.C., clients of Perry's—are illustrated in black and white, with a color plate of *Pallas Athene–Earth* (1961). Nordness, *Art USA Now*, 356–58.

102. Roland F. Pease Jr., in Nordness, *Art USA Now*, 356ff.

103. According to Mattison, *Painter's World*, 64, Hartigan based *The Hunted* on a cover of *American Gun* magazine that showed severed deer heads. Today, some might see this painting as an indictment of guns or hunting, but this would be misguided; Hartigan used the image as a visual way of venting her personal frustrations. (The painting was sold by Christie's on May 13, 1981, for a pitiful $4,000.)

104. "Written May 26, 1964—from Grace Hartigan," roll D249, Martha Jackson Gallery records, Archives of American Art, Smithsonian Institution.

105. Oldham, "Grace Hartigan," 30.

106. Oldham, "Grace Hartigan," 30.

107. The painting is owned by the Birmingham (Alabama) Museum of Art.

108. I have not been able to locate photographs of *Jolie* or *Joy*, and their whereabouts are unknown.

109. Hartigan letter to Samuel Wagstaff, April 20, 1964, Samuel Wagstaff Papers, Archives of American Art.

110. M. G. Lord, *Forever Barbie: The Unauthorized Biography of a Real Doll* (New York: Walker, 2004), 259.

111. Hartigan oral history interview, Archives of American Art.

112. Hartigan, "The Education of an Artist."

113. Hartigan letter to James A. Michener, June 15, 1967, Hartigan Papers. He later donated the painting to what is now the Blanton Museum of Art at the University of Texas at Austin.

114. Oldham, "Grace Hartigan," 30.

115. Salome, the Biblical figure whose sensual dance enticed King Herod to hand over the severed head of John the Baptist, has inspired many works of art. Hartigan letter to Jackson, March 3, 1964, Martha Jackson Gallery Archives, UB Anderson Gallery, University of Buffalo [NY], quoted in Angelica J. Maier, *Subtle Resistance: How Grace Hartigan, Joan Mitchell, and Martha Jackson Resisted Post–World War II Gender Constructions*, master of arts thesis, June 1, 2013, Department of Visual Studies, Graduate School of the University of Buffalo, p. 52.

116. After returning from the gallery opening ("crammed with your friends and admirers"), Beati Perry praised the paintings as "bumping, grinding, crashing beauties." Perry letter to Hartigan, November 24, 1964, Hartigan Papers.

117. Russo, *Profiles,* 104.

118. Stuart Preston, "Art: A Galaxy of Variety," *New York Times*, November 28, 1964.

119. Barbara Flanagan, "Lively Artist Revels at Labeling and Doesn't Like to Be Lionized," *Minneapolis Tribune*, [date unknown], 1963, Hartigan Papers.

120. In his 1969 Archives of American Art interview, Herbert Ferber—a leading sculptor associated with the Abstract Expressionist movement who had trained as a dentist in his youth—remarked that he still kept his dental practice open "because I don't trust the market for my sculpture."

121. Philip Roth, "Writing American Fiction," *Commentary* 35 (March 1961). In Roth's view, American intellectuals were facing an increasingly unreal and repellent world populated with newsmakers like Roy Cohen and Charles van Doren, the quiz show cheater.

122. "General Remarks by Grace Hartigan," seminar at the University of Minnesota, 1963, Hartigan Papers.

123. Author's interview with Hart Perry.

124. Gooch, *City Poet,* 439. Frank wrote about the event, in February 1964, in a letter to Rivers, describing it as having "a bit of the oddness of Jackie Kennedy's dinner with Marlon Brando."

125. LeSueur, *Digression on Some Poems,* 151.

126. Prioleau, *Seductresses,* 159.

127. *Self Portrait in Fur* sold at a Doyle New York auction on November 13, 2012, for $4,375, above its estimate (Lot 125).
128. May Tabak letter to Hartigan, mailed December 9, 1965, Hartigan Papers.
129. In another Hartigan version of the encounter, she called Leake and asked if she could teach graduate students. Mattison, *Painter's World,* 74.
130. For the history of MICA, I am indebted to Douglas L. Frost, emeritus vice president for development and author of *Making History/Making Art/MICA* (Baltimore: Maryland Institute College of Art, 2010), a lavishly produced history of the school. Hartigan told Frost in 2007 that Leake had called her and said that "he had a few graduate students he wanted me to meet" (176).
131. The downtown branch of the school, rebuilt near the previous site, continued to house mechanical and architectural drafting programs until its closure in the 1960s.
132. Anson, "America's Top Woman Painter."
133. Anson, "America's Top Woman Painter."

CHAPTER 14: TEACHING

1. In 2001, the institute—which had used several similar names simultaneously for decades—became formally known as the Maryland Institute College of Art, or MICA. To maintain historical accuracy, I am calling it "the institute" during its early years.
2. Known as The Station, the site now has national landmark status. It was added to the National Register of Historic Places in 1973.
3. All these upgrades were contingent upon obtaining accreditation from the Middle States Association of Schools and Colleges.
4. Contract for 1967–68, Hartigan personnel file, MICA. (All contract issues mentioned in this chapter are based on the contents of this file. I am deeply grateful to Provost Raymond Allen for allowing me unfettered access to the file.)
5. Hartigan letter to Eugene Leake, May 18, 1971, Hartigan personnel file, MICA.
6. Hartigan personnel file, MICA.
7. Eugene Leake letter to Hartigan, October 21, 1983, Hartigan Papers.
8. Grace Hartigan letter to Terence Diggory, September 11, 1994, courtesy of Terence Diggory.
9. Author's interview with Fred Lazarus at MICA, October 2, 2012. He was president of MICA from 1978 to 2014.
10. *A Picture Book for Grace,* Hartigan Papers.
11. Hartigan oral history interview, Maryland Historical Society.
12. Hartigan oral history interview, Maryland Historical Society.
13. Author's interview with Raymond Allen at MICA, July 16, 2012. He was an instructor at the institute from 1970 to 1983, returning in 1994 to become vice president and then provost.
14. Eventually, Mount Royal offered MFA degrees to students working in a variety of media.

15. Author's telephone interview with Babe Shapiro, January 17, 2013.

16. Quoted in Russo, *Profiles,* 89.

17. Author's interview with Leslie King-Hammond at MICA, October 3, 2012.

18. Undated statement, Hartigan personnel file, MICA.

19. Hirsh, *Grace Hartigan,* 40.

20. Jeriah Hildwine, in *Grace Hartigan: Shattering Boundaries* (video), Amici Productions, 2008.

21. Cara Ober, "Grace Hartigan: A Baltimore Legend, 1922–2008," *BmoreArt* blog, posted November 16, 2008; bmoreart.com/2008/11/grace-hartigan-baltimore-legend-1922.html.

22. Merle Spandorfer interview, 2001, Inventory and Oral History Project, Senior Artists Initiative, Philadelphia; www.seniorartists.org/mspandorfer.html.

23. See Phyllis Braff, "Creativity in the Later Years," in Landau, Braff, and Kraskin, *Mercedes Matter.*

24. Mercedes Matter letter to Hartigan, April 5, 1973, Hartigan Papers.

25. Mercedes Matter, "How Do You Learn to Be an Artist?" *New York Times*, September 2, 1973. Yet when Matter received an honorary degree from the institute in May 1981—shortly after Hartigan's husband died, so she was probably not present—Lazarus remarked that Matter's "insights have permeated all art schools, including the Maryland Institute."

26. Author's telephone interview with Jeriah Hildwine, November 8, 2012.

27. Author's telephone interview with Raymond Majerski, November 7, 2012.

28. Ryozo Morishita email to author, April 25, 2013.

29. Author's interview with Hildwine.

30. Hirsh, *Grace Hartigan,* 40.

31. Author's interview with King-Hammond.

32. Author's interview with Majerski.

33. Hans Hofmann, *The Search for the Real in the Visual Arts and Other Essays* (Cambridge, MA: MIT Press, 1967), 234.

34. James Gahagan, in *Hans Hofmann: Artist/Teacher, Teacher/Artist*, June 2003, PBS documentary produced by Madeline Amgott; www.youtube.com/watch?v=ZmPt9AINfDo.

35. Robert Richenburg, in Gahagan, *Hans Hofmann.*

36. Hartigan lecture, Skowhegan School of Painting and Sculpture.

37. Luther Young, "Grace Hartigan Took the Big Chance—and Won," *The [Baltimore] Sun*, September 13, 1981.

38. Author's telephone interview with Liz Wade Cairns, October 19, 2012.

39. Author's interview with Michel Modele at MICA, October 2, 2012.

40. Hartigan oral history interview, Archives of American Art.

41. VanDyke, *Painting from Popular Culture.*

42. Author's interview with Cairns.

43. Author's telephone interview with Joan Stolz, April 10, 2013.

44. Author's interview with King-Hammond.

45. Author's interview with King-Hammond.

46. King-Hammond later became founding director of the Center for Race and Culture at MICA.

47. Author's interview with King-Hammond.

48. Oldham, "Grace Hartigan," 30.

49. Author's interview with Lazarus.

50. Author's interview with Lazarus.

51. Hartigan lecture, Skidmore College.

52. Hartigan letter, October 4, 1982, responding to a student at the University of Virginia, Hartigan Papers.

53. Author's interview with King-Hammond.

54. Author's interview with King-Hammond.

55. Author's interview with King-Hammond.

56. King-Hammond memo to Hartigan, October 17, 1997, Hartigan Papers.

57. Audrey Flack oral history interview, Archives of American Art.

58. Author's interview with Stolz.

59. Author's interview with Allen.

60. Dominique Nahas email to author, January 7, 2013.

61. Author's interview with Hildwine.

62. Author's interview with Allen.

63. Author's telephone interview with Dan Dudrow, December 6, 2012.

64. Elizabeth Stevens, "The Art of Painting the Opera," *The [Baltimore] Sun*, April 3, 1986, p. 5C. Also in VanDyke, *Grace Hartigan*.

65. Stevens, "Art of Painting the Opera."

66. Author's telephone interview with Majerski.

67. The talk was held at School 33 Art Center. John Dorsey, "Baltimore's Stock Rising as Place for Artists to Work but It's a Long Way from N.Y.," *The [Baltimore] Sun*, October 26, 1987, pp. C1, C8.

68. Author's telephone interview with Ed Kerns, June 3–4, 2013.

69. After Hartigan's former lover, photographer Walter Silver, came to campus in 1975 at her invitation, he noted wistfully that her students "love you more than mine do me." Silver letter to Hartigan, undated, Hartigan Papers.

70. Hartigan letter to Irving Sandler, February 28, 1977, courtesy of Irving Sandler.

71. Author's telephone interview with Dore Ashton, February 7, 2011.

72. Author's interview with Suzi Cordish in Baltimore, October 4, 2012.

73. Hartigan, quoted in VanDyke, *Painting from Popular Culture*.

74. Author's interview with Modele.

75. Author's interview with King-Hammond.

76. Author's interview with King-Hammond.

77. Author's interview with Modele.

78. Undated statement, Hartigan personnel file, MICA.

79. Hartigan oral history interview, Maryland Historical Society.

80. Letter in Hartigan's personnel file, MICA.

81. Author's interview with Stolz.

82. Author's interview with Stolz.

83. John Dorsey, "Women Artists: Will New Museum Help Them or Put Them in a Ghetto?" *The [Baltimore] Sun*, Sunday April 12, 1987, pp. N1, N8.

84. Hartigan letter to Terence Diggory, December 12, 1994, courtesy of Terence Diggory. (In fact, she had joined the National Organization for Women [NOW] in 1985.)

85. Merle Spandorfer, quoted in Gloria Klaiman, *Night and Day: The Double Lives of Artists in America* (New York: Praeger, 2005), 125.

86. Hartigan, quoted in Nemser, *Art Talk,* 169.

87. Carla Waldemar, "Hartigan is Back in Style," *Twin Cities Reader*, [date unknown], 1984, pp. 23, 26, Hartigan Papers.

88. Author's interview with Modele.

89. Russo, *Profiles,* 94.

90. Author's telephone interview with Hildwine.

91. Author's telephone interview with Lauren Sleat, November 11, 2012.

92. Author's interview with Modele.

93. Albert Schweitzer, "Studio Visit with Albert Schweitzer," *BmoreArt* blog, March 1, 2009, accessed July 22, 2013; www.bmoreart.com/2009/03/studio-visit-and-interview-with-albert.html.

94. Author's telephone interview with Archie Rand, June 13, 2012.

95. Author's interview with Hildwine.

96. Author's telephone interview with Scott Kelly, November 2, 2012.

97. Hartigan letter to Ellen Breitman, November 24, 1986, courtesy of Ellen Breitman.

98. Author's interview with King-Hammond.

99. Hartigan letter to Terence Diggory, September 11, 1994, courtesy of Terence Diggory.

100. Hartigan letter to Terence Diggory, March 22, 2001, courtesy of Terence Diggory.

101. Author's telephone interview with Mina Cheon, November 1, 2012. All quotes from Cheon in this chapter are from this interview.

102. Hirsh, *Grace Hartigan,* 17.

103. Mattison, *Painter's World,* 132.

104. Richard Cavendish, *Visions of Heaven and Hell* (Maryknoll, NY: Orbis, 1983; reprint).

105. Mattison, *Painter's World,* 130.

106. *Grace Hartigan: Painting Art History*, curated by Sharon L. Hirsh, was shown at The Trout Gallery, Dickenson College (Carlisle, PA), September 12–November 1, 2003, and at the Maryland Institute College of Art, November 14–December 14, 2003.

107. Author's interview with Lazarus.

CHAPTER 15: UNRAVELING

1. Hartigan lecture, Skowhegan School of Painting and Sculpture.
2. Author's interview with Arthur Hartigan.
3. Author's interview with Robert Meyerhoff at his home in Maryland, October 4, 2012.
4. Author's telephone interview with Audrey Flack, December 3, 2013.
5. May Tabak letter to Hartigan, mailed February 26, 1962, Hartigan Papers.
6. May Tabak letter to Hartigan, mailed August 20, 1964, Hartigan Papers.
7. Price told Hartigan's student Ed Kerns that light "interfered with his thinking." Author's telephone interview with Kerns, June 3–4, 2013.
8. Author's telephone interview with Cynthia Navaretta, August 18, 2011.
9. Beatrice Perry letter to Hartigan, n.d. [September 1963], Hartigan Papers.
10. Author's interview with King-Hammond at MICA.
11. Barbara Guest letter to Hartigan, October 26, 1961, Hartigan Papers.
12. Author's interview with Fay Chandler in Boston, June 8, 2012.
13. Ryozo Morishita email to author, May 3, 2013.
14. Author's telephone interview with Ed Kerns, June 3–4, 2013.
15. Author's telephone interview with Ed Kerns, June 10, 2013.
16. Author's interview with Karen Gunderson in New York, June 5, 2012.
17. Author's telephone interview with Kerns, June 10, 2013.
18. Author's interview with King-Hammond.
19. Author's telephone interview with Stolz.
20. Winston Price, gift enclosure to Hartigan, 1967, Hartigan Papers.
21. Hartigan, quoted in Russo, *Profiles,* 102. Russo interviewed her in 1981.
22. Author's telephone interview with Kerns, June 3–4, 2010.
23. Author's interview with Kerns, June 3–4, 2010.
24. Author's interview with Kerns, June 3–4, 2010.
25. Statement by Hartigan in exhibition announcement, "Three American Painters," Grand Rapids [Michigan] Art Museum, 1968.
26. John Canaday, "Sometimes You Feel Sorry," *New York Times,* March 21, 1965.
27. John Canaday, "Art: Rockefeller's Taste," *New York Times,* July 10, 1962. Might Canaday have praised this painting because it was collected by Governor Rockefeller? The painting had been damaged in a fire in the Executive Mansion in 1961, and was restored before being shown in an exhibition from the governor's collection at the Brooklyn Museum.
28. Nemser, *Art Talk,* 160.
29. John Canaday, "Art: Lee Gatch and Robert Birmelin," *New York Times,* February 11, 1967.
30. Dennis Adrian, "New York: Grace Hartigan," *Artforum* 5, no. 8 (April 1967): 59.
31. Hartigan, in "Painting a Revolution," CBS Sunday Morning interview, February 28, 1993.
32. Luther Young, "Grace Hartigan took the big chance—and won," *The [Baltimore] Sun,* September 13, 1981.

33. Barbara Rose, "The Second Generation: Academy and Breakthrough," *Artforum* 4 (September 1965): 53–63.

34. VanDyke, *Painting from Popular Culture.*

35. Tim Higgins, "Hartigan Unveils a Body of Hidden Work," *The Morning Call* [Allentown, PA], September 29, 1990. Hartigan told another interviewer that "nobody" liked these works (including her husband), so she put them away. Jane Walker, "Artist Shows Body of Work at Lafayette," *The Express*, September 28, 1990, p. D14.

36. Hartigan letter to Fay Chandler, August 16, 1969, Hartigan Papers.

37. Amei Wallach. "Art: Grace Under Pressure," *Newsday*, January 20, 1991, Part II, p. 23.

38. Thomas T. Fenton, "New Vaccination System Studied," *The [Baltimore] Sun*, October 4, 1964, p. 26.

39. May Tabak letter to Hartigan, [ca. December 27, 1965], Hartigan Papers.

40. May Tabak letter to Hartigan, March 9, 1966, Hartigan Papers.

41. Hartigan letter to Barbara Guest, November 29, 1966, Uncat. MSS 271, Box 16, Barbara Guest Papers.

42. That year, Price published only three papers, as compared to seven in 1966 and eleven in 1968. The reason 1967 is the significant year rather than 1966 is that it took months for scientific papers to undergo the peer review process.

43. Hartigan, quoted in Wallach, "Grace Under Pressure," 23.

44. May Tabak letter to Hartigan, July 29, 1966, Hartigan Papers.

45. May Tabak letter to Hartigan, October 10, 1966, Hartigan Papers. Beati Perry had already noted Price's improved health—related to her by painter Jack Tworkov—in a May 1966 letter to Hartigan. But in a letter she sent on September 12, she worried that Price's health might not be conducive to her proposed visit. Hartigan Papers.

46. Hartigan letter to Guest, November 29, 1966. Uncat. MSS 271, Box 16, Barbara Guest Papers.

47. Winston Price letter to Robert Motherwell, August 11, 1968, Box 267, 1A/27: June–September 1968, Daedalus Foundation, New York.

48. Philip E. Sartwe, ed., *Preventive Medicine and Public Health*, 10th ed. (Princeton, NJ: Appleton-Century-Crofts/Prentice-Hall, 1973).

49. Hartigan, quoted in Russo, *Profiles,* 89. She also mentions the prostitutes and drugs in this interview (100).

50. Copy of lease in Hartigan Papers.

51. Russo, *Profiles,* 89.

52. Hartigan lecture, Skowhegan School of Painting and Sculpture.

53. Russo, *Profiles,* 89.

54. Russo, *Profiles,* 101.

55. Morishita email to author.

56. Information about Price from author's interviews with Kerns. Audrey Flack also mentioned Price's girth and skin condition, which Philip Guston noticed as early as fall 1975 (Guston letter to Hartigan, September 19, 1975, Hartigan Papers). It may have been a particularly bad case of his psoriasis, or a side effect of the medications he was taking.

57. Winston Price letters to Motherwell, July 30, 1959, and October 4, 1959, Box 267 W.H., 1959, Daedalus Foundation.
58. Pierre Matisse letter to "Mrs. G. Price," March 2, 1971, Hartigan Papers.
59. Hartigan letter to Chandler, August 2, 1974, Hartigan Papers. Guston became affiliated with the David McKee Gallery in New York in 1974, and exhibited new paintings there that year. *Smoking II* may be the painting now known as *Smoking in Bed II*. (*Smoking I* was painted in 1973; a drawing, *Smoking in Bed*, dates from 1974.) I have not been able to locate a painting titled *Night* that is dated before summer of 1974; Guston's painting known as *The Night* was painted in 1977.
60. Unsurprisingly, none of the research papers listed in his *curriculum vita* deal with schizophrenia.
61. Philip Guston postcard to Hartigan, February 16, 1954, and Guston letter sent January 31, 1972, Hartigan Papers.
62. Philip Guston letter to Hartigan, October 13, 1974, Hartigan Papers.
63. See "Philip Guston Talking," lecture at the University of Minnesota, March 1978, in *Philip Guston,* ed. Renee McKee (London: Whitechapel Gallery, 1982), 49–56.
64. Hartigan, quoted in Nemser, *Art Talk,* 166.
65. Hartrigan, quoted in Oldham, "Grace Hartigan," 29.
66. Hartigan oral history interview, Maryland Historical Society.
67. *Another Birthday* (1971) is in the collection of the Museum of Fine Arts, Boston.
68. Philip Guston letter to Hartigan, January 22, 1975, Hartigan Papers.
69. Philip Guston letter to Hartigan, October 12, 1975, Hartigan Papers.
70. Author's interview with Ed Kerns, June 10, 2013.
71. Author's interview with Kerns, June 10, 2013. Price's elderly mother Florence didn't seem to perceive any lack of closeness, however, writing a fond letter to Hartigan in June that quoted lines of sentimental poetry.
72. Ed Kerns email to author, August 5, 2013.
73. Author's telephone interview with Moran.
74. Hartigan letter to Chandler, May 31, 1974, Hartigan Papers.
75. Barber, "Making Some Marks," 50.
76. Pamela A. Brooks, "An 'Orange' reunion at Skidmore," [*Saratoga Springs, NY*] *Post-Star,* March 26, 1993, p. D3.
77. Barber, "Making Some Marks," 50.
78. Hartigan lecture, Skowhegan School of Painting and Sculpture.
79. Hartigan oral history interview, Maryland Historical Society.
80. Nemser, *Art Talk,* 171.
81. Handwritten note, "Response to Artforum inquiry," March 15, 1975, Hartigan Papers.
82. *Dragons and Other Animals* (Baltimore: Walters Art Gallery, 1966), unpaginated. (In 2001, the institution became known as the Walters Art Museum.) Hartigan talks about her discovery of the books in her Archives of American Art oral history interview.

83. Hartigan, handwritten "Statement for Tokyo Seibu Dept Store Sept 27," June 21, 1971, Hartigan Papers.

84. This painting was once owned by Adnan Khashoggi, the Saudi Arabian arms dealer (what did he see in it?). According to the U.S. Department of State "Art in Embassies" website (art.state.gov), he donated it to the Art in Embassies program in Washington, DC.

85. Hartigan, quoted in transcript of Nancy Baer interview (film), June 4, 1975, Hartigan Papers.

86. Author's interview with Majerski.

87. Albers, *Joan Mitchell*, 55–57. The color-vs.-line, female-vs.-male controversy was at its apogee in nineteenth-century France, with color theorist Charles Blanc equating an overuse of color to the Eve's temptation in the Garden of Eden. David Batchelor, *Chomophobia* (London: Reaktion Books, 2000), quoted in Maggie Nelson, *Women, the New York School, and Other True Abstractions* (Iowa City: University of Iowa Press, 2007), 23.

88. Hartigan oral history interview, Maryland Historical Society.

89. John Dorsey, "Art World's Spotlight Shines on Hartigan Once Again," *The* [*Baltimore*] *Sun*, October 28, 1990, pp. 1L, 3L.

90. Hartigan had made collages since the fifties, when she painted on arrangements of torn-up pieces of magazine photographs. She enjoyed the risk involved in these works; once the ripping or scissoring was done, there was no going back. See Brenda Richardson, *Grace Hartigan: Twenty-Five Years of Collage* (Baltimore: Baltimore Museum of Art, 1980).

91. Source for painting references, Mattison, *Painter's World*, 92.

92. Ann Wiseman, *Bread Sculpture: The Edible Art* (San Francisco: 101 Productions, 1975).

93. Author's interview with Flack. Nearly a decade younger than Hartigan, Flack was determined to live her life differently. In her view, Hartigan and other women Abstract Expressionists "abused themselves in terrible ways and paid a horrible price for their art."

94. Hartigan oral history interview, Maryland Historical Society.

95. Russo, *Profiles*, 102.

96. Mattison, *Painter's World*, 84, 92.

97. Author's telephone interview with Barbara Sesee.

98. Author's interview with Donna Sesee.

99. Author's telephone interview with Dan Dudrow, December 6, 2012.

100. Mattison, *Painter's World*, 98. It is possible that Hartigan was referring to a slightly later hip operation in this remark; beginning in the mid-seventies, she had three hip replacements and two knee replacements in the last decades of her life.

101. Barber, "Making Some Marks," 50.

102. Barbara Rose, "First-Rate Art by the Second Sex," *New York*, April 8, 1974, pp. 80–81.

103. Fay Chandler letter to Hartigan, June 25, 1974, Hartigan Papers.

104. Philip Guston letter to Hartigan, June 1, 1975, Hartigan Papers.

105. Hartigan letter to Chandler, November 25, 1975, Hartigan Papers.

106. Hartigan oral history interview, Maryland Historical Society. Hartigan was probably thinking primarily of Mark Rothko, who had committed suicide just five years earlier, though Sonia Sekula and Arshile Gorky had also killed themselves.

107. Hartigan letter to Chandler, March 19, 1976, Hartigan Papers. In 1976, the I-95 highway was still under construction.

108. Hartigan letter to Chandler, June 25, 1976, Hartigan Papers.

109. Author's interview with Flack.

110. Russo, *Profiles,* 103.

111. Handwritten document by Hartigan, n.d., Hartigan Papers.

112. Hartigan handwritten "Statement for Tokyo Seibu Dept Show." According to Mattison (*Painter's World,* 80), Jackson's bird was a macaw that often tried to bite female visitors to the gallery.

113. David Anderson letter to Hartigan, June 22, 1971, Hartigan Papers.

114. David Anderson letter to Hartigan, n.d. Hartigan Papers.

115. Gertrude Kasle oral history interview, July 24, 1975, Archives of American Art, Smithsonian Institution.

116. Grimaldis, for reasons best known to himself, has refused to speak with me about Hartigan.

117. John Russell, "Where to Go from Art of 1950s," *New York Times,* March 8, 1975, p. 16.

118. Philip Guston letter to Hartigan, May 15, 1972, Hartigan Papers.

119. Mattison, *Painter's World,* 90.

120. Hartigan oral history interview, Maryland Historical Society.

121. Margaret Pomfret, "Grace Hartigan," *Arts Magazine* 51, no. 10 (June 1977): 43–44.

122. Hilton Kramer, "Art: Grace Hartigan," *New York Times,* April 15, 1977.

123. Hartigan letter to Chandler, March 19, 1976, Hartigan Papers.

124. Author's interview with King-Hammond.

125. Although Price's condition may have fluctuated, friends had a way of emphasizing its positive aspects. In December 1976, Beati Perry wrote to Hartigan that on the couple's recent visit to New York, "Win was…so much more open and available than he has been for a long time." Hartigan Papers.

126. May Tabak letter to Hartigan, mailed January 15, 1979, Hartigan Papers.

127. Hartigan letter to Chandler, March 21, 1979, Hartigan Papers.

128. Author's interview with Meyerhoff.

129. Author's interview with Kerns, June 3–4, 2013.

130. Author's interview with Meyerhoff. This may have been the same painting Price saw on his trip to New York with Ryozo Morishita.

131. Author's interview with Chandler.

132. Mary Corey, "Low-key Tavern Draws Art Students," *The [Baltimore] Sun,* August 28, 1987.

133. Author's interview with Meyerhoff.

134. Johns Hopkins University has redacted portions of Price's personnel file, including any documents dealing with the termination of his employment there, so I do not know the exact cause or how it was worded.

135. Author's telephone interview with Kerns, June 3–4, 2013. Others have said that Win would sit in an empty office at Johns Hopkins, or in a park.

136. Author's telephone interview with Moran.

137. Author's interview with Arthur Hartigan. He was in Baltimore on a business trip—Grace was out of town—when he saw Price in a taxi with a young woman. "And I'm looking over and he spots me. And he sank down like this"—Hartigan slid down in his chair. "He knew what he was doing. And I found out from neighbors…that there were other girls coming." Hartigan spared his sister this information until after Price died. Ed Kerns told me that Win mentioned only one woman to him, and it sounded like a short-duration payback for Grace's own affairs.

138. MasterCard was then known as Master Charge.

139. Russo, *Profiles*, 94. The reason she gave in this interview was that it irked her to have to use her husband's card to pay for meals with visiting artists, collectors, and museum people. She did not share her husband's failings with interviewers.

140. Author's interview with Gunderson.

141. Draft of Hartigan letter, July 3, 1980, to a Dr. Voell, Hartigan Papers. It is not known whether Hartigan ever sent the letter.

142. Madeleine Burnside, "Grace Hartigan," *Art News*, December 1978, p. 145.

143. Hartigan letter to Irving Sandler, December 22, 1978, Box 11, Folder 16, Irving Sandler Papers, Getty Research Institute.

144. Elizabeth Stevens, "Hartigan Seeking Her Golden Age," *The [Baltimore] Sun*, November 19, 1979, p. D12. In her troubled state of mind, Hartigan initially consigned her paintings still at Genesis to its owner, Harrriet Lebish, but changed her mind and took them back.

145. Philip Guston letter to Hartigan, March 19, 1980, Hartigan Papers.

146. Barber, "Making Some Marks," 51.

147. Stevens, "Hartigan Seeking Her Golden Age."

148. Author's telephone interview with Brenda Richardson, September 9, 2011.

149. The exhibition included Hartigan's paintings *Months and Moons* and *Grand Street Brides*.

150. Author's interview with Richardson.

151. Author's interview with Richardson.

152. Richardson, quoted in John Lewis, "Fifteen Minutes and Counting," *Baltimore Magazine*, October 2010.

153. Author's interview with Richardson.

154. Brenda Richardson letter to Hartigan, July 21, 1983, Baltimore Museum of Art files.

155. Richardson letter to Hartigan, July 21, 1983, Baltimore Museum of Art files.

156. Hartigan letter to Richardson, April 29, 1996, courtesy of Brenda Richardson. Grace's *Barbie* and a late Guston would hang side-by-side the following year at the Birmingham Museum; Richardson had helped bring about the museum's purchase. Hartigan letter to Richardson, November 11, 1997, courtesy of Brenda Richardson.
157. Brenda Richardson letter to Hartigan, December 14, 1990, Hartigan Papers.
158. Author's interview with Richardson.
159. Hartigan letter to Richardson, December 28, 1990, courtesy of Brenda Richardson.
160. Author's interview with Richardson.
161. Charles Parkhurst letter to Hartigan May 21, 1968, Hartigan Papers.
162. Krasner in 1984 and Frankenthaler in 1989.
163. In 1987, Watkins Gallery, at American University, in Washington, D.C., organized Grace Hartigan: A Mini-Retrospective 1954–1984. Hartigan also had gallery retrospectives in New York—in 1989, at the Kouros Gallery (Grace Hartigan: Four Decades of Painting), and in 1991, at ACA Galleries (Five Decades, 1950–1990). In 2009, C. Grimaldis Gallery in Baltimore mounted Grace Hartigan: A Life in Painting. But these efforts lacked the clout of a major museum show with a definitive catalogue.
164. Author's interview with Arthur Hartigan.
165. Arthur Hartigan letter to Hartigan, August 19, 1975, Hartigan Papers.
166. Undated note from Hartigan's mother, enclosed in letter from Arthur Hartigan to Hartigan, August 25, 1975, Hartigan Papers.
167. Author's interview with Leslie. He did not recall the date or at which airport this occurred.

CHAPTER 16: RENEWING

1. Eugene Leake letter to Hartigan, April 7, 1981, Hartigan Papers.
2. Author's telephone interview with Kerns, June 3, 2013.
3. Author's interview with Meyerhoff.
4. Robert Jachens letter to Hartigan, September 9, 1983, Hartigan Papers.
5. Roland Pease letter to Hartigan, May 18, 1981, Hartigan Papers.
6. Russo, *Profiles,* 104.
7. Luther Young, "Grace Hartigan Took the Big Chance—and Won," *The [Baltimore] Sun,* September 13, 1981.
8. Goldberg, "Grace Hartigan Still Hates Pop," 30. It's not clear who the lover in the photo was, unless the man was actually Frank O'Hara, whose photograph Hartigan displayed in later years.
9. Author's interview with Chandler.
10. Hartigan letter to Chandler, June 27, 1984, Hartigan Papers.
11. Hartigan postcard to Chandler, August 4, 1991, Hartigan Papers.
12. Hartigan letter to Chandler, August 8, 1991, Hartigan Papers.
13. Carla Waldemar, "Hartigan Is Back in Style," *Twin Cities Reader,* [date unknown], 1984, p. 23, Hartigan Papers.

14. Hartigan, quoted in VanDyke, *Painting from Popular Culture*.

15. From Sharon L. Hirsh's interview with Hartigan, November 2, 2002, cited in Hirsh, *Grace Hartigan*. Hirsh discusses the art historical sources of this painting in detail on page 21.

16. Rainer Maria Rilke, "The First Elegy," *Duino Elegies*, translated by Stephen Mitchell (Berkeley, CA: Shambhala Publications, 1991).

17. Hirsh, *Grace Hartigan*, 41.

18. Hartigan, quoted in Hirsh, *Grace Hartigan*, 34. She was relating her response to her assistant Rex Stevens, who was puzzled at why she would paint the Angel Gabriel telling the Virgin Mary she would bear a son called Jesus if she didn't believe in this event.

19. Hirsh, *Grace Hartigan*, 41.

20. Arthur Hartigan letter to Hartigan, November 18, 2003, Hartigan Papers.

21. Hartigan letter to Arthur Hartigan, n.d., Hartigan Papers.

22. Hartigan letter to Chandler, August 4, 1982, Hartigan Papers.

23. Hartigan, quoted in John Dorsey, "Art World's Spotlight Shines On Hartigan Once Again," *The [Baltimore] Sun*, October 28, 1990.

24. Hartigan lecture, Skowhegan School of Painting and Sculpture.

25. Handwritten autobiographical document, n.d., Hartigan Papers.

26. Published in 1978 by Dover, the book incorporates selections from his first paper doll book, *30 from the Thirties* (1976), with paper-doll versions of Greta Garbo, Jean Harlow, Carole Lombard, and other stars of the silver screen.

27. Mattison, *Painter's World*, 108. For the title, Hartigan borrowed Horatio's words after Laertes has killed Hamlet in a sword fight (*Hamlet*, Act V, Scene II).

28. While dripping is associated with Jackson Pollock, whose earliest drip paintings date from 1946, other artists also used the technique in more limited ways. Hans Hofmann is generally believed to have been the first modern artist to incorporate drips in his paintings, albeit in a decorative manner.

29. Hartigan, quoted in Norma Broude, *Grace Hartigan: A Mini-Retrospective 1954–1984* (Washington, DC: Watkins Art Gallery, American University, 1987). The exhibition was on view from February 14 to March 14, 1987.

30. Bronzino (Agnolo di Cosimo), *Portrait of Lodovico Capponi*, ca. 1550–1555, at the Frick Collection, New York. The hands, face, and drapery background in Hartigan's painting are closely related to this portrait. The other Bronzino in New York—*Portrait of a Young Man*, 1530s, at the Metropolitan Museum of Art—is likely of a literary young man. His nose and more prominent eyes are closer to those of Hartigan's young man (though her figure lacks the wandering left eye of the Met's Bronzino).

31. Biographical information from Tierney's website, www.tomtierney.com/contents/01/intro01/page01.htm.

32. Elaine de Kooning produced a series of paintings of faceless men in the early fifties, but it is doubtful that Hartigan was influenced at this late date by them.

33. Information about Tierney's Elizabeth I and Empress Josephine paper dolls comes from the paper dolls, their costumes, and the notes (inside the front and back covers) in his *Great Empresses and Queens Coloring Book* (New York: Dover, 1982).

34. Author's interview with Ed Kerns.

35. Nemser, *Art Talk,* 159.

36. Hartigan letter to Terence Diggory, December 12, 1994, courtesy of Terence Diggory.

37. Manet, 1832–1883 was on view from September 10 to November 27, 1983; several works in the exhibition, which traveled to Paris in the spring and summer of 1983, are owned by the Met.

38. Robert Saltonstall Mattison, *Grace Hartigan: Painting the Renaissance* (New York: Gruenebaum Gallery, 1986), 2.

39. Hartigan, quoted in Lawrence Campbell, "To See The World Mainly Through Art: Grace Hartigan's *Great Queens and Empresses* (1983)," *Arts Magazine* 58 (January 1984): 89. Although Campbell knew Hartigan, this article is riddled with errors, including the misstated title of her painting *Grand Street Brides* and misinformation about the mannequins that were Hartigan's inspiration (he refers to them as if they were live women), about the location of her childhood home, and about the year she moved to New York.

40. VanDyke, *Painting from Popular Culture.*

41. Hartigan, quoted in Elisabeth Stevens, "Hartigan Seeking Her Golden Age," *The [Baltimore] Sun*, November 18, 1979, p. D12.

42. Author's interview with Rex Stevens, October 3, 2012. All quotes from Stevens are from this interview.

43. Details about Elaine de Kooning's life from Slivka, "Essay," 19–30.

44. Hartigan, Elaine de Kooning Memorial eulogy, May 12, 1990, Hartigan Papers.

45. Hartigan lecture, Skidmore College.

46. Audrey Flack oral history interview, Archives of American Art.

47. Forman, "A Palette Fresh and Brilliant," 15.

48. Stevens, "The Art of Painting the Opera," *The [Baltimore] Sun*, April 3, 1976, p. 5C.

49. Distinct Visions, Expressionist Sensibilities: An Exhibition of Three Milton Avery Distinguished Visiting Professors in the Arts, curated by Ann Schoenfeld at Edith C. Blum Art Institute, Milton and Sally Avery Center for the Arts, Bard College. March 6–May 6, 1983.

50. Gerrit Henry, "Grace Hartigan at Gruenebaum," *Art in America* 72, no. 5 (May 1984): 173.

51. Jeanne Silverthorne, "Grace Hartigan," *Artforum* 22 (May 1984): 91.

52. *Summer Street* (1956), *Billboard* (1957), *New England, October* (1957), *Montauk Highway* (1957), *Dublin* (1958–59), and *Sweden* (1959).

53. "Second generation" is commonly used to designate painters—regardless of their birth date—who came to Abstract Expressionism after its pioneers had developed it in the late forties.

54. Paul Schimmel, "The Lost Generation," in Schimmel et al., *Action/Precision*, 20.

55. Robert Rosenblum, "Excavating the 1950s," in Schimmel et al., *Action/Precision*, 17.

56. Grace Glueck, "Art: Gestural Approach, in Grey Gallery Show," *New York Times*, January 18, 1985.

57. Kenneth Baker, "Second Generation: Mannerism or Momentum?" *Art in America* 73 (June 1985): 102–11.

58. *Grace Hartigan and Irving Sandler* (video).

59. Steven Westfall, "Then and Now: Six of the New York School Look back," *Art in America* 73, no. 6 (June 1985): 118.

60. Forman, "A Palette Fresh and Brilliant," 15.

61. *Bacchus* (1595) is in the collection of the Uffizi Gallery in Florence, Italy. *Self-Portrait as Bacchus*, also known as *Young Sick Bacchus* (1593/1594), is in the Galleria Borghese in Rome. *Boy Bitten by a Lizard* (1593/1594) exists in two versions, in the National Gallery in London, and the Fondazione Roberto Longhi in Florence.

62. Author's interview with Julian Weissman in New York, June 5, 2012. Weissman had shown Hartigan's work when he was director of Gruenebaum Gallery. He later moved to ACA Gallery, where Hartigan was already showing, before founding Julian Weissman Fine Art, LLC.

63. Ronny Cohen, "Grace Hartigan," *Artforum*, April 1986, p. 106.

64. *The Knight, Death and the Devil* (1952), *River Bathers* (1953), *Grand Street Brides* (1954), *The Masker* (1954), *Show Case* (1955), *The Vendor* (1956).

65. The exhibition was co-curated by Paul Schimmel, chief curator at the Newport Harbor Art Museum, and Judith Stein, associate curator at the Pennsylvania Academy of Fine Arts, who were working on allied projects and decided to collaborate.

66. Hartigan, quoted in Edward J. Sozanski, "The Challenge to Abstract Art During the '50s: The Academy of Fine Arts Displays the Work of 13 NY Artists Who Followed Their Own Muse," *Philadelphia Inquirer*, October 23, 1988.

67. Willem de Kooning, quoted in David Sylvester, *Interviews with American Artists* (New Haven: Yale University Press, 2001), 50.

68. "Artist Grace Hartigan: New York Artist Made a Career in Baltimore," *Sunday [Baltimore] Sun Magazine*, Anniversary Issue, May 17, 1987, p. 34.

69. *Showcase* (1955) was donated in 1956. The museum now also owns an untitled Hartigan painting from ca. 1952, inscribed "To Walter" (bequest of Andrea Bolt, 2012); *Seated Figure*, from 1956, a drawing with cut, torn, and pasted paper (part of the 2005 bequest of museum curator William S. Lieberman), and additional silkscreens, including a Pallas Athena lithograph.

70. Hartigan's prices at Grimaldis had edged up to the high five figures at the time of her death, though by then other leading painters of the fifties were commanding far more.

71. Author's interview with Gunderson.

72. Forman, "A Palette Fresh and Brilliant," p. 13.

73. "New York Artist Made a Career in Baltimore," 34.

CHAPTER 17: PREVAILING

1. Hartigan telephone call to Robert Mattison, July 5, 1985, cited in Mattison, *Painter's World*, 122.
2. Author's interview with Stolz.
3. Author's interview with Stolz.
4. Author's interview with Kerns, June 4, 2013.
5. Mattison, *Painter's World*, 124; and Mattison, *Grace Hartigan*, 5.
6. Artist's Choice: Elizabeth Murray (also known as Elizabeth Murray: Modern Women) was shown at the Museum of Modern Art from June 20 to August 22, 1985.
7. *Grace Hartigan and Irving Sandler* (video).
8. The others included Helen Frankenthaler: A Painting Retrospective, organized in 1969 by the Whitney Museum of American Art (also seen in London, Berlin, and Hanover, Germany), and Helen Frankenthaler: Paintings, 1969–1974, at the Corcoran Gallery of Art in Washington, DC (1975). In 1989, the Modern Art Museum of Fort Worth organized a Frankenthaler retrospective that opened at the Museum of Modern Art in New York and was also shown at the Los Angeles County Museum of Art and the Detroit Institute of Arts.
9. The advertising copy wants us to believe that the "immensely talented wrist" that paints the paintings is the same one wearing the watch, yet the photo shows Frankenthaler with hers on her left hand. Because she was such a micromanager, it's a good bet that she insisted on vetting the copy before it was published (in 1990), but the negative may have been flipped.
10. E.A. Carmean, *Helen Frankenthaler: A Painting Retrospective* (New York: Harry N. Abrams/Modern Art Museum of Fort Worth, 1989).
11. Carmean, *Helen Frankenthaler*, 22.
12. Sonya Rudikoff, "Helen Frankenthaler's Painting," in *School of New York: Some Younger Artists*, ed. B. H. Friedman (New York: Grove, 1959), 12.
13. Carmean, *Helen Frankenthaler*, 22.
14. *Majas on a Balcony*, the version of the Goya painting Frankenthaler saw at the Met, is now listed as "attributed to" Goya.
15. Hartigan, cited in Hirsh, *Grace Hartigan*, 15.
16. Hirsh, *Grace Hartigan*, 22.
17. Hirsh, *Grace Hartigan*, 39.
18. VanDyke, *Painting from Popular Culture*, 9.
19. Hirsh, *Grace Hartigan*, 37.
20. Hirsh, *Grace Hartigan*, 33.
21. Hartigan oral history interview, Maryland Historical Society.
22. Fewer than 20 percent of shows in Paris were of art by women, according to Albers, *Joan Mitchell*, 292.
23. Albers, *Joan Mitchell*, 344.

24. Hartigan letter to Brenda Richardson, February 12, 1999, courtesy of Brenda Richardson. The foundation was established in 1994.

25. Author's telephone interview with Linda W. Johnson, June 25, 2013.

26. Vicky Hollowell letter to Hartigan, July 1, 1986, Hartigan Papers.

27. Baker died in 2001. Family information in this paragraph is from author's interview with Johnson.

28. Vicky Hollowell letter to Hartigan, January 15, 1987, Hartigan Papers.

29. Hartigan letter to Hollowell, June 17, 1987, courtesy of Vicky Jachens Herendeen.

30. Author's interview with Vicky Jachens Herendeen, June 21, 2013.

31. Valerie Lynn Jachens letter to Hartigan, August 11, 1987, Hartigan Papers.

32. Ellen Breitman letter to Hartigan, November 18, 1986, Hartigan Papers.

33. Hartigan letter to Breitman, November 24, 1986, courtesy of Ellen Breitman, who is still married to her "wonderful man."

34. Jeffrey Jachens postcard to Hartigan, August 8, 1988, Hartigan Papers.

35. Gift enclosure, Hartigan Papers.

36. *El Azteca* (1987) failed to reach its reserve price of $12,000 to $16,000 in a May 4, 2009, auction at Bonhams & Butterfields, Los Angeles and San Francisco (Lot 8090).

37. *Tarzana* (1987) is in the permanent collection of the University of Michigan Museum of Art.

38. Mattison, *Painter's World,* 135. (He erroneously refers to the designer as "Jane" Ewing.) Hartigan, he writes, was inspired by a photo of film star Betty Grable "floating in a pool, surrounded by dozens of equally curvaceous Grable dolls."

39. Hartigan lecture, Skowhegan School of Painting and Sculpture.

40. Annie Linskey, "Restless Creator' on a Half Century of American Art," *The [Baltimore] Sun,* November 23, 2003.

41. This group of paintings also included imagery based on visits to Miami Beach and Atlantic City.

42. Hartigan, quoted in Glenn McNeill, "Grace Hartigan, Clothing and Identity," *The [Baltimore] Sun,* May 25, 2000.

43. VanDyke, *Painting from Popular Culture.*

44. Stevens, "The Art of Painting the Opera," *The [Baltimore] Sun,* April 3, 1986, p. 5C.

45. Constance Adler, "Grace Notes," *Baltimore Magazine,* July 1988, p. 130.

46. VanDyke, *Painting from Popular Culture.*

47. VanDyke, *Painting from Popular Culture.*

48. O'Hara, *Collected Poems,* 63; first published in the March-April 1952 issue of *Partisan Review.* (According to the note on page 523, the third part of the poem was written separately in July 1951.) The title of the poem recalls Keats's "On First Looking into Chapman's Homer," which evokes the poet's excitement at the discoveries that can be made only through the imaginative world of literature.

49. Hartigan lecture, Skowhegan School of Painting and Sculpture.

50. Author's interview with Majerski.

51. Goldberg, "Grace Hartigan Still Hates Pop."
52. Wendell B. Bradley, "Don't Fear to Like Art, Abstractionist Urges," *Washington Post*, January 18, 1960, p. A3.
53. Glenn McNatt, "Uncovering Hidden Layers of Grace Hartigan," *The [Baltimore] Sun*, October 28, 2001.
54. Walter Thompson, "Grace Hartigan at Gruenebaum," *Art in America*, May 1988, p. 185.
55. Hartigan letter to Thomas Gruenebaum, August 15, 1987, Hartigan Papers.
56. Kouros Gallery letter to Hartigan, February 2, 1988, Hartigan Papers. Grace would get 40 percent of sales over $120,000; sales over $240,000 (wishful thinking) would involve a fifty-fifty split. Price list dated July 14, 1989, Hartigan Papers.
57. Mattison, *Painter's World*.
58. Jerry Tallmer, "A Lively Living Legend," *New York Post*, January 25, 1991, p. 47. Hartigan's painter friend Audrey Flack introduced her to ACA director Jeffrey Bergman at a holiday party.
59. Hartigan letter to Richardson, April 10, 1991, courtesy of Brenda Richardson.
60. Larson, "Gift Rap."
61. Hartigan letter to Paul Anbinder, March 26, 1990, Hartigan Papers.
62. Elaine Showalter, Lea Baechler, and A. Walton Litz, eds., *Modern American Women Writers* (New York: Charles Scribner's Sons, 1993).
63. *Grace Hartigan and Irving Sandler* (video).
64. John Dorsey, "Hartigan Looks Ahead after Brush with Disaster in Fire Beneath Her Studio," *[Baltimore] Sun,* January 14, 1992, pp. C1, C3.
65. April Kingsley letter to Hartigan, January 25, 1992, Hartigan Papers.
66. The exhibition was co-curated by Paul Schimmel at the Museum of Contemporary Art, Los Angeles, and Donna De Salvo at the Parrish Art Museum in Southampton, New York.
67. In her catalogue essay, "'Subjects of the Artists': Toward a Painting Without Ideals," Donna De Salvo described the objects in *Giftwares* as "kitschy items, especially cheaply made household goods." Russell Ferguson, ed., *Hand-Painted Pop: American Art in Transition, 1955–62* (Los Angeles: Museum of Contemporary Art/New York: Rizzoli, 1992), 70. The original objects in the window may have been cheaply made (though the painting predates the era of inexpensive imports from Japan), but Hartigan emphasizes their abstract qualities of shape and color; in my view, the painting is not about the ersatz quality of the items.
68. Hilton Kramer, in the *New York Observer*, quoted in Goldberg, "Grace Hartigan Still Hates Pop."
69. Sandler, *Sweeper-Up*, 238.
70. John Dorsey, "Art in Transition: Grace Hartigan Is Still Seeking New Ways to Express Her Artistry," *The [Baltimore] Sun*, August 15, 1993.
71. Hartigan, quoted in Carla Waldemar, "Hartigan Is Back in Style," *Twin Cities Reader*, [date unknown] 1984, p. 23, Hartigan Papers.
72. Dorsey, "Art in Transition."

73. Author's interview with Sandler.

74. VanDyke, *Painting from Popular Culture.*

75. Oldham, "Grace Hartigan," 29.

76. Hartigan letter to Richardson, April 10, 1991, courtesy of Brenda Richardson.

77. Hartigan, quoted in Hirsh, *Grace Hartigan,* 43.

78. Sidney Mishkin Gallery, Baruch College, City University of New York, March 18–April 22, 1994. The exhibition was curated by gallery director Sandra Kraskin, who wrote the catalogue essay.

79. Author's interview with Donna Sesee.

80. Elizabeth Stevens, "Hartigan Seeking Her Golden Age," *The [Baltimore] Sun,* November 9, 1979.

81. Author's interview with Modele.

82. Constance Adler, "Lunch with Grace Hartigan," 130.

83. Author's interview with Middleman.

84. Goldberg, "Grace Hartigan Still Hates Pop." In Eric Fischl's memoir, *Bad Boy,* written with Michael Stone, he describes this crucial stage of a painting as "that instant that is pregnant with some special kind of energy," which yields "an exquisite tension" between the imagery and the relationship of abstract forms. Eric Fischl, *Bad Boy* (New York: Crown, 2012), 101.

85. Pamela A. Brooks, "An 'Orange' Reunion at Skidmore," *The [Saratoga, NY] Post-Star,* March 26, 1993, p. D1.

86. Author's interview with Stevens.

87. Elaine de Kooning oral history interview, Archives of American Art, Smithsonian Institution.

88. Hartigan letter to Terence Diggory, March 22, 2001, courtesy of Terence Diggory.

89. Prioleau, *Seductresses,* 160.

90. The Rothko symposium, "Interchanges," took place at the Tate Gallery on June 27, 1987. It was introduced by Paul Wright and Irving Sandler; the panelists were Hartigan, Patrick Heron, and Bryan Robertson. The proceedings were taped, though never transcribed or digitized. Unfortunately, the museum was unable to locate a copy of the tape, so I was not able to obtain Hartigan's actual statements.

91. Hartigan was equally supportive of Sandler, praising his passion and scholarship in his memoir *A Sweeper-Up After Artists.* She wrote to him on January 7, 2004, that she read the book "with a lot of emotion and nostalgia."

92. Author's interview with Stolz.

93. Author's interview with Chandler.

94. Hartigan lecture, Skidmore College.

95. Russo, *Profiles,* 103.

96. Hartigan lecture, Skowhegan School of Painting and Sculpture.

97. Russo, *Profiles,* 100.

98. John Dorsey, "Art World's Spotlight Shines on Hartigan Once Again," *The [Baltimore] Sun,* October 28, 1990, pp. 1L, 3L.

99. John Dorsey, "Art in Transition: Grace Hartigan Is Still Seeking New Ways to Express Her Artistry," *The [Baltimore] Sun*, August 15, 1993.

100. Hartigan letter to Terence Diggory, July 24, 1974 (draft), Hartigan Papers.

101. Hartigan letter to Terence Diggory, September 11, 1994, courtesy of Terence Diggory.

102. Glenn McNatt, "Grace Hartigan, Clothing and Identity," *The [Baltimore] Sun*, May 25, 2000. I have not been able to locate this phrase in a search of the *New Yorker* archive.

103. Both Olitski and Caro were represented in Baltimore by Grace's gallery, C. Grimaldis.

104. Author's interview with Weissman.

105. Author's interview with Weissman.

106. Vicky Hollowell letter to Hartigan, December 22, 1992, Hartigan Papers.

107. Hartigan letter to Valerie Fuller, December 22, 2006, courtesy of Valerie Terrones.

108. Chronic alcohol use can damage the prefrontal cortex of the brain, responsible for "executive function"—which includes the ability to determine the consequences of an action and to suppress socially unacceptable behavior. Research into the link between alcoholism and lack of empathy includes a study published in *Alcoholism: Clinical & Experimental Research* 37, no. 2 (February 2013): 339–47.

109. Hartigan, quoted in VanDyke, *Painting from Popular Culture*.

110. Author's interview with Modele.

111. Author's interview with Moran.

112. Author's interview with Allen.

113. Catalogue essay and interview with Hartigan, Hirsh, *Grace Hartigan*. Hirsh is Charles A. Dana Professor of Art History at Dickinson College, Carlisle, PA.

114. Thanks to J. Bowers, "Grace and Will," *Baltimore City Paper*, November 19, 2003, for suggesting the comparison.

115. Author's interview with Gunderson.

116. Author's interview with Modele.

117. Author's interview with Modele.

118. Author's telephone interview with John Waters, September 25, 2013.

119. Author's interview with Lazarus.

120. Hartigan letter to Dorian and Jeffrey Bergen, July 1, 2001. Hartigan Papers.

121. Norman L. Kleeblatt, "Greenberg, Rosenberg, and Postwar American Art," in Kleeblatt, *Action Abstraction: Pollock, de Kooning, and American Art, 1940–1976* (New York: Jewish Museum/Yale University Press, 2008), 146.

122. Author's interview with Modele.

123. Author's interview with Moran.

124. Hartigan letter to Fay Chandler, November 5, 1990, Hartigan Papers.

125. Author's interview with Gunderson.

126. Author's interview with Cairns.

127. Author's interview with Moran.

128. Hartigan, quoted in Mary Carole McCauley, "A Restless Spirit: After a Surge of Fame, Painter Reinvented Her Art and Waited for World to Catch Up," *The* [*Baltimore*] *Sun*, November 17, 2008.

129. Barber, "Making Some Marks," 51.

130. VanDyke, *Painting from Popular Culture*.

Bibliography

ORAL HISTORY INTERVIEWS, ARCHIVES OF AMERICAN ART,
SMITHSONIAN INSTITUTION, WASHINGTON, D.C.

Aldrich, Larry. April 25–June 10, 1972.
Avery, Sally. February 19, 1982.
Baber, Alice. May 24, 1973.
Blackburn, Robert. December 4, 1970.
Burkhardt, Rudy. January 14, 1993.
de Kooning, Elaine. August 27, 1981.
de Nagy, Tibor. March 29, 1976.
Fine, Perle, January 19, 1968.
Flack, Audrey. February 16, 1989.
Frankenthaler, Helen. 1969.
Freilicher, Jane. August 4–5, 1987.
Hartigan, Grace. May 10, 1979.
Kasle, Gertrude. July 24, 1975.
Kienbusch, William. November 1–7, 1968.
McCray, Porter. September 17–October 4, 1977.
Motherwell, Robert. November 24, 1971–May 1, 1974.
Sander, Ludwig. February 4–12, 1969.
Schapiro, Miriam. September 10, 1989.
Sterne, Hedda. December 17, 1981.

RADIO, FILM, VIDEO, AND UNPUBLISHED INTERVIEWS
AND LECTURES

The Art of Harry Jackson (video). Written, directed, and narrated by Harry Jackson.
 1987. www.harryjacksonstudios.com.
The Art of Poetry (audio recording). Interview with Charles Bernstein, 1995. LINEbreak
 (radio series), http://jacket2.org/interviews/linebreak-barbara-guest-conversation-
 charles-bernstein

Fishko Files: Postwar Painters (audio recording). WNYC, October 1, 2010, www.wnyc
.org/shows/fishko/2010/oct/01/

"General Remarks by Grace Hartigan." Seminar at the University of Minnesota, 1963.
Irving Sandler Collection, Getty Research Institute, Los Angeles, CA.

Grace Hartigan and Irving Sandler (video). November 11, 1994. Fulcrum Gallery,
New York, *Artists Talk on Art* series, Douglas I. Sheer, executive producer.

Grace Hartigan: Shattering Boundaries (film). 2008. Amici Productions, Alice Shure
and Janice Stanton, producers.

Hans Hofmann: Artist/Teacher, Teacher/Artist (video). Narrated by Robert de Niro.
Madeline Amgott, producer. First broadcast on PBS June 2003.

Hartigan, Grace. "The Education of an Artist." Typewritten notes. Art Teachers Asso-
ciation, n.d. Courtesy of Irving Sandler.

Hartigan, Grace. Interview by Patrick Taylor. October 2, 1981. Hartigan Archive,
Special Collections, Syracuse University, Syracuse, NY.

Hartigan, Grace. Lecture (video). Schick Art Gallery, Skidmore College. March 26,
1993. Courtesy of Terence Diggory.

Hartigan, Grace. Lecture. Skowhegan School of Painting and Sculpture, Madison, ME.
Summer 1990. Museum Archives, Museum of Modern Art, New York.

Hartigan, Grace. Interview by Bob Lesser. April 20, 1965. "Listening to Pictures" pro-
gram, Brooklyn Museum. Archives of American Art, Smithsonian Institution,
Washington, DC. Gift of the Brooklyn Museum.

"Hartigan on 'Community.'" Notes. January 14, 1974. Courtesy of Irving Sandler.

Hartigan, Grace. Oral history interview. Paula Rome, interviewer. May 15, 1975. Oral
History Collections, Maryland Historical Society, Baltimore, MD.

Inside New York's Art World: Interview with Larry Rivers (video). 1978. Barbaralee
Dimondstein-Spielvogel Collection 1976–99, Rubenstein Library, Duke Univer-
sity, Durham, NC.

Inside New York's Art World: Interview with Lee Krasner (video). 1978. Barbaralee
Dimondstein-Spielvogel Collection 1976–99, Rubenstein Library, Duke Univer-
sity, Durham, NC.

Inside New York's Art World: Interview with Thomas Hess (video). 1977. Barbaralee Dia-
mondstein-Spielvogel Video Archive, David M. Rubenstein Rare Book & Manu-
script Library, Duke University, Durham, NC.

Kennan, George F. "International exchange in the arts," address at a symposium spon-
sored by the International Council of the Museum of Modern Art. May 12, 1955.
http://www.americansforthearts.org/sites/default/files/pdf/2013/by_program/
legislation_and_policy/issues/kennan_internationalexchange.pdf.

Meet the Artist: Grace Hartigan (video). Smithsonian American Art Museum. Available at
https://www.youtube.com/watch?v=e-mzSLQL1nk...index=27...list=PL3A50
F86AE9A35934.

Painters Painting: The New York Art Scene 1940–1970, 1972 (film). Produced and
directed by Emile de Antonio.

Painters and Poets: 60 Years of the Tibor de Nagy Gallery (audio recording). The New School, January 1, 2011.

"Painting a Revolution" (video). *CBS Sunday Morning*. February 28, 1993.

BOOKS, EXHIBITION CATALOGUES, AND DISSERTATIONS

Abel, Lionel. *The Intellectual Follies*. New York: W.W. Norton, 1984.

Acocella, Joan. *Twenty-Eight Artists and Two Saints*. New York: Pantheon, 2007.

Adams, Henry. *Tom and Jack: The Intertwined Lives of Thomas Hart Benson and Jackson Pollock*. New York: Bloomsbury, 2009.

Albers, Patricia. *Joan Mitchell: Lady Painter*. New York: Alfred A. Knopf, 2011.

Artists' Sessions at Studio 35 (1950). Chicago: Soberscove Press/Wittenborn Art Books, 2009.

Ashbery, John. *Reported Sightings: Art Chronicles, 1957–1987*. Cambridge, MA: Harvard University Press, 1991.

Ashton, Dore. *A Joseph Cornell Album*. New York: Da Capo, 2009.

Ashton, Dore. *The New York School: A Cultural Reckoning*. New York: Viking, 1973.

Auping, Michael. *Abstract Expressionism: The Critical Developments*. New York: Harry N. Abrams/Albright-Knox Art Gallery, 1987. Exhibition catalogue.

Auping, Michael, *Philip Guston Retrospective*. New York: Thames & Hudson, 2003. Exhibition catalogue.

Barr, Alfred H. Jr. *Defining Modern Art: Selected Writings*. New York: Harry N. Abrams, 1986.

Belasco, Daniel. *Between the Waves: Feminist Positions in American Art, 1949–62*. Ph.D. dissertation, New York University Institute of Fine Arts, September 2008.

Berkson, Bill, and Joe LeSeur, eds. *Homage to Frank O'Hara*. Bolinas, CA: Big Sky, 1998.

Bernstock, Judith E. *Joan Mitchell*. New York: Hudson Hills Press, 1988.

Brennan, Marcia. *Modernism's Masculine Subjects: Matisse, the New York School, and Post-Painterly Abstraction*. Cambridge, MA: MIT Press, 2004.

Breslin, James E. B. *Mark Rothko: A Biography*. Chicago: University of Chicago Press, 1993.

Broude, Norma. *Grace Hartigan: A Mini-Retrospective 1954–1984*. Washington, DC: Watkins Art Gallery/American University, 1987. Exhibition catalogue.

Broyard, Anatole. *Kafka Was the Rage: A Greenwich Village Memoir*. New York: Vintage Books, 1997.

Bush, Martin. *Goodnough*. New York: Abbeville, 1982.

Carmean, E. A. *Helen Frankenthaler: A Paintings Retrospective*. (New York: Harry N. Abrams/Modern Art Museum of Fort Worth, 1989. Exhibition catalogue.

Contemporary Art 1942–72: Collection of the Albright Knox Art Gallery. New York: Praeger, 1973.

Coolidge, Clark, ed. *Philip Guston: Collected Writings, Lectures, and Conversations*. Berkeley: University of California Press, 2011.

Cooper, Harry. *The Robert and Jane Meyerhoff Collection: Selected Works.* Washington, DC/Farnham, UK: National Gallery of Art/Lund Humphries, 2009. Exhibition catalogue.

Corbett, William. *Just the Thing: Selected Letters of James Schuyler.* New York: Turtle Point, 1994.

Corbett, William. *Philip Guston's Late Work: A Memoir.* Cambridge, MA: Zoland, 1994.

Crase, Douglas. *Both: A Portrait in Two Parts.* New York: Pantheon, 2004.

Crase, Douglas, and Jenni Quilter. *Painters & Poets: Tibor de Nagy Gallery.* New York: Tibor de Nagy Gallery, 2011.

Danchev, Alex. *Cézanne: A Life.* New York: Pantheon, 2012.

Dawson, Fielding. *An Emotional Memoir of Franz Kline.* New York: Pantheon, 1967.

de Beauvoir, Simone. *America Day by Day.* Translated by Carol Cosman. Berkeley: University of California Press, 1999.

de Kooning, Elaine. *The Spirit of Abstract Expressionism: Selected Writings.* New York: George Braziller, 1994.

de Kruif, Paul. *The Sweeping Wind.* New York: Harcourt, Brace & World, 1962.

Diggory, Terence. *Encyclopedia of the New York School Poets.* New York: Facts on File/ Infobase Publishing, 2009.

Diggory, Terence. "Grace Hartigan." In *Dictionary of Women Artists*, vol. 1, ed. Delia Gaze. London: Routledge, 1997.

Diggory, Terence. *Grace Hartigan and the Poets: Paintings and Prints.* Saratoga Springs, NY: Schick Art Gallery, 1993.

Diggory, Terence, and Stephen Paul Miller. *The Scene of My Selves: New Work on New York School Poets.* Orono, ME: National Poetry Foundation, 2001.

Doty, Robert, ed. *Jane Freilicher: Paintings.* New York: Taplinger/ Currier Gallery of Art, 1986. Exhibition catalogue.

Drawing on the East End, 1940–1988. Southampton, NY: Parrish Art Museum, 1988. Exhibition catalogue.

Edgar, Natalie, ed. *Club Without Walls: Selections from the Journals of Philip Pavia.* New York: Midmarch Arts Press, 2007.

Elderfield, John. *de Kooning: A Retrospective.* New York: Museum of Modern Art, 2011. Exhibition catalogue.

Elderfield, John. *Museum of Modern Art at Mid-Century: At Home and Abroad.* Studies in Modern Art 4. New York: Museum of Modern Art, 1994.

Elderfield, John, ed. *Painted on 21st Street: Helen Frankenthaler from 1950 to 1959.* New York: Abrams/Gagosian Gallery, 2013. Exhibition catalogue.

Feld, Ross. *Guston in Time: Remembering Philip Guston.* New York: Counterpoint/ Perseus, 2003.

Ferguson, Russell, ed. *Hand-Painted Pop: American Art in Transition, 1955–62.* Los Angeles: Museum of Contemporary Art/ New York: Rizzoli, 1992. Exhibition catalogue.

Ferguson, Russell. *In Memory of My Feelings: Frank O'Hara and American Art.* Berkeley: University of California Press, 1999. Exhibition catalogue.

Fischl, Eric. *Bad Boy*. New York: Crown, 2012.

Frank, Elizabeth. *Louise Bogan: A Portrait*. New York: Columbia University Press, 1986.

Frascina, Francis, and Charles Harrison. *Modern Art and Modernism: A Critical Anthology*. London: Paul Chapman/ Open University, 1982.

Friedman, B. H. *Alfonso Ossorio*. New York: Abrams, 1972.

Friedman, B. H. *Circles*. New York: Fleet, 1962.

Friedman, B. H., ed. *Give My Regards to Eighth Street: Collected Writings of Morton Feldman*. Cambridge, MA: Exact Change, 2000.

Friedman, B. H. *Jackson Pollock: Energy Made Visible*. New York: McGraw-Hill, 1972.

Friedman, B. H. *School of New York: Some Younger Artists*. New York: Grove Press, 1959.

Frost, Douglas L. *Making History/Making Art/MICA*. Baltimore: Maryland Institute College of Art, 2010.

Gaines, Steven. *Philistines at the Hedgerow: Passion and Property in the Hamptons*. New York: Little Brown, 1998.

Gaugh, Harry F. *The Vital Gesture: Franz Kline*. New York: Abbeville, 1985. Catalogue for the Cincinnati Art Museum exhibition The Vital Gesture: Franz Kline in Retrospect.

Gibson, Ann Eden. *Abstract Expressionism: Other Politics*. New Haven: Yale University Press, 1997.

Gooch, Brad. *City Poet: The Life and Times of Frank O'Hara*. New York: Knopf, 1993.

Goodrich, Lloyd, and John I. H. Baur. *American Art of Our Century*. New York: Whitney Museum of American Art, 1961.

Gordon, Alastair. *Weekend Utopia: Modern Living in the Hamptons*. New York: Princeton Architectural Press, 2001.

Gordon, Linda. *Dorothea Lange: A Life Beyond Limits*. New York: W. W. Norton, 2010.

Gouma-Peterson, Thalia. *Miriam Schapiro: Shaping the Fragments of Art and Life*. New York: Harry N. Abrams, 1999.

Gouma-Peterson, Thalia, Patricia Hills, et al. *Breaking the Rules: Audrey Flack, A Retrospective 1950–1990*. New York: Harry N. Abrams, 1992.

Grace Hartigan. Purchase, NY: Neuberger Museum of Art, 2001. Exhibition catalogue.

Grace Hartigan: A Life in Painting. Baltimore: C. Grimaldis Gallery, 2010. Exhibition catalogue.

Greenberg, Clement. *The Collected Essays and Criticism, vol. 2: Arrogant Purpose, 1945–1949*, ed. John O'Brian. Chicago: University of Chicago Press, 1986.

Greenberg, Clement. *Late Writings*. Minneapolis: University of Minnesota Press, 2003.

Gruen, John. *The Party's Over Now: Reminiscences of the Fifties— New York's Artists, Writers, Musicians, and Their Friends*. Wainscott, NY: Pushcart Press, 1989.

Guest, Barbara, *The Collected Poems*. Edited by Hadley Haden. Middletown, CT: Wesleyan University Press, 2008.

Hall, Lee. *Elaine and Bill: Portrait of a Marriage*. New York: HarperCollins, 1993.

Harding, James M. Jr., and Cindy Rosenthal, eds. *Restaging the Sixties: Radical Theaters and Their Legacies*. Ann Arbor: University of Michigan Press, 2006.

Harrison, Helen A., ed. *Such Desperate Joy: Imagining Jackson Pollock.* New York: Thunder's Mouth, 2000.

Harrison, Helen A., and Constance Ayers Denne. *Hamptons Bohemia: Two Centuries of Artists and Writers on the Beach.* San Francisco: Chronicle, 2002.

Hartigan '62. New York: Martha Jackson Gallery, 1962. Exhibition catalogue.

Herskovic, Marina. *New York School Abstract Expressionist Artists: Artists' Choice by Artists: A Complete Documentation of the New York Painting and Sculpture Annuals: 1951–1957.* New York: New York School Press, 2000.

Hirsh, Sharon L. *Grace Hartigan: Painting Art History.* Carlisle, PA: Trout Gallery, Dickinson College, 2003.

Hoban, Phoebe. *Alice Neel: The Art of Not Sitting Pretty.* New York: St. Martin's, 2010.

Hobbs, Robert. *Lee Krasner.* New York: Abbeville Press, 1993.

Hofmann, Hans. *The Search for the Real and Other Essays.* Cambridge, MA: MIT Press, 2005. Reprint.

Housley, Kathleen L. *Tranquil Power: The Art and Life of Perle Fine.* New York: Midmarch Arts, 2005.

Imagine! Painters and Poets of the New York School. Syracuse: Syracuse University Library, Special Collections Research Center, 2006. Exhibition catalogue.

Johnson, Joyce. *Minor Characters.* New York: Penguin, 1999.

Kaufmann, David. *Telling Stories: Philip Guston's Later Works.* Berkeley: University of California Press, 2010.

Kertess, Klaus. *Jane Freilicher: Paintings.* New York: Harry N. Abrams, 2004.

Kertess, Klaus. *Joan Mitchell.* New York: Harry N. Abrams, 1997.

Kingsley, April. *Emotional Impact: American Figurative Expressionism.* East Lansing: Michigan State University Press, 2013.

Kingsley, April. *The Turning Point: The Abstract Expressionists and the Transformation of American Art.* New York: Simon & Schuster, 1992.

Klaiman, Gloria. *Night and Day: The Double Lives of Artists in America.* New York: Praeger, 2005.

Kleeblatt, Norman L. *Action Abstraction: Pollock, de Kooning, and American Art, 1940–1976.* New York: Jewish Museum/ New Haven: Yale University Press, 2008. Exhibition catalogue.

Kraskin, Sandra. *Reclaiming Artists of the New York School: Toward a More Inclusive View of the 1950s.* New York: Baruch College, City University of New York, 1994. Exhibition catalogue.

Kuh, Katherine. *My Love Affair with Modern Art.* New York: Arcade, 2006.

La Moy, T., and Joseph P. McCaffrey, eds. *The Journals of Grace Hartigan, 1951–1955.* Syracuse: Syracuse University Press, 2009.

Landau, Ellen G. *Reading Abstract Expressionism: Context and Critique.* New Haven: Yale University Press, 2005.

Landau, Ellen G., Phyllis Braff, and Sandra Kraskin. *Mercedes Matter.* New York: MB Art Publishing, 2010.

Larsen, Kay. *Where the Heart Beats: John Cage, Zen Buddhism, and the Inner Life of Artists*. New York: Penguin, 2012.

Lehman, David. *The Last Avant-Garde: The Making of the New York School of Poets*. New York: Anchor Books, 1999.

Leigh, Ted, ed. *Material Witness: The Selected Letters of Fairfield Porter*. Ann Arbor: University of Michigan Press, 2005.

LeSueur, Joe. *Digressions on Some Poems by Frank O'Hara: A Memoir*. New York: Farrar, Straus and Giroux, 2003.

Levin, Gail. *Lee Krasner: A Biography*. New York: William Morrow, 2011.

Lewis, Sinclair. *Arrowsmith*. New York: Harcourt Brace, 1925.

Lisle, Laurie. *Louise Nevelson: A Passionate Life*. New York: Summit, 1990.

Livingston, Jane. *The Paintings of Joan Mitchell*. New York: Whitney Museum of American Art/University of California Press, 2002. Exhibition catalogue.

Lohser, Beate, and Peter M. Newton. *Unorthodox Freud: The View from the Couch*. New York: Guilford, 1996.

Lord, M. G. *Forever Barbie: The Unauthorized Biography of a Real Doll*. New York: Walker, 2004.

Lowry, Glen. *Art in Our Time: A Chronicle of the Museum of Modern Art*. New York: Museum of Modern Art, 2004.

Malina, Judith. *The Diaries of Judith Malina, 1946–1957*. New York: Grove, 1984.

Marquis, Alice Goldfarb. *Alfred H. Barr Jr.: Missionary for the Modern*. Chicago: Contemporary, 1989.

Marter, Joan. *Women and Abstract Expressionism: Painting and Sculpture, 1945–1959*. New York: Sidney Mishkin Gallery/ Baruch College, 1997. Exhibition catalogue.

Mattison, Robert Saltonstall. *Grace Hartigan: Painting the Renaissance*. New York: Gruenebaum Gallery, 1986. Exhibition catalogue.

Mattison, Robert Saltonstall. *Grace Hartigan: A Painter's World*. New York: Hudson Hills, 1990.

Mayer, Musa. *Night Studio: A Memoir of Philip Guston*. New York: Knopf, 1988.

McKee, Renee, ed. *Philip Guston*. London: Whitechapel Gallery, 1982. Exhibition catalogue.

Mecklenburg, Virginia M. *Modern Masters: American Abstraction at Midcentury*. London: D. Giles, 2009.

Miller, Dorothy. *12 Americans*. New York: Museum of Modern Art, 1956. Exhibition catalogue.

Munro, Eleanor. *Originals: American Women Artists*. New York: Simon & Schuster, 1979.

Myers, John Bernard. *Tracking the Marvelous: A Life in the New York Art World*. New York: Random House, 1983.

Nahas, Dominique. *Grace Hartigan: New Painting*. Baltimore: C. Grimaldis Gallery, 2007. Exhibition catalogue.

Naifeh, Steven, and Gregory White Smith. *Jackson Pollock: An American Saga*. New York: Clarkson N. Potter, 1989.

Nelson, Maggie. *Women, The New York School, and Other True Abstractions.* Iowa City: University of Iowa Press, 2007.

Nemser, Cindy. *Art Talk: Conversations with 12 Women Artists.* New York: Scribner, 1975.

New American Painting: As Shown in Eight European Countries 1958–1959. New York: Museum of Modern Art, 1959. Exhibition catalogue.

New American Painting as Shown in Eight European Countries 1958–1959. New York: Museum of Modern Art, 1959. Exhibition catalogue.

Newman, Amy. *Challenging Art: Artforum 1962–1975.* New York: Soho Press, 2003.

Nordness, Lee, ed. *Art USA Now*, vol. 2. New York: Viking, 1963.

Offit, Paul A. *Vaccinated: Triumph, Controversy and an Uncertain Future.* New York: HarperCollins, 2009.

O'Hara, Frank. *Art Chronicles: 1954–1966.* New York: George Braziller, 1975.

O'Hara, Frank. *The Collected Poems.* Edited by Donald Allen. Berkeley: University of California Press, 1995.

O'Hara, Frank. *In Memory of My Feelings.* New York: Museum of Modern Art, 2005.

O'Hara, Frank. *Selected Poems.* New York: Alfred A. Knopf, 2008.

O'Hara, Frank. *Standing Still and Walking in New York.* Edited by Donald Allen. San Francisco: Grey Fox, 1983.

Ottman, Klaus, and Korothy Kosinski. *Angels, Demons, and Savages: Pollock, Osorio, Dubuffet.* New Haven: Yale University Press, 2013. Exhibition catalogue.

Paintings by Grace George Hartigan. Poughkeepsie, NY: Vassar College Art Gallery, 1954. Exhibition catalogue.

Perl, Jed. *New Art City: Manhattan at Mid-Century.* New York: Vintage, 2007.

Perloff, Marjorie. *Frank O'Hara: Poet Among Painters.* New York: George Braziller, 1977.

Pisano, Ronald G. *Long Island Landscape Painting, Vol. II: The Twentieth Century.* Boston: Bulfinch, 1990.

Porter, Fairfield. *Art in its Own Terms: Selected Criticism 1935–1975.* Edited by Rackstraw Downes. Cambridge, MA: Zoland, 1979.

Potter, Jeffrey. *To a Violent Grave: An Oral Biography of Jackson Pollock.* New York: Putnam, 1985.

Prioleau, Betsy. *Seductresses: Women Who Ravished the World and Their Lost Art of Love.* New York: Viking, 2003.

Puniello, Françoise S., and Halina R. Rusak. *Abstract Expressionist Women Painters: An Annotated Bibliography.* Lanham, MD: Scarecrow, 1996.

Richardson, Brenda. *Grace Hartigan: Twenty-Five Years of Collage.* Baltimore: Baltimore Museum of Art, 1980. Exhibition catalogue.

Rivers, Larry, with Arnold Weinstein. *What Did I Do? The Unauthorized Autobiography.* New York: Thunder's Mouth, 1992.

Rose, Barbara. *Frankenthaler.* New York: Harry N. Abrams, 1970.

Rose, Barbara. *Lee Krasner.* Houston: Museum of Fine Arts/ New York: Museum of Modern Art: 1983. Exhibition catalogue.

Rosenberg, Harold. *The Tradition of the New.* New York: Da Capo, 1994.

Rosenquist, James, with David Dalton. *Painting Below Zero: Notes on a Life in Art.* New York: Knopf, 2009.

Rosenthal, Mark. *The Robert and Jane Meyerhoff Collection: 1949 to 1995.* Washington, DC: National Gallery of Art, 1996. Exhibition catalogue.

Rosenzweig, Phyllis. *The Fifties: Aspects of Painting in New York.* Washington, DC: Hirshhorn Museum and Sculpture Garden, Smithsonian Institution, 1980. Exhibition catalogue.

Rosenzweig, Phyllis. *Grace Hartigan and Abstract Expressionist Pointillism.* Baltimore: Loyola College, 1997.

Rubenfeld, Florence. *Clement Greenberg: A Life.* New York: Scribner, 1997.

Russo, Alexander. *Profiles on Women Artists.* Frederick, MD: University Publications of America, 1985.

Sandler, Irving. *Abstract Expressionism and the American Experience: A Reevaluation.* New York: School of Visual Arts, 2009.

Sandler, Irving. *A Sweeper-Up After Artists.* London: Thames & Hudson, 2004.

Sandler, Irving. *The Triumph of American Painting: A History of Abstract Expressionism.* New York: Praeger, 1970.

Sawin, Martica, *Nell Blaine: Her Art and Life.* New York: Hudson Hills, 1998.

Schimmel, Paul, B. H. Friedman, John Myers, and Robert Rosenblum. *Action Precision: The New Direction in New York 1955–60.* Newport Beach, CA: Newport Harbor Art Museum, 1985.

Schimmel, Paul, and Judith E. Stein. *The Figurative Fifties: New York Figurative Expressionism.* Newport Beach, CA: Newport Harbor Art Museum, 1988.

Schoenfeld, Ann. *Distinct Visions, Expressionist Sensibilities: An Exhibition of Three Milton Avery Distinguished Visiting Professors in the Arts.* Annendale-on-Hudson, NY: Avery Center for the Arts, Bard College, 1983. Exhibition catalogue.

Schueler, Jon. *The Sound of Sleat: A Painter's Life.* New York: Picador USA, 1999.

Shaw, Lytle. *Frank O'Hara: The Poetics of Coterie.* Iowa City: University of Iowa Press, 2006.

Shiff, Richard. *Between Sense and de Kooning.* London: Reaktion, 2011.

Siegel, Katy, ed. *Abstract Expressionism.* New York: Abrams, 2011.

Silverman, Kenneth. *Begin Again: A Biography of John Cage.* New York: Knopf, 2010.

Slifkin, Robert. *Out of Time: Philip Guston and the Refiguration of Postwar American Art.* Berkeley: University of California Press, 2013.

Solomon, Deborah. "An Interview with Helen Frankenthaler." In *Partisan Review: The 50th Anniversary Edition,* ed. William Phillips. New York: Stein and Day, 1984.

Sontag, Susan. *Against Interpretation.* New York: Dell, 1966.

Spike, John T. *Fairfield Porter: An American Classic.* New York: Harry N. Abrams, 1992.

Spring, Justin. *Fairfield Porter: A Life in Art.* New Haven: Yale University Press, 2000.

Spring, Justin. *Wolf Kahn.* New York: Abrams, 1996.

Spurling, Hilary. *Matisse the Master—A Life of Matisse: The Conquest of Color, 1909–1954.* New York: Knopf, 2007.

Spurling, Hilary. *The Unknown Matisse—A Life of Matisse: The Early Years, 1869–1908.* New York: Knopf, 2005.

Steinberg, Leo. *The New York School, Second Generation: Paintings by Twenty-three Artists.* New York: Jewish Museum, 1957. Exhibition catalogue.

Stevens, Mark, and Annalyn Swan. *de Kooning: An American Master.* New York: Knopf, 2005.

Stich, Sidra. *Made in U.S.A.: An Americanization in Modern Art, the '50s & '60s.* Berkeley: University of California Press, 1987.

Stiles, Kristine, and Peter Selz. *Theories and Documents of Contemporary Art: A Sourcebook of Artists' Writings.* California Studies in the History of Art. Berkeley: University of California Press, 1996.

Strausbaugh, John. *The Village: 400 Years of Beats and Bohemians, Radicals and Rogues.* New York: Ecco, 2013.

Sylvester, David. *Interviews with American Artists.* New Haven: Yale University Press, 2001.

Tabak, May. *But Not for Love.* New York: Horizon, 1960.

Tierney, Tom. *Great Empresses and Queens Coloring Book.* New York: Dover, 1982.

VanDyke, Jonathan. *Grace Hartigan: Painting from Popular Culture, Three Decades.* Harrisburg, PA: Susquehanna Art Museum, 2000.

Voss, Ralph. *A Life of William Inge: The Strains of Triumph.* Lawrence: University Press of Kansas, 1989.

Wilkin, Karen. *Tibor de Nagy Gallery: The First Fifty Years.* New York: Tibor de Nagy Gallery, 2000.

PERIODICALS AND NEWSPAPERS

Adler, Constance. "Lunch with Grace Hartigan: Grace Notes." *Baltimore Magazine,* July 1988, p. 130.

Adrian, Dennis. "New York: Grace Hartigan." *Artforum* 5, no. 8 (April 1967): 59.

"Anguish Gone." *Newsweek,* October 29, 1962, p. 51.

Anson, Cherrill. "America's Top Woman Painter." *Sunday [Baltimore] Sun Magazine,* March 17, 1963, pp. 17–22.

Arb, Renée. "Spotlight on de Kooning," *Art News* 47, no. 2 (April 1948): 33.

"Artist Grace Hartigan: New York Artist Made a Career in Baltimore." *Sunday [Baltimore] Sun Magazine,* Anniversary Issue, May 17, 1987, pp. 33–34.

"Artist's Comments." *Gallery News.* Brooklyn College Art Department, April 19, 1990.

Ashton, Dore. "Art: Painters Meet Poet." *New York Times,* January 25, 1959.

Baker, Kenneth. "Second Generation: Mannerism or Momentum?" *Art in America* 73, no. 6 (June 1985): 102–11.

Barber, Allen. "Making Some Marks." *Arts Magazine* 48, no. 9 (June 1974): 49–51.

Barr, Alfred H. "Is Modern Art Communistic?" *New York Times Magazine,* December 14, 1952, pp. 22–23, 28–30.

Baur, John I. H. "Eastern Artists." *Art in America* 42 (January 1954): 18–19.

"The Best?" [about Jackson Pollock]. *Time*, December 1, 1947.

Bixler, Sally Ann. "We Hitch Our Wagons." *Mademoiselle*, August 1959, p. 243.

Bowers, J. "Grace and Will." *Baltimore City Paper,* November 19, 2003.

Boxer, Sarah. "The Last Irascible." *New York Review of Books*, December 23, 2010.

Brach, Paul. "Two Postscripts." *Artforum* 3 (September 1965): 32.

Bradley, Wendell P. "Don't Fear to Like Art, Abstractionist Urges." *Washington Post*, January 18, 1960.

Brooks, Pamela A. "An 'Orange' Reunion at Skidmore." *The [Saratoga, NY] Post-Star*, March 26, 1993.

Campbell, Lawrence [L.C.]. "Grace Hartigan, Larry Rivers, Frank O'Hara." *Art News* 58 (December 1959): 18.

Campbell, Lawrence [L.C.]. "George Hartigan." *Art News* 50 (February 1951).

Campbell, Lawrence. "New Figures at the Uptown Whitney." *Art News* 54 (February 1955): 35.

Campbell, Lawrence [L.C.]. "Reviews and Previews: Grace Hartigan." *Art News* 54 (March 1955): 51–52.

Campbell, Lawrence [L.C.]. "To See the World Mainly Through Art: Grace Hartigan's *Great Queens and Empresses* (1983)." *Arts Magazine* 58, no. 5 (January 1984): 87–89.

Canaday, John. "Art: Rockefeller's Taste." *New York Times*, July 10, 1962.

Canaday, John. "In the Gloaming: Twilight Seems to be Settling Rapidly for Abstract Expressionism." *New York Times*, September 11, 1960.

Canaday, John. "Sometimes You Feel Sorry." *New York Times*, March 21, 1965.

Coates, Robert. "The Art Galleries." *The New Yorker*, January 17, 1948, pp. 56–57.

Coates, Robert. "The Art Galleries: Abroad and at Home." *The New Yorker,* March 30, 1946, pp. 83–84.

Cohen, Ronny. "Grace Hartigan." *Artforum* 24 (April 1986): 106.

Curtis, Cathy. "The Figurative '50s—for Sentimental Reasons: Clinging to the '50s and Exploring the '80s." *Los Angeles Times*, July 24, 1988.

Curtis, Cathy. "Insights to Figurative '50s: Artists at Newport Museum Relive Spirited New York Era." *Los Angeles Times*, July 20, 1988.

Darwent, Charles. "Grace Hartigan: New York School Painter Who Later Rejected Abstract Expressionism." *The Independent* [UK], December 8, 2008.

de Kooning, Willem. "What Abstract Art Means to Me." *Bulletin of the Museum of Modern Art* 18, no. 3 (Spring 1951): 4–8.

Devree, Howard. "About Art and Artists: Schucker, Grace Hartigan and Spruance Represented in One-Man Shows." *New York Times*, March 3, 1955.

Diggory, Terrence. "Questions of Identity in Oranges by Frank O'Hara and Grace Hartigan." *Art Journal,* Winter 1993, p. 46.

Donihi, Rosemary. "As Value Soars, Hartigan Won't Barter Art Again." *Washington Post*, January 20, 1960.

Dorsey, John. "Art in Transition: Grace Hartigan Is Still Seeking New Ways to Express Her Artistry." *The [Baltimore] Sun*, August 15, 1993.

Dorsey, John. "Art World's Spotlight Shines on Hartigan Once Again." *The [Baltimore] Sun*, October 28, 1990.

Dorsey, John. "Baltimore's Stock Rising as Place for Artists to Work but It's a Long Way from N.Y." *The [Baltimore] Sun*, October 26, 1987.

Dorsey, John. "Hartigan Looks Ahead after Brush with Disaster in Fire Beneath Her Studio." *The [Baltimore] Sun,* January 14, 1992.

Esterow, Milton. "Artists, on Tape, Explain Pictures at Exhibition." *New York Times*, April 26, 1968.

Esterow, Milton. "The Second Time Around." *ARTnews*, Summer 1990, pp. 152–53.

Fitzsimmons, James. "Art." *Arts & Architecture* 70 (April/May 1953): 4.

Fitzsimmons, James. "Art." *Arts & Architecture* 71 (March 1954): 30.

Fitzsimmons, James [J.F.]. "George Hartigan." *Art Digest* 27 (April 1, 1953): 17.

Fitzsimmons, James [J.F.]. "George Hartigan." *Art Digest* 25 (February 1, 1951): 18–19.

Fitzsimmons, James [J.F.]. "George Hartigan." *Art Digest* 26 (April 1, 1952): 23.

Flanner, Janet. "Profiles: King of the Wild Beasts–II." *The New Yorker*, December 29, 1951, pp. 26–49.

Forman, Debbie. "A Palette Fresh and Brilliant." *Cape Cod Times*, August 21, 1986.

Freilicher, Jane. Editor's Letters. *Art News* 61 (December 1961): 5.

Genauer, Emily. "Still Life with Red Herring." *Harper's Magazine*, September 1949, p. 89.

G.L. "10th St. Main Street of the Art World." *Esquire,* September 1959.

Goldberg, Vicki. "Grace Hartigan Still Hates Pop." *New York Times*, August 15, 1993.

Goodnough, Robert [R.G.]. "George Hartigan." *Art News* 51 (April 1952): 44.

Greenberg, Clement. "The Present Prospects of American Painting and Sculpture." *Horizon*, October 1947, pp. 29–30.

Grimes, William. "Grace Hartigan, 86, Abstract Painter, Dies." *New York Times*, November 18, 2008.

Hamill, Pete. "Beyond the Vital Gesture." *Art & Antiques*, May 1990.

Henry, Gerrit. "Grace Hartigan at Gruenebaum." *Art in America* 72, no. 5 (May 1984): 173.

Hess, Thomas [T.B.H.]. "New York's Avant-Garde" [review of the *Ninth Street Show*]. *Art News* 50, no. 46 (June 1951): 46–47.

Hess, Thomas. "Younger Artists and the Unforgivable Crime." *Art News* 56 (April 1957): 46–49, 64–65.

Hess, Thomas. "U.S. Painting: Some Recent Directions," *Art News Annual* 25 (1956): 75–192.

Holliday, Betty [B.H.]. "George Hartigan." *Art News* 52 (April 1953).

"Human Image in Abstraction." *Time,* August 11, 1958.

"Is Today's Artist With or Against the Past?" *Art News* 57, no. 4 (June 1958): 26–27, 44–46, 56–58.

"Is There a New Academy? Parts I, II." *Art News* 58 (Summer 1959): 34–37, 58–60.

Kramer, Hilton. "Art: Grace Hartigan." *New York Times*, April 15, 1977.

Kramer, Hilton. "The End of Modern Painting." *The Reporter*, July 23, 1959, pp. 41–42.

Kushner, Daniel J. "Text Painting: Grace Hartigan and Frank O'Hara at Tibor de Nagy Gallery." *Huffington Post*, February 23, 2011; http://www.huffingtonpost.com/daniel-j-kushner/text-painting-grace-harti_b_827263.html.

Lacayo, Richard. "Grace Hartigan 1922-2008." *Time,* November 17, 2008.

Larson, Kay. "Gift Rap." *New York Magazine*, December 10, 1990, p. 105.

Linskey, Annie. " 'Restless creator' on a half century of American art." *The [Baltimore] Sun*, November 23, 2003.

Lipman, Jean, and Cleve Gray. "The Amazing Inventiveness of Women Painters." *Cosmopolitan,* October 1961, pp. 62–69.

Macdonald, Dwight. "Action on West Fifty-Third Street—I." *The New Yorker*, December 13, 1953, pp. 49–82.

Macdonald, Dwight. "Action on West Fifty-Third Street—II." *The New Yorker*, December 19, 1953, pp. 35–72.

Matter, Mercedes. "How Do You Learn to Be an Artist?" *New York Times*, September 2, 1973.

Mattison, Robert S. "Grace Hartigan: Painting Her Own History." *Arts Magazine* 59 (January 1985): 66–72.

McCauley, Mary Carole. "A Restless Spirit: After a Surge of Fame, Painter Reinvented Her Art and Waited for World to Catch up." *The [Baltimore] Sun*, November 17, 2008.

McNatt, Glenn. "Grace Hartigan, Clothing and Identity." *The [Baltimore] Sun*, May 25, 2000.

McNatt, Glenn. "Uncovering Hidden Layers of Grace Hartigan." *The [Baltimore] Sun*, October 28, 2001.

McNay, Michael. "Grace Hartigan: American Abstract Expressionist Painter Who Once Declared Her Own Genius." *The Guardian* [UK], November 24, 2008.

McNeill, Glenn. "Grace Hartigan, Clothing and Identity." *The [Baltimore] Sun*, May 25, 2000.

Messerli, Douglas. "The Countess of Berkeley." *Jacket*, March 2006; http://jacketmagazine.com/29/messerli-guest.html.

"Mlle Merit Awards." *Mademoiselle,* January 1958, pp. 66–69.

Munro, Eleanor. "The Found Generation." *Art News* 60 (November 1961): 38–39, 75.

Nemser, Cindy. "Grace Hartigan: Abstract Artist, Concrete Woman." *Ms.,* March 1975, pp. 31–35.

Nochlin, Linda. "Rules of Abstraction." *Bookforum,* April/May 2009.

Ober, Cara. "Grace Hartigan: A Baltimore Legend, 1922–2009." *BmoreArt*, posted November 16, 2008; http://www.bmoreart.com/search?q+hartigan.

O'Hara, Frank. "George Hartigan." *Art News* 52 (February 1954): 45.

Oldham, Ned. "Grace Hartigan." *Black & White* [Birmingham, AL], June 11, 1998.

Poirier, Richard, "The Scenes of the Self." *The New Republic*, August 2, 1993, pp. 33–39.

Pomfret, Margaret. "Grace Hartigan." *Arts Magazine* 51, no. 10 (June 1977): 43–44.

"The 'Rawness,' the Vast." *Newsweek,* May 11, 1959, pp. 113–14.

Preston, Stuart. "Abstract Roundup." *New York Times*, February 7, 1954.

Preston, Stuart. "Art: A Galaxy of Variety." *New York Times*, November 28, 1964.

Preston, Stuart. "British Artists; Painters of This Century; One-Man Shows." *New York Times*, March 30, 1952.

Preston, Stuart. "Chiefly Modern." *New York Times*, January 21, 1951.

Preston, Stuart. "Diverse Exhibitions." *New York Times*, March 10, 1957.

Preston, Stuart. "Drawings and Paintings." *New York Times*, October 28, 1962.

Preston, Stuart. "Yesterday and Today." *New York Times*, April 5, 1953.

Rago, Louise Elliott. "We Visit with Grace Hartigan." *School Arts*, May 1960, pp. 35–36.

Reinhardt, Ad. "How to Look at Modern Art in America" (cartoon). *P.M.*, June 2, 1946.

Reinhardt, Ad. "How to Look at Modern Art in America" (cartoon). *Art News* 60 (Summer 1961).

Rose, Barbara. "First-Rate Art by the Second Sex." *New York Magazine*, April 8, 1974, pp. 80–81.

Rose, Barbara. "The Second Generation: Academy and Breakthrough." *Artforum* 4 (September 1965): 53–63.

Rosenberg, Harold. "The American Action Painters." *Art News* 51 (December 1952): 22–23, 48–50.

Rosenberg, Harold. "Parable of American Painting." *Art News* 53 (January 1954): 60–63.

Rosenberg, Harold. "Tenth Street: A Geography of Modern Art." *Art News Annual* 28 (1959): 120–37, 184–92.

Russell, John. "Where to Go from Art of 1950s." *New York Times*, March 8, 1975.

Saarinen, Aline B. "Is Abstract Art Dead?" *Mademoiselle,* February 1956, pp. 154–55.

Sandler, Irving [I.H.S.]. "Reviews and Previews: Grace Hartigan." *Art News* 61, no 9 (November 1962): 11.

Schoenfeld, Ann. "Grace Hartigan in the Early 1950s: Some Sources, Influences, and the Avant-Garde." *Arts Magazine* 60, no. 1 (September 1985): 84–88.

Schudel, Matt. "Grace Hartigan, Influential Painter and Educator." *Washington Post*, November 21, 2008.

Schuyler, James [J. S.]. "Reviews: Grace Hartigan." *Art News* 58, no. 4 (May 1959): 13.

Schwartz, Martin D. "Hartigan at the Tibor de Nagy Gallery." *Apollo* 70 (September 1959): 62–63.

[Sieberling, Dorothy]. "Women Artists in Ascendance: Young Group Reflects Lively Virtues of U.S. Painting." *Life,* May 13, 1957, pp. 74–77.

Silverthorne, Jeanne. "Grace Hartigan." *Artforum* 22, no. 9 (May 1984): 91.

Soby, James Thrall. "Interview with Grace Hartigan." *Saturday Review* 40 (October 5, 1957): 26–27.

Soby, James Thrall. "Non-Abstract Authorities." *Saturday Review* 38 (April 23, 1955): 52–53.

Sozanski, Edward J. "The Challenge to Abstract Art During the '50s: The Academy of Fine Arts Displays the Work of 13 NY Artists Who Followed Their Own Muse." *Philadelphia Inquirer*, October 23, 1988.

Stein, Judith E. "Alfred Leslie: An Interview." *Art in America,* January 2009, pp. 88–95.

Steinberg, Leo. " 'Twelve Americans': Part II." *Arts* 44 (July 1956).

Stevens, Elizabeth. "The Art of Painting the Opera." *The [Baltimore] Sun*, April 3, 1986.

Stevens, Elizabeth. "Hartigan Seeking Her Golden Age." *The [Baltimore] Sun*, November 9, 1979.

Tallmer, Jerry. "A Lively Living Legend." *New York Post*, January 25, 1991, p. 47.

Tang, Mina. "Painter Discusses Evolutionary Style." *Vassar Chronicle*, November 20, 1954, p. 5.

Thompson, Walter. "Grace Hartigan at Gruenebaum." *Art in America* 76 (May 1988): 185.

Tillim, Sidney [S.T.]. "Grace Hartigan, Helen Frankenthaler." *Arts* 47 (May 1959): 56.

"Vocal Girls." *Time*. May 2, 1960, p. 74.

V.Y. "Grace Hartigan." *Arts* 45 (March 1957).

Wagner, Catherine. "Freedom, Confinement and Disguise: An Interview with Barbara Guest." *How2* 2, no. 4 (Spring-Summer 2006); How2journal.com.

Waldmar, Carla. "Hartigan is back in style." *Twin Cities Reader*, [date unknown], 1984, p. 23.

Wallach, Amei. "Art: Grace Under Pressure." *Newsday*, January 20, 1991.

Westfall, Stephen. "Then and Now: Six of the New York School Look Back." *Art in America* 73, no. 6 (June 1985): 112–21.

Willard, Charlotte. "Women of American Art." *Look,* September 27, 1960, pp. 70–75.

"Women Artists in Ascendance: Young Group Reflects Lively Virtues of U.S. Painting." *Life*, May 13, 1957, p. 75.

Young, Luther. "Grace Hartigan Took the Big Chance—and Won." *The [Baltimore] Sun*, September 13, 1981.

Index

"GH" indicates references to Grace Hartigan. All Hartigan paintings mentioned in this book are listed under "Hartigan, Grace (paintings by)"; her works in other media are listed under "Hartigan, Grace (collages, drawings, lithographs, and watercolors by)." Endnote references are denoted by "n" after the page number.